QUEEN
ALL THE SONGS

QUEEN
ALL THE SONGS
THE STORY BEHIND EVERY TRACK

Benoît Clerc

BLACK DOG
& LEVENTHAL
PUBLISHERS
NEW YORK

CONTENTS

06_ Foreword

08_ Waiting for the Queen

24

54

156

184

278

294

398

426

510_ Glossary

512_ Bibliography

82

114

216

250

324

364

458

482

518_ Index

526_ Photo Credits

Queen commands the spotlight in front of a sold-out crowd in May 1982.

FOREWORD

Queen has never been one of those rock bands with a small but devoted following. The band is beloved by millions, first finding its footing in the small concert halls of London in the 1970s and then going on to play in stadiums with enough seating for 100,000 spectators. While Queen has enjoyed a massive fan following, they were never particularly celebrated by the music press, and the four members of the band didn't really adhere to the preconceived notions of how rock stars should behave. No hotel rooms were destroyed, and there was no ubiquitous drug use within the group. Far from rock 'n' roll caricatures, the members of Queen forged a reputation as hard workers who loved to spend their time recording in the studio and performing onstage. The group recorded an astonishing fifteen albums, often driving themselves (and their producers and technicians) to exhaustion.

Although carried by a lead singer known for his legendary charisma and stage presence, Queen was a collective made up of four personalities with boundless creativity: Brian May on guitar, John Deacon on bass, Roger Taylor on drums, and Freddie Mercury on vocals. Each member of the group participated in the writing of Queen's unforgettable catalog of songs, and all four men played an equally important role in shaping Queen's lasting musical legacy.

Since the release of their first album in 1973, the group has sold more than 300 million albums worldwide. The sheer number of hits can make you dizzy: "I Want to Break Free," "Another One Bites the Dust," "Radio Ga Ga," "Killer Queen," "We Are the Champions," "We Will Rock You," "Don't Stop Me Now," "The Show Must Go On," and of course the group's masterpiece, "Bohemian Rhapsody."

Generations of fans have followed the band, and the teenagers who flocked to the group in the early 1970s have passed their love of Queen on to their children, and to their children's children. Thanks to the phenomenal success of Bryan Singer's 2018 film *Bohemian Rhapsody*, young music lovers around the world have rediscovered the timeless songs written by the four brothers in arms. As further proof that time has done nothing to dampen Queen's legacy, the original music video for "BoRap" (as fans call it) now has over a billion views on YouTube.

Queen All the Songs celebrates the work of May, Mercury, Deacon, and Taylor, analyzing each song recorded by the quartet with love for the process and respect for the group. Some demos that the group recorded are not referenced in this book (including "Feelings" and "Silver Salmon") in order to focus on the titles that the musicians themselves deemed worthy of refining, recording, and presenting to the public as part of an album.

This book focuses on the adventures of the four men who made Queen into a legendary band. Special attention is paid to the writing and recording process of the group's classic songs and albums, with sidebars offering deep dives into the lives and loves of each of the four original band members. For this reason, *Queen All the Songs* offers smaller overviews on the group's side projects, including *The Cosmos Rocks* (the only studio album released by Queen + Paul Rogers), and the group's latest collaborations with Adam Lambert. Though these new recordings have introduced Queen to an entirely new generation of fans, they were created after Freddie's passing and are therefore given shorter analysis.

No study of Queen's repertoire, no matter how thorough, could be long enough and complete enough to fully bear witness to the major accomplishments achieved by these four gifted musicians. Instead, the book you have in your hands intends to shed light on the hidden stories behind the creation of these classic songs, offering behind-the-scenes secrets that can now be revealed.

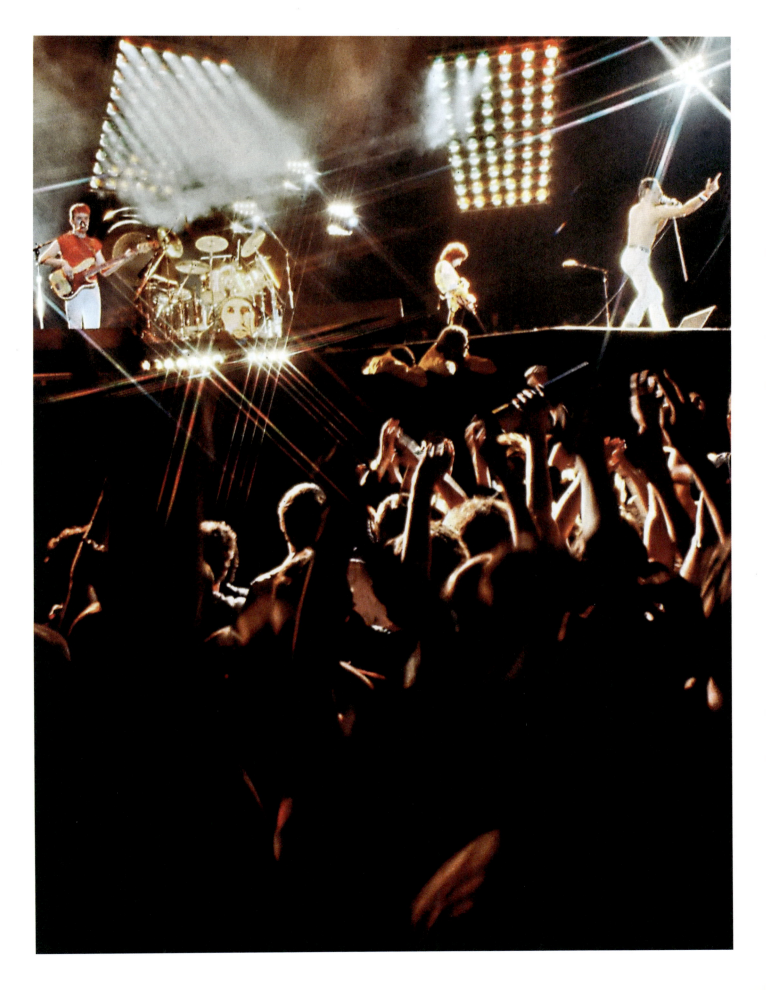

Roger Taylor, Brian May, John Deacon, and Freddie Mercury in 1974, photographed by Peter Mazel.

WAITING FOR THE QUEEN

It was in the swinging London of 1968 that the group Smile first appeared on the rock 'n' roll scene. This was a period in music history that was still under the soothing influence of Bob Dylan's American folk, and the Beatles were still undisputed kings of pop. But in Britain, the first inklings of a new wave of music were building. A new, frenetic energy seemed to be steadily replacing the mellow tones of the "flower power" era. The flower power movement had originated in the American West and it reached its apogee at the Woodstock festival in 1969, before coming to a tragic end a few months later at Altamont. A young fan died during a performance by the Rolling Stones, stabbed by one of the Hells Angels who was supposed to be providing security for the concert. It was also in 1968, in London, that the whirlwind of Led Zeppelin was forming, and this band's success cleared away all the memories of the "Summer of Love" and the hippie movement. The sky seemed to darken on album covers, and we discovered Deep Purple and Black Sabbath, who, with Jimmy Page's and Robert Plant's Led Zeppelin, formed the "holy trinity" of heavy metal.

It was into this turbulent setting that Smile was born, a young group consisting of three exuberantly dressed, well-educated musicians, confident with their high-pitched voices. They could be found at Kensington market, where their drummer, Roger Taylor, had a secondhand clothing stall. They got themselves noticed on the stages of the city's music venues, and their songs started to meet with some success.

From 1984 to Smile, Brian May's Early Days

The future founder of Smile was a man named Tim Staffell. In 1965 he was attending Ealing Art College in London, when he made the acquaintance of Brian May, a student of astrophysics at Imperial College London. Together, they scoured the city's clubs and watched bands like the Yardbirds perform. They soon started to frequent the frenzied performances of Jimi Hendrix in the smoky cellar venues of Britain's capital city, following the future rock legend as he appeared night after night in locations all around London and the surrounding suburbs in the mid-1960s.

In the summer of 1964, Brian May and his friend Dave Dilloway had formed their first group, called 1984 in homage to George Orwell's famous novel, which was experiencing a surge in popularity at the time. Tim Staffell soon joined them, and once the group was complete (a total of six musicians: two guitarists, a bassist, a drummer, a pianist, and a singer), 1984 was ready to cut its teeth along with the ever-growing number of fledgling rock groups forming all around the city. On October 28, 1964, the band played its first concert at St. Mary's Church Hall in Twickenham. Other bookings soon followed, but the stress of playing constant gigs finally got the better of the young Brian, who started at Imperial College London in the autumn of 1965. Despite an important gig with Pink Floyd and Jimi Hendrix during the Christmas on Earth Continued Festival on December 22, 1967, the guitarist decided to leave the group, choosing to focus on his studies rather than continuing to chase the

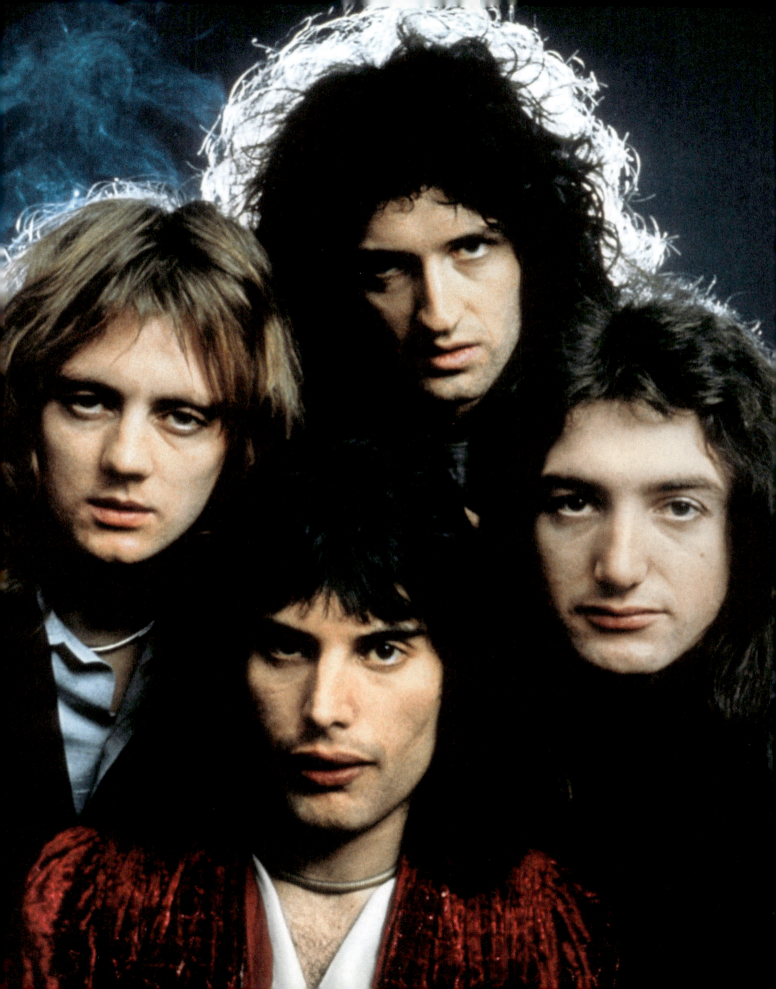

Freddie Mercury interviewed by a *Daily Express* journalist in his apartment in Shepherd's Bush, London, 1969.

Brian May, Roger Taylor, and Tim Staffell pose in front of the Royal Albert Hall in London as part of their first photo shoot for Smile.

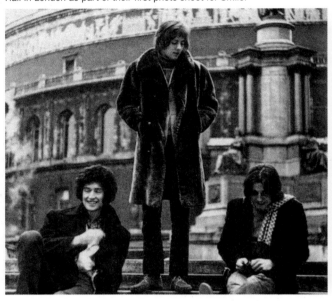

elusive dream of rock stardom. In a possible sign that Brian had made the right decision, when the remaining members of the group left the stage in the small hours of the morning on December 23 (their set was supposed to be in the evening of the twenty-second, but they didn't manage to take the stage until after midnight), the musicians of 1984 found their dressing room had been burgled, and their cars towed away and impounded.

Brian May and Tim Staffell began to work together again in the autumn of 1968, when they decided to pursue another project, accompanied for a while by keyboard and guitar player Chris Smith. A new start for a new band required a new name, and the group settled on Smile. The band's logo, which was created by Staffell, featured a large smiling mouth showing an impressive set of teeth. Coincidence or otherwise, the famous Rolling Stones emblem, designed by a London Royal College of Art student called John Pasche, appeared only two years after Smile's.

First Compositions, First Concerts

May and Staffell composed new music as a duo and also retained some cover songs in their repertoire. Both members agreed that finding an expert drummer was an essential next step for the group. One morning, May put up a little notice in the corridors of Imperial College, which, "in all modesty," advertised for nothing less than: "a Ginger Baker/Mitch Mitchell–type drummer"! Only someone with a fiery temperament would be able to measure up to the hotheaded drummers of Cream and Hendrix. This person turned out to be a young man named Roger Taylor, who was newly arrived in town with the express goal of joining a rock group as soon as possible. Taylor was determined to become a star. Brian May recalls his early experiences of watching Roger play during Smile's initial jam sessions in the music rooms of Imperial College. There were only two acoustic guitars, some bongos, and a drum kit in the little music room, but that was enough to leave a lasting impression on May: "I remember the first time I saw Roger on drums, his flamboyance blew me away."[1] The fact that the drummer took the trouble to tune his drums one by one was also enough to convince the guitarist, who was impressed by Taylor's high degree of professionalism. The chemistry worked straightaway between the three musicians, and a spirit of camaraderie that was necessary for the project to work well was quickly established. Smile was complete. When Pink Floyd came to Imperial College for a one-off concert on October 26, 1968, the support slot was offered to the new group. This was a godsend opportunity for Smile's first concert, and also quite a baptism by fire! Unfazed, the trio acquitted themselves well, delivering a brand of rock that would have been categorized as progressive for its time.

Freddie Mercury and the members of the group Ibex, in Bolton (near Manchester), on August 23, 1969. While the Woodstock festival had rocked America just eight days before this photograph was taken, Great Britain was unwittingly preparing for the birth of Mercury the icon.

While pursuing their studies, the three friends lined up other concerts, including supporting gigs for Yes and Tyrannosaurus Rex (subsequently T. Rex). Gradually the group began to establish quite a reputation. After a concert at the Revolution Club in London on April 19, 1969, the group met Lou Reizner, an executive producer with Mercury Records. Reizner was impressed by their stage performance and offered them a recording opportunity. The contract was signed in May, and recording began the following month at Trident Studios at St. Anne's Court. At the controls behind the console was a man named John Anthony, a young producer whose path was destined to cross with the musicians of Smile again later in their careers. Three numbers were recorded at that original session: "Earth" and "Step on Me," which made up the A- and B-sides of a single, and "Doin' Alright," which, for the time being, was not used. The disc was released in August 1969, but only in the United States, where Smile was unknown, and it did not sell at all. Disappointed, the group focused on concerts, and recorded some more songs in September, including the delicate "April Lady," sung by Brian May with backing vocals from Roger Taylor.

A Newcomer to the Group

The mood in Smile was not good after the relative failure of their first single, and the only person who seemed to believe in their potential was a friend of Tim Staffell, whom he had met at Ealing Art College. This newcomer had a passion for graphic arts, fashion, and literature, and he was presented to the other members of the group, who immediately took a liking to him. He admired their music and was always happy to accompany them to their concerts. He also didn't hold back in sharing his own vision for the group, losing no time in letting them know what he would do if he was their vocalist, which was a role that was currently occupied by his friend, Tim. The new groupie was no stranger to the microphone, and in recent months he had worked with a number of bands, including Ibex, Wreckage, and Sour Milk Sea, and he was confident that his inclusion in Smile would bring success to the group. In April 1970, tired and disappointed with the group's lack of success, Tim Staffell jumped ship to join the band Humpy Bong, leaving a vacancy for a new lead vocalist in Smile. The microphone was promptly taken up by the loyal admirer who had supported the group for many months. His name was Freddie Bulsara.

The new trio worked brilliantly. There was an excellent understanding between each of the members, and the young men worked tirelessly together. Always a source of ideas and suggestions, and determined to take this group to the top, Freddie suggested a change of name to his fellow band members. Roger and Brian, both great science fiction

QUEEN: ALL THE SONGS 11

Queen in 1973, preparing to conquer the United Kingdom … and the rest of the world.

enthusiasts, initially suggested the Grand Dance (inspired by "the Great Dance," a quotation from the C. S. Lewis novel *Out of the Silent Planet*) or the Rich Kids (coincidentally, this was the name chosen in 1977 by Glen Matlock, formerly of the Sex Pistols, for his new musical project). Naturally, and as usual, the singer already had something in mind. Seeking to assert a dandyish image for himself, and to convey a provocative and an ambiguous image for his new group, Freddie suggested Queen, which he hoped would be construed in the gayest possible sense, and with heavy camp overtones. This was not a name that his acolytes found convincing. Taylor remembers his initial reaction: "I didn't like the name originally and neither did Brian, but we got used to it. We thought that once we'd got established, the music would then become the identity more than the name."[2] Bulsara did not share this point of view: for him, a name was everything. For this reason, in the spring of 1970 he changed his own name and was thenceforth known as Freddie Mercury. Freddie also designed the group's logo, including the astrological signs of the group's four members: two majestic roaring lions for Roger and John, and a crab with enormous claws for Brian; and Virgo Freddie symbolized his own sign using two innocent fairies that both looked toward the letter *Q*, which was encircled by a crown. This crown represented the heights of stardom that the group was determined to reach. A phoenix looks down over the logo, ready to defend its comrades against any attack. This protection was to prove invaluable against the journalists of the British musical press…

Queen, On the Path to the Throne

In 1970, as the pace of rehearsals intensified, the group tried out multiple bass players. At the first series of Queen concerts, the following players all succeeded each other: Mike Grose, a survivor from Smile, then Barry Mitchell, and finally Doug Bogie. The compositions of new songs continued to flow, including the very Zeppelin-esque "Stone Cold Crazy" and "Doin' Alright," which May had co-written with Tim Staffell in the Smile days. In January 1971, at an evening event organized at the Maria Assumpta Teacher Training College in Kensington, May and Taylor met John Deacon. This young bassist had attended an earlier Queen concert on October 26 but hadn't been impressed. However, he did have some chemistry with the other three musicians, and an audition was arranged. On the day, equipped with a gleaming Rickenbacker bass, Deacon made a good impression. His place in the group was clinched when he began discussing his passion for electronics. (Much later in the group's career, Deacon designed the Deacy Amp, into which Brian May plugged his Red Special guitar at numerous recording sessions.) Deacon officially joined the group in March 1971, and went onstage for his first concert at Surrey College on July 2 of the same year. After their search for a bassist, the Queen band members would remain unchanged until the premature death of Freddie Mercury in 1991.

Gig dates continued to be booked, often at the universities attended by the musicians or their friends, but also in some smaller locations, ranging from the most obscure to the relatively famous. For example, on October 31, 1970, they played the famous Cavern Club in Liverpool, where the Beatles had cut their teeth ten years previously. The fortunate audience there got to experience Queen's new numbers, including: "Keep Yourself Alive," "Liar," and "Great King Rat." The group rehearsed relentlessly and kept themselves ready for any opportunity that might arise. Despite the inevitable disappointments and annoyances of their early days, Queen hung in there, and destiny finally smiled on them. Terry Yeadon and Geoff Calvar, two sound engineers at Pye Studios in central London, who had helped Smile to record their first demos ("Step on Me" and "Polar Bear"), got in touch with Roger and Brian and offered them a contract. They had both just taken over the De Lane Lea Studios in Wembley, and they needed a group that played at high volume to test the location's acoustics and sound insulation. In exchange, the group would be able to record a free demo. Five numbers were born from these sessions, which were supervised by the house sound engineer, Louis Austin: "Liar," "Keep Yourself Alive," "Jesus," "The Night Comes Down," and "Great King Rat."

It was at the De Lane Lea Studios that the group would meet John Anthony and Roy Thomas Baker, two producers at Trident. This production company was based in London's Soho neighborhood and had its own recording studios, as well as a complete management and publishing structure for their artists. Barry and Norman Sheffield ran Trident, and they were always looking for new talent. Following a good showing on March 24, 1972, at Forest Hill Hospital in London, the first Queen demos convinced the Sheffield brothers. Some of the terms of the contract the

12 INTRODUCTION

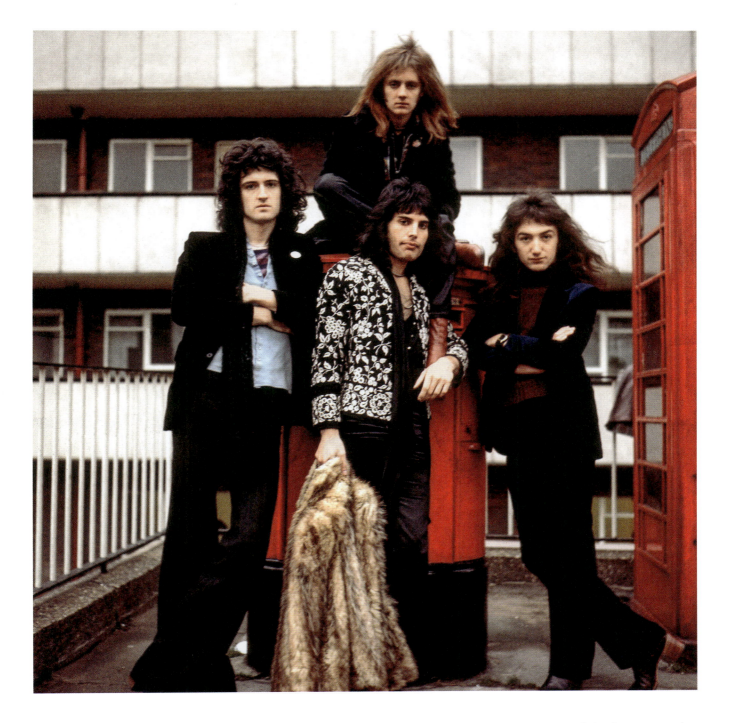

Sheffields offered the group, especially those points dealing with publishing rights, management, and rights linked to the recordings did require clarification. Once the contract was finally signed on November 1, 1972, the group began to rehearse and was given access to the recording studios in the summer on 1973 so they could work on their first album. A team was made available to the group and it included: David Hentschel, who supervised the sessions, and Roy Thomas Baker and John Anthony, who provided the production. At the height of their reputation in the early 1970s, Trident Studios had limited free slots for Freddie and his band. The musicians of Queen were relative unknowns at the time, and they could practice only at night, after the studios' occupants had left. Some of the big names that were recording at Trident in those days included David Bowie, Elton John, and Paul McCartney. The creative process was exhausting but also cathartic for Queen. The many compositions May and Mercury worked on were edited and tweaked until all the best content was created, and each idea had been experimented with to the maximum point. The members of the group invested all their energy in the recording process, and they devoted themselves to the task until they were finally worn out. This was the beginning of a long love affair between the members of Queen and the recording studio. Their recording sessions would eventually take them from Munich to Montreux, via rural France.

QUEEN: ALL THE SONGS 13

The young Farrokh Bulsara, who was to become Freddie Mercury.

FREDDIE MERCURY: THE BIRTH OF A STAR

Farrokh Bulsara was born on September 5, 1946, in Zanzibar, not far from the coast of what is now Tanzania. The little island offered the young boy the perfect setting for a gentle and peaceful childhood, until his departure for India at the age of seven. It was to this far-off continent that his parents, who were of Indian origin, sent him to study at the prestigious St. Peter's School in Panchgani, located approximately thirty miles from Bombay (now Mumbai). Far from his family, the young Farrokh mastered English and discovered sports, including English boxing and running. He spent the following eight years at this school, where his teachers nicknamed him Freddie. He learned discipline and rigor, and soon joined the school choir and took up piano lessons and dramatic art classes, which he attended assiduously. In 1963, after eight years of study, Farrokh failed his exams. He then returned to his family in Zanzibar, where serious ethnic and religious tensions were emerging. After the massacre of an estimated ten thousand people during the so-called Zanzibar Revolution on the nights of January 11 and 12, 1964, the Bulsaras fled their island home for the relative safety of London.

In the British capital, a new life awaited Freddie, who studied fine art at Isleworth Polytechnic. Then in 1966 he went to Ealing Art College, with the goal of becoming an illustrator. He soon tired of this new objective and took an interest in a young guitarist named Jimi Hendrix. Freddie attended a large number of Hendrix's London concerts. Before long, he got to know Tim Staffell, a fellow student at Ealing and singer for the group 1984.

Freddie Bulsara envisaged a new future for himself with Tim. He also became friends with Roger and Brian, 1984's drummer and guitarist, and then he met Mary Austin, a nineteen-year-old woman who worked at Biba, which at that time was a very fashionable London department store. Freddie and Mary established a love and friendship that lasted until his death.

Freddie was interested in fashion and literature. He wore provocative and eccentric clothes, and sang in a group called Ibex, with which he performed for the first time onstage on August 23, 1969, in Bolton, near Manchester. In the autumn of that year Freddie also sang with a band called Wreckage, then with a band called Sour Milk Sea, whose drummer, Boris Williams, would go on to found the Cure. Freddie was very motivated by the idea of joining a new group that had already established itself as the opening act for Deep Purple. He was so nervous on the day of the audition that he asked Roger Taylor and John Harris (who, at that time, was sound engineer for Smile) to go with him. Pretending to be assistants to the aspiring lead singer, Taylor and Harris carried a wooden box containing his microphone. While Freddie's makeshift entourage must have had a certain impact, it was his vocal performance that convinced the members of Sour Milk Sea. But after a few concerts, Freddie grew tired of the group and departed, preferring to focus on the secondhand clothes shop that he helped to run with Roger. It was at this time that he grew close to the members of Smile, whose own lead singer was set to depart the group in April 1970.

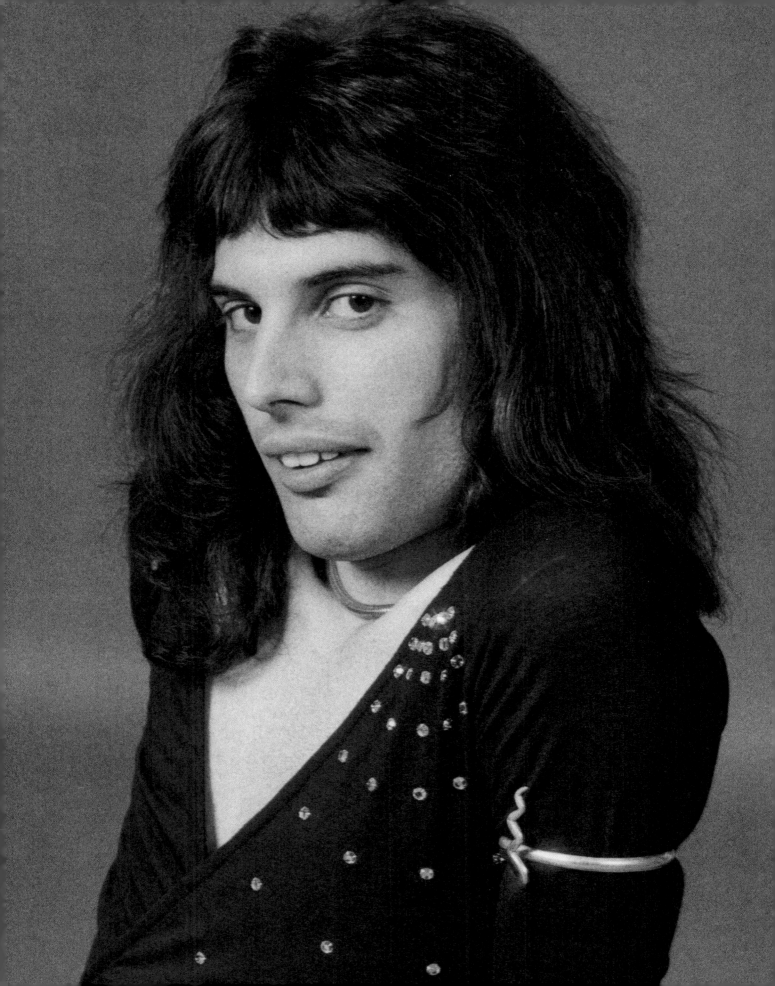

Brian May, the inspired Queen guitarist, in 1973.

BRIAN MAY: THE ROCK 'N' ROLL ACADEMIC

The son of Ruth and Harold May, Brian May was born on July 19, 1947, in Hampton Hill, in the outskirts of London. He grew up in a modest neighborhood and went to primary school in Feltham, not far from the street where Freddie Mercury and his family had moved after fleeing Zanzibar. This was a surprising coincidence, but Brian and Freddie did not meet at the time. Brian's father, Harold, who was a radio operator during World War II, was then working as a draughtsman for the Ministry of Aviation. Among other things, he was involved in the design of the Blind Landing System for aircraft, which would eventually be used for the future supersonic aircraft, the Concorde. Brian was introduced to music at a very young age by his parents, particularly his mother. His father helped him to make a crystal radio receiver, or galena crystal detector radio—on which he listened to Radio Luxembourg with some old wartime German headphones. He reluctantly attended piano lessons but seemed to genuinely enjoy the ukulele lessons given by his father. On his seventh birthday his parents gave him his first acoustic guitar, an inexpensive Egmond, which he treasured; he even presented it to the public at a press conference on October 1, 2014, when his book *Brian May's Red Special* was launched. The Red Special is the electric guitar he made with his father and which he used throughout his career, only very rarely bringing on another model for a music video, or for a concert. As Harold did not have the means to give his son a Fender Stratocaster—which was the guitar used by Hank Marvin (leader of the Shadows) and Buddy Holly—Harold decided to set about making a unique model, designed using recycled materials, so that he could help his young son realize his dreams. It should be said that they had already constructed a telescope together, and that father and son were very close. The guitar construction project still further cemented this closeness between Brian and his father. In the autumn of 1963, the Red Special was completed, and from then on Brian was never without it. Even though music was only a hobby for Brian, it increasingly gained an important place in his life. With his fascination for astronomy, he was brilliantly successful in his studies at the prestigious Hampton Grammar School, and then he attended the no less prestigious Imperial College London. His college studies began in the autumn of 1965, and he studied astrophysics. His great passion for the subject was further materialized in his doctoral thesis: *A Survey of Radial Velocities in the Zodiacal Dust Cloud* in 2007, and he was awarded his doctorate forty-two years after he started his studies.

Back to 1965, which was when Brian met Tim Staffell, a student at Ealing Art College in London. Together they formed the group 1984, which had May on guitar, Staffell on vocals, Dave Dilloway on bass, Richard Thompson on drums, John Sanger on piano, and John Garnham as second guitar. Brian involved himself in this project while continuing his studies, and the group began to line up many concerts, eventually booking themselves as the opening band for May's idol, Jimi Hendrix, on May 13, 1967, at Imperial College. Despite these opportunities and the recording of an initial demo, the young May decided to focus on his academic work and left the group at the beginning of 1968. Elements of family pressure, and the desire not to let his father down, were probably contributing factors in his decision-making. Fortunately for music lovers everywhere, Brian revised his decision in the fall of 1968 when he founded Smile with Tim Staffell. He was once again ready to do battle on the stage, and he was always equipped with his trusted Red Special.

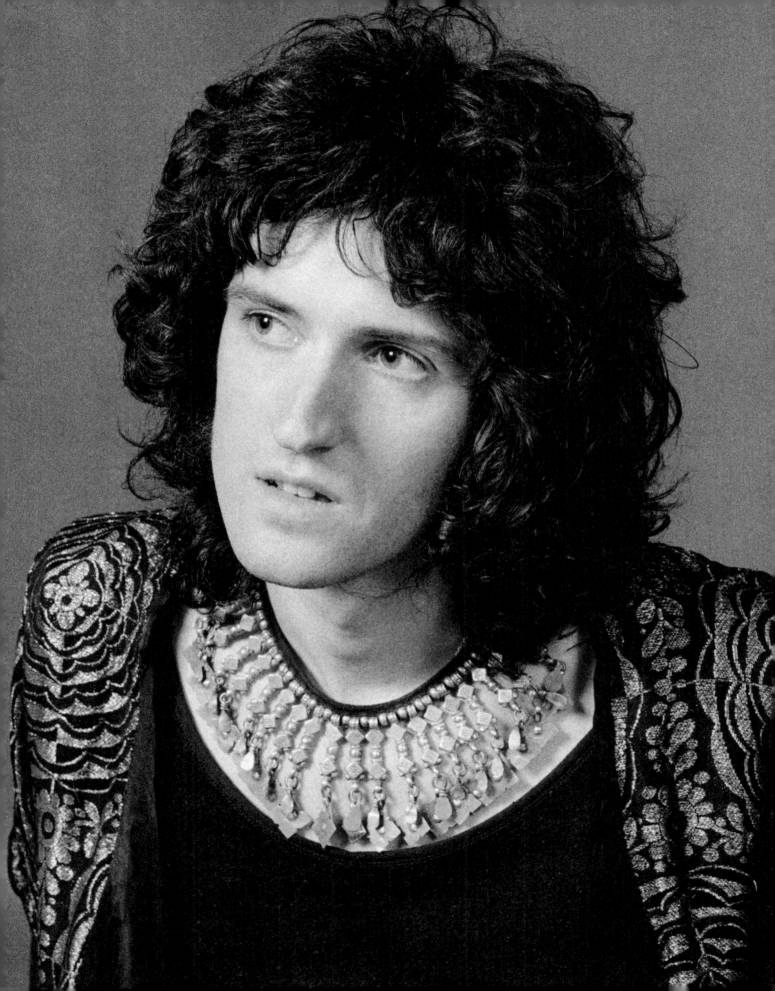

No fan could resist the charm and scathing wit of Queen's drummer, Roger Taylor.

ROGER TAYLOR: THE "LEGENDARY CORNISH DRUMMER"

During a concert tour for Smile that passed through his childhood town, Taylor mockingly nicknamed himself the "Legendary Cornish Drummer." It was this sense of humor and fiery temperament, along with his compositional talent and inimitable drumming abilities, that came to characterize Roger as a member of Queen.

Roger Meddows Taylor was born on July 26, 1949, in King's Lynn, in East Anglia, northeast of London. He and his family soon moved to Truro, in Cornwall in the southwest of the country. Very early on he learned to play the ukulele, and at the age of ten he joined his first group, the Bubblingover Boys, where they played a mix of rock (influenced by Jerry Lee Lewis and Little Richard) and jazz. In 1960 he attended the prestigious Truro Cathedral School, where he was required to be actively involved in the choir. This was his opportunity to discover vocal harmonization, which would prove valuable as a member of Queen. At the age of twelve he officially became a drummer. He built his first drum kit using a tom and a bass drum given to him by his father, then added other elements that he acquired gradually. He pursued his musical path with the support of his family, playing guitar in the group the Cousin Jacks before joining Johnny Quale and the Reaction in 1965. They played numerous concerts, until the departure of Johnny Quale in 1966, which left the group without a lead singer. Roger Taylor filled this vacancy, drumsticks in hand, confidently placing his drum kit at the front of stage during the Reaction concerts. Taylor moved to London in the fall of 1967 and began a course in dental surgery at the London Hospital Medical School. A few months later, Taylor was still thinking of ways to get himself back onstage when his roommate, Les Brown, showed him a little advertisement he'd found in the hallways of Imperial College. Roger responded to the ad and shortly afterward was called to audition for the group, Smile. This was the start of a big adventure for the already very accomplished Roger Taylor, then aged nineteen.

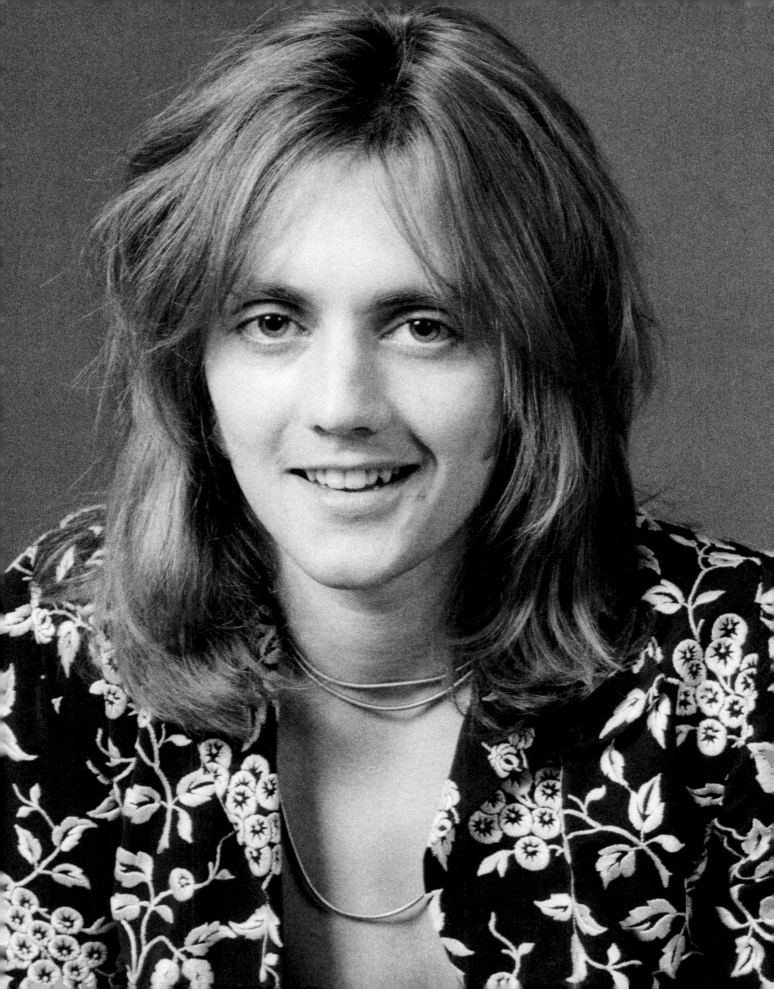

Queen's sensible and reserved bassist, John Deacon, in 1973.

JOHN DEACON: THE SOFT POWER

John Richard Deacon was born on August 10, 1951, in Leicester, England. He grew up on the outskirts of the city, initially in Evington, then in Oadby, where he moved in 1960 with his sister and parents, Arthur and Lillian. The young boy was quiet and reserved, but he was also fascinated by electronics, and he spent much of his time tinkering and making gadgets from spare parts. In 1965, just before he turned fourteen, John went to Beauchamp Grammar School, in the south of Leicester. Alongside his studies, he joined the group the Opposition, where he played guitar with bassist Clive Castledine, lead singer/guitarist Richard Young, and drummer Nigel Bullen. The Opposition played covers of songs by the Yardbirds and the Animals, and Deacon found himself attracted to the soul sounds of Detroit's Motown label, which was created by Berry Gordy in 1959 under the name of Tamla. The Opposition followed the traditional path of adolescent rock bands of the period, opportunistically taking whatever gigs they could get. In 1966, when Clive Castledine left the group, John took up the bass. The lineup changed, and the group renamed themselves the New Opposition before changing their name to Art in 1968.

This musical adventure lasted only a while, and John remained focused on his studies. His life changed when he met Brian May and Roger Taylor in 1971, and he joined Queen, becoming its final bassist. Quiet and inventive, Deacon played a key role in the group. Although it took him a year or so before he felt completely part of the band, he went on to compose some of Queen's greatest hits: "Another One Bites the Dust," "I Want to Break Free," and "You're My Best Friend," as well as many other successful but less well-known songs, including "Cool Cat" and "Rain Must Fall," which he co-wrote with Mercury.

Following a life devoted to rock 'n' roll, John Deacon—nicknamed Deaky by his musician friends—decided to leave Queen in 1997 and to live outside of the show business limelight, close to his wife and children. Even now, at a distance, Deacon is still the member of the group most focused on the business side of things, just as he was during the glory days of Queen.

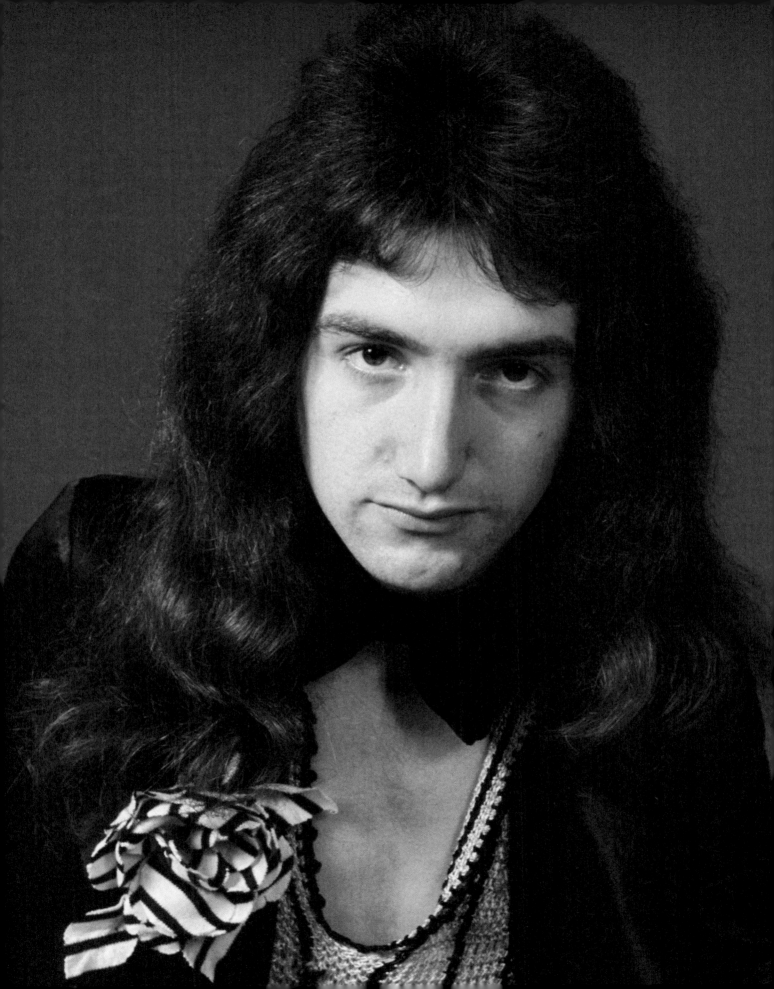

NORMAN SHEFFIELD: A VISIONARY BUSINESSMAN

By the time Queen met Norman Sheffield in the fall of 1971, he was already an established player in the world of British music. As the owner of Trident Productions Ltd.—which has its offices at 17 St. Anne's Court, in the heart of London's fashionable Soho neighborhood—the businessman managed an impressive mix of renowned recording studios that gave birth to a litany of famous albums, including The Beatles' *Abbey Road*. A former drummer himself, Sheffield gave up the instrument and opened a record store in the suburbs of London when he decided to start a family. Shortly after the store opened, he was able to install a small recording studio above the shop with the help of his brother, Barry. Together, the two brothers began recording local young artists after the store had closed for the day. Norman's own history as a working musician undoubtedly informed his gift for discovering new talent. Word of mouth soon spread, and the roster of artists hoping to record with the Sheffield brothers grew. In March 1968, Norman and Barry decided to move their operation to Soho, where they officially formed Trident Studios and began to build a small music empire. The Beatles hastened to the studios so they could finish the recording of *Abbey Road*, impatient to use the eight-track tape recorder that the Sheffields had just installed. This new piece of technology was one of the first eight-tracks in all of Europe! As their operation grew, the Sheffields began to play a larger role in the professional development of the groups they took on, eventually taking over talent management as well as recording and production duties under the umbrella of Trident Productions Ltd.

A Tumultuous Relationship with Queen

After listening to Queen's early recordings, which were laid down at De Lane Lea Studios in September 1971, Norman Sheffield offered the group a global management, production, and publishing contract. He made studio space available for the group during Trident's off-peak recording hours, and he also offered the fledgling group the expertise of two in-house producers: John Anthony and Roy Thomas Baker.

This working relationship would last through Queen's first three albums, but tensions grew between the group and their management team as the band became more and more successful. It seemed to the members of Queen that most of their profits were going to Trident instead of to the band members, who continued to live in a state of relative squalor. As negotiations over money grew tense, Norman Sheffield became the group's sworn enemy, with Freddie Mercury even going so far as to write a song about the terrible working relationship. The resulting track, "Death on Two Legs (Dedicated to . . .)" became the lead cut from *A Night at the Opera*. After much back and forth, and a significant amount of legal pain, Queen officially parted ways with Trident in August 1975.

A Considerable Legacy

The break with Queen came as a bitter shock for Norman Sheffield, who felt humiliated and betrayed after all the work he put in to help the group succeed. In later years, Brian May and Norman Sheffield would agree that the real problem had been a simple breakdown in communication between the group and Trident. Perhaps if certain discussions had taken place, and if certain assurances had been made, the situation would not have deteriorated so quickly or gotten so ugly. In the end, the businessman who was once so loathed by Freddie and the rest of the band went on to be appreciated and celebrated for his immense talent and his innate kindness.

Sadly, Norman Sheffield died in 2014, leaving behind an incredible musical legacy that made him a pillar of the international rock scene in the late 1960s and early 1970s. Many classic albums of the era were recorded at Trident Studios, including *Transformer* by Lou Reed, *The Rise and Fall of Ziggy Stardust and the Spiders from Mars* by David Bowie, and Elton John's self-titled second album, which includes the timeless track "Your Song."

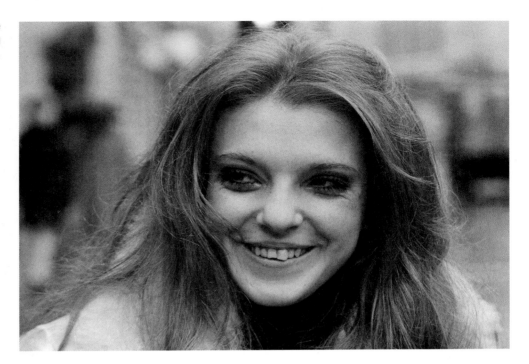

Mary Austin, Freddie Mercury's lifelong friend and confidante.

MARY AUSTIN: FREDDIE MERCURY'S MUSE

When Freddie Mercury met Mary Austin in 1970, she was a saleswoman at the fashionable Biba department store on Kensington High Street in London. All four members of Queen shopped at Biba regularly, as it was considered to be on the cutting edge of fashion. Brian May first noticed Mary and the two soon began dating. Eventually, Brian and Mary's short-lived fling came to an end and Freddie, who had become quite enamored with Mary during his visits to the store, made his intentions known.

The two lovebirds quickly moved in together in a tiny flat on Victoria Road. They shared a strong love for decorative objects, pretty tableware, and fashion, and the two soon made their new house into a home with a flair that was distinctly their own. Mary felt safe with Freddie, and all their friends from the time have testified to the happiness and tranquility that reigned in their small apartment.

Love of My Life

Freddie's bond with Mary Austin would change over time as the two shifted from a romantic relationship to a platonic friendship. But as Freddie ascended to the heights of rock and roll stardom, Mary would always serve as a source of strength and security, offering Freddie a safe space where he could always be himself. As Queen rose in popularity between 1972 and 1975, Mary was frequently at Freddie's side. She paid the rent on their Holland Road apartment when they moved in, and she kept their home in working order while Freddie was away on tour with the band. Of course, the matter of Freddie's sexuality was a constant source of tabloid fodder, and he happily teased journalists who got up the nerve to ask if he was gay. While Mary had her own questions about Freddie's predilections, the two never discussed the issue.

In the spring of 1975 Freddie met David Minns, who was then working as the manager for singer Eddie Howell. The two fell in love almost immediately, and while Freddie's sexuality may have remained a taboo subject, Freddie and David began to appear together on numerous occasions. Freddie wrote the song *You Take My Breath Away* for David, and the track eventually appeared on the album *A Day at the Races*. At the end of 1976, with Freddie and David spending more and more time together, the romantic relationship between Freddie and Mary finally came to an end.

Although they were no longer romantic partners, Mary and Freddie remained inseparable until the singer's death in 1991. After Freddie's passing, Mary was named as the inheritor to half of his considerable fortune. But perhaps the greatest tribute Freddie paid to the great love of his life was the song he wrote for her. Mary served as the inspiration for "Love of My Life," which appeared on *A Night at the Opera*.

ALBUM

QUEEN

Keep Yourself Alive . Doing All Right . Great King Rat . My Fairy King . Liar . The Night Comes Down . Modern Times Rock 'n' Roll . Son and Daughter . Jesus . Seven Seas of Rhye…

RELEASE DATES
United Kingdom: July 13, 1973
Reference: EMI—EMC 3006
United States: September 4, 1973
Reference: Elektra—EKS 75064
Best UK Chart Ranking: 24
Best US Chart Ranking: 83

Queen in Freddie Mercury and Mary Austin's flat on Holland Road, West Kensington, London, in early 1974.

HER MAJESTY'S FIRST STEPS

In January 1972, Queen began rehearsals of the titles that would make up their first album. Since the contract between the group and Trident Audio Productions had not yet been signed, a tacit partnership was established. Two producers were made available to the musicians: John Anthony and Roy Thomas Baker, but while they were granted access to Trident's recording studios at 17 St. Anne's Court, this was solely during slots not used by the other artists.

Laying the Foundations

The recording sessions for the first album began in the summer of 1972. John Anthony, the first producer assigned to its creation, quickly succumbed to the pace imposed by the four musicians. The nighttime recording sessions were held between 2 a.m. and 8 a.m. and took a heavy toll on his health, especially since he was also overseeing the recordings of albums by Home and Al Stewart. Anthony decided to take a break in Greece, and his colleague Roy Thomas Baker took over producing responsibilities. The young producer, who got his start at Decca before joining Trident in 1969, had already achieved success with titles including "All Right Now" by Free and "Bang a Gong (Get It On)" by T. Rex. The pace was ferocious, and like his predecessor John Anthony, Baker soon began to tire, but he was energized by the young group that was hungry to prove itself. May recalls: "We were fighting to find a place where we had technical perfection."[3] Each guitar was recorded four times and the vocal recordings were repeated, so much so that the general sound ended up being deteriorated due to the effect of multiple track bouncing, which is the process of combining multiple track stems into one master mix in order to save space on the console. The group had sixteen tracks, but this didn't seem to be enough for Baker, especially since the recording settings were lost every day, as Baker was forced to reset the console for the next artists coming in to use the studio. As a result of the excessive layering of tracks, hissing and natural degradation of the sound started to appear, but the group seemed happy with this effect, which unintentionally gave the mix a heavier *color*. Regarding the recording of the drums, Roger Taylor said: "There were a lot of things on the first album I don't like, for example, the drum sound."[4] Indeed, the percussion mixing was very muted and kept in the background—which was the fashion at the time. A quick listen to two other sonic masterpieces recorded during this period—*The Rise and Fall of Ziggy Stardust and the Spiders from Mars* by David Bowie (recorded at Trident Studios at the same time as *Queen*) and *Madman Across the Water* by Elton John, released in 1971—reveals the diminished role allocated to drums on pop albums in the early 1970s.

After his well-deserved rest in Greece, John Anthony resumed his position as producer alongside Roy Thomas Baker. He was then assisted by Mike Stone, a jack-of-all-trades at Trident Studios, who quickly became Queen's appointed sound engineer. Anthony taught his young apprentice the method he intended to apply to the mixing of the album: "We [had] to make this sound like a live

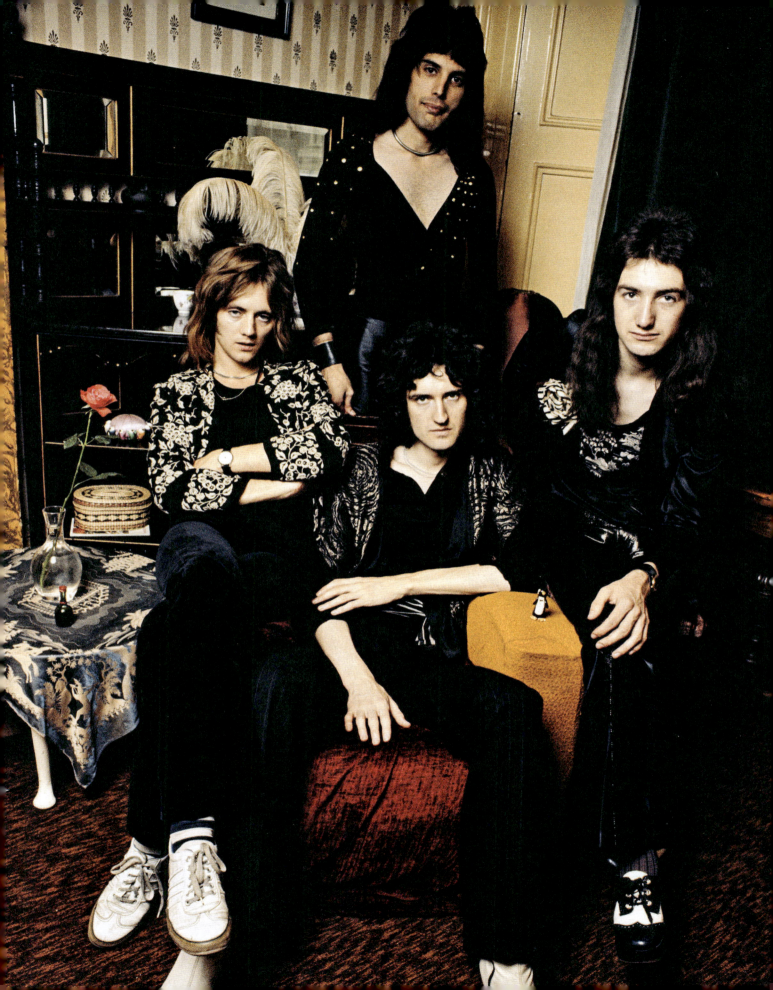

> During a session at Trident Studios, Freddie, Roger, and Brian were asked by producer Robin Cable to participate in the recording of two covers: "I Can Hear Music" by the Beach Boys and "Goin' Back" by Dusty Springfield. The resulting 45 rpm was released under the pseudonym of Larry Lurex (in reference to the singer Gary Glitter) and went on to become a highly sought after record for collectors.

FOR QUEEN ADDICTS
There is a short notice on the back of the album: "...and nobody played synthesizer." This ironic little note is intended for the bigwigs at the record company, who, when listening to the guitar overlays, stressed the fact that they loved the sound of the synth.

record. [...] I wanted it to show the balls and the energy of Queen's live show."[2]

A Team to Work on the Album

On November 1, 1972, the contract between Queen and Trident was officially signed. Norman Sheffield, who headed Trident with his brother Barry, then had to find a distributor for the album. For several months, the businessman had employed the services of an American named Jack Nelson, who worked for a small production company called Blue Thumb. Nelson was brought on to ensure the management of the group and to help them find a label. Nelson, who had fallen firmly under the Queen spell, was determined to move heaven and earth in order to ensure release of the disc. Norman Sheffield also worked closely with the music publishing company B. Feldman & Co., to whom he entrusted Queen's catalog. The company's director, Ronnie Beck, had the task of ensuring a wide publication of the group's songs across the various media at his disposal, and was remunerated by levying part of the copyright, thus assuring Queen of the full involvement of the publisher.

While this was happening, Jack Nelson was struggling to find a distributor. In January 1973, after many months of heated negotiations and setbacks, he had only one card left to play: he entrusted a copy of *Queen* to Ronnie Beck, who was leaving to attend MIDEM in Cannes. This international music industry trade show was to be the band's last chance. Once in France, Beck handed the recording over to Roy Featherstone, artistic director at EMI, who would later recount the electroshock of listening to the album. Among the hundreds of cassettes received at MIDEM, none had caught his attention until now. On the lookout for new talent for his label, Featherstone was blown away by the first tracks. He immediately sent a telegram to Sheffield asking him to block all other contracts on the group until his return from Cannes. The stars finally aligned, and a contract was signed between Queen, Trident, and EMI in March 1973. The record company released the album in the United Kingdom and the rest of Europe, and an option was placed for North America via the Elektra label. The North American option was contingent upon the band's performance in a concert on April 9, 1973, at the Marquee Club in London, which was attended by the founder of Elektra, Jac Holzman.

Though not completely convinced by Queen's performance, the businessman nevertheless fell in love with their music. Elektra would distribute the disk on American soil.

In Search of a Visual Identity

Thanks to the work of Phil Reed, who served as radio canvassing manager at B. Feldman & Co., Queen landed a spot on John Peel's *Sound of the Seventies* show. The group recorded its first BBC Sessions on February 5, 1973, in Studio 1 of the BBC Broadcasting House building at Langham Place, in the heart of London. An obligatory rite of passage for any self-respecting rock group, participation in the BBC Sessions was an unexpected springboard.

The band performed four songs that day: "My Fairy King," "Keep Yourself Alive," "Doing All Right," and "Liar." The sessions were produced by Bernie Andrews, and the sound engineer on set was John Etchells, who would later find himself at the controls of the *Live Killers* album in 1979.

This BBC appearance provided the group with essential publicity for the promotion of the album. The group took advantage of this moment to perfect their stage performance and to refine their image.

At the time, Queen gave relatively few concerts, preferring to focus on writing new songs and expanding their professional entourage. The all-important concert held at the Marquee Club on April 9, 1973, in the form of a showcase, began with a sensational performance of "Father to Son," a title that would go on to be featured on the group's second album. They ended the set at the Marquee Club with Gene Vincent's "Be Bop a Lula" in homage to the group's '50s idols. The group also worked on their stage outfits. This was one of the public's first opportunities to discover the loose clothing that Brian May wore in concert, offering him greater ease of play. With his extremely wide sleeves, the guitarist's costumes gave his movement (inspired by Who guitarist Pete Townshend) an elegant and theatrically effective look.

Queen also took advantage of this period to design the visuals for the upcoming disc, opting to work with photographer Douglas Puddifoot, whom Roger Taylor already knew from his teenage years in Cornwall. Brian May, who was acting as artistic director for the occasion, used a photo taken during a previous concert at the Marquee Club in London on December 20, 1972, for the front of the

Freddie Mercury and bassist John Deacon during rehearsals for the group's upcoming tour of Britain, which began on September 13, 1973, in Edinburgh.

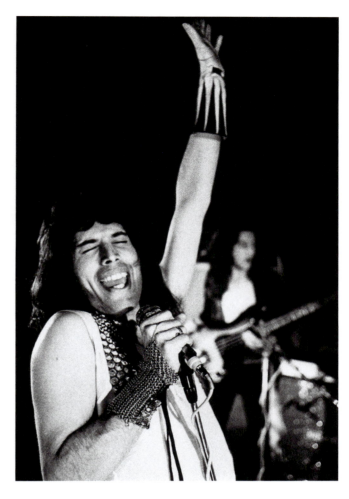

Bassist John Deacon is credited on the back of the album as "Deacon John." Faced with the musician's displeasure, Freddie announced at the time that it was simply a printing error, but the truth is quite different. The "printing error" was in fact a ploy by Mercury, who believed that this formulation lent the guarded bass player an air of elegance and charisma. On the group's next album "John Deacon" appeared on the back of the cover.

album jacket. In the photograph we can make out Freddie Mercury, his arms raised in the air, facing the audience, with a projector illuminating him like a divine light. For Brian, this image choice was obvious: "Freddie as a singer will be our figurehead: let's use him as such!"[5] Numerous concert images were chosen to illustrate the back cover of the album, and they were mixed with shots from the famous photo session organized a few months earlier at Freddie and Mary Austin's Holland Road apartment. The album was released on July 13, 1973, under the name *Queen*. After proposing a number of alternate titles, including "Top Fax, Pix and Info" and even "Deary Me" (an expression used by Roy Thomas Baker during the recording sessions), Roger Taylor finally had to comply with the majority decision: It would be an eponymous album.

A Reserved Reception

Despite very disappointing sales, the reviews for *Queen* were mostly positive. The magazine *Melody Maker* found that "Traces of Yes and Black Sabbath can also be found but structurally it seems to sound original,"[6] and *Rolling Stone* even dared to draw a comparison with the already extremely famous Led Zeppelin.[7] Encouraged by the positive feedback from the music press, EMI promoted the disc and in particular the single "Keep Yourself Alive," which was released on July 6. The group recorded a new BBC Session on July 25, 1973, and took the opportunity to introduce listeners to their lead single, while also performing "Son and Daughter," "Liar," and an unreleased track: "See What a Fool I've Been." A month later, the group filmed a promotional video ahead of the release of *Queen* in the United States, which happened on September 4, 1973. On November 12 of the same year, the group began a UK tour as the opening act for Mott the Hoople. While sales were not up to expectations, EMI's promotional plans worked as intended. The tour enabled Queen to grow in confidence as they found themselves faced with ever-increasing numbers of fans. Despite being on the receiving end of sometimes virulent criticism, the four friends continued with their tour dates and broadened their fanbase, eventually overshadowing the headline act. In less than six months, 15,000 copies of the disc were sold in Great Britain, and 85,000 copies were sold in the United States. Queen went on to be ranked among the most promising British groups in the January 5, 1974, issue of *Sounds* magazine.

By the end of 1973, the songs composed for the first album were already beginning to feel dated. All of them had been written at least two years earlier, and some had even had a life before Queen ("Doing All Right" with Smile, "Liar" with Ibex,...). The band had to start thinking seriously about next steps and, driven by the success of their fall tour, the group actively began preparing their second album.

FOCUS ON...

DE LANE LEA SESSIONS

1. Keep Yourself Alive (De Lane Lea Demo) / Brian May / 3:51
2. The Night Comes Down (De Lane Lea Demo) / Brian May / 4:23
3. Great King Rat (De Lane Lea Demo) / Freddie Mercury / 6:09
4. Jesus (De Lane Lea Demo) / Freddie Mercury / 5:06
5. Liar (De Lane Lea Demo) / Freddie Mercury / 7:52

In June 1971, Queen, who had been operating at full force for several months already—John Deacon having joined the band as the official bassist in February—organized their first photo session. It was Douglas Puddifoot, a friend of Roger Taylor's, who took the series of iconic publicity photos that would allow the musicians to find a solid partner to produce their first album. In order to record the first demo tapes that would be used to approach record companies, Brian May got back in touch with Terry Yeadon and Geoff Calvar, who had worked on five tracks for Smile, for whom May was the guitarist. The two sound engineers had just left their jobs at Pye Studios to prepare for the reopening of De Lane Lea Studios in a brand-new location near Wembley Stadium. Formerly located on Kingsway, in the heart of London, these studios saw numerous famous musicians, including Jimi Hendrix, the Animals, and the Rolling Stones, pass through their hallways. As luck would have it, Yeadon and Calvar were looking for a band capable of playing at a very high volume so they could test the acoustic quality of the new studios and ensure the proper functioning of all the equipment. In exchange for playing extremely loudly, the musicians would be able to produce a few tracks for free. Queen seized this opportunity and recorded their first demos, which are now known to fans as "The De Lane Lea Sessions." For many years, December 1971 was considered the official date of these sessions; however, the book *40 Years of Queen*, authorized by the band, includes rare photos of the session taken by Brian May and dating all the way back to September 1971.

Two executives from Trident Audio Productions, John Anthony and Roy Thomas Baker, came to witness the last-minute adjustments before the opening of the new studios. The former, who had produced Smile's single for the Mercury label in 1969, immediately recognized the drummer and the guitarist. Falling under the band's spell, the two producers were quick to talk to their boss, Norman Sheffield, who soon offered them a major opportunity.

First Steps in the Studio

Queen, concerned with precision and paying attention to the smallest details, took their time recording their first tracks. In total, five were recorded during these initial sessions: "Liar," "Keep Yourself Alive," "Jesus," "The Night Comes Down," and "Great King Rat." Louis Austin, the in-house sound engineer, was at the controls on this first EP, and he was assisted by Martin Birch, who would soon become famous in the heavy metal world, where he produced Black Sabbath and Rainbow, among others. But Birch's greatest contribution to hard rock was undoubtedly his work on numerous Iron Maiden recordings. On each of the British band's albums, he was credited with a different nickname: Masa on *Somewhere in Time*, the Juggler on *Fear of the Dark*, and Martin Farmer on *The Number of the Beast*.

The largest studio was made available to the musicians, which gave Roger Taylor's drums a wide and powerful sound thanks to the natural resonance of the room. Taylor was already using more drums than normal and was equipped with two sixteen- and eighteen-inch bass toms for his frequent drum rolls.

As for Brian May, he played on a wall of Marshall amps rented for the occasion by Yeadon and Calvar. The band fine-tuned their tracks with Louis Austin, and finally finished their first demo, which was distributed to various labels at the end of 1971. This experience opened the doors of Trident Audio Productions to the band; they selected Trident as their partners, taking advantage of the support structure, the studios, and the experience of in-house producer Roy Thomas Baker.

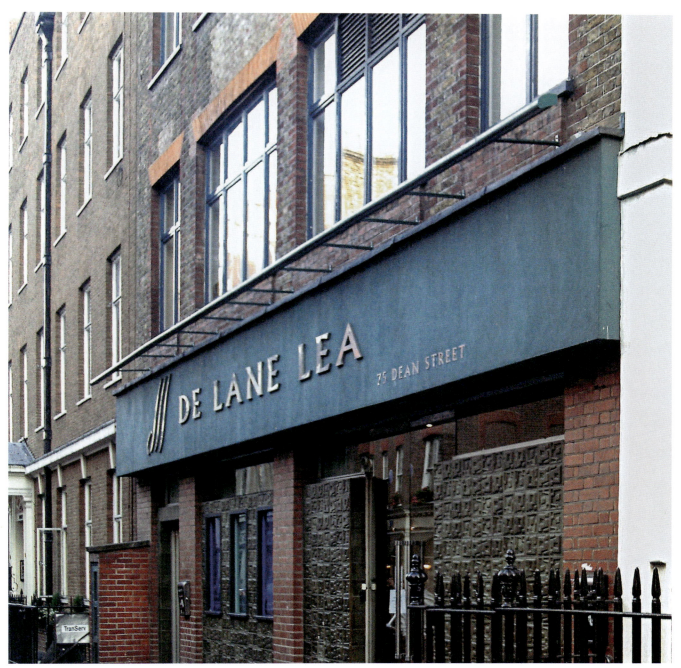
The current entrance to De Lane Lea Studios, at 75 Dean Street, Soho, London.

SINGLE

KEEP YOURSELF ALIVE
Brian May / 3:47

Musicians
Freddie Mercury: lead vocals, backing vocals
Brian May: electric and acoustic guitars, lead vocals, backing vocals
John Deacon: bass
Roger Taylor: drums, tambourine, lead vocals, backing vocals

Recorded
Trident Studios, London: June 1972

Technical Team
Producers: John Anthony, Roy Thomas Baker, Queen
Sound Engineer: Roy Thomas Baker

Single
Side A: Keep Yourself Alive / 3:47
Side B: Son and Daughter / 3:20
UK Release on EMI: July 6, 1973 (ref. EMI 2036)
US Release on Elektra: October 1973 (ref. EK-45863)
Best Chart Ranking: Did Not Chart

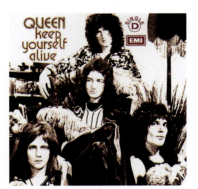

Cover of the Portuguese pressing of Queen's first single, "Keep Yourself Alive."

Genesis
Selected by the group to lead off its first album, "Keep Yourself Alive" was released as a single in Great Britain and the rest of Europe on July 6, 1973, a few days before the album itself was released.

Promotion was handled by EMI, which sent a copy to the BBC, but the disc, presented in the traditional white sleeve used to hold copies meant for the press, bore no inscription. The label had failed to include the name of the group and the title of the song. The single landed in the hands of Mike Appleton, producer of the famous show *The Old Grey Whistle Test*, broadcast on BBC2, and its host, Bob Harris, both of whom were seduced by the energy it gave off. Since there was no existing video clip, they took the liberty of illustrating the song with images taken from Franklin D. Roosevelt's 1932 presidential campaign film and played the single on July 23, 1973. The next day, the BBC2 switchboard was inundated with calls from viewers intrigued by this mysterious song. If this was a ploy on the part of EMI to whet the curiosity of radio programmers, then the technique certainly worked. EMI informed Harris and Appleton that they had the first single from a new band called Queen, and a promotion campaign was finally put in place around the group's first album.

Production
The first version of "Keep Yourself Alive," was recorded during the De Lane Lea sessions in 1971, and it was always the group's favorite. The intro was played on acoustic guitar before being dubbed by May's Red Special, which had been plugged into the wall of Marshall amps deployed for the occasion by Terry Yeadon and Geoff Calvar. Brian, who was the composer, argued at length during the sessions at Trident Studios to have the original version appear on the album, but had to give in to opposition from producer Roy Thomas Baker, who was satisfied with the current production of the track. Queen then suggested that Mike Stone, Baker's assistant, present his vision of the track by carrying out a new mixing to his taste. This latter version won all the votes, and so it was Stone's version that was kept for the album. Brian May was never satisfied with this choice, and had to resign himself to the fact that the magic that had worked so well on the original demo was lost forever.

32 QUEEN

Guitarists wanting a precise and regular palm mute like the one in the intro to "Keep Yourself Alive" use a flexible pick in the right hand to make it easier to go back and forth. May chose the opposite option, preferring the thickness of a sixpence coin that barely protrudes from his right thumb, and using its grooves to accentuate the attack on the strings.

FOR QUEEN ADDICTS

On the compilation *The Best Of Pantera: Far Beyond the Great Southern Cowboys' Vulgar Hits*, released in 2003, the group Pantera modified the intro to their hit "Cowboys from Hell" by adding a detuning effect on the first beat, which was absolutely identical to what May played on the "Keep Yourself Alive" attack. The trick made the two introductions extremely similar.

In the introduction to "Keep Yourself Alive" we find many of the elements of the future sound of Queen, such as the phaser effect used on the guitar played in palm mute, accompanied by the Premier New Era bell on drums (also present in the introduction to "Liar"). The hi-hat roll is also a signature found in many Roger Taylor drum patterns. This introduction to the song works extremely well and effectively draws the listener in—so much so that when listening to the 1981 hit "Edge of Seventeen," sung by former Fleetwood Mac member Stevie Nicks, listeners can clearly hear Taylor's influence on that track's producer, Jimmy Lovine.

Music Video

The filming of a promotional music video was planned at the Brewer Street Studios, located thirty kilometers west of London. Mike Mansfield, who would soon become famous for his gigantic concert recordings, was chosen for the production on August 9, 1973. Tensions ran high between the group and the filmmaker, who, in response to each of their suggestions, politely thanked the musicians and reminded them of their inexperience. In the end, the group fired Mansfield and dumped the video, which seemed to them to not be in keeping with their creative world. It is true that the psychedelic visuals do not present the musicians at their best, and they give the group a very dated look. All that's missing is a kaleidoscope effect to make you believe you're back in 1968 in an Iron Butterfly video. It was the opposite of what Queen was going for. Refusing to use the images filmed by Mansfield, the boys took matters into their own hands (as usual) and took over production on October 1, 1973, at St. Johns Wood Studios, accompanied by Barry Sheffield, one of the bosses at Trident. Technician Bruce Gowers ensured the smooth running of the day, and created a friendly relationship with the musicians that would lead to them working together again, most notably on the video for "Bohemian Rhapsody," which Gowers directed in November 1975. The shooting of "Keep Yourself Alive" was a great success. This film would be included in the double version of the *Greatest Video Hits 1* DVD in 2002.

DOING ALL RIGHT
Brian May, Tim Staffell / 4:09

Musicians
Freddie Mercury: lead vocals, backing vocals
Brian May: electric and acoustic guitars, piano, backing vocals
John Deacon: bass
Roger Taylor: drums, backing vocals

Recorded
Trident Studios, London: June–November 1972

Technical Team
Producers: John Anthony, Roy Thomas Baker, Queen
Sound Engineers: Roy Thomas Baker, Mike Stone, Ted Sharpe, David Hentschel

After the demise of Smile, the friendship between Staffell, May, and Taylor continued. On December 22, 1992, while Roger Taylor's group, the Cross, was performing on stage at the Marquee Club in London, his two former roommates joined him to perform "Earth" by Smile and "If I Were a Carpenter" by Tim Hardin.

In the ninth minute of the film *Bohemian Rhapsody*, Freddie proved himself when he hummed "Doing All Right" in front of May and Taylor; this got him the job of lead singer with Smile after the departure of Tim Staffell.

Genesis

Written by Brian May and Tim Staffell during the Smile period, the song was initially entitled "Feeling Alright," then "Doin' Alright," before finally becoming "Doing All Right." The two friends wrote it while living together in an apartment on Ferry Road in Barnes, London, where Roger Taylor would also eventually live. This song's accelerated chorus ballad was played during Queen's first concerts and is extremely popular with fans. It provided an income for life for Staffell, who finds it amusing to this day: "It never struck me as a particularly brilliant song. Though the royalties did help out in a bind!"[5] "Doing All Right" was one of the few songs co-written with a musician outside Queen.

Production

During the sessions, Brian May played the piano parts on the famous 1897 Bechstein available at the studio. Already famous for having been used in August 1968 by the Beatles during the recording of "Hey Jude" at Trident Studio (the Fab Four had also worked at Abbey Road Studios on the production of this track), it was Elton John who immortalized the piano in 1971 with his recording of "Your Song," the most famous song from his second, eponymous album. This is just one example of the prestige of the venue where Queen recorded, and from which they wished to profit. Freddie changed nothing from the original version and sang the song as Staffell performed it. From the production of their first album, the four musicians established a mode of operating that avoided any potential conflicts: whoever composed the song imposed his artistic direction, and the other three band members bent to his vision. Since "Doing All Right" was May's creation, and had already been recorded by Smile in 1969, Freddie settled for simply reproducing Brian and Tim's version without really leaving his mark on it.

John Etchells made a notable recording of the song on February 5, 1973, during the group's first BBC Sessions, when Roger Taylor sang all of the last verse. It was this version that appeared on the compilation *At the Beeb* in December 1995.

GREAT KING RAT
Freddie Mercury / 5:43

Musicians
Freddie Mercury: lead vocals, backing vocals
Brian May: electric and acoustic guitars, backing vocals
John Deacon: bass
Roger Taylor: drums, tambourine, backing vocals

Recorded
Trident Studios, London: June 1972

Technical Team
Producers: John Anthony, Roy Thomas Baker, Queen
Sound Engineers: Roy Thomas Baker, Mike Stone, Ted Sharpe, David Hentschel

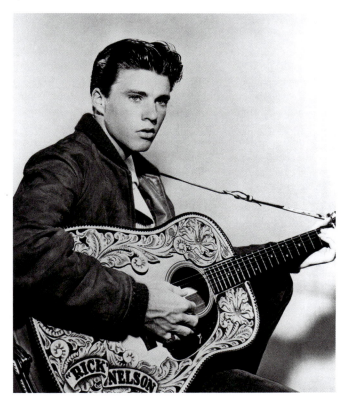

Singer Ricky Nelson popularized the song "Hello Mary Lou," which was frequently covered by Queen.

Genesis

In writing the lyrics for "Great King Rat," Mercury was inspired by the famous eighteenth-century English nursery rhyme "Old King Cole." The rhyme contains the recurring verse: *"Old King Cole was a merry old soul / And a merry old soul was he."* It is difficult to ignore Freddie's allusion in the chorus of his song: *"Great King Rat was a dirty old man / And a dirty old man was he."* As usual, the singer refused to explain his text, claiming that he wrote the lyrics according to the sound of the phrases and not their meaning. "I don't like to explain what I was thinking when I wrote a song. I think that's awful, just awful,"[8] he replied later when asked to explain the text of "Bohemian Rhapsody."

The fact remains that poetry's influence is heavily present in many of Freddie's lyrics, revealing a man who was keen on literature, and who made references here and there to his personal, artistic nature.

Production

Though "Great King Rat" already appeared in the De Lane Lea sessions, the version that the group recorded at Trident Studio was shortened by twenty-five seconds. In this medieval fable, Queen found all of the power of the songs recorded by their early 1970s contemporaries, Deep Purple. Led Zeppelin and Black Sabbath also liked to play on the listener's nostalgia for ancient times by asserting their taste for legends and folklore. A powerful and repetitive guitar riff accompanied by a catchy chorus make "Great King Rat" a perfect representation of the music of the era. By using this highly effective formula, Queen created a song that fits definitively into its time.

Finally, note that while we can detect the shadow of Jimmy Page in Brian May's playing and the long series of two-string bends that occur between 5:00 and 5:13, we must really look to Ricky Nelson and his "Hello Mary Lou" to find the song's major influence. As a great 1950s rock 'n' roll fan, Brian May himself once stated: "Hearing [Rick Nelson] bend strings, it was sort of impenetrable to me. I didn't know how that was done. The solo in "Hello, Mary Lou..." I must have listened to it a million times to figure out how that was done."[9] This guitar solo technique was extremely fashionable in the early 1970s.

MY FAIRY KING
Freddie Mercury / 4:08

Musicians
Freddie Mercury: lead vocals, piano
Brian May: electric and acoustic guitars, backing vocals
John Deacon: bass
Roger Taylor: drums, backing vocals
Recorded
Trident Studios, London: June–November 1972
Technical Team
Producers: John Anthony, Roy Thomas Baker, Queen
Sound Engineers: Roy Thomas Baker, Mike Stone, Ted Sharpe, David Hentschel

Genesis

For many observers, "My Fairy King" was the first step toward a type of song writing that would eventually lead Mercury to write "The March of the Black Queen" on *Queen II*, and then to write "Bohemian Rhapsody." The similarities in these song lie in their structure, Mercury having designed them by joining the musical parts together like the acts of an opera, which follow and complement each other. "My Fairy King," which was extremely complicated to reproduce on stage, was played very little at the time, but Freddie improvised notes from it during the "Hot Space" tour in 1982 and the "Works" tour in 1984.

Interestingly, it was in Freddie's own text that he found the inspiration for his stage name. On "My Fairy King" he sang *"Mother Mercury / Look what they've done to me"* and declared that he identified with the character. He would therefore call himself Freddie Mercury. In the song's text we find the lyricism that was so important to the singer, with his creatures and imaginary characters. As was the case with "Great King Rat," Freddie was undoubtedly inspired by his childhood memories while he was writing the song. In the song's lyrics, we see a clear tribute to the poem *The Pied Piper of Hamelin* by Robert Browning (1842), in which the hero is commissioned by the mayor of Hamelin to rid his city of rats. "My Fairy King" begins: *"In the land where horses born with eagle wings / And honey bees have lost their stings / There's singing forever / Lion's den with fallow deer / And rivers made from wine so clear."* Now, compare those lyrics with Browning's poem, which reads in part: *"The sparrows were brighter than peacocks here, / And their dogs outran our fallow deer, / And honey-bees had lost their stings, / And horses were born with eagles' wings."* Many great writers draw their inspiration from those who've come before them. In fact, the theme of Browning's medieval fable first appeared in one of the famous tales by the Brothers Grimm: "The Pied Piper of Hamelin," appeared in their *German Legends*, printed in 1816.

"My Fairy King" was the very first song recorded during the group's famous BBC Sessions on February 15, 1973, which took place at the BBC Broadcasting Studios on

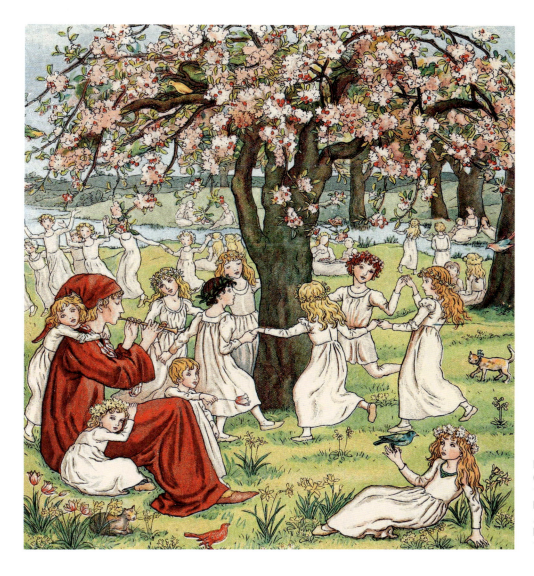

Illustration, by Kate Greenaway (1846–1901), of Robert Browning's *Pied Piper of Hamelin*, which inspired Freddie Mercury to write "My Fairy King."

Langham Place. For the first broadcast, the group did not play live. Brian May recalls: "We started off with backing tracks which were already in progress for the album, and overdubbed the vocals—a guitar here and there, and other things. So what you are hearing is a mixture of stuff recorded at Trident Studios and material recorded in the BBC studios. Time and facilities were tight, which dictated that we recorded the session in that way."[10] Since the musicians were reluctant to perform using playback, as was the case on another popular British show, *Top of the Pops*, the group chose to perform live during their following BBC Sessions. All these recordings are now grouped together in the celebrated album, *Queen: On Air*, which was released in November 2016.

Production

"My Fairy King" marks the first time Freddie showcased his piano skills on a Queen recording. Brian May had preceded him on the track "Doing All Right," but with this latest recording, the singer had found a musical companion that would play a much more significant role on the group's subsequent albums. Taking advantage of the available *backline*, Freddie used the famous Bechstein piano that took pride of place in Trident Studios. A genuine emblem of the studio, handcrafted in Germany a century earlier, this concert grand piano bore the serial number 44064 and contributed to the studio's prestige and success in the 1960s. It can be heard on numerous pop hits of the period, including "Candle in the Wind" and "Your Song" by Elton John, "Changes" and "Life on Mars" by David Bowie, and on the most famous of all: "Hey Jude" by the Beatles. Its ebony finish and excellent projection have earned it the title of "best rock 'n' roll piano" among connoisseurs. The instrument was sold in May 2018 on a famous auction site, for more than £350,000 sterling!

In terms of singing, the lead vocals and harmonization on this track come thick and fast, and bathed in reverb. Right from the introduction, Freddie's wolf howls are a clear wink at Robert Plant, whose howls mark the beginning of the "The Immigrant Song," a rock monument from the album *Led Zeppelin III*.

SINGLE

LIAR
Freddie Mercury / 6:25

Musicians
Freddie Mercury: lead vocals, Hammond organ
Brian May: electric and acoustic guitars, backing vocals
John Deacon: bass
Roger Taylor: drums, tambourine, backing vocals

Recorded
Trident Studios, London: June–November 1972

Technical Team
Producers: John Anthony, Roy Thomas Baker, Queen
Sound Engineers: Roy Thomas Baker, Mike Stone, Ted Sharpe, David Hentschel

Single
Side A: Liar (US Single Edit) / 3:03
Side B: Doing All Right / 4:09
US Release on Elektra: February 14, 1974 (ref. EK-45884)
Best US Chart Ranking: Did Not Chart

Starting in 1973, the sharing of song writing credits, and therefore the sharing of future royalties, became one of the first causes of disharmony within the group. The issue remained thorny until the release of the album *The Miracle* in 1989, at which point the band members decided to equally share credits on all of their songs.

Genesis

Co-written with guitarist Mike Bersin, who Freddie had previously sung with when he was a member of the group Ibex, this rock ballad was originally entitled "Lover." After the song was reworked with his Queen co-members, Mercury claimed ownership of the song, believing that he was the sole beneficiary since he had written the lyrics. This astonished his friends, who claimed to have also contributed to its composition.

Though effective and highly appreciated by concert spectators, "Liar" was not released as a single in the United Kingdom. The video, filmed at the same time as the video for "Keep Yourself Alive," was hidden away in the drawers at EMI until it was finally released as a bonus on the double DVD *Greatest Video Hits 1* on October 14, 2002.

In the winter of 1974, while Queen was preparing to release their second album, Elektra wanted to make the most of their growing success in Europe. In anticipation of the group's American tour, where they would be opening for Mott the Hoople, the label decided to release "Liar" as a single on February 14 in the United States (with "Doing All Right" on the B-side) and took the liberty of editing the song without the musicians' agreement. The introduction was cut by a minute and fifteen seconds, as were other parts of the track. Queen always disowned this shortened version, which would henceforth be known as "Liar (US Single Edit)." And it seems justice was done, since the song never met with the success the record company had hoped for.

Production

The liturgical sound of this track is just one more example of the recurring religious and mythological themes found throughout Queen's first album. Mercury is at confession when he sings *"I have sinned dear Father / Father, I have sinned / Try and help me, Father / Won't you let me in?"* The pious atmosphere of the verse is reinforced by the presence of the Hammond organ played by the singer beginning at 1:08. This church organ–sounding instrument was immortalized by Procul Harum in 1967 in their hit "A Whiter Shade of Pale," but also by Deep Purple and their incredible organist, Jon Lord. Though in Lord's case, he used to plug his organ into a Marshall amp with

Freddie (left), posing with members of the band Ibex in August 1969. On August 23 of that same year, he gave his first concert as a singer with Ibex at the Octagon Theatre in Bolton, near Manchester.

an added distortion effect, giving his instrument a much less solemn aspect!

The production of "Liar" is exceptionally powerful. There's a curious percussion section at the beginning of the track, which is characterized by the drum beats and a guitar riff, all of which seems tailor-made to give the band a chance to make a sensational stage entrance. Dee Snider, the lead singer of Twisted Sister (and a huge Queen fan), recounted his introduction to the song: "On the radio […] this song comes on, and it's "Liar." I can't identify the band. […] I literally stopped working—going, 'This is incredible, who's this band?! Who is singing?'"[11]

Not all of Snider's fellow Americans were equally struck by the single, unfortunately, and it took a few more months for Queen to achieve their first real success on the other side of the Atlantic.

QUEEN: ALL THE SONGS 39

THE NIGHT COMES DOWN

Brian May / 4:23

Musicians
Freddie Mercury: lead vocals, backing vocals
Brian May: electric and acoustic guitars, backing vocals
John Deacon: bass
Roger Taylor: drums, backing vocals
Recorded
De Lane Lea Studios, London: December 1971
Technical Team
Producer: Louis Austin
Sound Engineer: Louis Austin

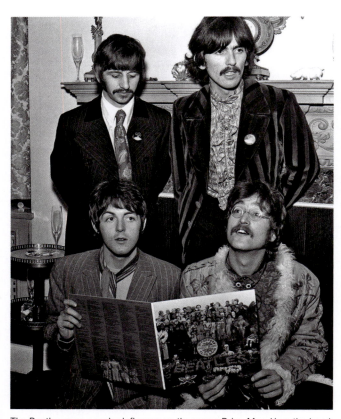

The Beatles were a major influence on the young Brian May. Here the band is shown presenting their mythical album *Sgt. Pepper's Lonely Hearts Club Band*, released in June 1967.

Genesis

Identified as Queen's first rock ballad, "The Night Comes Down" is one of the three tracks (along with "Keep Yourself Alive" and "Liar") that convinced Jac Holzman to distribute the group in American territory via his Elektra label. In the song, May describes his teenage years, which now seem far away, and he pays tribute to his idols, The Beatles, with a wink in the first verse: *"Lucy was high / And so was I,"* the reference being an obvious nod the psychedelic Beatles hit "Lucy in the Sky with Diamonds" by John Lennon and Paul McCartney in 1967. It is surprising to find an allusion to drugs in a text written by the shy and studious Brian May, but as Mercury frequently explained in interviews, the band shouldn't be required to explain their songs, and sometimes their lyrics were, in fact, just an assembly of words that sound right when joined together.

As if to announce the concept of the band's next album, the second verse of "The Night Comes Down" deals with the duality between black and white, and between day and night. By extension, future songs from the group would deal with the opposition between good and evil, and these contrasting themes would become identifiable in Queen's visual universe in the beginning of 1974, especially in the band's costumes and makeup.

Production

During his years as a member of another band called 1984 (named in tribute to the famous novel by George Orwell), Brian May became very close with the band's bass player, Dave Dilloway. At one point, Dilloway gave May an old German Hallfredh acoustic guitar from the 1930s, and in exchange, May gave Dilloway a six-string Egmond Toledo guitar that he'd originally gotten from his parents for his seventh birthday (and which he got back years later). It was this cheap Hallfredh acoustic guitar, with its powerful but imprecise sound, named my "Dilloway acoustic guitar"[12] by May, that would later be used on "The Night Comes Down."

Recorded during the De Lane Lea Sessions, the song struck just the right balance in terms of the sound Roy Thomas Baker was looking for when mixing the album. Roger Taylor, who was never satisfied with the drum sound on *Queen*, appreciated this take more than some of the others, and so the 1971 recording was chosen to appear on the album.

MODERN TIMES ROCK 'N' ROLL

Roger Taylor / 1:48

Musicians
Roger Taylor: lead vocals, drums
Freddie Mercury: backing vocals, piano
Brian May: electric guitar, backing vocals
John Deacon: bass
John Anthony: backing vocals

Recorded
Trident Studios, London: June–November 1972

Technical Team
Producers: John Anthony, Roy Thomas Baker, Queen
Sound Engineers: Roy Thomas Baker, Mike Stone, Ted Sharpe, David Hentschel

FOR QUEEN ADDICTS

It is the album's co-producer, John Anthony, who we hear warning the listener that the new guard of rock 'n' roll is coming when he proclaims, "*Look out!*" a few seconds before the end of the song.

"Modern Times Rock 'n' Roll" was sung onstage by Freddie, who successfully accepted the challenge of this unfamiliar, fast, and aggressive singing style. The band's performance of the song, filmed during their London concert in November 1974 and immortalized on the *Live at the Rainbow '74* DVD, is considered by many to be one of the best executions of this track, emphasizing the band's precise tempo and impeccable musical technique.

Genesis

Somewhat surprisingly, Mercury and May yielded their usual roles as composers to the fiery Roger Taylor for *Queen*'s seventh track. The latter made good use of the opportunity, producing a furious "Modern Times Rock 'n' Roll," and marking the album with his only contribution as a songwriter. In many ways, the song serves as a precursor to the drummer's future forays into punk, and to the more fantastical lyricism of Freddie and Brian. Always on the lookout for new trends, Taylor announces right from the first verse that the rock 'n' roll vintage year of 1958, when Chuck Berry reigned supreme with "Johnny B. Goode," and Richie Valens, Buddy Holly, and Jerry Lee Lewis ruled the airwaves, was officially a thing of the past. Without disrespecting his idols, the message is clear: the time has come to move forward and make room for new types of sound.

Production

In the recording of "Modern Times Rock 'n' Roll" we discover the raging voice of Roger Taylor, bathed in a short but highly pronounced delay effect (also audible on the future tracks, "I'm in Love with My Car" and "Tenement Funster"). The drummer/composer's signature songwriting themes also make their first appearance in this track. The pleasures and excesses of life as a rock star (which he had always dreamed of) are commented on in all of his songs: powerful motorbikes, extremely loud guitars and, of course, beautiful, smiling women. Taylor's light lyrics and frenzied cadences fit perfectly into Queen's musical universe.

Much of the band's press coverage from this era continued to highlight Led Zeppelin's influence on their music, and with good reason in the case of this devastating rock track, which the critics enjoyed calling Queen's "Communication Breakdown" (in reference to the song from Led Zeppelin's first album). This energy can also be found in other Taylor songs, such as "Sheer Heart Attack," from the *News of the World* album. A hellish rhythm and frenetic singing were now the trademark of the handsome blond on the drums.

QUEEN: ALL THE SONGS 41

SON AND DAUGHTER
Brian May / 3:21

Musicians
 Freddie Mercury: lead vocals
 Brian May: electric guitar, backing vocals
 John Deacon: bass
 Roger Taylor: drums, backing vocals
Recorded
 Trident Studios, London: June–November 1972
Technical Team
 Producers: John Anthony, Roy Thomas Baker, Queen
 Sound Engineers: Roy Thomas Baker, Mike Stone, Ted Sharpe, David Hentschel

Robert Plant, John Paul Jones, and Jimmy Page, from the band Led Zeppelin, who were regularly cited as Queen's major musical reference in the band's early days.

Genesis

Originally appearing on the B-side of the single "Keep Yourself Alive," "Son and Daughter" was the first song the band played with John Deacon. Deacon auditioned in 1971 and Brian May simply handed him a sheet of paper with the song's chord grid on it. The rest is history. "Son and Daughter" displays a clear influence from rock legend Jimmi Hendrix, which can be felt in the bluesy, midtempo arrangement of the track. Freddie Mercury's love for the voice of Robert Plant (he himself admitted: *"Robert Plant was always my favorite singer"*[13]) is also evident.

Brian May's lyrics pose a challenge to the strict educational policies imposed by British society in the 1960s. In the late '60s and early '70s, the winds of protest blew over many Western countries and shook the patriarchal foundations of both the United States and the United Kingdom. May had always had an excellent relationship with his own parents, and had never expressed any need to rebel against their authority. Nevertheless, many artists often sing what they don't dare to say, and in his lyrics, Brian May expressed anger at the limits parents impose on their children. On Queen's second album, another song by Brian entitled "Father to Son" dealt with similar struggles between a father and son. May went on to write even more songs dealing with the difficulty of family ties, including the magnificent "Sail Away Sweet Sister," on the album *The Game* in 1980.

Production

"Son and Daughter" had an incredible impact on future generations of musicians. The influence of the heavy introductory guitar riff is especially obvious in the rock-fusion movement, represented by the powerful and repetitive guitar riffs of Tom Morello and Rage Against the Machine in the early 1990s. In the late 2000s, the group Muse also paid homage to certain features of "Son and Daughter," with their own heavy introductory riff on "Hallelujah" and the saturated voice on their hit "Supermassive Black Hole." It is no secret that all great musicians are influenced by their predecessors, and Matthew Bellamy has always admitted to being a huge admirer of Queen…and Tom Morello.

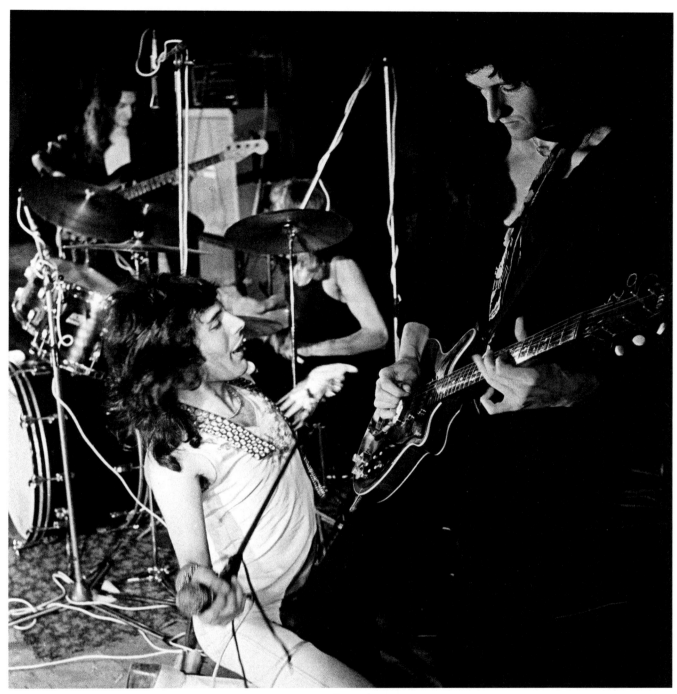

Freddie dressed in white and Brian in black during rehearsals for the band's first major tour. Perhaps this was the beginning of Queen's "White Side/Black Side" concept.

With the bass and guitar playing in unison during the beginning of "Son and Daughter" many critics have noted that the influence of Led Zeppelin's "Heartbreaker" is clearly discernible on the track, though Queen certainly showed an incredible amount of inventiveness on this track. The overlaid guitar beginning at 1:53 sounds like an analog Moog synth whose sound has been processed with a saturated reverb, but this is not the case. The famous "...*and nobody played synthesizer*" on the back of the album (see page 28) is there to remind us!

FOR QUEEN ADDICTS

The version of this song played during the BBC Sessions on December 3, 1973, contains a guitar solo that was later incorporated into the song "Brighton Rock."

JESUS
Freddie Mercury / 3:44

Musicians
Freddie Mercury: lead vocals, piano
Brian May: electric and acoustic guitars, backing vocals
John Deacon: bass
Roger Taylor: drums, backing vocals
Recorded
Trident Studios, London: June–November 1972
Technical Team
Producers: John Anthony, Roy Thomas Baker, Queen
Sound Engineers: Roy Thomas Baker, Mike Stone, Ted Sharpe, David Hentschel

Genesis
"Jesus" is one of the last songs in which Freddie Mercury drew inspiration from the Bible, or from his own relationship with religion. Subsequently, Freddie began to prefer delving into his imagination, creating worlds populated by mysterious characters, and referring to books he enjoyed or works of art that touched him. Here, Mercury surprisingly depicts a passage from the New Testament, which may perhaps go unnoticed by the lay listener. "Jesus" tells the story of the life of Christ, and writing the song required Freddie to depart completely from the religion in which he was raised. Born Farrokh Bulsara, Freddie's parents were members of the Indian Parsi community, and were fervent Zoroastrians. Though Freddie very rarely expressed his religious views, it is interesting to note that Zoroaster, the spiritual leader and founder of Zoroastianism, preached the duality between light and darkness, between good and evil. This focus on duality became one of the main themes of the band's highly conceptual second album, which featured Brian May's "Side White" versus Freddie Mercury's "Side Black."

In interviews with his colleague Martin Popoff in 2018, the famed American rock journalist Richie Unterberger noted that "['Jesus' is] not especially controversial, but a lot of people in the United States would consider it controversial to have any rock song about Jesus that's not like a Christian or gospel rock song."[11]

Production
The theme of religion, explicitly addressed in "Liar," is again dealt with head-on in this track, both in the lyrics, which tell the story of the Messiah, and in the production, which combines a medieval drum roll and a gospel choir on the chorus. The version from the De Lane Lea Sessions was recorded without a piano and features an even greater choral presence, bathed in reverb, which adds to the liturgical spirit of the track. After 1972, the song would not be performed on stage again, and when a fan requested the song at a concert in 1978, Freddie Mercury replied laconically: "We've forgotten that. We wanna do something new!"[5]

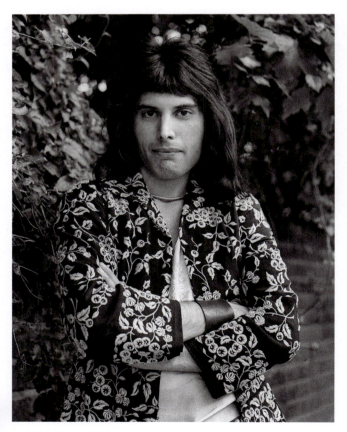

Freddie Mercury, looking elegant and refined, in 1973.

SEVEN SEAS OF RHYE...
Freddie Mercury / 1:15

Musicians
Freddie Mercury: piano
Brian May: electric guitar
John Deacon: bass
Roger Taylor: drums, tambourine

Recorded
Trident Studios, London: June 1972

Technical Team
Producers: John Anthony, Roy Thomas Baker, Queen
Sound Engineers: Roy Thomas Baker, Mike Stone, Ted Sharpe, David Hentschel

The port town of Rye, East Sussex, circa 1823.

Genesis

Before it became a breakout hit song on *Queen II*, "Seven Seas of Rhye..." appeared as an instrumental postlude at the end of the band's debut album. The track, written by Mercury, was in the draft stage when the band recorded *Queen*, but Roger Taylor later pointed out its importance on the record's track listing: "I think Freddie had half written the song and we thought it was a nice 'tail out' to the first album, with the idea of starting the second album with the song."[5] That idea was later abandoned, when the group opted to introduce *Queen II* with the instrumental "Procession." At that point, no one knew what lyrics Freddie would develop for the second version of the song, but in hindsight we can see a link between the kingdom of Rhye referred to in the song's title and the English village of Rye. This ancient port town in East Sussex was renowned in the Middle Ages as a center for maritime trade. The town's importance waned over time as the coastline receded, eventually falling almost three kilometers away from the village. In light of Mercury's fondness for medieval times, it's easy to see how this little piece of land, located an hour and a half from London, could have inspired a musical theme.

Despite the link it was supposed to create with the second album, "The Seven Seas of Rhye..." ultimately has little interest in Queen's larger discography, especially since its complete and extended version, released as a single the following year, was a success in every respect, peaking at tenth place on the British charts in March 1974.

Production

"Seven Seas of Rhye...," begins at a lower tempo than its sung version. When listening to the track, it's easy to imagine the musicians feeling freed from any technical constraints, and simply sharing a jam session at the end of a long and careful recording process. The tempo accelerates beginning at 1:03, and the track disappears in a fade-out at the end, which can leave the listener feeling perplexed after the precision of the structure of the previous tracks on the first album. Next to "Liar" or "Keep Yourself Alive," two tracks with almost pointillistic levels of accuracy and execution, this instrumental seems to have been added as a bonus track and doesn't contribute much to the homogeneity of the larger album.

OUTTAKES

MAD THE SWINE
Freddie Mercury / 3:23

Musicians
Freddie Mercury: lead vocals, backing vocals, and percussion
Brian May: electric and acoustic guitars, backing vocals
John Deacon: bass
Roger Taylor: drums, percussion, backing vocals

Recorded
Trident Studios, London: June 1972

Technical Team
Producers: John Anthony, Roy Thomas Baker, Queen
Sound Engineer: Roy Thomas Baker

Genesis

Recorded during the *Queen* sessions in 1972, "Mad the Swine" was intended to appear on the album, placed between "Great King Rat" and "My Fairy King." Rumors abound regarding its eviction from the track listing. Quarrels over the mixing of the drums and percussion were at first held responsible, until the lyrics of the song were more thoroughly studied by the fans. The text does indeed offer a few points worthy of discussion. First of all, it deals with religion, and when the band members took stock of the composition of the upcoming album, they realized that a few other tracks also touched on the same subject. There was "Jesus," of course, whose title speaks for itself, but there was also "Liar," which narrates the confession of a sinner to his priest. Queen came to the conclusion that unless they started claiming to be a Christian rock band, there was just too much religion for one record. The lyrics alone, however, are quite enough to have the song discarded. *"They call me Mad the Swine,"* says the narrator, who appears to be Jesus Christ, come to save mankind. Did Mercury imagine the reincarnation of Christ as a pig, or was this another one of his fantasies that no one could grasp? Either way, even at this highly contentious period, this type of comparison between Jesus Christ and a pig was just too controversial, and the band decided to put the song on the back burner.

Production

Although it lacks precision in its execution, this track fits perfectly with the spirit of Queen's first album. An acoustic guitar accompanies the opening vocals (probably Brian May's cheap Hallfredh, which had already been used on "The Night Comes Down"), but the real originality of the song lies in Roger Taylor's use of percussion, particularly on the introduction and on the guitar solo, which begins at 2:15. From a listener's standpoint, it's impossible to say whether he is using congas or bongos, but one thing is certain: Their presence on Queen's first album would have taken aback many a listener. These instruments give the song a world music vibe that's totally absent from the rest of the album!

FOR QUEEN ADDICTS

After being remixed by David Richards, the producer of the album *Innuendo*, "Mad the Swine" reappeared on the B-side of the *Headlong* EP in May 1991. That same year, the song also appeared as a bonus on the rerelease of the album *Queen* by Hollywood Records.

An image from Queen's *Innuendo* period, when "Mad the Swine" was finally released, twenty-nine years after its original recording.

QUEEN: ALL THE SONGS 47

Queen poses with Ian Hunter of Mott the Hoople (center) and Roy Thomas Baker (right), before a concert at the Forum de Montréal on January 26, 1977.

ROY THOMAS BAKER: THE FIFTH QUEEN

Roy Thomas Baker is one of those genius producers who left an indelible mark on the history of rock 'n' roll. Like Tony Visconti, Phil Spector, or Rick Rubin, he surrounded himself with the right kind of talent, following his instinct and personal taste like some kind of mad scientist. Baker was always searching for new sounds, and ready to try any kind of sonic experimentation.

Born on November 10, 1946, the young Roy began his career in 1960 as an assistant sound engineer at Decca Records. During his years as an apprentice, he had the good fortune to work alongside Gus Dudgeon, the in-house sound engineer at Decca who would later help create the sound of Elton John's first albums, eventually partnering with the singer and creating the Rocket Record Company label.

In 1969, Baker joined Trident Productions, founded by Norman Sheffield, where he worked as a producer and talent scout in a new branch called Neptune. When he met Queen, Baker had just finished producing the album *Exercises* for the Scottish band Nazareth. At the time, Queen was recording their first demos at De Lane Lea Studios. After convincing his boss of the talent of his new protégés, Baker went on to produce the albums *Queen*, *Queen II*, *Sheer Heart Attack*, *A Night at the Opera*, and *Jazz*. The major work of his early career is, of course, "Bohemian Rhapsody," which he co-produced with the members of Queen. "On a personal level, I feel closer to them than to anyone else. Because I'd only produced one album before *Queen*, I've matured as a producer as they've matured as a band. We've grown together."[14]

A Career Crowned with Success

After the success of "Bohemian Rhapsody," Mercury, May, Taylor, and Deacon realized that while they still needed a qualified sound engineer to provide the technical expertise they didn't possess, many of the production ideas were generated by the band members and not the producers. They therefore decided to produce their next albums on their own. Roy Thomas Baker remained on good terms with them, however, and went on to build a successful career in the United States, where he worked with bands like Journey, Foreigner, and the Cars. In the mid-1980s, Roy returned to Europe to produce songs by the Stranglers and Chris de Burgh. In 2005, he produced *One Way Ticket to Hell...and Back*, the second album by the British band the Darkness, a worthy successor to Queen (or true imitator, depending on your point of view).

Now recognized as an intrical part of the creation of the *Queen* sound, Baker is celebrated for his ingenuity, his penchant for risk taking, and his collaborative spirit, all of which make him a truly exceptional producer.

Brian May and his precious Red Special, before the great restoration of 1998.

BRIAN MAY'S RED SPECIAL FROM ACOUSTIC TO ELECTRIC

Brian May had been fascinated by guitarists from his earliest years. He listened to them on his crystal set and reproduced their chord progressions on the family banjolele. For his seventh birthday, his parents gave him a beautiful Egmond guitar, which the budding musician soon amplified thanks to a small microphone made by his father. It must be said that Brian's father, Harold May, was an ingenious man. A draftsman for the Ministry of Aviation, he had already constructed the family television set, radio, and record player. The younger May was delighted: he would be able to plug his new guitar into an amp (also homemade) and work on his technique. Imitating his idol Hank Marvin, from the group the Shadows, Brian liked to play a subtle note to note, as opposed to strumming, a more powerful rhythmic play in which all the strings are struck. Amplification was therefore necessary to ensure his guitar would be heard even at minimal volume.

As the years went by, and the future guitarist continued to fine-tune his playing, May often fantasized about what he would do if he was able to get his hands on a Fender Stratocaster or a Gibson Les Paul. Unfortunately, instruments of that caliber were priced out of reach for the May family budget. Indeed, even the European copies, which were somewhat less expensive, were still too costly. Brian would have been more than happy with the German Hofner Colorama owned by his friend John "Jag" Garnham, with whom he founded his first band, which they called 1984. But once again, the May family could not afford such an expense. In the fall of 1962, Harold offered to help his son build his own six-string guitar. In a makeshift workshop, in the only unused room in the May household, the father and son designed what would be an absolutely unique guitar, eventually baptized as the "Red Special."

A Work of Art

The design and construction of the Old Lady—Brian May's other nickname for his guitar—took a full two years. During that time, Brian and his father worked to perfect the instrument, which was built almost entirely from salvaged material. The body of the guitar came from the top of a solid oak table that had been hanging around the house. At first, Brian wanted the body to be hollow and equipped with an f-hole so that he could play with an appropriate resonance of sound. After some thought, the younger May eventually opted for a solid body, like the Fender Stratocaster, which limits the risk of feedback during use. Brian did, however, hide some hollow parts in the instrument, which he called "*acoustic pockets*," and which gave the guitar greater sound versatility. He carefully selected the oak pieces and then assembled them using Cascamite, an extremely powerful wood glue, ensuring the guitar's longevity. During the assembly process, which took days, bricks were used to hold the whole thing together. Meanwhile Brian and Harold worked on a new task: making the neck of the Old Lady. The duo used a century-old mahogany mantel for this purpose, and the advanced age of the wood would ensure that the neck would not move over time, despite the tension of the strings.

Brian decided that there would be twenty-four frets on the instrument, which would allow him to play two octaves. Usually, on the neck of a guitar, you move to the higher octave at the twelfth fret; however, most electric guitars have only twenty-one or twenty-two frets total, so they are missing one or two frets on the upper octave. Brian purchased the small metal rods that were used to separate the fret spaces from instrument maker and guitar dealer Clifford Essex on Earlham Street in London. May sanded the neck of the instrument with sandpaper until he obtained the ideal shape for his fine, delicate style of play. The guitar was perfectly designed to suit the preferences of its future user, and nothing was left to chance. While other six-strings have flat necks, the Red Special's is slightly curved, like that of the Hofner Colorama May dreamed of. Now he had to find a way to bend the frets before inserting them into the thin notches on the neck. To achieve this, Brian designed a small metal mold that could receive and bend each fret until it perfectly fit the century-old guitar neck.

The neck also had to be fitted with a truss rod. This is an iron rod that passes through the instrument and is fitted at the end with an adjusting screw that allows the tension of the wood to be changed in the event that it has bent over time. In 2017, Brian May revealed that the wood of his Red Special has never moved and that the truss rod has never been used, a rare and quite incredible feat. The original mechanics, on the other hand, have

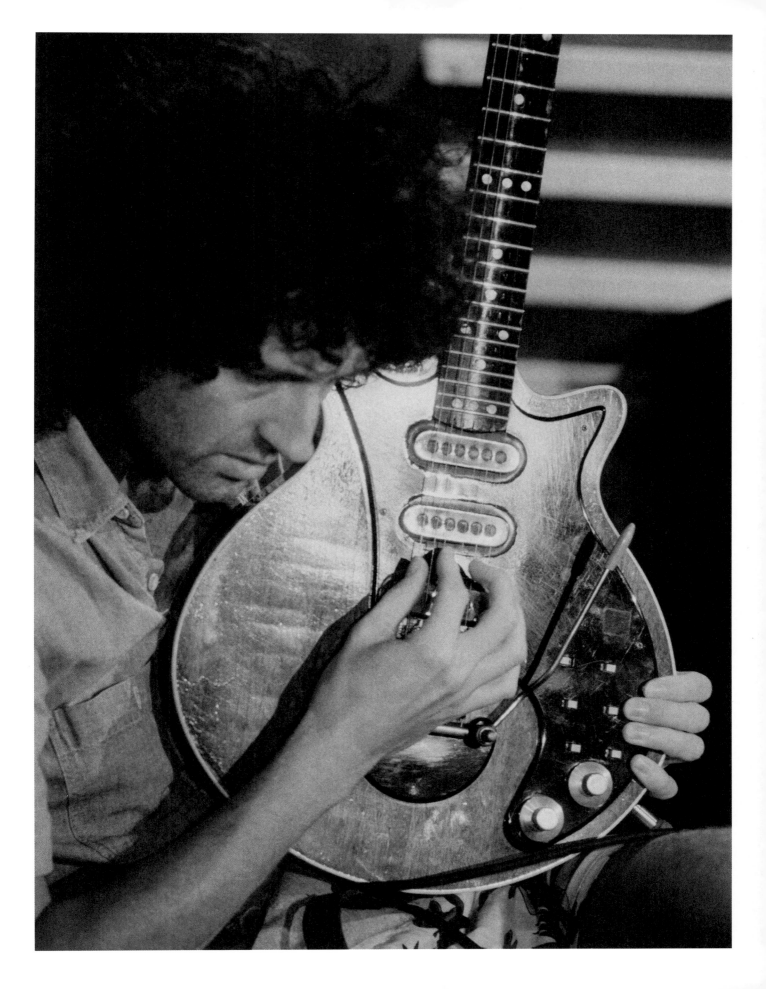

FOCUS ON...

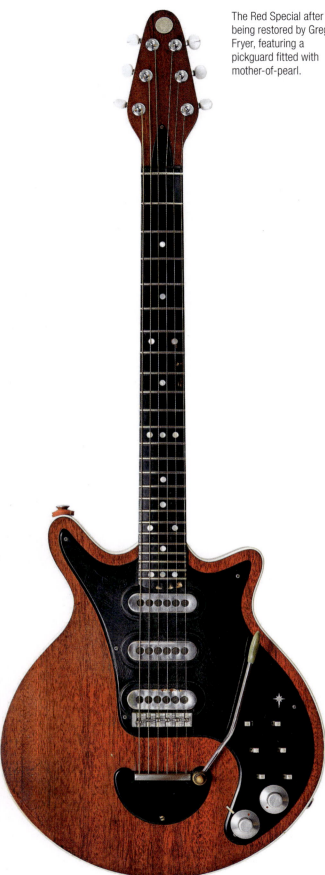

The Red Special after being restored by Greg Fryer, featuring a pickguard fitted with mother-of-pearl.

The three Burns Tri-Sonic pickups detailed here are the only parts of the guitar that Brian May and his father didn't construct themselves.

been changed many times over the course of the years since they didn't hold the tuning well. The Old Lady is now equipped with a pair of Schaller locking M6 tuners with pearloid knobs.

After the neck was complete, the father-son duo then constructed each part of the delicate bridge. But Brian, being a huge admirer of the Shadows, wanted his guitar to be equipped with a vibrato, which, with the help of a metal rod, allows the user to play on the pitch of the notes. To make the vibrato, Harold used two small springs that originally came from the valves of a motorcycle, and a piece of the pannier rack from Brian's bicycle. To complete the work, the young musician shaped the rounded end of one of his mother's knitting needles into the ideal shape for a grip.

Though electronics were one of his father's specialties, the original pickups that Brian's father designed had to be quickly changed in favor of three Burns Tri-Sonics, which were the only ones available in the music store Brian frequented. The first pickups simply didn't support the guitarist's bends, and Brian had to deal with offkey noises every time he played his new guitar. Pickups are a simple series of mounted coils, each equipped with an on/off switch, that can sense the vibrations produced by a musical instrument, helping to send the sounds made by the instrument into the amplifier so they can be heard. Lastly, the pearl dots that mark frets 3, 5, 7, 9, and 12 of each octave of the neck were made from buttons that the young musician selected from his mother's sewing box.

A Precious Restoration

In 1998, the Australian instrument maker Greg Fryer gave the Red Special its first restoration. Captivated by the Old Lady, which must have been incredibly resilient in order to survive thirty years playing concerts all round the world, Fryer noted the high quality of the guitar and praised the astonishing work of Brian and Harold. Brian May, then in the middle of recording his album *Another World*, was unable to be present during the restoration, but each morning the two men took stock of the work. The pickups in particular received special care and were covered with a paraffin-based mixture to reduce feedback problems. The vibrato system was also completely cleaned, and the fifth mother-of-pearl knob was replaced.

In the fall of 1964, once the original guitar was finished, Brian salvaged the electronic circuitry from a Vox Fuzz Box pedal and fit it on his Red Special by sliding it under the protective plate. A small hole had been drilled next to the rows of white knobs in order to pass the on/off switch, which gave the instrument its biting, crunchy, fuzzy sound, similar to that of Jimi Hendrix, the young guitarist's idol. But after a few months, Brian backtracked and removed the system, leaving a gaping hole in place of the switch, which he plugged with either black adhesive tape or a sticker. In order to cover this hole during his restoration years later, Greg Fryer made a small mother-of-pearl star, inspired by the logo on the cover of Brian May's first solo album *Back to the Light*, which was released in 1992.

The last known modification to the Red Special was an addition made by Brian May himself. May added a commemorative sixpence piece on the guitar head. Released in 1993 to coincide with the tour that followed his first album, the coin features May's profile and the inscription "Brian May—Back to the Light."

A Rich Lineage

Numerous copies of the Red Special, some of which were recognized and approved by the artist, have been produced over the years. The American company Guild released a very faithful reproduction in the mid-1980s, named the BHM01, and then Burns UK offered a more affordable version in the early 2000s. Beginning in 2004, the guitarist himself marketed replicas of his Old Lady, via a company he created specifically for this purpose: BMG, or Brian May Guitars. In a nod to the past, *BMG* was the name of the music magazine published by Clifford Essex, the instrument maker from whom Brian bought his original frets. The initials for the magazine stood for "Banjo, Mandolin and Guitars." The range of instruments Brian May offers today consists of faithful replicas, as well as variations of the famous six-string guitar: a bass model (the BMG Bass), a travel version (the BMG Mini May), a ukulele (the BMG Uke) and an electro-acoustic (the BMG Rhapsody Electro-Acoustic). Fans are certain to find something to suit them from among the descendants of the famous six-string, but none will match the unique Red Special, built with four hands in Harold May's little workshop.

QUEEN: ALL THE SONGS 53

ALBUM

QUEEN II

Procession . Father to Son . White Queen (As It Began) . Some Day One Day . The Loser in the End . Ogre Battle . The Fairy Feller's Master-Stroke . Nevermore . The March of the Black Queen . Funny How Love Is . Seven Seas of Rhye

RELEASE DATES
United Kingdom: March 8, 1974
Reference: EMI—EMA 767
United States: April 9, 1974
Reference: Elektra—EKS 75082
Best UK Chart Ranking: 5
Best US Chart Ranking: 49

> The members of Queen pose with actress and Queen Elizabeth look-alike Jeannette Charles in September 1974.

THE BLACK AND WHITE ALBUM

By the time they were released in 1973, the most recent recordings on Queen's first album were more than eighteen months old. The group no longer felt comfortable supporting an album that they felt was starting to seem dated. Worse yet, the members of Queen felt that they'd lost ground in the glam-rock movement they started, with David Bowie and Roxy Music having broken through with the public during the long months Mercury and his band spent waiting for Trident to find a distributor. Faced with the relative failure of their first album and its lead single "Keep Yourself Alive," not to mention the deluge of nauseating criticism they were receiving from a relentless music press, the band remained united and embarked on a new project, encouraged by the Sheffield brothers and everyone at Trident.

The Kitchen-Sink Album

Less than a month after the release of their first album, Queen was back at 17 St. Anne's Court to begin recording their second album. This time, the band negotiated official daytime use of the studios and obtained a reasonable budget from Trident for the production of the disc (which they greatly exceeded). With the planned Mott the Hoople tour set to begin in November 1973, the four band members, bubbling with inspiration and creativity, were determined to use every tool at their disposal to ensure that these new recording sessions resulted in something special. By this point, Mercury no longer got along with John Anthony, who had co-produced Queen's first album, and it was decided that he would not return for a second collaboration. The idea of working with David Bowie was discussed—he had just co-produced Lou Reed's *Transformer* album with Mick Ronson—but the future Thin White Duke, was too busy recording the *Pin Ups* album and kindly declined the proposal. In the end, it was another sound engineer from the studios, Robin Geoffrey Cable, who assisted Roy Thomas Baker on the tracks for the second album. In the studio, it was former jack-of-all-trades Mike Stone, who had earned his stripes on the production of the first record, who manned the controls behind the console.

Once the team was complete, work could begin. The future album was given the provisional title "Over the Top," and it effectively set the tone for the sessions, which would prove to be as exhausting for the technicians as it was stimulating for the four musicians. As a group, Queen informed Roy Thomas Baker that as their lead producer, any proposal from him would be welcomed, and that they wanted this album to sound "homemade." It was this experimental approach suggested by the band that led the producer to describe *Queen II* as "the kitchen-sink album."[2] Mercury and May explained to Baker that the future album would be separated into two distinct parts: Side 1, which would be named the White Side and would feature Brian's songs; and Side 2, which would be named the Black Side, and would feature all of Freddie's songs. Concept albums were very much in vogue at the time: The Who had been extremely successful with their rock opera *Tommy* in 1969 and were preparing to repeat the experience with *Quadrophenia*, set to be released in the fall of 1973.

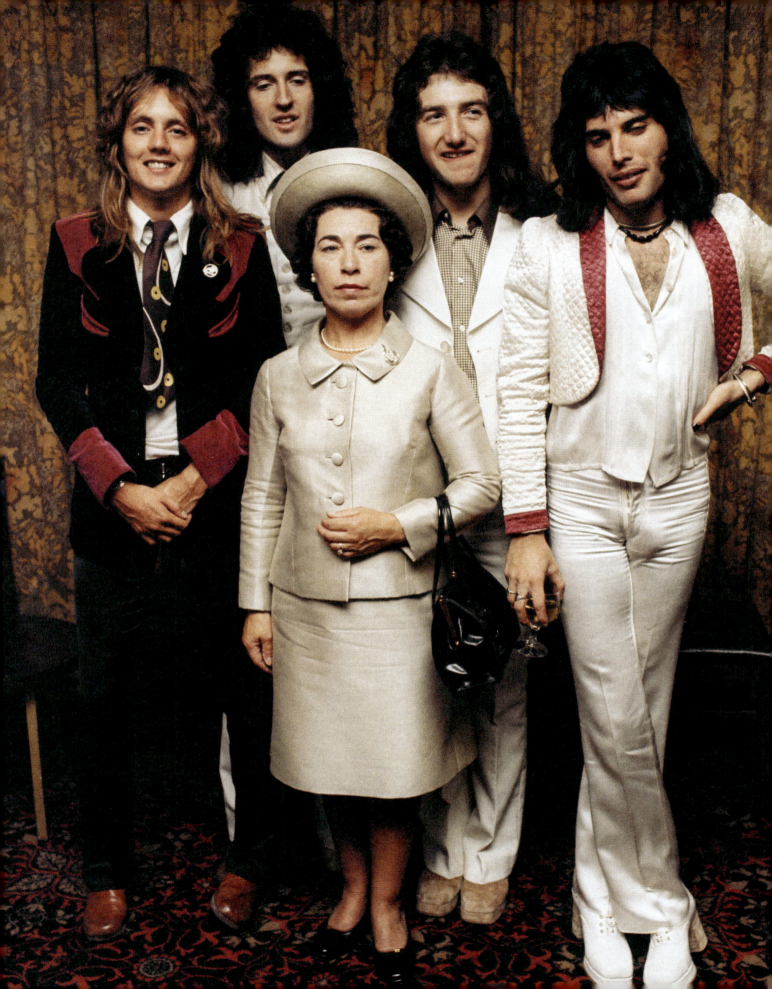

Marlene Dietrich immortalized by famed photographer George Hurrell on the set of Josef von Sternberg's *Shanghai Express* in 1932.

Upon first listening to *Queen II,* many listeners are left in a state of awe, as the songs are so rich, the arrangements so complex, and production quality so magnificent. During their recording sessions, the group worked to define their artistic process, which consisted of stacking layers of sound in order to create a wall of harmonies. Everything was precisely calculated, and the masterpieces started flowing, from the powerful "Ogre Battle" to "The March of the Black Queen" to the poignant "Nevermore." Roger Taylor said of this titanic project: "We were working a 16-tracks set-up, so we were constantly thinking about how many tracks we could bounce down without losing quality. It was a massive amount of work. We really were consciously trying to break the boundaries of what people thought they could do in the recording studio."[15]

Ten Million Viewers

After the exhausting recording sessions, they were all proud of the work they had accomplished. Brian was very pleased with the result, and for the first time Roger seemed happy with the sound of his Ludwig drums.

Once the recordings and mixings were completed, the band set out on a British tour as the supporting act for Mott the Hoople, which lasted until December 22, 1973. As they performed at concerts in Liverpool, Newcastle, Glasgow, Edinburgh, and Manchester the members of Queen gained greater stage confidence, and a newfound sense of success as the group became more recognizable. Then Mel Bush, the promoter of their shows, offered to produce Queen's first headlining tour. Twenty-two dates were scheduled in the United Kingdom between March 1 and April 2, 1974, and at each performance the group was able to appreciate the growing interest of a public that was increasingly receptive to their music.

In order to refine their stage visuals, Queen began collaborating with stylist Zandra Rhodes, who designed new outfits for the musicians. The band also worked with photographer Mick Rock, who found fame by immortalizing Lou Reed for the cover of his album *Transformer* in 1972.

On February 21, 1974, a stint on the cult BBC1 show *Top of the Pops* changed the group's destiny. David Bowie had to cancel his appearance on the show, and Queen was called in to replace him. The conditions at the studio were awful: the group had to sing in playback, the cymbals were fitted with silencers and the hosts made a series of skits and funny faces in front of the band during their performance.

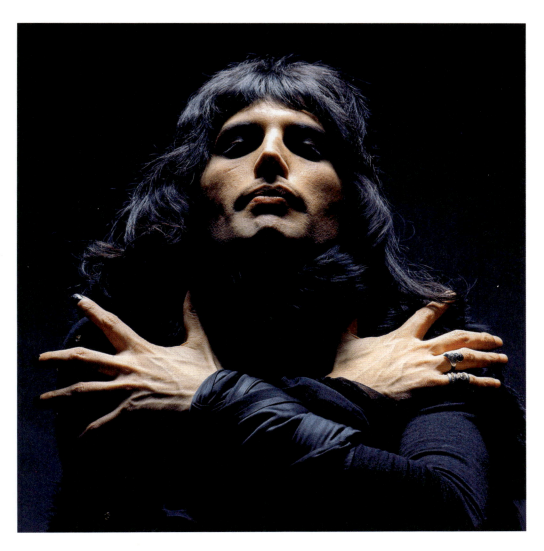

Freddie Mercury photographed by Mick Rock for the cover of *Queen II*.

It was so distracting that it was difficult for the musicians to keep their poise. The experience would remain a bad memory for the band, but ten million viewers had watched the show. And with just one month to go before the release of their second album, it was the broadcast of this show that helped anchored Queen's name and their music in the minds of the public.

Attacking America

In the spring of 1974, Queen toured North America with Mott the Hoople. May, Taylor, and Mercury had always maintained that nothing could be taken for granted until the group made a breakthrough in the United States. The musicians would have to prove themselves and promote their second album, while at the same time battling against the press, who were publishing increasingly venomous articles about band. Sarcasm abounded, and British journalists questioned whether the rockers were as good onstage as they were at looking elegant and distinguished in photographs. This marked the start of a war between Queen and the British press, which lasted right up to Mercury's death in 1991. At the time, the band clung to the support of their ever-increasing fan base and continued to move forward despite their issues with the press. *Queen II* took fifth place in the UK charts upon its release, and the North American tour, where the band was able to share the bill (and the whisky) with another young band named Aerosmith, was a success. The journey was marked by a stop in New Orleans, where the four musicians felt very much at home. This visit inspired May to write the lyrics of one of the group's most famous songs: "Now I'm Here," which would appear on the following album. It was during this time that the team met Peter Hince. Then a roadie for Mott the Hoople, Hince would later become the group's technical supervisor. The trip to America was like a dream come true for Queen, until they reached New York. On the morning of May 13, before setting off for a concert in Boston, Brian May found himself unable to move. The guitarist had contracted hepatitis, and Queen was forced to cancel the end of the tour. Carried to his seat on the plane by the other band members, the extremely weakened May would have to spend several weeks in bed.

Faced with this aborted American adventure, Queen had only one solution: return to the recording studio and resume work as a trio while their guitarist regained his strength.

QUEEN: ALL THE SONGS

PORTRAIT

Zandra Rhodes in the early 1970s.

ZANDRA RHODES: A STYLIST TO THE AVANT-GARDE

In the spring of 1974, Queen's second album was released. Mick Rock's now-famous album photography worked to accentuate the band's solemn and androgynous style, and Freddie Mercury, very much aware of the power of the image for a band still trying to break through, was determined to refine the musicians' look even further. At this time, the singer was known for wearing a tight-fitting outfit on stage that featured white flames that looked like they were escaping from his torso, arms, and ankles. Nicknamed the "*Winged Messenger*," this outfit was designed by Wendy Edmonds. But the band, which had negotiated a substantial budget for the development of its stage outfits with EMI, wanted a new wardrobe. Highly attracted to the avant-garde and glamourous costumes designed by Zandra Rhodes for Marc Bolan, the leader of the band T. Rex, Freddie and Brian contacted the stylist and offered her the opportunity to create Queen's next stage costumes.

From Illustration to Haute Couture

Zandra Rhodes was born on September 19, 1940, in Chatham, England. As a teenager, she was introduced to the world of fashion by her mother, who was a teacher at the Medway College of Art. Originally wanting to become an illustrator, Zandra was admitted to this prestigious college in 1957, and allowed to skip directly into classes typically reserved for second year students. Eventually, Zandra would turn to textile printing, which became her specialty. She continued in this direction by studying at the Royal College of Art, before opening her first shop with Sylvia Ayton in 1967. They called their store the Fulham Road Clothes Shop, after the street in London where the store was located. In 1969, the two friends split up, and Zandra opened her studio in Paddington. While she had previously been involved only in patterns and textile printing, she began developing new skills and started specialized in designing modern and quirky clothing. Her collaboration with actress Natalie Wood, who wore Zandra's clothes on the pages of American *Vogue* in 1970, turned Zandra into a star of British haute couture overnight.

A Wedding Dress for Freddie

In early 1974, the stylist received the guitarist and singer of Queen at her studio. Though she had been completely unaware of their existence only a few weeks earlier, friendly relations were quickly established between Zandra and Freddie when he tried on a variety of her tunics, and the proceeded to jump and whirl around the room making sure nothing would hinder him on stage. Freddie finally chose a top that Zandra, influenced by the outfits of model Tina Chow, had originally designed as a wedding dress. She

Freddie Mercury onstage in 1974, dressed by Zandra Rhodes.

Brian May wearing an outfit designed by Zandra Rhodes on the cover of the June 7, 1974, issue of *Daily Telegraph Magazine*.

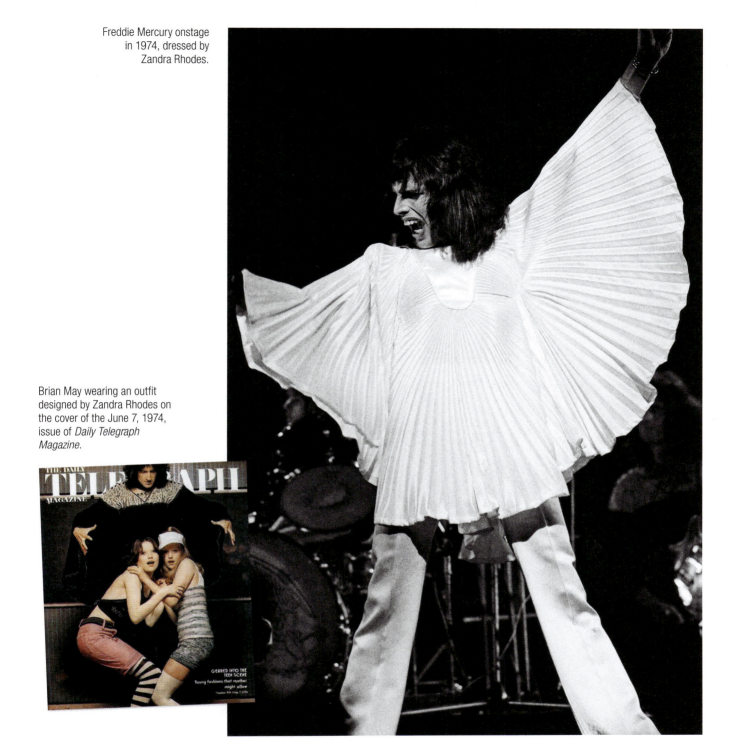

eventually created a variation of the outfit for Freddie that was made entirely of cream-colored satin, and which the singer wore for the solo photo shoot he did with Mick Rock in June 1974. Brian May also wore Zandra Rhodes's outfits; either in black or white depending on his mood. It was more difficult to dress John and Roger, as the bass player wasn't enthusiastic about dressing up, and the drummer became suffocatingly hot on stage in his satin outfits.

Though for many it is impossible to disassociate Queen from the early work of Zandra Rhodes, and vice versa, Rhodes went on to become a world fashion icon, creating designs for Princess Diana, Elizabeth Taylor, and Sarah Jessica Parker among others. Distinguished by her signature pink hair and matching makeup, Zandra helped the members of Queen create some of the most iconic images in rock and roll history. The photographs of Brian May proudly strumming his guitar with his wide black satin sleeves have become an integral part of the band's iconography and are recognizable to fans around the globe.

QUEEN: ALL THE SONGS 61

Mick Rock, the celebrated rock star photographer, poses with Freddie Mercury in 1974.

MICK ROCK: A GOLDEN EYE BEHIND DARK GLASSES

After the release of their first album on July 13, 1973, the members of Queen were thinking about the future of the band and preparing for their British tour as the supporting act for Mott the Hoople. It was around this time that the group first took an interest in the work of Mick Rock. An old friend of Syd Barrett, the former singer from Pink Floyd, Mick Rock knew everybody who was anybody in London, and in a relatively short period of time he became the most sought after photographer in the city's rock scene, working with the likes of Lou Reed and David Bowie.

The photographer was immediately won over by the confidence and kindness of the members of Queen. At their invitation, he attended a concert held on November 2, 1973, at Imperial College in London, then organized a first photo shoot in the same month. The photos from this shoot would eventually be used to promote the group's upcoming tour.

At first, the group posed with a giant scepter. Brian May was not impressed with the results, and the photos were not released until several decades later. Then the photographer suggested that the musicians pose shirtless. When the image was released, the press criticized the band for its lack of manliness, but Mercury's goal had been achieved: The press were talking about Queen.

The Black and White Concept

In January 1974, Mercury called on the photographer once again to shoot the cover of *Queen II*, the concept of which Mercury explained to Rock. Side 1 of the album, called the White Side, would feature Brian's songs, while Side 2, the so-called Black Side, would feature songs by Freddie. Mercury wanted to emphasize the duality between good and evil that lies within each of us. The band gave the photographer carte blanche in the hopes of getting a stellar image. Rock immediately thought of a photo of Marlene Dietrich that had been given to him by his friend John Kobal, a famous film historian. It had been taken in 1932 by George Hurrell on the set of Josef von Sternberg's *Shanghai Express*, when the actress was thirty-one years old. Rock was inspired by the famous actress's pose.

A photo session was quickly organized, and the legendary series of the four musicians dressed in black with their faces obscured by shadow were all taken on that day. It was during this session that the iconic photograph of the entire band was taken and chosen for the album cover. Freddie, in particular, crosses his arms over his chest, taking up the iconic pose of Marlene Dietrich. The photos "in white" illustrating the White Side of the album were shot on the same day and were featured in the album booklet.

The "Man Who Photographed the '70s"

Known for his omnipresence at parties, concerts, and other events held in the rock scene of the 1970s, Mick Rock (his real last name) was without a doubt the most prolific music photographer of his time. He is credited with the famous photograph of actor Tim Curry staring at the viewer, as white as the string of pearls around his neck, which was used for the promotion of the 1974 film *The Rocky Horror Picture Show*. He was also close to the London and New York scene of the 1980s and famously immortalized the Stooges, Blondie, Mick Jagger, the Ramones, and Roxy Music. Also influential in the fashion world, he photographed top model Kate Moss on numerous occasions.

A beautiful retrospective of his work for Queen is collected in the book *Classic Queen*, published by Overlook Omnibus in 2007, and his photographs are often exhibited and sold to the general public, as during the fall 2019 exhibition held at the Morrison Hotel Gallery in New York.

PROCESSION
Brian May / 1:13

Musicians
Brian May: electric guitar
Roger Taylor: drums
Recorded
Trident Studios, London: August 1973
Technical Team
Producers: Roy Thomas Baker, Queen
Sound Engineer: Mike Stone

FOR QUEEN ADDICTS
A year earlier, in March 1973, another concept album had been released, beginning with heartbeat simulations similar to those on "Procession." It was *The Dark Side of the Moon*, the eighth Pink Floyd album.

Even before the credits rolled, viewers of the 2018 film *Bohemian Rhapsody* got the opportunity to rediscover Brian May's signature sound. As a special surprise for the film, the guitarist rerecorded Alfred Newman's famed theme music, which plays over the 20th Century Fox studio's logo, adding his famous guitar harmonizations.

Genesis

Coming across as a blend between a wedding march and funeral procession, the introduction to *Queen II* bears Brian May's clear stamp. Its gravity underlines the solemn tone of the entire disc, and its title evokes the religious aspect of the themes soon to be addressed. The band's dark and mysterious faces appear on the album's cover, giving the listener an idea of the album's baroque character, with Freddie Mercury even laying his hands folded on his chest, as if at his own wake. On future albums, May would regularly add such interludes to Queen's catalog, creating famous melodies with his own trademark. This was the case in 1980 with "The Wedding March" on *Flash Gordon*, where an extract from the opera *Lohengrin*, by Richard Wagner, is magnified by the guitarist's renowned Red Special. It was also the case in 1975, when the group closed *A Night at the Opera* with a remarkable version of "God Save the Queen."

"Procession" is a brilliant prelude to the White Side of *Queen II*, marked at the beginning by weak beats that announce the pattern of the march to come, and quoting the next track "Father to Son" in its end riff. This piece of music would also serve as the introduction the band used to take the stage for all of their concerts between September 1973 and May 1975.

Production

With the help of his Red Special, Brian May used this track to build a monument to contemporary music. May used harmonic techniques on the guitar that had never been heard before. And even more surprising, the guitarist was able to simulate a variety of instruments (organs, violins, brass...), which he would do again during the recording of "Good Company" in 1975.

May had already started recording the guitars for "Procession" using his traditional Vox AC30 amps, but he chose to use the small one-watt Deacy amp made by John Deacon for the harmonization portion of the track, which, thanks to its germanium transistors, caused a natural distortion of sound that was amazing to hear and that couldn't be imitated. Subsequently the guitarist regularly used this amp during the band's recording sessions.

FATHER TO SON
Brian May / 6:14

Musicians
Freddie Mercury: lead vocals, backing vocals, piano
Brian May: electric guitar, piano, backing vocals
John Deacon: bass, acoustic guitar
Roger Taylor: drums, tambourine, backing vocals
Recorded
Trident Studios, London: August 1973
Technical Team
Producers: Roy Thomas Baker, Queen
Sound Engineer: Mike Stone

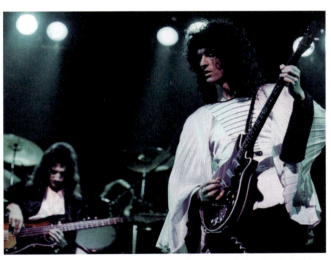

Brian May and John Deacon dressed in satin onstage in London in 1974.

Genesis
Following the "Procession" instrumental prelude, "Father to Son" is the first song on the album that fully delves into the themes of transmission and cultural heritage that are prevalent throughout the disc. May had always been very close to his father, Harold, and the listener can easily imagine that he is referring to his relationship with his father in this song's lyrics, which constitute a dialogue between a child and his father, focusing on a letter the father gives to his son, the meaning of which the son will only grasp when he is an adult. While the subject had been brilliantly addressed in Cat Stevens's unforgettable "Father and Son" in 1970, May makes this track his own, giving it a simultaneously lyrical and serious tone.

The band opened its concerts with the "Procession" / "Father to Son" duo between September 1973 and October 1974, the first bars of the second song being perfectly suited to the musicians' entrance to the stage.

Production
While the introduction may be reminiscent of "Baba O'Riley" by the Who, which was featured on the *Who's Next* album in 1971, the remaining bars of "Father to Son" are unique. Influenced by the violin harmonizations he studied as a teenager via his crystal radio set, Brian May wanted to find a way to use this method within the band, leading the quartet to stack their vocal tracks, thereby creating the unmistakable Queen sound that everyone knows today. While May also performed the piano parts on "Father to Son," it was John Deacon, the retiring bass player that liked to stay on the periphery within the band, who played acoustic guitar on the track. His rhythmic guitars are particularly present at the end of the track, where "Father to Son" takes on a Flower Power aura, marked by the final, repeating chorus, which was so reminiscent of John Lennon's *"All we are saying / Is give peace a chance,"* which was released in 1969. Before reaching this melodic end, Brian himself plays incisively, and at the 2:11 point, he even manages to slip in a small nod to the riff from "Son and Daughter" which appeared on the band's first album.

WHITE QUEEN (AS IT BEGAN)
Brian May / 4:37

Musicians
Freddie Mercury: lead vocals, backing vocals
Brian May: electric and acoustic guitars
John Deacon: bass
Roger Taylor: drums

Recorded
Trident Studios, London: August 1973

Technical Team
Producers: Queen, Roy Thomas Baker
Sound Engineer: Mike Stone

FOR QUEEN ADDICTS

In order to make it sound like a sitar, Brian May modified the bridge of his cheap Hallfredh guitar. It was this modification that gave his notes their metallic coloring, which can be heard more distinctly on "Jealousy," included on the album *Jazz* in 1978.

Many hardcore Queen fans will argue that you have to listen to the "White Queen" take recorded during the BBC Sessions of April 3, 1974, to experience all the romanticism and melancholy of this song.

Genesis

Brian May wrote "White Queen (As It Began)" on the benches at Imperial College when he was still a student. Spellbound by one of his classmates, Brian spent three years not daring to speak to her. He finally paid tribute to her through this song. Did this muse ever know that she was the inspiration for a song by one of the biggest rock bands in the world?

While he was writing, May was also immersed in Robert Grave's work *The White Goddess*, which deals with the figure of women in art according to their social position, sometimes depicted as a virgin, a mother, or a queen. As he wrote, a link between his young student crush and the archetype of the idealized women was created in the mind of the young May: "I saw [her] every day at College, and [she] was to me the ultimate goddess."[5]

This secret love gave birth to one of the band's first rock ballads, which would find its place in opposition to "The March of the Black Queen," on the Black Side of the album.

Production

The song is structured in two very distinct parts. The repetitive introduction reveals the subject: "*So sad her eyes / As it began*" and comes back at the end of the track at 4:04 for a smooth coda. But the greatest achievement of "White Queen (As It Began)" is its poignant melodic verse, which would go on to inspire the biggest FM rock bands of the 1980s, when the slow-rock style was in vogue. Equipped with his famous 1930s Hallfredh acoustic guitar, Brian May supports the melancholic aspect of the song with a very effective chord descent reminiscent of the 1984 hit: "Still Loving You," by the Scorpions. Roger Taylor maintains a heavy tempo thanks to his twenty-inch Premier Super Zyn Ride cymbal, on which he plays rolls with mallets. It is the baize finish on Taylor's mallets that provides this matte sound featured on the album, similar in style to the percussive sounds created by a symphony orchestra.

"White Queen (As It Began)" was to remain one of May's most personal songs, as he explained: "'White Queen''s got a lot of real emotion in it for me. Though it wasn't really a hit, it's one of the songs I'd like to be remembered for."[16]

SOME DAY ONE DAY
Brian May / 4:22

Musicians
Freddie Mercury: backing vocals
Brian May: lead vocals, backing vocals, electric and acoustic guitars
John Deacon: bass
Roger Taylor: drums, backing vocals

Recorded
Trident Studios, London: August 1973

Technical Team
Producers: Queen, Roy Thomas Baker
Sound Engineer: Mike Stone

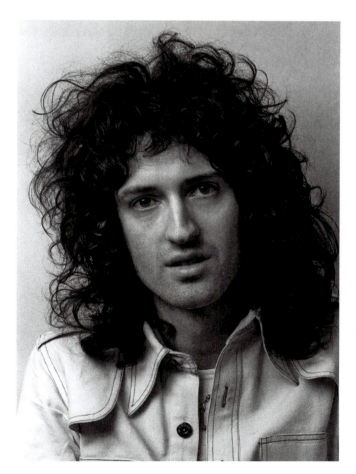

Brian May in November 1974. Romanticism and melancholy were the hallmarks of the talented guitarist's compositions during this period.

Genesis

This love song, far from the thunderous Hendrix riffs that May liked to study, reveals all of the Queen guitarist's romanticism, as well as his ability to write simple and effective songs. The guitar rhythm in this track is a prologue of sorts to the future folk song "'39," which became one of the masterpieces of the monumental 1975 album, *A Night at the Opera*. In the lyrics we find the common fantasy tales that were so specific to the May/Mercury duo. Appearing to continue the comparison between his beloved and a fantasized queen, which began on the previous track "White Queen (As It Began)" Brian sings, *"A misty castle waits for you / And you shall be a queen."* He confirms his nature as a genuine sentimentalist, stating: "['Some Day One Day'] was born of my sadness that a relationship seemingly couldn't be perfect on earth."[5]

Production

Reminiscent of the great years of folk music, "Some Day One Day" doesn't quite find its place on Queen's second album, despite the brilliant performance from Brian May, who appears for the first time as lead singer on a track.

The psychedelic aspect of the track is underlined by guitar improvisations that seem to scroll backward and a cleverly deployed phaser effect that, though present throughout the mix, doesn't really contribute to the cohesiveness of the record. It must be admitted, however, that the naiveté of the track corresponds rather well with the spirit of May's White Side. The guitarist has given very little information regarding the instruments used during the recording sessions of *Queen II*. Having acquired his first acoustic Martin D-18 at this period, the musician has confirmed that it was used to create the very folk Americana rhythm of "Funny How Love Is." It is a safe bet that it is also this American beauty we hear on "Some Day One Day."

Roger Taylor during an interview with the Japanese magazine *Music Life*, in June 1974.

THE LOSER IN THE END
Roger Taylor / 4:04

Musicians
Roger Taylor: lead vocals, backing vocals, drums, marimbas
Brian May: electric and acoustic guitars
John Deacon: bass

Recorded
Trident Studios, London: August 1973

Technical Team
Producers: Queen, Roy Thomas Baker
Sound Engineer: Mike Stone

FOR QUEEN ADDICTS
"The Loser in the End" was never played in concert but did appear on the B-side of the Japanese pressing of the "Seven Seas of Rhye" single.

Genesis

Roger Taylor's admiration for Led Zeppelin's drummer is evident from the very first bars of this song. He makes no bones about it: "The best drummer? Easy. John Bonham is better than everyone else. It's really quite simple."[16]

It's true that the allusion to "When the Levee Breaks," from the album *Led Zeppelin IV*, is obvious in the introduction of "The Loser in the End," but this quickly fades away. This is the second song written and sung by Taylor to appear on an album by the group. The drummer also wrote a number of songs that he set aside for his various personal projects, notably his solo albums, the first of which, *Fun in Space*, was released in 1981.

"The Loser in the End" acts as a transition within the album, marking the end of the so-called White Side and the beginning of the Black Side. While the first listening may surprise, because the track's musical fingerprint is clearly not from the same school as that of May and Mercury (who was often missing from songs written by Taylor), the song ultimately finds its place within the larger concept album, even though opinions are divided about its effectiveness. Even the *Record Mirror*, always ready to give Queen an amiable review, declared that "['The Loser in the End'] must be the worst piece of dross ever committed to plastic."[5]

Production

Taylor hammered out a powerful drum sound right from the opening moments of the track, shedding the muffled mixing that displeased him so much on the first album. A long delay effect was added on the crash cymbal, and a similar effect was added to the drummer's voice, which became his signature when singing with Queen. The effect had previously been used on "Modern Times Rock 'n' Roll." Roger Taylor also played marimbas, which was not at all in keeping with the musical aesthetic of the group, but which confirmed the "kitchen sink" label given to the album by Baker.

Drummer or not, Roger Taylor was also a huge collector of six-string guitars. Brian May testified to this several times when asked about the number of instruments in his possession: "How many guitars I've got? Not as many as Rog'!"[17]

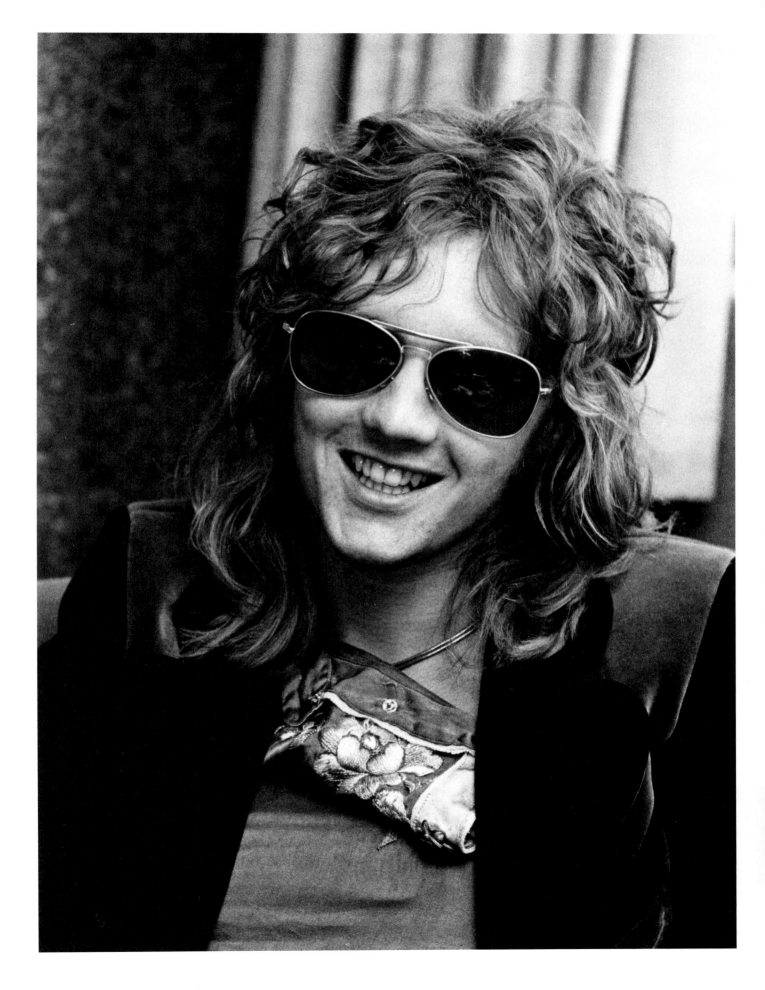

Freddie onstage in November 1973, dressed in a costume by Wendy Edmonds, who would soon be replaced by designer Zandra Rhodes.

OGRE BATTLE
Freddie Mercury / 4:08

Musicians
Freddie Mercury: lead vocals, backing vocals
Brian May: guitars, backing vocals
John Deacon: bass
Roger Taylor: drums, gong

Recorded
Trident Studios, London: August 1973

Technical Team
Producers: Queen, Roy Thomas Baker
Sound Engineer: Mike Stone

Genesis

Undoubtedly one of the greatest songs composed by Freddie Mercury, "Ogre Battle" is also one of the band's heaviest tracks. The singer plunges us into a fantasy world, where ogres lay hidden in mountains made of two-way mirrors: *"The ogre-men are still inside / The two-way mirror mountain."* The members of Queen were huge fans of fantasy literature, and the world of J. R. R. Tolkien is very present in the lyrics of this song, whose protagonists are reminiscent of the characters in the *Lord of the Rings* trilogy, published in 1954–1955 and extremely popular in the mid-1970s. Freddie Mercury invites us into the song with the repeated line *"Come to the ogre battle fight!"* the metaphor between this fight and Queen's show being barely concealed.

The song, which had already been played at concerts in 1972, was initially intended for the band's first album, but its musical aesthetic didn't really fit with the themes and sounds of the first album. Written by Freddie on the six-string then handed on to May to be perfected by his Red Special, "Ogre Battle" stands out with its powerful guitar riff played in palm mute. The song has gone on to influence generations of musicians.

Production

With "Ogre Battle" Queen attained a hitherto unreached level of perfection in their recording studio experiments. The work on the voice harmonizations is exceptional and perfectly accomplished. Roger Taylor's lead voice is crystalline and accurate and perfectly matches those of his colleagues. The verses sung by Mercury are supported by an unerring melody, and refrains of precisely measured power, backed by a question-and-answer between voice and guitar that works wonderfully.

For the introduction to the track, Roger Taylor used the sixty-inch Paiste Symphonic Gong available at Trident Studios. Once the gong had been recorded, the group decided to play the recording backward to give it a so-called "reverse" effect, which creates a crescendo of sound. Fully satisfied with the result, May asked Roy

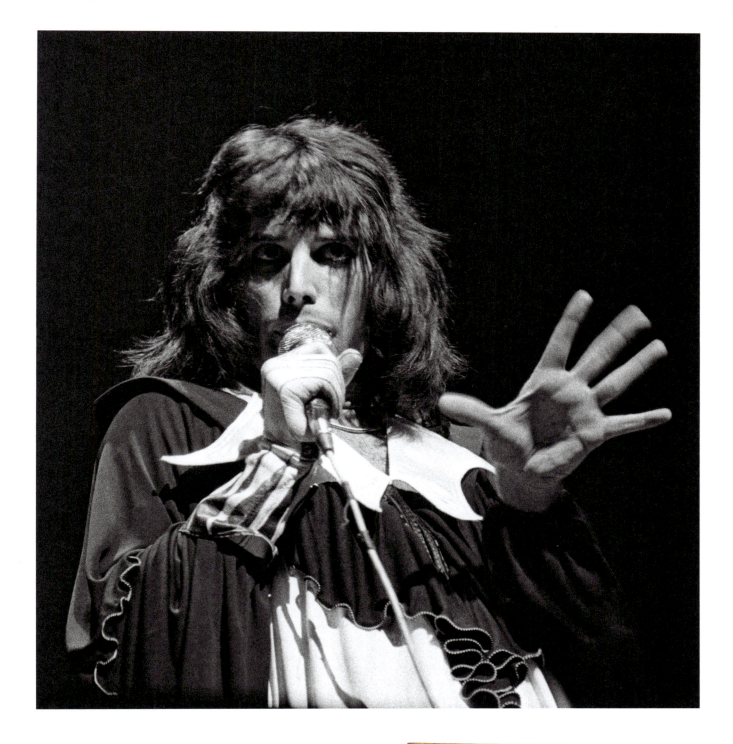

Thomas Baker to apply the same treatment to the introductory guitar riff. "The riff is palindromic; it sounds the same forwards and backwards."[5] Of course, the effect was immediate, and the group decided to keep it. The introduction was then played wholeheartedly with the inverted guitar gimmick, returning to its original direction at 0:47, before giving way to Freddie Mercury's melodic verse.

For Queen Addicts

Like his idol John Bonham of Led Zeppelin, Roger Taylor was quick to adopt the gong as an element of musical decoration used to back up his drums. It made its first appearance during the *A Night at the Opera* tour and was used during the finale of "Bohemian Rhapsody," after Freddie Mercury's legendary *"Anyway the wind blows."*

THE FAIRY FELLER'S MASTER-STROKE

Freddie Mercury / 2:41

Musicians
Freddie Mercury: lead vocals, backing vocals, piano, harpsichord
Brian May: guitars, backing vocals
John Deacon: bass
Roger Taylor: drums, percussion, backing vocals

Recorded
Trident Studios, London: August 1973

Technical Team
Producers: Queen, Roy Thomas Baker
Sound Engineer: Mike Stone

Genesis

Shortly before the start of the recording sessions in August 1973, Mercury took the rest of the group along with Roy Thomas Baker to visit the Tate Gallery (now Tate Britain). The singer's goal wasn't simply to strengthen the bond between the members of Queen with a cultural excursion, but also to share a discovery he had made during one of his visits to the museum. He wanted to show his fellow band members a painting by Richard Dadd called *The Fairy Feller's Master-Stroke*. A nineteenth-century English painter, Dadd painted his masterpiece at the Bethlem Royal Hospital in Bromley, a psychiatric institution in the suburbs of London commonly known as Bedlam. Dadd was incarcerated at Bethlem Royal Hospital after murdering his father in 1843, believing his actions were guided by the Egyptian god Osiris and convinced that his father was the devil in disguise. While in the hospital, the painter worked for nine years on his most famous work, which shows an outdoors scene populated by disturbing imaginary characters lurking behind the bushes.

Mercury borrowed the painting's title for the second song on his Black Side. The title refers to characters as curious as those of the painter and fits perfectly into the phantasmagorical universe that Mercury and May wanted to develop on the album.

In his text, Freddie revels in the medieval world he loves, using vocabulary from another age: "*Tatterdemalion and the junketer / There's a thief and a dragonfly trumpeter.*" Or again: "*Pedagogue squinting wears a frown / And a satyr peers under lady's gown.*" The singer, who was developing his persona as a British dandy at this time, would henceforth address his interlocutors by calling them "*my dear.*" He also deepened his taste for high culture by studying the writings of Tolkien and drawing inspiration from the works of Salvador Dalí, Alphonse Mucha, and Arthur Rackham. While Mercury's interest in art enriched his songwriting throughout his career, in "The Fairy Feller's Master-Stroke" the listener is given a vast number of references to decipher, leading Dee Snider, the singer from Twisted Sister and a huge Queen fan, to declare: "I needed an

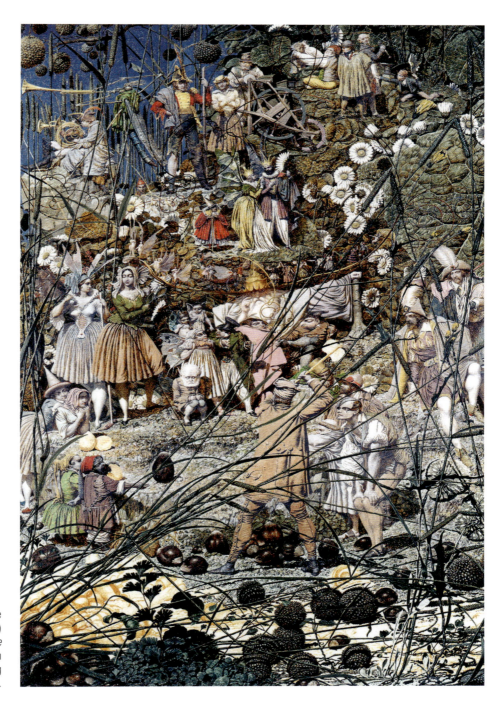

The madness of Pre-Raphaelite painter Richard Dadd (1817–1886) is expressed in his major work, *The Fairy Feller's Master-Stroke*, which inspired Mercury to write a song with the same name.

Encyclopaedia Britannica to look up that shit, because it wasn't words, it was phraseology. I found out that everything had meaning and was poetic. Just brilliant."[11]

Production

Freddie Mercury hated electric pianos. No one could get him to use a Fender Rhodes or a Wurlitzer EP200, like the one John Deacon would use on the future hit "You're My Best Friend." On the other hand, the sounds offered by mechanical keyboards delighted the singer, who was ready to abandon the Bechstein piano at Trident Studios for a Thomas Goff harpsichord, nicknamed the "Steinway of harpsichords." The English instrument manufacturer, who set up his workshop in 1933, is also famous for designing clavichords that are smaller and easier to transport. Freddie, who played the harpsichord on the introduction to this track, used its medieval sound to lend an old-fashioned color and feeling to his song. This was a subtle and mischievous choice, the keyboard leaving its mark on "The Fairy Feller's Master-Stroke" just as the Mellotron organ had stamped its seal on "Lucy in the Sky with Diamonds" by the Beatles.

QUEEN: ALL THE SONGS 73

NEVERMORE
Freddie Mercury / 1:19

Musicians
Freddie Mercury: lead vocals, backing vocals, piano
Brian May: guitars, backing vocals
John Deacon: bass
Roger Taylor: backing vocals
Recorded
Trident Studios, London: August 1973
Technical Team
Producers: Robin Geoffrey Cable, Queen
Sound Engineer: Mike Stone

Genesis
With the ballad "Nevermore," Mercury wrote one of his most beautiful melodies, appreciated and celebrated by many fans as being on par with "Love of My Life" despite being less well known to the general public. Just as Brian May had made his mark on the disc with his harmonizations for "Procession," with this short and moving composition Freddie began adding little interludes that would henceforth be at the heart of all the band's future albums. "Nevermore" gives the listener a minute and nineteen seconds of respite before the auditory onslaught of the album resumes, and this would also be the case with "Dear Friends" and "Lily of the Valley" on the *Sheer Heart Attack* album.

Placed at the heart of the album's Black Side, "Nevermore" enables listeners to catch their breath after the disturbing "The Fairy Feller's Master-Stroke." It was the first time Freddie Mercury had approached the theme of love in such a direct manner, using the word *love* in an uninhibited way, as if his convoluted turns of phrase on the previous track could now give way to a simpler and clearer text: *"You sent me to the path of nevermore / When you say you didn't love me anymore."* Rumor had it that the song was written for Mary Austin, a nineteen-year-old London girl with whom Freddie was supposedly having a passionate love affair. But as usual, the singer would not reveal the meaning of his lyrics, later telling journalists who questioned him about the lyrics: "Oh gosh! You should never ask me that! […] I concentrate on […] melody, then the song structure, then the lyrics come after."[18] So we will never know whether or not the lovely Mary inspired the artist to write "Nevermore"!

Production
The arpeggios that Mercury performed on the Bechstein grand piano were colored in part by the natural reverberation of the instrument, renowned for its projection and resonance. But just as he had worked on the singer's voice to give it depth of field and space, Roy Thomas Baker used the full range of devices available to him at Trident Studios to enhance the sound of Mercury's playing on the Bechstein. This suite of effects would be readily available in any professional recording or mixing control room of the time, and included preamps, compressors, and a multitude of other

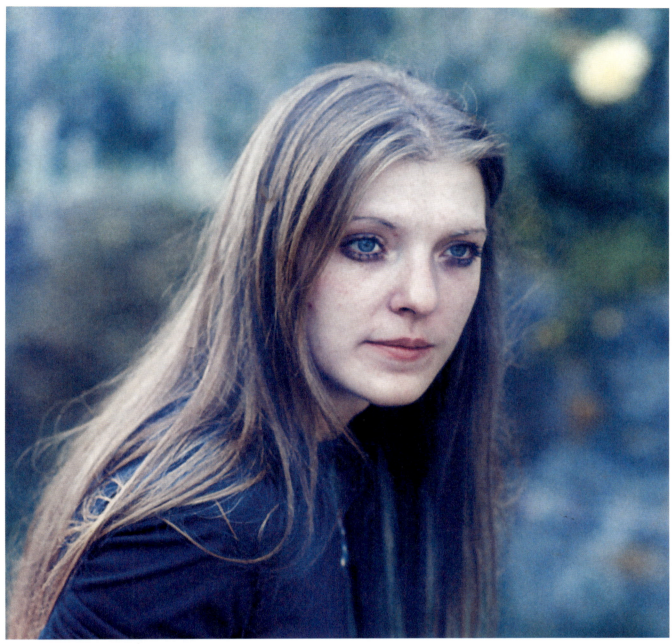

Mary Austin, Freddie Mercury's great love and muse. The young saleswoman from the popular London department store Biba shared Freddie's passion for decoration and fashion.

sound-processing methods, which could be used either before or after a recording was made, depending on the producer's preference. Trident Studios was equipped with four EMT 140 plate reverbs, which could be used either during the recording stage, via the control room, or added later in the remix room. The reverb used on "Nevermore" gives the track spectacular color, as if it were being performed in a concert hall in front of thousands of people. However, this method of sound processing does not stand up well to the passage of time, and now sounds somewhat old fashioned. The magnificent "Love of My Life," which shares a similar writing style, underwent the opposite treatment, with a light and discreet reverb, allowing it to pass into posterity without having suffered the ravages of time.

FOR QUEEN ADDICTS

Though fairly easy to reproduce on stage and loved by the fans, "Nevermore" has never been performed in concert by Queen. Its only public performance was on April 3, 1974, during the recording of the BBC Sessions at the Langham studios.

THE MARCH OF THE BLACK QUEEN

Freddie Mercury / 6:34

Musicians
Freddie Mercury: lead vocals, backing vocals, piano
Brian May: guitars, tubular bells, backing vocals
John Deacon: bass
Roger Taylor: drums, backing vocals
Roy Thomas Baker: castanets

Recorded
Trident Studios, London: August 1973

Technical Team
Producers: Queen, Roy Thomas Baker, Robin Geoffrey Cable
Sound Engineer: Mike Stone

FOR QUEEN ADDICTS

In 1993, the Japanese publishing company Quest Corporation launched a series of video games called *Ogre Battle*, the first volume of which is called *Ogre Battle: The March of the Black Queen*, in homage to the band.

Genesis

In his December 1974 interview with Caroline Coon from *Melody Maker*, Freddie Mercury said, "'March of the Black Queen,' that took ages."[19] It is certainly one of the group's most mysterious songs, and perhaps one of the most personal for Mercury, who was working on it long before he met Taylor and May. Written in the same spirit as "The Fairy Feller's Master-Stroke" and "Ogre Battle," the text of "The March of the Black Queen" is populated with fantasy characters placed in a setting born in the brilliant singer's imagination.

As usual, Freddie refused to elaborate on the meaning of his lyrics, but in the description of the black queen, we get a hint of the superstar he will soon become: *"I reign with my left hand / I rule with my right / I'm lord of all darkness / I'm queen of the night."* This verse offers one of Mercury's first concrete allusions to his sexuality, and in his later songwriting there would be more and more references to his romantic preferences, which were ambiguous. Indeed, there was already an implicit reference to Mercury's sexual orientation in the group's name; the word *Queen* often being used to imply homosexuality. In the same interview with *Melody Maker*, when asked how his androgynous character came to life onstage, Mercury replied: "I play on the bisexual thing because it's something else, it's fun. But I don't put on the show because I feel I have to and the last thing I want to do is give people an idea of exactly who I am. I want people to work out their own interpretation of me and my image. I don't want to build a frame around myself and say, 'This is what I am' or 'This is all I am.'"[19]

Production

With a structure as complex as the future "Bohemian Rhapsody," and a rougher melody than many of Queen's other tracks, this song is somewhat less accessible for fans, even if its climax at 6:10 shines with insistent and powerful backing vocals.

"The March of the Black Queen" was conceived by the singer in several sections, which were recorded separately and then mixed together. Situated as the third track from the end of the disc, it appears as a high point in the magical universe Mercury was working to create in 1971.

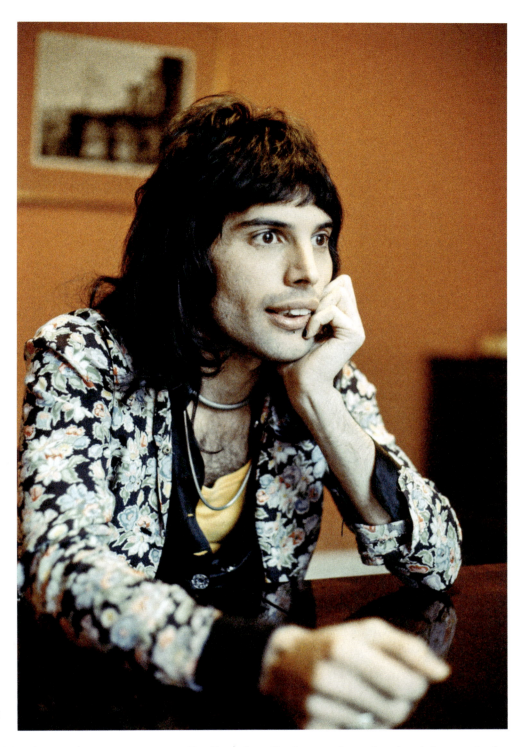

Freddie Mercury in London on February 12, 1974.

Roger Taylor later revealed that the tape became so worn due to the layering of tracks that it became completely transparent, thus reaching the limit of its capacity. Indeed, the multiple sections assembled one by one resulted in a small rock opera.

With contributions from Roy Thomas Baker on the castanets at 2:30 and Brian May on the tubular bells at 2:39, this song gave rise to various ideas that would later come to be featured on the album *A Night at the Opera*. Indeed, it is impossible not to be reminded of the piano-guitar introduction to "Death on Two Legs (Dedicated to...)" when we hear the chord descent in the guitar riff at 0:36, supported by the piano chords, even if the tone of the two songs is somewhat different. And what about the transition to the conclusion of the song at 5:40, when Brian's guitar and the piano die out, an effect used again at the end of "Bohemian Rhapsody"? In many ways, "The March of the Black Queen" marks the band's final step in building the complex, yet popular rock songs that would make them so successful. Nevertheless, this song remains less well-loved than many of Queen's other classic tracks.

QUEEN: ALL THE SONGS 77

FUNNY HOW LOVE IS
Freddie Mercury / 2:50

Musicians
Freddie Mercury: lead vocals, backing vocals, piano
Brian May: acoustic and electric guitars, backing vocals
John Deacon: bass
Roger Taylor: drums, backing vocals
Recorded
Trident Studios, London: August 1973
Technical Team
Producers: Robin Geoffrey Cable, Queen
Sound Engineer: Mike Stone

FOR QUEEN ADDICTS
The acoustic guitar used by May on the recording of "Funny How Love Is" wasn't his famously cheap Dilloway, but a gleaming new Martin D-18 that he had just bought himself. It was this American model that May used on "'39," during the concert in Hyde Park on September 18, 1976.

Genesis
Rest assured, this isn't a Beach Boys track that somehow slipped onto the *Queen II* album, but rather an original Freddie Mercury composition. Since the band had offloaded John Anthony prior to beginning their latest round of recording sessions, Roy Thomas Baker was responsible for this track's production. Faced with the magnitude of the task imposed by Queen, the producer enlisted the help of a colleague from Trident Studios, Robin Geoffrey Cable, who was brought on to assist in the recording of "Nevermore" and "Funny How Love Is." Cable was already familiar with Queen, having organized the Larry Lurex project in 1972. He had bumped into Mercury, May, and Taylor in the studio corridors when they were working on their first album, and he had wrangled them into participating on cover versions of "I Can Hear Music" by the Beach Boys and "Goin' Back" by Dusty Springfield, though Freddie's identity as the singer on these tracks was concealed behind the Larry Lurex pseudonym.

Production
As the sound engineer on Elton John's greatest albums (*Madman Across the Water*, *Tumbleweed Connection*, *Elton John*,...), Robin Geoffrey Cable began his career with the Trident team. The Sheffield brothers, who had given him free reign on the Larry Lurex project, now gave him the chance to advance from sound engineer to producer. He only shone in this role, however, because of his willingness to imitate the work of Phil Spector, the brilliant but problematic sound inventor responsible for such masterpieces as "The Long and Winding Road" by the Beatles. On "I Can Hear Music," Cable attempted to reproduce the *wall of sound* technique invented by Spector. But the fact remains that while Robin Geoffrey Cable may have achieved his goal, the technical prowess does not actually serve the song, which belongs to the folk music register, and seems out of place with Queen's larger body of work. The colorful mix of the track, as well as its upbeat melody, make the song something of an unidentified sound object on Mercury's Black Side, whose structure up until that point had been a cohesive mix of dark and moody tracks.

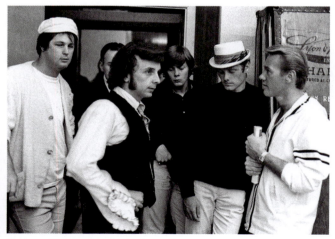
Producer Phil Spector with the Beach Boys and Bobby Hatfield of the Righteous Brothers in 1965.

SINGLE

SEVEN SEAS OF RHYE
Freddie Mercury / 2:48

Musicians
Freddie Mercury: lead vocals, piano
Brian May: guitars, backing vocals
John Deacon: bass
Roger Taylor: drums, tambourine, backing vocals
Roy Thomas Baker: Stylophone on "I Do Like to Be Beside the Seaside"
Ken Testi: backing vocals on "I Do Like to Be Beside the Seaside"

Recorded
Trident Studios, London: August 1973

Technical Team
Producers: Queen, Roy Thomas Baker
Sound Engineer: Roy Thomas Baker

Single
Side A: Seven Seas of Rhye / 2:48
Side B: See What a Fool I've Been / 4:32
UK Release on EMI: February 23, 1974 (ref. EMI 2121)
US Release on Elektra: June 20, 1974 (ref. EK-45891)
Best UK Chart Ranking: 10
Best US Chart Ranking: Did Not Chart

Small and practical, the Stylophone is one of the world's best-selling musical instruments.

Genesis

"Seven Seas of Rhye" first appeared as the instrumental finale on Queen's first album. The song, unfinished at the time, was reworked by Freddie Mercury with the aim of making it a hit. The track was chosen to be the only single from the group's second album, with the unreleased "See What a Fool I've Been," composed by Brian May, on the B-side. The song quickly became a hit after the group's successful performance in front of 10 million television viewers (performed in playback, much to the displeasure of the four musicians), during the BBC flagship music show *Top of the Pops* on February 21, 1974. Thus, Queen made the news a few weeks before setting out on their American tour as the supporting act for Mott the Hoople, and long before the band's second album would actually be released. This strategy for promoting a group's upcoming album holds just as true today: artists must obtain the maximum amount of public exposure prior to the release of their discs, which helps ensure a huger amount of sales from the first weeks of the record's release.

Initially, *Queen II* was to open with "Seven Seas of Rhye" in order to ensure continuity with the first album. But the choice of "Procession" as an introduction proved to be a more workable option, and the single easily found its place at the end of the disc, where it would help hint at the more "mainstream" pop-rock direction that Queen would offer on their third album.

Production

To close the track, the four musicians called on their friends to sing a traditional popular tune, "I Do Like to Be Beside the Seaside," popularized by Mark Sheridan in 1909. Queen and their friends form an apparently inebriated choir, including long-time friend of the musicians Ken Testi, who played the role of tour manager in their early days, where he struggled mightily to find concert dates while they were still unknown.

Although an air of mystery hangs over the Dubreq Stylophone used to accompany the voices, Brian May maintains that it was Roy Thomas Baker who played it, underlining the melody sung by the choir. This pocket instrument, equipped with a small keyboard and a pen, had its heyday when Brian Jarvis introduced it to the market in 1968.

OUTTAKES

SEE WHAT A FOOL I'VE BEEN

Brian May / 4:32

Musicians
Freddie Mercury: lead vocals, backing vocals
Brian May: guitar
John Deacon: bass
Roger Taylor: drums

Recorded
Trident Studios, London: August 1973

Technical Team
Producers: Queen, Roy Thomas Baker
Sound Engineer: Roy Thomas Baker
Assistant Sound Engineer: Nicholas Bradford

Genesis

Brian May never made a secret of his love for the blues. As the guitarist with Smile, he had already performed "See What a Fool I've Been" in concert, in homage to the great American Delta blues guitarists such as Charley Patton, Tommy Johnson, and Papa Charlie Jackson. This style of music takes its name from the northwestern region of the state of Mississippi, which is shaped like a delta. Most of the compositions by the pioneers of the genre are about broken love affairs, long journeys, and thwarted dreams. Listening to "Yellow Dog Blues," which Sam Collins sang in 1927, you understand why music lovers are so drawn to this style, which features an approximately tuned guitar, a bottleneck that slides down the neck of the six-string, and heartbreakingly plaintive vocals. Every guitarist worth their salt has to study the classics, and Brian May is no exception to this rule. At the end of the 1960s, he fleetingly heard a song that stayed in his head for days. He then used it as inspiration to write the kind of blues song he liked, the kind that even his idol Jimi Hendrix would have enjoyed. The song, entitled "See What a Fool I've Been," was included in the set list of some of Smile's concerts.

When Queen recorded their second album in the summer of 1973, the same blues song, which the band had already performed at the BBC Sessions in July, was produced at Trident Studios. Brian May assumed the authorship of the song, but he confessed that it was inspired by a song he had only very vague memories of and whose name he had forgotten. He can easily lay claim to the composition of "See What a Fool I've Been," since from a musical theory point of view nothing sounds more like a blues piece than another blues piece. All singers belonging to this style have deep stories to tell, but the chord scales used are often identical. What makes the difference, of course, is the practice of the instrument, the style of play, and the interpretation.

While the mystery persists surrounding the origin of "See What a Fool I've Been," Patrick Lemieux, one of Queen's most meticulous recordkeepers, told the story of his investigation to solve this enigma on the *QueenOnline* website in 2014. In 2004, he decided to embark on an in-depth study of great blues songs bearing similarities to May's recording. He eventually found a resemblance to a song by harmonica

Musicians Sonny Terry and Brownie McGhee influenced Brian May to write the bluesy "See What a Fool I've Been."

player Sonny Terry and guitarist Brownie McGhee, who were a famous duo in the 1950s and '60s. The song was called "That's How I Feel." Lemieux got in touch with Jacky Smith, head of the Queen fan club, who sent a copy of the compact disc containing the song to Greg Brooks, the band's official archivist. Brian May was then duly informed that a fan might have finally unraveled the mystery of "See What a Fool I've Been," and the disc was sent to him. The next day, the guitarist announced on his site that it was indeed "That's How I Feel" that inspired the Queen track.

The track did not appear on the *Queen II* album, but it was regularly performed in concert and eventually appeared on the B-side of the single "Seven Seas of Rhye," released on February 23, 1974.

Production

Admittedly, "See What a Fool I've Been" would not easily have found a place on the track listing of *Queen II*, since, despite its musical qualities, the song doesn't really mesh with the spirit of the album or the themes it deals with. What's more, when listening to the track, one might get the feeling they were listening to a song by Led Zeppelin, as Mercury's voice is so inspired by the style of Robert Plant. In comparison, the version recorded during the BBC Sessions of July 1973—available on the *Queen: On Air* box set—testifies more broadly to the band's playing power, thanks to the compact and massive rhythm of the Deacon-Taylor duo. Brian May perfectly masters the blues solo and develops it throughout the song.

On May 31, 1998, the musician once again proved his love for the blues on the set of the German radio show *Gute Nacht, Gottschalk*, where he launched into a solid improvisation alongside Rick Parfitt, the guitarist from Status Quo. For this occasion, May used a one-watt battery-powered Vox travel amplifier (the equivalent of today's Vox AC1 series), which he covered with a towel, the speaker facing up. The result was amazing: the guitarist immediately obtained the same sound as when he used his wall of nine Vox AC30 amps on stage. The purity of this moment, which can still be found on old recordings of the show, confirms the famous musicians' adage that "the sound is in the fingers, not in the equipment used."

ALBUM

SHEER HEART ATTACK

Brighton Rock . Killer Queen . Tenement Funster . Flick of the Wrist .
Lily of the Valley . Now I'm Here . In the Lap of the Gods . Stone Cold Crazy .
Dear Friends . Misfire . Bring Back That Leroy Brown .
She Makes Me (Stormtroopers in Stilettos) . In the Lap of the Gods…Revisited

RELEASE DATES
United Kingdom: November 8, 1974
Reference: EMI—EMC 3061
United States: November 12, 1974
Reference: Elektra—7E-1026
Best UK Chart Ranking: 2
Best US Chart Ranking: 12

Deacon, Taylor, and Mercury pose for photographer Koh Hasebe from *Music Life* magazine in June 1974.

THE END OF THE AMERICAN DREAM

In the spring of 1974, Mercury and his band toured with Mott the Hoople in the United States, introducing Queen to the American public and promoting the single "Seven Seas of Rhye." The highlight of the tour was a series of six sold-out concerts at New York's Uris Theater (renamed the Gershwin Theatre in 1983). The day after the last date, as the band was preparing to head to Boston, Brian May became seriously ill, necessitating a thorough medical checkup. It turned out that the guitarist had contracted hepatitis, forcing Queen to cancel the end of the tour and return to the United Kingdom as quickly as possible. This was a huge frustration for the whole band, which was no longer there to promote the single when it was released in North America on June 20, 1974. Brian, totally floored by the illness, needed a full six weeks of rest.

A Third Album...with No Guitarist

While their guitarist and friend was recovering, Taylor, Mercury, and Deacon got back to work at Rockfield Studios in Wales. The musicians were housed on-site in this rural setting, away from the distractions of the city, enabling them to immerse themselves fully in their work. Brian was soon back with his friends at this comfortable venue and was able to follow the evolution of the writing, though he remained very weak. But in August, the unfortunate guitarist fell victim to a duodenal ulcer and had to be taken to King's College Hospital in London, where his physical condition was stabilized, but his morale was low. Convinced that his bandmates would tire of his health issues and try to get rid of him, May worked on his own compositions, which he later presented to them. But when May returned to Rockfield Studios, the trio had already made significant progress on several tracks, with John Deacon taking on the role of guitarist. The convalescent had to catch up fast, recording the many missing six-string parts. To the existing tracks he also added four songs he wrote during his forced rest: "Brighton Rock," "Now I'm Here," "Dear Friends," and "She Makes Me (Stormtrooper in Stilettoes)." Finally, Mercury closed the sessions in September with a song he wrote in just a few hours: "Killer Queen."

Her Majesty in Second Place on the British Charts

Recorded between June and September 1974, the album was co-produced by Roy Thomas Baker and Queen. Two new recruits assisted the now stalwart sound engineer, Mike Stone, at the helm: Geoff Workman at Wessex Sound Studios and Gary Langan, who would work on the mixes for "Now I'm Here" and "Brighton Rock." The latter would always remember the good-natured atmosphere that reigned between Queen and Baker, despite the fifteen-hour days and the hellish pace imposed by the ultra-perfectionist musicians. One evening, after a dinner shared with the band and the technicians, the producer politely asked Freddie to return to work and put the finishing touches to "Killer Queen." The singer, who could sometimes be a bit of a diva, categorically refused, telling his friend, "I'm not leaving this chair, dear!"[2] Roy Thomas Baker then called in the

84 SHEER HEART ATTACK

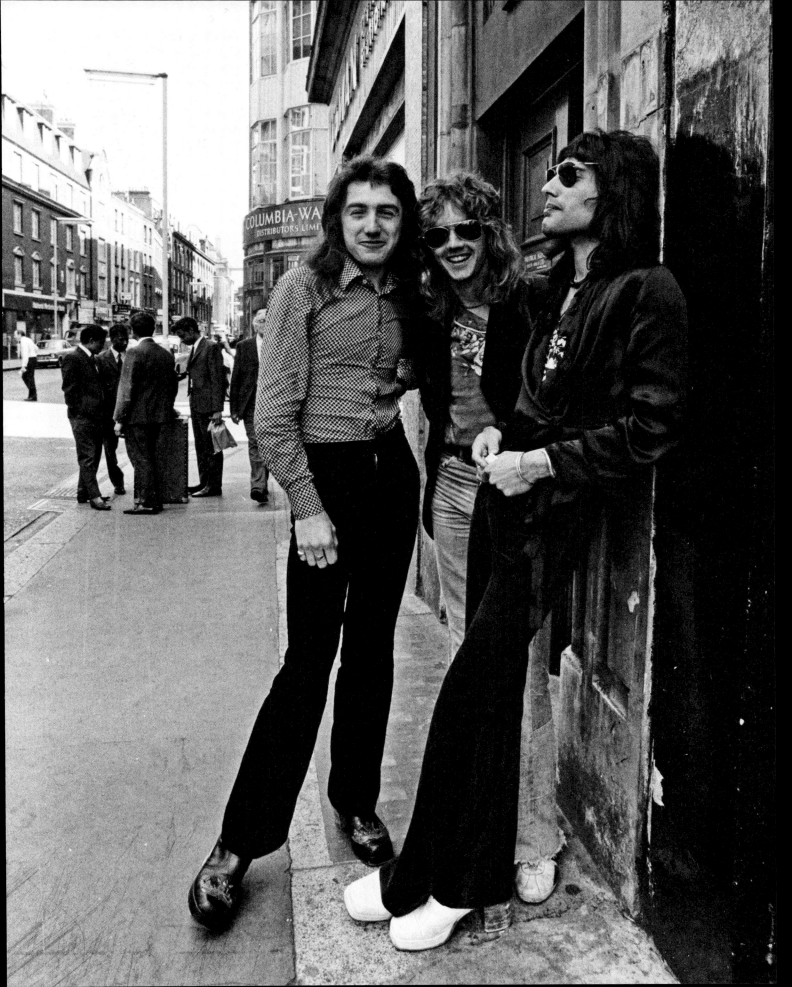

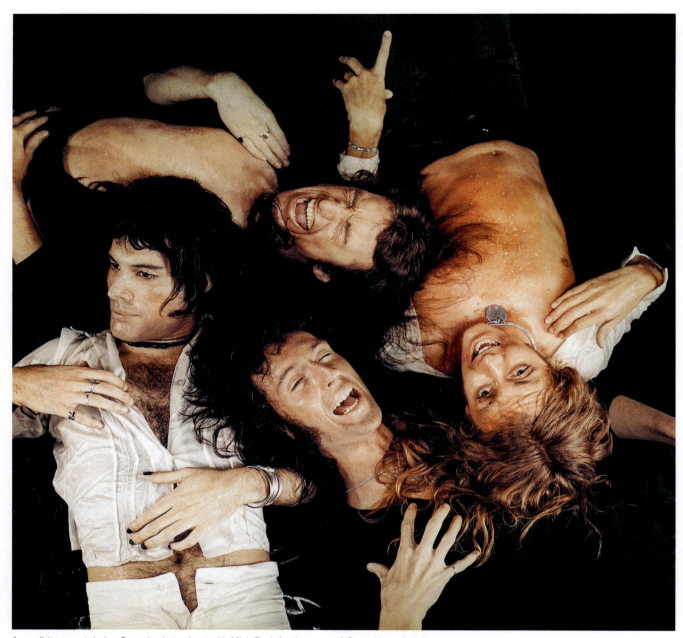

A candid moment during Queen's photo shoot with Mick Rock for the cover of *Sheer Heart Attack*.

roadies, who lifted the singer and carried him to the seat of his piano so that work could resume.

Once the disc was finished, Queen embarked on a British tour, with nineteen dates in eighteen different cities. The series of concerts began on October 30, 1974, in Manchester and ended with two exceptional performances on November 19 and 20 at the Rainbow Theatre in London, a mythical venue that the band had always dreamed of playing. The tour was a triumph. The first single, "Killer Queen," by Freddie Mercury, reached number two on the British charts in December 1974. Their successful performance on *Top of the Pops* in mid-October undoubtedly helped to convince viewers but, in any case, the song was a huge success and ensured the album would be highly acclaimed after its release on November 1. Like it's lead single, the album itself also went on to reach second place on the British charts.

Time for Change

With their third album, the group clearly wanted to turn a new page in terms of their sound, and their song writing. The tracks are more accessible, with a less progressive-rock aesthetic, and there are a number of crowd-pleasing potential hits, including "Killer Queen" and "Now I'm Here." The band's visual aesthetic also evolved. Queen, who had once again asked Mick Rock to produce their album cover, wanted to project a more virile image, without costumes or makeup, except for a dash of eyeliner for

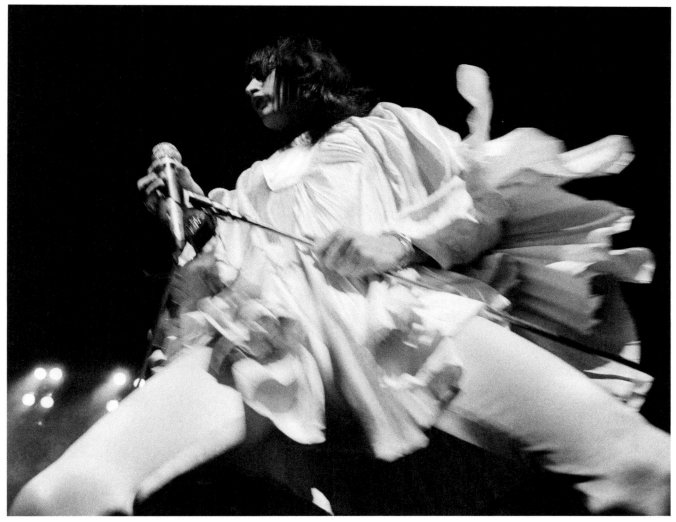
Freddie Mercury at London's Rainbow Theatre in November 1974.

Freddie. Before the photo, however, the musicians covered their torsos with petroleum jelly and sprayed themselves with droplets of cold water. The photograph, taken from a bird's-eye view, thus shows four stranded and sweating, shipwrecked-looking people. This was 1974, the period of "Ziggy Stardust" and *The Rocky Horror Picture Show*. Taken in context, the album cover is very much in keeping with this glam-rock look of the day, when rockers were happy to experiment on the border between the masculine and feminine.

Nevertheless, the musicians abandoned the sexual ambiguity of the promotional photos used for their first two albums, and their silk clothing and perfectly straightened hair fell by the wayside. Queen's image was changing, to Freddie's great pride, and he humorously declared: "We're showing people we're not merely a load of old poofs. We are capable of other things."[20]

It was at this time that the singer began to talk about his homosexuality to some of his close friends and family. On tour, when he was away from Mary, his fiancée, he confided in his friends and frequently made jokes about it, even going so far as to tackle the subject implicitly in the song "Lily of the Valley."

The band kicked off a European tour on November 23, 1974. Full houses and a receptive audience reinforced the group's feeling that a milestone had been reached. Thanks to the success of their hit "Killer Queen," Mercury and his band played dates in Sweden, Germany, Finland, Belgium, the Netherlands, and finally Spain, where the six thousand tickets for their Barcelona concert were sold out in just one day! But back in London, the musicians were faced once again with great financial hardship. Their debts owed to the Sheffield brothers were piling up, preventing them from leaving substandard housing and lifestyles that didn't match their success. The tension was mounting with Trident, who was taking weekly payments from the group in order to reimburse the £200,000 the label committed to the band's development. As the group ended their European tour and prepared for a second tour in North America, followed by a second tour in Japan, they seriously considered changing labels, a decision that would change their destiny forever.

John Reid, Queen's manager from 1975 to 1978, holds a bottle of champagne at a Rocket Records launch party in 1973.

JOHN REID: THE MANAGER WITH A FIERY TEMPERAMENT

John Reid was born on September 9, 1949, in Paisley, Scotland. When he came of age, he left his native country and moved to London, fleeing the small village in which he had been forced to hide his homosexuality. He decided to live his life as he wished and joined the record industry in 1967, first working at EMI, then moving the following year to work as head of the prestigious Tamla Motown label for the United Kingdom. His career quickly took off, and the young wolf of the music business conquered some of the biggest names in the industry, such as Motown Europe's John Marshall, who recalls: "John was very good with people, very energetic. [...] He was very young, but you could see he was going places."[21] Reid was very close to David Croker, director of the American Bell label, which occupied the office next door to his. At a Christmas party organized by Motown in the late 1960s, Croker introduced Reid to one of his friends, a former session musician for EMI named Reg Dwight. One day Dwight, who often hung out in the hallways of the record company searching for the latest album releases, left Reid a promotional copy of his freshly mixed second album, which bore his stage name: *Elton John*.

In 1971, John Reid set up his own artist support company, called John Reid Enterprise, and became the manager of Elton John. The two men began a passionate love affair, which eventually came to an end in 1975, but their professional relationship would last until 1998.

Queen's Right-Hand Man

Shortly before beginning the recording sessions for their fourth album, Mercury and his group had to settle their dispute with the Trident label, whom they saw as enriching themselves at the band's expense. They also had to find new partners to work with. After exploring a range of possibilities, Queen chose John Reid as their new manager. Reid had proven himself alongside Elton John, and his fiery temperament, his efficiency, and his knowledge of the music scene confirmed the musicians in their decision. Once the deal was sealed, Reid told the band: "You go away and make the best record you can make. I'll take care of business."[22] That was all it took to reassure the artists that they could write and record their masterpiece, *A Night at the Opera*.

Assisted by Jim Beach, the band's lawyer, Reid managed to make an agreement with Trident, and in August 1975, Norman Sheffield, the label's boss, released Queen from their contract, in exchange for generous financial compensation and royalties on the group's next six albums.

Another Difficult Break for Queen

Despite their manager's outspoken nature, relations between Queen and Reid were healthy and friendly. Freddie Mercury even wrote the song "The Millionaire Waltz" for him, in homage to his taste for pomp and pure English elegance. Indeed, it was well known within the industry that Queen's manager was rarely seen without his perfectly pressed suit.

But after two years of satisfactory collaboration, the musicians found themselves faced with a problem. Elton John, Reid's protégé, was at the height of his stardom and no longer wanted to share his manager with Mercury, who had also become a superstar. In January 1978, the musicians and their manager split. The agreement was signed in John Reid's car, parked in the garden of Roger Taylor's country house, where Queen was recording music videos for "We Will Rock You" and "Spread Your Wings." The agreement stipulated that John Reid would receive a lifetime 15 percent royalty on all of Queen's previously recorded albums. This second business split left a bitter taste in the mouths of the four musicians, who decided that they would manage their affairs alone from then on, with Jim Beach, their lawyer and soon-to-be defacto manager, serving as their only advisor. To this day, Jim Beach is still Queen's sole representative.

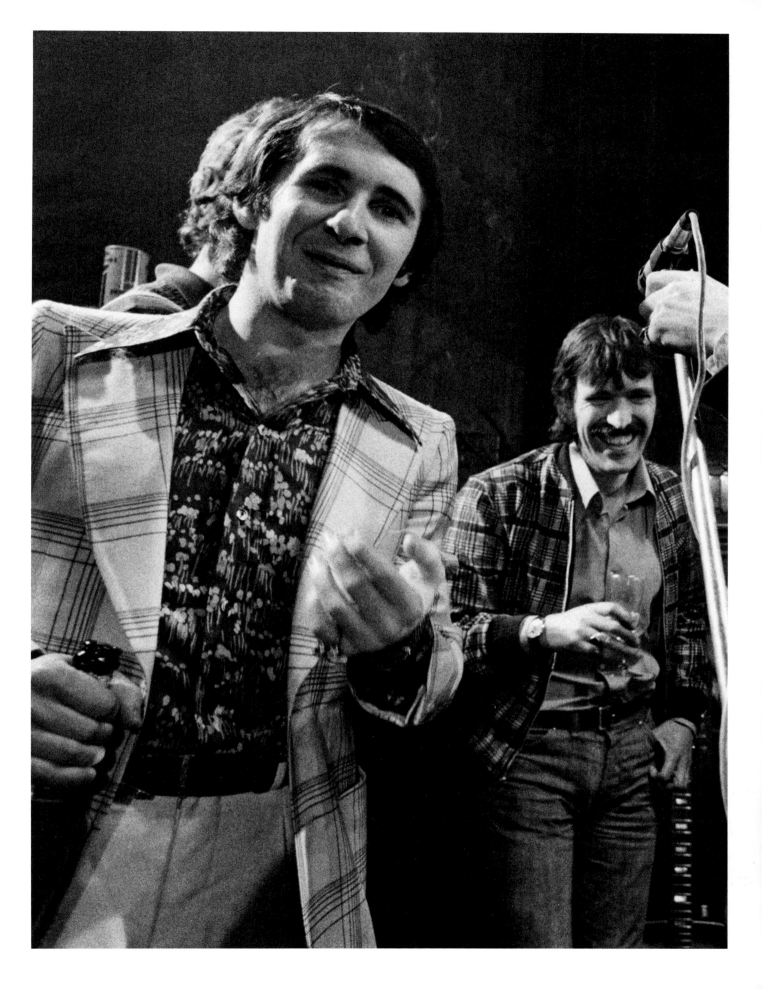

BRIGHTON ROCK

Brian May / 5:10

Musicians
 Freddie Mercury: lead vocals, backing vocals
 Brian May: electric guitar, backing vocals
 John Deacon: bass
 Roger Taylor: drums, backing vocals
Recorded
 Rockfield Studios, Monmouth, Wales: July 7–28, 1974
 Trident Studios, London: September 1974 (mixing)
Technical Team
 Producers: Queen, Roy Thomas Baker
 Sound Engineer: Mike Stone
 Assistant Sound Engineers: Neil Kernon (Trident)

> The song was given a number of working titles, including "Happy Little Day," "Blackpool Rock," and "Bognor Ballad."

Brighton Beach is the beachside getaway for many Londoners, and it served as the meeting place of Jimmy and Jenny, the heroes of Queen's song "Brighton Rock."

Genesis

Just as Coney Island is known as a weekend retreat for New Yorkers wanting to escape the city and enjoy the attractions of the seaside, Brighton Beach is renowned for its family atmosphere in East Sussex, an hour's train ride south from London. Its famous pier makes the resort the ideal backdrop for the opening song of *Sheer Heart Attack*, which tells the story of the summer romance between an English couple, Jenny and Jimmy, who are forced to leave one another at the end of the holidays. In these lyrics we discover a sarcastic and humorous side to Brian May's songwriting, perhaps a result of his own summer spent recovering in a hospital bed. For example, in the song's last verse we get a hint at the large age gap separating the two lovers, as we're told that Jenny fears her mother's reaction, while Jimmy is more apprehensive about his wife's.

Many of the song's references are easily recognizable. For example, the song's title is taken from the famous 1938 novel *Brighton Rock* by Graham Greene, in which the British author recounts the wanderings and misdeeds of a young man named Pinkie in the seaside resort. The book, which was a great success on its release, was adapted for the big screen by John Boulting in 1947—and would later be adapted again by Rowan Joffé in 2011.

The song's text also refers overtly to religion, quoting the hymn "Rock of Ages," which was written by the Reverend Augustus Toplady in 1763. The title of this hymn refers to the thousand-year-old limestone cliff in the Mendip Hills near Bristol, England. Though brittle and seemingly unstable, this stone landmark is famous for never having given way, despite the severe weather conditions in this part of England. Thus, the expression *Rock of Ages* has come to symbolize a safe and protective place. As usual with Queen, no clarification has been given on the meaning of the lyrics, and listeners are free to interpret them as we wish.

Production

This song was born while May was playing with the band Smile, whose song "Blag" already contained some of the same ingredients. The fifty-second-long "Brighton Rock" guitar solo also has its roots in the song "Son and Daughter," which appeared on Queen's debut album. This long tribute to May's idols—Jimi Hendrix, Jeff Beck,

90 SHEER HEART ATTACK

FOR QUEEN ADDICTS

In the middle of the amusement park sound effects that introduce the track, we hear at 0:12 a melody that is not on the Elektra "Authentic Sound Effects" disc. It is in fact the popular tune "I Do Like to Be Beside the Seaside," whistled by one of the members of the band, and which closed the *Queen II* album at the end of "Seven Seas of Rhye."

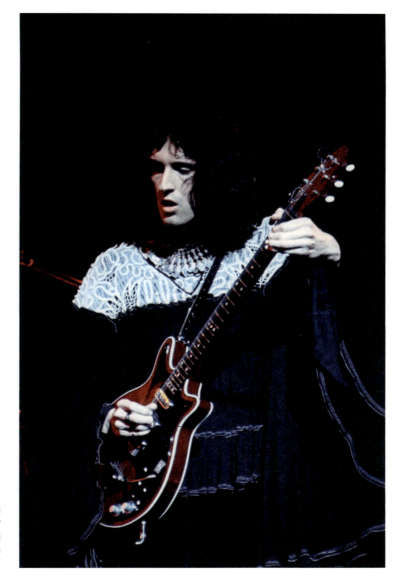

Alone on stage in 1974, Brian May performs the long guitar solo from "Brighton Rock."

and Jimmy Page—was played by the guitarist using his famous Echoplex effect, which allowed the sound of the guitar to be repeated over a period of time chosen by the musician. The rhythm of this repetition was adjusted in real time using a pedal on which May beat the desired tempo. This process, known as *tap delay*, has been widely used ever since. The process also allowed Brian to stack the guitar parts in real time during concerts, harmonizing them as he liked, and enabling him to play the multiple tracks recorded in the studio. He would sometimes make exaggerated use of tap delay during the group's concerts, and the "Brighton Rock" solo could last up to twelve minutes!

On the console side, Roy Thomas Baker is clearly still very much attached to the "kitchen sink album" concept imposed on the previous disc, even if this time the objective is clear: Queen wants an efficient production, intended to woo the listening public. We nevertheless find in the introduction to "Brighton Rock," the sounds of an amusement park, which establish the song's setting. The amusement park sound effect, called *Carnival Midway*, is taken from the disc *Authentic Sound Effects Volume 1*, released by Elektra Records in 1964. In "Brighton Rock", the amusement park effect is interrupted at 0:27 by May's Red Special, which in turn gives way to a rock whirlwind, where Freddie's lead vocals mix with the effective pop melody refrains sung in chorus by the rest of the band.

"Brighton Rock," with its false adolescent candor and its 140-beats-per-minute tempo, immerses the listener in the new Queen universe. There is no longer any question (at least for the moment...) of mythological or biblical digression, and the group is clearly focused on producing direct and effective hits. The transition from the Zeppelinian universe to a more obvious pop-rock realm is successfully managed, and the track finds a natural place as the lead slot on the group's third album. The whole band knew this was a pivotal record, one that would require all of their energy and inspiration, and thanks to the band's work ethic and artistic sincerity, their move to a more straightforward sound proved to be a huge triumph.

SINGLE

KILLER QUEEN
Freddie Mercury / 3:00

Musicians
Freddie Mercury: lead vocals, backing vocals, piano and tack piano, finger snapping
Brian May: electric guitar, backing vocals
John Deacon: bass
Roger Taylor: drums, triangle, tubular bells, backing vocals

Recorded
Wessex Sound Studios, London: early and late August 1974
Trident Studios, London: September 1974 (mixing)

Technical Team
Producers: Queen, Roy Thomas Baker
Sound Engineer: Mike Stone
Assistant Sound Engineers: Geoff Workman (Wessex), Neil Kernon (Trident)

Single
Side A: Killer Queen / 3:00
Side AA: Flick of the Wrist / 3:21
UK Release on EMI: October 11, 1974 (ref. EMI 2229)
US Release on Elektra: October 21, 1974 (ref. E-45226)
Best UK Chart Ranking: 2
Best US Chart Ranking: 12

> **ON YOUR HEADPHONES**
> For anyone wondering what the triangle on John Deacon's microphone stand was used for during concerts in this period, just listen to his unforgettable performance at 0:56 and 2:15, then you'll appreciate that with a band like Queen, it's the small details that make all the difference!

> **FOR QUEEN ADDICTS**
> An unusual event took place on the Dutch TV show *Top Pop* on November 22, 1974, when instead of playing his faithful Red Special, Brian May used a Fender Stratocaster that was the same color as John Deacon's Jazz Bass. In the end it didn't matter; the performance was done in playback and the instruments weren't plugged in.

Genesis

Though "Killer Queen" was one of the last songs recorded for the album (in September 1974) it was the title that would change the destiny of the band. Written by Freddie Mercury over the course of a single weekend, the song became the lead single from the *Sheer Heart Attack* album. Released on October 11, it shot straight to number two in the UK charts, just behind "Gonna Make You a Star" by David Essex. In a new move for the group, the UK single release had no B-side but instead featured two A-sides, the second of which was "Flick of the Wrist."

"Killer Queen" was an immediate success, despite the doubts of Brian May, who wasn't entirely comfortable with the track's pop direction. Freddie often joked about this, willingly admitting that the song would be perfectly at home in the discography of the late Noel Coward, an actor and pianist famous for his good taste and slightly old-fashioned elegance. But it was precisely this pursuit of versatility that would make the band's reputation over the years, as the four musicians always aimed to take risks in their music.

When Kenny Everett, a friend of Freddie Mercury and famous Capital Radio disc jockey, decided to broadcast "Killer Queen" at the end of 1974, he warned his friend Mike Moran, himself a musician (who would later co-produce *Barcelona* in 1988): "I'm going to play something on the radio, [...] have a listen to this, it's the best record that's ever been made by anybody ever."[18] From then on, Queen could count on the unflagging support of the radio host, who would soon play a decisive role in the group's success.

The song begins with the sound of Freddie's finger snaps, then the magic quickly takes hold as you listen to the unstoppable, infectious melody. This is a new sound that the artists are offering, clearly aimed at a wider audience. As Taylor confirms: "'Killer Queen' showed a completely new side to the band. In a matter of a week, we stopped being compared to Led Zeppelin and became our own entitity."[16] The text, which comes straight from the imagination of the dandy Mercury, quotes the legendary line of Marie-Antoinette, the queen of France who was executed in 1793. To the person who informed her that her subjects were starving and had no more bread to eat, she supposedly replied "Let them eat cake!" We see here all the discreet erudition contained in

1974

92 SHEER HEART ATTACK

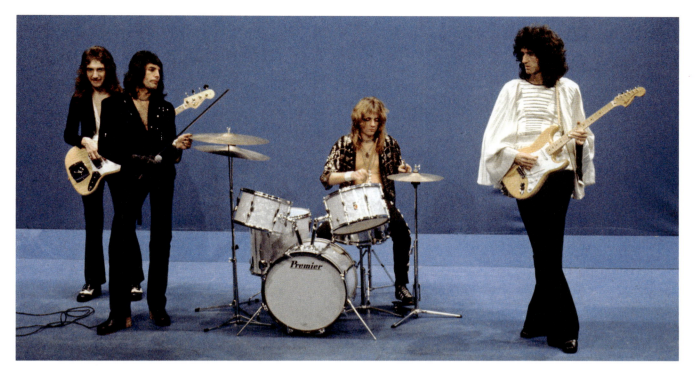

Queen lip-syncing during their appearance on the Dutch show *AVRO's TopPop* on November 22, 1974. The band performed without plugging in their instruments.

Freddie's writing, who in his interviews compared the "killer queen" heroine of his song to his idol Liza Minnelli, who performed the unforgettable "Mein Herr," in Bob Fosse's seminal 1972 film *Cabaret*. In the years since the song's release, a number of other people have declared themselves to be the source of Mercury's inspiration for the song. These include former EMI press attaché Eric Hall, who claimed in Maureen Goldthorpe's documentary *The Story of Queen: Mercury Rising* that he kept Moët & Chandon champagne in his office at EMI, and that Freddie himself had told him that he was at the center of his song.

Production

Right from the introduction, the sound of the piano on this track must have been a surprise to Queen's fans, who had grown accustomed to the warm and powerful sound of the century-old Bechstein at Trident studios. This new piano timbre resembles that of the American *honky-tonk* pianos, which take their name from the notorious bars and saloons of the Wild West. Honky-tonk music is the music of the people, and in the rough bars where it rang out during America's Great Depression, it was most certainly not played on Bechstein or Steinway grand pianos. The great distinctive feature of the honky-tonk sound is that the piano sounds slightly out of tune, because instrument cost money, which bar owners would naturally not want to pay. During the recording of *Killer Queen*, Freddie Mercury made two identical piano takes, but with two different instruments: the first with the prestigious studio grand piano, and the second with a piano whose sound was much closer to the honky-tonk models. Known as a jangle, or tack, piano (detuned piano), this instrument was modified in order to transform its sound. Thumbtacks were attached to the hammer felts, and with each percussion on the strings, a brilliant sound was produced—a sound quite close to that of the harpsichord. Indeed, this instrument is sometimes known as a *harpsipiano*. It is the mix of the two takes that gives the introduction to "Killer Queen" its very particular sound, which we find again later on "Bring Back That Leroy Brown," the ragtime track that appears toward the end of the album.

As for the guitarist, whose Red Special guitar offers a variety of tuning options, in *Killer Queen* May delivers a catchy and harmonious solo, with a discreet and understated effect that nevertheless deserves to be emphasized. His guitar has three pickups: a bridge, a center, and a neck. For each of them there are two white switches, visible on the black plastic protection plate. One of the switches turns the pickup on, and the other allows the pickup to be out of phase, the effect of which is to delay the electrical frequency and thus the arrival of the audio signal. May uses his pickups in phase at the beginning of the solo and shifts one out of phase for the second part at 1:40. Though you have to listen carefully to hear it, these tricks enable Brian to change the sound of his guitar whenever he wants.

Also note the presence of a wah-wah pedal at the beginning of the third verse, starting at 2:03, and coming in response to Freddie's singing, which is processed through a phasing effect each time the words "*laser beam*" are sung. The effect was created by a brand-new Countryman Type 968 Phase Shifter. Trident Studios had just purchased it, and the quality of the sound processing it offered was exceptional. The band's producer, Roy Thomas Baker, had suggested that the group try the new toy, and it didn't take long to persuade the four musicians to use it in the production of their albums.

QUEEN: ALL THE SONGS 93

TENEMENT FUNSTER
Roger Taylor / 2:47

Musicians
Roger Taylor: lead vocals, backing vocals, drums
Freddie Mercury: piano
Brian May: electric guitar
John Deacon: bass, acoustic guitar

Recorded
Rockfield Studios, Monmouth, Wales: July 7–28, 1974
Wessex Sound Studios, London: early August 1974 (voice)
Trident Studios, London: September 1974 (mixing)

Technical Team
Producers: Queen, Roy Thomas Baker
Sound Engineer: Mike Stone
Assistant Sound Engineers: Geoff Workman (Wessex), Neil Kernon (Trident)

COVER
On the "Special Edition" version of their album *Black Clouds & Silver Linings*, released in 2009, the band Dream Theater offered an identical cover of the "Tenement Funster" / "Flick of the Wrist" / "Lily of the Valley" medley.

Genesis
When it came to occupying the space left to him on each of the band's albums, Roger Taylor took his role extremely seriously. Only the third song written and recorded by the drummer to appear on a Queen album, after "Modern Times Rock 'n' Roll" and "The Loser in the End," "Tenement Funster" gives us a behind-the-scenes look at the young rock star's world, where it's all about girls, guitars, fast cars and, of course, the pleasure Taylor gets out of this new life that's offered to him: "*Hummm, I like the good things in life*," he sings at 1:51! In his book *Queen: Complete Works*, Georg Purvis underlines the link that can be made between the song and the compositions of T. Rex's singer, Marc Bolan. Indeed, we can see that their musical universes are very close. According to Purvis's analysis: "Even the title seems like a combination of T. Rex's 'Jeepster' and 'Tenement Lady.'"[5] He added that the working title of Taylor's song was "Teen Dreams," probably in reference to T. Rex's 1974 hit "Teenage Dream."

Production
The song opens with a medley to which "Flick of the Wrist" and "Lily of the Valley" are added on Side 1 of *Sheer Heart Attack*. The Beatles had experimented with the same idea on their *Abbey Road* album in 1969. The Fab Four had used numerous tracks in the making of their album and had linked them together to create their famous medley. Frequently employed on the concept albums of the 1970s and '80s, the method consists of seguing a group of songs together, without pausing between them or lowering the sound volume. It is an adaptation of the famous "potpourri" medleys performed in French dance halls between the wars, when singers mixed the most well-known passages from the hits of the time into the same song.

The song's writing, with its chord progressions and melody changes within each verse, is chiseled and well-perfected. We sense that the composer is now assuming his double role as both drummer and singer, which Taylor confirmed to *Modern Drummer* journalist Robert Santelli: "Half my job in Queen is drumming; the other half is singing."[23] While the delay effect is still present in the drummer's voice, what's most interesting about this track is the dull and muffled sound of Taylor's drums.

Roger Taylor playing on a drum set emblazoned with the band's logo at the Rainbow Theatre in London on November 19, 1974.

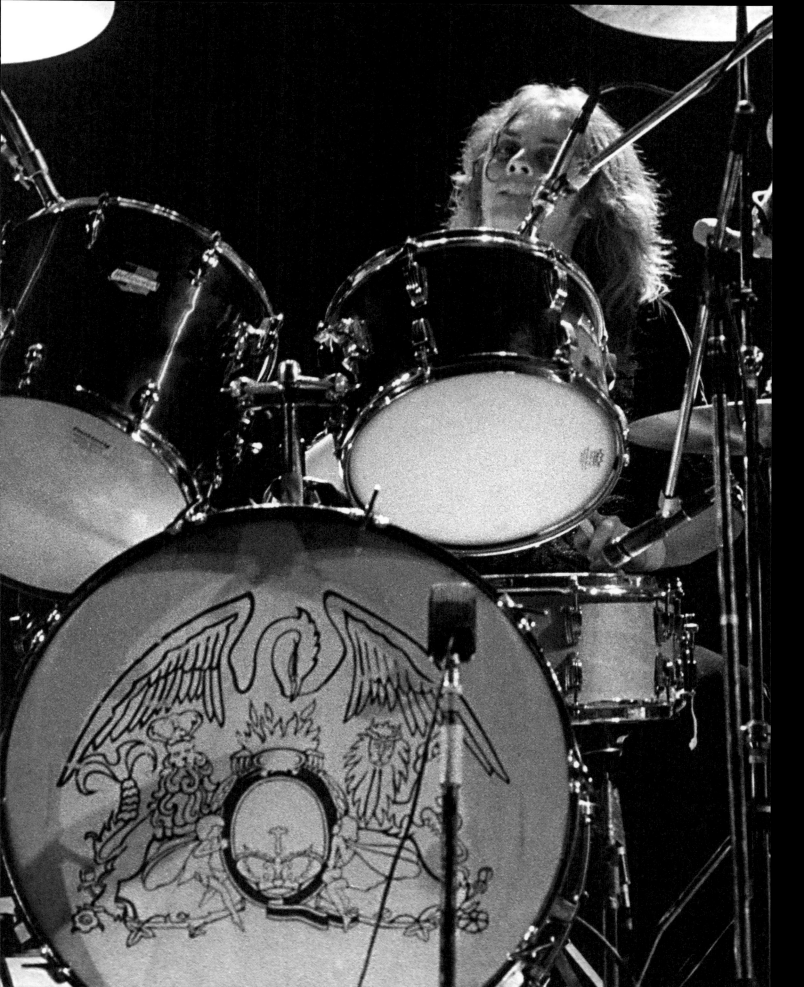

FLICK OF THE WRIST
Freddie Mercury / 3:21

Musicians
Freddie Mercury: lead vocals, backing vocals, piano
Brian May: electric guitar, backing vocals
John Deacon: bass
Roger Taylor: drums, tambourine, backing vocals

Recorded
Rockfield Studios, Monmouth, Wales: July 7–28, 1974
Wessex Sound Studios, London: early and late August 1974
Trident Studios, London: September 1974 (mixing)

Technical Team
Producers: Queen, Roy Thomas Baker
Sound Engineer: Mike Stone
Assistant Sound Engineers: Geoff Workman (Wessex), Neil Kernon (Trident)

Genesis

When Queen recorded *Sheer Heart Attack* in the summer of 1974, the relationship between the band and Trident was still running smoothly, though resentment was mounting against the Sheffield brothers. In the lyrics to "Flick of the Wrist," Freddie revealed the first source of discontent with the label's bosses: They paid the musicians a salary of only £20 a week, keeping them in a financially precarious lifestyle. While the band had not yet achieved total success, it was enjoying a growing level of fame, and the financial situation of the band members was out of step with that of its producers.

On October 11, the "Killer Queen" single was released in the UK. There was no B-side on the reverse. Instead, the group offered a second track on the A-side, and that track was "Flick of the Wrist." Perhaps the band wanted to offer two effective songs in a row, in a bid to double their chances of attaining a good placement on the charts; or, perhaps they were thumbing their noses at a record company that imposed too strict a financial burden on the members of the group.

The title of the song refers to the gesture made in signing a contract, which, according to the narrator, would have terrible consequences: *"Flick of the wrist and you're dead."* The time for settling scores was fast approaching, and the images and metaphors used by Freddie Mercury are nothing compared to the venomous "Death on Two Legs (Dedicated to…)" that would open the next album. Nevertheless, the rage is clearly there when he writes: *"Prostitute yourself he says / Castrate your human pride / Sacrifice your leisure days / Let me squeeze you till you've dried."*

Production

As mixed as its success was, "Flick of the Wrist" is nevertheless an incredibly effective track, and the version played at the Rainbow Theatre in London in November 1974 is one of the best expressions of the song's power. Its guitar flourish at the end, complete with a wild riff and drum backing, easily outdoes the album's smooth transition to "Lily of the Valley," which appears as the next track.

A great piece of underrated pop rock, "Flick of the Wrist" is divided into two distinct parts. The verses are heavy and

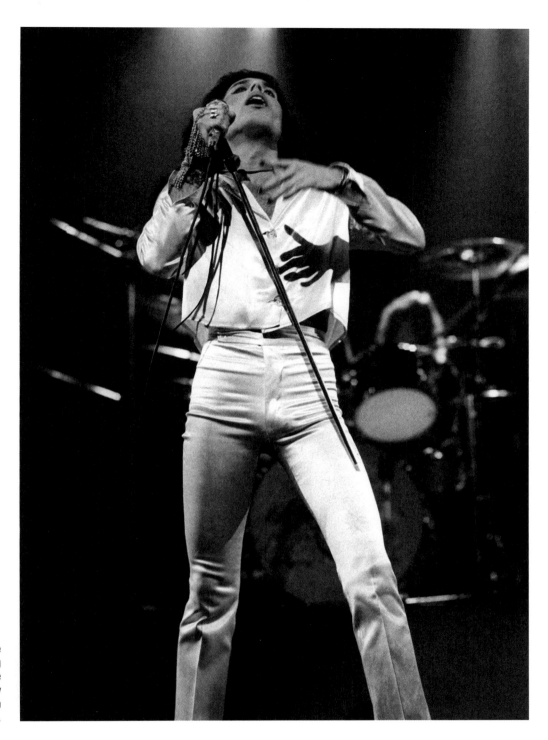

Freddie Mercury in one of his many alternating stage outfits during the concert at the Rainbow Theatre in London on November 19, 1974.

aggressive, sung by a furious Mercury, who accompanies himself on the piano and on the backing vocals, which are worthy of the great FM hits of the 1980s.

May's guitar solo follows a striking technique employed by many pop-rock guitarists. The first eight-bar segment of his solo revolves around a single chord, coupled with an impressive palm mute, which gives the guitar riff a sensation of rising toward an inevitable melodic explosion. Relief comes at 2:06, when a sharp change of direction sends May into a second phase of the solo, which extends to 2:28.

These last eighteen seconds offer a formula that would be borrowed by many subsequent artists, such as Matthew Bellamy, from the group Muse. Thanks to its unstoppable melody and its compact and powerful sound, the track is very close to those released on *News of the World* in 1977. Though "Flick of the Wrist" never became one of Queen's biggest hits, it does offer a testament as to why the musicians chose to abandon the prog-rock experiments of their first two albums in favor of this more powerful approach to performing.

QUEEN: ALL THE SONGS 97

Freddie Mercury and Mary Austin in their apartment on Holland Road in London.

LILY OF THE VALLEY
Freddie Mercury / 1:43

Musicians
Freddie Mercury: lead vocals, backing vocals, piano
Brian May: electric guitar
John Deacon: bass
Roger Taylor: drums

Recorded
Wessex Sound Studios, London: early August 1974
Trident Studios, London: September 1974 (mixing)

Technical Team
Producers: Queen, Roy Thomas Baker
Sound Engineer: Mike Stone
Assistant Sound Engineers: Geoff Workman (Wessex), Neil Kernon (Trident)

Genesis

As short as it is poignant, the lullaby "Lily of the Valley" takes us back to the lyrics of the group's first two albums, where mythology was a recurring source of inspiration for Freddie. He doesn't hesitate to reference his favorite subject matter again here, writing, "*Neptune of the seas, an answer for me please*" and "*Serpent of the Nile, relieve me for a while*." Though the singer once again takes us into an elusive universe, we find ourselves in more familiar territory than when he previously lead us to Rhye, in the aptly named "Seven Seas of Rhye" from *Queen* and *Queen II*. According to Brian May, the lyrics on this latest track offer insight into the doubts the author was having at the time: "'Lily of the Valley' [is] about looking at his girlfriend and realizing that his body needed to be somewhere else."[24] At the time, Freddie was still in a relationship with the young Mary Austin, and had apparently not yet become aware of his homosexuality. At least, he makes no mention of it outside of the obliquely written lines of his mysterious lyrics, which are rich in symbols and images to be deciphered. In the end, "Lily of the Valley" enjoyed the privilege of appearing on the B-side of the single "Now I'm Here" when it was released in the United Kingdom on January 17, 1975.

Production

Like the earlier "Nevermore," which was at the heart of the *Queen II* album, "Lily of the Valley" marks a momentary pause in the middle of an album that is otherwise filled with a propulsive sense of energy. These little piano interludes would recur frequently on the band's albums, much to the delight of fans, as it is in these moments that Mercury displays his most melodic writing and his most gorgeous harmonies. That said, the execution of May's guitar parts must once again be underlined. The virtuoso surprises, particularly in his ability to maintain long notes, are truly something to behold as these were usually played by polyphonic synthesizers, which were very popular at the time. But true to its motto, the group would not use this type of instrument on the album, preferring to simulate the keyboard layers with a drone effect on the guitar, most noticeable beginning at 1:15. Novice listeners could easily be mistaken during a first listen!

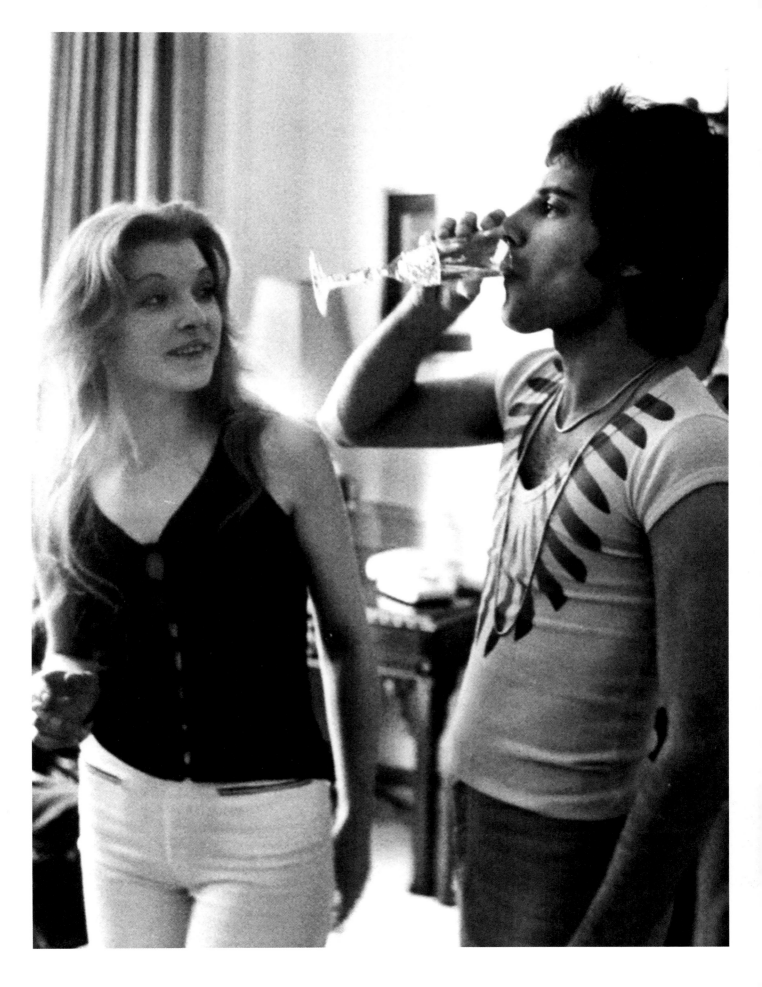

SINGLE

NOW I'M HERE
Freddie Mercury / 4:15

Musicians
Freddie Mercury: lead vocals, backing vocals, organ
Brian May: electric guitar, backing vocals, piano
John Deacon: bass
Roger Taylor: drums, backing vocals

Recorded
Trident Studios, London: September 1974

Technical Team
Producers: Queen, Roy Thomas Baker
Sound Engineer: Mike Stone
Assistant Sound Engineers: Neil Kernon (Trident)

Single
Side A: Now I'm Here / 4:15
Side B: Lily of the Valley / 1:43
UK Release on EMI: January 17, 1975 (ref. EMI 2256)
Best UK Chart Ranking: 11

Chuck Berry and his 1958 Gibson ES-350T, whose riffs greatly influenced Brian May and Freddie Mercury.

Genesis

Recorded by the band in September 1974 at Trident Studios, "Now I'm Here" is one of Brian May's four contributions to the album's track-listing.

It is a true declaration of love for America, which the band discovered in the spring of 1974 while on tour with Mott the Hoople. The song makes references to this trip and to the encounters the group experienced while out on tour. The guitarist declared: "The American Tour [...] blew me away. I was bowled over by the amazing aura rock music has in America."[5] "Now I'm Here" lines up numerous references to this important journey. May explicitly references the headliner with his lyric "*Down in the city just Hoople and me*," but he becomes more mysterious when he writes "*Down in the dungeon just Peaches and me.*" When May speaks of the dungeon, is it a reminder of Queen's interest in the medieval world? The answer is more likely to be found on Toulouse Street in the city of New Orleans, Louisiana. After their April 21, 1974, concert at the St. Bernard Civic Center, the band spent several days in the city's French Quarter and visited the Dungeon club, where Brian met the mysterious Peaches. This meeting seemed to trouble the guitarist, who was in a relationship with his longtime girlfriend Chrissie Mullen. He would refer to this encounter again in the song "It's Late," on the *News of the World* album.

"Now I'm Here" was released as a single on January 17, 1975, with "Lily of the Valley" on the B-side. It went on to reach eleventh place in the British charts, thanks to the band's appearance on *Top of the Pops* the day before the single's release, which gave them significant exposure. The second and last single from *Sheer Heart Attack*, this track remains a touchstone for many guitarists thanks to its incisive riffing and singular tonality.

Production

The introduction to this track is marked by the sound experiments of producer Roy Thomas Baker. He used a delay on Mercury's voice in order to repeat his words and harmonize the phrase endings. This is exactly the same process that May was able to reproduce live thanks to his Echoplex boxes, but here the technique is applied to Freddie's voice. The experiment pleased the band so much that they decided to use it again on their following album. It must

FOR QUEEN ADDICTS

On *Top of the Pops* on January 16, 1975, Brian May was once again unfaithful to his famous Red Special, this time appearing with a Gibson Les Paul.

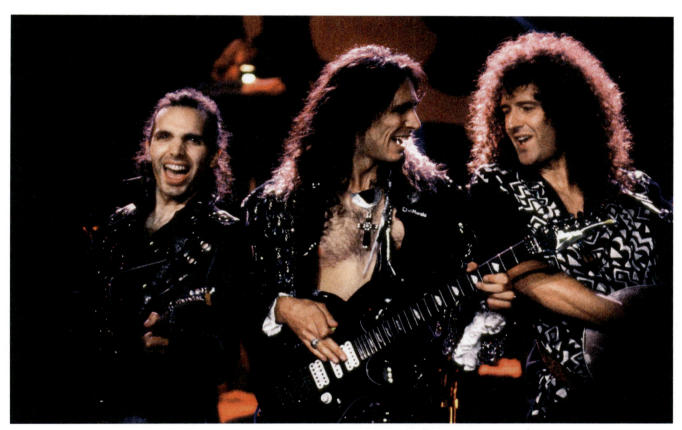

A meeting of giants: Joe Satriani, Steve Vai, and Brian May perform at the "Rock Legends" festival in Seville in 1991.

also be mentioned that the main guitar riff on "Now I'm Here" is a tribute to 1950s rock 'n' roll, especially in the long instrumental part at the end of the song, where the guitar takes us straight back to the great era of Chuck Berry and Carl Perkins. May's guitar improvisations add a rockabilly touch to the last sequence of the song, which was usually extended during live performances and was much appreciated by audiences for its nostalgic feel. As a last wink to this musical style that Queen loved so much, Freddie Mercury sings "*Go, Go, Go Little Queenie*" at 3:50, paying homage to Chuck Berry by taking up the chorus of his hit "Little Queenie," released in 1959 on the album *Chuck Berry Is on Top*.

On October 19, 1991, Brian May took part in the "Rock Legends" festival in Seville as part of the promotion for Seville Expo '92, which was scheduled to be held in the Spanish city the following April. "Now I'm Here" entered the all-time hall of fame as May was joined onstage by fellow six-string stars Steve Vai, Joe Satriani, and Nuno Bettencourt, as well as Gary Cherone, from the band Extreme, who accompanied the group on the microphone.

IN THE LAP OF THE GODS

Freddie Mercury / 3:22

Musicians
Freddie Mercury: lead vocals, backing vocals, piano
Brian May: classical and electric guitars
John Deacon: bass
Roger Taylor: drums, timpani, backing vocals

Recorded
Rockfield Studios, Monmouth, Wales: July 7–28, 1974
Wessex Sound Studios, London: early August 1974
Trident Studios, London: September 1974 (mixing)

Technical Team
Producers: Queen, Roy Thomas Baker
Sound Engineer: Mike Stone
Assistant Sound Engineers: Geoff Workman (Wessex), Neil Kernon (Trident)

Jazz musician Malcolm Cecil's TONTO studio served as the setting for one of the main scenes in Brian De Palma's 1974 movie *Phantom of the Paradise*.

Genesis

From the very first bars of the track, Freddie Mercury plunges listeners back into the lyrical universe that he had mostly abandoned after *Queen II*. Reminding listeners that although the band has now focused on producing hits, Freddie was still very much attached to the worlds of mysticism and fantasy. The artist makes reference to Greek mythology with the expression "*In the lap of the gods.*" The phrase has its roots in Homer's *Iliad*, when Automedon, Achilles's charioteer in the Trojan War, says that the battle's outcome is "in the lap of the gods." Despite its classical references, "In the Lap of the Gods" is most definitively a love song, sung by Freddie and supported by a powerful and repetitive chorus.

Production

Worthy of the finale of a grand Italian opera, the attack in "In the Lap of the Gods" is breathtaking in more ways than one. Once we've become accustomed to Taylor's falsetto voice, and to the panning effects applied to Mercury's vocals (audible with headphones between 0:32 and 0:40), the piano kicks in. Then the verse begins, with the singer's voice again modified by Roy Thomas Baker, probably in order to provide the lyricism desired by the band. Once again, the parallels between a Queen track and Brian De Palma's *Phantom of the Paradise* are clear. Mercury reminds us of Winslow Leach, the injured composer and broken-voiced hero of De Palma's film, who tries to sing through filters manipulated by the evil producer played by Paul Williams. Roy Thomas Baker *pitches* Freddie's voice. This process, which Prince frequently used during his career (notably on the track "Rainbow Children" in 2001), enables the original note to be raised or lowered, just as one can descend or go up the keyboard of a piano. The voice retains the same note so that it can be accompanied by the same piano chords, but with several octaves of difference.

To many fans, this song seems unfinished, as if it were a fragment of a work. The somewhat clumsy end of the song confirms that this little musical interlude probably resulted from a jam session between the musicians, rather than a finished composition. But the energy produced during the introduction alone is enough to justify the presence of "In the Lap of the Gods" on the album.

STONE COLD CRAZY

Freddie Mercury, Brian May, John Deacon, Roger Taylor / 2:16

Musicians
Freddie Mercury: lead vocals, backing vocals
Brian May: electric guitar
John Deacon: bass
Roger Taylor: drums

Recorded
Rockfield Studios, Monmouth, Wales: July 7–28, 1974
Trident Studios, London: September 1974 (mixing)

Technical Team
Producers: Queen, Roy Thomas Baker
Sound Engineer: Mike Stone
Assistant Sound Engineer: Neil Kernon (Trident Studios)

FOR QUEEN ADDICTS

The members of thrash metal band Metallica have always claimed "Stone Cold Crazy" as one of their favorite songs. They even performed a cover of the song in 1990 on the *Rubáiyát* compilation released by Elektra Records to mark the label's fortieth anniversary. Metallica would go on to receive a Grammy Award for their efforts.

Genesis

Considered to be a precursor of the heavy metal style, "Stone Cold Crazy" is a distillation of raw energy. The song, whose creation dates back to the band's early years, is the first track credited to all four members. Freddie seemed to be the original writer of the song, but not being able to agree on this point, they all decided on this unusual option of sharing credit.

The track is steeped in history, as it was played at the band's very first concert in Truro, Cornwall, on June 27, 1970. The concert had been planned long beforehand, and the posters still promised the group Smile, but it was Queen who took to the stage that night. Mike Grose played bass at the time, and the concert was organized by friends of Roger Taylor's mother to benefit the Red Cross. According to Brian May, the reason the song had been left sitting in a drawer for all those years was simple: "I think the truth is we weren't sure it was good enough for the first album and it didn't fit the format of the second."[25] Taylor himself looks back fondly on that early performance in his home county: "[Freddie] didn't have the technique he developed later on; he sounded a little bit like a very powerful sheep."[26] The song was played as the opening track, and thus "Stone Cold Crazy" is, in fact, the very first song the band ever played live in concert.

Production

In a 2016 interview with Jamie Humphries, a journalist with GuitarInteractive.com, Brian May describes how he uses his Red Special to achieve that "bite" sound on the guitar:[27] His renowned guitar was fitted with three pickups, each of which could be turned off if necessary. He explains that he had chosen to use the bridge pickup and neck pickup in tandem, with the bridge pickup put out of phase. The opposition between the two pickups creates an almost imperceptible but persistent buzz, resulting in a "crunchy" sound that all guitarists like to achieve when playing a powerful solo or riff. The first two bars of the introduction are marked by another pronounced guitar effect. Brian May plays a natural harmonic on the seventh fret of the low E string and uses his vibrato rod by pushing it toward the body of his Red Special, which relaxes the strings and immediately lowers the pitch of the note. This is yet another example of May's ability to bend a guitar's pitch to suit his needs.

DEAR FRIENDS
Brian May / 1:08

Musicians
Freddie Mercury: lead vocals, backing vocals
Brian May: piano

Recorded
Associated Independent Recording (AIR) Studios, London: mid-August 1974
Trident Studios, London: September 1974 (mixing)

Technical Team
Producers: Queen, Roy Thomas Baker
Sound Engineer: Mike Stone
Assistant Sound Engineer: Neil Kernon (Trident Studios)

COVER
The British band Def Leppard produced a surprising cover of "Dear Friends" in 2006. The bassist, Rick Savage, plays all the instruments on this version, which was released on a bonus EP that was distributed exclusively in Walmart stores as part of a cover album called "Yeah!"

Genesis
In the summer of 1974, while Roger, John, and Freddie moved into the Rockfield Studios in Wales, Brian May was still sick and confined to his hospital bed. He composed on his own while the trio worked on the first songs of the new album without him. Feeling responsible for the premature end of the American tour, Brian was convinced that his friends, hungry for success, would soon be looking for a new guitarist. Although brotherhood was the keystone of the group, nothing reassured him: Isolated and far from the studios, he wanted to reclaim his place within Queen as soon as possible. It was during this period that he wrote "Dear Friends," a little lullaby that breaks the rhythm of the hurricane-force *Sheer Heart Attack*, and the second lullaby on the album after "Lily of the Valley," written by Mercury.

The text speaks for itself: *"So dear friends your love is gone / Only tears to dwell upon."* Yielding to his paranoia, May seems to speak directly to the other musicians in the group, regretting the loss of their friendship. Even more explicitly, he adds: *"Go to sleep and dream again / Soon your hopes will rise and then."* It is easy to see that May has become resigned to staying in his hospital bed forever so that the group can move forward and realize their dreams of glory.

Production
Upon his return, Brian May presented this track to his friends, who immediately adopted it. Freddie gave an extremely moving performance of the song, providing the piano accompaniment himself. The delicate backing vocals support the singer's warm and reassuring voice, making "Dear Friends" a hymn to reunion and friendship, which is, in fact, the exact opposite of the song's original message.

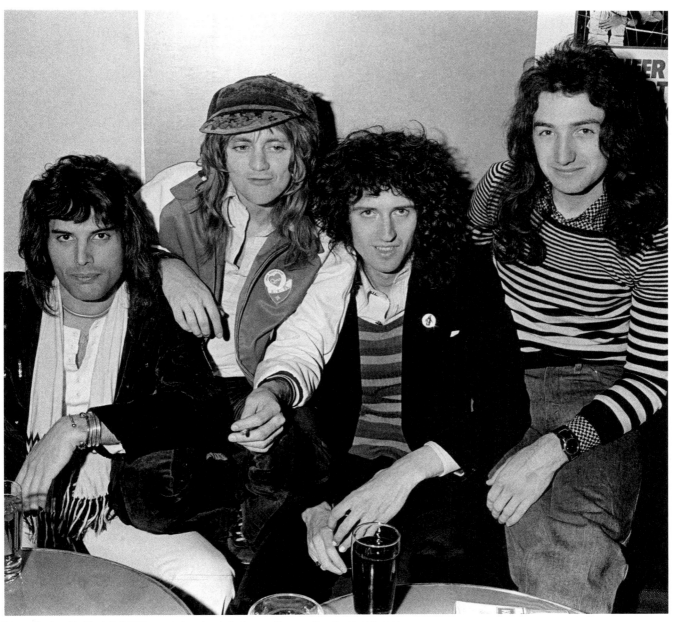
The entire band in the fall of 1974, ready to unleash their new album on the stages of Europe.

QUEEN: ALL THE SONGS 105

MISFIRE

John Deacon / 1:50

Musicians
Freddie Mercury: lead vocals, backing vocals
Brian May: electric guitar
John Deacon: bass, electric and acoustic guitars
Roger Taylor: drums

Recorded
Rockfield Studios, Monmouth, Wales: July 7–28, 1974
Wessex Sound Studios, London: early August 1974
Trident Studios, London: September 1974 (mixing)

Technical Team
Producers: Queen, Roy Thomas Baker
Sound Engineer: Mike Stone
Assistant Sound Engineers: Geoff Workman (Wessex), Neil Kernon (Trident)

COVER
The American singer Neko Case released an amazing version of this track on her 1997 album *The Virginian*, featuring a country-style snare drum pattern that gives the song an extra dose of American color.

Genesis

In 1977, John Deacon was interviewed by Bob Harris, host of the BBC2 show *The Old Grey Whistle Test*, who was then making a documentary on Queen. Deacon admitted that it took him several years to really feel like part of the band. His legendary coolness and his tendency to stand toward the back of the stage when the group performed garnered him a reputation as the "discreet Queen bassist." But history will prove that he was far more than just a passive musician. When he offered "Misfire" to Roger Taylor and Freddie Mercury, they both agreed to help him bring his project to fruition, as this had become the established working method among the members of Queen.

Though Deacon may be discreet on stage and taciturn in interviews, the lyrics he wrote for "Misfire" are full of mischief and playfulness. While it may seem like an innocent folk song with Flower Power accents, a second reading of the lyrics quickly reveals the song's hidden, bawdy nature. The song is actually very saucy, with innuendos in every line. It is implicitly about a woman (or a man) asking her lover not to "miss" and to "aim well." It doesn't take much to guess the true meaning the bass player wanted to give to the song: *"Your gun is loaded / And pointing my way / There's only one bullet / So don't delay."* For his first track, Deacon wrote lyrics that Freddie, always fond of offbeat humor and saucy jokes, would be delighted to sing. Deacon appeared much more well behaved the following year, once he was married and a father, when he penned his first hit for Queen, the sensitive and thoughtful "You're My Best Friend."

Production

With Brian May out of commission, it was Deacon who played most of the guitar parts on this track, but he would never pick up the microphone, telling everyone within earshot that he is a poor singer: "I can't sing a single note,"[16] he later declared. He barely dared to contribute to the backing vocals in concert, doing his best to stay hidden behind his Fender Precision.

The folk guitar rhythm displayed in this song is lively and cadenced by Roger Taylor's Ludwig Golden Tone bell. The song is effective, and the melody would not have displeased Elton John, a great specialist of this type of

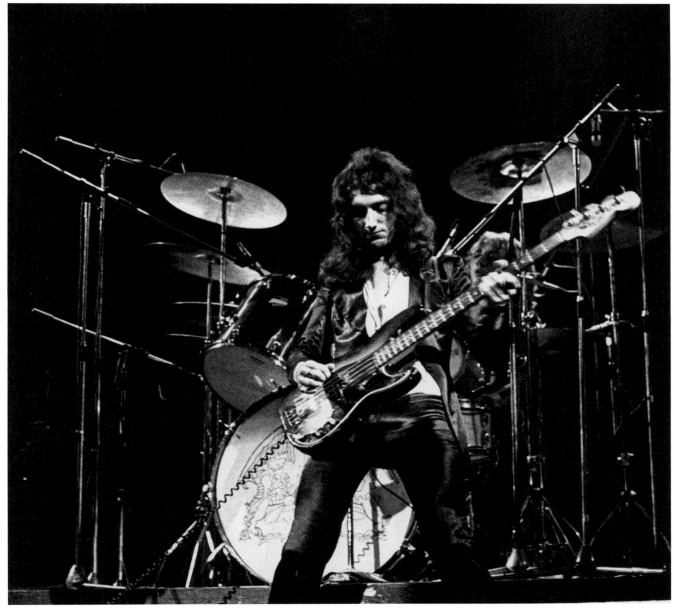
The quiet but talented John Deacon and his Fender Precision, on the stage of the New Theatre in Oxford, England, on November 18, 1974.

melodic pop song. We are reminded of "Grey Seal" and "Jamaica Jerk-Off" on *Goodbye Yellow Brick Road* or "Daniel" on *Don't Shoot Me I'm Only the Piano Player*, two albums released in 1973 by the legendary pianist. At 0:03 we hear Roger Taylor's latest toy, a fourteen-inch Hollywood Meazzi tom. This Italian brand, which was prominent in the jazz scene of the 1950s and 1960s, appealed strongly to the drummer, who was particularly seduced by this so-called "tunable floor tom" The name was given to a drum set on the ground (like a bass tom), but equipped with a pedal controlling a system to adjust its tone. This same function is found on an orchestral timpani, whose pedal allows the instrument to be tuned by activating a lever that presses on the drumhead. For the *Sheer Heart Attack* tour, Roger Taylor removed the tuning system and the feet from the tom in order to hang it in the middle position in the drum battery. The musician was enamored with the sound this created and soon after adopted a series of Remo Rototoms, which were also reputed for their tonal adjustment system.

FOR QUEEN ADDICTS

During the group's studio sessions, the working title of this song was "Banana Blues"!

QUEEN: ALL THE SONGS 107

BRING BACK THAT LEROY BROWN
Freddie Mercury / 2:15

Musicians
Freddie Mercury: lead vocals, backing vocals, piano, tack piano
Brian May: electric guitar, banjolele
John Deacon: bass, double bass
Roger Taylor: drums

Recorded
Wessex Sound Studios, London: early and late August 1974
Trident Studios, London: September 1974 (mixing)

Technical Team
Producers: Queen, Roy Thomas Baker
Sound Engineer: Mike Stone
Assistant Sound Engineers: Geoff Workman (Wessex), Neil Kernon (Trident)

ON YOUR HEADPHONES
If we listen carefully at 0:59, we discover bass player John Deacon on a stealthy four-beat bar.

One of Brian May's many banjoleles, immortalized for *Guitarist* magazine in 2010.

Genesis

The band's first foray into the ragtime style, "Bring Back That Leroy Brown" is breathtakingly virtuosic. The track would have been perfectly suited to the hit music hall shows of the 1920s and '30s, such as *The Hollywood Revue of 1929*, which featured the first performance of the now famous song, "Singing in the Rain," sung by Cliff Edwards, who accompanied himself on the ukulele. Harold May taught his son, Brian, to play the banjolele, which is a four-stringed instrument with the neck of a ukulele but attached to the body of a banjo. Famously used by George Formby, a well-known British music hall star between the Great World Wars, the banjolele was tuned like a ukelele, and the instrument enabled the young Brian to reproduce the songs he heard on his favorite radio show, *Uncle Mac's Children's Favourites*. Airing from 1954 to 1967, the show played children's favorite tunes as selected by its host, Derek McCulloch, who went by the nickname Uncle Mac. Children sent in their requests by mail, and the host ensured that all kinds of music were represented on air, thus introducing the young listeners to a variety of musical styles. The young Brian May's favorite tracks were "Nellie the Elephant" by Mandy Miller and "The Laughing Policeman" by Charles Penrose.

As further proof that Queen's fate was already set in stone, the young Freddie Mercury, born Farrokh Bulsara, who had just come to Great Britain with his family, grew up only a stone's throw away from Brian's childhood home in Feltham, and listened to the same program every Saturday morning. The two musicians never met when they were children, but they brought their shared childhood influences to bear on "Bring Back That Leroy Brown."

The lyrics refer to a song by American singer Jim Croce, which was released in March 1973, and went on to spend two weeks at the top of the US charts. The song, entitled "Bad Bad Leroy Brown," tells the story of a young outcast wandering the streets of his town. "Bring Back That Leroy Brown" should undoubtedly be interpreted as a tribute from Mercury to Croce, who tragically lost his life in a plane crash in September 1973, just a few short months after his song met with such great success.

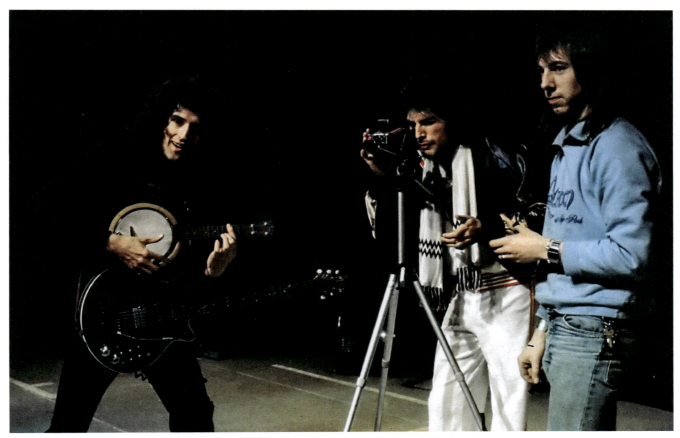

Brian May, Freddie Mercury, and the band's chief roadie, Peter Hince. May is shown with his banjolele placed over his Red Special, which is how he performed the solo from "Bring Back That Leroy Brown."

Production

Always ready to draw from his broad base of musical knowledge, here Freddie Mercury offers a musical style where the piano is used as a simple instrument, and no longer treated as a sacred object used for playing "noble" music. As on *Killer Queen*, he uses a tack piano, whose Bastringue sound fits perfectly with the theme of the song. A great admirer of the jazz sound created during the period between the two World Wars, Mercury demonstrates impressive dexterity on this cut, producing jumping but precise notes on the tack piano, recalling the sound of the piano used in comedy films from the silent era. While Queen's vaudevillian experiments culminated on the album *A Night at the Opera* with the tracks "Lazing on a Sunday Afternoon," and the spectacular "Good Company," "Bring Back That Leroy Brown" appears on *Sheer Heart Attack* as a curiosity, which could have been ignored if the musicians' technique and mastery of the ragtime genre had not been so impressive.

FOR QUEEN ADDICTS

In 2008, an Abbott banjolele that once belonged to George Formby was auctioned off for £72,000. The lucky buyer's name was…Brian May.

SHE MAKES ME (STORMTROOPER IN STILETTOES)
Brian May / 4:09

Musicians
Brian May: lead vocals, backing vocals, acoustic and electric guitars
John Deacon: bass, acoustic guitar
Roger Taylor: drums

Recorded
Associated Independent Recording (AIR) Studios, London: mid-August 1974
Trident Studios, London: September 1974 (mixing)

Technical Team
Producers: Queen, Roy Thomas Baker
Sound Engineer: Mike Stone
Assistant Sound Engineer: Neil Kernon (Trident Studios)

Genesis
The guitarist's third composition for *Sheer Heart Attack*, "She Makes Me (Stormtrooper in Stilettoes)" is an elusive song with folk accents that transports the listener to the Summer of Love in America in 1967. Like most of the other May-penned tracks on this album, "She Makes Me" is tinged with a sense of melancholy, most likely owing to May's inability to participate in the recording of the new album. The hidden side of the guitarist is revealed here, showing us all of his flaws and wounds, and serving as a perfect follow-up to "Dear Friends," which was also composed during May's illness and convalescence.

It is not easy to interpret the lyrics, but we can guess that the author is preoccupied by a painful romantic relationship. When he sings "*I know you're jealous of her / She makes me need*" and "*I know the day I leave her / I'd love her still*," we know that the outcome of this romance will not be happy. It's also possible to draw parallels between this song and the track "Now I'm Here," which deals with May's meeting of the mysterious Peaches at the Dungeon club in New Orleans.

The track is intriguing for another reason: As the movie *Star Wars* had not yet been released in 1974, the term *stormtrooper* clearly does not refer to the troops of Darth Vader. They are in fact the Sturmtruppen of 1914, the assault troops of the German army sent to the front lines on the battlefields of World War I. Stilettos, in contrast to the virile uniforms of the German soldiers, are shoes with extremely thin heels that are often perilously high, and are seen as a symbol of exaggerated femininity. One wonders what could have gone through the guitarist's mind when he came up with the title of this song. Perhaps it was the memory of a woman dressed up as a soldier? This is indeed the kind of character that you might meet at the Dungeon club in the mid-1970s, as this venue was for catering to customers with an "anything goes" type of attitude.

Production
Brian's voice on this psychedelic track takes on a tone similar to that of Paul McCartney, with the spirit of Pink Floyd mixed in for good measure. The guitarist had already tried on this musical aesthetic on the track "Some Day

1974

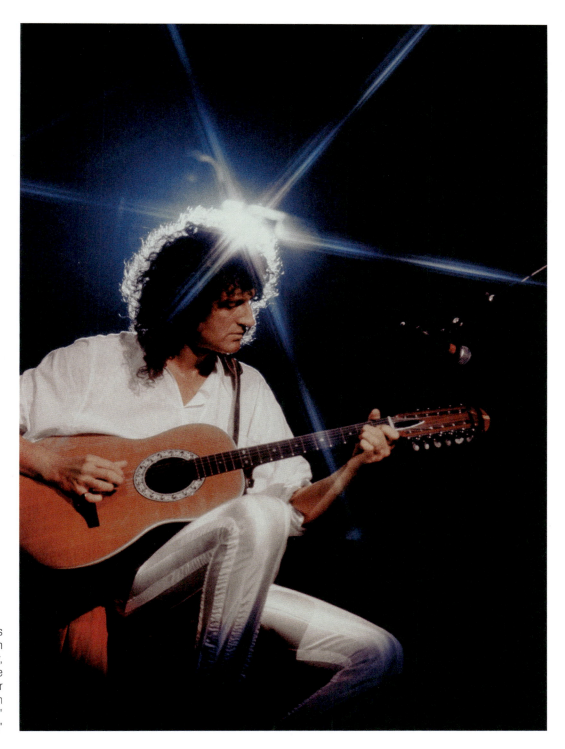

Brian May and his twelve-string Ovation 1615 Pacemaker guitar, which was used in "She Makes Me (Stormtrooper in Stilettos)" and later in the famous tracks "'39" and "Love of My Life."

One Day." The brilliance of the Ovation Pacemaker 1615 twelve-string acoustic guitar (which May would use again on *A Night at the Opera*), coupled with the stellar backing vocals, and the reverb-drenched drum sound supported the psychedelic effect for which May was striving. As with "Funny How Love Is" on the album *Queen II*, an uninitiated listener hearing the backing vocals at 1:02 could easily attribute the musical influence of this track to the Beach Boys. However, from 2:56 onward, a harmonic change and multiple sound effects darken the scene that has been set. At 3:02 we hear the guitar strings struck, followed by a long delay, and then the sound of distant police sirens, which are then followed by the breaths of a guitarist who seems to be breathing his last. The psychedilic and heavy atmosphere that May creates at the end of the track is closer to Pink Floyd's experimentations than many of the other straightforward hits that Queen was offering on their third album.

IN THE LAP OF THE GODS... REVISITED

Freddie Mercury / 3:45

> Freddie at the piano during the unforgettable performance of "In the Lap of the Gods...Revisited" at Wembley Stadium in July 1986.

Musicians
Freddie Mercury: lead vocals, backing vocals, piano
Brian May: electric guitar, backing vocals
John Deacon: bass
Roger Taylor: drums, backing vocals

Recorded
Rockfield Studios, Monmouth, Wales: July 7–28, 1974
Trident Studios, London: September 1974 (mixing)

Technical Team
Producers: Queen, Roy Thomas Baker
Sound Engineer: Mike Stone
Assistant Sound Engineer: Neil Kernon (Trident Studios)

Genesis

Sheer Heart Attack ends with a track that has become one of the most anticipated songs performed live at Queen's concerts. "In the Lap of the Gods...Revisited" is not a single, and is relatively unknown to the general public. But it is one of Freddie Mercury's most beautiful compositions, and it's famous for its place in the band's set list. Indeed, it closed all the concerts on the band's *Sheer Heart Attack*, beginning with their first performance at the Manchester Palace on October 30, 1974. At first glance, the song has no connection with its namesake, which also happens to be the seventh track of the album. Written by Mercury, this ballad seems designed for the stage and appears to be his first attempt at a popular anthem. The singer would repeat the experience with the worldwide hit "We Are the Champions" in 1977.

The version of this song that was filmed for the *Live at Wembley Stadium* video in 1986 would be enough to convince even the most reluctant listeners of its quality. The closing chorus, performed by eighty thousand hysterical spectators, shows the sheer excess and power of Queen, then at the peak of their career. Even now, all these years later, it's impossible not to shiver while watching this performace.

Production

"In the Lap of the Gods...Revisited" and "We Are the Champions" have a very precise musical structure that leaves nothing to chance. As in the waltzes of Chopin or Shostakovitch, these two tracks are composed in three beats, which gives them a balanced and catchy rhythm. The skill required to compose these two songs may escape the listener, but one way or another they'll find themselves naturally swaying from side to side as they listen to the pure genius of Mercury's popular waltzes. Add to that the unstoppable melody of "In the Lap of the Gods...Revisited," and you have a genuinely classic track. Other famous songs make use of the same rhythmic structure, including "You've Got to Hide Your Love Away" by the Beatles, "Hallelujah" from Leonard Cohen, as well as "Nothing Else Matters" by Metallica.

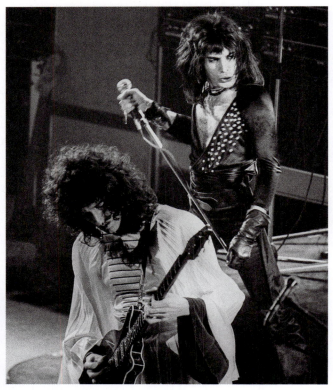

Brian May and Freddie Mercury onstage in 1974.

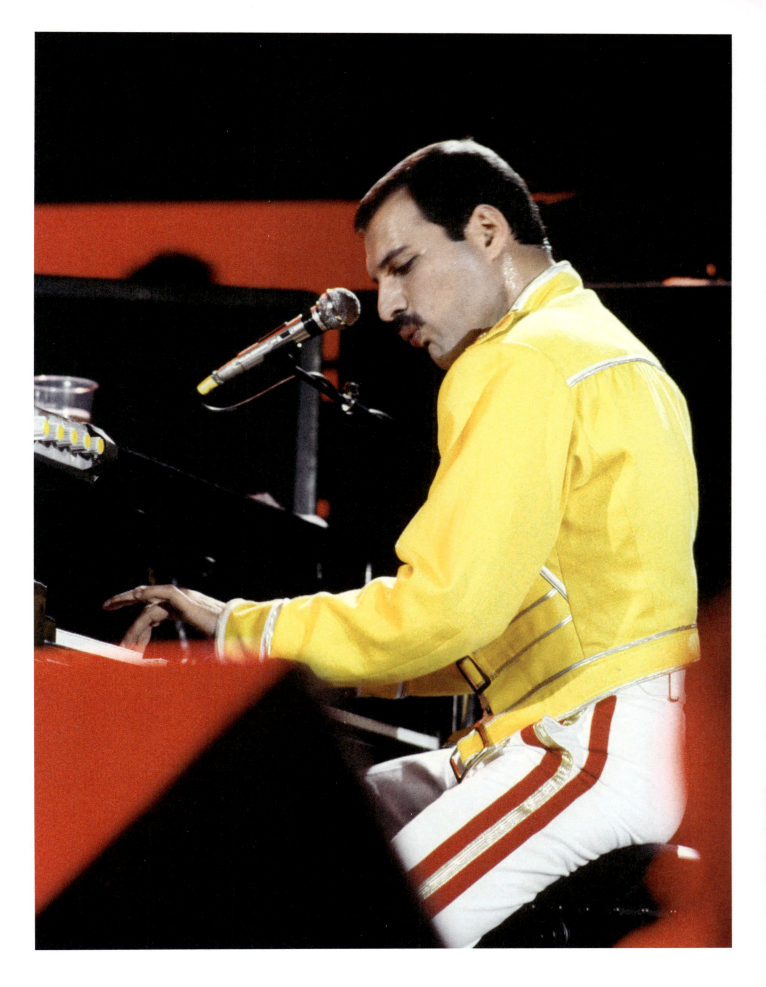

ALBUM

A NIGHT AT THE OPERA

Death on Two Legs (Dedicated To…) . Lazing on a Sunday Afternoon .
I'm in Love with My Car . You're My Best Friend . '39 . Sweet Lady .
Seaside Rendezvous . The Prophet's Song . Love of My Life . Good Company .
Bohemian Rhapsody . God Save the Queen

RELEASE DATES
United Kingdom: November 21, 1975
Reference: EMI—EMTC 103
United States: December 2, 1975
Reference: Elektra—7E-1053
Best UK Chart Ranking: 1
Best US Chart Ranking: 4

The members of Queen explore Japan in April 1975. Japan would go on to become one of the group's favorite tour destinations.

AN EIGHT-HANDED MASTERPIECE

In April 1975, Queen flew to Japan to begin its first tour in Asia. The welcome awaiting them at Tokyo's Haneda Airport was an exceptional one for a Western group. Hundreds of fans (thousands, according to Roger Taylor) greeted the musicians with banners and placards. The group, which had received disastrous reviews for each of its albums in the United Kingdom, was feted in Japan by enthusiastic journalists and admirers. This was a source of comfort for the quartet, who, once again, had to break off their American winter tour, following their lead vocalist's laryngitis, which had compounded into a total loss of voice. A curse seemed to loom over the group, who had to wait until the following year before fully transforming their bad luck with a triumphant tour of the United States.

From their first concert at the Budokan in Tokyo, on April 19, the quartet was jubilant. "Suddenly we were The Beatles,"[2] recalls Brian May. The eight concerts they performed provided ample evidence that Queen mania was hitting Japan. But when the musicians returned to the United Kingdom, it was another story altogether. Roger went back to his tiny room in London; Brian and Chrissie Mullen, his longtime partner, returned to their flat, which had no running water. Freddie and Mary Austin lived in a little dark, damp apartment, and John Deacon, who was about to get married, had Trident refuse him the advance of £4,000 that he needed to purchase a house. The journalist Rosemary Horide, who had supported Queen from the outset, remembers the situation the group was in: "Quite often, I would go to an interview, and I would buy a couple of bottles of wine on my expenses because they didn't have any money."[22] The contrast between the success they experienced in Japan and the four musicians' living conditions at home in the UK heightened the band's tensions with Trident, especially as their record sales were becoming more and more significant. Mercury and his band reproached the Sheffield brothers for not paying them the money earned from the first two albums, and the success of the single "Killer Queen" added weight to their claims. As for the label managers, they made an investment of £200,000 in the group, which was meant to reimburse some of the costs they had incurred during the recording of the first two albums. The brothers were thus taking out a significant portion of the musicians' weekly salary in order to earn back their investment, which was leaving the band members with barely enough money to make ends meet. There was one particular detail that was really the last straw, according to Roger Taylor: "One of the management just bought a Rolls-Royce, and then we thought that something was going on here."[22] But the musicians were bound to Trident by a watertight contract. And to cap everything, the band had no manager, and thus no one to fight in their corner in the event of a dispute.

A Change of Entourage

With all of this going on, it's no wonder Queen sought to change their professional representation. Bob Mercer, who had signed the group with EMI, put the musicians in touch with Jim Beach, the famous lawyer from the firm Harbottle & Lewis. Mercer set about looking for ways to help the band members break contracts with Trident. He teamed up with

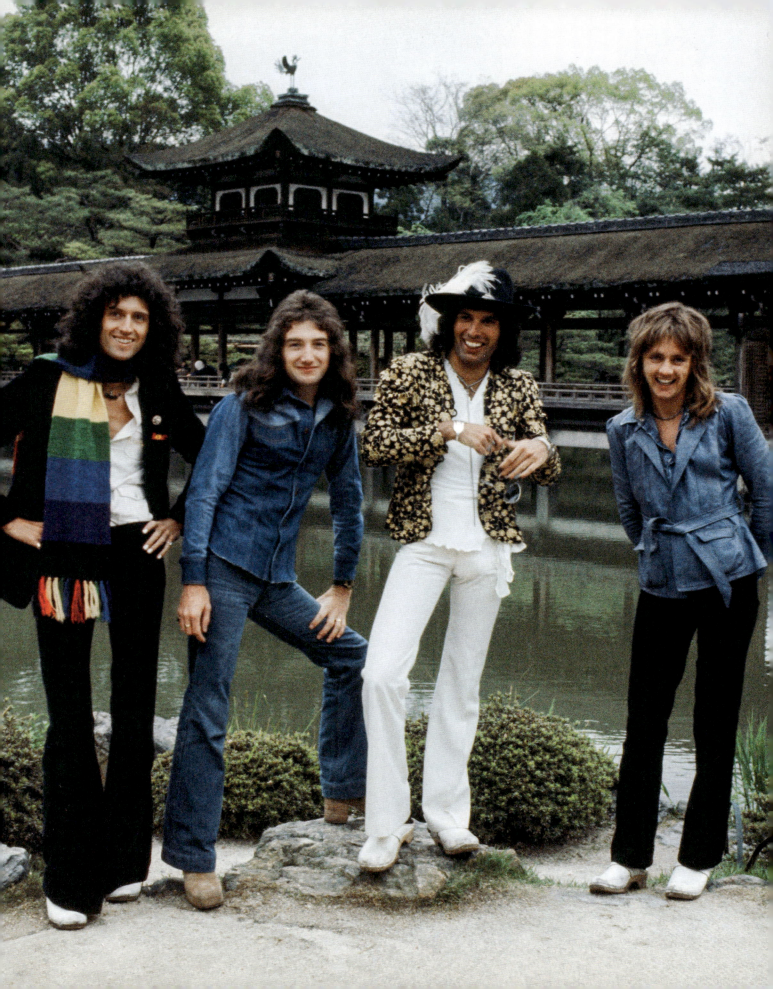

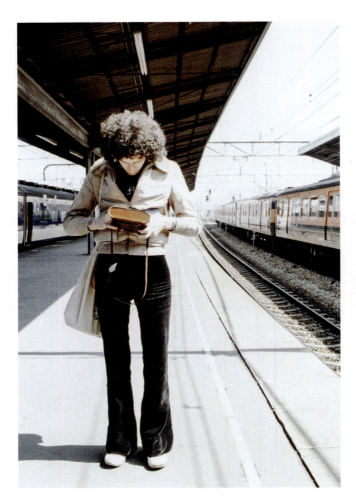

Brian May inspecting one of his many cameras in Kyoto during the group's Japanese tour in April 1975.

FOR QUEEN ADDICTS
The group's famous photo shoot at Ridge Farm was immortalized by none other than Brian May, who served as the photographer.

John Reid, the band's newly-recruited manager, who had also worked for Elton John for four years. Reid's professionalism and effectiveness were well known, and he provided the group with the security it needed, encouraging them to focus on writing their next album while he dealt with public relations and the press. Reid, whose priority remained Elton John, provided the group with a "constant" manager, Pete Brown, who joined the very private circle of musicians at that time and handled day-to-day issues. This new "factotum" could not have envisaged the scale of the task awaiting him, which included meeting all the needs of the quartet and fulfilling the whims of the future superstar Mercury.

Eventually, the Beach-Reid duo found a route to an amicable resolution with Trident, and in August 1975, an agreement was signed with the Sheffield brothers. They released the musicians from their contract and received an indemnity of £100,000, advanced by EMI Publishing, which obtained the publishing rights to the Queen catalog of songs. Trident was also paid 1 percent of the rights to the band's next six albums. The group had found their way out of a stagnating relationship, but this agreement left behind a bitter taste, which the band would not soon forget.

Back to the Countryside
In an atmosphere that was now calmer, Queen could get back to the task of writing their next album. To find the necessary inspiration for the creation of the successor to *Sheer Heart Attack*, the group shut itself away during July 1975 in Penrhos Court, a property in Herefordshire, England, near the border with Wales. This large house was owned by Joan Murray, who leased her barn to artists as a way of supplementing her income. Her daughter Tiffany, who was six at the time, remembers the advertisement her mother placed in the *Times*: "Country house available. Rehearsal space for bands. No heavy rock."[28] Tiffany Murray was later to become a writer and in 2010 published *Diamond Star Halo*, a novel inspired by her childhood memories. When promoting her book, she told of her daily encounters with members of the group and various anecdotes surrounding the creation of "Bohemian Rhapsody." Queen spent two weeks writing and composing at Penrhos Court, and they benefited much from the homecooking of the lady of the house, and friendly breaks with Cleo, the property's big Great Dane. It was from this warm atmosphere that most of the numbers from the group's fourth album were born. When they had made good progress with the writing, Queen installed themselves at Ridge Farm Studios, located in the small village of Rusper, in West Sussex, and spent much of August rehearsing. "The setting in Ridge Farm was, and is, rather picturesque and quite peaceful. It was a good place to create. We were separate from everyone else, away from the distractions of family life and business, etc. We

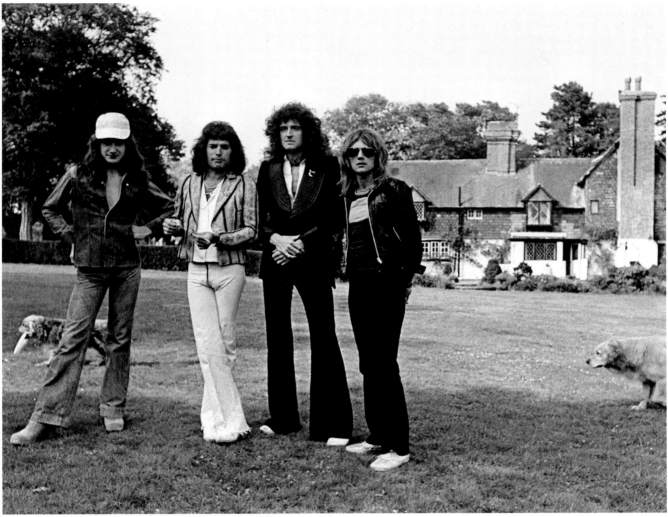
Queen takes a break between two work sessions at Ridge Farm Studios, in August 1975. This photograph was taken by Andre Csillag, who was also with group during Live Aid in 1985.

were just the four of us, and our people, and our music,"[29] Brian May would later recall.

The musicians even found time to participate in a small piece published in the Japanese version of *Music Life Magazine*, in which they were photographed playing tennis, drinking tea, and lounging poolside!

The Birth of a Masterpiece

At the end of August, Queen went to Rockfield Studios in Wales, to start recording the album. For the production, the group once again reunited with the loyal Roy Thomas Baker, who had left Trident to join the stables of John Reid. At the mixing desk was another Queen stalwart, Mike Stone, who shared ever closer artistic affinities with the group. It was in this location—now mythical, due to Queen—that the core material of each song on *A Night At the Opera* was laid down. The piano, bass, and drums were recorded live, under concert conditions. The guitars and vocals were recorded at Sarm East Studios, then the vocal overdubs were divided up and recorded at the Sarm East Studios, Roundhouse Studios, Scorpio Studios, and Lansdowne Studios. In total, six locations were required for the creation of this album. Effectively, the musicians worked independently (or in pairs), each focusing on their own song, in a different studio. May, who sometimes lamented the sense of competition within the group, had to resign himself to the process if he wanted to finish some of his own compositions, such as "The Prophet's Song," while Freddie moved ahead with his own mysterious rock opera project.

The production of *A Night at the Opera* lasted through autumn 1975. The full album was released on November 21, carried by the single "Bohemian Rhapsody," which was a huge success upon its early release on October 31. Although the English press was lukewarm on the track, the song was a popular triumph. On *Top of the Pops*, the group presented a now-classic video that was recorded at Elstree Studios in Hertfordshire, located to the north of London. Afterward, the song entered the charts and stayed there for seventeen consecutive weeks. The video the group presented on *Top of the Pops* was made by Bruce Gowers and combined concert clips with images from the photo shoot the group had done with Mick Rock for the *Queen II* album cover.

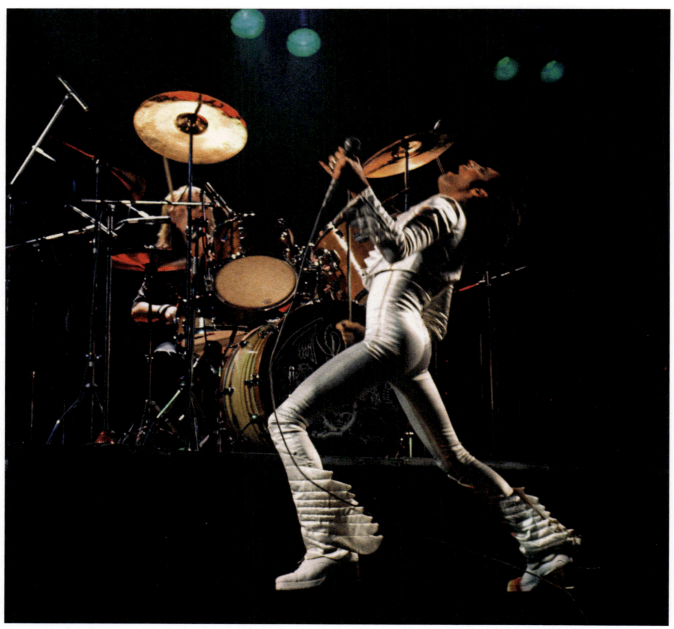

Freddie Mercury onstage in his "Winged Suit," created by the designer Wendy Edmonds.

1975

On November 14, 1975, Queen embarked on a new British tour, beginning at the Liverpool Empire. Each show was introduced with a recording from radio DJ Kenny Everett, who announced, *"Ladies and Gentlemen...A Night at the Opera."* Then the operatic portion of "Bohemian Rhapsody" was played along with its heavy rock conclusion, at which point the group took the stage. At the end of these concerts, Freddie threw roses to his public, but only after the group's personal manager, Pete Brown, had removed the thorns so that the singer would not hurt himself. The group's British tour concluded with a concert at the Hammersmith Odeon in London on December 24, which was filmed for posterity.

Due to an overwhelming demand for tickets, the date was added by the tour's promoter, Mel Bush. This date, which was scheduled at the last moment, was to be the high point of a triumphant tour. The concert was broadcast live on *The Old Grey Whistle Test*, on BBC2, as well as on BBC Radio 1. For this special occasion, the introduction to the set was changed. The host of *The Old Grey Whistle Test*, Bob Harris, presented the group, and the concert began with "Now I'm Here," taken from the album *Sheer Heart Attack*.

After years of negative coverage from the UK music press, Queen was declared best group, and "Bohemian Rhapsody" best British single by all the leading reviewers

120 A NIGHT AT THE OPERA

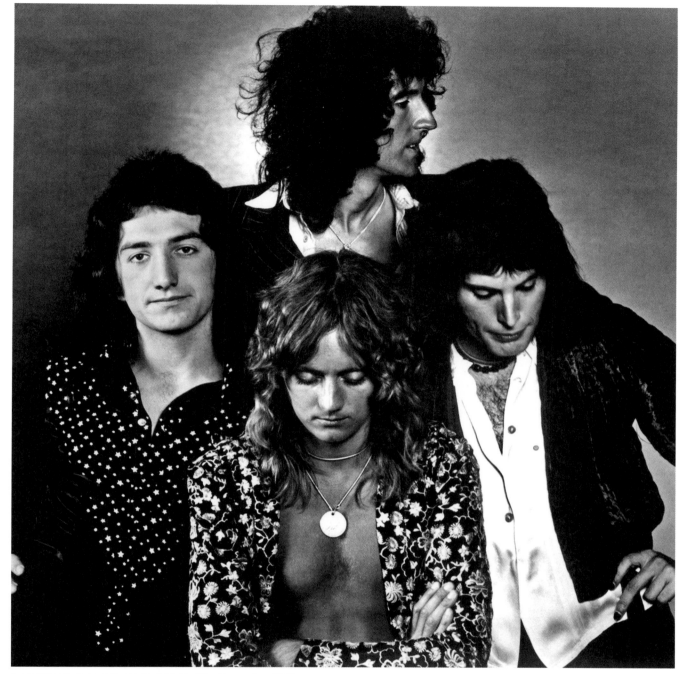

A promotional photo of Queen for *A Night at the Opera*, circa 1975.

of the time. *A Night at the Opera* was top of the charts on December 27, 1975.

On January 20, Mercury, May, Deacon, and Taylor flew to the United States, where a six-week tour awaited them, followed by another trip to Japan, then a stint in Australia. In the spring of 1976, the band returned to their home country as newly minted rock superstars. On June 18, 1976, John Deacon's song "You're My Best Friend" was released as a single and was also a resounding success.

The group was on cloud nine. That same summer, Brian married Chrissie Mullen at the Catholic Church of St. Osmund in Barnes, a neighborhood in London where the young couple had also just purchased a modest residence. John Deacon and his wife, Veronica, also invested in a humble abode in Putney, while Roger Taylor enjoyed the royalties from the song "I'm in Love with My Car," which had been judiciously placed on the B-side of the "Bohemian Rhapsody" single, and had gone on to sell 1 million copies. For Freddie and Mary, on the other hand, the situation had deteriorated. The couple amicably parted ways, ending their long-term relationship.

QUEEN: ALL THE SONGS 121

Freddie onstage at Cardiff Castle on September 10, 1976. Contrary to some accounts of the evening, "Death on Two Legs (Dedicated to…)" was not performed at this concert.

DEATH ON TWO LEGS (DEDICATED TO……)

Freddie Mercury / 3:43

Musicians
Freddie Mercury: lead vocals, backing vocals, piano
Brian May: electric guitar, backing vocals
John Deacon: bass
Roger Taylor: drums, backing vocals

Recorded
Rockfield Studios, Monmouth, Wales: August–September 1975 (accompanying track)
Scorpio, Lansdowne, and the Roundhouse Studios, London: mid-September–November 1975
Sarm East Studios, London: September–November 1975

Technical Team
Producers: Queen, Roy Thomas Baker
Sound Engineer: Mike Stone
Assistant Sound Engineers: Gary Langan (Sarm), Gary Lyons (Sarm), Dennis Weinreich (Scorpio)

FOR QUEEN ADDICTS
In 2013, Norman Sheffield published his memoirs, which include many recollections from his years at Trident. The autobiography, in which the producer seeks to defend himself against Queen's numerous accusations, is called *Life on Two Legs*!

Genesis

A few days after the release of their fourth album, which was scheduled for November 21, 1975, Queen went to the Roundhouse Studios in North London for a press conference and a meeting with the top brass at EMI. Friends of the band were also present, and the champagne was flowing. The event became quite the party, and the evening was a big success, with all of the guests predicting a resounding success for the group's new album. But news travels fast in London, and word soon reached Norman Sheffield that the album included some less than flattering lyrics that seemed to have been explicitly addressed to him, even though his name was not specifically mentioned. The producer, who had released the group from their contract three months previously, had effectively come out of his professional relationship with Queen as the big financial winner, much to Freddie Mercury's rage. The song in question on the new album was the opening track, with the understated title of "Death on Two Legs (Dedicated To...)." The title itself set tongues wagging. To whom could this diatribe possibly be directed? It didn't take long for close listeners to come up with an answer, especially since the song's lyrics contain some fairly obvious references. By all accounts, the song was a settling of scores: *"You suck my blood like a leech / You break the law and you preach / Screw my brain till it hurts / You've taken all my money / And you want more."* Among many other provocative phrases, Mercury also asks: *"Mister know-all / Was the fin on your back / Part of the deal? (shark!)"*

Despite Brian May's qualms about including such a bold declaration on the album, Freddie Mercury was determined to keep the reference on the final recording. Nothing would stop him in his wish to "set the record straight" with regards to Sheffield. The businessman later stated bitterly: "Facing up to the prospect that we were losing Queen was hard for me—and everyone else at Trident. We'd put so much time, money, and effort into developing them. It felt like a real kick in the teeth. […] I felt no consideration had been given to me and all the Trident crew that had helped them so far. […] Clearly Freddie's and the band's gratitude for what Trident had helped to create and achieve was non-existent. Four years of hard work by a lot of people, massive financial support seemingly meant

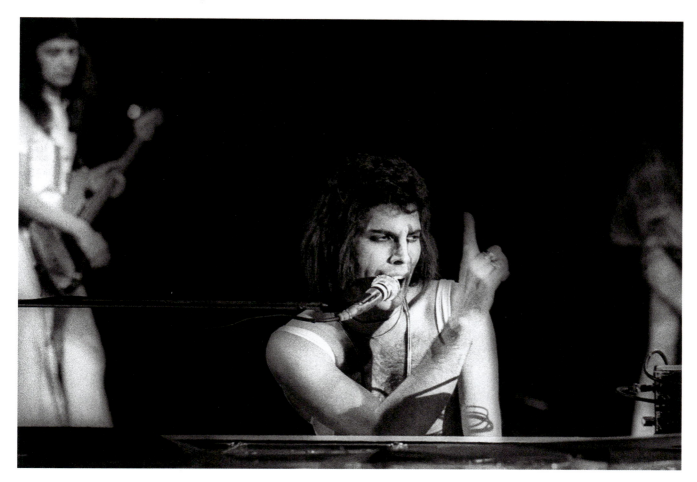

absolutely nothing. What gratitude!"[30] Once news of the song reached Norman Sheffield, he promptly informed EMI that he was going to do all he could to prevent the release of the group's new album, and he also threatened Mercury with legal proceedings. But once again, Sheffield and the group reached a substantial financial settlement, and the album was released as planned. As the famous adage goes: *"There's no business like show business"!*

Production

The opening track on Queen's fourth album, as described by Martin Power in his book *Queen: The Complete Guide to Their Music*, is a heavy metal tango. Once the listener makes it past the dark and disquieting opening provided by May's guitar, the cadence of the piano begins at 0:39, and the tango-inspired sound is unmistakable. The guitar riff, which doubles the piano melody and which returns with each refrain, has the razor sharpness of a shark's tooth. It gives the song's introduction a mordant and incisive character, which fits Freddie's text marvelously well. The song's rhythmic pattern is punctuated by numerous descending tom-tom passages, a signature of Roger Taylor's drum playing style. The percussionist, who was always increasing the size of his drum kit, made full use of his extensive battery. An example of his predilection for rolls can be heard at the bridge passage in the song, beginning at 1:47.

During the voice recording sessions at Sarm East Studios, Gary Langan, the sound engineer, testified to the violence that Freddie Mercury inflicted on himself in order to fully immerse himself in the anger of the song he had written: "In the studio, Freddie was insistent on having the headphones so loud in order to reach the high notes that his ears started bleeding."[2] Although Mercury later stated that the anecdote actually related to his throat, it is still clear that the anger and defiance felt in this track was clearly no laughing matter during the "Death on Two Legs (Dedicated To...)" recording sessions.

The piano chords in the opening track were placed on each beat of the song's introduction, which reminded Freddie Mercury of the staccato violins in the *Psycho Suite* theme, Bernard Herrmann's terrifying composition for Alfred Hitchcock's 1960 film *Psycho*. Before "Death on Two Legs" was chosen as the final title by the singer, its working name was *Psycho Legs*.

QUEEN: ALL THE SONGS

LAZING ON A SUNDAY AFTERNOON

Freddie Mercury / 1:07

Musicians
Freddie Mercury: lead vocals, backing vocals, piano
Brian May: electric guitar
John Deacon: bass
Roger Taylor: drums

Recorded
Rockfield Studios, Monmouth, Wales: August–early September 1975
Sarm East Studios, London: September–November 1975

Technical Team
Producers: Queen, Roy Thomas Baker
Sound Engineer: Mike Stone
Assistant Sound Engineers: Gary Langan (Sarm), Gary Lyons (Sarm)

ON YOUR HEADPHONES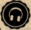
At 0:24 a sound effect is deployed that will be used again on the *Jazz* album in 1978. This sound is of a bicycle bell, which echoes the phrase *"Bicycling on every Wednesday evening."*

Genesis

As a follow-up to the raw power and anger that ricochets through the album's opening track, Queen chose a less unsettling song for the number two slot on the disc. One can readily imagine the surprise of a heavy metal fan who rushed out to buy *A Night at the Opera* from their favorite record shop, putting the 33⅓ rpm vinyl on their turntable, only to discover the second song: "Lazing on a Sunday Afternoon"! The song is a clear descendent of "Bring Back That Leroy Brown," which appeared on the group's third album, *Sheer Heart Attack*. This juxtaposition of songs is just one more example of the ways in which Queen is not a traditional *rock band*. This is a group that does not impose any artistic limitations on itself, and which draws upon multiple sources of inspiration in order to create a rich catalog of music.

The lyrics of "Lazing on a Sunday Afternoon" describe a "typical" week in the life of a traditional Londoner: work on Monday, honeymoon on Tuesday, and bicycling on Wednesday. The narrator, who dances a waltz at the zoo on Thursday, also states, not without a touch of irony: *"I come from London Town, I'm just an ordinary guy / Fridays I go painting in the Louvre."* In its fantastical way, the track depicts a gentle slice of life, accompanied by the jazz style that Mercury loved so much.

In an interview with Martin Popoff in 2018, Paul McCartney explained what, in his view, justified the influence of jazz as a musical style on so many of Queen's albums, and more generally as an influence on the music of the group's contemporaries: "[It comes from] our parents' generation. It was there when we were kids, when we were in short trousers growing up. It was all around. It was on the radio, mainly. Through the BBC, you were exposed to a lot of music. [...] I mean, you'd go to a local park and there might be a brass band playing. Your parents would have stories of the music hall. My dad used to work in a music hall. [...] All my aunties and uncles were exposed to this music and knew it all. They knew it by heart. [...] There was just a lot of that around."[11]

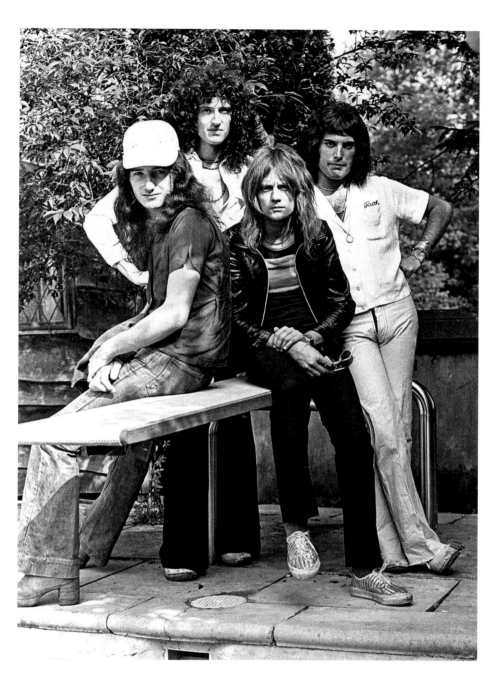

Queen hangs out by the pool at Ridge Farm Studios, where they were recording their new album in August 1975.

Production

As a great admirer of the music hall sound, this track allows Freddie Mercury to show his full dexterity on the piano. A Bechstein IV piano was used for the *A Night at the Opera* recording sessions, as it was easier for the singer to play and it had a more supple sound than the famous "Hey Jude" piano at the old Trident Studios, which had been used to record the tracks on the group's first three albums.

The song is one of the shortest in the Queen repertoire, though it does manage to leave room for a bright, skipping piano intro, and a majestic guitar solo from 0:52. How is it possible to incorporate so many elements, with such precision, into a piece lasting only sixty-seven seconds? Therein lies the magic and the genius behind so many of Queen's tracks. From the first seconds, the strange effect that covers Mercury's voice grabs the listener by the ears; it sounds almost as if a megaphone was used in the recording of the vocals. The producer of this track, along with so many others, was Roy Thomas Baker, who revealed that the effect on Freddie's voice was created by having Freddie sing in one studio, and then broadcasting his voice on a pair of headphones, which were then placed in a big jam tin that also contained a static microphone with a wide sound pickup spectrum. This DIY improvisation gives Freddie Mercury's voice its "lo-fi" sonority, as though it is passing through an old telephone, with a sound that is devoid of all its bass frequencies.

QUEEN: ALL THE SONGS 125

I'M IN LOVE WITH MY CAR

Roger Taylor / 3:05

Musicians
Roger Taylor: lead vocals, backing vocals, drums
Freddie Mercury: backing vocals, piano
Brian May: electric guitar, backing vocals
John Deacon: bass

Recorded
Rockfield Studios, Monmouth, Wales: August–September 1975
Scorpio, Lansdowne, and Roundhouse Studios, London: mid-September–October 1975

Technical Team
Producers: Queen, Roy Thomas Baker
Sound Engineer: Mike Stone
Assistant Sound Engineer: Dennis Weinreich (Scorpio)

ON YOUR HEADPHONES
Although the song is dedicated to Johnathan Harris and his Triumph TR4, it is Roger Taylor's car, an Aston Martin Spider, that we hear at the end of the track, beginning at 2:36.

A classic Triumph owned by Johnathan Harris, Queen's concert sound engineer.

Genesis

Like his idol John Bonham of Led Zeppelin, Roger Taylor is a big fan of cars with big engines. In 1974, he did not own models as prestigious as those of his favorite drummer, like the Ford 1954 or the AC Cobra, but he still worshipped at the altar of beautiful cars. When listening to the demo of "I'm in Love with My Car," in which Taylor sings of his love for his super-powered car, Brian May, after a moment's reflection asked his friend: "Are you joking?"[31] It must be said that the lyrics are full of double entendres and metaphors: *"When I'm holding your wheel / All I hear is your gear / When my hand's on your grease gun / Oh, it's like a disease, son."* The drummer shared his passion for cars with Johnathan Harris, who served as a sound engineer for the band while they were on tour, and who lived only for his Triumph TR4. (Brian May questioned the make of Harris's beloved car in his book *Queen in 3-D*, writing that he thought Harris had a TR5, though he couldn't say for sure.) Roger Taylor even dedicated the track to Harris, writing: *"Dedicated to Johnathan Harris, boy racer to the end."* Taylor later remembered the relationship that the sound technician had with his high-powered car: "The guy who used to mix our sound, our front sound, a very dedicated lifelong roadie [...] was a guy called John Harris. He didn't have a girlfriend, he didn't like to eat much, he wasn't interested in stamps or drinking, or any of the normal interests of life, but he would wash his car a lot, and he was interested [in] and a fan of his car."[32] He added: "I like cars myself, and I can relate to that. I find my cars a lot more interesting than my girlfriend most days."[32]

Chris Taylor, known as "Crystal," was Roger's personal technician and longtime friend, and recalled that the drummer had always been really unlucky with his various performance vehicles: "His Ferrari burst into flames on his way to the south of France, and his Aston Martin also burst into flames."[33]

When the time came for selecting the B-side of the "Bohemian Rhapsody" single, Roger Taylor, who wanted his song to be chosen at all costs, locked himself in a closet at Sarm East Studios and refused to come out until the other three granted him his wish. The group finally agreed, and the single went on to sell over a million copies, earning Taylor as much money as "Bohemian Rhapsody" did for

Brian, Freddie, and Roger in April 1975, during the group's Japanese tour.

Mercury. Roger quickly became staggeringly wealthy, but he also became the subject of a new, thorny issue for the band: royalty sharing.

Production

Taylor's voice, as was customary for Queen, is treated to a slight delay on this track, which was also used onstage, making the song a much-awaited centerpiece for fans in attendance at Queen's concerts. The powerful backing vocals on this cut support Taylor's rugged voice along with the song's numerous drum rolls. The song takes on a grittier undertone, beginning with the bridge passage at 1:18, which features a short and powerful guitar riff, syncopated rhythm, and Taylor's cavernous voice, all of which work together to create a real rock 'n' roll moment for the listener. At this point, even the novice listener will have noticed that we are back in the world of Roger Taylor, where oil and grease hold sway, sometimes literally.

FOR QUEEN ADDICTS

In 1978, the group also dedicated *Jazz* to Johnathan Harris, who had been their live sound engineer since the early Smile period. At the time, Harris had to quit his role due to illness, though he eventually rejoined the group in 1979 for the *Jazz* European tour and the "Crazy Tour," which traveled through smaller venues in Great Britain.

SINGLE

YOU'RE MY BEST FRIEND
John Deacon / 2:50

Musicians
Freddie Mercury: lead vocals, backing vocals
Brian May: electric guitar, backing vocals
John Deacon: bass, electric piano
Roger Taylor: drums, backing vocals

Recorded
Rockfield Studios, Monmouth, Wales: August–September 1975
Sarm East Studios, London: mid-November 1975

Technical Team
Producers: Queen, Roy Thomas Baker
Sound Engineer: Mike Stone
Assistant Sound Engineers: Gary Langan (Sarm), Gary Lyons (Sarm)

Single
Side A: You're My Best Friend / 2:50
Side B: '39 / 3:30
UK Release on EMI: May 18, 1976 (ref. EMI 2494)
US Release on Elektra: May 18, 1976 (ref. E-45318)
Best UK Chart Ranking: 1
Best US Chart Ranking: 9

The sleeve of the Dutch 45 rpm of "You're My Best Friend."

Genesis

The first piece John Deacon composed for Queen was "Misfire," which appeared on the *Sheer Heart Attack* album. On this latest album there was once more a place reserved for a new Deacon track. The song, dedicated to Veronica Tetzlaff, whom Deacon married on January 18, 1975, gives pride of place to their stable and reassuring relationship: *"In rain or shine / You've stood by me girl / I'm happy at home."* This last phrase caused Taylor to rail against what he considered to be the maudlin concepts of hearth and home, reminding his colleagues that they were a rock group and not a knitting circle! But it was exactly this aspect of the song that the public responded to when it was released as the album's second single on May 18, 1976. With its accessible themes, "You're My Best Friend" has gone on to remain one of Queen's biggest successes, even though its reputation has never quite matched that of "Bohemian Rhapsody," which had come out seven months earlier.

"'39," by Brian May, was the track chosen to appear on the single's B-side. This decision was not by chance. Freddie and Roger had made a fortune with the massive sales of the 45 rpm "Bohemian Rhapsody" / "I'm in Love with My Car," so the next two-track single was offered to the other two musicians in an attempt to alleviate some of the tension simmering within the group regarding the sharing of royalties and the even splitting of money among the quartet.

The song's video was filmed in April 1976 while the group was simultaneously beginning their first rehearsal sessions for their fifth album, which took place at the Ridge Farm Studios. Despite the stifling heat of the spring of 1976, the location was propitious for the group's creativity. The musicians selected a ballroom as the location for their video shoot and, with little regard for health and safety, they set up a large number of candles to create a romantic atmosphere. In the video, the keyboard part of the song, which had originally been played in the studio on a Wurlitzer EP200, was simulated by John using Mercury's grand piano. This minor detail would have to be dealt with at a later date, if at all. All that mattered was the visibility of the artists, which would help ensure the promotion of the song. "You're My Best Friend" is still one of Queen's most frequently played songs on American radio stations.

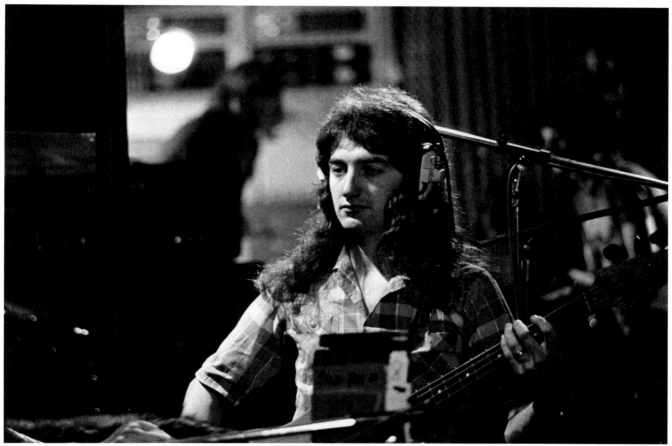
John Deacon photographed in the recording studio by Peter Hince in 1975. The group's technical manager often had a camera around his neck, and photography was his second passion.

Production

Deacon wanted Freddie to play the very short keyboard part that runs right through the song, but the singer, who hated electric pianos, refused, and left it to the bassist to do this. Unlike mechanical pianos, this family of electronic instruments needs to be plugged into the mains and amplified, as they have no soundboard. For this occasion John used a Wurlitzer EP200, which became the signature instrument of the piece (and not a Hohner Pianet T, or Fender Rhodes, as is sometimes stated), providing a warm sound and sonority that had already proved its worth when the instrument was used on hits such as "I Heard It Through the Grapevine" by Marvin Gaye, or "The Logical Song" and "Goodbye Stranger" by Supertramp. Onstage, Mercury played the grand piano when the group performed the song, which gave it a cooler sound, but also made it much more of a straightforward rock song.

The vocal tracks on this song are all doubled and harmonized in the refrains, particularly on "*Oooh, you make me live.*" As always, each member of the group played to their strengths: Roger took care of the high notes, Brian the lower notes, and Freddie placed himself in the midrange, thereby creating that unmistakable Queen sound.

As a little nod to the number that made the four musicians world superstars: The end of "You're My Best Friend" is identical to that of "Killer Queen," which ended with a fade-out at 2:42, during which the same guitar chord is repeated nine times. On this new hit written by Deacon, the same finale appears at 2:38, but with only four repetitions.

'39

Brian May / 3:30

Musicians
Brian May: lead vocals, backing vocals, acoustic and electric guitars
Freddie Mercury: backing vocals
John Deacon: double bass
Roger Taylor: bass drum, tambourine, backing vocals

Recorded
Rockfield Studios, Monmouth, Wales: August–September 1975
Sarm East Studios, London: September–November 1975

Technical Team
Producers: Queen, Roy Thomas Baker
Sound Engineer: Mike Stone
Assistant Sound Engineers: Gary Langan (Sarm), Gary Lyons (Sarm)

In 2007, Brian May finally finished his PhD thesis, which he titled *A Survey of Radial Velocities in the Zodiacal Dust Cloud*. Thirty years after first beginning his research, which had been put to the side as Queen began to achieve fame and notoriety, Brian May finally obtained his doctorate.

FOR QUEEN ADDICTS
Coincidence or not, "'39" is the thirty-ninth song to appear on a Queen album.

Genesis

"'39" was Brian May's first song for *A Night at the Opera*. Like "The Prophet's Song," this is a very personal number. The guitarist, a future astrophysics PhD, makes his passion for astronomy the theme of his composition. His song came to him in a dream, and in the small hours of the morning he awoke and started writing the lyrics. The words narrate the adventure of a team of astronauts who set out in the year '39 (the century is unspecified) to discover a new world. The first couplet tells of the courage of the volunteers, the second relates their return to Earth one hundred years later, whereas only one year had gone by on the spacecraft. Brian May used the song as a chance to explore Einstein's special theory of relativity, and particularly his ideas surrounding the concept of time dilation. More precisely, May was inspired by the paradox of Langevin's twins, where one twin travels at the speed of light and experiences the passage of time more slowly than their sibling, who had remained on earth.

Six years after the international success of David Bowie's *Space Oddity*, May picked up on the themes of space travel explored in that album while also nodding to the work of film director Stanley Kubrick and his 1968 masterpiece, *2001: A Space Odyssey*. The bravery and isolation of the hero, and the distress felt by an intrepid explorer who has lost his points of reference and all those closest to him are both major drivers of the works of Kubrick and Bowie, and they were similarly inspiring for Brian May. *"Don't you hear my call / Though you're many years away / Don't you hear me calling you,"* sings the hero of May's song, who seems just as alone and isolated as Bowie's Major Tom and his *"Here am I floating round my tin can / Far above the moon / Planet Earth is blue / And there's nothing I can do."*

The parallels between the life of solitude led by an astronaut and the relative solitude experienced by a musician on the road is implicit, and this feeling of loneliness and longing for home was a constant theme in songs written by Brian May, particularly in "Long Away," "Sleeping on the Sidewalk," or "Leaving Home Ain't Easy."

The guitarist, who has expressed a great affection for "'39," does admit to a certain amount of frustration regarding the song's legacy: "Obviously you have certain of your own babies if you write the song and you want them to be heard

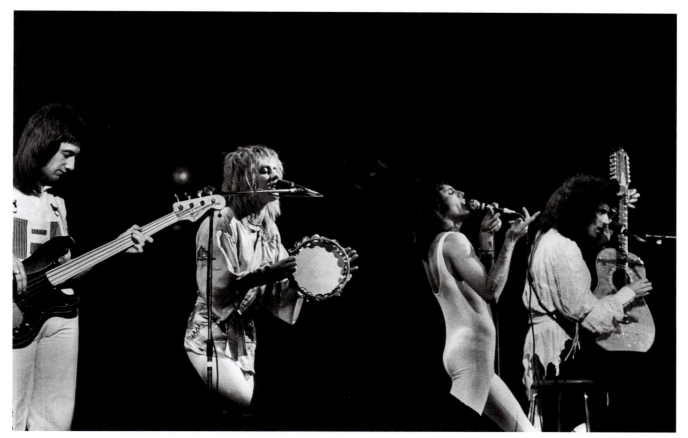

Queen performs "'39" live onstage at Chicago Stadium on January 28, 1977. John Deacon is shown using his Fender Precision Fretless, which produces a sound similar to that of a double bass.

in a wide area. And if you miss that opportunity, it's kind of gone forever. [...] In my case, these things are 'Long Away' and '39' of this album, which could have been a single. [...] If the song doesn't become a single, it doesn't have the opportunity to become part of life [of the people]."[31] "'39" was, however, to remain one of the songs most appreciated by diehard the fans. Among this group of fans was a certain George Michael, who confided that he had regularly listened to "'39" during his younger days in New York. George Michael would go on to deliver an unforgettable performance of the song at the "Freddie Mercury Tribute Concert," which was held at Wembley Stadium on April 20, 1992.

Production

As usual when one of the members of the group was in the midst of creating new work, no artistic boundaries were set in advance. What Brian May offers on this track is a folk ballad that has all the marks of American country music: double bass drum on the beat and tambourine on the offbeats and harmonized backing vocals on the refrains. "'39," which sounded like it could be off a Crosby, Stills & Nash album, was acoustic folk,"[34] as the journalist Howard Gensler put it. Roger Taylor calls "'39" "science-fiction space-folk."[31] John Deacon, who had never played the double bass in a studio context, had to put up with a number of jokes, particularly from Brian May, who found the situation amusing and set Deacon the challenge of recording his part without playing any out-of-tune notes. John won the bet hands down, impressing everyone in the studio with his performance only a few days after the guitarist proposed the bet. Brian May performs the main vocals on the song, supported by the traditional, perfectly coordinated backing voices of Taylor and Mercury.

Rarely used until then, the main instrument in "'39" was May's Ovation Pacemaker 1615 twelve-string guitar. During the recording process, May made use of a little musician's trick for achieving a better attack: he inverted the position of certain strings on his guitar. This small scordatura adjustment facilitated May's playing and gives his guitar a brighter sound and an impressive amount of projection, which can be heard right from the song's opening notes.

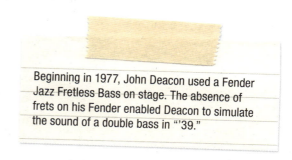

Beginning in 1977, John Deacon used a Fender Jazz Fretless Bass on stage. The absence of frets on his Fender enabled Deacon to simulate the sound of a double bass in "'39."

SWEET LADY
Brian May / 4:02

Musicians
- Freddie Mercury: lead vocals, backing vocals
- Brian May: electric guitar, backing vocals
- John Deacon: bass
- Roger Taylor: drums, backing vocals

Recorded
- Rockfield Studios, Monmouth, Wales: August–September 1975
- Sarm East Studios, London: September–November 1975

Technical Team
- Producers: Queen, Roy Thomas Baker
- Sound Engineer: Mike Stone
- Assistant Sound Engineers: Gary Langan (Sarm), Gary Lyons (Sarm)

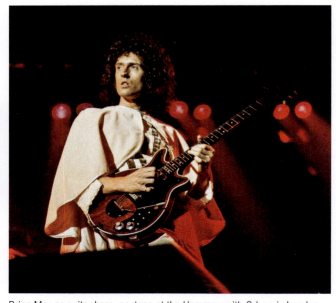

Brian May as guitar hero, onstage at the Hammersmith Odeon in London on November 29, 1975.

Genesis

Moving away from the heavy numbers featured on the group's first three albums, certain Queen compositions now flirted with new musical styles. This was the case with the very pop-centric "You're My Best Friend" by Deacon, or Mercury's forays into jazz, including "Lazing on a Sunday Afternoon" and "Seaside Rendezvous." At the time, Brian May started to wonder about the current state of the group's identity, which had been forged as a rock-band. Determined to bring out their more rock-oriented facets, he wrote "Sweet Lady," with strong guitar chops, a very effective introduction, and powerful riff on the refrains. The celebrated American musician Roger Manning Jr., who worked for many years alongside the Grammy winning recording artist, Beck, made note of his love for this number: "'Sweet Lady,' good Lord, that's like progressive hard rock [...]. It's musicianly, but you still want to bang your head."[11] The speed of execution on the number and its overall energy made it a perfect ambassador for heavy metal *made in Britain*! Even Queen's compatriots, Judas Priest, couldn't outdo them—though not for lack of trying—when they released their formidable track "Exciter" in 1978!

Production

The song is characterized by its three-time structure, a very rare time signature for a hard rock track (as this is the musical style here—hard rock is not really so different from heavy metal, even though specialists sometimes argue this point quite strongly). Brian May deliberately opted to give this song a waltz rhythm—a choice also made by Taylor on "I'm in Love with My Car"—explaining that a dedicated heavy metal follower would not be used to this time signature, and that it would therefore create a sense of unease in the listener that sits very well with the piece. The guitarist wanted his number to be heavy, the diametric opposite of "You're My Best Friend." The part guitar solo is particularly strong, with its accelerating percussion rhythm and racing guitar. On stage, May's improvisations broke out from the confines of his construct with his nine Vox AC30 amps, and gave the audience new moments of excitement worthy of the big concerts of Iron Maiden, a benchmark British hard rock group founded in 1975...the year in which *A Night at the Opera* was released.

SEASIDE RENDEZVOUS

Freddie Mercury / 2:14

Musicians
Freddie Mercury: lead vocals, backing vocals, piano, tack piano
John Deacon: bass
Roger Taylor: drums, triangle, sound effects

Recorded
Rockfield Studios, Monmouth, Wales: August–September 1975
Sarm East Studios, London: September–November 1975

Technical Team
Producers: Queen, Roy Thomas Baker
Sound Engineer: Mike Stone
Assistant Sound Engineers: Gary Langan (Sarm), Gary Lyons (Sarm)

On September 4 and 5, 2009, members of the English band Muse gave two free concerts in their hometown, Teignmouth, to celebrate their ten years of playing together. Forty thousand fans congregated on the sea front to see the return of their local sons. This event, which was a big success, was called A Seaside Rendezvous in homage to the Queen song.

Genesis

As a great admirer of 1920s jazz, Freddie Mercury liked to pay homage to the English songwriting style that extolled the virtues of seaside recreational pastimes. The song's title references classics of the music hall such as "You Can Do a Lot of Things at the Seaside" by Stanley Kirkby, whose lyrics describe the lightness that reigned in the golden years of the Roaring Twenties: *"Have you ever noticed when you're by the sea / The things that you can do there with impunity?"* The same sense of insouciance is featured heavily in "Seaside Rendezvous," where the narrator praises the delights of the Mediterranean, here and there slipping in some words of French: "C'est la vie Mesdames et Messieurs." The artists of the 1970s and 1980s very often referenced this black-and-white world, with a nostalgia for the interwar period of their parents' youth.

Production

The piano played by Freddie Mercury—a Yamaha C-7, with its brighter sound, that replaced the usual "white Bechstein"—is from time to time supported by a tack piano, which we hear fairly frequently on other songs by the group. From the first notes (especially at 0:03 and 1:02), we hear some of the notes played on the Bechstein doubled by the tack piano, whose hammer felts have drawing pins inserted into them, giving its interventions a brighter sound. From 0:52, a fanfare fills the studio. Roger Taylor and Freddie Mercury simulate all the instruments by vocal means, dividing up the tasks between them: the kazoo solo is performed by the drummer (at 0:52), and the brass (trumpets, trombones, and tuba, at 0:59). As well as the various bells used by Roger, particular praise must go to the magnificent tap-dancing interlude, which he performed by placing thimbles on his fingers and tapping on the studio mixing desk. Freddie was amused by Taylor's involvement in this newfangled recording device: "I'm going to make him tap dance too; I'll have to buy him some Ginger Rogers tap shoes."[5]

In addition to "playing" the thimbles on this track, there was another very un-rock 'n roll instrument used on this song: the swannee (slide) whistle, whose short appearance at 1:18 emphasizes the real sense of fun that must have pervaded the studio that summer of 1975.

THE PROPHET'S SONG
Brian May / 8:20

Musicians
Freddie Mercury: lead vocals, backing vocals
Brian May: acoustic and electric guitars, toy koto, backing vocals
John Deacon: bass
Roger Taylor: drums, backing vocals

Recorded
Rockfield Studios, Monmouth, Wales: August–September 1975
Sarm East Studios, London: mid-September–November 1975

Technical Team
Producers: Queen, Roy Thomas Baker
Sound Engineer: Mike Stone
Assistant Sound Engineers: Gary Langan (Sarm), Gary Lyons (Sarm)

A sharp listener may notice in Freddie Mercury's vocal line a certain similarity between "The Prophet's Song" at 6:50 and "Flash's Theme" at 1:55. This theme is the only single from the original *Flash Gordon* soundtrack, released by the group in 1980 and titled simply, "Flash."

FOR QUEEN ADDICTS
The working title of "The Prophet's Song" was "People of the Earth."

Genesis
Often considered to be Brian May's "Bohemian Rhapsody," "The Prophet's Song," was at one point considered for the first single for the album but was eventually eclipsed by Mercury's masterpiece. It is, however, an anthology number on which the guitarist worked solidly for two weeks, locking himself away at Sarm East Studios while the other three musicians laid down the material for a number of other tracks at the Rockfield Studios in Monmouth.

As with "'39," Brian May was inspired by a dream in which the world was coming to an end, annihilated by the disintegration of human relationships: "In the dream, people were walking on the streets trying to touch each other's hand, desperate to try. […] I felt that the trouble must be—and this is one of my obsessions, anyway—that people don't make enough contact with each other. […] I worry about it a lot. I worry about not doing anything about it. Things seem to be getting worse."[35] According to a famous anecdote, the song was still in the middle of being mixed when Kenny Everett, a friend of the group and a disc jockey on Capital Radio, "borrowed" a premix of "The Prophet's Song" from Baker and broadcast some extracts as an exclusive on his program. Brian, who had been recording night and day and had just dozed off, exhausted, in the small hours, was thus awoken by his own song, which was playing on the radio.

The song, which clocks in with a final playing time of 8:20, is one of the high points on the album. It was played for the first time in concert at the Liverpool Empire on November 15, 1975, and was particularly appreciated for Freddie Mercury's vocal improvisations.

Production
This number is distinguished in its structure, which is subdivided into various segments that are quite different from each other, much like "Bohemian Rhapsody." It thus reflects the progressive song writing style of the *Queen II* album, where many longer pieces were developed, including "Ogre Battle" and "The March of the Black Queen."

From the introduction, the country of Japan was a major focus. The four musicians, who, in a short space of time had attained the status of demigods in the Land of the Rising Sun, thereafter continued to pay homage to a country that had welcomed them with open arms, while the British press had

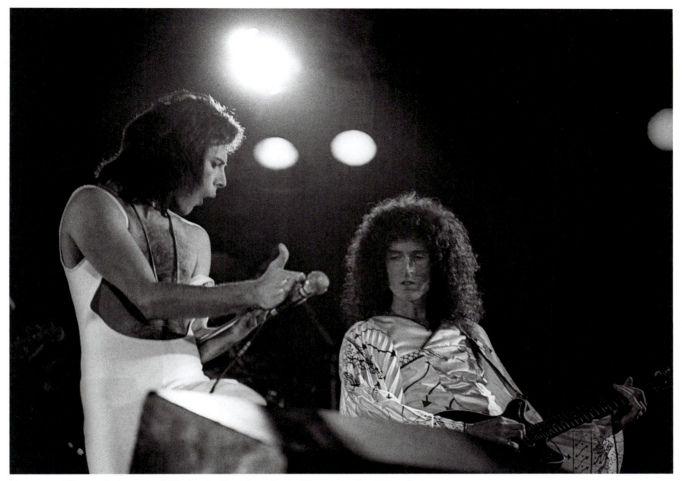

Mercury and May created an unbeatable duo, but Freddie performed the a cappella passage from "The Prophet's Song" alone onstage during the *A Night at the Opera* tour.

turned their backs on them. Brian May first worked out some chords on his new Tokai Hummingbird F120 acoustic guitar. In 000 ("triple zero") format, inspired by the Martin 000-45 model, this guitar lacks the bass sonorities produced by its dreadnought-class (D-size) big sister. May purchased it during the group's first tour of Japan in April 1975.

The six-string guitar is accompanied by a toy koto, which was a present from a Japanese fan, and which gives the song an extra layer of authentic color. This small, plucked stringed instrument was only sixteen inches long and looked more like a toy (hence its name in English) than a real koto, which is about eight feet long. Based on sheet music written for this newly-discovered instrument, Brian set himself a large number of objectives for this album. Extending his personal challenge to playing instruments he did not know, he even recorded some harp parts on "Love of My Life." But apart from some Japanese-inspired experimentations on the toy koto that were much appreciated by fans, "The Prophet's Song" is marked by an extended vocal break that lasts for two minutes and twenty-eight seconds, during which Mercury is on his own, freely improvising with vocal harmonies. The procedure used to create this effect is identical to that of Brian May's solo onstage in the middle of "Brighton Rock" (see page 90). The singer's voice is recorded on a delay, which is then repeated at a frequency chosen by Baker. Freddie then just had to sing over the first track recorded, harmonizing each line directly. Using this technique, Freddie was able to improvise all kinds of overdubs, which he did up until the 5:50 mark, at which point the instruments come back in, newly supported by a very heavy guitar. To give his Red Special such a heavy sound on the song's riff, Brian May tuned it in quite a special way. The lowest string, normally tuned to *E*, was taken down a tone to a *D*. A guitar tuned in this way is said to be in "drop *D*" tuning, which gives it a darker sonority. May again used this tuning on the number "Fat Bottomed Girls," on the *Jazz* album, in 1978.

Brian May has always been fond of musical instruments forged in the Far East, and in 2014 he acquired a Korean gayageum, which is thought of as the big brother of the toy koto.

QUEEN: ALL THE SONGS 135

LOVE OF MY LIFE
Freddie Mercury / 3:34

Musicians
Freddie Mercury: lead vocals, backing vocals, piano
Brian May: acoustic and electric guitar, harp, backing vocals
John Deacon: bass
Roger Taylor: cymbals

Recorded
Rockfield Studios, Monmouth, Wales: August–September 1975
Sarm East Studios, London: mid-September–November 1975

Technical Team
Producers: Queen, Roy Thomas Baker
Sound Engineer: Mike Stone
Assistant Sound Engineers: Gary Langan (Sarm), Gary Lyons (Sarm)

> Although it is now among the most popular Queen songs, "Love of My Life" was oddly never part of the sets for the concert tours that followed *A Night at the Opera* and *A Day at the Races*. Adapted for acoustic guitar, it was played for the first time in Portland, Oregon, on November 11, 1977, at the launch of the *News of the World* tour.

> Brian May took on the task of transforming Freddie's voice and piano into an acoustic ballad more suited to concerts. In his book *Queen in 3-D*, published in 2017, May said this work on the arrangements influenced him for a recent collaboration with the singer Kerry Ellis.

1975

Genesis
Played on the piano by Freddie Mercury and accompanied on the harp by Brian May, "Love of My Life" is a delicate ballad that, as legend has it, the author wrote for the love of his life: Mary Austin. But according to John Reid, who was the group's manager at that time, the chronology indicates that the song had a quite different origin: "Freddie actually wrote 'Love Of My Life' for David Minns. Freddie told me that. 'Love Of My Life' was for Minns."[18] When Queen was recording *A Night at the Opera*, the relationship between the singer and his love was indeed coming to an end. The attractive sales assistant at Biba had reconciled herself to the simple fact that her partner liked men. At the time, Freddie was seeing David Minns, who worked as the manager of the singer Eddie Howell, and with whom he had fallen deeply in love. Regardless of who served as the inspiration for Mercury to write this marvelous song, it is widely agreed that Mary Austin was one of the great loves of Freddie's life. The pair always remained close, and Mary inherited all of his property when he died.

Although this song did not meet with the same degree of success as some of the band's bigger hits, Roger Taylor described the enthusiasm it generated in some of their concerts: "There are certain songs which are more popular in different countries, and we did used to vary the songs that we played. For instance, in South America, there was a song that was a major hit, called 'Love of my Life,' which was never a hit anywhere else. So we'd always include that, and that became a major part of the show there."[36] The piece became a hymn, sung as a chorus by the audience, with Mercury often breaking off from singing halfway through the song. The version of the song that appears on the *Live Killers* album in 1979 speaks volumes: The singer and the guitarist, accompanied by his twelve-string, interpret the song and extend it with a majestic rendition of "'39," at which point Roger Taylor and John Deacon return to the stage, respectively carrying a bass drum and tambourine, and a bass.

Production
Once the piano tracks had been done at Rockfield Studios, Freddie Mercury's voice was recorded at Sarm East Studios on Osborne Street, south of Brick Lane, in London. But the

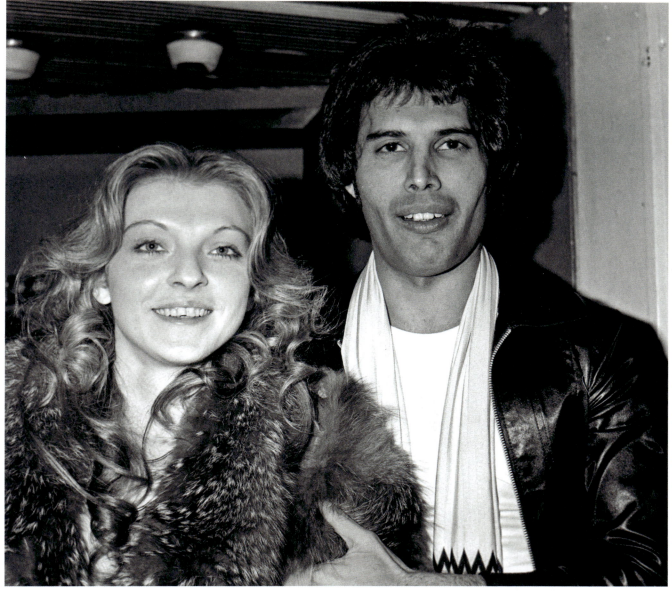
Freddie and Mary Austin, who inspired the song "Love of My Life." Austin would remain by Freddie's side until his death.

most delicate part of the production was the recording of the harp, played by Brian May. The guitarist, who had never tackled this instrument, recalls the constraints he had to deal with: "We spent ages tuning in, and then every time somebody opened the door and the cold air came in, it needed tuning all over again. The same happened when I moved one of the pedals. How people fine-adjust these things for concerts I can't imagine."[29]

Finally, May recorded each of the introduction's chord arpeggios separately, retuning the instrument between each take. Despite all of the difficulties encountered in the studio, the final track turned out beautifully. The idea for including the harp was something Freddie wasn't going to give up on easily, having decided he was definitely going to see his idea through in one way or another. As he stated in *New Musical Express*: "There's a lovely little ballad, my classical influence into it. Brian is going to attempt to use a harp, a real life-size harp. I'm going to force him to play till his fingers drop off."[37] May added some chords, supporting the melody played on the piano, using his twelve-string Ovation Pacemaker 1615 guitar, already used on "'39."

For Queen Addicts

In 1979, after a resounding tour success, the version of "Love of My Life" from the *Live Killers* album appeared as a single. On the sleeve of the single the song was called "Love of My Live" (with a *v*) on the sleeve, although its original name did appear on the disc label.

GOOD COMPANY
Brian May / 3:23

Musicians
Brian May: lead vocals, backing vocals, electric guitar, ukulele
John Deacon: bass
Roger Taylor: drums

Recorded
Rockfield Studios, Monmouth, Wales: August–September 1975
Sarm East Studios, London: September–November 1975

Technical Team
Producers: Queen, Roy Thomas Baker
Sound Engineer: Mike Stone
Assistant Sound Engineers: Gary Langan (Sarm), Gary Lyons (Sarm)

Genesis

As a child, Brian May never missed his favorite show, *Uncle Mac's Children's Favourites*, which was broadcast on BBC radio on Saturday mornings. The program played all kinds of music and contributed significantly to the guitarist's musical education (see page 108), helping form his interest in jazz, swing, and particularly big band music, which featured orchestras that consisted of large numbers of wind instruments. The most famous exponents of this genre were Glenn Miller and his orchestra, as well as the well-known vibraphonist, Lionel Hampton, and his group. When he grew up and widened the scope of his musical education, May's preference moved to a more retro kind of jazz, which took him back to the interwar period and the youth of his parents, Harold and Ruth. Much to May's delight, a big band known as the Temperance Seven had a major success in 1960s England, using old jazz tunes from the Roaring Twenties. In 1961, the band released a song called "You're Driving Me Crazy," and it reached the top of the British charts. The producer of this disc was none other than George Martin, the future producer of the Beatles. The Temperance Seven had a tongue-in-cheek sense of humor that the public appreciated and the group consisted of a tuba, a trombone, a trumpet, a percussionist, two saxophonists, and a pianist. The young Brian May became a real fan of the Temperance Seven, and he began to study the structure of their songs, and the role of each instrument and its importance in the orchestra. The instrument that gave the big band its Dixieland "New Orleans" color was undoubtedly the banjo, which May was fond of. In fact his father played the banjolele, a cross between a small ukulele and a banjo, popularized by the actor and singer George Formby, and which the guitarist used for the first time on the recording of "Bring Back That Leroy Brown," on *Sheer Heart Attack*.

In 1975, when the group shut itself away in the studio to record *A Night at the Opera*, the guitarist proposed a song that would secure his reputation once and for all as a master technician. The title is an homage to the Temperance Seven, and Brian May was determined to see his crazy idea through to its conclusion: re-creating a big band sound using his Red Special guitar as the only instrument. May also worked on the lyrics to include a play on verses that

The Temperance Seven and their whimsical swing sound influenced Brian May in his own experimentation with big band music. Their impact is especially present in the song "Good Company."

did not necessary rhyme; this was done in homage to his childhood hero George Formby, who took a wicked pleasure in stepping out of the rhyme to give his songs a lighter touch. As in the second couplet: *"Soon I grew and happy too / My very good friends and me / We'd play all day with Sally J. / The girl from number four."* As in a number of the songs he wrote for the group, May emphasizes the ravages of success (in this case that of a tradesman) on family life. The virtuoso later declared that the star system of the music industry was a machine that crushed people and destroyed families.

Production
As with the recording of "The Prophet's Song," Brian locked himself away on his own at Sarm East Studios in order to work on his masterpiece. Not content with providing the vocals and ukulele, he had also decided to reproduce the sounds of a big band using his unique Red Special guitar in the solo, which can be heard between 2:39 and 3:10. All the instruments of a big band are present: trumpets, trombones, clarinets, and so on…This task, which involved the musician painstakingly recording each and every note, was a colossal undertaking. "I spent days and days doing those trumpet and trombone things and trying to get into the character of those instruments. The others were doing other things and they'd pop in front from time to time and say 'Well, you haven't done much since we last saw you…'"[38] May used a wah-wah pedal to quickly modify the tonality of each of the instruments. He connected a small Deacy Amp 1-watt amplifier designed by John Deacon, which fit perfectly with his Red Special.

He was particularly inspired by the piece "Pasadena," recorded by the Temperance Seven in 1961 and his final recording included crash cymbal chokes at 0:03, a bass simulating the sound of a tuba at 0:21, and a muted trumpet sound reproduced on the wah-wah at 0:48. This phalanx of production trickery represented May at the height of his technical powers.

BOHEMIAN RHAPSODY
Freddie Mercury / 5:55

Musicians
Freddie Mercury: lead vocals, piano
Brian May: electric guitar, chant
John Deacon: bass
Roger Taylor: drums, timpani, gong, vocals

Recorded
Rockfield Studios, Monmouth, Wales: August 18, 1975
Scorpio Sound Studios, London: September 1975
Sarm East Studios, London: September 1975 (final mix)

Technical Team
Producers: Queen, Roy Thomas Baker
Sound Engineer: Mike Stone
Assistant Sound Engineers: Gary Langan (Sarm), Gary Lyons (Sarm)

Single
Side A: Bohemian Rhapsody / 5:55
Side B: I'm in Love with My Car / 3:12
UK Release on EMI: October 31, 1975 (ref. EMI 2375)
US Release on Elektra: December 2, 1975 (ref. E-45297)
Best UK Chart Ranking: 1
Best US Chart Ranking: 9

FOR QUEEN ADDICTS

When "Bo Rhap" took first place in the British charts on November 29, 1975, it stole the crown from another popular hit: "You Sexy Thing." One evening, when Queen came to see Hot Chocolate in concert, the band's singer, Errol Brown, chided Freddie and his friends with a friendly: "You bastards! That was my chance of a Christmas number one."[2]

Genesis

In July 1975, the group took itself off to a secluded property in Herefordshire, on the border of Wales, to write their new album. The rural location was conducive to inspiration, and was owned by Joan Murray and her daughter, Tiffany. The latter would go on to became a successful writer, and was inspired by her memories to write the novel *Diamond Star Halo*, which was published in 2010. When she promoted her book, Tiffany cited a number of anecdotes from her summer spent with the band. Freddie used to get up early in the morning, long before the others, and Joan, who made coffee for the musicians, enjoyed seeing the star trying out melodies on the piano. Once, the singer played her mother the first notes of his future masterpiece and asked her what she thought of it. "It's fantastic!"[39] exclaimed his hostess. "It's a bit long,"[39] responded Mercury.

Now considered to be one of the greatest songs in the history of rock, "Bohemian Rhapsody" has no birth certificate that provides an exact date. The song's melodic part has its roots in the time the singer spent as a member of Smile in 1970. Chris Smith was the keyboard player for the group at the time, and he remembered that his colleague "Freddie had lots of bits of songs"[22] that he regularly suggested to his musician friends. One of these melodies was called "The Cowboy Song," and it started with the words: *"Mama, I just killed a man."*

The singer, who had been working on his new composition for a while, had already presented it to the album's producer. Roy Thomas Baker remembers the day when Freddie invited him to his place: "We were going out to dinner one night and I met Freddie at his apartment in Kensington. He sat down at his piano and said, 'I'd like to play you a song that I'm working on at the moment.' He played the first part and said 'This is the chord sequence.' [...] He played a bit further through the song and then stopped suddenly, saying, 'This is the where the opera section comes in!'"[40] The producer was naturally surprised, but having already worked with Decca Records as assistant sound engineer on a number of recordings of the D'Oyly Carte Opera Company, he was not averse to the idea of producing an operatic section for Queen, and he rose to this new challenge.

The singer spent the month of August at Rockfield Studios, where he wrote down all of his ideas in a large

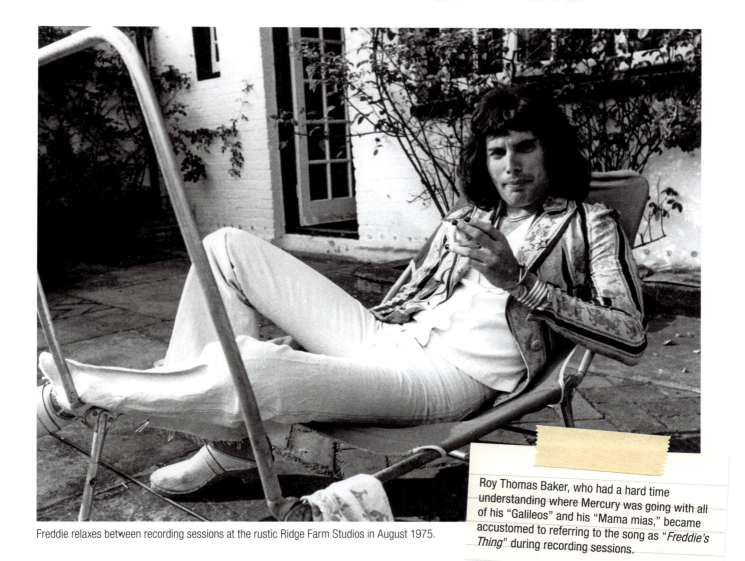

Freddie relaxes between recording sessions at the rustic Ridge Farm Studios in August 1975.

Roy Thomas Baker, who had a hard time understanding where Mercury was going with all of his "Galileos" and his "Mama mias," became accustomed to referring to the song as "*Freddie's Thing*" during recording sessions.

number of accounts books that he had inherited from his father. The song was to be made up of three distinct parts: a ballad section, an operatic section, and one rock section. Freddie Mercury specified in many interviews, including one given in Sydney in 1985, that the process of creating *A Night at the Opera* followed a very proactive period from an artistic point of view: "We just had so much that we wanted to bring out. [...] We had all kinds of songs and 'Bohemian Rhapsody,' [...] it was like three songs. [...] So I just put out the three together."[41] As for the text, it is nothing short of extraordinary. There are many theorists who seek out the deep meanings of "Bo Rhap," but none have been able to fully unravel its mystery. "People should just listen to it, think about it and then decide what it means,"[2] declared the singer.

From the photographer Mick Rock to Roger Taylor, everyone has their own interpretation of this immortal song. One can imagine that its author had a number of ideas at the back of his mind when writing it, but Freddie was known to enjoy linking words and adding them together if they sounded right. For his part, Brian May recalls his own frame of mind, when he was absorbed in the production of one of his songs: "We didn't speak to each other about lyrics. We were just too embarrassed to talk about the words. When we were recording 'Bohemian Rhapsody,' it was a nerve-racking time. We were all very competitive and we knew there was a lot at stake. At the same time, we wouldn't open our hearts to each other, which meant that we all somewhat focused on our own songs. I was working on this song of mine, 'The Prophet's Song.'"[15] A few words from the group's disc jockey friend, Kenny Everett, might offer the best theory as to the song's final meaning: "Freddie told me 'Bohemian Rhapsody' was just random, rhyming nonsense."[42]

Production

It took three weeks of recording to give birth to the song in its final form. The piano, bass, and drums were first recorded at Rockfield Studios in Wales. The guitar and the main vocals were recorded at Sarm East Studios, and the multiple vocal overdubs in the song's operatic section were recorded at Scorpio Studios in London. The three separately recorded sections were then put together during the mixing of the piece at Sarm East Studios. The sound engineer

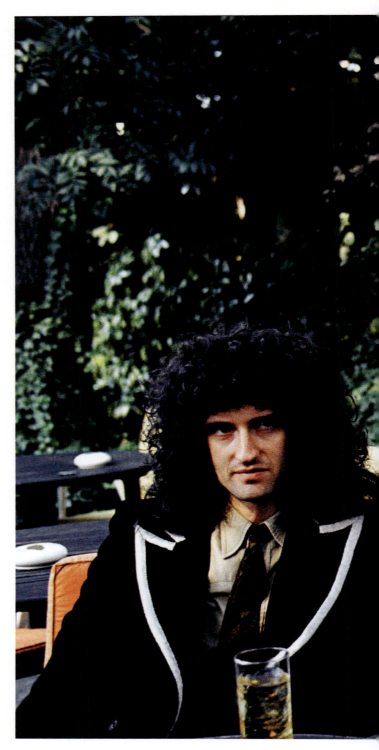

Queen riding high on the worldwide success of "Bohemian Rhapsody" shortly before their big Hyde Park concert in September 1976.

ON YOUR HEADPHONES

At 2:02, the sound of bells ringing can be heard, and this new effect was produced by Brian May using his trusty Red Special. The savvy guitarist used a sixpence piece as a pick, rubbing the strings between the bridge and the tailpiece, as this is the only place on the guitar from which a gentle, high-pitched sound can be emitted.

Gary Langan remembers: "The song arrived in three sections […] and Fred knew what he was doing. With Queen, unlike some bands, the big picture was very much in place. The reason for being in the studio was to complete this picture."[43] Roy Thomas Baker, who was present throughout the process, says that because the three segments of the piece were recorded separately, some space had to be left after each portion so that the next segment could be joined on to it. So, as each section was recorded, thirty seconds of empty air were left at the end so that Freddie could add on the next part. Recording the song in three distinct portions also created a problem with ensuring the regularity of the tempo across each section. Brain May later explained that an audio pace keeper was used to help enable the group to keep the same tempo over all three sections.

When laying down the so-called basic tracks at Rockfield Studios, nothing was left to chance. Deacon's bass was recorded three times: the first recording captured the instrument connected to his "DI" control box (i.e., directly linked to the mixing desk), which also provided a neutral sound. The next two recordings used two microphones that were placed in front of John's Hiwatt amplifier and also in the middle of the room to add, if necessary, some space and air to the mixing.

As with all the tracks on this album, the drums were placed in the middle of a big room, and multiple microphones were configured around them—not in front of each item of the drum kit, as was the traditional practice—apart from the snare drum, which Baker recorded with a proximity mic so as to be able to vary its volume. This is a procedure that producers use to provide a powerful sound full of natural reverb from the whole drum kit. Roger also used a Paiste gong at the end of the piece, which would go on to become a future live signature that the drummer used when playing in concert; this was an effect of his admiration for John Bonham.

Brian May used three Vox AC30 amplifiers for his portions of the song, and he added multiple technical pirouettes to many of his finishing touches. He plays almost invisible harmonics on the second couplet and only appears discreetly throughout the entire beginning of the number, before finally imposing his impressive power chords at the 2:18 mark. The scores he wrote for "Bohemian Rhapsody" will undoubtedly go down in history, from the timeless riff at 4:06 to the final, very gentle section—which is reminiscent

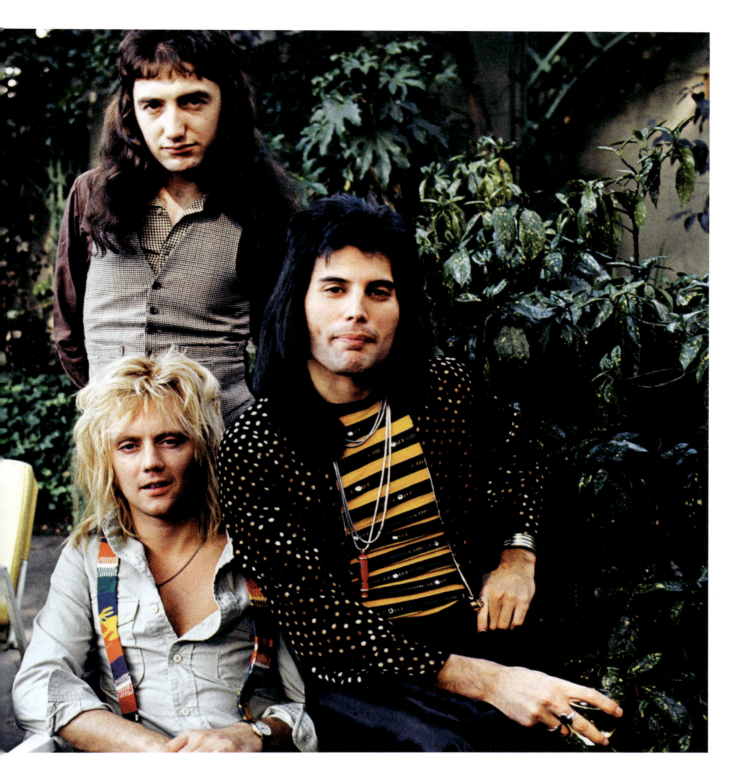

of the melodic pause in "The March of the Black Queen" at 5:40. For the solo, May used offset-, neck-, and center-placed microphones on his guitar, and the sound this produces is the song's not-so-secret weapon.

When recording the operatic part of the song, each member of the band recorded his voice according to his natural predisposition. Roger takes care of the higher notes with his high tessitura, Brian sings the bass notes, and Freddie, whose voice covers a very wide register, sings the mid-range. John Deacon does not sing at all on the track as he was still not very confident of his vocal capabilities. In the final rock section, Freddie Mercury doubles his voice, as he knows so well how to do by this point in the group's career. In this doubling, Freddie borrowed a technique from John Lennon, which consisted of singing the second line slightly out of phase, which adds a little extra life to the song. In total, 180 voice tracks were recorded and stacked up, with the producer once again applying the bouncing procedure

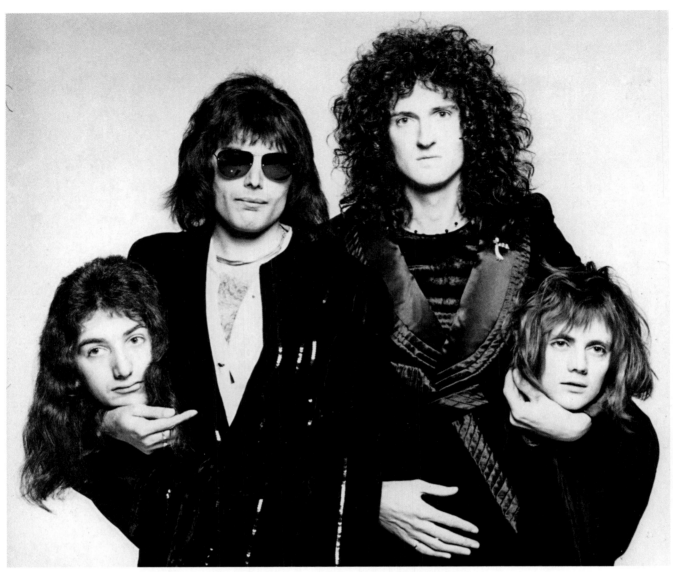

A rare photo by Terry O'Neill. This image was ultimately not chosen for the "Bohemian Rhapsody" single in 1976.

used by the group to tie all of the vocals together. The technique is simple: Once the takes have been checked, they are transferred to a single track, thus freeing up space on the mixing desk and on the tape recorder. In the case of "Bohemian Rhapsody," legend has it that after more than ten bounces, the tape was so worn that it risked disintegrating. Queen was in a hurry to complete the piece before it was too late, and a distintegrated tape would have been a total and irreversible disaster.

Once the three sections had been joined together and the mixing completed, the time had come to hear the masterpiece in its final form. Gary Langan was permanently affected by the experience: "I was standing at the back of the control room the day 'Bohemian Rhapsody' was completed, and I knew I was hearing the greatest piece of music I was ever likely to hear. There are two feelings you get in your body about a new number. One's in your head, [...] the other is in your stomach, when you *know*. That time, it got me right in the pit of my stomach. Queen knew it too."[44]

A Single That Became an International Success

Freddie was convinced that "Bohemian Rhapsody" should be the first single from *A Night at the Opera*. Everyone from John Deacon to the record company wanted to dissuade him from this idea, as the song lacked a catchy refrain, was overly long (5:55) and its format did not lend itself to radio airplay. John Reid, the group's main manager, even had his protégé Elton John listen to the piece. Elton also tried to reason with Freddie, but to no avail. Pete Brown, at that time Queen's number two manager, feared that this would be the end of the group if "Bo Rhap" was chosen as a single. Only Roy Thomas Baker defended the choice to Paul Watts, who was the current international managing director with EMI: He argued that if Richard Harris could succeed with the seven-minute-long "MacArthur Park" in 1968, then why couldn't Queen? When EMI refused to release the song as a single, Freddie managed to get Kenny Everett to purloin the track one day, just as he had done with "The Prophet's Song" while May was still working on it. The day after this "theft," the Capital Radio DJ decided

Freddie wears his winged shoes at the piano while onstage at London's Hammersmith Odeon in 1975.

While "Bohemian Rhapsody" has been frequently reissued, two reissues in particular enabled the song to return to the forefront of the international rock scene: the first followed the death of Freddie Mercury in 1991, and the second was featured on the original soundtrack of the film *Wayne's World*, directed by Penelope Spheeris, in 1992. The movie has gone on to attain cult status, marking the spirit of a new generation hearing this classic track for the first time.

to play "Bohemian Rhapsody" fourteen times, triggering an unprecedented tsunami of enthusiasm from the listeners who flooded the station's switchboard with calls asking when the new Queen single was going to be released. EMI had no choice but to give in, and they released the song on 45 rpm on October 31, 1975, accompanied by the very muscular "I'm in Love with My Car," by Taylor. The song quickly reached ninth place on the British charts before going on to take the first-place spot in the British Top 20. It remained in the rankings for fourteen weeks in total.

The First Music Video in History

Once more, the planets seemed to have aligned for the musicians during the recording of the music video for "Bohemian Rhapsody," though they did face a small technical problem during the video's production. Having been asked to appear once more on the cult British program *Top of the Pops* in November 1975, they were only too aware that it would be impossible for them to exactly reproduce the operatic part of their song live. Furthermore, they hated the idea of lip-syncing again on television, and they were also extremely busy with rehearsals for their next tour. But the group felt they could not turn down this kind of media exposure in the middle of promoting their album. So the group, now in a position of strength with their indisputable success, declared that a video would replace them during the broadcast.

Bruce Gowers, a young director who had already filmed the concert at the London Rainbow Theatre in November 1974, was called upon, with production provided by Lexi Godfrey for Jon Roseman Productions. Gowers went to Elstree Studios, north of London, where Queen had set up to rehearse for their upcoming British tour. It was decided that the video would be divided into two distinct sections. The ballad and the rock parts were played live and in front of a few spectators (some faces are visible in the front row), and the operatic part was made into a short film, which brought to life the famous photo shoot with Mick Rock done for the album cover of *Queen II*. For this occasion, the members of the group once again got out the clothes they wore on the day of the album cover shoot, and they once again resumed their legendary poses.

After just three days of filming and with a budget of £4,500 sterling, Gowers had, without knowing it, created the very first music video, six years before the birth of MTV. A few days later, this mini film was broadcast on *Top of the Pops*, and the song rose to first place on the British charts, initially reaching the top spot on November 29, and staying there for nine consecutive weeks.

Today, "Bohemian Rhapsody" is the third best-selling single ever in the United Kingdom, after "Do They Know It's Christmas?" by the Band Aid collective in 1984, and "Candle in the Wind 1997," recorded by Elton John following the death of Princess Diana.

PORTRAIT

KENNY EVERETT: THE FANTASTICAL DISC JOCKEY

Born Maurice James Christopher Cole on December 25, 1944, Kenny Everett was a British local-radio pioneer. Operating from an unauthorized frequency at the end of the 1960s, Everett was a part of Radio London, whose station was located on a boat that constantly sailed the North Sea. In April 1965, he began his career alongside Dave Cash, with whom he hosted the very popular *Kenny & Cash Show*. In the same year, the duo also recorded some schoolboy prank songs with Decca Records, including the amusing "The 'B' Side" and "Knees."

In 1967, Kenny Everett joined BBC Radio 1. After three years with the station, he was dismissed for having gently mocked Mary Peyton, the wife of the United Kingdom's Minister of Transport. He then went on to join the team at Capital Radio, where his musical knowledge found a very well-deserved niche. He became the disc jockey on a new program for which he was the only person in charge: *The Breakfast Show*, which later became *The Kenny Everett Audio Show*.

It was at the beginning of the 1970s that Everett met Freddie Mercury, and the two had an immediate rapport.

Kenny Everett, the radio disc jockey who broadcast "Bohemian Rhapsody" fourteen times in a day, transformed the previously unknown song into a worldwide pop phenomenon.

From left to right, Freddie Mercury, comedian Billy Connolly, and Kenny Everett at a party given for Mercury's thirty-eighth birthday, on September 5, 1984. The party was held at the Xenon Club in London.

Their love of music brought them together, but also the shared secret of their homosexuality, which led them to begin frequenting the best London nightlife venues together. This was a habit that they would continue to share over the following decade.

By 1975, Kenny Everett's influence over the airwaves made him an integral part of Queen's success. As a long-term fan, the disc jockey obtained a copy of "Bohemian Rhapsody" even before the new album was released. Norman Sheffield, manager of Trident, Queen's record label, claimed in his autobiography *Life on Two Legs* that he was the one who gave the copy to Everett, whereas legend has it that the DJ purloined a copy of the song during a visit to the studio. While the facts may never be agreed upon, there is no denying that Everett played the song fourteen times on the radio station over the course of a single day. This led to a tidal wave of calls to the Capital Radio switchboard, which thus persuaded EMI that the song would in fact make a good single. History has since confirmed the wisdom of this decision, and "Bohemian Rhapsody" has earned its rightful place as one of the greatest songs in rock history, and much of this success is thanks to the efforts of Kenny Everett, who sadly passed away on April 4, 1995, following an AIDS-related illness.

Brian May performing "God Save the Queen" from the roof of Buckingham Palace as part of the golden jubilee celebrations for Queen Elizabeth II, on June 3, 2002. The golden jubilee marked the Queen's fiftieth year as England's reigning monarch.

GOD SAVE THE QUEEN
British national anthem, arranged by Brian May / 1:12

Musicians
Brian May: electric guitar
Roger Taylor: drums, timpani, orchestral cymbals
Recorded
Trident Studios, London: October 27, 1974
Technical Team
Producers: Queen, Roy Thomas Baker
Sound Engineer: Mike Stone
Assistant Sound Engineer: Neil Kernon

At the press presentation of *A Night at the Opera* in November 1975, which took place at Roundhouse Studios in London, Freddie stood up when "God Save the Queen" was played, and addressed the journalists and VIPs present with an imperious: "Stand up you bastards!"[38]

Genesis

In the spring of 1974, following a successful American tour, the group was making progress with writing *Sheer Heart Attack*, and were planning to record their new album over the summer. That autumn, once the album had been recorded, the musicians had the benefit of a short break before starting their next tour, which was to begin on October 30 at the Manchester Palace in Britain. On October 27, a few days before the release of their new album, Brian and Roger went back to Trident Studios with an idea. During the *Queen II* tour, which had started at the Blackpool Winter Gardens on March 1, 1974, the group had noticed that very often before they came onstage, the audience would sing the United Kingdom's national anthem, "God Save the Queen." May decided to give it his own interpretation, with the assistance of his accomplice Roger Taylor. The recording was carefully preserved and was added, a year later, to the final track listing of the *A Night at the Opera* album. This piece was a nod to the royalty that Brian and his friends aspired to, though it was royalty of a different sort; and the song was also a loving homage to their country. "God Save the Queen" became the instrumental music that the band used to come onstage for the next twelve years.

Production

As he had done during the recording of "Procession" on the *Queen II* album, Brian May also put his stamp on his version of "God Save the Queen" by creating a complete harmonization of all the guitar parts performed on the track. In order to confer an appropriately solemn character to the song, Roger Taylor was given orchestral cymbals, with a sound that was not as bright as that of the Paiste, Premier, and Zildjian cymbals that he normally used. He also struck the timpani with drumstick rolls worthy of the greatest classical percussionists. The duo played a vintage version of this anthem on the occasion of Queen Elizabeth II's Golden Jubilee on June 3, 2002. For this event, Roger Taylor was on the timpani in an orchestra partly consisting of young musicians from the Royal Academy of Music, and Brian was posted on the roof of Buckingham Palace, hair blowing in the wind and his Red Special standing at attention.

148 A NIGHT AT THE OPERA

OUTTAKES

KEEP YOURSELF ALIVE LONG LOST RETAKE

Brian May / 3:51

Musicians
Freddie Mercury: lead vocals, backing vocals
Brian May: acoustic and electric guitars, backing vocals
John Deacon: bass
Roger Taylor: drums, tambourine, backing vocals

Recorded
Sarm East Studios, London: June 1975

Technical Team
Sound Engineer: Mike Stone
Assistant Sound Engineers: Gary Langan, Gary Lyons

Genesis

In June 1975, as the members of Queen were getting ready to go into the studio to begin work on their fourth album, Elektra, their American distributor, proposed the rerecording of the single "Keep Yourself Alive," taken from Queen's first album. This number, which had a fleeting exposure in the United States when it appeared on October 9, 1973, was destined to further benefit the group's reputation.

A session had been booked at the London Sarm East Studios in June 1975. The idea was to record the piece without changing its essence or structure but just giving it more modern color—similar to the group's latest releases, such as "Killer Queen" or "Now I'm Here." The production was rapid, and the group wrapped after just one day of recording. The song was called "Keep Yourself Alive (Long Lost Retake)," and an acetate was mastered, with a shorter mixing on the B-side.

For unknown reasons, Elektra did not use this recording but instead released the album version, slightly edited—the song ended with a fade fifteen seconds sooner than on the original—on July 15, 1975, in the United States. "Keep Yourself Alive (Long Lost Retake)" remained in EMI's archives until 1991, when Hollywood Records, Queen's new distributor in North America, decided to reissue all of the group's discography, supplemented by rare tracks. The song then appeared on the *Queen* album bonus CD.

Production

While its structure remained identical, the song was nevertheless a completely new version of its predecessor, particularly in its interpretation. From the introduction, there is perceptible feedback interference on the guitar launching Brian May's famous riff. The percussion is louder and played more powerfully. Roger Taylor did not like the stifled sound of his instrument during the group's sessions for their first album and this new take on the drums enabled him to benefit from better sound quality. His solo, which includes percussion on nine bars from 2:15, is shortened to four, and two extra beats are added before the song's reprise. Shortly after this section of the song, there is the question-and-answer between Roger and Brian, whose

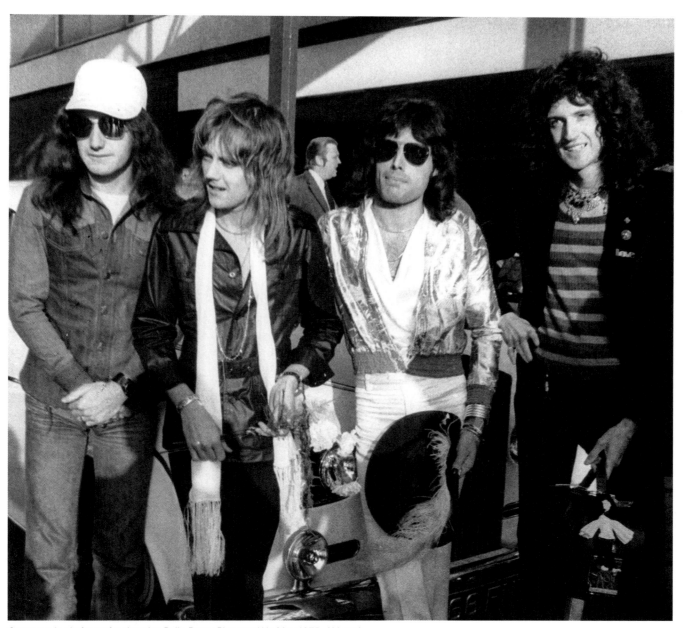

Queen posing in front of a gleaming Rolls-Royce Phantom V in May 1975. Although Mercury did not have a driver's license, this English beauty was one of his favorite cars.

voices have matured, on *"Do you think you're better every day?"* sung by the drummer, and *"No, I just think I'm two steps nearer to my grave,"* proclaimed by the guitarist.

Close listening to the two versions of "Keep Yourself Alive" reveals that the sound and tone of each version is different, according to the period in which it was produced.

QUEEN: ALL THE SONGS 151

COLLABORATION

MAN FROM MANHATTAN
Eddie Howell / 3:22

Musicians
 Eddie Howell: lead vocals, acoustic guitar
 Freddie Mercury: piano, backing vocals
 Brian May: guitar, backing vocals
 Barry De Sousa: drums
 Jerome Rimson: bass
Recorded
 Sarm East Studios, London: early January 1976
Technical Team
 Producer: Freddie Mercury
 Sound Engineer: Mike Stone
 Assistant Sound Engineers: Gary Langan, Gary Lyons

In 1969, the young British composer Eddie Howell sent a demo with two of his songs to Chrysalis Records. The music publisher, impressed by his effective writing and refrains, opened the doors of the legendary Parlophone label to Howell, making it possible for him to release his single "Easy Street." Howell was heavily influenced by the songs and sounds of The Beatles, and when "Easy Street" was released, it was a heartfelt homage to "Penny Lane" by the Fab Four.

A Fortuitous Encounter

In 1975, Howell signed with the Warner Bros. label, and released his first album, *The Eddie Howell Gramophone Record*. Many famous musicians appeared on the record, including the bassists Percy Jones and Jerome Rimson, the guitarist Gary Moore, and the drummer for Genesis, Phil Collins. The label staked everything on their new protégé and launched the album with an acoustic concert at the Thursday Club, on Kensington High Street, on October 23, 1975. That evening, the singer's manager, David Minns, arrived with his boyfriend, a certain Freddie Mercury. Eddie Howell performed his album, and added to his set a song called "Man from Manhattan," which had never been recorded. After the concert, Queen's vocalist, who at that time was in the midst of promoting *A Night at the Opera*, suggested to Eddie that this new song should be produced. The young artist naturally agreed to the star's proposal on the spot.

The Man from Manhattan

Upon hearing a demo of the song, Freddie Mercury confirmed his earlier proposal. "I was impressed by the fact that he already knew the song inside out. That was obvious the first time he played it through on the piano. He'd got the feel right, it was absolutely perfect,"[45] declared Howell in 1995. Given the growing fame of Mercury, Warner Bros. provided a significant budget for the recording of this song, which took place at Sarm East Studios in January 1976. The session was staffed by a dream team. The location's sound engineer, Mike Stone—a celebrated technician who was drawn to Queen's albums—was at the controls. Freddie Mercury provided the production, piano score, and lead vocals. Brian May added a large number

Despite creating a hit song with Freddie Mercury, Eddie Howell's singing career was stalled by an administrative imbroglio.

of guitar parts, including a high-quality solo that immediately put the Queen signature on the number. Musically, Howell's main inspiration was "Dead End Street" by the Kinks, but Freddie's expertise and his involvement added a new color to the song, while at the same time respecting its creator's original vision. "He did a lot of pre-production work on the song's structure and the harmony arrangements. I was really impressed by the way he wrote out his harmony parts. It was like maths. He'd sit there with a piece of paper and write, F-sharp, G, A."[45]

...The Harder They Fall

The single "Man from Manhattan" came out on March 5, 1976, and accompanied a new version of Eddie Howell's album, which now had the same title as his emergent new hit. It was an immediate success in a large number of European countries, where the single was massively broadcast on the radio airwaves. Sadly, the hit was stopped in its tracks midway into its meteoric success, when the Musicians' Union, a much respected UK organization that defends the interests of musician artists, found out that the American bassist Jerome Rimson, who played on the track, did not have a valid work permit for the British territories at the time of the recording sessions. The song's broadcast was prohibited forthwith on all British media, and the song, now banished for life from the radio, was relegated to the Warner Bros. archives.

Eddie Howell continued his career as a composer, notably writing songs for Samantha Fox and the New Zealander Jon Stevens, who in 1979 had a big success in his own country with the Howell-penned disco number "Jezebel."

FOCUS ON...

Mercury and his famous microphone stand strut their stuff in front of an audience of 200,000 at London's Hyde Park. The legendary concert took place on September 18, 1976.

CONCERT IN HYDE PARK (SEPTEMBER 18, 1976)

A Gift for the English Fans

While in the midst of recording their fifth album at Manor Studio in Oxfordshire, England, the members of Queen decided that it would be good to have a break. Following their unbelievably successful year in 1976, they considered it an appropriate opportunity to take the time to celebrate the millions of sales of "Bohemian Rhapsody" with the same public that had made the group into rock 'n' roll royalty. The idea for an exceptional event had already been touched upon during a previous tour, and it finally came to fruition after careful consideration and reflection with their manager, John Reid. The band decided to organize a massive free concert in Hyde Park, where Pink Floyd had performed on June 29, 1968, in the company of Tyrannosaurus Rex, Roy Harper, and Jethro Tull. The date chosen for the concert was Saturday, September 18, 1976, the anniversary of the death of the group's idol, Jimi Hendrix. With the support of the businessman Richard Branson, founder of Virgin Records and owner of the Manor Studio, the group rapidly obtained the necessary authorizations. "It was an idea we had when we were touring in Japan. We thought it would be nice to do something different in England [...]. And we thought we'd like to do a free concert, and the best possible venue that occurred to us was Hyde Park, because it was more central than any other. It was an awful lot of trouble to get permission to play in the park, to hold the event, it cost us a fortune, etc., but in the end, it was worth it. We wanted to just make a good gesture, to do something for nothing."[46] The group launched into three warm-up dates across the United Kingdom in early September. Two concerts were played at the "Scottish Festival of Popular Music" at the Edinburgh Playhouse on September 1 and 2, and a third concert was given at Cardiff Castle in Wales, on the tenth of the month.

For Brian May, who was totally committed to its organization, this concert was a source of concern, as the relations between Queen and the British press had deteriorated considerably: "I remember thinking: We've covered a lot of places around the world but England doesn't really think we're that cool."[22] But the welcome that the group received when they came on stage for this particular concert dispelled the guitarist's fears. "It was packed beyond belief. And it was really like coming home to [a] sort of hero's welcome."[22]

The Return of the Queen

On September 18, the group crammed into a laundry van to make their way to the backstage entrance. A crowd of between 150,000 and 200,000 had massed in front of the stage to support them, to show their loyalty, and also to applaud the group's opening act, singer Kiki Dee, guitarist Steve Hillage, and their group, Supercharge.

The UK television personality Bob Harris announced each of the musicians, whose entrances to the stage was preceded by the introduction—on tape—from the album *A Day at the Races*, which at that point was still

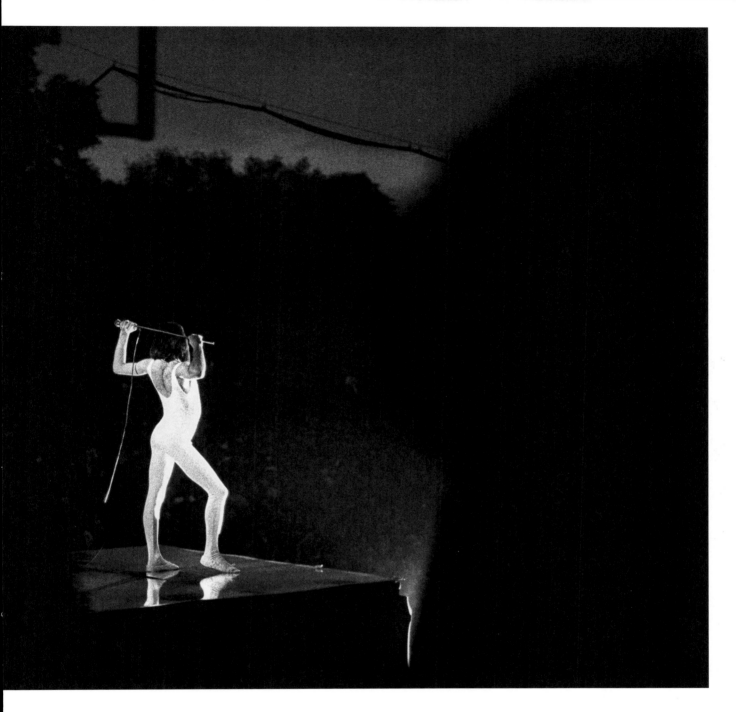

unknown to the public. Then Taylor struck the gong and launched the proceedings, playing the Japanese-sounding riff from "Tie Your Mother Down," which opened the disc, before launching into the operatic section of "Bohemian Rhapsody." All of this was done on tape before the band finally arrived on stage during the rock portion of "Bohemian Rhapsody." Brian May then launched into "Ogre Battle," following which Mercury addressed the audience, declaiming the now famous line, "*Good evening, everybody! Welcome to our picnic by the Serpentine.*" Then followed a string of effective numbers taken from the group's first three albums. The band's objective was to offer the public an overview of their career so far.

The concert was a success, but its finale was marred by the police. The show overran its allotted time and law enforcement would not allow the musicians to go back onstage to play their encore, and so the evening ended as the band finished playing the mythical song "In the Lap of the Gods...Revisited." Bob Harris was left with the difficult task of announcing to the public—who at this point were chanting: "*We want Queen! We want Queen!*"—that the show was over.

Brian May had this to say regarding the magical experience: "I think 'Hyde Park' was one of the most important concerts in our career. [...] It was wonderful to come back, see this crowd and feel this reaction."[47]

ALBUM

A DAY AT THE RACES

Tie Your Mother Down . You Take My Breath Away . Long Away . The Millionaire Waltz . You and I . Somebody to Love . White Man . Good Old-Fashioned Lover Boy . Drowse . Teo Torriatte (Let Us Cling Together)

RELEASE DATES
United Kingdom: December 10, 1976
Reference: EMI—EMTC 104
United States: December 18, 1976
Reference: Elektra Records—6E-101
Best UK Chart Ranking: 1
Best US Chart Ranking: 5

The members of Queen pose for photographer Lord Lichfield a few weeks before the launch of *A Day at the Races*. Here, Freddie is shown wearing his famous ballet shoes, which he would wear for every appearance on the group's forthcoming tour.

A NEW SENSE OF FREEDOM

The glorious year resulting from the huge success of *A Night at the Opera* meant that Queen was now freed from financial worries, the accumulated royalties from their album sales now guaranteed a comfortable future. The bad feeling surrounding the composition of titles such as "Death on Two Legs (Dedicated to...)" had disappeared, and the musicians' professional team was now firmly established. Brian May recalls: "The added ingredient of *A Day at the Races* was this feeling of freedom which we actually had. Because we had escaped the old situation. [...] We weren't indebted anymore. [...] It was a great freedom and joy."[22] Keen to once again capture the magic at work on their previous album, the group set about recording their new album with a confident sense of calm.

All Their Own Work

By the summer of 1976, Queen seemed to have found its work rhythm. The winter tour of Australia—eight concerts in eleven days—had been a total success. No longer were they met with the chilly response that they'd received during previous Australian appearances in February 1974, when they'd served as the opening act for Mott the Hoople.

By now, thanks to the single "Bohemian Rhapsody," Mercury and his fellow artists had become worldwide superstars. After a few weeks of well-deserved rest—during which, among other things, Brian May was able to organize his marriage to Chrissie Mullen—the group was ready to focus on the forthcoming album. In early July, as the single "You're My Best Friend," composed by John Deacon for the album *A Night at the Opera*, was just being released in Europe, Queen headed back to the recording studios. For this new album, the greater part of the recording sessions took place in a magnificent manor house belonging to Richard Branson, owner of Virgin Records. The Manor Studio (often referred to simply as "the Manor") was in Shipton-on-Cherwell in Oxfordshire, England, and it consisted of an eight-room residential complex as well as a swimming pool, a billiard room, and tennis courts. Just having completed a twelve-month renovation, the studios were also now equipped with high-end equipment and the soundproofing necessary for the musicians' erratic timetables. Before the soundproofing had been installed, locals had complained endlessly about the noise, even calling the police during the recording of Mike Oldfield's famous album *Tubular Bells*.

At the Manor, the musicians spent until July recording the rhythm and melodic backing tracks of some of the songs, and they finished recording the album between the end of July and November, though this second recording portion took place at Sarm East Studios and Wessex Sound Studios.

Wishing to regain control of the production of their songs, Queen decided to forego the services of the always reliable Roy Thomas Baker. Instead, the technical team worked under the direction of Mike Stone, who had served as the sound engineer on the group's previous albums. Baker, who had also been rewarded with international

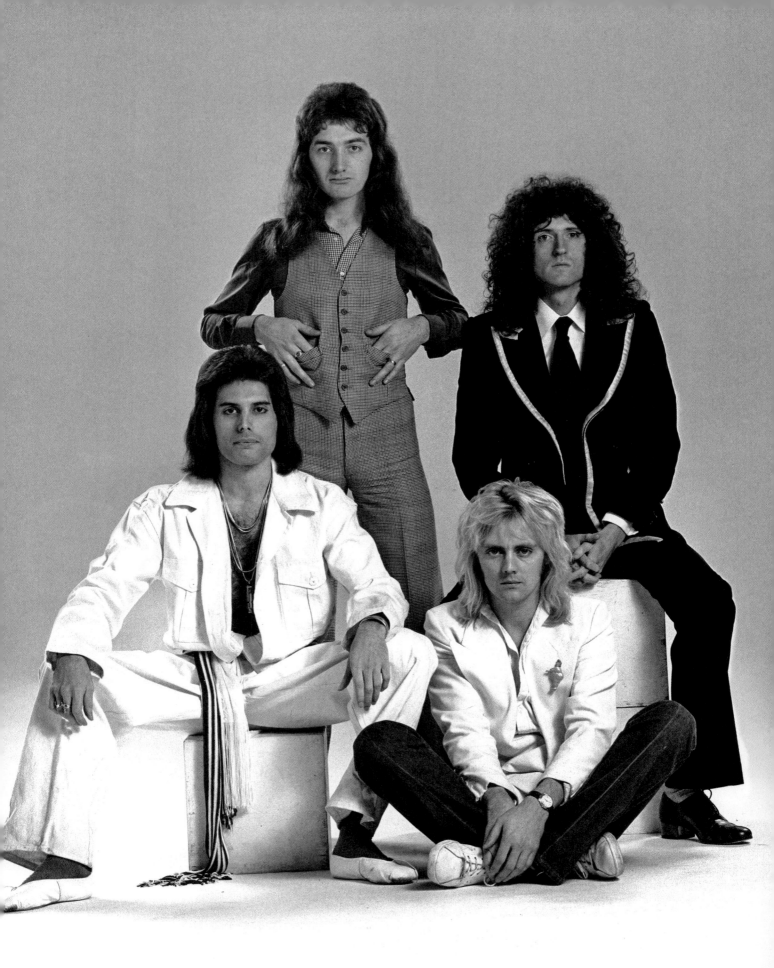

success thanks to *A Night at the Opera*, took the opportunity to embark on new American projects centered around a collaboration with Ian Hunter of Mott the Hoople, who was then busy preparing his new solo album, *Overnight Angels*.

Freddie Mercury talked about this split in 1977: "We just felt that, for this one, we needed a bit of a change. We were quite confident in doing it ourselves. [...] Taking more responsibility has been good for us. Roy's been great, but it's a progression, really—another step in our career. We simply felt that it was now or never."[48] Despite the split, the group remained on friendly terms with Baker.

Late Summer Concerts

After their world tour of the United States, Japan, and Australia between January and April 1976, Queen felt the need to reconnect with their British public, deciding in late August to give four concerts in the UK, even though the new album was far from ready. Two concerts were put on September 1 and 2, 1976, at the Edinburgh Playhouse, as part of the "Scottish Festival of Popular Music," and a third one at Cardiff Castle in Wales. The most important event of this late summer tour was, however, the enormous free concert in Hyde Park, London, given by Queen for their English fans. Before an audience of more than 150,000, the group played for the first time one of the songs from the new album: "You Take My Breath Away." More specifically, it was Freddie Mercury who performed this majestic work for voice and piano before an awestruck public. Although the show was cut short by the police (since the concert had run over the permitted time), it was a memorable evening, predicting great things for the release of the album a few months later.

160 A DAY AT THE RACES

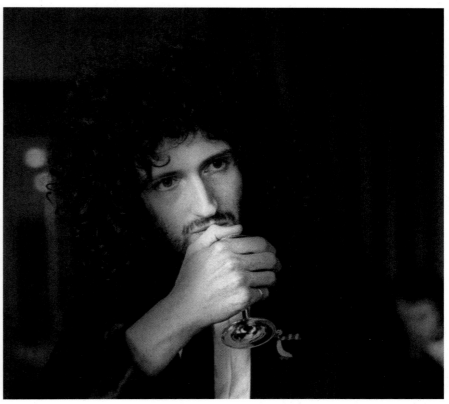

(Left) As part of the promotion for their new album, Queen enjoyed an actual day at the races at Kempton Park on October 16, 1976. All four members of the group are present and accounted for along with Mary Austin and John Reid (center, with dark glasses).

(Below) Brian May at Kempton Park on October 16, 1976. The guitarist would later explain that his short beard was an indication of the deep depression he was suffering from at the time.

(Next page) Freddie Mercury (right), wearing his famous harlequin costume. The costume was inspired by Léon Baskt's design for the dancer Vaslav Nijinski circa 1910.

A Triumphant Launch

The final recording sessions at Sarm East Studios and Wessex Sound Studios took place in an amicable atmosphere, and Queen was soon ready to present their new songs to the press. In a nod to the title of the album, *A Day at the Races*, EMI organized a promotional event at Kempton Park Racecourse on October 16, 1976. Although not all that enthusiastic about Queen's music, the British journalists were eager to accept EMI's invitation with its promise of a free buffet and as much alcohol as they could drink. On this occasion, Freddie Mercury, Brian May, John Deacon, and Roger Taylor were merely spectators. Sitting on the terraces with the rest of their team, they entered into the excitement, betting on their favorite horses and applauding Marmalade and the Tremolos, who performed between races.

On this occasion Brian May appeared with a beard, an indication, he was to say, of the depression that haunted him for many years: "I think the beard is also a sign of me getting depressed. Making albums was quite a grim time for me, because it was always a bit of a fight. We were all pulling in different directions. When you're on tour, things are, in a sense, more aligned. You're all trying to do the same thing."[29]

The event was a triumph. Groucho Marx, whose movies *A Night at the Opera* (1935) and *A Day at the Races* (1937) had inspired the titles of Queen's two most recent albums, even sent a telegram wishing the group good luck. And they needed all the luck they could get because, as usual, the British press was savage in its criticism. Nick Kent, of *New Musical Express*, who had already made it clear to the whole world that he did not like Queen, dismissed the album with the words, "I hate this album. [It] is grotesquery of the first order."[49] The magazine had, in fact, already rejected the baroque glam rock characteristic of

QUEEN: ALL THE SONGS 161

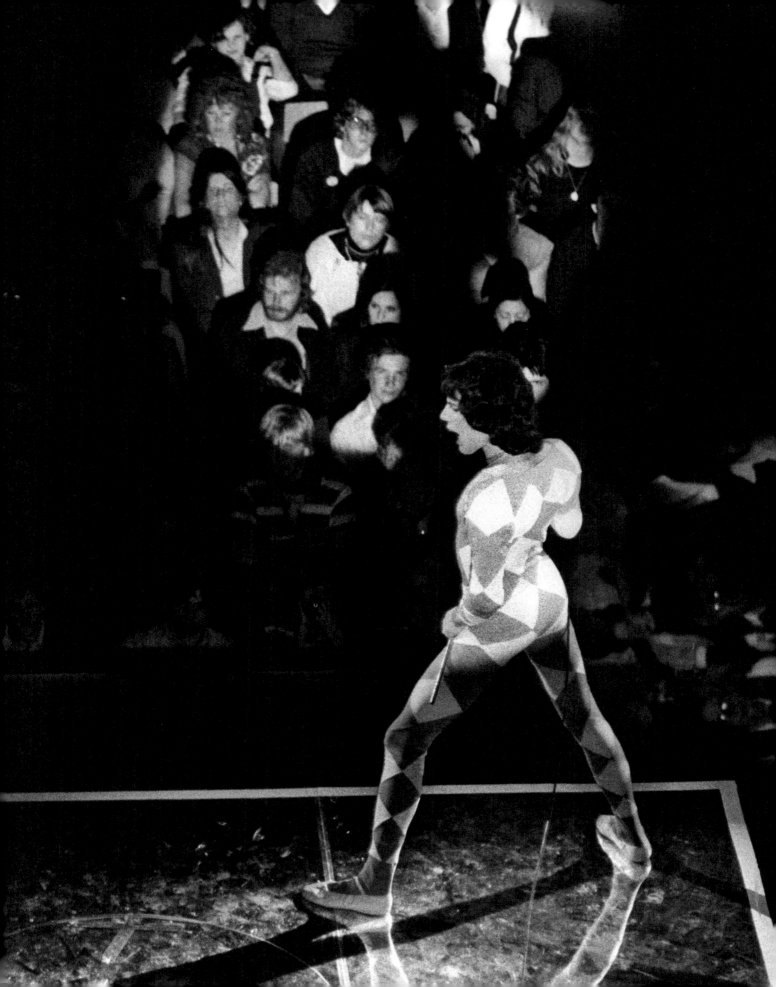

On March 4, 1977, when they had a free day after two concerts at the Forum in Inglewood, California, a city near Los Angeles, Queen met the then eighty-six-year-old Groucho Marx to give him a golden disc of *A Night at the Opera* and *A Day at the Races*, albums that had borrowed their name from two Marx Brothers movies. Groucho was to die five months later.

The front page of England's *Daily Mirror* from December 2, 1976, covered the Sex Pistols' first live appearance on British television.

this group, preferring a new style of street music performed by youths with pink-dyed hair and ears pierced by safety pins. Seeming to have a grudge against the entire world, the style of music played by these artists was an urgent and aggressive rock. The ambassadors of the new movement had names like the Clash and the Damned. It was as if a tidal wave had hit London, sweeping away all traces of the flamboyant rock with which Queen was associated. Punk had arrived.

Queen vs. Punk

"Somebody to Love," the first single from the album *A Day at the Races*, was released in the UK on November 12, 1976, finding immediate success and going to number two on the UK charts. With this final gospel song, Freddie Mercury, at the top of his form, paid homage to his idol Aretha Franklin.

A few days after the launch of the album, on December 1, Queen was scheduled to appear on the *Today with Bill Grundy* program on Thames Television. The group canceled the appearance because Freddie had a dental appointment! Required by the host, Bill Grundy, to find a replacement, EMI sent along its new protégés and top division punks, the Sex Pistols, in a move to promote their first single, "Anarchy in the UK," released at the same time as "Somebody to Love." The program was a disaster for the television channel. The group hurled insults at Grundy who, relatively relaxed amid these young people, did nothing to restrain their crazy language. It was to be a red-letter day for historians of rock music because the Sex Pistols shot to overnight stardom, unleashing punk in a storm that would overwhelm Queen in the months to come. As for the unfortunate host, he would be dismissed by the TV channel two months later, his career in tatters.

Queen's new album was released in the UK on December 10, 1976. *A Day at the Races* quickly climbed to first place for disc sales, but the themes tackled in the songs seemed at odds with the mood of the time. The "[diners] at the Ritz" of "Good Old-Fashioned Lover Boy" or the grandiloquence of "The Millionaire Waltz" and "Somebody to Love" were completely out of step with a British society experiencing at the time a deep social economic crisis with soaring rates of unemployment. To see Freddie Mercury drinking champagne onstage seemed inappropriate when contrasted with the problems of real people. The rock press seized on this faux pas, but Queen was convinced that they had produced a sincere album, faithful to their style of songwriting, with the ingredients that had made their name: lightness, imagination, and the stylishness of their lead singer. Was it because of the lukewarm reviews—despite the enormous success of the album—that the group was about to make a change of direction? Or was it just a desire to explore new artistic routes? "The answer is blowing in the wind," as Bob Dylan put it. Whatever the reason, Queen was to take a radically new direction, championing a new sound and new compositions. In the interim, in January 1977, the group flew over to North America for a two-month tour and forty-one concerts.

(Top left) Brian and Freddie were gifted with hockey jerseys bearing their names while performing at the Forum de Montréal on January 26, 1977. (Top right) John Deacon puts himself in the expert hands of the group's hairdresser. (Bottom) Brian makes a wardrobe adjustment while Freddie puts on makeup before going onstage during the group's 1977 tour.

QUEEN: ALL THE SONGS 165

TIE YOUR MOTHER DOWN
Brian May / 4:46

Musicians
Freddie Mercury: lead vocals, backing vocals
Brian May: electric guitar, vocals
John Deacon: bass
Roger Taylor: drums, vocals

Recorded
Wessex Sound Studios, London: September–November 1976
Sarm East Studios, London: November 5, 1976

Technical Team
Producers: Queen
Sound Engineer: Mike Stone
Assistant Sound Engineers: Timothy Friese-Greene (Wessex), Gary Langan (Sarm), Gary Lyons (Sarm)

Single
Side A: Tie Your Mother Down (Single Version) / 3:45
Side B: You and I / 3:25 (EMI); Drowse / 3:43 (Elektra)
UK Release on EMI: March 4, 1977 (ref. EMI 2593)
US Release on Elektra: March 8, 1977 (ref. E-45385)
Best UK Chart Ranking: 31
Best US Chart Ranking: 49

FOR QUEEN ADDICTS

For the first time on a Queen disc, at 3:22, Brian May uses a glass bottleneck for the slides, so adding to the bluesy character of the song. It consists of a small glass tube slipped onto the middle, or ring, finger of the left hand, according to need, and then slid up and down the neck of the guitar to the required note.

Genesis

In September 1970, before the arrival of Deacon, Queen was looking desperately for a bass player to consolidate their rhythm section. Brian May was once again in Tenerife working on his thesis in astrophysics. Every morning, the doctoral student and his professor, Dr. Ken Reay, worked together at the Teide Observatory. But one particular day, the scholarly guitarist's mind was immersed in his thoughts and his guitar, and he was strumming it as he watched the sun rise. According to Ken Reay, "Brian was forever talking about Queen and showing me photographs of them in their stage clothes. He would fish out his acoustic guitar and if we weren't working of an evening he sat outside on the steps of the observatory and played."[44] It was during this trip that, using a now-lost Spanish acoustic guitar, Brian wrote the riff for "Tie Your Mother Down."

In 1976, when the group was recording *A Day at the Races*, he suggested this piece, which was immediately included among the album's tracks. The powerful and effective riff in this extraordinary rock 'n' roll moment was inspired by one of May's idols, guitarist Rory Gallagher, famous for his contribution to the music of Taste in the late '60s.

The title of the song, "Tie Your Mother Down," seems somewhat violent for someone like May, but he explained how it came about in an interview in 1998: "When I played that riff I used to sing the phrase 'Tie your mother down' just as a joke, really. Years later when we finally came to record the song properly, I fully expected this to be changed, but Freddie believed it to be perfect. I thought it was a crap title, but Freddie said it meant something to him."[50]

The words convey the impatience and passion of a young man speaking to his school-age girlfriend: "*It's gotta be tonight my little school babe / Your mamma says you don't / Your daddy says you won't / And I'm boilin' up inside.*" This is why the girl needs to "*Tie your mother down*" and "*Lock your daddy out of doors*"…Interviewed by Kenny Everett on Capital Radio, Freddie Mercury played the innocent: "I don't know why [he wrote this], I think he was in one of his vicious moods!"[51]

The song was selected to be the second single from the album and was released in the UK on March 4, 1977, but it did not have the success of "Somebody to Love." There are those who believe that "You and I," by Deacon, would have

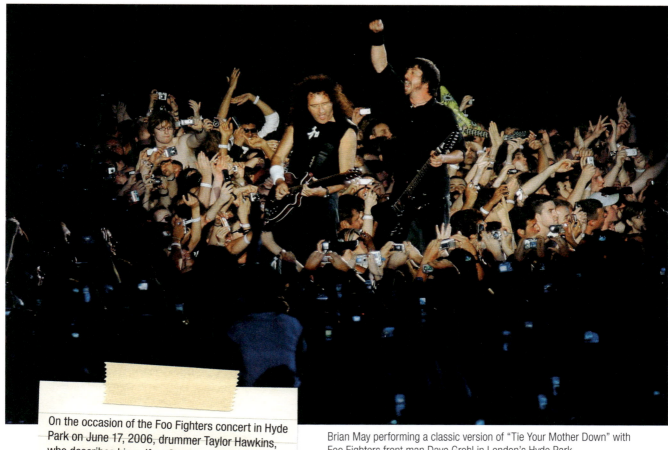

On the occasion of the Foo Fighters concert in Hyde Park on June 17, 2006, drummer Taylor Hawkins, who describes himself as Queen's number one fan in the world, organized an epic meeting. Roger Taylor and Brian May joined the group on the stage for an unforgettable reprise of "Tie Your Mother Down," Dave Grohl doubling May's riff in front of eighty-five people. A never-to-be-forgotten moment!

Brian May performing a classic version of "Tie Your Mother Down" with Foo Fighters front man Dave Grohl in London's Hyde Park.

been a better choice, as its very tuneful pop melody was likely to have pleased more people.

Widely approved, nevertheless, by the public, "Tie Your Mother Down" was played at every one of the group's concerts from January 1977 until the mythic concert at Knebworth in 1986.

On September 16, 1998, playing live and unplugged on the American music channel VH1, Brian May performed a bluesy version of "Tie Your Mother Down." He started by telling a story in the way that the stars of the Delta blues in the 1920s used to do, recounting the adventures of the characters in their songs. Here, it's the story of a young boy coming to collect his girlfriend to go to the movies and being forbidden to by her parents. This version makes perfect sense of the song and underlines the extent of the influence of the true origins of American rock 'n' roll on the English guitarist.

Production

After two triumphant tours in Japan, the musicians felt a particular affection for that country. *A Day at the Races* is studded with Japanese references, not least in the melody of "Tie Your Mother Down" from 0:39, accompanied by Roger Taylor with repeated—and perhaps rather trite—use of a gong.

After this short but explicit tribute to his Japanese friends, Brian May launches into a strange harmonic suite that was used for the official introduction to the album. Before the entry of the famous Tenerife riff, he creates a melodic spiral with his Red Special, once again giving the impression that a synthesizer has been used. The melody played in this passage rises up in harmony and then descends in a loop back to the first note, causing a sense of confusion for the listener. Brian May later explained the inspiration behind the composition of this instrumental prelude: "I was trying to do a sound analog of the M. C. Escher painting where you keep walking up a staircase, but never get anywhere. It's an optical illusion. I was trying to do a sound illusion.' There are a lot of tracks on there, all distributed across the stereo spectrum. Everything is swirling around you, but you're always in the same place."[52] This short introduction also appears on the album as a postlude after the last song on the disc.

QUEEN: ALL THE SONGS 167

YOU TAKE MY BREATH AWAY

Freddie Mercury / 5:04

Musicians
Freddie Mercury: lead vocals, backing vocals, piano
Brian May: electric guitar
John Deacon: bass
Roger Taylor: percussion

Recorded
The Manor, Shipton-on-Cherwell, Oxfordshire: July 1976
Wessex Sound Studios, London: November 2, 1976
Sarm East Studios, London: November 5, 1976

Technical Team
Producers: Queen
Sound Engineer: Mike Stone
Assistant Sound Engineers: Timothy Friese-Greene (Wessex), Gary Langan (Sarm), Gary Lyons (Sarm)

Genesis

When Queen performed "You Take My Breath Away" in front of more than 150,000 people in Hyde Park on September 18, 1976, it had not yet been recorded. Halfway through the concert, Brian May, John Deacon, and Roger Taylor left the stage after a magnificent rendering of May's beautiful "'39," the fifth song from their album *A Night at the Opera*. Only Freddie remained on the stage and, moving to sit at the piano, he turned to address a silent and expectant audience: "Right now, I'm gonna do a very special song, this is a new song from our forthcoming album. It hasn't quite been recorded yet. Anyway, this song's called 'You Take My Breath Away.'"[53] Alone, in front of a crowd stretching as far as the eye could see, and although he was to say several times subsequently that he was very nervous about playing this piece that meant so much to him, he gave an outstanding and deeply felt performance. In its melancholy melodic line and despairing message addressed by the narrator to his soulmate, the ballad recalls "Nevermore" from the group's second album.

The version of "You Take My Breath Away" that Mercury recorded for *A Day at the Races* is longer than the Hyde Park version. With the addition of an introduction, a guitar solo, and harmonized vocals on the reprise, it stretches out without becoming repetitive. This distillation of melancholy was composed by the singer for the man he had fallen madly in love with a few months earlier, David Minns, Eddie Howell's manager. Eddie was a young English singer who was soon to collaborate with members of the group.

Production

The tours in Japan made by Queen from April 1975 had a profound influence on the group. After Brian May's Japanese-style introduction to "Tie Your Mother Down," it was now Mercury's turn to reference his love of the Land of the Rising Sun. The piano part is based on a particular harmonic scale known as "kumoi." This Japanese scale, similar to the Western pentatonic scale, gives an Eastern color to the song, restrained but sufficient to be regarded by Japanese music lovers as a subtle tribute.

Freddie wanted a very gentle treatment for "You Take My Breath Away." So that the guitar solo would not shatter

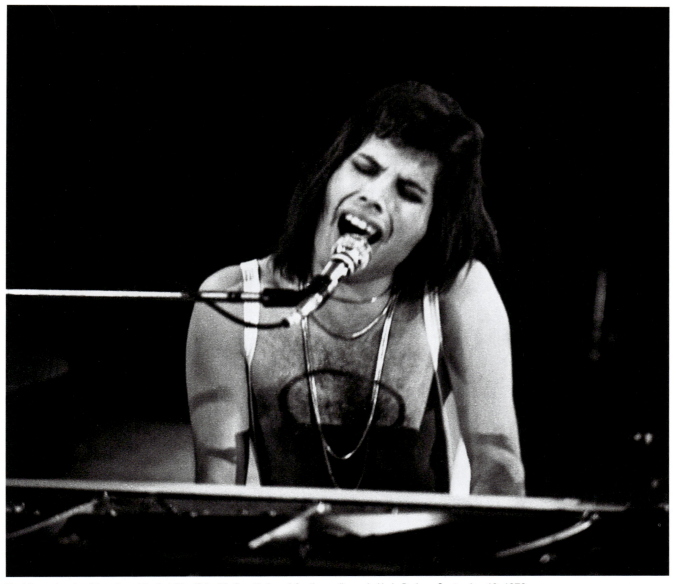
Freddie performing his poignant ballad "You Take My Breath Away" for the audience in Hyde Park on September 18, 1976.

the calmness of the title, Brian May plays the notes in a very particular way, explaining in 1983: "Instead of using my pick, I tap the fingerboard with the right hand [...]. It sustain [sic] itself [...]. If you even stand in exactly the right place, it feeds back in any position so I can just warble around and it's very smooth."[54] For the vocals, Mercury performs all the ensembles himself, constructing his own harmonies under the direction of Mike Stone—"*the* vocal guy,"[2] as Roger Taylor called him. Stone, who had learned the trade at the side of producer Roy Thomas Baker, was to become an essential ingredient in the Queen sound. Although production was in the hands of Mercury and his fellow musicians, Queen's modern and powerful sound was due to him. When Queen took a new direction on their subsequent disc, it was Stone once more who was in charge of the sound balance, giving ever more emphasis to the guitars and the voices.

FOR QUEEN ADDICTS

Before broadcasting "You Take My Breath Away" in 1976, Kenny Everett introduced the song by referring to the multitracking of Mercury's voice: "So, this is Freddie, plus Freddie, plus Freddie, plus Freddie, plus Freddie..."[51]

QUEEN: ALL THE SONGS 169

SINGLE

LONG AWAY
Brian May / 3:35

Musicians
Brian May: lead vocals, electric guitar
John Deacon: bass
Roger Taylor: drums, backing vocals
Freddie Mercury: backing vocals

Recorded
Wessex Sound Studios, London: October 26, 1976
Sarm East Studios, London: November 5, 1976

Technical Team
Producers: Queen
Sound Engineer: Mike Stone
Assistant Sound Engineers: Timothy Friese-Greene (Wessex), Gary Langan (Sarm), Gary Lyons (Sarm)

Single
Side A: Long Away / 3:25
Side B: You and I / 3:35
US Release on Elektra: June 7, 1977 (ref. E-45412)
US Chart Ranking : Did Not Chart

FOR QUEEN ADDICTS

Brian May played "Long Away" for the first time on stage on May 11, 2010, at the Scala, London. The Coattail Riders were performing that evening. This was one of the groups in which Taylor Hawkins played drums—the other being Foo Fighters—and Hawkins who invited his friends Roger Taylor and Brian May to join him.

Genesis

"Long Away" is one of the songs that Brian May had hoped to see released as a single in the UK. In any event, only Elektra in the United States decided to bring it out as a 45 rpm on June 7, 1977, with Deacon's "You and I" on the B-side. The single was a flop, probably because listeners were surprised to hear Queen's "new singer." For Brian May himself sang the song, with vocal backing from Taylor and Mercury. The American distributor was taking a risk with this choice, although the two sides of the disc had a coherence that could easily have appealed to a public in search of tuneful pop. Brian May was disappointed that Queen never performed the song live.

Production

It is often interesting to know what inspires an artist to write a certain song. In the case of "Long Away," May was thinking about life as a rock star. The instrumental section, on the other hand, was the result of a desire to use a new instrument. For the first time, in this song, May is playing a 1967 Burns Double Six guitar with, as its name suggests, twelve strings. Originally equipped with three Burns Tri-Sonic pickups, like those May had used for his famous Red Special, this guitar had been altered. It now had three single coil pickups such as can be found on a Fender Stratocaster, giving the warm and velvety sound that Brian so much admired in Hank Marvin, guitarist for the Shadows. He was to justify this acquisition in an interview: "I used this on 'Long Away.' Funnily enough, I think I bought it because I liked the pickups, but I fell in love with the guitar once I started playing around with it and the song materialized. The guitar actually inspired the riff that powers the song."[55] Things might have turned out quite differently because May's first choice had been a twelve-string Rickenbacker guitar, but nice as it was, it did not suit him: "I couldn't play Rickenbackers because the necks are too thin. I like a very fat and wide neck. My fingers only work in that situation. I always wanted to play a Rickenbacker—because John Lennon did. Roger [Taylor] collects extremely fucking rare guitars, and he has a Rickenbacker. But I can't play it."[56]

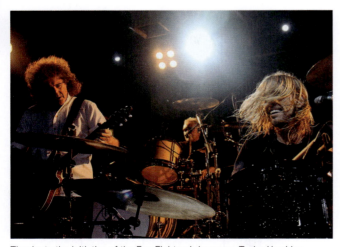

Thanks to the initiative of the Foo Fighters' drummer, Taylor Hawkins, Brian and Roger were able to appear onstage for a performance of "Long Away" in May 2010.

THE MILLIONAIRE WALTZ

Freddie Mercury / 4:54

Musicians
Freddie Mercury: lead vocals, backing vocals, piano
Brian May: electric guitar, backing vocals
John Deacon: bass
Roger Taylor: drums, backing vocals

Recorded
The Manor, Shipton-on-Cherwell, Oxfordshire: July 1976
Wessex Sound Studios, London: November 16, 1976

Technical Team
Producers: Queen
Sound Engineer: Mike Stone
Assistant Sound Engineer: Timothy Friese-Greene (Wessex)

In November 1976, when Kenny Everett invited Freddie Mercury to Capital Radio to promote the new album, the disc jockey said of "The Millionaire Waltz": "It's a bit gay, and weird, and strange."[51] And Mercury answered: "It's very out of the Queen format, really, and we thought we'd like to do that on every album. I think I went a bit mad on this one."[51]

Genesis

After the notable success of "Bohemian Rhapsody," nothing could dissuade Freddie Mercury from composing new songs along the same lines. In writing "The Millionaire Waltz," he once again divided up the piece into different sections, the result being one of the key pieces of the album *A Day at the Races*. The title was inspired by John Reid, the group's new manager, who had saved them from the clutches of Trident and provided them with a welcome period of calm. The text is implicit, Freddie playing the role of a lover lamenting the lost joys of happiness with Reid: *"Now I am sad you are so far away / I sit counting the hours day by day."*

Production

A lot more work was involved in recording this song than for "Bohemian Rhapsody." Brian recalled: "It was our great musical excess [...]. It makes 'Bohemian Rhapsody' look easy."[57] It is unbelievably bombastic and very tuneful, and it rises up in the middle to a crescendo only to give way to a classic guitar solo. Although it follows a tried-and-tested recipe, "The Millionaire Waltz" remains one of the jewels in the album.

For his modern waltz, based on the traditional 3/4 structure, Mercury took his inspiration from the Austrian composer Johann Strauss II. Listening to the piano part you would think you were hearing an orchestra playing his opus 314, *The Blue Danube*. But it is in the writing for the solo guitar that the resemblance is closest. Freddie wanted May to repeat what he had done in "Good Company," where he had demonstrated how he could reproduce the sound of a brass band using only his guitar. This time the singer demanded a full orchestra for his song! Brian obliged, and from 2:51 of "The Millionaire Waltz" he conjures up nineteenth-century Vienna, providing Freddie with tubas, piccolos, and cellos. Then suddenly, at 3:13, Roger Taylor suddenly interrupts with a clash of orchestral cymbals. Once again, Brian May was cleverly able to rise to the challenge of a song, the lyricism and madness of which were due to its creator, Freddie Mercury.

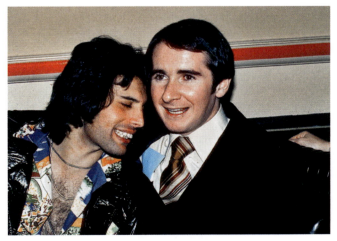

Over a period of three highly successful years, Queen's career launched into the stratosphere. Much of their success was owed to the stylishness and professionalism of John Reid.

After the success of "You're My Best Friend," John Deacon's compositions became more assured, and his catchy pop numbers would go on to win the group many new fans.

YOU AND I
John Deacon / 3:25

Musicians
Freddie Mercury: lead vocals, backing vocals, piano
Brian May: electric guitar, backing vocals
John Deacon: bass, acoustic guitar
Roger Taylor: drums, backing vocals

Recorded
Sarm East Studios, London: November 5, 1976
Wessex Sound Studios, London: November 16, 1976

Technical Team
Producers: Queen
Sound Engineer: Mike Stone
Assistant Sound Engineers: Timothy Friese-Greene (Wessex), Gary Langan (Sarm), Gary Lyons (Sarm)

Genesis

Seeing the success of his composition "You're My Best Friend" for the previous album, John Deacon realized that he had acquired a certain standing as a songwriter. It would take several months—indeed, years—for the quiet bass player to feel he was really part of the group, but by 1976 he had become one of its pillars. His style, with its lightness of touch, is easily recognized and is composed of simple harmonic progressions and particularly catchy melodies.

Roger and John composed one song each per album, and whereas the drummer tended to focus on old-style rock 'n' roll, John homed in on Queen's pop side. Deacon's contribution to *A Day at the Races* is called "You and I," and it might well have been a hit if it had been released as a single. It featured as the B-side of the "Tie Your Mother Down" single, released on March 4, 1977, and of "Long Away" when that 45 was marketed in America by Elektra the following June. Mercury was to remark: "That was a track by John Deacon, his contribution to this album. His songs are good and are getting better every time, actually. I'm getting a bit worried, actually. He's sort of quiet [...]. Don't underestimate him, he's got a fiery streak underneath all that."[51]

Production

"It's very John Deacon, with more raucous guitars. After I'd done the vocals, John put all these guitars in, and the mood has changed."[48] This was how Freddie Mercury described the composition process to Wesley Strick of the music magazine *Circus* in October 1977. John Deacon was certainly in charge of the song's rhythm guitar sections, while Brian was responsible for the guitar solo at 1:40, introduced by a slight drop in volume reminiscent of the days of "Keep Yourself Alive." Freddie hammered out a piano part that simply doubled the guitar chords. The song is an effectively structured piece of pop music with a memorable melody. The reserved John Deacon had stepped out of the shadow to reveal himself as a talented composer who would soon provide the group with many number one hits in charts worldwide.

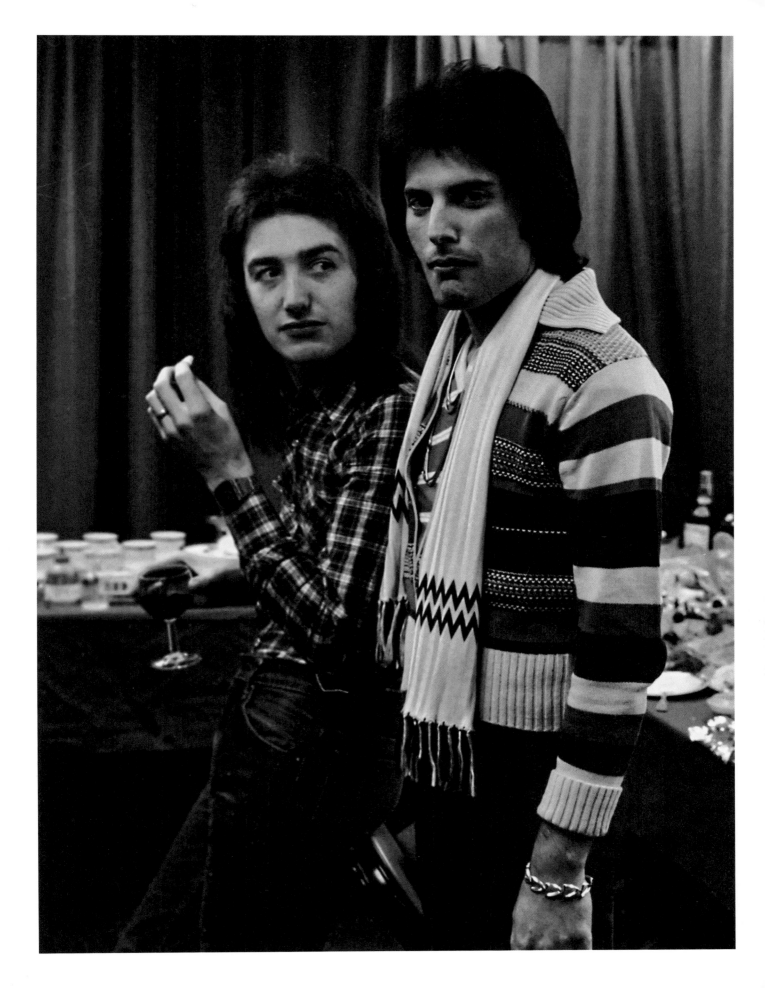

SINGLE

SOMEBODY TO LOVE
Freddie Mercury / 4:56

Musicians
Freddie Mercury: lead vocals, backing vocals, piano
Brian May: electric guitar, backing vocals
John Deacon: bass
Roger Taylor: drums, backing vocals

Recorded
The Manor, Shipton-on-Cherwell, Oxfordshire: July 1976
Sarm East Studios, London: October 1976

Technical Team
Producers: Queen
Sound Engineer: Mike Stone
Assistant Sound Engineers: Gary Langan (Sarm), Gary Lyons (Sarm)

Single
Side A: Somebody to Love / 4:56
Side B: White Man / 4:59
UK Release on EMI: November 12, 1976 (ref. EMI 2565)
US Release on Elektra: December 10, 1976 (ref. E-45362)
Best UK Chart Ranking: 2
Best US Chart Ranking: 13

Genesis

The first single taken from *A Day at the Races* is credited to Freddie Mercury. It is well known that Freddie drew inspiration from his many musical enthusiasms; here it was his passion for the singer Aretha Franklin that gave rise to this Queen anthem. Brian May confirmed this: "He absolutely loved Aretha. Freddie would like to be an Aretha Franklin."[22] According to drummer Roger Taylor, the song is "a white gospel if you want to call it that." The song's lyrics are written in the spirit of the classic songs of American slaves, who were known to sing work songs to help pass the time on a hard day of forced labor. Paradoxically, gospel singing became popular for its cheer and hope, whereas here, in "Somebody to Love," Mercury talks about loneliness, sadness, isolation, and his desperate quest for love. While this could appear extraordinarily naive, Freddie's melancholy—like the American blues of the early twentieth century—is universal.

He was proud of this composition, believing it could compete with the popular "Bohemian Rhapsody": "From my point of view, 'Bohemian Rhapsody': OK, big hit. But I think a song like 'Somebody to Love' is, in my estimation, a better sort of songwriting hit, a better song."[22]

The title came out as a single in the UK on November 12, 1976, rising rapidly up the charts to number two, just behind the hit "If You Leave Me Now" by Chicago. In October, when the song was being recorded there, a video was filmed at Wessex Sound Studios. Bruce Gowers, who made the video, had already done those for "Bohemian Rhapsody" and "You're My Best Friend" and was by now a trusted friend. He filmed the members of the group as they played and recorded the vocals, all four singing into one mic. John Deacon appears as one of the four but in fact never sang, believing his voice to be less good than those of the others. While preparing the video, Gowers added footage from the Hyde Park concert of September 18 but did not synchronize it, since the song was not part of the set list that day.

Very different from the solemnity of the "Bohemian Rhapsody" video, that of "Somebody to Love" is relaxed, showing Mercury the star in a casual shirt, all the musicians smiling, as if the group had gained in maturity, their songs able to stand alone without the need for sequins

Known for her passionate combination of soul and jazz, Aretha Franklin was one of Freddie Mercury's greatest inspirations.

174 A DAY AT THE RACES

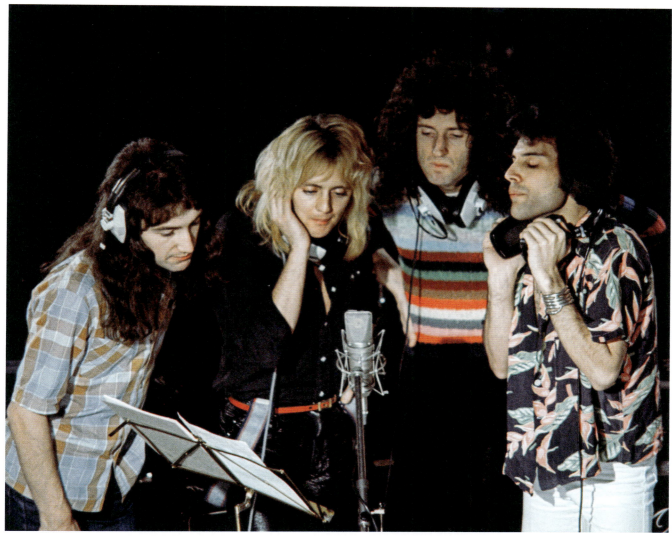
Flowery shirts and a relaxed atmosphere reigned at Manor Studio in Oxfordshire, England, where the group recorded *A Day at the Races*.

and spotlights. This direction would be taken for the next album, *News of the World*.

Production

One only has to listen once to "Nobody Like You," from the 1962 album *The Electrifying Aretha Franklin*, to understand why Mercury was so inspired by her work. As in "Somebody to Love," the time signature is 3/4, which is to say, three beats in a bar. This was a rhythm frequently used by Mercury in the writing of his most effective pieces—"In the Lap of the Gods...Revisited" or "We Are the Champions," for example. It has the mood of the soul music of the 1960s and is a tribute not only to Aretha Franklin but also to Nina Simone, who better than anyone was able to inhabit this kind of music. Freddie confirmed this: "I just wanted to write something in the Aretha Franklin kind of mode. I was inspired by the gospel approach she had on her earlier albums."[58]

The title was to become one of the group's classics. Brian May summed it up with these words: "That was part of Freddie's great gift: to take a song and keep building it until it almost became something else. Until it belongs to everybody. 'Somebody to Love' was like that."[59]

In 1993, a new version of "Somebody to Love" made it to the top of the British charts. George Michael had given an outstanding performance of it with Queen at the concert commemorating Freddie Mercury, held at Wembley Stadium on April 20, 1992. When the song was released on disc the following year, it had a huge success throughout the world.

QUEEN: ALL THE SONGS 175

The breathtaking lighting effects of Queen's concerts became more and more ambitious from one tour to the next.

WHITE MAN
Brian May / 4:59

Musicians
Freddie Mercury: lead vocals, backing vocals
Brian May: electric guitar, backing vocals
John Deacon: bass
Roger Taylor: drums, backing vocals

Recorded
The Manor, Shipton-on-Cherwell, Oxfordshire: July 1976
Sarm East Studios, London: October 24 and November 15, 1976
Wessex Sound Studios, London: November 19, 1976

Technical Team
Producers: Queen
Sound Engineer: Mike Stone
Assistant Sound Engineers: Timothy Friese-Greene (Wessex), Gary Langan (Sarm), Gary Lyons (Sarm)

FOR QUEEN ADDICTS
The working title of "White Man" was "Simple Man," words used in the first few lines of the song.

1976

Genesis
"'White Man' is [...] a very bluesy track. [It] gave me the opportunity to do raucous vocals. [...] It'll be a great stage number."[48] Freddie Mercury's description perfectly sums up this title composed by Brian May. We can feel the spirits of Led Zeppelin and Jimi Hendrix hovering above the guitarist. His song is a furious polemic against the colonists settling in the New World in the sixteenth century. May's text underlines in particular the atrocities inflicted on the American Indian inhabitants.

Long fascinated by the United States, Brian May seems here to take a different view of the country, and it is with the unaffected simplicity that sometimes characterizes his lyrics that he offered "White Man" to the group. Together they constructed a powerful number and one that was probably one of Queen's most hard-hitting. Although it was released as the B-side of "Somebody to Love," "White Man" is still today one of Queen's least-known songs.

Production
In order to give his guitar riff a heavy and aggressive sound, Brian May used a drop *D* tuning on his Red Special, meaning that he tuned the bottom E string down a tone to *D*. This tuning is used in many classic examples of the genre, including Led Zeppelin's "Moby Dick," Rage Against the Machine's "Killing in the Name" or Marilyn Manson's "The Beautiful People." May was to use this tuning again in "Fat Bottomed Girls," on the 1978 album *Jazz*. At the time of "White Man," Brian stuck to his Red Special for the whole time onstage and would retune it before playing this song. For the recent tours of Queen + Adam Lambert, on the other hand, Pete Malandrone, May's long-standing guitar tech, has provided a copy of the famous guitar made by the famous British instrument maker Andrew Guyton, ready-tuned to drop *D*. Guyton was to make two further replicas of the guitar for the movie *Bohemian Rhapsody*.

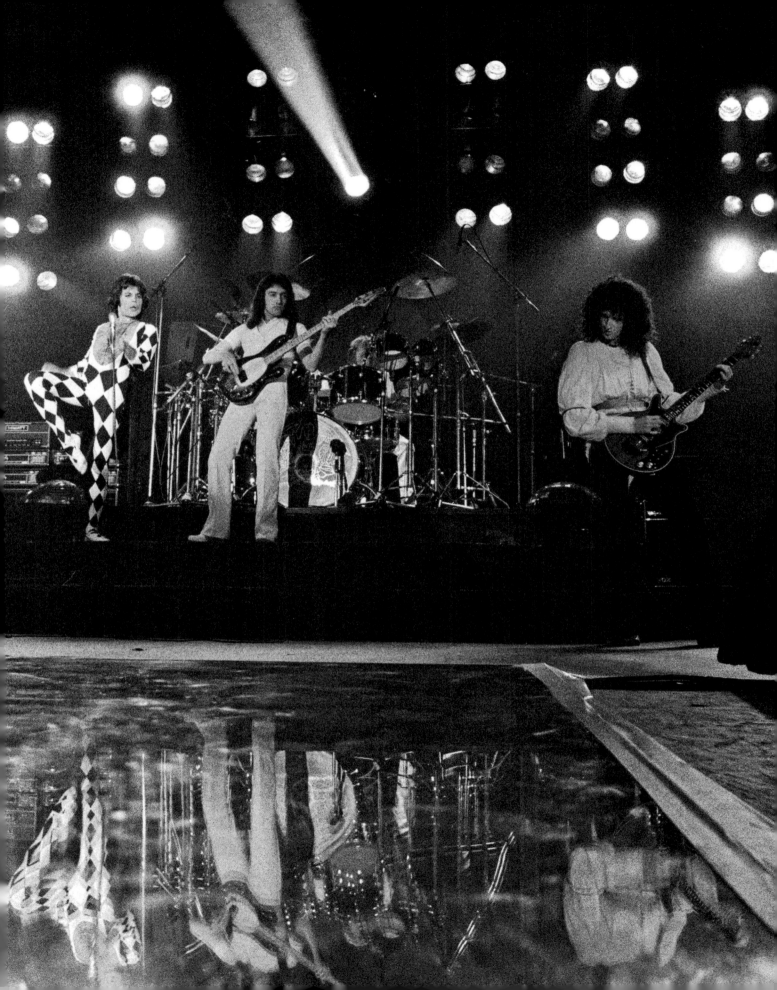

GOOD OLD-FASHIONED LOVER BOY

Freddie Mercury / 2:53

Musicians
Freddie Mercury: lead vocals, backing vocals, piano
Brian May: electric guitar, backing vocals
John Deacon: bass
Roger Taylor: drums, backing vocals
Mike Stone: additional vocals

Recorded
The Manor, Shipton-on-Cherwell, Oxfordshire: July 1976
Sarm East Studios, London: October 24 and November 5, 1976

Technical Team
Producers: Queen
Sound Engineer: Mike Stone
Assistant Sound Engineers: Gary Langan (Sarm), Gary Lyons (Sarm)

ON YOUR HEADPHONES
At the bridge in the song (1:43), we hear the sound engineer Mike Stone singing out to the narrator: "Hey boy! Where do you get it from? / Hey boy! Where did you go?"

The song was never played again in a concert after 1978 as Queen turned away from its vaudeville phase to concentrate on rock.

Genesis

In an interview in January 1977, Freddie Mercury commented, "'Good Old-Fashioned Loverboy' [*sic*] is one of my vaudeville numbers. I always do a vaudeville track."[48] Although Queen could be seen as a rock group with fierce riffs, Mercury and perhaps also May ("Good Company" from *A Night at the Opera*), delighted in deviating sometimes into swing and ragtime. As Mercury puts it: "Though 'Loverboy' [*sic*] is more straightforward than 'Seaside Rendezvous' [...]. It's quite simple piano-vocals with a catchy beat; the album needs it to sort of ease off."[48] It is true that after the anger and energy of "White Man," the song gave listeners' ears a chance to rest while their feet tapped to the irresistible rhythm of the song.

The lyrics are dedicated to David Minns, with whom Freddie had fallen passionately in love a few months earlier. They describe his elegance, his old-fashioned style, and his very traditional values. Minns commented later that if the song had really been written for him, it was in actual fact a self-portrait of Freddie: "Freddie [...] wrote that song, [...] which was about our relationship. He wrote that song about him, you know, dressing up, getting himself organized. He was courting. He was wooing me. That was all part and parcel of his performance."[60]

On January 4, 1977, Queen left for North America and a forty-one-concert tour. The New York concert in Madison Square Garden on February 5 was the high point of a triumphant reception. It was at this time that Freddie fell in love with Joe Fanelli, a twenty-seven-year-old chef, and he persuading Fanelli to follow him to London once the tour was over. This obviously marked the end of his relationship with Minns, and it was a bittersweet tribute to the rejected lover when "Good Old-Fashioned Lover Boy" came out on May 20, 1977, as a worthy addition to the group's first four-track release, entitled *Queen's First EP*.

The song is still a Queen classic, even if its release brought out the British music press's worst instincts. As usual, the rock critic Nick Kent spluttered with rage when writing about Queen, giving a sour account of the album and, by implication, "Good Old-Fashioned Lover Boy": "All these songs with their precious pseudo-classical piano

178 A DAY AT THE RACES

Ever the clotheshorse, Freddie was famous for his "crazy shopping" sprees during Queen's tours in Japan.

obbligato bearings, their precious impotent Valentino kitsch mouthings on romance, their spotlight on a vocalist so giddily enamoured with his own precious image—they literally make my flesh creep."[49] A well-deserved backlash saw Kent being criticized for the repetitions of the word *precious* in his article, its implications leading readers to accuse him of homophobia.

Production

Queen's last foray into vaudeville, this song marked the end of a page in the history of the group. Mercury's joyful and emphatic rhythms are accompanied by guitar solos carefully crafted by Brian May as orchestra parts and the lyricism of the multilayered vocals: All these elements disappeared at the end of the song and were never to reappear in the group's repertoire. For after *A Day at the Races*, Queen turned toward a cruder kind of rock.

A new version was later recorded for the video of the group shown on *Top of the Pops* on June 15, 1977. On this occasion, Freddie's vocal part is slightly different, particularly at the bridging passage where he changes "*When I'm not with you / I think of you always / I miss those long hot summer nights*" to "*When I'm not with you / I think of you always / I miss you.*" Was it fear of possible complaints from prudish television viewers that led Mercury to change his lyrics? We'll never know. The concluding section was provided by Roger Taylor, hidden away behind his drums but always ready to take the limelight. Most of the guitar parts (almost nonexistent in the original version) were also rerecorded for the occasion, giving pride of place to a Red Special. The chords were marked over the words, giving greater incisiveness to the whole. May also rewrote his guitar solo, a gift to the fans who are always on the lookout for rare versions of their favorite songs.

QUEEN: ALL THE SONGS 179

DROWSE
Roger Taylor / 3:43

Musicians
Roger Taylor: lead vocals, backing vocals, drums, timbales, rhythm guitar
Brian May: acoustic and electric guitars
John Deacon: bass

Recorded
The Manor, Shipton-on-Cherwell, Oxfordshire: July 1976
Sarm East Studios, London: November 5, 1976
Wessex Sound Studios, London: November 19, 1976

Technical Team
Producers: Queen
Sound Engineer: Mike Stone
Assistant Sound Engineers: Timothy Friese-Greene (Wessex), Gary Langan (Sarm), Gary Lyons (Sarm)

Roger Taylor, Queen's drummer, friendly jokester, and keeper of the peace.

Genesis

Roger Taylor, from whom we had come to expect intense and energetic numbers ("I'm in Love with My Car," "Modern Times Rock 'n' Roll"), comes up here with a ballad with elements of folk supported by a strong melody and meticulous production. Interviewed on television by Sally James, Roger commented that "[This is] my annual track. I suppose I seem to have a bit of a rock 'n' roll tag. I have my quiet moments as well, and this is one of those."[61] The words describe the monotony of everyday life seen by a young person, skeptical about the future, whose Sunday afternoons are passed in lazy idleness. The writer Georg Purvis expressed this adolescent ennui perfectly in his book *Queen—Complete Works*: "[The narrator is] essentially too young to enjoy what adults could but already past the border of childhood innocence."[5]

Production

Roger Taylor plays rhythm guitar in the recording of the song while Brian May slides his bottleneck up and down the neck of his Red Special. This technique increases the psychedelic sound of the song and is reminiscent of Geoffrey Robin Cable's production for "Funny How Love Is" for the *Queen II* album.

When recording this song for *A Day at the Races*, Roger wanted as broad a sound as possible, taking advantage of natural resonance. The sound engineer Mike Stone was faced with a huge challenge. By now, Roger's percussion section was enormous, with twelve drums, including a bass drum. Completing the kit were splash, crash, and China cymbals. How could they manage? Fortunately, the group had the use of the residential wing of the Manor Studios, where they were recording at the time. The technicians' solution was to put the drummer and all his kit in the billiard room. Rod Duggan, in charge of maintenance at the Manor, related how he had to deal with the collateral damage caused by vibrations from the drums: "Roger Taylor had his kit in there [...]. The mic leads would go out of the window [of the billiards room], across the lawn, and then through the door of the control room. Every morning there was at least one broken lightbulb on the billiard table [...]. All the lightbulbs were shaking out of the billiard lamps onto the green felt."[62]

TEO TORRIATTE (LET US CLING TOGETHER)

Brian May / 5:51

Musicians
Freddie Mercury: lead vocals, backing vocals
Brian May: guitar, keyboard, piano, harmonium, toy piano, backing vocals
Roger Taylor: drums, tambourine, backing vocals
John Deacon: bass

Recorded
Sarm East Studios, London: November 5, 1976
Wessex Sound Studios, London: November 19, 1976

Technical Team
Producers: Queen
Sound Engineer: Mike Stone
Assistant Sound Engineers: Timothy Friese-Greene (Wessex), Gary Langan (Sarm), Gary Lyons (Sarm)

ON YOUR HEADPHONES
At the end of the final song, at 4:41, we hear the return of Brian May's whirling guitar sound from the introduction to the album. It is once again the melodic loop with which the guitarist sought to recreate the drawings of M. C. Escher, master of the optical illusion.

FOR QUEEN ADDICTS
"Teo Torriatte (Let Us Cling Together)" was released as a single on March 25, 1977, in Japan only. The B-side featured "Good Old-Fashioned Lover Boy." The song was never performed live except in Japan—during the 1979, 1981, and 1982 tours.

Genesis
Relatively unknown to the wider public, "Teo Torriatte (Let Us Cling Together)" is one of Queen's most beautiful songs. In 1976, the world by now at their feet, it was toward their much-loved Japan that the group turned with this powerful number composed by Brian May. Concealed here and there throughout *A Day at the Races* are numerous hints of Japanese music—from the introduction to "Tie Your Mother Down" to the pentatonic kumoi scales used by Mercury in "You Take My Breath Away." They were intended for Queen's Japanese fans, who had opened their arms to the group even before success in the UK had arrived, giving them the courage to continue their labors in search of longed-for fame. Nothing could be more spectacular than the final number of this album. "I wrote the song 'Teo Torriatte (Let Us Cling Together)' about this strong bond we as Queen felt with the Japanese people,"[29] May was to say in 2017.

Freddie is the lead singer, venturing into Japanese for some of the verses, which were translated from English by the interpreter Chika Kujiraoka, a friend of Brian's whom they had met during one of their tours in Japan. Apart from the few French words slipped into "Seaside Rendezvous," this was the first time Queen had sung in a foreign language.

Production
The song begins with a series of chords played by Brian May on a Vox keyboard, doubled by a quiet piano. It is surprising to find this modern instrument in Queen's music since the group never truly departed from the beaten path, preferring to exploit the full possibilities offered by their instruments rather than seeking new ones. That said, we have the Wurlitzer on "You're My Best Friend" and the Dubreq Stylophone on "I Do Like to Be Beside the Seaside." Here, at 4:26, Brian May completes the song's sound palette with a harmonium, something of a surprise for the listeners but a sound that, in 1976, was entirely consistent with this era of experimentation. May also plays a toy piano, and Freddie sings this song with great delicacy, his voice literally soaring in the bridge at 3:27. It ends with a moving choral sung by all the members of the group and a number of other people present that day. Classic Queen!

COMPILATION

QUEEN'S FIRST EP

Queen performing live onstage. The rhythmic basis of Queen's output is underpinned by Deacon's Fender Precision guitar and Taylor's Ludwig drums.

Side A
1. Good Old-Fashioned Lover Boy / 2:53
2. Death On Two Legs (Dedicated to…) / 3:44

Side B
1. Tenement Funster (Single Version) / 2:56
2. White Queen (As It Began) (EP Version) / 4:35

UK Release on EMI: May 20, 1977 (ref. EMI 2623)
Best UK Chart Ranking: 17

A New Format

EMI chose an unusual format for the last single from the *A Day at the Races*. Released on May 20, 1977, it was, in fact, more of a mini-compilation than a classic single. The disc was called *Queen's First EP*, an EP (extended play) being a disc that was longer than a single but shorter than an album-length LP (long play). Side A featured "Good Old-Fashioned Lover Boy" and "Death on Two Legs (Dedicated To…)" with "Tenement Funster" and "White Queen (As It Began)" on Side B. The logic behind the selection of these numbers, already released in the same versions on previous albums and so familiar to Queen fans, was hard to discern. Even the idea of equal shares in the royalties was not observed, since no composition by Deacon was included. Two of the numbers were composed by Freddie Mercury, one by Roger Taylor, and the last by Brian May.

A Lukewarm Reception

Although Queen was able to persuade EMI to charge the same price for the EP as for a single, the reviews were disastrous. By releasing a disc with no new songs on it, the group was accused by the press of milking the public for yet more money. Queen's fans paid little attention to this release, and *Queen's First EP* got no higher than seventeen on the UK charts.

This flop followed hard on the heels of that of the previous single, "Tie Your Mother Down," which struggled to reach thirty-first place for sales in the UK. The musicians, just then in the middle of their European tour, became aware that a new wind was blowing. Queen was still offering what had become known as "old-fashioned" rock, at a time when punk music was taking over in the UK. But it was not yet to be the end of Queen. Determined to retain their crown and keep their fans, the group was to take a new direction on their next album with a less sophisticated and more aggressive form of rock.

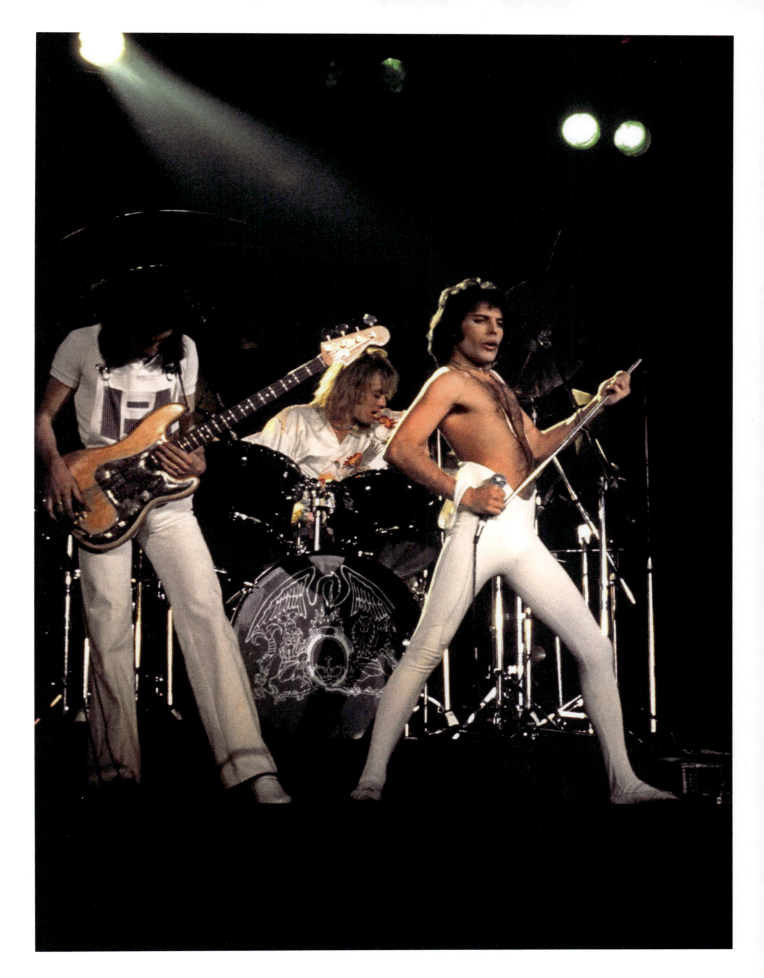

ALBUM

NEWS OF THE WORLD

We Will Rock You . We Are the Champions . Sheer Heart Attack . All Dead, All Dead . Spread Your Wings . Fight from the Inside . Get Down, Make Love . Sleeping on the Sidewalk . Who Needs You . It's Late . My Melancholy Blues

RELEASE DATES
United Kingdom: October 28, 1977
Reference: EMI—EMA 784
United States: November 1, 1977
Reference: Elektra—6E-112
Best UK Chart Ranking: 4
Best US Chart Ranking: 3

Behind all the makeup, Freddie Mercury was actually much more nonconformist than all the punk musicians of the time.

PUNK-PROOF QUEEN

After returning from their North American tour in April 1977, Queen had to adapt to the growing influence of punk music, personified by bands like the Sex Pistols, the Damned and the Clash. As the band's manager John Reid pointed out: "The punk stuff was supposed to be the opposite of what Queen did. They're coming from two opposite points of view: it was Anarchy in one side and monarchy in the other."[22] This was the first real obstacle Her Majesty had to face during her rise to power.

The album *A Day at the Races*, with its timeless songs, admittedly sold well—despite a frosty reception from rock critics—but ultimately it hadn't sold any better than *A Night at the Opera* from the previous year, and that worried the musicians.

The End of An Era

As usual, the British music press had their knives out for Mercury and his band. In June 1977, journalist Tony Stewart, who had written a rave review of the album *A Night at the Opera* just a year earlier in the *New Musical Express* (*NME*), was invited to John Reid's home in London to interview Freddie Mercury. The singer presented himself with all his usual flamboyance, and the day unfolded in a relaxed and pleasant atmosphere. Lunch was served to the journalist and his photographer, who immortalized the musician in a photograph taken on the patio of Reid's home. In spite of the seemingly relaxed afternoon spent with Mercury, Stewart felt that a link had been severed between the rock star and those who supported him; explaining in 2011 that "There was a butler, there was a bodyguard, [...] a few people with feather-dusters!"[22] The entire interview was published in the June 18, 1977, edition of *NME*, under the headline, "Is This Man a Prat?"[63] This latest blow marked the symbolic end of Freddie's already tenuous relationship with the British press.

As disrespectful as it was, the *NME* article only highlighted the change in Mercury's personality. It didn't have anything bad to say about the quality of the band's musical output. Over the course of Queen's winter tour, the singer had become a real rock star and had seemingly embraced every imaginable cliché that came along with his new persona. His personal entourage included a bodyguard, a masseur, and a hairdresser, as well as a dancer friend who set out his outfits for him. John Reid also assigned Freddie an assistant named Paul Prenter, who later became his personal manager.

In addition to their newfound rock stardom, the single members of Queen also found new success in love. Though Freddie had ended his relationship with David Minns, he had recently started dating a young cook named Joe Fanelli. Meanwhile, Roger Taylor was enjoying an idyllic love affair with Dominique Beyrand. Taylor had met Beyrand a year earlier when she was Richard Branson's personal assistant. At the time, Branson worked with the band to help organize their Hyde Park concert.

A Return to Their Rock 'n' Roll Roots

On July 27, 1977, the band moved to the Basing Street Studios to record the successor to *A Day at the Races*. The musicians were convinced that they had reached the end

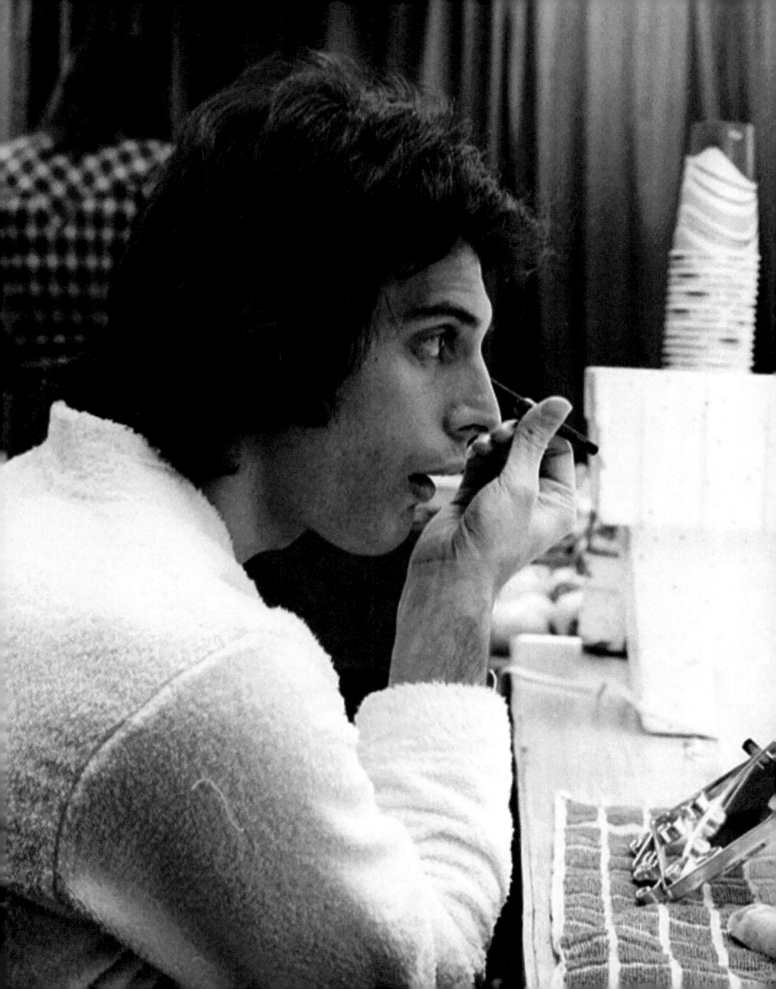

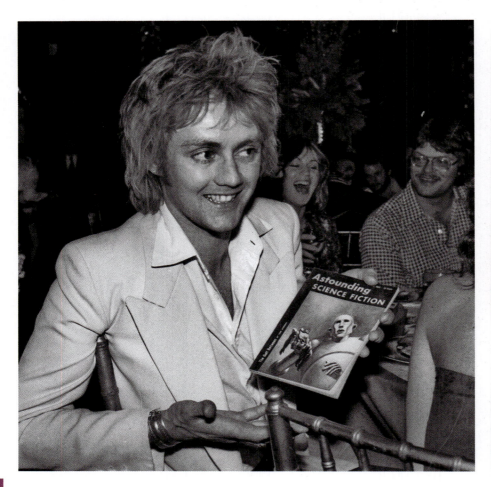

As with the group's two previous LPs, the band members hoped to use the title of a Marx Brothers movie as the title of their album. In this case, *Duck Soup* was the option the group proposed, but they were turned down by Groucho Marx, who sent them an amusing telegram: "I would like it to be named after my next movie: *The Rolling Stones' Greatest Hits*."[2]

Roger Taylor holding the October 1953 issue of *Astounding Science Fiction* magazine. The magazine's illustrations, which were created by Frank Kelly Freas, inspired the cover of *News of the World*.

of their musical experimentation phase, and they wanted to go back to their roots and produce a livelier and more spontaneous album. This change in direction would lead the band to face accusations of opportunism in the face of the emergence of the punk movement. This left the band feeling obliged to justify their change in artistic direction, as Brian May explained: "People said, 'You're doing that because of punk.' But it wasn't, really. It was that we'd gone as far as we could into the sort of baroque, complex, incredibly elaborate arrangement stuff, and we thought it'd be fun to go back to the way we used to play when we first started, which could be quite simple: guitar, bass, and drums."[64]

Roger Taylor had always been more rock-oriented than Freddie, as clearly shown on the tracks he wrote for the first albums, such as "Modern Times Rock 'n' Roll" or "Tenement Funster," and he was the first member of the group to fully embark on this new creative path. In the spring of 1977, the drummer began working on new songs in his personal studio. He recorded two songs that were released as a single under his own name on August 26. On the A-side was "I Wanna Testify," a cover of a song that the band the Parliaments had sung in 1967, and the B-side featured an original composition called "Turn on the TV." Taylor invested his own money in the production of the single, which did not achieve the level of success he had hoped for. "[It was] simply a bit of fun,"[2] he stated later.

Not all of the members of Queen rejected punk outright, but their interest in this new musical genre was tempered with a touch of suspicion. While Mercury hated the genre, Brian May appreciated its spontaneity and energy, though he couldn't bring himself to endorse the nihilistic and anarchistic message that accompanied so much of the punk aesthetic. As the guitarist explained, "Maybe I'm a sheltered soul, but I was a bit bewildered by all this stuff around them. The whole punk ethos was a bit manufactured and I never took it seriously."[2] As for Roger Taylor, on "Sheer Heart Attack" he had offered a real punk track, complete with a powerful guitar riff and fast tempo drums. The fact that this track dates back to the writing sessions for the *Queen* album, which took place in 1974 and well before the explosion of punk, serves as further proof that Queen was always one step ahead of the musical trends.

Uncomfortable Co-existence with the Sex Pistols

Fate seemed to be toying with members of Queen by constantly placing the punk movement's flagship band, the Sex Pistols, in their path. First, both bands were signed to the same record company, EMI. Then, it was the Sex Pistols who replaced Queen on the *Today with Bill Grundy* show after Queen had canceled their appearance. Airing on December 1, 1976, the sensational show catapulted the just-released single "Anarchy in the UK" to the top of the charts (see page 164). In August 1977, as Queen moved into Studio 1 at Wessex Sound Studios, the musicians realized that their neighbors were the Sex Pistols, who had come

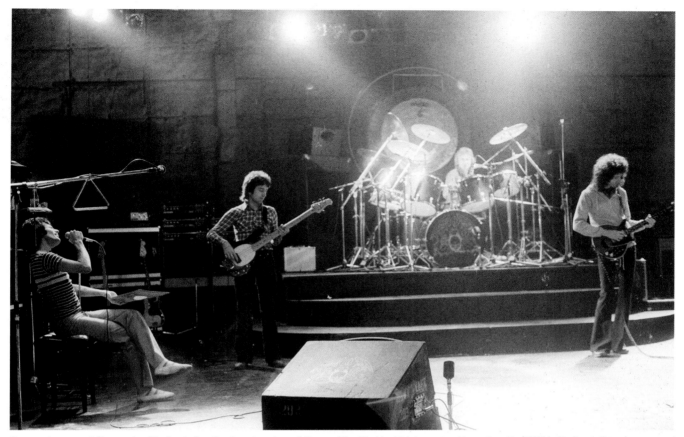
Queen rehearses at Shepperton Studios before the American tour of *News of the World*, which began on November 11, 1977, in Portland, Oregon.

to record their debut album! It was almost as if the powers that be at EMI got a kick out of sowing discord between the groups. And finally, and perhaps most egregiously, the most famous track from the Sex Pistols' first album would turn out to be "God Save the Queen," which was the exact same title as the last track off of *A Night at the Opera*.

The two bands managed to cohabitate successfully at Wessex Sound Studios and made progress with the recording of their respective albums. Although their musical universes might have clashed, the musicians from each group did have a respectful appreciation for one another. The relationship between the bands even became friendly, before an unfortunate event that is now the stuff of rock 'n' roll legend soured the relationship. In June 1977, the journalist Tony Stewart had asked Freddie about his red-and-white stage outfit, which had been inspired by the costumes of the Russian dancer Vaslav Nijinski. Stewart also asked Mercury about his relationship to dance and the unlikely connection between his popular music and the classical ballets he loved. In response, Freddie Mercury said simply: "*Darling, I'm bringing ballet to the masses.*"[63] Then, as Queen's technical manager Peter Hince recounts, "One day we were in the control room, and Fred was sat at the desk, and suddenly we heard this voice, and it was Sid Vicious who'd come in [...]. And he crawled into the room, [asking,] 'Have you succeeded in bringing ballet to the masses, yet?'"[22] About the incident, Roger Taylor would later bluntly assess, "Sid was a moron, you know, he was an idiot."[22] A few years later, in an interview with Molly Meldrum, Freddie Mercury explained his reaction to the Sex Pistols' bassist: "I called him Simon Ferocious or something, and he didn't like it at all."[41]

In Frank's Hands

After just ten weeks in the recording studio, *News of the World* was released on October 28, 1977. The album cover was adapted from an illustration by Frank Kelly Freas, which had originally been published in October 1953 and appeared on the cover of *Astounding Science Fiction* magazine. The image showed a giant robot with a sad expression holding a dead man in his hand, like a toy that the robot had accidentally broken. It was science fiction fan Roger Taylor who had suggested the harrowing image. Frank Kelly Freas agreed to adapt his original artwork for the record cover. For this new image, the robot holds Brian May and a bloodied John Deacon in his hand, while Mercury is shown falling from his hand into the void. When we open the cover, we find that the robot has pierced the roof of a public building—probably a concert hall—and Roger Taylor is shown plummeting from the roof. Terror can be seen on the faces of a group of onlookers who are fleeing from the scene. The cover of *News of the World* is undoubtedly one of the most beautiful album covers in the history of rock. The robot, whose expression is more tender than disturbing, was given the nickname Frank by the band, in honor of the album's illustrator.

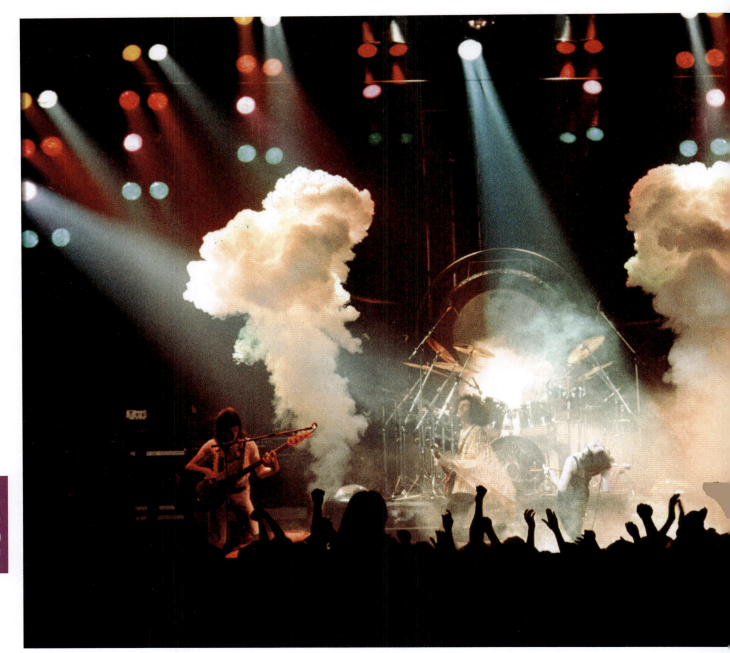

Year's End in California

This new album was a major success in the United Kingdom, thanks in large part to its two lead singles: the popular anthems "We Are the Champions" and "We Will Rock You," which were released on October 7, 1977.

The year ended on a high note for Queen, who embarked on a hugely successful American tour. It was the band's fifth tour of the states, and it included two sold-out nights at New York's Madison Square Garden on December 1 and 2, 1977. Brian May's parents, Ruth and Harold, attended both concerts. After applauding the band's magnificent performance, Harold, who had never fully accepted his son's decision to turn his back on a promising scientific career for the life of a rock star, told him "OK, I get it now. I can see why this has got you and I can see that it's worthwhile."[65] This tour offered the band a real taste of victory, because there was no longer any doubt that Queen had finally conquered America. The last concert of the tour took place on December 22 at the Inglewood Forum in Los Angeles. To close out the show, the band brought Father Christmas to the stage (Mercury's bodyguard in costume). Carrying Freddie on his back, Father Christmas was joined by the head of EMI, who was dressed up as a gingerbread man, and by John Reid, who was dressed as an elf. Three professional dancers also danced around Freddie: Stasha Vlasuk, Denise Russo Heep, and Jane Padgett. A Christmas tree and numerous other characters also wandered around the stage under a shower of confetti.

Back in the United Kingdom, the band took a few months to rest before setting off on a four-week tour of Europe in April 1978. In the meantime, John Reid, their stand-in Christmas elf, and the group's manager since 1975, quit his job.

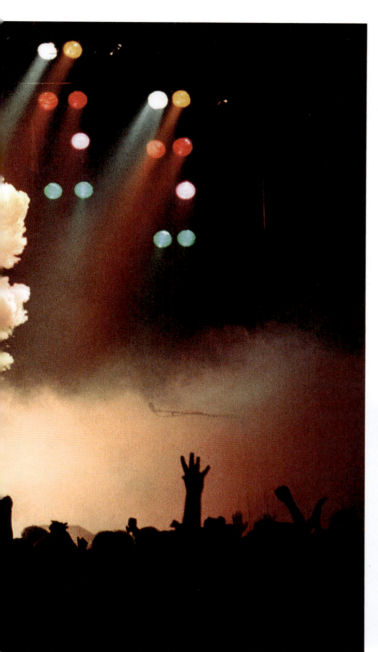

(Left) Queen in Inglewood, California, on December 22, 1977. At this point, the band was a major success in the United States.

(Below) Brian May and his parents backstage in December 1977 at Queen's Madison Square Garden concert in New York City.

FOR QUEEN ADDICTS

Brian May flew his parents to the United States on the Concorde so they could attend the band's concerts at Madison Square Garden in December 1977. May's father had helped to design the high-tech plane's Blind Landing System, and this flight was the first time Harold would see his work in action.

From Music to Business

John Reid's departure made the way for Jim Beach to become the group's new manager. Abandoning his position as a lawyer with the law firm Harbottle & Lewis, Beach started his new position by creating three separate structures to organize the group's business: Queen Production Ltd. for record production, Queen Music Ltd. for record publishing, and Queen Films Ltd. for future videos. As for John Deacon, he was focused on overseeing the group's internal finances, as Freddie Mercury revealed in an interview with *Circus* magazine: "'John keeps a very close eye on our business affairs,' says Freddie. 'He knows everything that's going on and shouldn't be going on. If God forsakes us now the rest of the group won't do anything unless John says it's all right.'"[66] The ever-discreet bass player was determined to put a halt to the evaporation of Queen's profits, and he took his role very seriously. But faced with the new income tax laws recently put into effect by the government of Labor prime minister James Callaghan, the band feared for its fortune. The new law removed a cap on income tax, and, like the Stones before them, Queen opted for tax exile, claiming that a large part of their activity took place abroad. In the spring of 1978 Queen decided to head off on a European tour in order to escape the excessive new tax law. When the tour was finished later that fall, the band bypassed the UK completely, and flew on to North America. Meanwhile, between July and October of 1978, Queen recorded their new album abroad in France and Switzerland. This was to be the first album the group recorded outside of the United Kingdom.

WE WILL ROCK YOU
Brian May / 2:01

Musicians
Freddie Mercury: lead vocals, backing vocals, claps, stomps
Brian May: electric guitar, backing vocals, claps, stomps
John Deacon: claps, stomps
Roger Taylor: claps, stomps

Recorded
Wessex Sound Studios, London: August 1977
Sarm East Studios, London: September 1977 (mixing)

Technical Team
Producers: Queen, Mike Stone
Sound Engineer: Mike Stone
Assistant Sound Engineers: Richard Stokes (Wessex), Gary Lyons (Sarm), Gary Langan (Sarm)

FOR QUEEN ADDICTS
The music videos for "We Will Rock You" and "Spread Your Wings" were shot on the same day, which explains why John and Roger are shown using the same instruments in both videos.

Genesis

On May 29, 1977, in the middle of their tour for the album *A Day at the Races*, Queen performed at the New Bingley Hall in Stafford, England. The hall, which has since been closed, was known at the time for its concerts featuring musicians like the Rolling Stones and the Who. That evening, the entire audience was on its feet singing along with Freddie Mercury. As Brian May recalled: "It's one of those gigs that you love: It's so sweaty and hot, the atmosphere is great, everybody's jumping down, making noise, and what they were doing is singing along. In those days, it was really new, I have to tell you. You just didn't go to concerts where people sang with rock bands. But in this particular occasion, they didn't stop."[22]

After they'd finished their set, the band returned to the backstage area when they suddenly heard the audience singing "You'll Never Walk Alone." Written by Richard Rodgers and Oscar Hammerstein II in 1945 for the musical *Carousel*, and originally performed by Christine Johnson, the song has since become the anthem of choice for several soccer teams in the United Kingdom. The effect on Queen was immediate. Though the musicians had recently decided to pare down their productions after the baroque experiments of their previous two albums, they drew inspiration from the audience's participation in order to create work they could truly share with the public. As Brian May later explained: "So we went home that night, thinking [...]: The audience is a bigger part of the show as we are now, so let's embrace it. But what can an audience do? What could you ask them to do? They're all crowded in there, they can't do much. They can stamp their feet, they can clap their hands, and they can sing. And they would be leading the song rather than the singer!"[64]

When the guitarist presented "We Will Rock You" to Freddie Mercury, the effect was immediate. Freddie loved it. Brian May would later explain the structure and meaning of the lyrics, saying: "In my head, it was the song of the three ages of men. The first age is the boy who thinks he can change the world. The second age is the man who thinks he's used to changing the world. And the third age is the old man coming to terms with the fact that he surrenders what he can do."[64]

Freddie Mercury was soon to become as famous a character as Jerry Siegel and Joe Shuster's Superman.

For some music historians, "We Will Rock You" is considered to be the first rap song, coming long before the larger movement and the first tracks of its pioneers, including Grandmaster Flash and the Sugarhill Gang.

Always in search of stage effects that would bring them even closer to their fans and widen their audience, the musicians now set themselves the goal of creating a unifying and timeless track, like a national anthem that their fans could recite by heart.

Ranked among the five hundred greatest songs of all time by *Rolling Stone* magazine in 2004, "We Will Rock You" hit number two on record charts in the United Kingdom and reached as high as number four in the United States. In the years since, "We Will Rock You" has gone on to become a top international sports anthem and can be heard being sung by fans in sports stadiums throughout the world.

Production

For the recording of the famous "boom boom cha" that serves as the rhythmic base for the song, no drums were used. Immortalized at Wessex Sound Studios, the rhythm was crafted by Brian May and the record's chief sound engineer, Mike Stone. The rhythm was kept deliberately simplistic, like a military march, so that the audience could easily reproduce it at future concerts. To get the right sound Stone first installed drum risers, which were rectangular platforms that could be adjusted for height and used to raise the instruments onstage. Next, Mercury, May, Deacon, and Taylor sat down on piano benches and began to beat out the famous rhythm with their hands and feet on the risers. Stone called on everyone he could find in the studio corridors to participate in creating the rhythmic base of the song. Andy Turner, then a young assistant sound engineer, recalls, "Early one evening, they came and rounded up me, [...] and Betty the tea lady, who lived in the council house next door to the studio, and got us all up on these drum risers [...]. We all stood there and did the 'boom-boom cha' take after take after take."[2] May and Stone then used a very short delay effect, in which the repetition frequency of the notes was set to the tempo of the song, to reinforce the impression of a huge crowd that the guitarist was seeking to reproduce.

Onstage, the famous beat was led by Taylor's drums in order to help guide the audience. May's guitar, which appeared only at the end of the title track in the studio version, often appeared in the intro when the group played the song live, coming in well before Freddie's vocals.

The Video

In January 1978, the band set to work on a music video for their song, which had been an international hit since its release on the B-side of the single "We Are the Champions" on October 7, 1977. The musicians, their technicians, and the director Rock Flicks met in the garden of a country house Roger Taylor had bought in Surrey, located just south of London. In the final video, the musicians appear almost frozen, standing in a snowy landscape, with rubber boots on their feet and gloves on their hands. They were placed on the drum risers set up for the occasion. Why was the scene set like this? Why was the group forced to film in such frigid conditions? That remains a mystery…

WE ARE THE CHAMPIONS
Freddie Mercury / 3:00

Musicians
Freddie Mercury: lead vocals, backing vocals, piano
Brian May: guitar
John Deacon: bass
Roger Taylor: drums

Recorded
Basing Street Studios, London: end of July 1977
Sarm East Studios, London: September 1977 (mixing)

Technical Team
Producers: Queen, Mike Stone
Sound Engineer: Mike Stone
Assistant Sound Engineers: Robert Ash (Basing Street), Gary Lyons (Sarm), Gary Langan (Sarm)

Single
Side A: We Are the Champions / 3:00
Side AA: We Will Rock You / 2:01
UK Release on EMI: October 7, 1977 (ref. EMI 2708)
US Release on Elektra: October 25, 1977 (ref. E-45441)
Best UK Chart Ranking: 2
Best US Chart Ranking: 4

> As soon as it was released in the United States, the song was adopted by the New York Yankees as the anthem for their team. The Philadelphia 76ers also used the track to warm up the crowd before basketball games.

Genesis

A sports anthem par excellence, "We Are the Champions" is inseparable from "We Will Rock You." Freddie wrote the song after being inspired by his experiences on tour during the spring of 1977. At each concert, spectators would stand up and sing along to the chorus of "Killer Queen" or "Bohemian Rhapsody." As Brian May recalls: "In a place like Birmingham, they'd be so vociferous that we'd have to stop the show and let them sing to us. So both Freddie and I thought it would be an interesting experiment to write a song with audience participation specifically in mind."[67] While May composed "We Will Rock You," it was Mercury who wrote "We Are the Champions." A tribute from the singer to his audience, the lyrics also seem to be a celebration of Queen's victory over their detractors, particularly the British press. The group denied this interpretation, arguing that the *we* of the song is a collective *we*, and that it is not just about the band members. But when you read the lyrics, there is little room for ambiguity: "*You brought me fame, and fortune, and everything that goes with it / I thank you all.*"

The song provoked mixed reactions from within the quartet, especially from Brian May, who never stopped commenting on its genesis: "I was kind of quite shocked because I thought, 'Are we really gonna stand up and say we are the champions, as opposed to every other group and every other person on the face of this earth?' And he said, 'Actually, that's not what it is. Rock 'n' roll is the only place where everybody has the feeling of being in a team, but you're not fighting anybody.'"[64] But faced with such a narcissistic lyric, the guitarist had his doubts: "I remember saying, 'You can't do this, Fred. You'll get killed.' He just said, 'Yes, we can.'"[24]

Production

Immediately recognizable from its piano introduction, the song adopts the same formula as "In the Lap of the Gods… Revisited" and makes use of a three-beat bar. This little trick worked wonders, allowing Freddie to write songs that could be taken up and carried by the audience. Brian May's guitar solo, which appears near the end of the track, reinforces the lyrical aspects of the song and even harmonizes

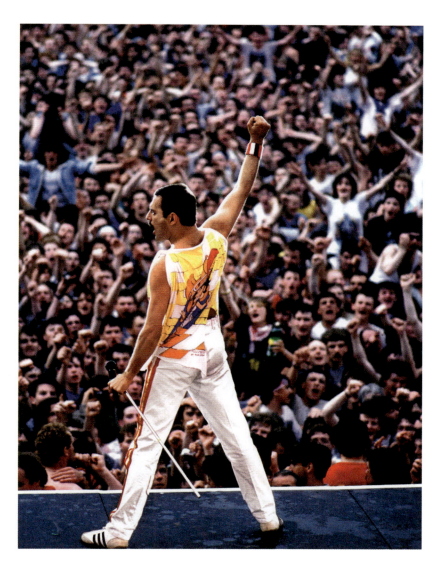

Freddie Mercury strikes a champion's pose during the band's last tour in 1986.

with Mercury's voice at 2:09. The writing of the song went through several stages, as the guitarist recounts: "I had done the guitar for that one fairly early on. Everyone said, 'That's fine.' [...] While Freddie was mixing the thing, I took a cassette tape [...] and the plan was they were going to finish it off in the morning. [...] I thought the guitar just didn't make it. It seemed weak in comparison to the way the song had evolved. [...] So I redid everything. There's a little piece towards the end when I was trying to make the guitar sing along with Freddie's vocals. [...] That's the sort of thing I like to listen to now. It's a nice moment that's been captured there."[68]

The Video

The accompanying video was shot on October 6, 1977, at the New London Theatre, in the Camden district of London. At the request of the musicians, more than one thousand members of the Queen fan club were invited to appear in the video, representing the crazed public. Bob Harris, the famous presenter of Radio Luxembourg, who had supported Queen from the very beginning, played the role of warm-up act and gave instructions to the extras on set: "We're gonna finish filming for 'We Are the Champions,' which, of course you know, is the new single from the band. [...] We'd like your involvement if you would, towards the end. [...] Shoot and sing with the band!"[64] Bruce Gowers, who served as the director on the "Bohemian Rhapsody" and "Somebody to Love" videos, was unavailable, so Derek Burbridge took charge of operations. Eventually, Burbridge would make a name for himself in the industry, going on to direct most of the music videos for the Police.

The song was released as a single (with "We Will Rock You" on the AA-side) the day after the video was completed. "We Are the Champions" is a popular sports anthem which, over the years, has become a staple of sporting events, sung by crowds in stadiums all over the world as a symbol of unity and victory. When the band performs today, the song serves as the conclusion of the group's final encore.

QUEEN: ALL THE SONGS 195

SHEER HEART ATTACK
Roger Taylor / 3:24

Musicians
Freddie Mercury: lead vocals, backing vocals
Roger Taylor: lead vocals, backing vocals, bass, rhythm guitar, drums
Brian May: electric guitar

Recorded
Wessex Sound Studios, London: August 1977
Sarm East Studios, London: September 1977 (mixing)

Technical Team
Producers: Queen, Mike Stone
Sound Engineer: Mike Stone
Assistant Sound Engineers: Richard Stokes (Wessex), Gary Lyons (Sarm), Gary Langan (Sarm)

Genesis

It's no coincidence that this song is named after Queen's third album, which was released in 1974. Roger Taylor had originally written this track for *Sheer Heart Attack*, but in the end the group felt the song didn't quite fit with the overall mood of the disc. In the summer of 1977, as everyone was proposing songs for the successor to *A Day at the Races,* the track seemed to be a perfect response to Queen's critics who were currently accusing the band of copying the then-popular style of punk music. The song, written before the punk movement even existed, sounds like a furious Sex Pistols track. Taylor was always up-to-date with the latest musical trends, and his input would consistently help to anchor Queen and drive them forward. As Brian May recalls, "Roger was much more aware than the rest of us. He sort of kept in touch with what was going on. I remember him talking about the Sex Pistols very early on, and getting excited about it."[64] The drummer recalls his first meeting with the punk band's singer in the corridors of Wessex Sound Studios: "We were recording *News of the World* in the same studio the Sex Pistols were recording their first album in. I mean, the first time I ever saw John Rotten, I was really shocked, cause I had never actually seen the whole *thing* in person. He sort of crystallized the whole punk attitude, and there's no doubt about it, the guy had amazing charisma."[69]

The song is a pure distillation of Roger Taylor–style rock 'n' roll. It was first released as a single in the UK on February 10, 1978, where it appeared on the B-side of "Spread Your Wings." When it was released as a single in the United States later that year, "Sheer Heart Attack" was paired with "It's Late."

Production

Roger Taylor doesn't just play drums on this track; he also serves as the song's bassist and guitarist. (He had played guitar on the demo track, a portion of which was used for the final recording.) An avid collector of rare guitars, he used his 1967 Fender Esquire Broadcaster for this song. The rhythm of the track is fast and relentless, similar to "Search and Destroy" by Iggy and the Stooges, which was released in 1973. The great curiosity of the song surrounds the lead vocals. Freddie is credited as the lead singer, but

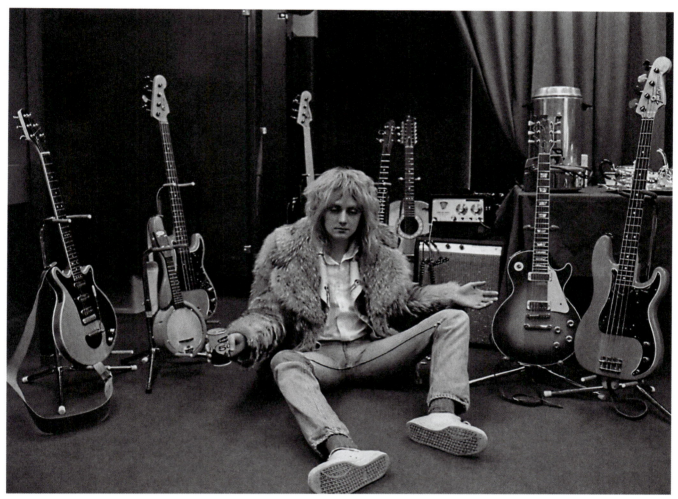

Roger posing among Brian's and John's instruments backstage during the American tour of *News of the World*.

many listeners swear they recognize Taylor's voice on the track. In 2003, Brian May demystified this source of discussion and discord on his website: "Well, it's mixture [...]. Roger had done a demo, and our usual practice was to use the demo's as a bed for the final track. Roger had sung it all, but the decision was made to get Freddie to [do] the job for the record. Roger was keen that Freddie sing it pretty much like the demo to retain the (kind of Punkspoof?) atmosphere. [...] But it's Freddie you hear doing the verses—double tracked. However, Roger's voice is there in odd lines, joining in on 'Hey hey hey,' and ''ticulate,' and the choruses are, I think, all of us, but with Roger up front [...]. In fact, it sounds to me like ALL Roger in the choruses in the mix now I listen to it..."[70]

FOR QUEEN ADDICTS

On August 24, 2017, on the occasion of the promotion of his book *Queen in 3-D*, Brian May took part in an interview on the radio show *Jonesy's Jukebox*, hosted by none other than Sex Pistols cofounder and guitarist Steve Jones!

As part of his preconcert ritual, Brian tuned his Red Special himself and warmed up on a small Fender amplifier.

ALL DEAD, ALL DEAD
Brian May / 3:10

Musicians
Brian May: lead vocals, piano, electric guitar
Freddie Mercury: backing vocals
John Deacon: bass
Roger Taylor: drums

Recorded
Basing Street Studios, London: July 27, 1977
Sarm East Studios, London: September 1977 (mixing)

Technical Team
Producers: Queen, Mike Stone
Sound Engineer: Mike Stone
Assistant Sound Engineers: Robert Ash (Basing Street), Gary Lyons (Sarm), Gary Langan (Sarm)

Genesis
Songs are sometimes used to exorcise childhood sorrows. For example, when music programmer Redbeard interviewed Brian May on his 2017 show *In the Studio with Redbeard*, he asked May how he came up with the lyrics to "All Dead, All Dead," a gentle ballad full of nostalgia and melancholy. The question was clearly an uncomfortable and emotional one for the guitarist: "This is going to be an owned-up time…I don't think I've ever talked about that track…Nobody's ever wanted to know about that track […]. It's very embarrassing to talk about this…Well, I think the things that started it off was my cat, losing my cat. My cat died when I was a kid, and I kind of never got over it. I think it was one of those things which surfaces now and again in different ways. I think I wrote the song for the album, thinking that I was writing it about something completely different, but I think part of it was sort of getting it out of my system."[71] The text evokes the nostalgia often felt for a lost loved one, and we now know for whom this beautiful and gentle ballad was intended.

Production
Brian May played the piano and sang lead vocals for this track, supported by Freddie Mercury on the backing vocals on the choruses. A guitar solo begins in at 1:44, featuring multiple guitar layers in order to create the illusion that a synthesizer has encroached into the band's sound. But this is not the case, and as soon as the guitar disappears, the piano and vocals regain their central roll.

A completely new version of the song, entitled "All Dead, All Dead" (Original Rough Mix), was offered on the anniversary edition of the album, which was released in 2017. This version is sung by Freddie Mercury, who added a few lyrics to his introduction, as if to underline the subject broached by his friend: *"Memories, memories, how long can you stay, to haunt my days?"* While this recording clearly shows Freddie's investment in his friend's composition, it lacks the emotional power of the original version. But it is impossible to blame the singer, since the subject of the lyrics was taboo among the members of Queen, as Brian May would later confirm: "In those days, we never talked about it in the band. We didn't talk about what things were about. Never."[71]

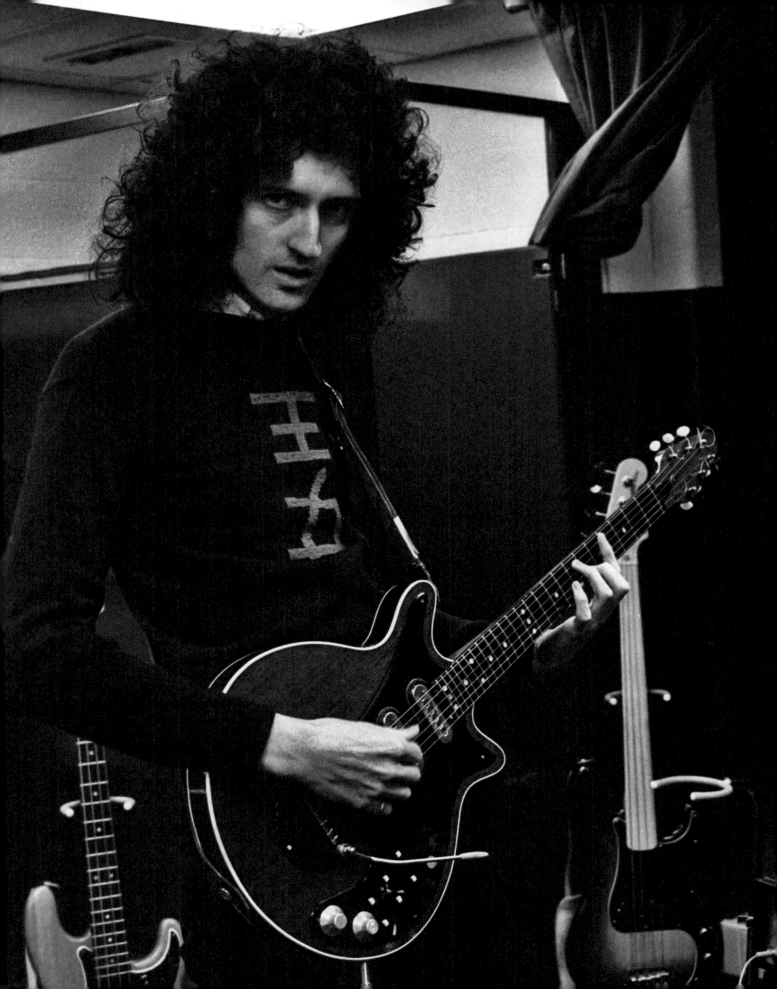

SPREAD YOUR WINGS
John Deacon / 4:36

Musicians
Freddie Mercury: lead vocals, piano
Brian May: electric guitar
John Deacon: bass, acoustic guitar
Roger Taylor: drums

Recorded
Basing Street Studios, London: late July 1977
Sarm East Studios, London: September 1977 (mixing)

Technical Team
Producers: Queen, Mike Stone
Sound Engineer: Mike Stone
Assistant Sound Engineers: Robert Ash (Basing Street), Gary Lyons (Sarm), Gary Langan (Sarm)

Single
Side A: Spread Your Wings (single edit) / 4:28
Side B: Sheer Heart Attack / 3:24
UK Release on EMI: February 10, 1978 (ref. EMI 2757)
Best UK Chart Ranking: 34

1977

> The video for "Spread Your Wings" was shot on the same day as the video for "We Will Rock You" at Roger Taylor's house in Surrey. It was also on this icy day in January 1978 that the termination of the contract between Queen and their manager, John Reid, was signed in the back seat of his car, which was parked in the driveway.

Genesis

The band regretted having released "Tie Your Mother Down" as a single from *A Day at the Races* instead of John Deacon's "You and I" which the musicians agreed would have made a better choice. Therefore, it was decided that the honor of appearing as the second single from the album *News of the World* would go to one of the two songs composed by the bass player. Released on February 10, 1978, "Spread Your Wings" did not meet with great success in the United Kingdom, only reaching thirty-fourth place on the charts. It was nevertheless one of Queen's most popular songs, thanks in particular to its choruses, with their unstoppable pop melodies.

The song's lyrics are touching and contribute to the melancholic aspect of the track, which tells the story of Sammy, who works cleaning the floor of the Emerald Bar. Secretly, Sammy dreams of changing his life, though his bullying boss accuses him of having no ambition: *"You're always dreaming / You've got no real ambition / You won't get very far."*

The habitually press-shy Deacon eventually revealed the story behind the song in 1978: "The song has to do with a number of personal experiences from recent years. I'd rather not say about what in detail, because I don't like to explain songs. People should figure it out for themselves, I think! [...] It's not always easy, let me tell you. You deal with a lot of things that aren't always pleasant. Of course, money is wonderful, but I don't need to be very rich. I just don't want to fall back into a state of poverty, which a number of fairly famous musicians have ended up in. I want to try to keep something for the future!"[72]

Despite the failure of the "Spread Your Wings" single, the band was now fully aware of the bass player's writing talent and his important place on the team, as Brian May explained: "John is probably the slowest writer, he's newer to it, but at the same time he's written a hit in America ["You're My Best Friend"], which I haven't and that's great [...]. The creative balance has shifted to become more of a group thing [...]. I think this is a very important time for the group, where it would be easy for us to go off and do each's separate thing, but our strength, and of any group, is that we

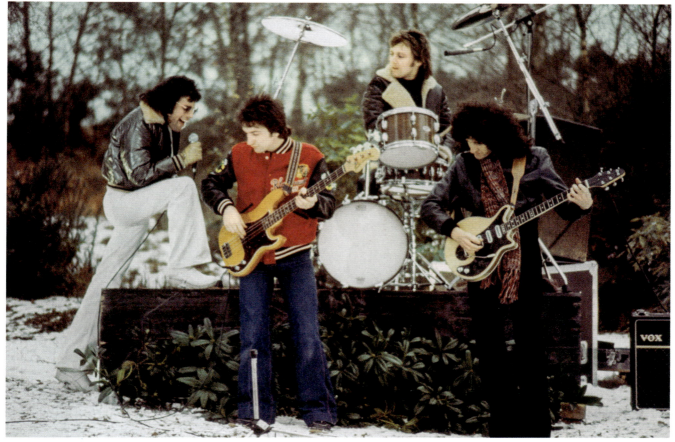

Brian May used a substitute guitar whenever the conditions of one of the group's music video shoots threatened his Red Special. In this case, bad weather forced Brian to use a John Birch replica as his substitute.

realize how to use each other in a complementary fashion. That's the most important thing we have."[73]

Production

Freddie sang Deacon's track superbly, emphasizing the lyrics with his compelling vocal dexterity, which is especially clear on the attack of the second verse and also during the song's poignant climax, at 1:42. John is featured on the acoustic guitar, which was used to introduce the chorus at 0:51 and again at 2:49. In addition to vocals, Freddie was at the piano. Notably, "Spread Your Wings" was the band's first song with no backing vocals to be released as a single, which proves once again that Queen was choosing subtlety and efficiency for the production of their new compositions. Notably, this is one of the few songs released by the band in the 1970s that ends with a fade-out rather than a clean and precise ending.

The Video

The video was shot in January 1978 by director Rock Flicks in the snowy garden of Roger Taylor's country house in Surrey. On this occasion, and for the first time, Brian May used a copy of his Red Special guitar, built by British instrument maker John Birch with assistance from his colleague John Diggins. "I had no proper spare, which was a very difficult situation to be in, because if I broke a string I'd have to pick up the Stratocaster or Les Paul, which would sound totally different from my guitar. So we came up with the idea of making a replica of my guitar, and I had three spare pickups that I'd bought as back-ups, so he built it around those," recalls Brian May. But he soon had to deal with a number of technical problems. "There were problems—it turned out that the pickups didn't have the warmth that mine had and the guitar was made of different materials, so it really didn't have the sustain. The tremolo wasn't as accurate and the neck was a lot thinner, because it was regarded as insane to make a neck as thick as mine. It was closer than the Gibson or the Fender to sounding like my guitar, but it didn't really fulfill the job very well [...]. Having said that, it was a nice piece of work."[55]

Despite Brian May's respect for the two craftsmen, the guitar was broken into three pieces on August 9, 1982, during a concert at the Brendan Byrne Arena in East Rutherford, New Jersey. The musician threw the instrument across the stage, no doubt annoyed by the repeated problems caused by the poor six-string. In 2006, the guitar, named the John Birch Replica, was finally repaired by Andrew Guyton and returned to May in perfect condition, after twenty-four years of convalescence.

FIGHT FROM THE INSIDE

Roger Taylor / 3:02

Musicians
Roger Taylor: lead vocals, backing vocals, drums, rhythm and bass guitars
Brian May: electric guitar

Recorded
Basing Street Studios, London: July 1977
Sarm East Studios, London: September 1977 (mixing)

Technical Team
Producers: Queen, Mike Stone
Sound Engineer: Mike Stone
Assistant Sound Engineers: Robert Ash (Basing Street), Gary Lyons (Sarm), Gary Langan (Sarm)

Genesis

For his second contribution to the disc, Roger Taylor pulled out this rock track that features a repetitive, heavy, and very catchy riff. Appreciating the energy and power of punk music, he underlines its ephemeral aspect and futility: *"You're just another picture on a teenage wall."* The song, written before the summer of 1977, was one of four tracks the drummer had worked on in his personal studio. He kept two of them—"I Wanna Testify" and "Turn on the TV"—for his first solo project (which was released as a single in August) and offered the other two to the band. "Fight from the Inside" has more in common with the rough side of tracks like "I'm in Love with My Car" or "Tenement Funster." It certainly contrasts with the gentler "Spread Your Wings," which is located earlier in this album's sequencing, but this dichotomy enabled the band to achieve the balance they were seeking for the album. "Roger has more material than the group's done," said Brian May, "but it's just a question of choosing material to give albums the right balance."[73] The drummer also provided lead vocals for this track and made it known that he wished to be considered as a singer within the band going forward. In an interview with the group on BBC Radio 1 in December 1977, when host Tom Browne introduced Roger as the drummer, Roger added, "And occasional vocals."[46]

Production

Taylor played bass on the final version of the song, just like he did on the song's initial demo recording. In the band's recording process, the final version of the song was frequently an extension of the demo that the musicians had worked on beforehand. This was how Deacon found himself playing guitar on "Spread Your Wings" and "Who Needs You," and it was how Taylor ended up playing guitar on "Sheer Heart Attack." Some of the tracks recorded as demos ended up in the final mix rather than being rerecorded in the studio.

Taylor's voice on this track is aggressive, perfectly serving the song's theme as he sings, *"You gonna fight from the inside / Attack from the rear."* "My voice sounds like sodding sandpaper!"[16] Roger quipped in 2006. A comparison that was somehow still more flattering than the one made by Freddie Mercury during the same period. "He's got a dog's whistle peak!"[22]

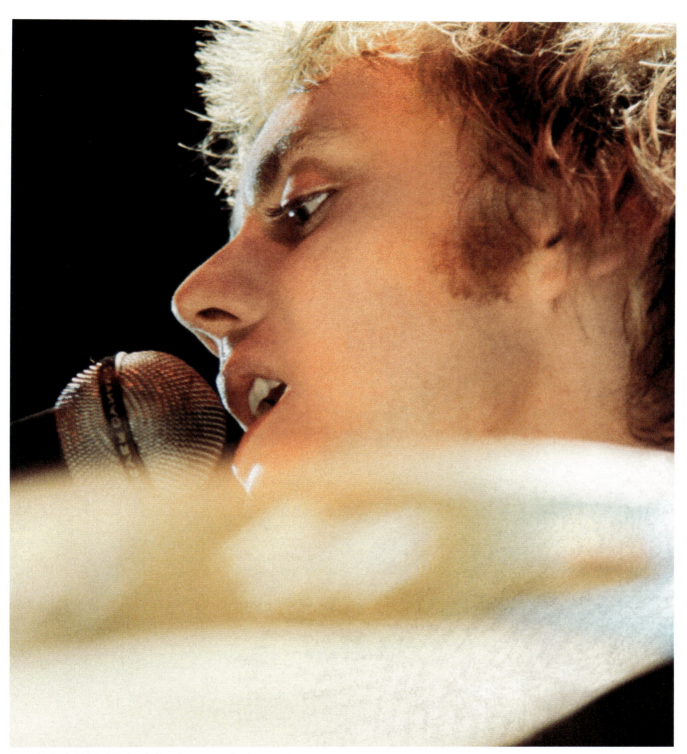
Roger Taylor is highly skilled as both a drummer and a singer onstage.

GET DOWN, MAKE LOVE

Freddie Mercury / 3:51

Musicians
 Freddie Mercury: lead vocals, backing vocals, piano
 Brian May: electric guitar
 Roger Taylor: drums
 John Deacon: bass

Recorded
 Wessex Sound Studios, London: August 1977
 Sarm East Studios, London: September 1977 (mixing)

Technical Team
 Producers: Queen, Mike Stone
 Sound Engineer: Mike Stone
 Assistant Sound Engineers: Richard Stokes (Wessex), Gary Lyons (Sarm), Gary Langan (Sarm)

Genesis

Freddie Mercury wrote only three tracks for *News of the World*. "Get Down, Make Love" was considered by the members of Queen to be a depiction of New York's gay scene, which the singer enthusiastically frequented on their American tours. While the musician didn't openly claim to belong to the gay community, he made no secret of his wild private life: "New York is Sin City. I slut myself when I'm there."[2] This is the first song in which Mercury evokes sexual abandonment and the joys of the flesh, as he did more frequently in the early 1980s, particularly on the album *Hot Space*. The lyrics of "Get Down, Make Love" are quite explicit: "*You take my body / I give you heat / You say you're hungry / I give you meat.*"

It was also at this time that the singer changed his stage look. Legend has it that after his meeting with Glenn Hughes, the famously mustachioed biker from the Village People, Freddie decided to adopt a similar image. So we discover a leather-clad Mercury with matching sunglasses and cap, revealing his hairy chest under a web of gold chains.

Production

The song's most curious passage is its break, which occurs between 2:37 and 3:18, and was described as an "erotic interlude"[74] by Brian May. The guitar notes mingle with Mercury's voice, to the rhythm of the hammering strokes of Deacon's bass and Taylor's drum. The guitarist once again fools the listener, who thinks he can hear the polyphonies of a Moog synthesizer. May is actually plugged directly into the console, without going through his traditional Vox amp, making use of the Eventide harmonizer effect racks available at Wessex Sound Studios. "That's the harmonizer thing, which I use. I've used it as a noise rather than a musical thing. It's controlled because I had a special little pedal made,"[74] explained the musician. As with many guitar effects that use pedals (placed on the floor and foot activated) or rack mounted (plugged into the console in the studio or onstage and activated by the sound engineer), there are several options available, and

For a time, Freddie adopted some of the dress codes of New York's gay community into his own style, including the leather and biker goggles shown here.

each effect has a specific role. Here, the purpose of the harmonizer is to harmonically double (or triple, depending on the setting) the note played by the musician. But since these modules are very sensitive and react very precisely to whatever the musician plays, it is very common for guitarists to use them to create strange sounds.

COVER

In October 1990 the industrial rock group Nine Inch Nails, fronted by the charismatic Trent Reznor, released a sultry cover of "Get Down, Make Love" as a bonus to their single "Sin."

QUEEN: ALL THE SONGS 205

SLEEPING ON THE SIDEWALK

Brian May / 3:05

Musicians
Brian May: lead vocals, backing vocals, electric guitar
Roger Taylor: drums
John Deacon: bass

Recorded
Wessex Sound Studios, London: August 1977
Sarm East Studios, London: September 1977 (mixing)

Technical Team
Producers: Queen assisted by Mike Stone
Sound Engineer: Mike Stone
Assistant Sound Engineers: Richard Stokes (Wessex), Gary Lyons (Sarm), Gary Langan (Sarm)

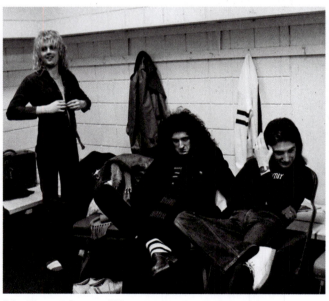

Brian May wearing one of his numerous pairs of clogs, which he liked to match with all his outfits when not onstage.

Genesis

"That was the quickest song I ever wrote in my life,"[74] said Brian May regarding this blues track. Just as in "Long Away," which appeared on *A Day at the Races*, the guitarist addresses a theme that is dear to him: the life of an artist on the road, with its moments of loneliness and disillusionment. Queen's relationship with its producers is also at the heart of this song. Like Pink Floyd's famous "Have a Cigar," which ironically recounted the relationship between the band and its label, "Sleeping on the Sidewalk" tells the story of a trumpet player who, starting from nothing, becomes a star under the encouragement of his producer before finally ending up on the street. It's a fear that stayed with the band, who were determined to hold on to the profits they'd earned after years of hard work.

Production

The song was conceived during a group jam session while Freddie Mercury was away. Mike Stone was on the console, Roger Taylor was on his drums, and John Deacon had his Fender Precision bass on his shoulder. Brian May suggested that they play a freshly written song following a classic blues scale, on which he wanted Roger to play "a simple blues shuffle beat type thing."[75] Legend has it that the band started playing without knowing that the tape recorder was on, but Brian May would later claim that everyone knew about it. The guitarist wanted to change their working method for this track: "English traditional recording at that time was: everybody has to be sealed off from everyone else. You know, the guitar has to be in this little cubicle, the drums have to be hidden away […]. There's no way that anything shall meet, except when it gets on the tape, and I thought it would be fun to do it opposite and just set up in the studio, so we can see each other and hear each other and play, so you wouldn't be able to change anything, but you would get the live feel."[71]

So Mike Stone started the recording, the band began playing, and the first take was the one that would be kept for the album.

WHO NEEDS YOU

John Deacon / 3:07

Musicians
 Freddie Mercury: lead vocals, backing vocals, cowbell, maracas
 Brian May: classical and electric guitars, maracas
 John Deacon: classical guitar
 Roger Taylor: drums

Recorded
 Basing Street Studios, London: July 27, 1977
 Sarm East Studios, London: September 1977 (mixing)

Technical Team
 Producers: Queen, Mike Stone
 Sound Engineer: Mike Stone
 Assistant Sound Engineers: Robert Ash (Basing Street), Gary Lyons (Sarm), Gary Langan (Sarm)

ON YOUR HEADPHONES
Turn up the volume at 1:22 to hear Freddie whisper, "Oh Muchachos!" (Oh boys!). This little contribution from Freddie reveals the light and relaxed atmosphere that reigned in the studio during the recording of this Latin-inspired ballad.

Genesis

With "Who Needs You," Queen attempted their first-ever foray into Latin music. Behind its gentle arrangements the song hides a set of spicy lyrics, in which the narrator is determined to take his revenge on a girlfriend who has abused his naiveté. Freddie Mercury sings the track, declaring to the girl: *"You were oh so, so sophisticated / Never interested in what I'd say / I had to swallow my pride / So naive you took me for a ride / But now I'm the one to decide."* As the bass player would later explain, "That arose spontaneously in the studio. I wrote it with the help of an acoustic guitar and it turned out to lend itself perfectly to that approach. We've also done a reggae-like version. Our songs change constantly when we're in the studio."[72]

Production

"Who Needs You," with its cha-cha-cha rhythm, has all the makings of a seaside song, played by the local band and to be enjoyed with a drink in your hand and the wind in your hair. But behind its lightness, its production hides absolute treasures of execution, such as its various classical guitar solos, majestically performed by Brian May. The six-string rhythm is played by Deacon, and the maracas are played by the singer and the guitarist, each placed on one side of the stereo. Freddie's voice is smooth and delicate, and the singer even tries a Spanish accent when he says *"I like it, I like it!"* right in the middle of May's main solo at 1:34. Even though the song is acoustically produced, Brian May reels off a few layers of Red Special in a few select places and delicately uses his guitar harmonics between 1:50 and 2:00, as if to symbolize the sound of bells.

Freddie and Brian, who is shown wearing one of Zandra Rhodes's signature outfits.

IT'S LATE
Brian May / 6:26

Musicians
Freddie Mercury: lead vocals, backing vocals
Brian May: electric guitar, backing vocals
John Deacon: bass
Roger Taylor: drums, backing vocals

Recorded
Basing Street Studios, London: late July 1977
Sarm East Studios, London: September 1977 (mixing)

Technical Team
Producers: Queen, Mike Stone
Sound Engineer: Mike Stone
Assistant Sound Engineers: Robert Ash (Basing Street), Gary Lyons (Sarm), Gary Langan (Sarm)

Single
Side A: It's Late / 6:26
Side B: Sheer Heart Attack / 3:24
US Release on Elektra: April 25, 1978 (ref. E-45478)
Best US Chart Ranking: 74

ON YOUR HEADPHONES
During their performance of "It's Late" from the October 1977 BBC Sessions, Mercury and May also performed the "erotic interlude" from "Get Down, Make Love" (see page 204).

Genesis

After raising the subject previously in "Now I'm Here" and "She Makes Me (Stormtrooper in Stilettoes)," Brian May once again implicitly addresses his romantic relationship with the mysterious Peaches (see page 100). The guitarist, then in a relationship with Chrissie Mullen, had fallen under the spell of this young woman whom he'd met in the spring of 1974 in New Orleans.

Though the artist never mentions the enigmatic Peaches by name, the lyrics are crystal clear, narrating a triangular romantic relationship in which the author has become entangled. The structure of the lyrics was precisely thought out by the guitarist, who explained his work to radio host Redbeard in 2017: "It was fairly personal, and it's written in three parts. It's like the first part of the story is at home, the guy is with his woman. The second part is in a room somewhere. The guy is with some other woman that he loves and can't help loving, and doesn't know what to do. And the last part is: He's back with his woman, trying to talk about it and rationalize it and make sense of it all. I think I'd write it almost the same if I had to write it again today."[71] The epilogue to the Peaches episode took place at the launch party for the *Jazz* album in New Orleans, on October 31, 1978, when Brian May left the party early to go in search of the beautiful American woman. "You know that feeling, where everything's going on, everything's wonderful, fabulous, but inside there's this big hole?" the guitarist asked in 1998. "I'd fallen in love some years before in New Orleans and I expected that I would see her, but she wasn't there. I didn't find her but she found me later on."[2] Still in a relationship with Chrissie Mullen, May was long tormented by the mess that this encounter caused and the conflict that raged between his rock star life and his family life.

"It's Late" was released as a single only in the United States on April 25, 1978. Despite its strong potential and high emotional impact, it didn't achieve the success the band had hoped for, never reaching higher than seventy-fourth on the US charts.

Production

In February 1977, while Queen was performing two nights in a row in Texas, Brian May went to the Mother Blues club in Dallas to listen to Rocky Athas perform.

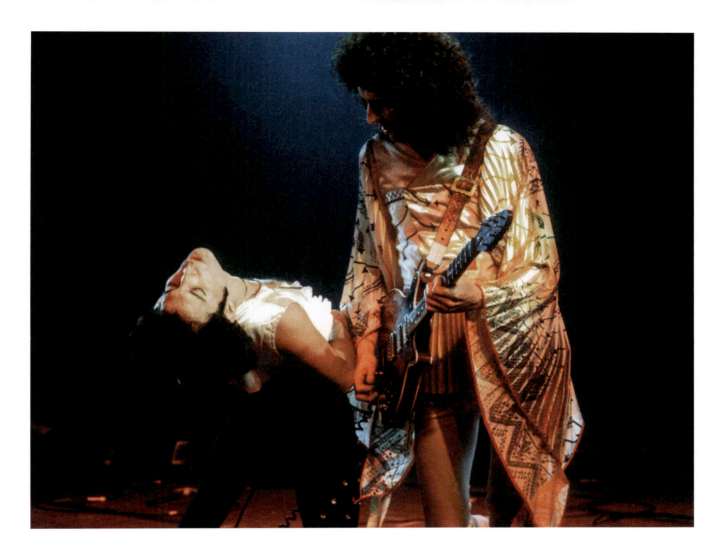

This singer-guitarist used a totally new technique, then called *hammering*, or *tapping*, which he claimed to have borrowed from Billy Gibbons, the guitarist and singer from ZZ Top. After the concert, May met the bluesman and told him, "That's great! I'm going to nick it!"[76] The guitarist later explained this new way of playing in detail: "That was actually hammering on the fingerboard with both hands. [...] I was so intrigued by it, I went home and played around with it for ages and put it on 'It's Late.' It was a sort of a double hammer. I was fretting with my left hand, hammering with another finger of the left hand, and then hammering with the right hand as well. It was a problem to do onstage; I found it was a bit too stiff. It's okay if you're sitting down with the guitar. If I persevered with it, it would probably become second nature, but it wasn't an alleyway which led very far, to my way of thinking. It's a bit gimmicky."[54]

In February 1978, one year after Brian May's discovery of this newfangled technique, a certain Eddie Van Halen popularized this style of playing in his instrumental track "Eruption," from the band Van Halen's eponymous first album. He would go on to become one of the most famous guitar heroes of the 1980s, achieving even further fame as the soloist on Michael Jackson's "Beat It."

For Queen Addicts

In 1983, in a video shot by a production company called Star Licks, Brian May explained precisely how to perform the solo of "It's Late." Now available on the "Brian May Official" YouTube channel, the video is a must-watch for diehard fans and students of the guitar.

With "My Melancholy Blues," Freddie Mercury paid tribute to the divas he admired most: Aretha Franklin and Liza Minnelli.

MY MELANCHOLY BLUES
Freddie Mercury / 3:33

Musicians
Freddie Mercury: lead vocals, piano
John Deacon: bass
Roger Taylor: drums

Recorded
Wessex Sound Studios, London: August 27, 1977
Sarm East Studios, London: September 1977 (mixing)

Technical Team
Producers: Queen, Mike Stone
Sound Engineer: Mike Stone
Assistant Sound Engineers: Richard Stokes (Wessex), Gary Lyons (Sarm), Gary Langan (Sarm)

1977

Genesis

With "My Melancholy Blues," Queen made their first overt foray into the jazz style, providing *News of the World* with a final track that completes the album's broad musical palette, on which rock, punk, cha-cha-cha, blues, and even rap styles are represented.

As the title indicates, this song is a pure distillation of melancholy and sadness. The atmosphere is reminiscent of songs from the film *Cabaret*, which Mercury adored, such as "Heiraten (Married)" or "Maybe This Time," which was performed by the singer's idol, Liza Minnelli. There is every reason to believe that Mercury is referring to himself in the song's lyrics, which evoke his new status as a star: *"I'm causing a mild sensation / With this new occupation / I'm in the news / I'm just getting used to my new exposure."* Queen revisited the cabaret-jazz atmosphere again in their next album with "Dreamers Ball," which was written by Brian May.

Production

The track was recorded at Wessex Sound Studios in London in August 1977. The booth, which had been completely refurbished two years earlier, provided sound engineer Mike Stone with a recording quality that was second to none, and the brand-new Cadac console and the high-end Neumann and AKG microphones enabled the technicians to work in the best possible conditions. Freddie Mercury played "My Melancholy Blues" on the Bösendorfer Imperial piano in Studio 1. Known for its warm and brilliant sound, the instrument also includes an unusual feature: it is the only concert piano that covers eight octaves, thanks to its ninety-seven keys (instead of the usual eighty-eight). This track also offered John Deacon the chance to introduce his new Fender Precision Fretless bass guitar, which, as the name suggests, was equipped with a fretless neck. The instrument, used onstage when the band performed "39," produced a sound similar to that of a double bass, perfectly in keeping with the jazz atmosphere that Mercury wanted for "My Melancholy Blues."

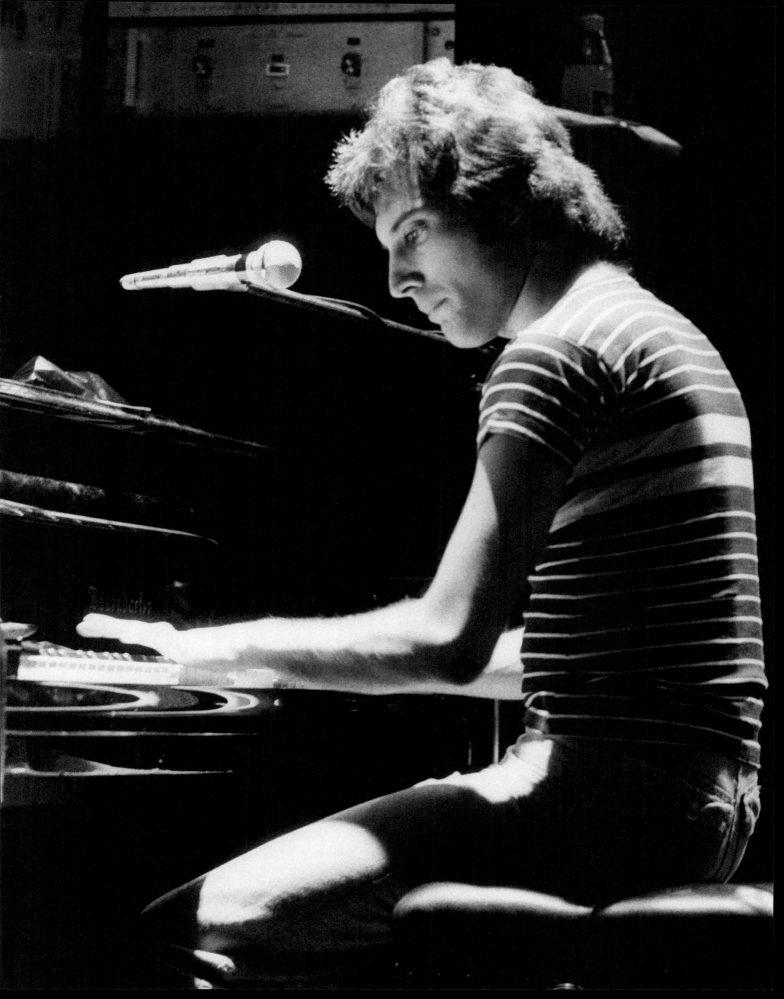

MIKE STONE: THE FIFTH MEMBER OF QUEEN

In the late 1960s, the young Mike Stone was a teaboy at Trident Studios. *Teaboy* is a colloquial term used in Britain to describe any kind of entry-level or assistant work, and Stone's new job offered him the chance to learn the trade by watching producers work on records by artists such as David Bowie and Elton John, while waiting for a job as assistant sound engineer to become available. As Brian May explains, "[This was] the way things were in those days. You didn't go to university to learn how to be an engineer. You did your apprenticeship by signing up as a teaboy in a studio, and then, if you were lucky, you got to be an assistant engineer, and if you were very lucky and worked hard for a long time you got to be an engineer."[29]

A Trusted Hand at the Controls

By 1972, Mike Stone had risen through the ranks to become a sound engineer, and he began working alongside Roy Thomas Baker, who was in charge of producing Queen's first album for Trident. Very quickly, Stone made himself indispensable at the controls and became close to the quartet, owing to his friendly demeanor and his technological know-how. Assisted by Brian May, Mike Stone notably took over the mixing of the single "Keep Yourself Alive," which the band wasn't satisfied with. Stone was able to provide the band with a version of the song that lived up to their expectations. It is this version that finally appeared on the album *Queen* in July 1973.

In 1976, when the band decided to produce their own records, Mike Stone remained with the group, since they considered him to be an essential part of their production process. One of Stone's primary responsibilities was the managing of the group's vocal harmonies, which were often arranged in complex layers. A brilliant technician and an outstanding visionary, Mike Stone was the architect of the harmonic structure of "Bohemian Rhapsody" and "Somebody to Love," as well as "Good Old-Fashioned Lover Boy." He was also behind the production of the hit "We Will Rock You," where he endlessly multiplied the famous "boom boom clap" as well as providing back-up vocals in the chorus.

A Last Tribute

After having collaborated with numerous artists, including Asia and Whitesnake, during the 1980s, Mike Stone unfortunately fell victim to his penchant for alcohol. The sound engineer and producer sadly died in 2002, just as he was planning to remix Queen's first six albums in the new DTS Surround format. Brian May wrote a eulogy for him: "Sadly we will have [to] do it without his physical presence. But his personality and influence are still with us, loud and clear."[77] In his book *Queen in 3-D*, the guitarist admiringly commented on a rare snapshot of Mike and Freddie Mercury taken during the recording sessions for *A Night at the Opera* in 1975: "The fabulous Mike Stone was immensely underrated [...]. Amazingly talented guy, very funny. [...] Mike has incredible ears for blending sound. He would just gently touch all the tone controls on the desk [...] and would magically make things blend together in the right way. Quite amazing!"[29]

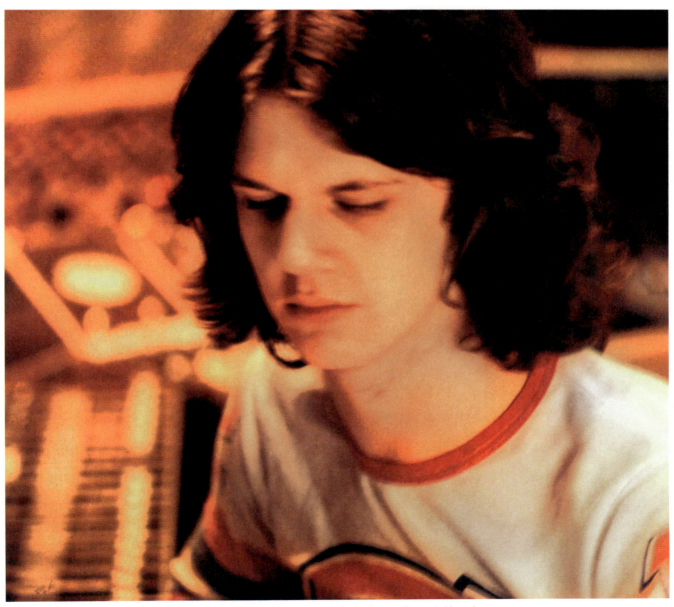
The student surpasses the master: Mike Stone eventually took Roy Thomas Baker's place at the control board, and his immense talent would help him to produce some of Queen's greatest hits.

FOCUS ON...

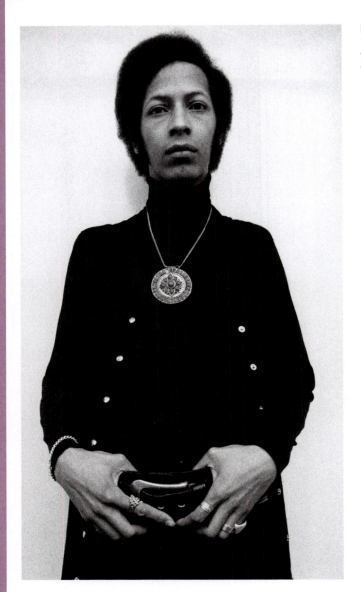

Peter Straker, photographed in 1970 during his starring run in the hit London production of the Broadway musical *Hair*.

PETER STRAKER: "THIS ONE'S ON ME"

A British singer of Jamaican origin, Peter Straker made his name as Hud in the first British version of the musical *Hair*, which debuted in 1968. His perfectly mastered voice, as well as his taste and talent for dance and comedy, helped him find his place in the theater where he earned roles in the rock operas *Tommy*, *The Rocky Horror Picture Show*, and *The Phantom of the Opera*. In 1972, he released his first single, "The Spirit Is Willing," which was an adaptation of sorts based on "Jesu, Joy of Man's Desiring," composed by Johann Sebastian Bach in 1723. The track reached fortieth place on the British charts but failed to make Straker a household name.

A Solid Friendship

It was at Provan's restaurant in November 1975 that Straker first met Freddie Mercury. The singer from Queen was accompanied by John Reid, while Straker was dining with his manager, David Evans. The two businessmen knew each other well, and introductions were quickly made. The two singers quickly became friends and they began to meet at Provan's regularly. Peter Straker recalls: "I then invited him to my birthday party and [...] he was very shy, but he did turn up and had a good time and we really became good friends after that."[18] After that first festive evening in 1975, the two artists spent more and more time together, touring London's theatres, cinemas, and opera houses over the following two years until they became inseparable.

A Production with a Queen-ian Flavor

When Freddie Mercury founded his company Goose Productions Ltd. in the spring of 1977, the first artist he

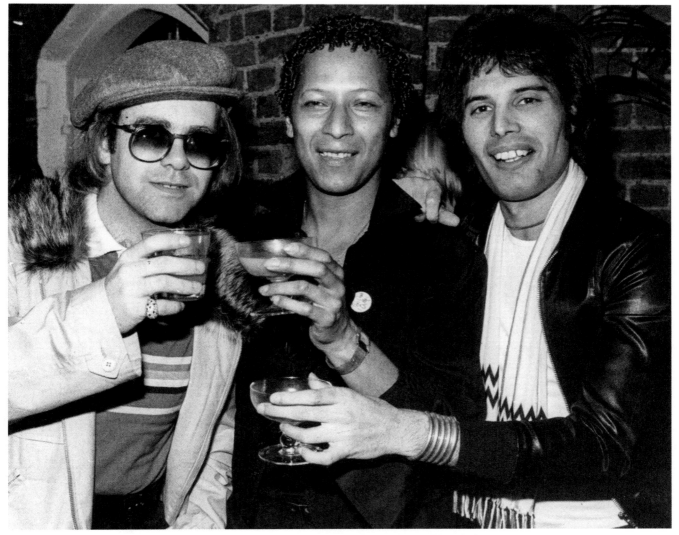
Peter Straker remained one of Freddie Mercury's closest friends until the latter decided to distance himself a few months before Freddie's death. Elton John, on the other hand, would remain close to Freddie until the end.

signed was Peter Straker, who dreamed of recording his first album. Freddie invested £20,000 to produce his friend's record, and he also secured the backing of EMI to distribute the disc, as the label could not refuse the rock star anything. The musicians hired for the recording were Mike Allison and Mike Franks on guitars, Peter Russell Brewis on the keyboard, Marc Fox on bass, and Alan Savage on drums. Entirely produced by Freddie Mercury and Roy Thomas Baker, the album was recorded at the Wessex Sound and Sarm East Studios in the spring of 1977, just before recording began on *News of the World*.

Released in November 1977, the disc contained ten uneven tracks that failed to make any headway with the public. Despite a catchy lead single, "Ragtime Piano Joe," that featured style and arrangements reminiscent of Queen's music hall digressions "Bring Back That Leroy Brown" and "Seaside Rendezvous," Peter Straker's album, entitled *This One's on Me*, was not as successful as Mercury's previous production, the song "Man from Manhattan" by Eddie Howell.

From Jamaica to the Flat Country

Despite the failure of Straker's first album, Goose Productions Ltd. produced a follow-up record in 1978, entitled *Changeling*. Freddie Mercury did not participate in the production process on this album, instead entrusting the task to Tim Friese-Greene, the former assistant sound engineer at Wessex Sound Studios who had gone on to become a producer.

Straker's career has had its ups and downs, but the quality of his vocals has earned him well-deserved recognition, and indeed he remains a highly prolific artist. One of the highlights of his career was his 2013 show *Peter Straker's Brel*, in which he performed songs by the famous Belgian singer Jacques Romain Georges Brel, which were translated into English for the occasion.

QUEEN: ALL THE SONGS 215

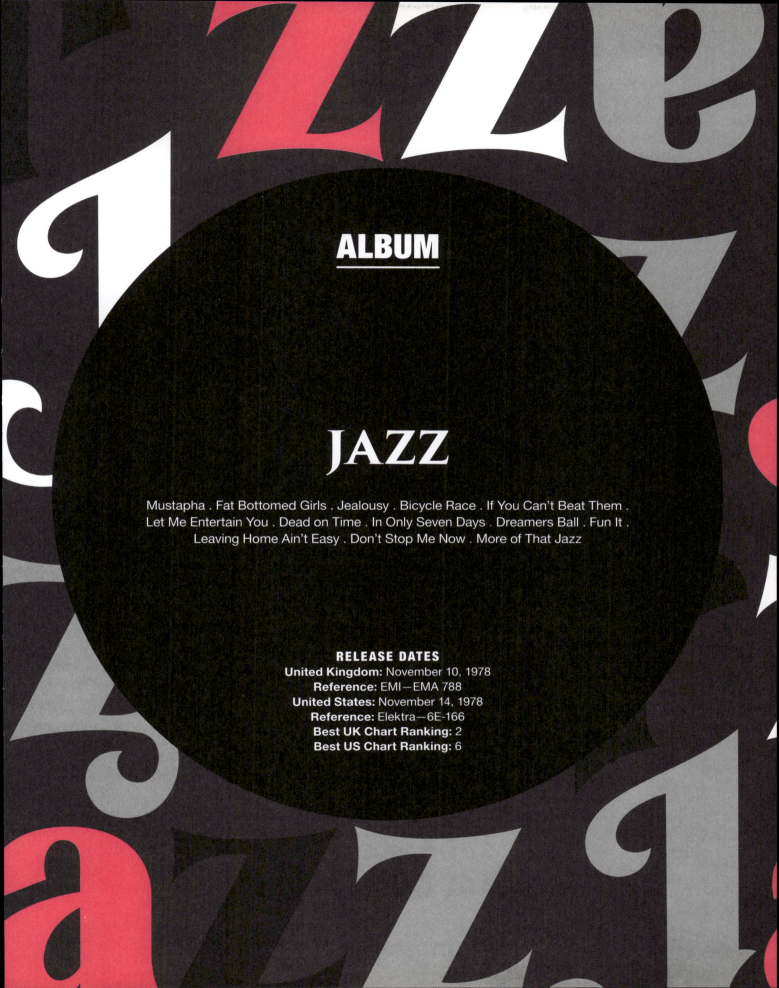

ALBUM

JAZZ

Mustapha . Fat Bottomed Girls . Jealousy . Bicycle Race . If You Can't Beat Them . Let Me Entertain You . Dead on Time . In Only Seven Days . Dreamers Ball . Fun It . Leaving Home Ain't Easy . Don't Stop Me Now . More of That Jazz

RELEASE DATES
United Kingdom: November 10, 1978
Reference: EMI—EMA 788
United States: November 14, 1978
Reference: Elektra—6E-166
Best UK Chart Ranking: 2
Best US Chart Ranking: 6

The New York City skyline shown in the background of this photograph is merely a backdrop. This photograph of Queen was taken in the corridors of Super Bear Studios, located in the French Alps.

A REUNION WITH ROY THOMAS BAKER

For fiscal reasons (see page 191), Queen decided to record *Jazz* outside of the British territory, which was a first for the group. Two studios were chosen for the creation of the successor to *News of the World*: the Mountain Studios in Montreux, located opposite Lake Geneva in Switzerland, and the Super Bear Studios, located in the French Alps. The recording for the disc was scheduled to take place over a four-month span, from July to October 1978. In order to ensure that they also avoided tax liabilities in these host countries, the musicians spent two months in Switzerland, and then two months in France, the period for which tax on income was inapplicable in both countries.

As Mike Stone was not available to handle the technical production on this new album, Mercury and his band called upon the services of Roy Thomas Baker, the producer of their first four albums, who had played an integral part in the creation of numbers such as "Killer Queen," "You're My Best Friend," and "Bohemian Rhapsody." The group, who had decided to produce its albums on its own beginning with *A Day at the Races*, now preferred to focus on the writing and to entrust the recording to an expert. "There was no argument or anything," as Taylor put it, concerning the group's earlier separation from Baker in 1976. "We just wanted to produce ourselves. It's simple as that. [...] We found that we could after two albums, but we also thought that for *Jazz*, it was too much strain and we don't really need extra stress, so we decided to get in somebody to take care of the technical end. As usual, we did a joint production."[78]

Remotivating the Troops

Baker was delighted to join Queen again; he left the United States where he now lived, and joined the group for the summer. At the time, Baker was basking in the success of the first (eponymous) album from the Cars, which he had produced. "Roy had done the Cars album in a few weeks, and it had been a huge hit, which made us think." Brian May explained. "[...] With *Jazz* he came back incredibly focused, and we thought it might re-ignite the flame within the band."[79] During that summer of 1978, a "reignition" was exactly what the band needed. After years of relentless touring and recording, the band members needed a chance to reaffirm their bond, and to rekindle the sense of team spirit and camaraderie that had been present in the studio during their earlier recordings. In the past six years, the group had imposed a frenetic recording pace upon itself, recording an album a year and then taking the album on a worldwide concert and publicity tour. Despite endless months spent together on the road, the musicians had somehow drifted apart from each other. For the American portion of the *News of the World* tour, the group no longer took one single car to the backstage entrance before each show; instead, they opted to take four separate limousines, each one conveying one musician and their entourage. "I don't think we were as much of a group at the time,"[2] said Roger Taylor with a hint of regret. This sentiment was confirmed by Brian May: "To be honest, there were times when we couldn't tolerate each other offstage."[2]

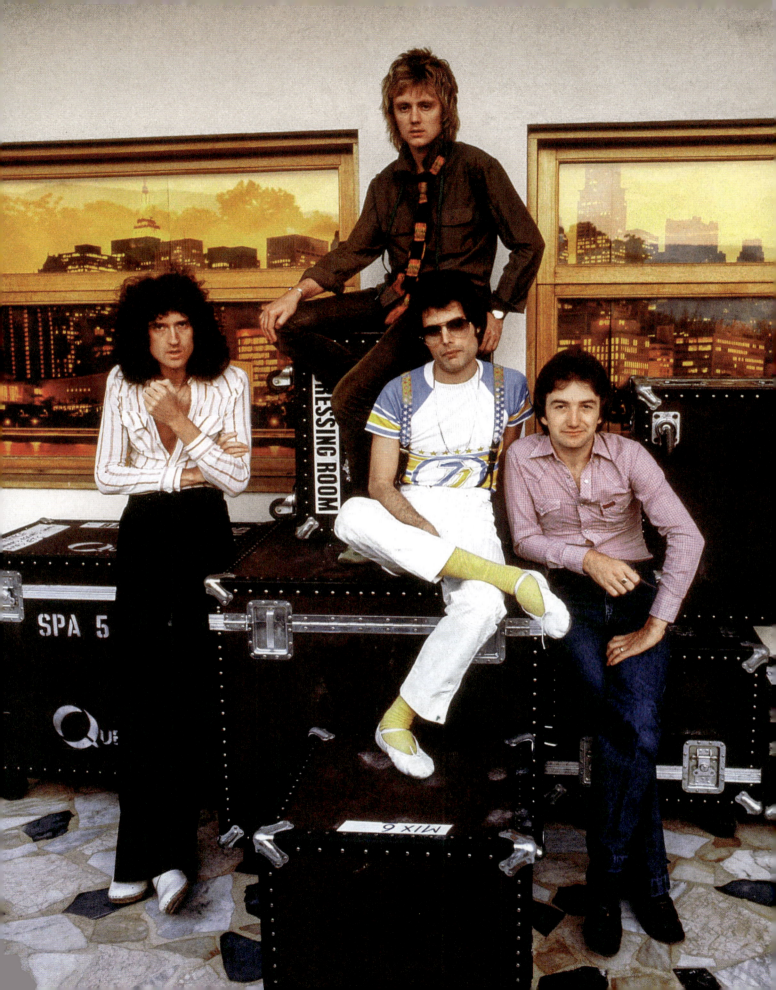

Queen's recording space at Mountain Studios in Montreux, Switzerland.

For Queen Addicts

When Roy Thomas Baker arrived at the Super Bear Studios in September 1978, he had the carpet ripped out because he feared it would make the acoustics too flat. But after a few recording tests were done in the newly carpet-less space, Baker changed his mind and had the carpet relaid by the technical team.

The Mountain Studios were built in Montreux, Switzerland, in 1975. The building had previously caught fire during a Frank Zappa concert on December 4, 1971, sending smoke drifting over Lake Geneva, and inspiring Deep Purple's famous song "Smoke on the Water."

1978

A New Environment for a New Album

Roger Taylor and John Deacon were the first members of the band to arrive in Switzerland, in July 1978. Working with a paired down team behind the scenes, the two musicians gathered for early rehearsals in a room rented from a local dance school that was vacant during the summer holidays. (It should be noted that despite corroboration in multiple biographies and anecdotes from the period, Peter Hince claims that these rehearsals took place in Munich, Germany.) Roy Thomas Baker was the de facto producer of this disc, assisted by sound engineers Geoff Workman and John Etchells. The latter had already worked with Queen on their BBC Sessions in February 1973 since, at the time, he was a sound technician at the radio channel working specifically on radio broadcasts. Peter Hince, the technical manager, was also present, as well as Chris "Crystal" Taylor, Roger's personal technician. (Chris Taylor's surname is a coincidence; the two had no family connection.)

Freddie Mercury had stayed in London to tie up the final administrative details on the production of the second album from his friend Peter Straker (see page 215). Brian May was with his wife, Chrissie, who had just given birth to their first son, James.

By the end of July, 1978, the singer and the guitarist had joined the rest of the team, and Queen moved in to the Mountain Studios in Montreux, Switzerland, which were located inside a local casino. At last, with all four members present and their team assembled, the recording sessions could begin. The instruments were installed in the "lounge," an immense room in which Queen—determined as they were to work on their group's cohesion—could record live and in the same room. The production control room was in the basement, and Baker and his sound engineers had to communicate with the musicians using the traditional talk-back method (a microphone system used by sound recording engineers to communicate with studios) as well as a series of screens that had been installed for the occasion, and allowed the engineers to watch what was happening in the studio. Later, a photo taken by Peter Hince would be used to illustrate the inside of the album sleeve upon the album's release. Showing a room full of instruments, cables, and microphones, the members of the band can be seen

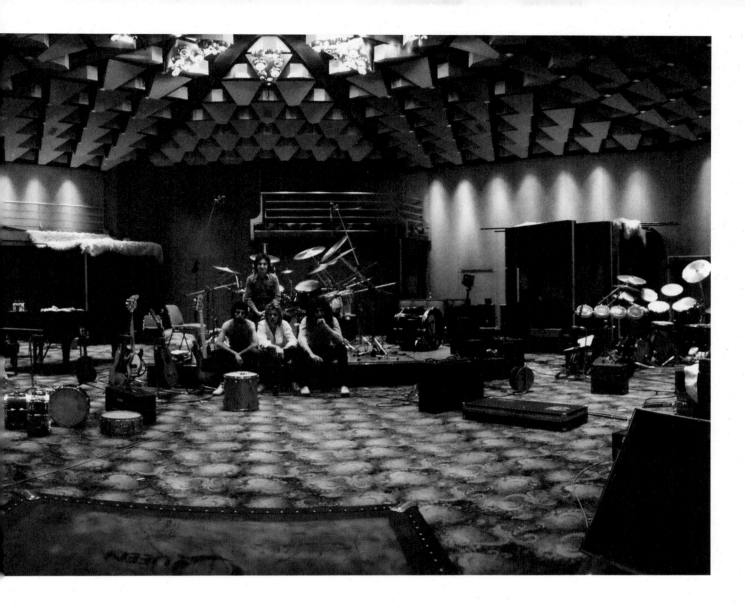

standing well apart from one another, each man an island unto himself. The photo perfectly captures the relative lack of warmth and collegial ambiance that pervaded these sessions: "Around the *Jazz* album, we were all getting into our own things and nobody much liked what the other guys were doing,"[2] May commented later.

The atmosphere became more relaxed when, at the beginning of September, the group moved on to France to record the last vocals and overdubs before tackling the final mixing of the album. The Super Bear Studios, where Mercury and his troupe set themselves up, are located in the village of Berre-les-Alpes, in the hills of Nice. This relatively rural location included only a modest residential complex with a small pool. These relatively Spartan accommodations helped the group bond and relax somewhat between work sessions.

Jazz was completed in the autumn of 1978. The first single off the album, "Bicycle Race," was released on October 13 in the United Kingdom, accompanied on a double A-side by the rollicking track "Fat Bottomed Girls." The full *Jazz* album was officially released on November 10, 1978, and reached number two on the British charts. Its American release would go on to reach number six on the *Billboard* charts. The album sleeve, with its cylindrical logos, was proposed by Roger Taylor in a nod to the work of early optical artist Victor Vasarely, whose work was very much in vogue at the time owing to the album art he created for David Bowie's *Space Oddity* in 1969. On April 28, 1978, Queen was passing through Berlin to play a show at the mythical concert hall, Deutschlandhalle. While in the German capital, the percussionist had spotted a design similar to Vasarely's work scrawled on a wall, and inspiration struck.

When the album was released the press was unsurprisingly critical, as they always were when it came to Queen. Dave Marsh, writing in *Rolling Stone*, had this to say: "There's no jazz on Queen's new record, in case fans of either were worried about the defilement of an icon. Queen hasn't the imagination to play jazz—Queen hasn't the imagination, for that matter, to play rock & roll. *Jazz* is just more of the same dull pastiche that's dominated all of this British supergroup's work."[80] Ouch! Despite their antipathy for the rock music press ("They don't like us, we don't

QUEEN: ALL THE SONGS 221

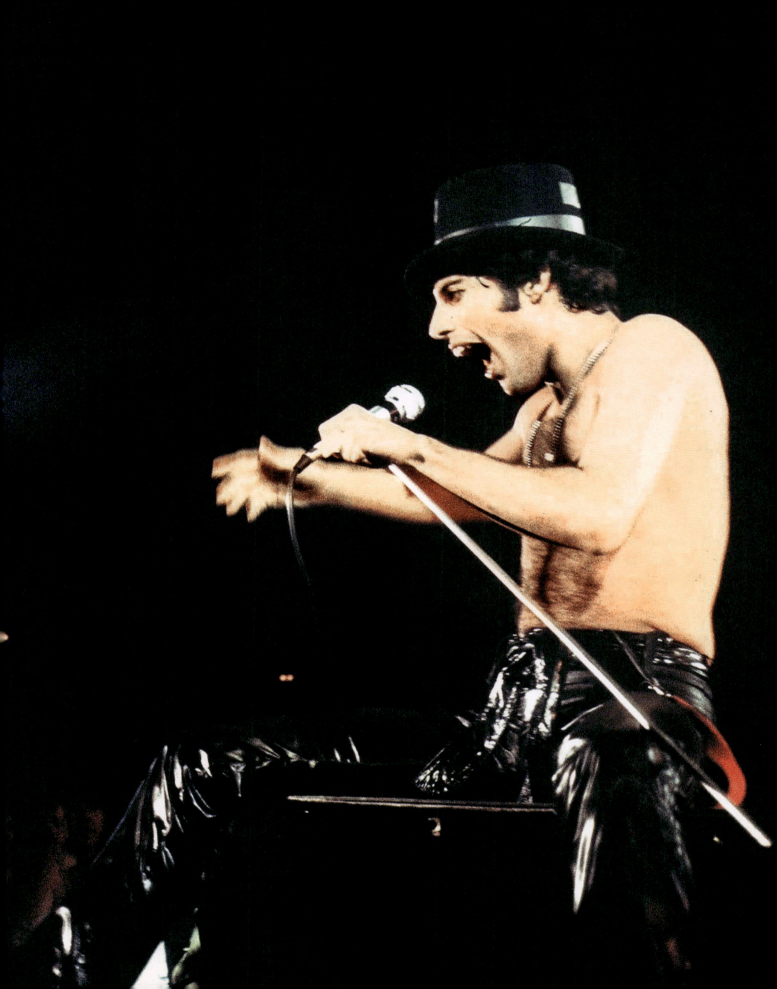

(Previous page) Freddie interacts with the audience at the Pavillon de Paris, in France, circa 1979.

(Right) New lighting and a new set: Brian May is shown here in Rotterdam on January 29, 1979, in the middle of the *Live Killers* tour.

like them,"[81] declared Freddie Mercury), the four musicians seemed to share the journalists' assessment of *Jazz*, at least in some respects. The very cold, almost clinical sound of the record was not really to the band's liking and seems to have been a result of Baker's experiences working with the Cars in America the previous year. According to Brian May, "*Jazz* suffered from having too much level in too short a space."[5] Roger Taylor was equally unenthusiastic about the album, saying: "*Jazz* was disappointing...I don't think it really worked with Roy."[2] With his trademark honesty, the drummer was the first to question his own work on the two songs he wrote for the album: the very funky "Fun It"—which was a precursor of sorts to the disco / new wave style of the 1980s that the group later developed on their tenth studio album, *Hot Space*—and the very disappointing "More of That Jazz", which was the last track on *Jazz*: "My songs are very patchy. Instantly forgettable."[2]

The album is dedicated to John Harris, Queen's front-of-house sound engineer, and the band's loyal companion from their earliest days, who had recently left the team for health reasons. Brian May wrote about him: "John [...] would drive the Transit van, look after and set up all the on-stage gear, and then mix the live sound in the show. He was almost a fifth member of the band, when the band was young. [...] In the end we parted company, and I guess I still have some regrets. I feel like we didn't take care of him as well as we could have done. But of course, the way we toured changed radically [...]. It all became much bigger so, in a sense, we employed specialists to do each job. It was sad to lose John, but he did a great job in the beginning, without a doubt, and deserves praise, respect and... thanks!"[29]

A sell-out North American tour followed the release of *Jazz*, running from October 28 to December 20, 1978, after which the group returned to London to spend Christmas with their families. Then, starting on January 17, 1979, the group set off on a European tour beginning at the Ernst-Merck Halle in Hamburg, Germany. When they'd completed their tour of the "Old Continent," Queen had performed twenty-eight times in total, including three memorable nights at the Pavillon de Paris between February 27 and March 1, 1979. The atmosphere in Paris was supercharged; in the front row, the audience had equipped themselves with bicycle bells that they rang at the appropriate moments in "Bicycle Race." No concert was given in the United Kingdom during the *Jazz* tour, with Queen thus avoiding the need to declare profits in British territory.

The musicians then flew to Japan in April 1979, pleased to once again find themselves among the fans who had supported them so unconditionally since their earliest days in 1975. During this visit to the Land of the Rising Sun, Queen included "Teo Torriatte (Let Us Cling Together)" in its set, which Brian May had composed in 1975 as a thank-you to the group's Japanese fans.

By Popular Request: Queen's First Live Album

Following Queen's breakneck touring pace over the past five years, the fans were clamoring for a disc combining the best tracks the group had played in concert. Live albums had been growing in popularity since the early '70s, and some group's live albums even reached the same heights of popularity as their more polished studio offerings: *Live at Leeds* by the Who, which appeared in 1970, *Made in Japan* by Deep Purple (1972), *The Song Remains the Same* by Led Zeppelin (1976), and *Frampton Comes Alive* by Peter Frampton (1976) all met with great public acclaim. Queen recorded many of their European concert dates in the winter of 1979 (especially those performances given in Brussels and Paris) with the express goal of working on a live album. In March 1979 the group went back to Mountain Studios in Switzerland to work on finalizing the mixing of the future *Live Killers*, which they released on June 22, 1979, in Great Britain and on June 26 in the United States.

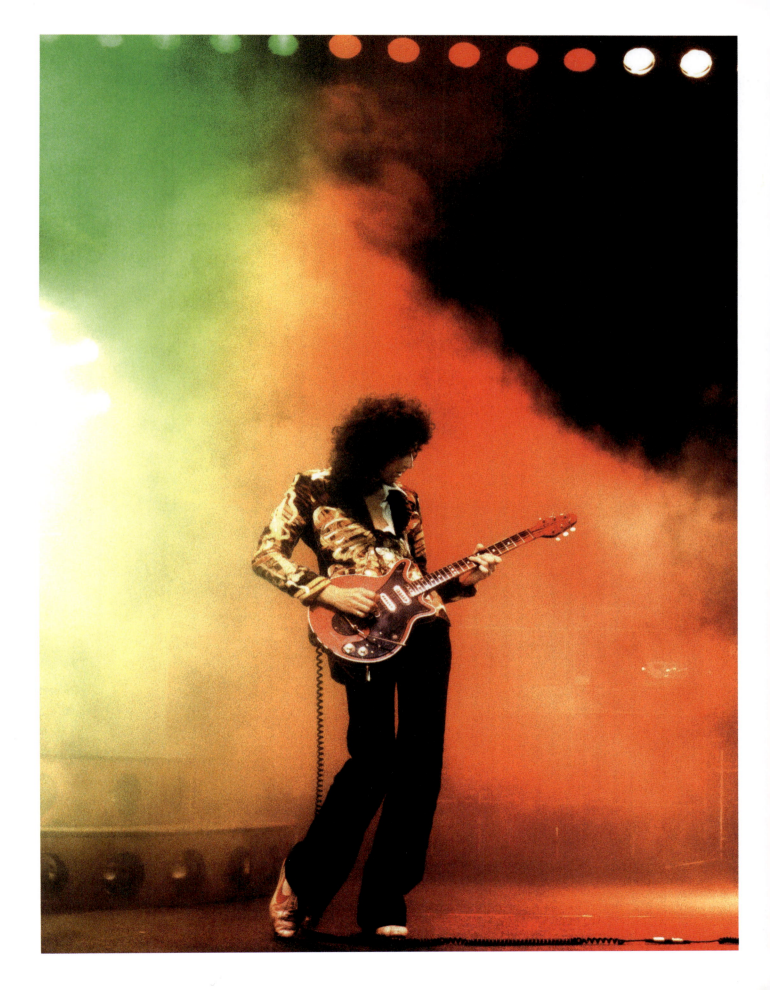

FOCUS ON...

LAUNCH OF THE *JAZZ* ALBUM, OCTOBER 31, 1978: AN ANTHOLOGY FEST

To celebrate the release of their seventh album in the autumn of 1978, Queen decided to arrange a suitably extravagant and memorable party. Beginning at the end of that summer, Jim Beach, the group's manager, had been looking for a venue where the musicians would feel at home and therefore empowered to throw the wildest party they could think of. In the end, the group decided on New Orleans as the location of their release party despite having called it a "place of debauchery" during their first visit to the city in 1974. The event took place on Halloween in the ballroom of the New Dreams Fairmont Hotel, after Queen's concert in the city's Municipal Auditorium.

More than four hundred people, including fifty-two EMI international managers, flew in from around the world in order to attend what promised to be an unforgettable event. Tony Brainsby, who was working as a press officer for EMI in the United Kingdom, had about a hundred British journalists flown to New Orleans on a chartered plane just for the occasion.

At Her Majesty's Pleasure

Upon their arrival, guests found a gigantic ballroom containing a forest of potted trees, ready to receive frolicking witches and ghosts ready to celebrate Halloween. Cocktails in hand, guests patiently awaited the group's entrance. "I remember walking into the ballroom where there must have been 400 or 500 people," recalls Sylvie Simmons, American correspondent of *Sounds* magazine. "The tables were laden with pyramids of food—shrimps, oysters, lobsters, all kinds of meats—like a bizarre medieval fantasy banquet for a king."[38]

Backstage, dozens of artists in costume had been hired for the event and stood waiting to perform their various roles. Bob Gibson, one of the two managers of the American public relations company Gibson and Stromberg, who had

Queen's launch of the *Jazz* album would go down in history as one of the all-time greatest rock 'n' roll parties.

The morning after: The members of Queen (along with Roy Thomas Baker) struggle through a press conference the day after the launch party for *Jazz*.

helped Jim Beach to organize the event, described the scene as follows: "Queen wanted a lot of street people. [...] We held auditions over a period of three or four days, and hired a total of 60 or 70 entertainers. All kinds of people turned up, but we had to draw the line at the guy whose act was that he bit the heads off live chickens."[38]

When their concert was finished, the members of Queen made their entrance, accompanied by the Olympia Brass Band, a famous New Orleans ensemble. It was midnight before the party could officially begin.

A Tod Browning–esque Atmosphere
The entourage that followed the group's entrance included all sorts of highly colorful personalities, circus-like personalities incorporating snake charmers and fire eaters among other, more unsavory personages. The panoply of characters was not so far from the Tod Browning film *Freaks*, which followed the life of a circus troupe in the 1930s that was similarly populated by out-of-the-ordinary creatures.

Later in the evening, there were mud-wrestling women, a few of whom were seen disrobing in front of the shocked gaze of a group of Japanese journalists. By all accounts it was certainly a party for the ages, and in keeping with the decadent spirit of the late 1970s.

Better Tomorrows
"I remember I felt quite ill the next day,"[22] Roger Taylor later recounted in an amusing recollection of the album release party. It must be said that the following day's press conference given by the group along with their producer, Roy Thomas Baker, presented some pretty tired musicians, showing all the signs of a memorable evening, which reportedly cost the group more than $200,000. "Whenever we went to New Orleans, every colorful person in town would turn out, and that's why we had the launch there. A lot of strange stuff did go on that night. Of course it's been exaggerated, but I'm not going to spoil the fun."[82] Brian May, who left the party early, described his memory of the evening: "I'm an incurable romantic and I'd fallen in love in New Orleans a few years earlier, and because the girl in question didn't turn up at the party I went off in a car to try to find her. Didn't succeed. Very un-rock'n'roll thing to do."[82] (See page 208.)

The soirée, which was one of the most spectacular events ever organized by a group to promote a record, became a legend in New Orleans, where debauchery, pleasure, and spectacle form at least a part of the city's DNA. "We just wanted to have a bit of fun,"[83] concluded Freddie Mercury in a rare moment of understatement.

MUSTAPHA

Freddie Mercury / 3:01

Musicians
Freddie Mercury: lead vocals, backing vocals, piano
Brian May: electric guitar
John Deacon: bass
Roger Taylor: drums, bells

Recorded
Mountain Studios, Montreux: mid-July–August 1978
Super Bear Studios, Berre-les-Alpes: September 1978

Technical Team
Producers: Queen, Roy Thomas Baker
Sound Engineer: Geoff Workman
Assistant Sound Engineer: John Etchells

ON YOUR HEADPHONES
There is no point in turning up the volume upon first listening to "Mustapha": the low volume at the start of the number is a ploy by Roy Thomas Baker, and is baked into the original recording. Before the guitar enters at 1:25, the producer had mixed the song in mono, which explains its relatively quiet sound. When the guitar begins, the producer changed the sound mixing from mono to stereo and added a slight increase in volume.

Genesis

The first number on the *Jazz* album begins with singing that resembles a traditional muezzin performing the customary Muslim call to prayer. It's a moment that is equally jarring and intriguing. Freddie Mercury proclaims in a distant voice swathed in reverb: "*Ibrahim, Ibrahim, Ibrahim, Allah, Allah, Allah, Allah will pray for you.*" Here the singer is undoubtedly paying homage to a childhood spent in Zanzibar, Tanzania, where Islam was the faith of more than 99 percent of the local citizens. The young Freddie Mercury (born Farrokh Bulsara), was born into the Zoroastrian faith and grew up surrounded by a large number of Muslim friends and followers.

The sounds and language used by Mercury in this song are very close to Arabic, but it seems that the singer constructed his lyrics from scratch, inventing phrases and expressions that sounded right for his song and excluding any overt religious messaging. Indeed, Mercury later confirmed that this was the case: "It is complete gibberish. It isn't any language at all except in a few spots."[5] There is in fact only one English phrase in the text: "*Allah will pray for you.*" The rest of the words, such as the untranslatable "*Mustapha Ibrahim, al havra kris vanin,*" are just a creative mixture of meaningless sounds whose only purpose is to create a specific feeling within the listener.

In many ways, the choice to open the successor to *News of the World* with "Mustapha" was a curious one. While the previous album aimed to reach a wider audience by offering a roster of songs with universal appeal, like "We Will Rock You" and "We Are the Champions," it seems that Queen was no longer afraid of alienating their fans by taking a somewhat more esoteric direction with their next album. The producer John Tatlock later affirmed in an interview with the website the *Quietus* that this was "probably the weirdest opening track in rock LP history."[84] Dave Marsh, a major detractor of Queen in his editorial contributions to the *Rolling Stone* magazine, had a more decisive view on the matter: "'Mustapha' [...] has about as much to do with Middle Eastern culture as street-corner souvlaki."[80] Regardless of Marsh's opinion, the track was eventually released as a single in Germany, Spain, Bolivia, and the former Yugoslavia.

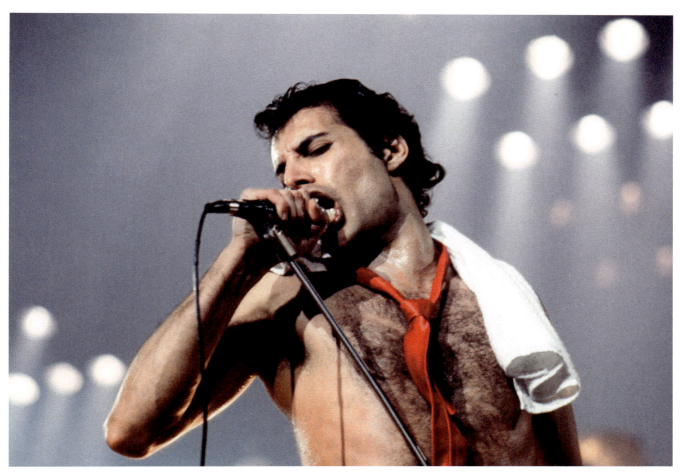
Freddie under the stage lights on the *Live Killers* tour. The group said that the new lighting gave off a level of heat that was almost unbearable.

During subsequent concerts, Mercury often sang the introduction of the song a cappella. But following requests from numerous fans, "Mustapha" was played in full during the *Game* tour in 1980. It was on this tour that a mysterious spectator filmed an incredible performance of the song during a Queen concert at the Saint Paul Civic Center in Minneapolis on September 14, 1980. Now available on YouTube, this clandestine recording serves as a testimony to Queen's remarkable staging and impressive skills in live performance.

Production
At just over three minutes long, "Mustapha" creates a mosaic of Middle Eastern references, including a guitar riff that makes use of scales specific to Arabic music. Brian May adapted the tonality on his Red Special using a wah-wah pedal, while Taylor hammered out a new-fangled rhythm on his drum kit. Meanwhile the words of the song and Mercury's vocal interpretation convey an overtly Arabic sound and tonality. Interestingly, the percussion pattern—with each beat sounded on the snare drum and accompanied by the piano on the off beats—is close in sound and cadence to traditional Jewish folk songs performed throughout Central and Eastern Europe. Even more curiously, the sound of bells that can be heard beginning at 2:34 is not that of a traditional bell per se, but rather of so-called hawk bells, which were originally used during medieval times and often attached to the legs of hawks and falcons. In the end, Queen created a song that incorporates a real mix of genres but without ever parodying this traditional music or showing any lack of respect.

SINGLE

FAT BOTTOMED GIRLS
Brian May / 4:16

Musicians
 Freddie Mercury: lead vocals, backing vocals
 Brian May: electric guitar, backing vocals
 John Deacon: bass
 Roger Taylor: drums

Recorded
 Mountain Studios, Montreux: mid-July–August 1978
 Super Bear Studios, Berre-les-Alpes: September 1978

Technical Team
 Producers: Queen, Roy Thomas Baker
 Sound Engineer: Geoff Workman
 Assistant Sound Engineer: John Etchells

Single
 Side A: Bicycle Race / 3:01
 Side AA: Fat Bottomed Girls (Single Edit) / 3:22
 UK Release on EMI: October 13, 1978 (ref. EM 2870)
 US Release on Elektra: October 24, 1978 (ref. E-45541)
 Best UK Chart Ranking: 11
 Best US Chart Ranking: 24

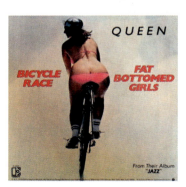

ON YOUR HEADPHONES
As a hat tip to the first official single from the album, "Bicycle Race," which he had just written, Freddie Mercury declaims: *"Get on your bikes and ride"* at 3:22.

Genesis

On October 13, 1978, the first single from the *Jazz* album was released. The 45 rpm included two A-side A tracks and no B-side. The main number, "Bicycle Race," was written by Freddie Mercury, and the second, "Fat Bottomed Girls," was penned by Brian May. This is a very melodic and effective number. When it comes to explaining the meaning behind the song, the wisdom of Brian May speaks for itself: "I think the chorus just popped into my head as a tune and a set of words. [...] And 'Fat Bottomed Girls' became a song about the girls who help the spirits of the performers backstage, I suppose. The groupies or whatever. [...] I remember thinking, 'Freddie's going to have to sing this and I'm going to write it so you can take it any way you like.'"[56] The risqué lyrics narrate a young Freddie Mercury's first encounter with the female gender: *"I was just a skinny lad / Never knew no good from bad / But I knew life before I left my nursery / Left alone with big fat Fanny / She was such a naughty nanny / Heap big woman, you made a bad boy out of me."* Needless to say, a song like this would be considered very controversial these days, but the 1970s were a time of audacity in the world of rock 'n' roll, and the members of Queen took full advantage of their moment to create a song that really pushed the envelope.

Production

Beginning with the introduction, the group's celebrated vocal harmonies are featured front and center in the form of a powerful and melodic a cappella refrain. The song is anchored by a pleasantly bluesy guitar sound, provided by Brian May's Red Special, which used drop *D* tuning for the entirety of the song. Using this technique for the third time after "The Prophet's Song" from *A Night at the Opera* and "White Man" from *A Day at the Races*, Brian May tuned the *E* string down a tone, which gave the guitar's rhythm a heavier sound and a darker tone. "I actually conceived it as fitting the 'swamp' style of the Deep South of the USA. I admired those guys with a dobro on their knee and a foot stamp, which I saw as organically congruent with ZZ Top and electric southern boogie."[85]

230 JAZZ

JEALOUSY
Freddie Mercury / 3:13

Musicians
Freddie Mercury: lead vocals, backing vocals, piano
Brian May: acoustic guitar
John Deacon: bass
Roger Taylor: drums

Recorded
Mountain Studios, Montreux: mid-July–August 1978
Super Bear Studios, Berre-les-Alpes: September–October 1978

Technical Team
Producers: Queen, Roy Thomas Baker
Sound Engineer: Geoff Workman
Assistant Sound Engineer: John Etchells

Single
Side A: Jealousy / 3:13
Side B: Fun It / 3:29
US release on Elektra: April 27, 1979 (ref. E-46039)
Best US Chart Ranking: Not Ranked

ON YOUR HEADPHONES
Lost to time because of a mixing error that happened in 1978, the percussion track featuring a bass drum is missing from the original version of "Jealousy." The missing percussion was later added back into the number for the rerelease of the remastered album in 2011.

Genesis

In "Jealousy" Freddie Mercury opted to marry a gentle ballad with jazz overtones. Addressing himself directly as a villain, Mercury uses his text to express just how much damage his feelings of jealousy have caused him: "*Jealousy look at me now / Jealousy you got me somehow / You gave me no warning / Took me by surprise.*" As per usual with the members of Queen, Freddie was loath to go into great detail regarding his lyrics. "You'd think we would talk about our lyrics with each other, but we never did. It was kind of an unwritten law that you really didn't explain your lyrics to the other guys."[56] And this rule didn't just apply to the songs that the band members had written for themselves. In an interview some years later with *Total Guitar*, Freddie went on to say: "Actually, I've always thought it was a bad idea to explain songs too much. I remember being so disappointed with what Paul Simon had to say about his writings—it destroyed my mental images."[85] So it should come as no surprise that the origins of "Jealousy" are opaque at best. If the lyrics refer to Freddie's relationship with any specific person, the details have since been lost to history.

Production

Featuring Freddie on the piano, Taylor on drums, and John Deacon on the Fender Precision Fretless bass (the lack of frets causing it to sound like a double bass), "Jealousy" leaves only a few seconds of time for Brian May to include a post-refrain guitar riff. May did not get his Red Special out of its case for the recording of this number, but instead used his old Hallfredh guitar, which he had converted for the recording of "White Queen (As It Began)" on *Queen II*. "I have a very old, cheap [Hallfredh] which makes that buzzy sound that's on 'Jealousy' and 'White Queen,'" he explained. "I've never seen another one like it. I made it sound like a sitar by taking off the original bridge and putting a hardwood bridge on. I chiseled away at it until it was flat and stuck [a] little piece of fretwire material underneath. The strings just very gently lay on the fretwire, and it makes that sitar-like sound."[54]

QUEEN: ALL THE SONGS 231

SINGLE

BICYCLE RACE
Freddie Mercury / 3:01

1978

Musicians
Freddie Mercury: lead vocals, backing vocals, piano, bicycle bells
Brian May: guitar, background vocals, bicycle bells
John Deacon: bass, bicycle bells
Roger Taylor: drums, backing vocals, bicycle bells

Recorded
Mountain Studios, Montreux: mid-July–August 1978
Super Bear Studios, Berre-les-Alpes: early September 1978

Technical Team
Producers: Queen, Roy Thomas Baker
Sound Engineer: Geoff Workman
Assistant Sound Engineer: John Etchells

Single
Side A: Bicycle Race / 3:01
Side AA: Fat Bottomed Girls (Single Edit) / 3:22
UK Release on EMI: October 13, 1978 (ref. EMI 2870)
US Release on Elektra: October 24, 1978 (ref. E-45541)
Best UK Chart Ranking: 11
Best US Chart Ranking: 24

ON YOUR HEADPHONES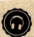
As a nod to the second A-side single, the backing vocalists on "Bicycle Race" sing "*Fat Bottomed girls, they'll be riding today.*"

Thumbing his nose at Elektra, which had removed the naked cyclist posters from the *Jazz* album art, Freddie Mercury performed a live rendition of "Bicycle Race" at the group's Madison Square Garden concert on November 17, 1978. As he sang, he was surrounded on stage by a pack of young women on bicycles.

Genesis

On July 19, 1978, the group was rehearsing the songs for *Jazz* during the annual Tour de France bicycle race, which happened to be passing through Montreux at the same time Queen was there. Watching the bike riders make their way through the hilly terrain, Freddie was suddenly overtaken with a passion for the sport and seduced by the racers with their toned leg muscles. So he decided to write "Bicycle Race" and suggested that Brian May should provide his own version of the event, which he did, composing a song that would go on to become "Fat Bottomed Girls"—which, in the end, had nothing to do with bicycles. Nevertheless, the two songs were released as a double A-side single. The group had followed this model previously when they released singles for "Killer Queen" and "Flick of the Wrist" in 1974 and "We Are the Champions" and "We Will Rock You" in 1977. The purpose of this approach was to give as much opportunity as possible for both songs to succeed, rather than relegating one of the songs to the B-side. However, it was agreed that "Bicycle Race" would be the official lead single from *Jazz*. The song hit number eleven on the British charts when it was released on October 13, 1978, thanks in no small part to an unforgettable photo shoot and video that were created to go along with the single.

A Video with an Element of Scandal

"I remember the huge disappointment," Roy Thomas Baker recalled with amusement when he was asked about the video for "Bicycle Race." "But none of us could be in the photo shoot because we [were in] exile, so we couldn't go back and see it."[22] It is easy to understand the musicians' frustration, as they attempted to coordinate the London-based filming of the video from their location at the Super Bear Studios in France. On September 17, 1978, sixty-five professional female models were recruited to cycle around the Wimbledon Greyhound Stadium circuit in London. Also of note was that all sixty-five women happened to be stark naked.

The video was made by David Mallet, and it combined images from this sunny-day bike ride with previously

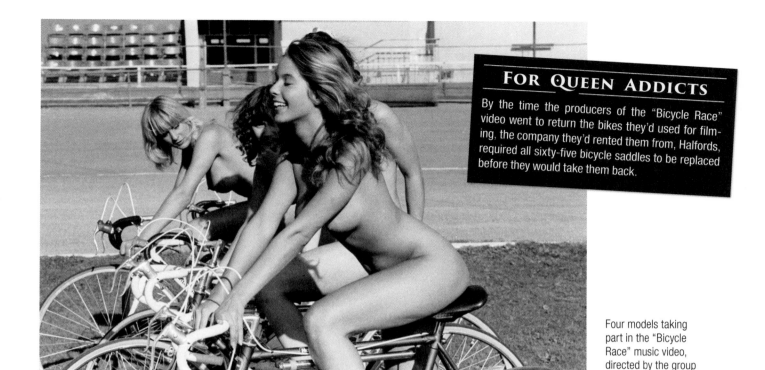

FOR QUEEN ADDICTS

By the time the producers of the "Bicycle Race" video went to return the bikes they'd used for filming, the company they'd rented them from, Halfords, required all sixty-five bicycle saddles to be replaced before they would take them back.

Four models taking part in the "Bicycle Race" music video, directed by the group while abroad.

recorded concert footage. A photo shoot with the cyclists was also arranged and an image taken from the start of the "race" was used as a poster that was included in the British release of *Jazz*. Almost immediately, Elektra had to deal with an outcry from scandalized record shops, and this bonus feature was removed from the albums distributed to the American market. Later, when the 45 rpm of "Bicycle Race" was released in the United Kingdom, the record company categorically refused to feature one of the models on the record sleeve. A pair of underwear was hastily drawn onto the model so that the single could see the light of day.

Freddie Mercury, witty as ever, commented: "It's cheeky, naughty, but not lewd. Certain stores, you know, won't run our poster. I guess some people don't like to look at nude ladies."[86] The "Bicycle Race" video, despite its plethora of images that bordered on bad taste (or perhaps because of these images), became emblematic of the singer's naughtiness. Having been roundly criticized by the print media, the group tried to justify itself as best it could. *Rolling Stone*'s Dave Marsh, who was permanently appalled by Queen and their media escapades, provided the last word on this chaotic episode: "Queen may be the first truly fascist rock band. The whole thing makes me wonder why anyone would indulge these creeps and their polluting ideas."[80]

When he was asked about the video in 2008, Brian May had only this to say: "I was a different person in those days. We all were. I must say that we hadn't really thought that one through. We didn't intend it to be disrespectful to women, it was more in the spirit of English seaside postcard humor."[82]

Production

Beyond the irreverent nature of the imagery used for the video and press materials, "Bicycle Race" is a proper piece of rock music, garnished with rhythmic innovations and musical risk taking. The refrains are carried by Freddie's piano arpeggios, featuring couplets that make reference to stalwarts of American culture including: *Star Wars*, Peter Pan, Superman, *Jaws*, and John Wayne.

The guitar part was very complicated for Brian May to write. He explained the song's complexity as follows: "Freddie wrote in strange keys. Most guitar bands play in A or E, and probably D and G, but beyond that there's not much. Most of our stuff, particularly Freddie's songs, was in oddball keys that his fingers naturally seemed to go to: E-flat, F, A-flat. They're the last things you want to be playing on a guitar, so as a guitarist you're forced to find new chords. Freddie's songs were so rich in chord-structures, you always found yourself making strange shapes with your fingers. Songs like 'Bicycle Race' have a billion chords in them."[43]

To add a personal touch to his song, Mercury decided to include twenty seconds of bicycle bells during the introduction to the guitar solo, which begins at 1:45. Peter Hince, the group's technical manager recalls the episode: "In addition to our arsenal of instruments we added bicycle bells! Every bike shop in the area was scoured in order to build a collection of various tones and actions of bell." [87]

While Freddie often opted for leather when performing onstage, John Deacon went for a more academic look!

IF YOU CAN'T BEAT THEM

John Deacon / 4:15

Musicians
Freddie Mercury: lead vocals, backing vocals
Brian May: electric guitar, backing vocals
John Deacon: bass
Roger Taylor: drums, backing vocals

Recorded
Mountain Studios, Montreux: mid-July–August 1978
Super Bear Studios, Berre-les-Alpes: September 1978

Technical Team
Producers: Queen, Roy Thomas Baker
Sound Engineer: Geoff Workman
Assistant Sound Engineer: John Etchells

FOR QUEEN ADDICTS
While the title of the song—"If You Can't Beat Them"—may sound like a personal motto for Mercury and the rest of Queen, in reality, the group was known to chant "*Blind 'em and deafen 'em!*" before heading out onto the stage.

Genesis

"If You Can't Beat Them" was written as a radio-friendly, hard rock anthem. In many ways this track, with its generous sound that's swathed in reverb, serves as a spiritual predecessor to Queen's next record, *The Game*, and offers a glimpse at the type of sound the group would produce as they headed into the 1980s. "If You Can't Beat Them" was written by John Deacon, who was always ready to knock out a hit for the group, but sadly this track did not go on to become a hit, and it hasn't thrived in posterity. However, on the rare instances when this song is performed live, including early concerts at the Pavillon de Paris on February 28 and March 1, 1979, the song is always a hit with the audience.

Production

The structure of the song, with its melodic couplets and refrains chanted by backing vocals, seems tailor-made for the MTV era—unfortunately, the channel wouldn't launch until 1981. There is no doubt that "If You Can't Beat Them" paved the way for hits like "We're Not Gonna Take It" by Twisted Sister and "Runaway" by Bon Jovi, which would both become anthems of the early 1980s. Brian May played all the six-string parts on the track, which was unusual, since John Deacon usually played at least some of the guitar parts in his own compositions, particularly when the song called for an acoustic guitar. The guitar riff in "If You Can't Beat Them" begins at 3:06 and is processed with a phaser effect, which runs right through the song. This effect was applied by Roy Thomas Baker during the recording of the take itself, which was somewhat unusual as this type of artifice was more commonly added during the postrecording mixing process. "I'm not one of these, 'Oh, we'll cut this and leave the effect for the mix.' I actually record the effects. There is the artistic reason: People play differently when they hear the effect and are playing to it. Secondly, it makes it so much easier to mix, because the effects are already there."[88]

The backing vocals, which play such an important part in the song's repeated refrains, are fairly straightforward in comparison to the group's previous work on *A Night at the Opera*, where vocals were layered over each other. Brian May said as much in 1991: "Some of our backing tracks on the *Jazz* album had become quite perfect but had lost the initial enthusiasm."[5]

LET ME ENTERTAIN YOU
Freddie Mercury / 3:01

Musicians
Freddie Mercury: lead vocals, backing vocals, piano
Brian May: electric guitar
John Deacon: bass
Roger Taylor: drums

Recorded
Mountain Studios, Montreux: mid-July–August 1978
Super Bear Studios, Berre-les-Alpes: September–October 1978

Technical Team
Producers: Queen and Roy Thomas Baker
Sound Engineer: Geoff Workman
Assistant Sound Engineer: John Etchells

FOR QUEEN ADDICTS
When Freddie Mercury announces in the second couplet: *"Stickells see to that,"* he is addressing Gerry "Uncle Grumpy" Stickells, who worked as Queen's American tour manager beginning in 1975.

Genesis
"Let Me Entertain You" was written by Freddie Mercury as a thumbing of the nose to the British press, who had been pretty tough on Queen as they worked to become the biggest rock group in the world. Freddie, as a master of self-mockery, uses the song to address his public like a ringmaster, or an emcee opening a show: *"Let me welcome you Ladies and Gentlemen / I would like to say hello / Are you ready for some entertainment? / Are you ready for a show?"* As a great admirer of musicals, Mercury definitely drew inspiration for this track from the legendary musical *Gypsy*, which first appeared on Broadway in 1959. The play tells the story of the burlesque entertainer known as Gypsy Rose Lee, who sang one "Let Me Entertain You," one of the most famous songs from the musical's libretto. The lyrics of the song are filled with risqué double entendres: *"I'll make you feel good / I'd want your spirit to climb / So let me entertain you / We'll have a real good time."* In Queen's song, the words are spiced up from beginning in the second verse, when Mercury launches into an acerbic criticism of show business: *"I've come here to sell you my body / I can show you some good merchandise."* Beginning in the third verse, Mercury drops any semblance of fiction or storytelling, and sings the song from his own point of view: *"Hey if you need a fix / If you want a high / Stickells see to that / With Elektra and EMI / We'll show you where it's at."* Dave Marsh, of *Rolling Stone*, who clearly had very strong views about each of the songs on *Jazz*, wrote: "When Mercury chants, in 'Let Me Entertain You,' about selling his body and his willingness to use any device to thrill an audience, he isn't talking about a sacrifice for his art. He's just confessing his shamelessness, mostly because he's too much of a boor to feel stupid about it."[80] That's show business!

Production
The introduction contains one of Queen's signature sounds, in which Taylor hammers out the drum on each beat in unison with Deacon's bass. The sound is reminiscent of the solo from "Get Down, Make Love" on *News of the World*. After the introduction, the rest of the track becomes more rhythmic, and the guitar riffs mesh with the drum patterns, recalling the great days of Deep Purple and their classic track "Black Night." The episodic structure of "Let Me

The burlesque comedienne Gypsy Rose Lee (1911–1970), whose life inspired the musical *Gypsy*.

Entertain You" fits perfectly within the kind of tracks that Mercury wrote so well, where each verse takes on a different musical interpretation. The guitarist adorns the first verse, rolling out an uninterrupted riff. In the second verse, the drums and bass play in a syncopated rhythm, calling back and forth to each other.

At the end of the number, we hear May, Taylor, Mercury, and an unidentified female voice engaged in random conversation that sounds like the kind of exchanges that members of the audience might have after a Queen concert: *"Where's my backstage pass,"* *"That Brian May, he's outta sight, man,"* or *"That was a bit of all right, wasn't it?"*

QUEEN: ALL THE SONGS 237

DEAD ON TIME
Brian May / 3:23

Musicians
Freddie Mercury: lead vocals, backing vocals
Brian May: guitar, backing vocals
John Deacon: bass
Roger Taylor: drums, backing vocals

Recorded
Mountain Studios, Montreux: mid-July–August 1978
Super Bear Studios, Berre-les-Alpes: September 1978

Technical Team
Producers: Queen, Roy Thomas Baker
Sound Engineer: Geoff Workman
Assistant Sound Engineer: John Etchells

Genesis
As a member of one of the most successful rock bands in the world, Brian May spent months tied up in the studio, recording new music, and maintained a constant touring schedule that kept him away from his family. In "Dead on Time" May once again addresses his sense of life and time going by too quickly. Beginning with "Good Company" on *A Night at the Opera*, the guitarist continually questioned the choices he made that took him away from his home and family. "Leaving Home Ain't Easy" which also appeared on Side 2 of the 33 rpm *Jazz* album, is another such song that referenced May's growing concerns.

Production
With moments of real virtuosity, the guitar riff and solo in "Dead on Time" are played at a blistering tempo of 144 beats per minute, which leaves no room for hesitation. However, the ingenuity and technique deployed in the writing of the guitar part were not properly appreciated. When asked whether the solo writing in "Dead on Time" created particular difficulties because of the speed of execution, Brian May replied with great candor: "That was something I was quite pleased with, but really nobody else was. It's something which nobody ever mentions very much. 'Fat Bottomed Girls' I thought was okay, but fairly banal. I thought people would be much more interested in 'Dead on Time,' but it didn't really get that much airplay."[89]

One evening, when the group was working at the Super Bear Studios in the south of France, there was a storm, and lightning flashed through the sky. Brian May grabbed a portable recorder and captured all the sounds he could: thunder, rain, and wind. The sounds were mixed into the song beginning at the 3:00 mark, as Mercury cries out: "*You're dead.*" The group respectfully credited the sound effect in the album's sleeve notes with a sober inscription: "*Thunderbolt courtesy of God.*"

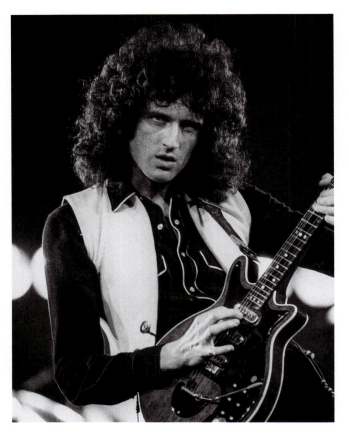

Brian May is celebrated for his thunderous riffs, both onstage and in the studio.

IN ONLY SEVEN DAYS

John Deacon / 2:30

Musicians
Freddie Mercury: lead vocals, piano
Brian May: electric guitar
John Deacon: bass, acoustic guitar
Roger Taylor: drums

Recorded
Mountain Studios, Montreux: mid-July 1978
Super Bear Studios, Berre-les-Alpes: September 1978

Technical Team
Producers: Queen, Roy Thomas Baker
Sound Engineer: Geoff Workman
Assistant Sound Engineer: John Etchells

A studious composer and demanding musician, John Deacon wrote some of Queen's greatest hits.

Genesis

"If I'd just been a bass player all my life with the band, if that had been all my input, I wouldn't be as satisfied as I am because I only consider that as part of what I do. There's the songwriting and also being involved in the decision-making processes—arguing or whatever—which is nice; to be able to have a part in the band's destiny."[90] "In Only Seven Days" is John Deacon's second contribution to *Jazz*, after "If You Can't Beat Them." The song is sung by Freddie, who gives his all in this amusing little number, which describes the narrator's time on vacation and his burgeoning romance with a young lady he meets during his travels. The song ends up with the inevitable return home, when the singer hums, with a heavy heart: "*I'm so sad alone.*"

While the instrumental part of the song, along with the melody, are reminiscent of "You're My Best Friend," which was Deacon's first hit, "In Only Seven Days" is more striking for its naiveté and candor.

Production

It cannot be denied that on *Jazz*, one can easily guess the author of each song. The classically rock 'n' roll–sounding pieces are usually by Brian May, while the stranger, more unique songs, or songs with sexually explicit lyrics, are by Mercury. Taylor's songs have a straightforward drive and thrust and are full of momentum, and the pieces by Deacon carry his hallmark taste for gentle and languorous melodies. "In Only Seven Days" is no exception to this rule. Freddie Mercury plays a piano score written by the bassist and gives a perfect vocal rendition that is warm and gentle, staying true to the song's melody. Brian May adds color to the song with discreet layers of electric guitar, and John Deacon himself plays all the acoustic guitar parts. The production is meticulous and without artifice, and the gentle "In Only Seven Days" could have been a real 1980s hit, like "I Just Called to Say I Love You" by Stevie Wonder or "Last Christmas" by Wham! Unfortunately, the song was just a little too ahead of its time.

Freddie Mercury at one of the three highly charged concerts given at the Pavillon de Paris in February and March of 1979.

DREAMERS BALL
Brian May / 3:30

1978

Musicians
 Freddie Mercury: lead vocals, backing vocals
 Brian May: electric and acoustic guitars
 John Deacon: bass
 Roger Taylor: drums

Recorded
 Mountain Studios, Montreux: August 1978
 Super Bear Studios, Berre-les-Alpes: September 1978

Technical Team
 Producers: Queen, Roy Thomas Baker
 Sound Engineer: Geoff Workman
 Assistant Sound Engineer: John Etchells

Genesis

After the band's concerted effort to make more straightforward rock songs on *News of the World*, fans could've been forgiven for thinking that the group had left behind their desire to create tracks inspired by the sounds of the blues, choosing instead to focus solely on creating rock anthems. Brian May's musical experiments as an alchemist of sound working with his Red Special had been shelved since "The Millionaire Waltz," in favor of thunderous riffs on "It's Late," "Fat Bottomed Girls," and "Dead on Time." But it seems that Roy Thomas Baker's return to the production team helped the group get back to their first love, which explains the inclusion of Brian May's "Dreamers Ball" with its music hall–inspired rhythms.

Production

Inspired by the sounds of the blues, with its languorous guitars and very traditional chord progressions, "Dreamers Ball" takes the listener to New Orleans, that city that had grown so dear to the members of Queen in the years since their first concert in the city, in April 1974. May's playing on the acoustic guitar is intentionally raw and rough, which conveys such an authentic feel, and his Red Special intervenes only in a complementary capacity, although it does take on a greater role toward the end of the song.

From 1:45, when the electric guitar solo begins, one can almost visualize the members of Queen strolling down Rampart Street, at the heart of New Orleans's French district. May's guitars play in harmony as a way of imitating the brass band sound of the jazz age, and they're accompanied by a blues riff played on an unplugged six-string that was recorded in a traditional, stripped-down manner: "For acoustic guitar, generally I use one mike a few inches away from the sound hole and very often one a little further away,"[89] the guitarist explained.

"Dreamers Ball" is an example of the range of musical styles enjoyed by Mercury and his band, who definitely seemed to be pushing against the confines of the pop-rock style, which they found to be quite narrow. The group was about to make a radical change of course, pushing themselves in a new direction on the albums to come.

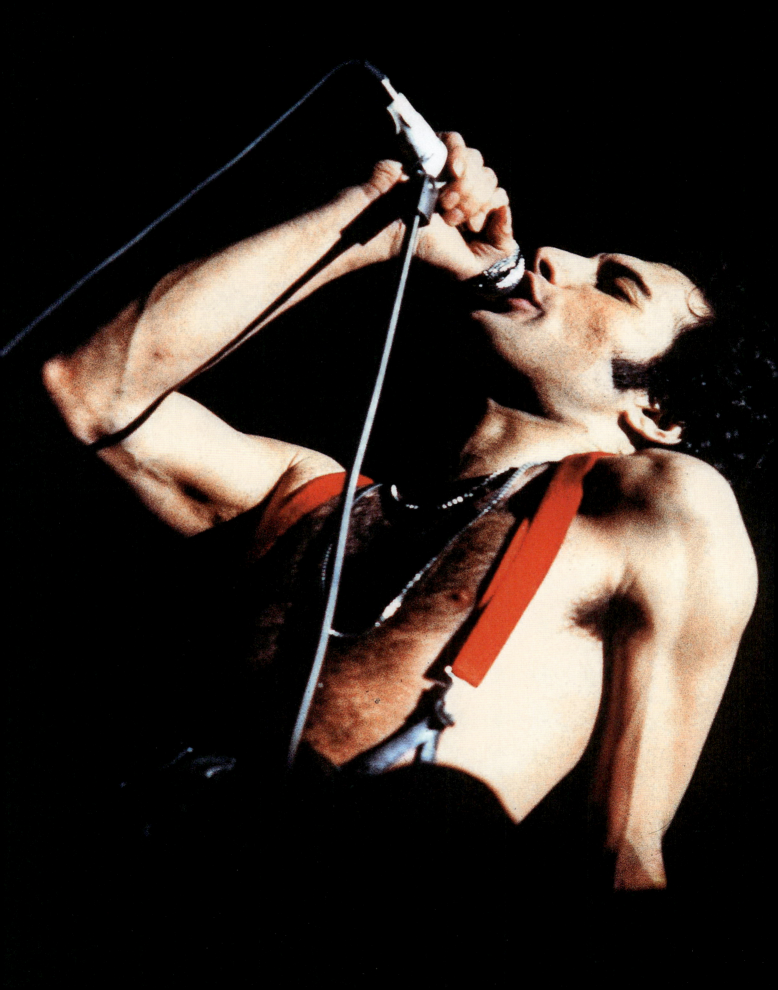

FUN IT

Roger Taylor / 3:29

Musicians
Freddie Mercury: lead vocals
Brian May: electric and acoustic guitars, backing vocals
Roger Taylor: lead vocals, backing vocals, drums, electric guitar, bass

Recorded
Mountain Studios, Montreux: mid-July–August 1978
Super Bear Studios, Berre-les-Alpes: September 1978

Technical Team
Producers: Queen, Roy Thomas Baker
Sound Engineer: Geoff Workman
Assistant Sound Engineer: John Etchells

Genesis

Appalling or *inspired*, *irrelevant* or *avant-garde*—these are all terms that could be used to describe this song written by Roger Taylor. As he proved with his previous track, "Sheer Heart Attack," one of the first songs of the punk movement in 1974, Queen's drummer always found a way to be on the cutting edge of musical trends. Unfortunately, "Fun It" might have been too far ahead of its time, and it was not as successful as "Sheer Heart Attack." Taylor had always flirted with disco in his songwriting, and while "Fun It" was certainly danceable, it also marked a definitive new direction in Queen's discography. The words, which extol the pleasures of dance as a physical outlet and release, are true to the canons of disco. The lyrics also fit perfectly with Roger Taylor's history of songwriting, which always focused on the pleasures of the body and the finer things in life. But the number is closer in sound to the new wave funk of a song like "The Beast," which appeared on the 1982 Blondie album *The Hunter*. "Fun It" marks a clear departure from the "authentic" disco offered by popular groups from the late 1970s like Munich Machine, headed by Giorgio Moroder. Taylor was looking to the future, and with a single song he propelled Queen into the 1980s.

Production

The production of this number marks a revolution in Queen's discography. From the first bar, the group makes clear that it's turning the page on the 1970s, leaving behind the period where they were inspired by Led Zeppelin or Jimi Hendrix. Here, the sound of the drums is cold and dry, in a nod to the emerging "cold wave" trend, exemplified by artists like Joy Division and the Sisters of Mercy. In order to prepare the fans for the metamorphosis that was taking place in the group's sound, Taylor included a new toy in his drum kit that can be heard from the first bar of the piece, at 0:03: a Pollard Syndrum Quad 478 synthesizer. This is not a keyboard that would be used to replace Brian May's guitar tracks, but rather a series of four pads that were linked to a central module, from which a specific sound could be selected and which would be triggered when struck. In short, this invention marks the birth of the electronic drum kit. Early versions were popularized by the Simmons brand, with their famous octagon red and black pads that

Roger Taylor with Blondie's Clem Burke and Debbie Harry.

were widely used during the 1980s. The most famous users of these instruments were Prince in the United States, Depeche Mode in Great Britain, Indochine in France, and Kraftwerk in Germany.

Having previously made their resistance to the synthesizer known—calling it the "enemy" of rock 'n' roll because of its sound modeling and lack of naturalness in its audio samples—Queen gave in to the electronic charms of the drum kit because, as always, they wanted to explore new musical realms. At first, Roger Taylor chose to use the Syndrum as a tom tom simulator, without adding any futuristic sound effects, but this would soon change once Taylor discovered the huge scope of sounds offered by the device.

The second surprise in the production of "Fun It" is that Roger and Freddie share the vocals. Roger covers the verses, and Freddie the pre-refrains, then both join together for the refrains. In the end, it's impossible not to be carried away by the rhythm of this dance anthem, with its celebration of dancing and night life. While adding a drum kit and a dash of disco sound may seem like a moment of sacrilege on the part of Taylor, there's no denying that "Fun It" is a musical success, and it would mark a turning point in Queen's discography. The group was in a phase of change, and their message to the fans was clear: Go with the flow and try to keep up.

QUEEN: ALL THE SONGS 243

Brian May, his wife Chrissie Mullen, and their two children, James and Louisa, at Japan's Fukuoka Airport on October 19, 1982.

LEAVING HOME AIN'T EASY

Brian May / 3:15

Musicians
Brian May: lead vocals, backing vocals, electric and acoustic guitars
John Deacon: bass
Roger Taylor: drums

Recorded
Mountain Studios, Montreux: mid-July–August 1978
Super Bear Studios, Berre-les-Alpes: September 1978

Technical Team
Producers: Queen, Roy Thomas Baker
Sound Engineer: Geoff Workman
Assistant Sound Engineer: John Etchells

1978

ON YOUR HEADPHONES
Beginning at 0:56, Roger Taylor doubles the side drum strokes on the fourth beat of each bar, which helps drive the number's tempo.

Genesis

After the birth of his first child, James (nicknamed Jimmy), on June 15, 1978, Brian May became even more torn by the idea of having to leave home for worldwide tours and long hours of recording. On *Jazz*, which was recorded in studios located in Switzerland and France, May's absence was even longer than on previous albums, when Queen was still recording in British studios. But despite his misgivings, Brian was a famous musician and a bona fide rock star, and that career requires a person to spend long amounts of time on tour and on the road. May knew that was the case, and every new song he wrote on the subject emphasizes the paradox of his situation. He had reached the pinnacle of his profession and was in a place where countless other musicians would kill to be, and yet he couldn't help but feel that he was shirking his duties in other areas of his life. Songs like "Good Company," "Long Away," and "Sleeping on the Sidewalk" clearly expressed May's longing to return home to his family, while other songs like "Now I'm Here" and "Tie Your Mother Down" showed May's capacity for fun and pleasure. "Leaving Home Ain't Easy" is clearly a May song, full of emotion, uncertainty, and melancholy.

Production

Brian's voice on this track owes a clear debt to Paul McCartney, and the production of this number was also very much influenced by the Beatles, with its meticulous clarity and lyrics characterized by the sincerity of their author. The poignant melody and May's romantic vocal interpretation serve the content of the lyrics well. Two acoustic guitars support the piece: The first plays a riff with a muffled effect, and the second provides the rhythm, while Brian adds discreet layers with his Red Special. The break, which begins at 1:52, features the narrator's wife imploring him to stay, and this is the most emblematic moment of the song and of May's conflicting desires to be a rock star and to live a peaceful home life. This powerful effect was created during production, and has a surprising provenance, which May later explained: "The lady's part? It's me. We slowed down the tape to record it so it comes out speeded up."[5] To add to the enigmatic aspect of the break, the guitarist's voice was covered with a phaser effect similar to the effect used on other May songs including "'39" from *A Night at the Opera*.

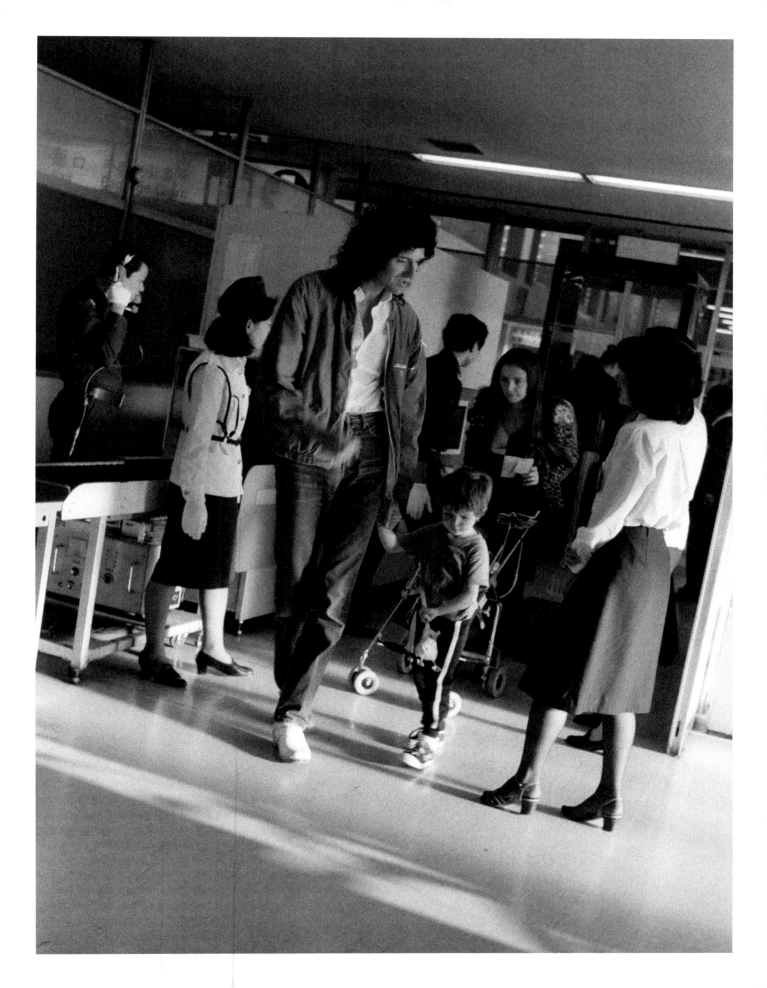

SINGLE

DON'T STOP ME NOW
Freddie Mercury / 3:29

Musicians
Freddie Mercury: lead vocals, backing vocals, piano
Brian May: electric guitar, backing vocals
John Deacon: bass
Roger Taylor: drums, tambourine, backing vocals

Recorded
Mountain Studios, Montreux: mid-July 1978
Super Bear Studios, Berre-les-Alpes: September 1978

Technical Team
Producers: Queen, Roy Thomas Baker
Sound Engineer: Geoff Workman
Assistant Sound Engineer: John Etchells

Single
Side A: Don't Stop Me Now / 3:29
Side B: In Only Seven Days / 2:30 (EMI); More of That Jazz / 4:16 (Elektra)
UK Release on EMI: January 26, 1979 (ref. EMI 2910)
US Release on Elektra: February 20, 1979 (ref. E-46008)
Best UK Chart Ranking: 9
Best US Chart Ranking: 86

In "Don't Stop Me Now" Freddie Mercury explicitly references Lady Godiva, an eleventh-century noblewoman and a classic character from the British middle ages. She was married to the Earl of Mercia, and legend has it that she begged her husband to cancel the oppressive taxes he had imposed upon his subjects. The earl agreed, but only on the condition that his wife first parade through the city of Coventry naked and on horseback, which he thought she would never do.

Genesis

With its catchy melody, three-part refrains, and the repetition of the song's title in the backing vocals, "Don't Stop Me Now" is one of Queen's most famous songs and also one of the tracks best loved by fans. Unfortunately, the penultimate song on *Jazz* also marks a real break in the relationship between the four musicians. Written by Mercury, this ode to excess implicitly describes its author's issues surrounding sex and substance abuse. At the time, Freddie was living a fairly unrestrained lifestyle, which included multiple romantic partners and an ever-increasing amount of drug use. This constant need for indulgence created a distance between Freddie and the rest of the members of Queen, who were growing increasingly concerned about his lifestyle. As Brian May commented later: "I thought it was a lot of fun but, yes, I did have an undercurrent feeling of 'Are we talking about danger here?' because we were worried about Freddie at this point and I think that feeling lingers."[91] Roger Taylor confirmed that although the song is regularly sung at karaoke bars and by participants in TV talent shows, "They don't know the darkness behind it."[79]

The song was released in the United Kingdom on January 26, 1979, as part of the second 45 rpm from *Jazz*. It was relatively successful at the time, reaching only ninth place on the charts. But as time progressed, "Don't Stop Me Now" went on to become a classic for the group, which Brian May confirmed in an interview in 2011, saying: "It's become [I think] almost the most successful Queen track. [...] It's a sort of anthem to people who want to just be hedonistic."[91]

Production

Run at 156 beats per minute, "Don't Stop Me Now" is still a straightforward paean to rock excess. Featuring no flourishes or artistic experimentation of any kind, the song is carried by Mercury's vocals and piano. Roger Taylor imposes the rhythm, unleashing his tambourine in the refrains, which rely on the song's extremely effective backing vocals. Brian May's solo is one of the best known and most loved from Queen's entire discography, and it was achieved by dephasing the microphones used to record his Red Special. May's solo has since gone on to be revered and re-created by generations of budding guitarists who dream of imitating the muffled sound he was able to achieve.

MORE OF THAT JAZZ

Roger Taylor / 4:16

Musician
Roger Taylor: lead vocals, backing vocals, drums, maracas, electric guitar, bass

Recorded
Mountain Studios, Montreux: mid-July 1978
Super Bear Studios, Berre-les-Alpes: September 1978

Technical Team
Producers: Queen, Roy Thomas Baker
Sound Engineer: Geoff Workman
Assistant Sound Engineer: John Etchells

Genesis

The last song on the album and the second song written for *Jazz* by Roger Taylor, "More of That Jazz" bears the hallmark signatures of its creator: an obvious introduction, a drum solo, and a repetitive and driving guitar riff. These features are all accompanied by a fierce voice calling out for an end to all that jazz. Concerning the subject of the album's title, Taylor confirmed: "That's got nothing to do with jazz, the style of music. It means bullshit and a lot of other things too. It is also a visual strong word, sounds strong and looks strong."[78] Be that as it may, the drummer seems to be criticizing this style of music, which he finds repetitive: "*All you're given / Is what you've been given / A thousand times before / Just more, more / More of that jazz.*" The song, which was later renounced by its author, did not create any indelible memories for the fans or for the members of Queen, and it offered a decidedly tame conclusion for a decidedly uneven album, which was nevertheless peppered with such timeless numbers as "Don't Stop Me Now" and "Fat Bottomed Girls."

Production

In addition to his role as a percussionist, Roger Taylor also appeared as a guitarist, bassist, and singer on this track. Impressive as Taylor's talents may be, the real stroke of inspiration in this song occurs at the end of the piece, when Taylor opts to include extracts of other songs from the album. Beginning at 3:13, samples from "Dead on Time," "Bicycle Race," "Mustapha," "If You Can't Beat Them," and "Fun It" all appear in turn, before ending with the a cappella introduction to "Fat Bottomed Girls."

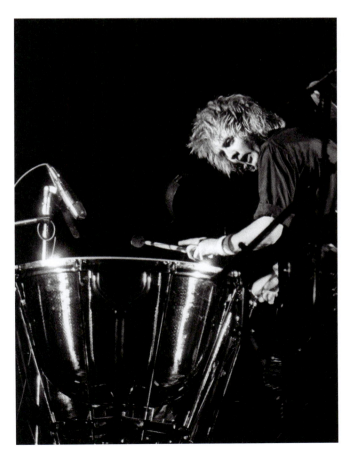

Roger Taylor onstage in Oakland, California, in December 1978.

LIVE ALBUM

LIVE KILLERS

> **FOR QUEEN ADDICTS**
> A fascinating report by the late Belgian journalist Gilles Verlant details the organization and backstage planning that went in to putting on a Queen concert, specifically those performed by the group at the Forest National in Brussels on January 26 and 27, 1979. Verlant's video interviews can be found on YouTube, and they include numerous accounts by members of the band.

The stage lighting on the *Live Killers* tour was so hot that the group took to calling it the "pizza oven."

Release Dates
United Kingdom: June 22, 1979
Reference: EMI—EMSP 330
United States: June 26, 1979
Reference: Elektra—BB-702
Best UK Chart Ranking: 3
Best US Chart Ranking: 16
Recorded: Manor Mobile in Europe (Lyon, Barcelona, Zurich, Frankfurt, Paris, Rotterdam), between January and March 1979
Mixing: Mountain Studios, Montreux
Sound Engineer: John Etchells
Assistant Sound Engineer: David Richards
Producer: Queen

Disc 1—Side 1
1. We Will Rock You (Fast)
2. Let Me Entertain You
3. Death on Two Legs (Dedicated to…)
4. Killer Queen
5. Bicycle Race
6. I'm in Love with My Car
7. Get Down, Make Love
8. You're My Best Friend

Disc 1—Side 2
1. Now I'm Here
2. Dreamers Ball
3. Love of My Life
4. '39
5. Keep Yourself Alive

Disc 2—Side 1
1. Don't Stop Me Now
2. Spread Your Wings
3. Brighton Rock

Disc 2—Side 2
1. Bohemian Rhapsody
2. Tie Your Mother Down
3. Sheer Heart Attack
4. We Will Rock You
5. We Are the Champions
6. God Save the Queen

The Best of Queen on a Double Album

Between February 27 and March 1, 1979, Queen completed their European tour, ending with three concerts at the Pavillon de Paris, in France. In each country along the way, the group had recorded their performances with the aim of creating their first live album, which they awaited with great impatience. After the Paris concerts, the musicians quickly returned to the Mountain Studios in Montreux, Switzerland, and began the production of their live disc with the help of John Etchells, one of the sound engineers who had worked on the studio version of the *Jazz* album.

The objective was clear: It was essential for the highly charged atmosphere of the concerts to come through on the disc, and to accurately convey the energy the group created onstage. This was a requirement of extreme significance, considering the live album would present all of Queen's greatest hits in one double album, including "We Will Rock You," "You're My Best Friend," "Bohemian Rhapsody," and "Keep Yourself Alive."

An (Mostly) Authentic and Sincere Disc

With the objective of producing a faithful record of the group's concerts, Brian May and his colleagues focused on the choice of tracks to be included, and on the overall mixing of the live album, rejecting the idea of reperforming certain imperfect parts, even though it was considered customary to touch up live albums. "I think, in a way, we might have been too honest because we didn't do any overdubbing. The only patching up we did was to use different parts of different nights when we'd had problems. […] But the sound, in retrospect, is a bit too live and a bit too rough. […] So I think it might have been a good idea to go in and work on it so that it sounded better. It's a hard decision to make, you know, because when you put it out, you want to be able to say that it is live,"[74] said Brian May. The guitarist also explained: "I think *Live Killers* was a kind of evidence of what we were doing live late in the seventies. In some way[s], I'm unsatisfied. We had to work hard in every concert and there were serious sound problems. There were concerts that […] had sounded great but then when we listened to the tapes they sounded awful. We recorded ten or fifteen shows, but we could only use three or four of them to work on […]. *Live Killers* isn't my favorite album…"[92]

The introduction to "Death on Two Legs (Dedicated to...)" was cobbled together in the studio, which was quite surprising. When Freddie Mercury presented this number to the public, the phrase "*This next song is from* A Night at the Opera. *This is about—*" is abruptly interrupted with three bleep sounds. The three audible signals were deliberately left in as the group's way of denouncing the censorship applied by the record company. In truth, this is how Freddie actually introduced "Death on Two Legs" in concert: *"This is about a dirty nasty man, we call him motherfucker. Do you know what motherfucker means? I'm sure you have a word for it. We call him...We also call him Death on Two Legs!"* Certain that the manager of Trident Productions, Norman Sheffield—to whom this song was dedicated—would take them to court for such an insult, the managers of EMI insisted that this introduction could not appear on the live album.

In addition, the photo used on the record sleeve, which shows the four musicians greeting their public, is also the product of slight alterations, which Brian May revealed in his 2017 book, *Queen in 3-D*. The record sleeve image, credited to the photographer Koh Hasebe, shows May extending his Red Special toward the ceiling, which is covered in mounted floodlights. May was actually added into the photograph after it was already taken. "It's the shot of me that we snuck into the cover of the *Live Killers* album (not many people knew that—until now!)."[29]

A Half-Hearted Reception

When *Live Killers* appeared on June 22, 1979, the 33 rpm double album was very successful in the United Kingdom,

> The European tour for *Live Killers* was massive, with more than thirty technicians required to ensure that each night's stage production ran smoothly. The ceiling lights gantry alone required a large number of roadies to ensure that it had been assembled safely. The lighting system was commonly referred to as "the Pizza Oven" by the band members because of the heat it gave off.

where it reached number three on the charts. Interestingly, it did not make it to the American top ten, topping out at sixteenth place. The critics were harsh once again, and this time they spared neither the music nor Freddie Mercury, who was at the height of his eccentricity. David Fricke, of *Rolling Stone*, wrote: "Queen is just another ersatz Led Zeppelin, combining cheap classical parody with heavy-metal bollocks."[93]

Notwithstanding the views of the critics and the regrets of the musicians, *Live Killers* is an excellent live album. At the beginning of the 1980s, the group's concerts got better and better due to the four musicians' technical development, but this disc is a testament to the spontaneity and sincerity of the group, and it also serves as a kind of marker for the end of the band's so-called No Synth Era. The age of the MTV superstar was about to begin, and Queen's penchant for spontaneity would soon be replaced by perfectly choreographed shows that reached new heights of technical perfection.

ALBUM

THE GAME

Play the Game . Dragon Attack . Another One Bites the Dust . Need Your Loving Tonight . Crazy Little Thing Called Love . Rock It (Prime Jive) . Don't Try Suicide . Sail Away Sweet Sister (To the Sister I Never Had) . Coming Soon . Save Me

RELEASE DATES
United Kingdom: June 30, 1980
Reference: EMI—EMA 795
United States: July 1, 1980
Reference: Elektra—5E-513
Best UK Chart Ranking: 1
Best US Chart Ranking: 1

1980

Freddie revealed his mustache for the first time on the cover of the "Play the Game" single.

THE MUNICH ADVENTURE

By the time the group's double album *Live Killers* was released on June 22, 1979, the musicians had already gotten back to work in the studio. At the beginning of June, after arriving directly from Japan—where their *Jazz* tour had just ended—the team set up for two months in a new venue, at the Musicland Studios in Munich, Germany. Located in the basement of the huge Arabellahaus building, which housed a hospital, a hotel, and private apartments, the recording complex was created in 1969 by Italian producer Giorgio Moroder, who was internationally famous for the tracks he wrote and produced for Donna Summer, the queen of disco. It was here that the diva's greatest hits—"Love to Love You Baby," "The Hostage," and "I Feel Love" were created. Artists including Led Zeppelin, Deep Purple, the Scorpions, and the Rolling Stones worked on some of their most famous albums here, the most famous of which is undoubtedly *Black and Blue* by the Stones.

Tired of the grueling routine of constant work in the studio followed by promotional appearances and then a tour, which the band had been repeating over and over again since 1973, Queen came to Munich for a change of scene and to give themselves time to relax and recalibrate. Not a single song had been written and no album production had been planned. After the constant misunderstandings of the *Jazz* period and a harrowing year of touring, the group came to Germany with the simple goal of simply being together and creating together, before returning to the United Kingdom.

Mack Arrives on the Scene

Musicland's resident sound engineer was Reinhold Mack (simply known as "Mack"), who was renowned for his expert work on the records of the experimental British rock band Electric Light Orchestra. "I was just in Los Angeles working with Gary Moore. One day I meet Moroder who said Queen is in the Studio in Munich. You should go there! But when I arrived in Munich, no one knew of anything, and in the Studio there was just heaps of equipment."[94] Peter Hince, the group's technical head, explained to the producer, who had just gotten off the plane, that for tax reasons Queen had to stay out of UK territory for a while longer. An idea then sprouted in Mack's head, who asked Hince if he could put together a set of instruments for the band, just in case they should need them. Shortly after, and still when no official recording sessions had been planned, the musicians recorded "Crazy Little Thing Called Love."

Queen quickly bristled at Mack's temperament and new way of doing things, which were unnerving to say the least. "We already had our own methods of working in place," explained Brian May. "Mack immediately blew all that apart, because he had methods of his own. And Mack was not a person who easily compromised. His attitude [...] was something like, 'Well, if you don't like my methods you should try recording somewhere else!'"[29] The man Freddie Mercury would later call a genius would eventually co-produce the record and bring a new, more modern sound to the band who now found themselves at the end of

252 THE GAME

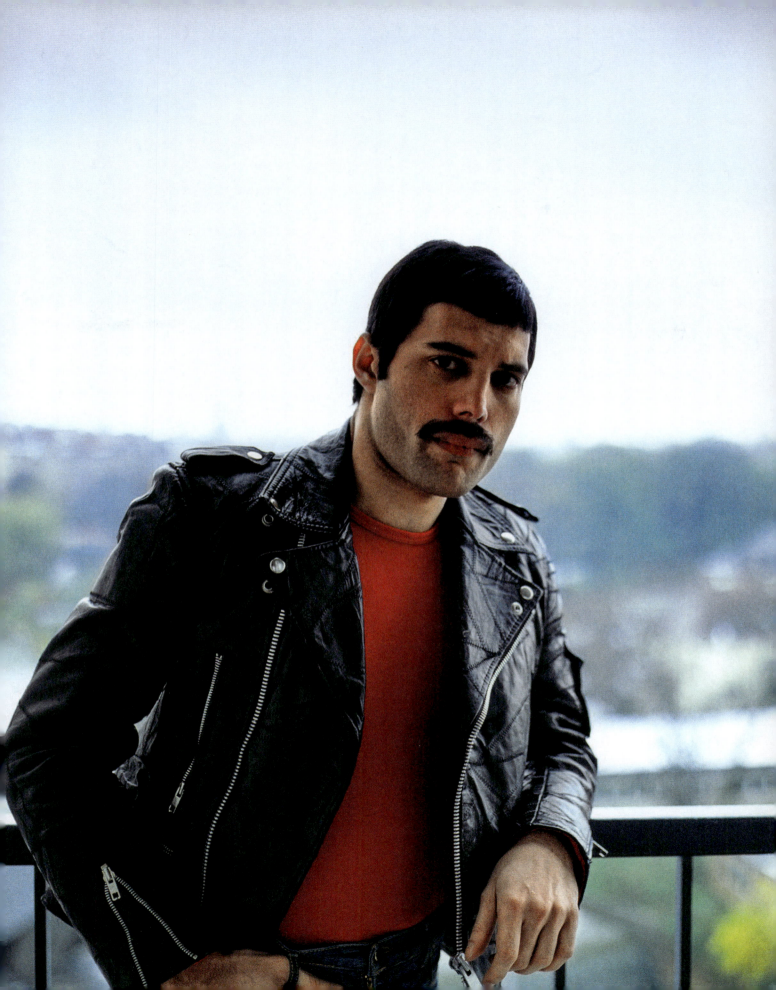

a decade in which punk was fading into memory and disco was gasping its last breaths.

The Beginnings of a New Album?

"One of my fortes is I work really fast," explained Mack, "and Queen work very slowly. I only discovered how slow later on. My plan was to get them to change because they'd become so stuck in their ways."[2] The group's new method of writing and recording seemed to work well. In the course of just a few weeks, dozens of songs were composed, some were demoed, and four were recorded, but there was no question of a new album being ready yet. Brian May had written two tracks, the ballads "Save Me" and "Sail Away Sweet Sister," and Freddie Mercury had composed the rockabilly-tinged "Crazy Little Thing Called Love." Roger Taylor had also completed one track, "Coming Soon," but in spite of the creative energy flowing between the musicians, tensions were still persistent, as Brian May would later recount: "We went through a bad period in Munich. We struggled bitterly with each other. [...] We all tried to leave the band more than once. But then we'd come back to the idea that the band was greater than any of us."[43]

The musicians had wanted to own their own recording studio in London for several years, but for tax reasons (see page 191) they decided to change tack and purchase Mountain Studios in Montreux, where they had recorded *Jazz* the previous year, and which had recently gone on sale.

Jim Beach, the band's manager, was in charge of carrying out the transaction, and in July 1979 Queen became the owners of their very own recording complex. "We did like the studio and we liked the friendly little town of Montreux, so this led to us buying the studio, and it became our own 'Mountain Studios,'" Brian May explained in 2017. "In this very homely environment, we made so many recordings over the years [...]. There is so much to say about Montreux, because it became our second home, and particularly for Freddie, towards the end of his life, it was a place where he didn't have the problem of camera lenses being stuck in his face the whole time. [...] For us as a band it was also a great escape because we were able to work very quietly and privately [...] and, in a sense, be a family."[29]

Freddie Mercury in the Footsteps of Baryshnikov

While Roger Taylor made the most of the end of the summer, using the time to fine-tune the writing of his first solo album, *Fun in Space*, which he recorded at the Mountain Studios in the fall of 1980, Freddie Mercury spent his time working on a project that was as surprising as it was risky. After singer Kate Bush's refusal to attend a charity gala organized by the Royal Ballet in London, Joseph Lockwood, who was one of the directors of the band's record label, EMI, and also a close friend of Freddie's, suggested that the leader of Queen replace her. As the singer would later recount, "I only really knew about ballet from watching it on television, but I always enjoyed what I saw. Then I became very good friends with Sir Joseph Lockwood at EMI, who was also chairman of the Royal Ballet board of governors. I began to meet people who were involved in ballet and I became more and more fascinated by them."[95] The star had just two weeks of rehearsals in which to familiarize himself with the dance techniques of his new colleagues, including company dancer Derek Deane, who would later bear witness to the singer's commitment: "He would try absolutely anything. In fact, we had to hold him back in case he

Peter Hince, Queen's chief roadie and photographer, checks the action of John Deacon's Fender Precision guitar.

Roger Taylor behind the pinball machine at Musicland Studios in Munich.

Freddie Mercury during rehearsals with the Royal Ballet of London in August 1979.

did himself an injury."[96] On October 7, 1979, at the London Coliseum theater, in front of more than two thousand people, the newly christened dancer performed, accompanied by the prestigious Royal Ballet of London. Freddie entered the stage carried by three dancers, then performed two songs by Queen: "Bohemian Rhapsody," in an instrumental version that had been entirely rearranged for the occasion, and "Crazy Little Thing Called Love." Roger Taylor was in the audience that night and later had this to say about that memorable evening: "There was only one person in the world that could have gotten away with it. Freddie was performing in front of a very stiff Royal Ballet audience, average age ninety-four, who did not know what to make of this silver *thing* that was being tossed around onstage in front of them. I thought it was very brave and absolutely hilarious."[2]

It was during this event that Freddie Mercury met the man who would later become his personal assistant: Peter Freestone. "I was in the right place at the right time," Freestone would later recount. "[...] I was in charge of costumes at the Royal Opera House in London. [...] After hearing him sing 'Crazy Little Thing Called Love' and 'Bohemian Rhapsody,' I congratulated him, and he asked me questions about my work. And that was it. Two weeks later, Queen's management called me to ask me if I could take care of the costumes for the band's tour in England. The first year, I was indeed in charge of the costumes. Then Freddie wanted me to move in with him at his house in London. And in twelve years, I never signed a single contract. [...] I answered the phone, entertained visitors, did the shopping and the bills, cooked, cleaned. I made sure that Freddie could concentrate exclusively on his music."[97] Freestone remained with Mercury until the singer's death on November 24, 1991.

Of the two songs that Mercury performed in the ballet, only "Bohemian Rhapsody" was already known to the public. The second song, "Crazy Little Thing Called Love," had just been released as a single in Great Britain, on October 5, and for the first time in the band's history, the single was not taken from any album. With its fresh, pure rockabilly style, the single proved a huge hit in the UK as Queen prepared to embark on their first tour of Britain since the spring of 1978.

The Fall "Crazy Tour"

For this four-week tour, the band asked tour manager Gerry Stickells to find small, intimate venues to perform in so they could be as close to their audience as possible. "We had played the big places," recalled Brian May, "and although

QUEEN: ALL THE SONGS 255

1980

FOR QUEEN ADDICTS

Roger Taylor refused to call the album "Play the Game," after its opening track, arguing that in Great Britain such an expression meant total submission to the rules imposed by the established authorities. "I don't particularly sympathize with that view,"[5] joked the drummer.

Queen during the *Game* tour in Detroit on September 20, 1980.

we loved them, and felt it was good that more and more people could come and see us, we also felt we were losing touch with the audience. Our whole show was about audience contact—we felt close to them, they felt close to us. But with those big places they were so far away, so distant."[1] A series of twenty concerts followed, taking the band to venues such as the Apollo Theatre in Manchester and Bristol's Hippodrome. John Harris, Queen's original sound engineer, left the band after this tour and was replaced by an American named James "Trip" Khalaf, who later went on to work for artists including Roger Waters and Madonna. During this series of concerts, the single "Crazy Little Thing Called Love" was released in the United States on December 7, 1979. The song was a great success and ended the year at the top of the charts. In January 1980, Brian May's song "Save Me" was released in the UK and was also well received, which encouraged the group to return to the studio to create other songs in a sober, melodic rock vein.

Back to Germany

In February 1980, Queen and the team met up with Mack once again at Musicland Studios in Munich. Brian May was assisted by his personal technician, Brian "Jobby" Zellis, who continued to work with him until 1992. Roger Taylor was accompanied by the loyal Chris "Crystal" Taylor, with whom he had been working since 1976. Technical manager Peter Hince remained available for John Deacon and Freddie Mercury, who was accompanied by his usual inner circle (including his personal manager, Paul Prenter), and the newcomer Peter Freestone.

The group was extremely productive despite the distractions offered by Munich's nightlife. While Freddie

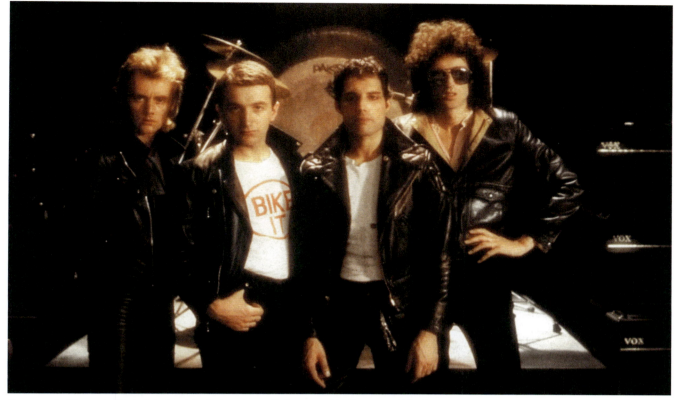
Queen went with a rockabilly look in this John Rodgers image that was used for the cover of *The Game*.

frequented the city's many gay clubs, including the well-known Old Mrs. Henderson, the other musicians spent their nights at the Sugar Shack, often accompanied by Reinhold Mack, who would later recount that "The Sugar Shack became known as 'The Office.' We'd be down there after the studio at least every other day."[2] Indeed, the team went down there to have a drink and enjoy the pleasures of the night, but also to test new songs, using the venue as a makeshift rehearsal space once the other revelers had left. The musicians were then able to take advantage of the club's particularly powerful sound system, as Brian May explains: "Anything with a bit of groove and space sounded good. [...] We played some of our stuff, like 'Tie Your Mother Down,' and it didn't work because it was crammed with so many things that there was no space. After that we became obsessed with leaving space in our music and making songs that would sound great in the Sugar Shack."[2] One of the group's new songs passed the test with flying colors. Secretly written by John Deacon, and with clear disco influences, the song was "Another One Bites the Dust."

The Oberheim OB-X: A New Friend with Multiple Sounds

As part of his constant search to simplify arrangements and make them more efficient, Roger Taylor instigated a revolution of sorts that would forever alter Queen's artistic balance. Always in search of new sounds and perennially on the lookout for the latest trends, the drummer introduced his colleagues to his new toy, a brand-new OB-X synthesizer, which had just been launched on the market by the American company Oberheim. The keyboard offered a breathtaking range of sounds and was immediately adopted by the band, as John Deacon explained: "We wanted to experiment with all that new studio equipment. We had always been keen to try out anything new or different while recording. The synthesizers then were so good; they were very advanced compared to the early Moogs, which did little more than make a series of weird noises. The ones we were using could duplicate all sorts of sounds and instruments—you could get a whole orchestra out of them at the touch of a button. Amazing."[5]

New songs were soon created in the Munich studios using the newfangled instrument, including the now-famous "Another One Bites the Dust" as well as "Dragon Attack" and "Play the Game," which gave its name, in part, to the album released on June 30, 1980. For the first time since 1974's *Sheer Heart Attack*, Queen posed for the album cover. Dressed in leathers, the musicians were captured for the occasion by photographer John Rodgers. Their label, EMI, was delighted, seeing the band's photograph as an opportunity for better promotion in an era when musical artists were being raised to hero status.

In a short space of time, *The Game* reached number one on both the British and American charts, propelled by the single "Play the Game" which was released on May 30, 1980, and then by the song that would become one of Queen's greatest hits: "Another One Bites the Dust."

PORTRAIT

The brilliant Reinhold Mack behind the console at Musicland Studios in Munich in 1979.

REINHOLD MACK: THE PRODUCER WHO TOOK QUEEN INTO THE 1980s

Reinhold Mack was born in 1949 in a Germany that still bore the scars of World War II. His parents ran a musical instrument shop, and the young Mack joined an amateur rock band during his high school years, whose exploits he would later recount: "We were terrible. We made the papers because we were called 'the loudest band on earth'—lots of people claim that, but we were pretty loud. Our loudness covered up the awfulness."[98]

Humble Beginnings

The years went by. At the age of twenty-three, young Reinhold (now known to his friends and family simply as "Mack"), moved to Munich to stay with his girlfriend, Ingrid, who was a student at the city's university. As the producer recalls, "The one thing I knew: I liked music. But how do I get somewhere with that? As a musician? Unlikely. But perhaps if I worked in a Studio, I thought in my naiveness, I could jump in if someone drops out."[94] The young man then went to work at Allach Studios in Munich, which would become the Union Studios ten years later. "I cleaned up and took notes,"[94] recalls Mack who, biding his time, served as the acting studio gofer. Finally, one day, one of the sound engineers refused to work with a band he considered mediocre and left: "The people looked at me and asked if I could do that."[94] At only twenty-five years old, Mack quickly became the studio favorite. The composer Ralph Siegel soon asked him to mix a track for him, as did singers Peter Alexander and Udo Jürgens.

The Encounter with Giorgio Moroder

It was at this time that Mack met Giorgio Moroder, an Italian producer who had just set up Musicland Studios in the basement of the Arabellahaus complex in northeast Munich. Moroder asked Mack to mix one of his tracks and, extremely satisfied with the result, hired him at Musicland for a starting salary three times higher than what he was earning at Allach Studios. Mack then discovered disco and worked alongside Moroder to make records with his own band, Munich Machine, while also producing albums for well-known rock bands like T. Rex and Electric Light Orchestra.

The encounter that would change his life happened in 1979, when Queen arrived from Japan with their technical team and all their stage equipment. As Mack explains, "Ratty [Peter Hince], the roadie from Queen, said: We need a room to store our things, because we have to remain outside of England for two more weeks. I asked if I should build up a small set for the band."[94] And so it was that Queen, who hadn't planned to record anything in Munich, recorded one of their greatest hits: "Crazy Little Thing Called Love."

A friendly and respectful bond was quickly forged between the group and Mack. Mercury became a very close friend of the producer, who later named him as godfather to his youngest son, who coincidentally was also named Freddie. In addition to the five albums he co-produced with Queen, Mack worked on other projects with the band's musicians, starting with their various solo albums: Freddie Mercury's *Mr. Bad Guy*, Brian May's *Star Fleet Project*, and Roger Taylor's *Strange Frontier*.

Freddie Mercury was very close to Reinhold Mack's children and once asked the producer's eldest son, Julian, what he would like for his birthday: "All I want is for you to show up to my party in the costume from the 'It's a Hard Life' video." The star complied and duly appeared in red peacock attire. "I can do this on stage. I can do this at this party…,"[99] the distinguished guest declared.

May played a Fender Stratocaster for the video of "Play the Game."

SINGLE

PLAY THE GAME
Freddie Mercury / 3:30

1980

Musicians
Freddie Mercury: lead vocals, backing vocals, piano, synthesizer
Brian May: electric guitar, backing vocals
John Deacon: bass
Roger Taylor: drums, backing vocals

Recorded
Musicland Studios, Munich: February–April 1980

Technical Team
Producers: Queen, Reinhold Mack
Sound Engineer: Reinhold Mack

Single
Side A: Play the Game / 3:30
Side B: A Human Body / 3:42
UK Release on EMI: May 30, 1980 (ref. EMI 5076)
US Release on Elektra: June 6, 1980 (ref. E-46652)
Best UK Chart Ranking: 14
Best US Chart Ranking: 42

> In the summer of 1980, it was announced that Andy Gibb, the youngest of the Gibb siblings, whose three brothers, Barry, Maurice, and Robin, formed the band the Bee Gees, had recorded a version of "Play the Game" in Munich over the winter as a duet with Freddie Mercury. Mack, the producer of the album, confirmed the story, but no one has ever heard the song.

> The OB-X synthesizer is the little brother of the OB-1, which was launched in 1976 by Tom Oberheim, who also gave his name to one of the heroes of the *Star Wars* film series, Obi-wan Kenobi.

Genesis
Majestically opening the band's so-called Synth Era, "Play the Game" is an effective ballad, bearing the habitual Freddie Mercury signature: a catchy melody, backing vocals on the choruses, and lyrics full of romanticism. It represents a successful transition to a decade that would be marked by the use of synthetic instruments in all types of new musical currents, such as new wave, hip-hop, and even FM hard rock, and represented in the music of bands like Journey and Europe.

Recorded at Musicland Studios during a second recording session in the winter of 1980, the song was written by a Mercury in love. Although the message is universal—*"It's so easy / When you know the rules / It's so easy / All you have to do is fall in love"*—everything suggests that the singer penned his composition thinking of the new object of his affection: a certain Tony Bastin whom he met in a club in Brighton during the group's tour of Britain, where Queen played two concerts at the Brighton Centre on December 10 and 11, 1979. It was love at first sight between the twenty-eight-year-old bike messenger and the rock star, and their relationship lasted for almost two years.

"Play the Game" was the third single released from the album (even though, in reality, the first two singles, "Crazy Little Thing Called Love" and "Save Me," appeared respectively eight and five months before the release of *The Game*) and it discreetly climbed to fourteenth place on the UK charts. The B-side of the single is a track that does not appear on the album: "A Human Body," which was written by Roger Taylor.

Production
Right from the introduction we hear the drummer's new toy, an Oberheim OB-X analog synthesizer. The second polyphonic synthesizer available on the market that also featured memory (after the Prophet-5, developed by the company Sequential Circuits in 1978), the Oberheim OB-X was popularized by numerous artists including Jean-Michel Jarre, Depeche Mode, and Tangerine Dream. Queen was one of the first bands to use this instrument, with its amazing capacities and revolutionary sounds.

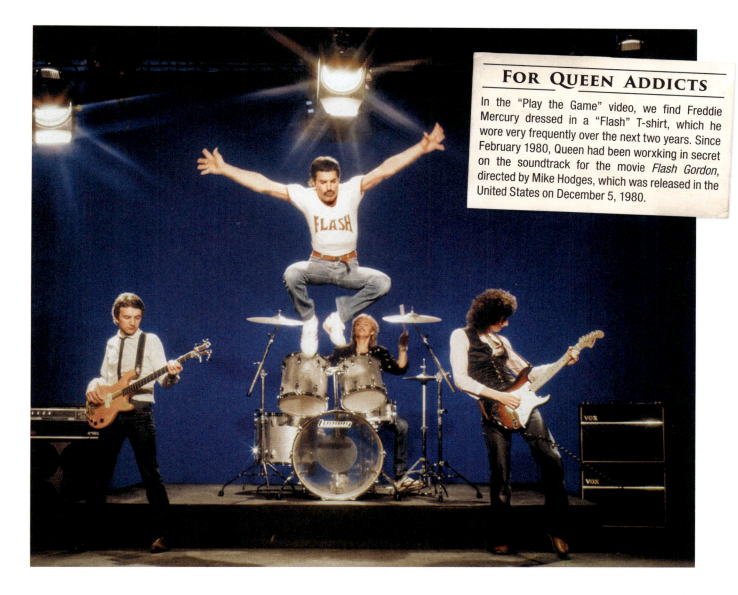

FOR QUEEN ADDICTS

In the "Play the Game" video, we find Freddie Mercury dressed in a "Flash" T-shirt, which he wore very frequently over the next two years. Since February 1980, Queen had been worxking in secret on the soundtrack for the movie *Flash Gordon*, directed by Mike Hodges, which was released in the United States on December 5, 1980.

The Video

Like the song's very modern arrangements, the accompanying video is definitely anchored in a new era for Queen and features remarkable visual effects. Filmed in front of a blue screen so that a multicolored smoke animation could be inserted during the editing, the members of the band performed their song in playback instead of playing live. Freddie Mercury, meanwhile, holds a wireless microphone in his hand, a revolutionary object for the singers of the 1980s. The video, shot on May 29, 1980, at London's Trillion Studios by director Brian Grant (who would go on to make a number of music videos for artists including Donna Summer, Dolly Parton, and Duran Duran), features freeze-frames, slow motion, and reverse motion. These newfangled techniques, considered groundbreaking at the time, make the video an unmistakable product of its time. However, it was another detail that caught the attention of Queen fans when the "Play the Game" video was first broadcast on television. For the first time, John Deacon did not perform with his faithful Fender Precision bass (or his occasional Music Man StingRay). He plays—or rather pretends to play—on a gleaming Kramer Custom DMZ 4001, the head of which has abandoned the traditional 1970s shape for a modernity that would mark the instruments put on the market in the years to come.

One may also wonder why Brian May swapped his famous Red Special guitar for a Fender Stratocaster copy. Fearing that the beautiful Red Special could get damaged, or even broken, during the planned Mercury guitar throw that happens at 2:24, Brian May replaced his beloved guitar with a cheap six-string.

But the real novelty of the video was of course Freddie's famous mustache, which can also be admired on the sleeve of the single, and which he revealed to the public here for the first time. The mustache was to become his emblem and his brand image. More than just a change of style, in 1980 the mustache was a clear sign of belonging to the gay community, although the singer's sexuality was still somewhat of an open secret.

The video for "Play the Game" represents a real renaissance for Queen, who managed to modernize their image in the space of a single video.

DRAGON ATTACK
Brian May / 4:18

Musicians
Freddie Mercury: lead vocals, backing vocals
Brian May: electric guitar, backing vocals
John Deacon: bass
Roger Taylor: drums, percussion, backing vocals

Recorded
Musicland Studios, Munich: February–May 1980

Technical Team
Producers: Queen, Reinhold Mack
Sound Engineer: Reinhold Mack

The members of Queen presented the Sugar Shack with several of their gold records as a way of saying thank you for the hours spent in this Munich nightlife hotspot.

Genesis
With its midtempo and guitar riff played in unison by John Deacon on the bass, "Dragon Attack" is rock 'n' roll in pure concentrate. The six-string gimmick is reminiscent of the one that can be heard on "Son and Daughter," also written by Brian May and present on the band's first album from 1973.

The song was conceived after a night out at the Sugar Shack, the Munich club where the musicians spent their nights during the recording of *The Game* in the winter of 1980. Back in the studio in the middle of the night, the musicians embarked on a drunken jam session, which culminated in the album's heaviest track. The lyrics refer to Mack, and when Freddie sings *"Take me back to the Shack,"* there can be little doubt that the venue was a big inspiration to Brian May! As an amused Mack recalled, "Brian was a vodka-and-tonic man. I don't think I ever saw him take a drug. But if Brian was loaded he could lose his thread completely."[2] Brian May candidly confirms the ambivalence of that Munich period: "We spent vast amounts of time in the Sugar Shack, generally hanging in there until the lights came on, and dawn was coming up outside, living in a fantasy world of vodka and barmaids, and very loud rock music. In the beginning it was quite healthy and stimulating, I have to say, but after a number of months, it went downhill and we spent much more time in the club than in the studio. I think we all got into difficulties, emotionally and spiritually if you like. If you want an insight, the song 'Dragon Attack' is a figurative portrayal of all that madness. Munich was our great stimulator but also our great downfall."[29]

Production
The sound is particularly pared down on this track, where the guitar riff serves as the master, but disappears with each verse phrase sung by Mercury. The track blends a very rock 'n' roll, guitar-forward sound and with an extremely effective bass/drums groove. In "Dragon Attack" we are treated to a powerful formulation that will be copied many times: riff on the verses, power chords on the choruses, vocals interspersed between the guitar parts and solo on the gimmick. You only need to listen to Aerosmith's 1986 version of their track "Walk This Way" (in collaboration with hip-hop group Run-DMC) to understand the influence that

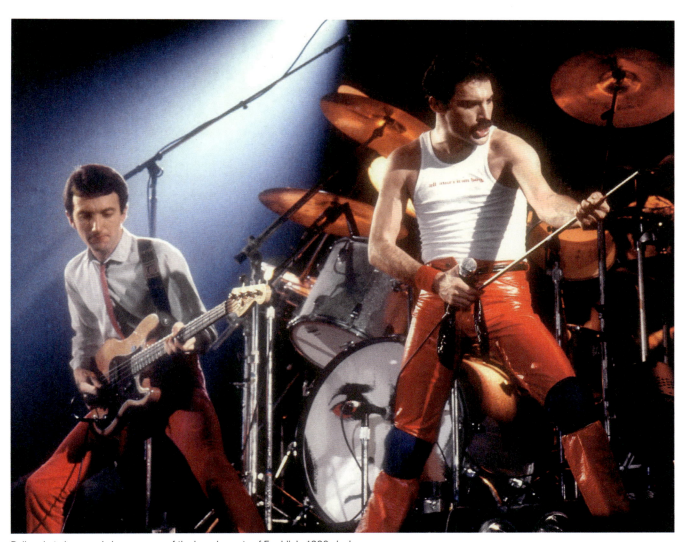
Roller-skate knee pads became one of the key elements of Freddie's 1980s look.

"Dragon Attack" had on the rock-rap fusion movement that followed. Even the attack of the solo on "Walk This Way," which begins at 1:32, is reminiscent of the solo on Queen's track, which starts at 1:00.

With the exception of Mercury, Queen's musicians were normally known for their sobriety and seriousness in the studio. But on this occasion it would appear that alcohol had a positive influence on their creativity the night they recorded the track. Taylor's percussion solo starts at 1:33 and mixes a variety of drums, demonstrating the drummer's controlled and effective power. This is followed by a bass portion that seems to have been captured live, so much so that its imperfections and slightly curling notes give it an authentic and sincere color. And what can we say about the a cappella gospel part performed by May, Taylor, and Mercury starting at 2:43, except that it is a moment of grace, simultaneously reminiscent of the amazing harmonies on "Somebody to Love" while fitting perfectly into this extremely modern production. This song is a genuine marvel of rock composition, and it rightfully appeared on the B-side of one of Queen's biggest hits, when it was released as a single in August 1980 along with "Another One Bites the Dust."

QUEEN: ALL THE SONGS 263

SINGLE

ANOTHER ONE BITES THE DUST
John Deacon / 3:35

John photographed by Peter Hince during a sound check in 1980.

1980

Musicians
Freddie Mercury: lead vocals, backing vocals
Brian May: electric guitar
John Deacon: bass, electric guitar, piano
Roger Taylor: drums

Recorded
Musicland Studios, Munich: February–May 1980

Technical Team
Producers: Queen, Reinhold Mack
Sound Engineer: Reinhold Mack

Single
Side A: Another One Bites the Dust / 3:35
Side B: Dragon Attack / 4:18 (EMI); Don't Try Suicide / 3:52 (Elektra)
UK Release on EMI: August 22, 1930 (ref. EMI 5105)
US Release on Elektra: August 12, 1980 (ref. E-47031)
Best UK Chart Ranking: 7
Best US Chart Ranking: 1

FOR QUEEN ADDICTS

The bass line of "Another One Bites the Dust" seems to be passed down from generation to generation. Christopher Wolstenholme, the bassist with the English band Muse, didn't hesitate to use it as inspiration for the verses of the song "Panic Station," which appeared on the album *The 2nd Law* in 2012.

At the time of its release in the United States, a rumor (which has since been refuted) was circulating about the presence of a hidden message in the middle of "Another One Bites the Dust." When played backward, the listener was supposed to be able to hear the phrase "Smoke marijuana."

Genesis

"John was like a bird, who stays quiet until it finally lays a perfect egg."[100] It was with these words that Reinhold Mack, the producer of the album, described Queen's quiet but brilliant bassist. A few months prior to the first recording session for *The Game*, during Queen's American tour, John Deacon took advantage of a moment of rest between the two concerts on November 16 and 17, 1978, at Madison Square Garden in New York City and attended a recording session for the band Chic, which was founded by guitarist Nile Rodgers and bassist Bernard Edwards. While disco music was in its waning days, Chic were recording their third album, *Risqué*, which produced the hit "Good Times." The bass line of this future hit immediately gave the bassist the idea for a track that would function as an astute mix of disco, funk, and rock. "John Deacon was sitting right next to me when 'Good Times' was recorded,"[101] said Nile Rodgers. Though Deacon might have lifted the bass line for [...] 'Another One Bites the Dust,'" Rodgers himself admitted that he drew inspiration for "Good Times" from a Kool and the Gang track, "Hollywood Swinging," that was released in 1974. And while it is true that the resemblance between the three bass lines is striking, the song that sprang from Deacon's imagination is completely original, as John explained: "I listened to a lot of soul music when I was in school, and I've always been interested in that sort of music. I'd been wanting to do a track like 'Another One Bites the Dust' for a while, but originally all I had was the line and the bass riff."[102]

The other musicians were willing to pursue the song, but Roger, though open-minded, had difficulty accepting the idea that Queen could evolve into funk. "Gradually I filled it in and the band added ideas," Deacon explained. "I could hear it as a song for dancing but had no idea it would become as big as it did."[102] Released in August 1980, "Another One Bites the Dust" would go down in history as one of Queen's greatest hits.

With the track completed, everyone seemed satisfied with the result. The technical staff, in particular, urged the band to offer the track as a single. But one fan's opinion would prove to be the decisive factor in deciding the song's fate. After one of Queen's four concerts at the Los Angeles Forum in July 1980, Michael Jackson came to visit the musicians in their dressing room backstage. The young

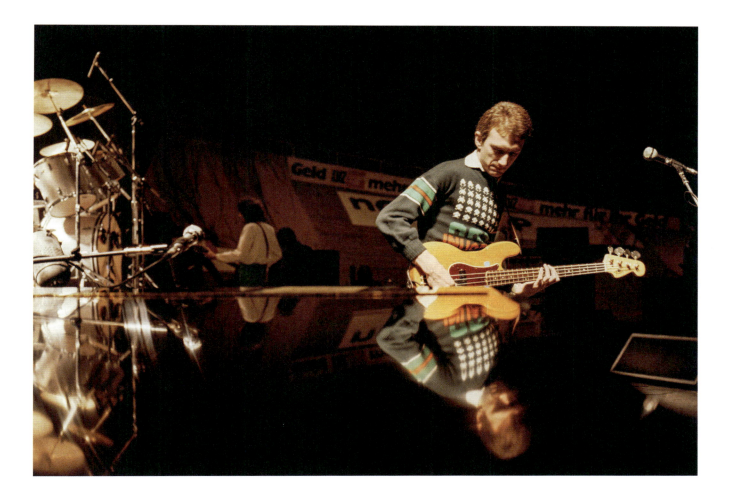

singer, whose solo album *Off the Wall* was itself a blend of funk and disco, strongly encouraged the band to release "Another One Bites the Dust" as a single. It must be said that over the previous few weeks, the track had been circulating among DJs on New York and Detroit radio stations, and faced with the enthusiasm generated by its broadcasts, even EMI was beginning to believe in the song's commercial potential. "Another One Bites the Dust" was finally released as a single on August 12, 1980, in the United States, where it was met with near-universal praise. In the United States alone, 3 million copies of the single were sold, sending it to the number one spot on the Billboard charts; it also took the top position in Argentina, Spain, Canada, and Mexico.

Production

When John Deacon presented Mack with his bass line, the producer was immediately seduced by the minimalism of the sound, as well as the groove it inspired. "[John Deacon] had the idea, and he played it to me and said, 'What do you think of this riff?' And I said, [...] 'Let me figure out something.'" The producer then created a drum loop on which Deacon could start playing. Shortly after, Freddie was intrigued by what he heard: "Have you got a line? What type of vocals do you imagine?" to which John replied: "I haven't really got much, but something like 'another one bites the dust.'"[11] "This is big! This is important! I'm going to spend a lot of time on this!"[67] enthused the singer. In love with rhythmic music designed for dance, Mercury then committed himself fully to producing the track.

Deacon played all the funk parts of the song on a Fender Telecaster because, as far as he was concerned, "it's the most cleanly cut for the rhythm involved in the songs."[103] As for the bass parts, they were recorded with his Music Man StingRay, which offered such a twangy and precise sound that it was later adopted in the 1980s by many funk rock bassists, starting with Flea, from the American band Red Hot Chili Peppers. The drums were filled with covers to help get the driest possible sound, though this went very much against what Roger Taylor usually liked, namely a "big" drum sound bathed in natural reverb.

All four members of the band worked on the track, although Brian came on the scene at the end of the creative process: "I was fine about doing it, as my job was to inject these dirty little guitars around Deakey's percussive riff."[2] To achieve this, the guitarist once again used the Eventide Harmonizer effect rack, which he used extensively on the break from "Get Down, Make Love," when the band was recording the *News of the World* album. We can recognize the strange sound of the effect adopted by May from 1:58, on the song's instrumental break.

With its simple yet polished production, "Another One Bites the Dust" became a massive hit celebrated and enjoyed in nightclubs around the world, much to the delight of its creator.

NEED YOUR LOVING TONIGHT

John Deacon / 2:48

Musicians
Freddie Mercury: lead vocals, backing vocals
Brian May: electric guitar, backing vocals
John Deacon: bass, acoustic guitar
Roger Taylor: drums, backing vocals

Recorded
Musicland Studios, Munich: February–May 1980

Technical Team
Producers: Queen, Reinhold Mack
Sound Engineer: Reinhold Mack

Single
Side A: Need Your Loving Tonight / 2:48
Side B: Rock It (Prime Jive) / 4:31
US Release on Elektra: November 18, 1980 (ref. E-47086)
Best US Chart Ranking: 44

John Deacon and Reinhold Mack at Musicland Studios in Munich.

Genesis

A pop-rock song par excellence, "Need Your Loving Tonight" bears the signature of John Deacon's previous compositions, such as "Misfire," "You're My Best Friend," and "In Only Seven Days." Driven by a simple and repetitive rhythm played on acoustic guitar, the track is effective and pleasant but is not among the bass player's greatest successes. The lyrics, which narrate the despair of someone who has lost the love of his life, overuses the expressions "I love her" and "I love you." Deaky, as his friends nicknamed him, described his writing technique in 1982: "I find it difficult to write songs. I usually start from the musical side. It's not a very good way of working. It makes it difficult because I then have a melody and have to put words to it afterwards. But it just seems to be the way I go about it. I should sit down and write some words out first and then try to put music on it. It should be simpler that way."[103]

Production

Deacon played acoustic guitar on the track, which he liked to do on tracks that he wrote for Queen.

Mack explained the extremely original technique he used to achieve the simultaneously muffled and punchy snare drum sound for the song: "You don't mic the snare drum from an angle down toward it and one at the bottom. I just use one on the side."[11]

For the first time, Freddie's voice was altered with a slight reverb effect, which would be used again on other tracks off the album, especially on the next track, "Crazy Little Thing Called Love." This is no coincidence since, with "Need Your Loving Tonight," the band had been making forays into the rockabilly genre, which was then experiencing a revival in popularity. Mercury, May, and Taylor had always been big fans of this style of music, and the band regularly covered American rock standards from the 1950s and 1960s on stage, including "Jailhouse Rock" by Elvis Presley and "Hello Mary Lou" by Ricky Nelson. It was undoubtedly for this reason that Elektra released the song as a single in the United States in November 1980, hoping to reach an American audience that appreciated this musical style, but "Need Your Loving Tonight" failed to achieve the success they had hoped for in the land of Uncle Sam.

SINGLE

CRAZY LITTLE THING CALLED LOVE
Freddie Mercury / 2:44

Musicians
Freddie Mercury: lead vocals, backing vocals, acoustic guitar
Brian May: electric guitar, backing vocals
John Deacon: bass
Roger Taylor: drums, backing vocals

Recorded
Musicland Studios, Munich: June–July 1979

Technical Team
Producers: Queen, Reinhold Mack
Sound Engineer: Reinhold Mack

Single
Side A: Crazy Little Thing Called Love / 2:44
Side B: We Will Rock You (Fast—Live Killers Single Edit) / 3:07 (EMI); Spread Your Wings (US Live Killers Single Version) / 5:17 (Elektra)
UK Release on EMI: October 5, 1979 (ref. EMI 5001)
US Release on Elektra: December 7, 1979 (ref. E-46579)
Best UK Chart Ranking: 2
Best US Chart Ranking: 1

Freddie admitted he knew only a handful of guitar chords.

Genesis

When he joined up with the band at Musicland Studios in June 1979, Freddie was accompanied by Queen's faithful technical manager, Peter "Ratty" Hince, who earned his nickname from the way he would sneak like a little rodent among the packing cases to stow the group's equipment after their concerts. After a day's travel that had been complicated by strikes at London's Heathrow Airport, Freddie and Ratty were unwinding in a suite at the Munich Hilton before heading to the studios. While taking his bath, Mercury, seized by a sudden inspiration, shouts: "Ratty, quick—come here! [...] Get me a guitar! Now!"[87] Freddie did not know many guitar chords, but the ones he could play allowed him to write one of Queen's most famous songs in a matter of minutes. Mercury and Hince left the Hilton and hurried across to Musicland, where Mack, Taylor, and Deacon were waiting for them; May was away on personal business. Understanding the urgency of the situation, the band began playing and Mack began recording. The basics of the song were laid down in less than an hour. The name of the game was "Quickly, let's finish it before Brian gets here, otherwise it takes a little longer!"[22] The beloved guitarist was known as a great perfectionist and was indeed unable to work in a hurry, so when he arrived at the studios, he discovered a song that was almost finished. As he later recalled, "I came back and thought, 'Oh my God, it's almost finished. Let me put some guitar on it before they stick it out.' [...]. All I really did was add a kind of ersatz rock and roll solo and some backing harmonies and it was done."[67]

The title is a tribute to the heyday of rock 'n' roll and in particular to Elvis Presley, who had died two years earlier. Mercury and May had always expressed their admiration for "the King," as well as for other rockers including Cliff Richard and Chuck Berry. Roger Taylor clearly expressed what the band's intention had been at the time of recording: "We wanted it like an almost slightly early Elvis feel."[104] It must be added that in 1980, there was renewed interest in rockabilly music and style. If *Grease*, Randal Kleiser's 1978 movie, became emblematic of this trend, the *Happy Days* series, broadcast from 1974 on ABC in the United States, clearly cemented the rock 'n' roll wave, which Queen would largely benefit from with their

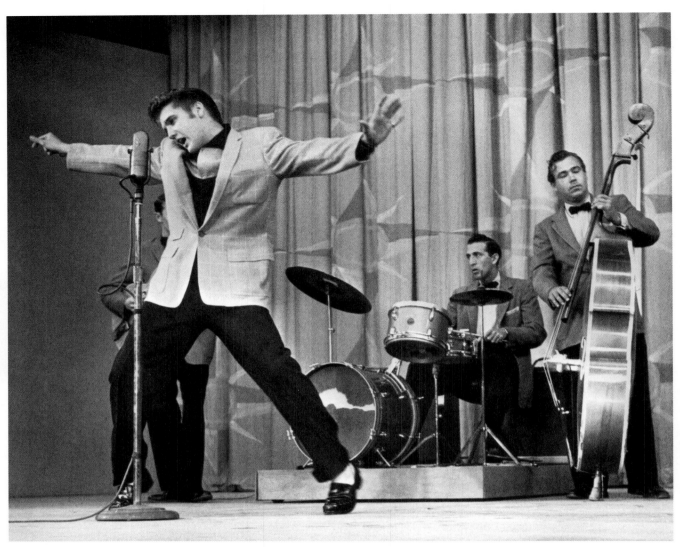

Famous for his pelvic thrusts and his warm and sensual voice, Elvis Presley strongly influenced Freddie's performance of "Crazy Little Thing Called Love."

release of "Crazy Little Thing Called Love," further paving the way for bands such as Brian Setzer's Stray Cats. The band denied having acted strategically, however, with Brian May explaining in 1989: "There was a movement which we didn't know anything about in America at that time, to sort of revive rockabilly, and it happened soon after 'Crazy Little Thing.' So soon after that people were saying, 'Oh, of course you pioneered this resurgence of rockabilly,' and we would say, 'Well, actually, we don't know anything about it, we just made a track that we liked.'"[104]

It was released as a single on October 5, 1979, in Great Britain. Elektra did not like the track at all and refused to release it in the United States. But American DJs, who had managed to get their hands on British imports, broadcast the song massively on radio stations throughout the country. Faced with pressure from listeners, Elektra finally changed their minds and released "Crazy Little Thing Called Love" as a single on December 7. It was a huge success, and the song, supported by an effective and very rock 'n' roll video, rapidly climbed to the top of the American charts.

A Video Homage to the 1950s

Director Dennis De Vallance, who had filmed the sixty-five nude models on bicycles during the shooting of the "Bicycle Race" video in September 1978, was once again asked to work on the video for "Crazy Little Thing Called Love." Shooting for the video took place at the Trillion Studios in London. The band was dressed all in leather, and Mercury, parodying his idol Elvis Presley, wiggled his hips while sliding his hand through his hair, in a loving imitation of the King. With four professional dancers (two men and two women), Mercury even performed some dance steps arranged by British choreographer Arlene Phillips. All the clichés of 1950s American rock 'n' roll are present in the video, starting with Mercury sitting astride a (stationary) motorcycle wearing the type of outfit worn by Henry Winkler, who played "the Fonz" on *Happy Days*. Even the normally sensible Brian May can be seen

268 THE GAME

Freddie on the set of the video for "Crazy Little Thing Called Love" directed by Dennis De Vallance. Leather, garter belts, and an oversized motorcycle all feature heavily in this rockabilly-inspired video.

wearing sunglasses that are far too wide for his face. From 1:45, Mercury parades on a stage from which hands emerge to keep the rhythm going with synchronized clapping to the music. To get this image, the band's entire entourage was told to lie under the stage with their hands stretched upward for the sequence!

Production

Exceptionally, it was actually Freddie who played rhythm guitar on "Crazy Little Thing Called Love." The Mercury-Taylor-Deacon trio recorded the track before May's arrival at the studio, so the group's "official" guitarist wasn't able to put his now-legendary acoustic guitar spin on the introduction. The singer also played this six-string part in concert. From 1979 to 1982, he used Brian's acoustic twelve-string Ovation Pacemaker 1615, until Peter Hince brought up a question that seemed to him to be of major importance: "Fred—you look a bit poofy playing that acoustic guitar on stage—it doesn't work. [...] It's not really rock and roll—posing like that with an acoustic. It's—poofy. [...] What about playing a Fender Telecaster [...] The feel of the song is very '50s—the era of the Telecaster. [...] I know how much you like using white on stage—I'll get you a white Telecaster."[87] Hince then offered the singer a guitar bought in New York, then a second one that was much lighter, which Mercury adopted in 1984.

Meanwhile, Brian's mission was to give "Crazy Little Thing Called Love" a real 1950s vibe, which he did thanks to his little riffs and guitar solo. But his Red Special, as versatile as it was, simply didn't fit the song's retro direction. Mack then said to May, in a rather pushy tone: "If you want it to sound like a Telecaster, why don't you just use a Telecaster?"[105] The guitarist did so, and borrowed Roger Taylor's 1967 Fender Esquire, which had been hanging around in a corner of the studio. As Brian recounted, "[Mack] put it through a Mesa/Boogie, which is an amplifier I don't get on [with] at all; it just doesn't suit me. I tried it, and it sounded okay."[89] Indeed, somewhat better than OK! The single "Crazy Little Thing Called Love" sold more than a million copies in the United States alone!

ROCK IT (PRIME JIVE)
Roger Taylor / 4:31

Musicians
Roger Taylor: lead vocals, backing vocals, drums, electric guitar, synthesizer
Freddie Mercury: vocals, backing vocals
Brian May: electric guitar, backing vocals
John Deacon: bass
Reinhold Mack: synthesizer

Recorded
Musicland Studios, Munich: February–May 1980

Technical Team
Producers: Queen, Reinhold Mack
Sound Engineer: Reinhold Mack

Roger Taylor, here with his Oberheim OB-X, introduced Queen to the world of synthesizers.

Genesis
Continuing his career as a singer with light and carefree lyrics, Roger Taylor here offers a very rock 'n' roll track, in the same vein as "Crazy Little Thing Called Love" by Mercury or Deacon's "Need Your Loving Tonight." The drummer totally acknowledges the lightness of his work: "We're not trying to solve the problems of the world and who isn't just entertainment? […] 'Rock It' is totally elemental. It's the most basic song ever that just says you can enjoy rock and roll. That's all. […] I think it's very pretentious to say that there's great importance to it; that's what the press seem to spend all their time doing."[106]

With its introduction often compared to that of the hit "My Coo Ca Choo" by Alvin Stardust, "Rock It (Prime Jive)" seemed to perfectly represent Queen's taste for easy, light music, simply intended to please and entertain, which once again drew the wrath of the British press, which gave little credit to popular artists.

Production
The production of the track proved to be a source of quarrels within the team. Roger Taylor, who had already recorded the drums, synths, and rhythm guitars, wanted to perform his song, while Mack insisted that it should be Mercury. So two versions of the song were recorded. May voted for Freddie's version while Deacon voted for Taylor's. The producer then suggested keeping Freddie's voice for the introduction, and Roger's for the rest. But he had a problem with the drummer's vocals, as he later explained, "Roger has a very particular voice, broken, that makes his musical phrases too short, as opposite to Freddie, who was able to make them longer. To avoid the lyrics to be so little, each time Roger ended up a verse I added some synth effects so there wouldn't be so much space before the next one."[100] These small notes from the Oberheim OB-X unfortunately give the track a clearly outdated edge, bordering on parody. Note, however, the mastery with which Brian May performs a very heavy solo, from 2:33, with a tapping part that would even make acknowledged master and guitar hero Eddie Van Halen green with envy.

DON'T TRY SUICIDE

Freddie Mercury / 3:52

Musicians
Freddie Mercury: lead vocals, backing vocals, piano
Brian May: electric and acoustic guitars, backing vocals
John Deacon: bass
Roger Taylor: drums, backing vocals

Recorded
Musicland Studios, Munich: February–May 1980

Technical Team
Producers: Queen, Reinhold Mack
Sound Engineer: Reinhold Mack

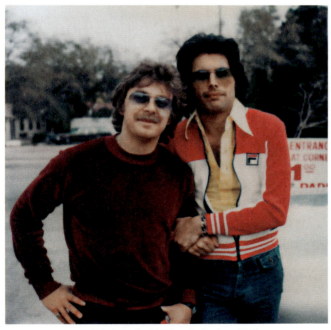

Freddie Mercury and his lover David Minns in the late 1970s. Minns was also Eddie Howell's manager.

Genesis

With its somewhat grim title, "Don't Try Suicide" is a snapshot of black humor written by Mercury for his former lover, David Minns, who attempted suicide after their breakup in 1978. The rejected lover testified bitterly to the end of their relationship: "Jim Beach [then the band's lawyer] rang me to tell me that my relationship with Freddie was over and could he please have a letter from me stating that I would not make any claims against Freddie, financial or otherwise, or go to the press. In my honor, he later wrote the song 'Don't Try Suicide.' How sweet of him."[60] No one knows if Mercury was intending to defuse tensions with his ex-boyfriend when he wrote: *"Don't try suicide / Nobody's worth it / Don't try suicide / Nobody cares / Don't try suicide / You're just gonna hate it / Don't try suicide / Nobody gives a damn."* But it's not clear whether the interested party fully appreciated Freddie's sense of humor…

Production

Like "Crazy Little Thing Called Love" or "Rock It (Prime Jive)," this track was heavily inspired by 1950s rock 'n' roll. This is particularly noticeable on the guitar solo, at 2:18, behind which the piano chords are hammered by Mercury, who plays like Fats Domino on the choruses of "Ain't That a Shame." On the other hand, with its guitar chord bathed in chorus effect and squeezed between the bass lines, the introduction of the title refers to a much more recent song: "Walking on the Moon," by British band the Police, from their album *Reggatta de Blanc*, which had been released a few months earlier, in October 1979.

QUEEN: ALL THE SONGS 271

SAIL AWAY SWEET SISTER (TO THE SISTER I NEVER HAD)

Brian May / 3:32

1980

Musicians
Brian May: lead vocals, backing vocals, electric and acoustic guitars, synthesizer
Freddie Mercury: piano, vocals, backing vocals
John Deacon: bass
Roger Taylor: drums, backing vocals

Recorded
Musicland Studios, Munich: June–July 1979

Technical Team
Producers: Queen, Reinhold Mack
Sound Engineer: Reinhold Mack

Genesis

Recorded during the summer 1979 sessions in Munich, "Sail Away Sweet Sister" is, like "Save Me" (also composed by Brian May), a melancholy ballad accompanied by a deep text. The title contains everything for which the guitarist is renowned: catchy refrains, harmonized choruses that take us back to the time of *A Day at the Races*, and a multitrack solo that plays with stereo effects.

The lyrics are very explicit. The guitarist addresses the sister he never had and whose absence seems to be the cause of many problems for the musician, who would later elaborate: "There always was this thing about me. I felt that I'd missed out on life by being an only child. And I think, I thought, that explained some of my endless running around, looking for the right woman, to sort of share my problems."[104]

Production

When he sets about recording one of his tracks, Brian literally plunges into the production of the song, not counting the hours, until he gets lost in details that may seem insignificant, such as the placement of a note of his solo in the panning at the time of mixing. But it is of course these tiny details that make his productions so successful. "Brian May is a tremendously meticulous musician," declared Mack, the coproducer of the disc. "I remember he made up the songs like an architect, I mean, floor by floor, starting on the foundations. He kind of knew the levels the building should have, but he didn't know how many windows he was going to put [in], or how big the attic would be. Besides he's very rigorous and exigent with himself."[100]

May shares the singing of the delicate "Sail Away Sweet Sister" with Freddie Mercury, who comes in at 1:43 to interpret the bridge, and whose very high notes correspond better to his vocal range, or tessitura. When the guitarist began mixing the solo part with Mack, he asked that the guitars be placed from right to left, since the different harmonizations he had recorded played a role in the question-and-answer game that he liked to develop in his compositions ("Good Old-Fashioned Lover Boy" is another example). "It would be fun when you listened on

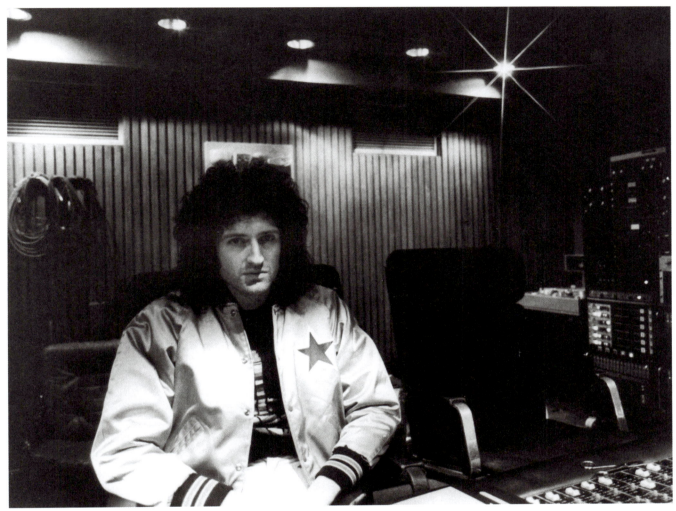
Brian May's compositions are frequently marked by the melancholy of their creator.

headphones,"[29] he later explained. To achieve this, he simply had to find a balance among the different six-string tracks, working solely on this part, the other instrument tracks being muted (*off*, in musical jargon). But the producer had his own methods, even if this meant confusing May. He chose to make a mix with all the channels of the console turned on, playing with the faders, and Brian's solo got lost in the middle of the drums, piano, and bass. "Of course it all made sense to him, but sitting beside him, you had no clue what he was working on at any one time. I asked him if we could hear all the bits of the solo separately and locate them in the stereo space. He looked at me strangely: 'Probably not.'"[29]

FOR QUEEN ADDICTS

"Sail Away Sweet Sister" was the last song Brian May would sing with Queen until "Lost Opportunity," originally recorded for the album *Innuendo* in 1991 but eventually dropped from the record's track list.

QUEEN: ALL THE SONGS 273

COMING SOON
Roger Taylor / 2:50

1980

Musicians
Freddie Mercury: lead vocals, backing vocals
Brian May: electric guitar
John Deacon: bass
Roger Taylor: drums, electric guitar, synthesizer, backing vocals

Recorded
Musicland Studios, Munich: June–July 1979

Technical Team
Producers: Queen, Reinhold Mack
Sound Engineer: Reinhold Mack

Genesis
The second song written by Roger Taylor for *The Game*, "Coming Soon" is the kind of pure rock compendium its author loves to compose, complete with a very heavy metal guitar solo. As usual with the drummer, the lyrics are light and amusing, this time parodying a common expression in the advertising world: "Coming soon to your neighborhood!" If the lyrics are partially elusive, they have, according to their author, no other purpose than to entertain: "There's no grand design behind our music. We're basically here to entertain people; hopefully with intelligently made music […]. I write songs as a hobby. I'm not really what you'd call a professional songwriter. […] I'm not a Paul McCartney who gets up and writes a song before breakfast."[103]

Written and recorded for the first time during the *Jazz* sessions in 1978, "Coming Soon" was rerecorded during the winter of 1980 at Musicland, with a more modern sound, in line with the other titles that had already been recorded for the upcoming album. Another Taylor composition, entitled "A Human Body," was originally intended to appear on *The Game* but was finally judged too melodic for an album that seemed to lack rock tracks. "Coming Soon" therefore replaced it, giving rhythm to the album's second side thanks to the drum pattern played on Taylor's bass tom and snare drum.

Production
It is indeed Freddie who sings on the track, though Roger is never far away, providing support on the choruses. The drummer made use of his Oberheim OB-X synthesizer to give his creation a futuristic side, which he went on to develop further in his first solo album, *Fun in Space*, released a year later.

The song's riff, with its impressive palm mute as well as numerous gimmicks from the Red Special, rolls out the red carpet to May's brilliant solo, which makes its debut at 1:45. "Coming Soon" is a remedy for gloom, during which it is almost impossible not to move your head to the rhythm.

Roger Taylor, the joker of the group.

SAVE ME
Brian May / 3:48

Musicians
Freddie Mercury: lead vocals, backing vocals
Brian May: electric and acoustic guitars, piano, backing vocals, synthesizer
John Deacon: bass
Roger Taylor: drums

Recorded
Musicland Studios, Munich: June–July 1979

Technical Team
Producers: Queen, Reinhold Mack
Sound Engineer: Reinhold Mack

Single
Side A: Save Me / 3:48
Side B: Let Me Entertain You (Live Single Edit) / 3:14
UK Release on EMI: January 25, 1980 (ref. EMI 5022)
Best UK Chart Ranking: 11

Genesis

Probably the greatest track on the album *The Game*, "Save Me" was composed by Brian May and recorded during the first working sessions at Musicland Studios in the summer of 1979. Inspired by a close friend's breakup, the guitarist wrote a universal lyric, which serves an effective and very melancholic melodic line. May explains: "I wrote it about a friend, someone who was going through a bad time, and I imagined myself in their shoes, kind of telling the story. Someone whose relationship is totally fucked up and how sad this person was."[104] Brian May also wrote the storyboard for the video. Shot by director Keith McMillan on December 22, 1979, on the stage of the Alexandra Palace in London, the film blends animation with images of the band onstage.

In spite of its poignant melody and effective arrangements, the song, released as a single on January 25, 1980, shortly before Queen returned to Munich to record the rest of the album, stagnated at a modest eleventh place in the British charts.

Production

A genuine revolution in the band's sound, the Oberheim keyboard was used for the first time to create layers, synthesizing those traditionally played by string orchestras. Like almost all bands of the 1980s, Queen would subsequently develop this process using the Yamaha DX7 and Roland D-10 keyboards.

The backing vocals are also very present in the choruses of the song, and Brian May would later shed light on this return to the roots: "*The Game* was a result of a new environment. Working in Munich with a new engineer produced a really different approach. We started to put a whole lot of importance on the backing track once again. The emphasis was on rhythm and clarity."[103] Benefitting from a powerful vocal line by Freddie Mercury and a guitar solo rooted in the period to come, where guitar heroes will be kings, "Save Me" rounds off Queen's eighth album in perfect style.

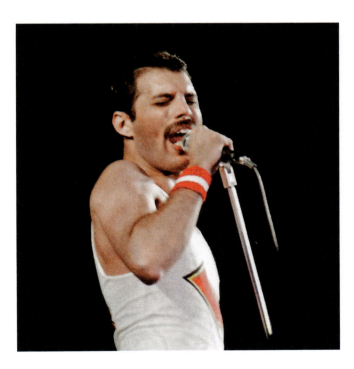

Freddie frequently wore red and white onstage between 1981 and 1986.

OUTTAKES

A HUMAN BODY
Roger Taylor / 3:42

> Robert Falcon Scott, who inspired Roger Taylor to write "A Human Body," was only the second explorer to ever reach the South Pole.

Musicians
Freddie Mercury: backing vocals
Brian May: electric guitar, backing vocals
John Deacon: bass
Roger Taylor: lead vocals, backing vocals, drums, electric guitar, synthesizer

Recorded
Musicland Studios, Munich: February–May 1980

Technical Team
Producers: Queen, Reinhold Mack
Sound Engineer: Reinhold Mack

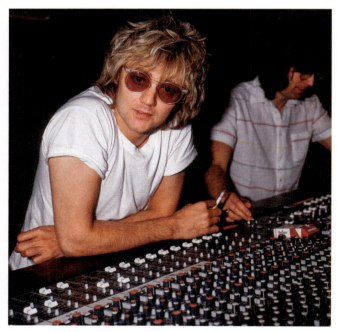

In addition to being a highly skilled drummer, Roger Taylor was also a talented singer and composer.

Genesis

Initially recorded for the album *The Game*, this composition by Roger Taylor was considered too melodic by the other members of the band, who felt that the balance of the album required a more rhythmic and rock-sounding track. It was finally replaced by "Coming Soon."

The lyrics of the song narrate the adventures of Robert Falcon Scott, the renowned British explorer who lost his life in 1912 during his last expedition to Antarctica. Roger Taylor pays tribute to this respected figure, whose achievements are commemorated in the United Kingdom. He was nevertheless a controversial character, as his errors of command allegedly caused the deaths of his entire team as they returned to base camp after reaching the South Pole.

The song was featured on the B-side of "Play the Game" when it was released as a single on May 30, 1980.

Production

While the title is reminiscent of "Drowse," a previous composition by Taylor, featured on the album *A Day at the Races*, "A Human Body" contains all the elements that would appear on the drummer's debut album, *Fun in Space*. In the fall of 1980, Taylor began recording his first solo album at Mountain Studios in Montreux, now owned by Queen. Drums and guitars are both played here by the drummer, who also sings the main part of his title. Freddie Mercury and Brian May are backing vocalists on the choruses, their participation being limited to this unobtrusive intervention.

While the song doesn't present any great interest in the band's discography (appearing rather as a solo track by its drummer), it does introduce an interesting element in Queen's musical universe. From 0:41, Taylor's robotic voice can be heard dictating the word "*human*" in a monotone. To give his voice this futuristic effect, the drummer uses a new synthesizer, the Roland VP-330, equipped with a tool that will be widely used by other bands during the 1980s: the Vocoder. The voice, picked up by a microphone plugged into the instrument, is modified according to the notes played on the keyboard. The idea was revolutionary, and as usual, Taylor was always one step ahead. He later went on to reuse this process on the first hit he wrote for the band in 1984: "Radio Ga Ga."

ALBUM

FLASH GORDON

Flash's Theme . In the Space Capsule (The Love Theme) . Ming's Theme (In the Court of Ming the Merciless) . The Ring (Hypnotic Seduction of Dale) . Football Fight . In the Death Cell (Love Theme Reprise) . Execution of Flash . The Kiss (Aura Resurrects Flash) . Arboria (Planet of the Tree Men) . Escape from the Swamp . Flash to the Rescue . Vultan's Theme (Attack of the Hawk Men) . Battle Theme . The Wedding March . Marriage of Dale and Ming (And Flash Approaching) . Crash Dive on Mingo City . Flash's Theme Reprise (Victory Celebrations) . The Hero

RELEASE DATES
United Kingdom: December 8, 1980
Reference: EMI—EMC 3351
United States: January 27, 1981
Reference: Elektra—5E-518
Best UK Chart Ranking: 10
Best US Chart Ranking: 23

Following this gig at the CNE Grandstand in Toronto on August 30, 1980, *Star Wars* creator George Lucas became strongly opposed to Queen using the image of Darth Vader onstage, and threatened the group with legal action.

QUEEN'S FIRST MOVIE SOUNDTRACK

In the late 1970s, famed Italian movie producer Dino De Laurentiis was meeting with director Mike Hodges to discuss their upcoming production of *Flash Gordon*, the classic comic strip from illustrator Alex Raymond, which first appeared in 1934. Dino De Laurentiis was already famous for bringing Italian cinema to Hollywood, and, in particular, the works of Federico Fellini, whose celebrated films included *La Strada* (1954) and *Nights of Cabiria* (1957). This new production was aimed at reaching a wider audience, and so particular attention needed to be paid to the film's visual effects. Unfortunately the producer and the director didn't see eye to eye on this point. Hodges wanted to create a movie with a deliberately kitsch color scheme, an approach that had worked well for Richard Donner's *Superman* in 1978. De Laurentiis, on the other hand, conceived of the movie as a grandiose epic, along the lines of George Lucas's *Star Wars,* which had come out in 1977.

Knowing that a second Superman movie was in the pipeline, Mike Hodges anticipated that his movie about the hero Flash Gordon would be the first of a series and did his best to plan accordingly. For the title role, the director chose a relative newcomer to Hollywood named Sam Jones. Jones was a former marine with peroxide-blond hair and bulging muscles, and it was hoped that he would become the new embodiment of the 1970s superhero. Casting was completed with the addition of Ornella Muti as Princess Aura, and the inclusion of famed Swedish actor Max von Sydow, celebrated for his roles in movies by his fellow Swede, Ingmar Bergman.

Plans for the film came together without delay, and a budget of $35 million was set even though it far exceeded the budget of the first *Star Wars* movie, which was made for a mere $11 million. With their plans in place, the producer and director turned their attention to the soundtrack. De Laurentiis originally had Pink Floyd in mind, but Mike Hodges was set on using Queen, anticipating that their music would add to the value of the movie. Initially, De Laurentiis was skeptical, as he had never heard of the band. Legend has it that when Hodges initially suggested Queen, De Laurentiis responded by saying, "Who are the queens?" Somehow he had never heard of the greatest rock group of the late '70s. Nevertheless, De Laurentiis eventually allowed himself to be persuaded, and Queen was approached to work on the project.

A Project Led By Brian May

At the beginning of 1980, Queen had just finished recording four new songs at Musicland Studios in Munich ("Save Me," "Sail Away Sweet Sister," "Coming Soon," and "Crazy Little Thing Called Love") and were in the midst of completing the final sequencing for their next album, *The Game*. But when the proposal to record the soundtrack for *Flash Gordon* came in from Dino De Laurentiis and Mike Hodges, the offer seemed too good to pass up. May and Taylor were both huge fans of sci-fi and fantasy, and they were excited at the prospect of taking on this new project, so they encouraged Deacon and Mercury to take part. "We'd been offered a few [soundtracks], but most of them were where the film is

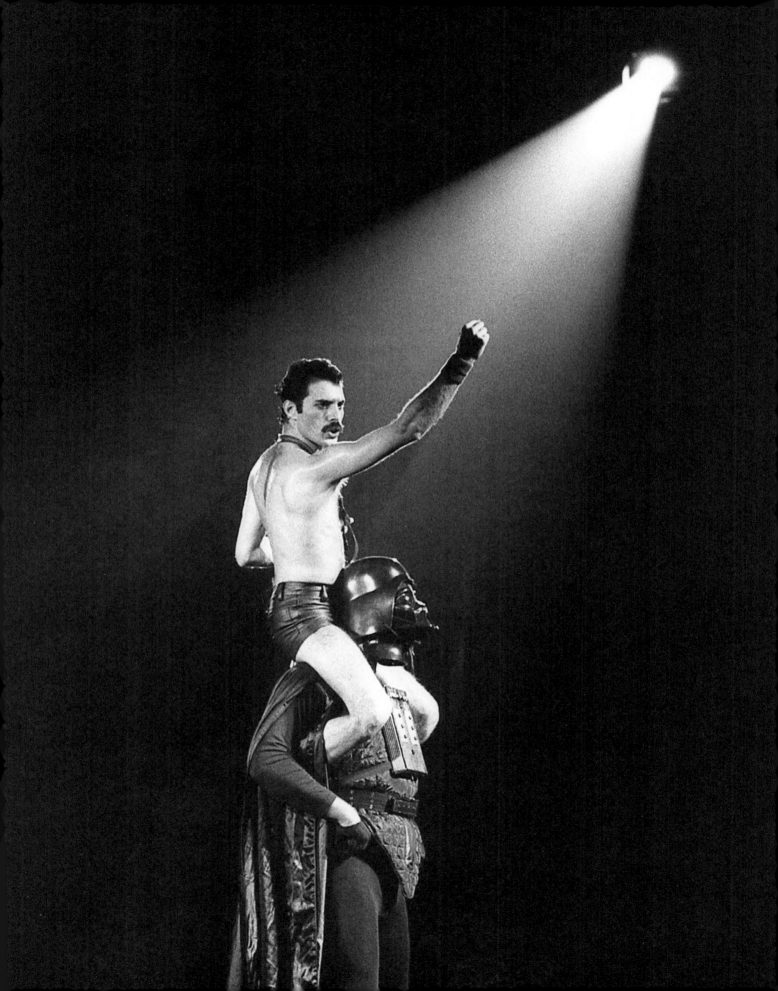

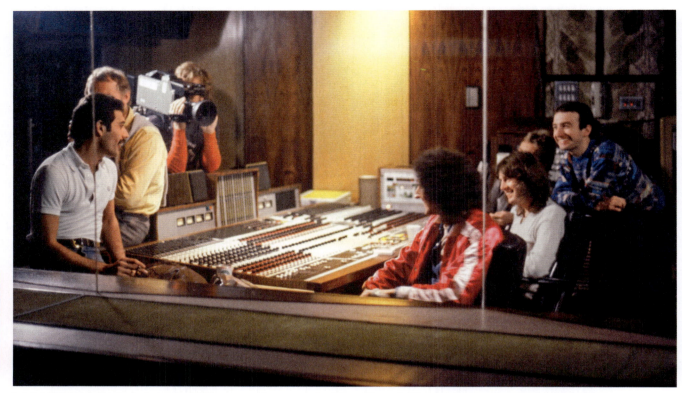

Images of Queen in the studio during the 1980s are rare. Here we see Freddie and the rest of the group in a session on October 22, 1980.

written around music, and that's been done to death [...], but this one was different in that it was a proper film and had a real story which wasn't based around music."[5] Shown a twenty-minute extract from the movie, the group were persuaded to sign on to the project. "We had a certain amount of the music done before seeing any footage," guitarist Brian May explained in California. "John, Freddie, Roger, and I sat down together and said, 'I'll take this scene and I'll take this one.'"[107]

In February 1980, when the new recording sessions for *The Game* started up again at the Musicland Studios, the group was also simultaneously writing and producing the first compositions for the *Flash Gordon* soundtrack. The plan was to record these new tracks in various London studios during the autumn and winter of 1980, and between two concert tours that the group had planned.

Brian May took responsibility for the project and was credited as coproducer of the disc along with Reinhold Mack, who was also the producer for *The Game*. The learning curve for May was steep, and he would later comment: "I learned a completely new job because I had never composed any soundtrack before."[92] The first weeks of composition were highly productive, and within the space of a few weeks, three new musical themes for the album had been created, including "Flash's Theme," "Football Fight," and "The Kiss."

Despite time spent on this parallel project, however, the group also needed to find time to concentrate on the production and promotion of their latest album, *The Game*, which was released on June 30, 1980. May was not able to complete the *Flash Gordon* project until the autumn, often working only with Reinhold Mack while the other members of the group were busy with their own side projects, including Roger Taylor, who had just finished recording his first solo album, *Fun in Space*. As May said later, "Everyone else was too busy when it came time to finishing the thing off. All this stuff was laid down and roughly mixed, but it needed reorganizing for the album."[5] Mack himself would later comment: "It was a technical nightmare. There was just me and Brian and so many tape recorders and tapes and cassettes with bits and pieces of dialogue."[2]

Howard Blake: An Understanding Collaborator

To add to the cinematic effect of the music, Dino De Laurentiis decided to complete Queen's original soundtrack with an orchestral score. Queen turned initially to David Bowie's orchestrator, Paul Buckmaster, but he stepped down from the project just as recording sessions were about to begin. De Laurentiis then approached Howard Blake, asking him to compose ninety minutes of music for the movie in the shortest amount of time possible. After much negotiation, Blake was granted just ten days to finish the score. The stress of the task combined with chronic bronchitis meant that the composer got no sleep at all in the last three days of composing, and he eventually passed out from exhaustion.

The recording sessions took place at the Anvil Studios in Denham, England, during the late summer of 1980. Eighty musicians from the Royal Philharmonic Orchestra

The producer Dino De Laurentiis in Hamburg, Germany, on February 23, 1981.

worked nonstop for three days to produce an excellent final product. Unfortunately, when the movie came out, the composer was dismayed to discover "that much of my score had been replaced with synthesized music." With a typically British stiff upper lip, he commented simply: "A disappointment,"[108] although in reality the greater part of the music that appeared in the movie was his work.

Conclusion of the Flash Interlude

Flash Gordon was released on December 5, 1980, with the original soundtrack following three days later. The disc features the Oberheim OB-X synthesizer, which the group also adopted in the winter of 1980 for the recording sessions for *The Game*. On *Flash Gordon* the synthesizer effect was used more extensively, its chords combining with Brian May's typical rock riffs in the two songs on the disc: "Flash's Theme" and "The Hero" (the sixteen other tracks were instrumental interludes).

The soundtrack was hailed as a success, its kitschy sounds and simple melodies were particularly suited to Queen's style, and the members of the group were happy to have been able to contribute to the movie. Often underestimated, the disc is richly rewarding. Take, as one example, Brian May's reworking of Richard Wagner's "Wedding March." Unusually, even the British press would offer praise for Queen's contribution to the movie, though it was largely eclipsed by the international success of their album *The Game* and its four hit singles, including the major hit "Another One Bites the Dust." As for the movie *Flash Gordon*, it was not as successful as anticipated, and the idea of a follow-up was quickly abandoned. Recognizing Queen's role in the movie, the actor Chaim Topol, who played Dr. Hans Zarkov, commented: "I think that was the best thing in the film."[109]

FOR QUEEN ADDICTS

Howard Blake's compositions were the penultimate recordings to take place at Anvil Studios in Denham, England, before it was demolished in 1980. The last movie soundtrack to be recorded there was John Williams's score for *The Empire Strikes Back*, the second film in the *Star Wars* franchise.

The tracks on *Flash Gordon* include many lines of dialogue taken from the movie. This was the first time something like this had been added to a disc of a soundtrack. The idea was revived in 1994 by Quentin Tarantino for *Pulp Fiction*, particularly in the introduction to Dick Dale's famous "Misirlou."

> Fascinated by fantasy literature, Brian May took charge of the *Flash Gordon* project.

FLASH'S THEME
Brian May / 2:46 (single) / 3:29 (album)

Musicians
Freddie Mercury: lead singer
Brian May: guitar, piano, synthesizer, vocals
John Deacon: bass
Roger Taylor: drums, vocals

Recorded
The Town House, Advision Studios, London: February–March 1980
The Music Centre, London: October–November 1980

Technical Team
Producers: Brian May, Reinhold Mack
Sound Engineer: Alan Douglas

Single
Side A: Flash (Single Version) / 2:46
Side B: Football Fight / 1:28
UK Release on EMI: November 24, 1980 (ref. EMI 5126)
US Release on Elektra: January 27, 1981 (ref. E-47092)
Best UK Chart Ranking: 10
Best US Chart Ranking: 42

ON YOUR HEADPHONES
Each time the song reaches its refrain, just as Mercury sings "Flash," the name is followed by a crash of drums that are meant to imitate a crash of thunder. To create this thunderous effect, Brian May simultaneously struck four piano keys at once (*C, D, E,* and *F*) and coupled them with the sounds of the cymbal and the bass drum. This can be heard most clearly at the 1:09 mark.

Genesis

Brian May quickly undertook the organizing of recording for *Flash Gordon*. Composed by May, the soundtrack album soon became an important part of Queen's discography. The only single to be drawn from the album, "Flash's Theme," was retitled as "Flash" when it was released as a 45 rpm on November 24, 1980. Coupled with "Football Fight" by Freddie Mercury on the B-side, this single became a big hit in the UK even before the movie came out in theaters. The video for the song, made by Mike Hodges at Anvil Studios in Denham, shows the group playing in front of a cinema screen projecting the movie, which is similar to the way professional orchestras work when recording movie soundtracks in the studio. "Flash" was performed frequently during Queen's European tour in the autumn of 1980, and it went on to play an important role in their 1982 tour for *Hot Space*, where it served as the introduction to their set.

Soon acquiring cult status with Queen fans, this song is extraordinarily effective, combining a cinematic feel and scope with typically Queen-style elements, including the crash of percussion coinciding with the famous "Flaaaaash," insistent riffs on the Red Special, and Freddie Mercury's instantly recognizable falsetto and harmonizing vocals.

Production

The piano motif of "Flash's Theme," which is a key element of the track, was also used by Howard Blake in another track, "The Ring (Hypnotic Seduction of Dale)," which was performed by the Royal Philharmonic Orchestra. This instrumental piece can be found on the full version of the *Flash Gordon* soundtrack, which was released on the fortieth anniversary of the movie in 2018. In composing this famous piano effect, where the same note is hammered out on every beat, it is likely that Brian May was influenced by the effective minimalism of the famous and chilling theme from *Jaws*, which was composed by John Williams in 1975. Brian May said in 2019, "I really had this thing in my head. This sort of 'poum poum poum poum'… And it became the underscore of the film, which is something that I was really pleased about. […] It's all about thunder and lightning, you know: 'FLASH!' and the thunder comes."[109]

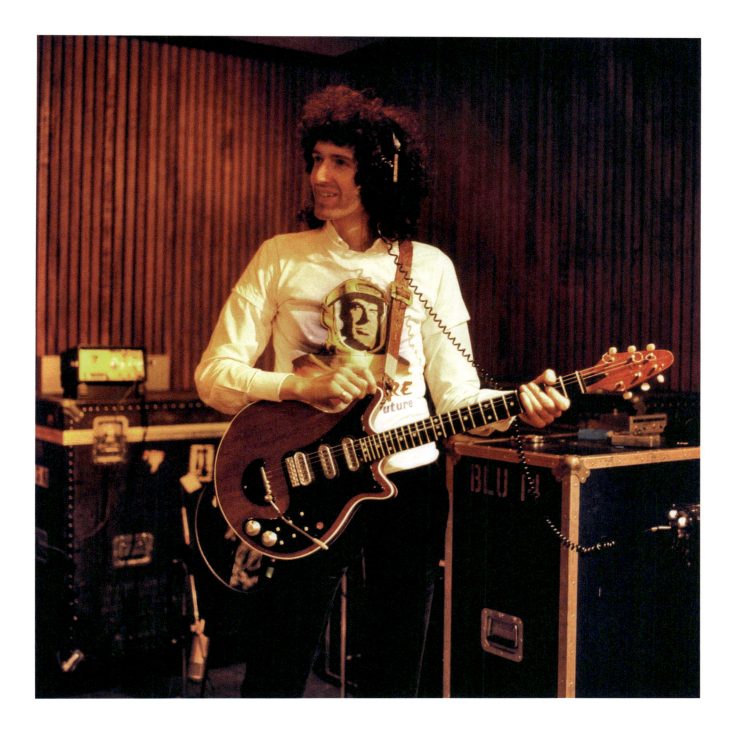

There is no doubt that this one-note melody works brilliantly. It underlines the tension present from the opening credits of the film, which depict the attacks on Earth by the evil Ming, who unleashes all manner of catastrophes on the blue planet. In his book *Queen Unseen,* Peter Hince, the group's chief technician, recalled that during the recording sessions at the Town House studio, Brian was failing to get the right piano sound for the song, despite arranging all sorts of microphones around the instrument. Seeing his frustration, Hince suggested recording the piano using a technique that had worked successfully at the group's concerts and was known for its warm and precise sound. It involved using a system of Helpinstill microphones equipped with several sensors installed inside the instrument, similar to the piezo pickups placed under the bridge of an acoustic guitar. The two men scoured the city of London in search of the necessary equipment, eventually finding what they needed in storage at the Edwin Shirley Trucking Company, which was a transportation company that specialized in moving stage equipment. Peter Hince described this nocturnal adventure thus: "After waking up the night-watchman and scouring 2,000 square feet of equipment-packed space by torchlight, we finally arrived back at the Townhouse with the various component parts—some three hours later. The things you do for art…"[87]

QUEEN: ALL THE SONGS 285

IN THE SPACE CAPSULE (THE LOVE THEME)

Roger Taylor / 2:42

Musicians: John Deacon: guitar / Roger Taylor: drums, timbales, synthesizer / **Recorded:** The Town House, Advision Studios, London: October–November 1980 / The Music Centre, London: October–November 1980 / **Technical Team:** Producers: Brian May, Reinhold Mack / **Sound Engineer:** Alan Douglas

Roger Taylor composed this mysterious theme using multiple layers of synthesizer, overlaid with rolls on shallow, single-headed drums known as timbales. The effect is to notch up the viewer's feelings of tension as the space craft carrying Flash, Dale Arden, and Dr. Hans Zarkov moves inexorably toward the Sea of Fire. The guitar heard in the first seconds of the track was recorded by John Deacon on a Fender Telecaster that belonged to Roger Taylor.

MING'S THEME (IN THE COURT OF MING THE MERCILESS)

Freddie Mercury / 2:40

Musicians: Freddie Mercury: synthesizer / Roger Taylor: drums / Howard Blake: orchestration / **Recorded:** The Town House, Advision Studios, London: October–November 1980 / The Music Centre, London: October–November 1980 / Anvil Studios, Denham (orchestration): October–November 1980 / **Technical Team:** Producers: Brian May, Reinhold Mack / **Sound Engineer:** Alan Douglas / **Sound Engineers for the Orchestration:** Eric Tomlinson, John Richards

Brian May said of this piece: "We already had a lot of music that could be lined up with various characters and scenes. But, for instance, we didn't really have a Ming (the Merciless) theme which worked, so at that point Fred said, 'Okay, I'll write the Ming theme.' And he went home and came back the next day with the Ming theme written."[5] Buried beneath the layers of the Oberheim OB-X, this track accompanies the appearance of the emperor, Ming, as he meets his prisoners: Flash, Dale Arden, and Zarkov.

THE RING (HYPNOTIC SEDUCTION OF DALE)

Freddie Mercury / 0:57

Musicians: Freddie Mercury: synthesizer / Roger Taylor: drums / **Recorded:** The Town House, Advision Studios, London: October–November 1980 / The Music Centre, London: October–November 1980 / **Technical Team:** Producers: Brian May, Reinhold Mack / **Sound Engineer:** Alan Douglas

Written by Freddie Mercury, this musical theme is played entirely on the OB-X, with the singer using the pitch bend wheel on the left-hand side of the keyboard to raise and lower the pitch of each note. When released, the wheel of the OB-X automatically returned whatever note was playing to its original pitch. The very simple melody was used to accompany an erotic scene where the heroine, Dale Arden, hypnotized by the laser beam from Ming's ring, appears to be experiencing the passionate embrace of an unseen lover.

FOOTBALL FIGHT

Freddie Mercury / 1:28

Musicians: Freddie Mercury: synthesizer / Brian May: guitar / John Deacon: bass / Roger Taylor: drums / **Recorded:** The Town House, Advision Studios, London: February–March 1980 / The Music Centre, London: February–March 1980 / **Technical Team:** Producers: Brian May, Reinhold Mack / **Sound Engineer:** Alan Douglas

Selected as the B-side of the "Flash" single, "Football Fight" represents a new direction in Queen's music. For the first time, the song's main riff is played on the synthesizer over a driving pop rhythm led by Roger Taylor and John Deacon. Considered innovative at the time, this mix of synthesizer, saturated guitar, and rock drums was to be copied endlessly throughout the 1980s. Van Halen's hit tune "Jump," which was released in December 1983, is a perfect example of this sound.

In the film, this track provides the background for a scene where Flash Gordon kills a group of imperial guards, picking them off one by one with a metal ball.

There is an alternative version of the piece, played on the piano and released under the title "Football Fight" (Early Version, No Synths!) This second rendition of the song was made available for the deluxe edition of the *Flash Gordon* album, which was released in 2011.

Actor Sam J. Jones as Flash Gordon.

IN THE DEATH CELL (LOVE THEME REPRISE)

Roger Taylor / 2:24

Musicians: Roger Taylor: drums, timbales, synthesizer / John Deacon: guitar / **Recorded:** The Town House, Advision Studios, London: October–November 1980 / The Music Centre, London: October–November 1980 / **Technical Team: Producers:** Brian May, Reinhold Mack / **Sound Engineer:** Alan Douglas

This piece of music was written to accompany a scene in which Flash Gordon tries to comfort his girlfriend, Dale Arden, before the curious stares of their fellow-prisoners, known as the snake-men. The instrumental theme "In the Death Cell (Love Theme Reprise)" was composed by Taylor and designed to illustrate this romantic moment while also subtly calling back to "In the Space Capsule (The Love Theme)," which was also composed by Taylor.

EXECUTION OF FLASH

John Deacon / 1:05

Musicians: John Deacon: guitar / Howard Blake: orchestration / **Recorded:** The Town House, Advision Studios, London: October–November 1980 / The Music Centre, London: October–November 1980 / Anvil Studios, Denham (orchestration): October–November 1980 / **Technical Team: Producers:** Brian May, Reinhold Mack / **Sound Engineer:** Alan Douglas / **Sound Engineers for the Orchestration:** Eric Tomlinson, John Richards

John Deacon composed this instrumental piece and played it on a Fender Telecaster, creating a sound somewhat reminiscent of the chiming noise frequently heard before announcements are made over the loudspeakers in airports and train stations. The effect is somewhat clumsy when synchronized with the film. Deacon's soporific melody appears at a dramatic moment when it looks as though the hero is about to be killed by poisonous gas.

QUEEN: ALL THE SONGS 287

THE KISS (AURA RESURRECTS FLASH)

Freddie Mercury / 1:44

Musicians: Freddie Mercury: voice, synthesizer / Howard Blake: orchestration / **Recorded:** The Town House, Advision Studios, London: February–March 1980 / The Music Centre, London: February–March 1980 / Anvil Studios, Denham (orchestration): February–March 1980 / **Technical Team: Producers:** Brian May, Reinhold Mack / **Sound Engineer:** Alan Douglas / **Sound Engineers for the Orchestration:** Eric Tomlinson, John Richards

Composed by Freddie Mercury, this theme is one of the most successful pieces of music on the soundtrack. Mercury and Howard Blake worked together on "The Kiss," which featured the singer's soaring and magnificent vocals. Many feel that this particular track ought to be mentioned more frequently as one of the greatest themes to appear in a film of the 1980s. It is considered by many to be the equal of other famous themes of the day, like those featured in *Once Upon a Time in America* (Sergio Leone, 1984), and *The Mission* (Roland Joffé, 1986), both of which were written by the famed Italian composer, Ennio Morricone. Unfortunately, the poor performance of *Flash Gordon* at the box office meant that its soundtrack was woefully underpraised in its time.

ESCAPE FROM THE SWAMP

Roger Taylor / 1:43

Musicians: Roger Taylor: timbales, synthesizer / **Recorded:** The Town House, Advision Studios, London: October–November 1980 / The Music Centre, London: October–November 1980 / **Technical Team: Producers:** Brian May, Reinhold Mack / **Sound Engineer:** Alan Douglas

When Roger Taylor recorded the timbales piece for "Escape from the Swamp," he never imagined that his idea would reappear in virtually every action movie released between 2000 and 2010. This ominous drum sound has now become a constantly reappearing element in films and TV shows that feature moments of tension (talent shows, quiz shows, and competition shows of every kind). The sound is so famous that it has now been synthesized and made available with computer-assisted music software such as Action Strikes from the Komplete series produced by Native Instruments. In 1980, by contrast, Roger Taylor achieved his sound using only his hands, his mallets, and his Ludwig Ringer timbales. The resulting music sounds much more natural.

ARBORIA (PLANET OF THE TREE MEN)

John Deacon / 1:41

Musicians: John Deacon: synthesizer / **Recorded:** The Town House, Advision Studios, London: October–November 1980 / The Music Centre, London: October–November 1980 / **Technical Team: Producers:** Brian May, Reinhold Mack / **Sound Engineer:** Alan Douglas

Of minor significance on the album, this composition by John Deacon is chiefly notable for its use of one of the functions of the Oberheim OB-X, which allowed Deacon to emulate the sound of a flute. This function was a common feature on most synthesizers dating from the 1980s.

FLASH TO THE RESCUE

Brian May / 2:44

Musicians: Brian May: guitar, piano, synthesizers, vocals / Freddie Mercury: lead singer / Roger Taylor: drums, vocals / John Deacon: bass / **Recorded:** the Town House, Advision Studios, London: October–November 1980 / The Music Centre, London: October–November 1980 / **Technical Team: Producers:** Brian May, Reinhold Mack / **Sound Engineer:** Alan Douglas

Based on "Flash's Theme" and again featuring the insistent single note on the piano that appeared earlier in the film's score, "Flash to the Rescue" adds little to its predecessor besides some synthesizer notes and a few pieces of dialogue from the movie.

Actors Ornella Muti and Max von Sydow in a scene from *Flash Gordon*, which was much maligned when it was released but has since gone on to achieve cult status with fans.

VULTAN'S THEME (ATTACK OF THE HAWK MEN)

Freddie Mercury / 1:12

Musicians: Freddie Mercury: synthesizers / Roger Taylor: drums / **Recorded:** The Town House, Advision Studios, London: October–November 1980 / The Music Centre, London: October–November 1980 / **Technical Team:** Producers: Brian May, Reinhold Mack / Sound Engineer: Alan Douglas

"Vultan's Theme" is an exciting piece of music that would go on to become a commonly imitated feature of the soundtracks for superhero movies and action movies of the 1980s. Composed by Mercury, the song featured heavy synthesizers and a propulsive drum beat that created a compelling and energetic musical background for a scene depicting the attack of an imperial spaceship led by a group known as the Hawk Men and featuring the beloved character of Vultan, played by the British actor Brian Blessed.

BATTLE THEME

Brian May / 2:18

Musicians: Brian May: guitar, synthesizer, vocals / Roger Taylor: drums, vocals / Freddie Mercury: lead vocals / John Deacon: bass / **Recorded:** The Town House, Advision Studios, London: October–November 1980 / The Music Centre, London: October–November 1980 / **Technical Team:** Producers: Brian May, Reinhold Mack / Sound Engineer: Alan Douglas

This is a version of the song "The Hero" that would be used again at the end of the film, to accompany the closing credits. Previewed here and enlivened with a collective "Flash!!" the song is used to help dramatize the battle between the Hawk Men and Ming's imperial guards. Leading the attack, Vultan raises his weapon to the sky before a final assault, defying fate with the cry: "Who wants to live forever?" Interestingly, Brian May used these words six years later for the title of one of his most beautiful songs, written for Russell Mulcahy's movie *Highlander*. As composer of "Battle Theme," May would later say that this sequence was his favorite part of the film because it reminded him of the time when, as a child, he used to watch *Flash Gordon* on television every Saturday morning.

QUEEN: ALL THE SONGS 289

> Despite a large number of films under his belt, actor Sam J. Jones did not achieve the new level of fame he'd hoped for following the release of *Flash Gordon*.

1980

THE WEDDING MARCH

Richard Wagner (arranged by Brian May) / 0:58

Musicians: Brian May: guitars / Roger Taylor: cymbals; bass drum / **Recorded:** The Town House, Advision Studios, London: October–November 1980 / The Music Centre, London: October–November 1980 / **Technical Team: Producers:** Brian May, Reinhold Mack / **Sound Engineer:** Alan Douglas

This is May's version of the German composer Richard Wagner's famous piece titled "The Bridal Chorus," which appeared in his opera *Lohengrin* and was originally composed in 1850. As in "Procession" off the *Queen II* album, and again in his reprise of "God Save the Queen" on *A Night at the Opera*, May leaves his mark on "The Wedding March" by adding layers of guitar harmonization and using stereo effects to give greater breadth to the piece. Often compared to Jimi Hendrix's famous interpretation of "The Star Spangled Banner," performed at the Woodstock festival in August 1969, this version of "The Wedding March" aimed at something different, according to Brian May: "I had heard Hendrix's thing but his approach is very different really. The way he did those things was to put down a line and then sort of improvise another line around and the whole thing works on the basis of, erm, things going in and out of harmony, more or less, by accident. It's very much a freeform multi-tracking thing whereas my stuff is totally arranged. I'll make sure that the whole thing is planned and treated like you would give a score to an orchestra to do. It's a complete orchestration. So it's a different kind of approach really but I enjoy doing those things. It's sort of indulgence really but, at the same time, I thought it would be funny for that 'Wedding March' to come out that way. Because, all our people, who know our music, would recognize that immediately as one of our treatments."[74] As an interesting side detail, May dropped a subtle nod to another famous composer into his song. Beginning at 0:44, May changes up the song's chord progression for two bars, hinting at Frédéric Chopin's equally famous "Funeral March," which features a melody that closely resembles Wagner's "Wedding March."

MARRIAGE OF DALE AND MING (AND FLASH APPROACHING)

Brian May / 2:04

Musicians: Brian May: guitar, piano, synthesizers, vocals / Roger Taylor: drums, vocals / Freddie Mercury: lead vocals / John Deacon: bass / **Recorded:** The Town House, Advision Studios, London: October–November 1980 / The Music Centre, London: October–November 1980 / **Technical Team: Producers:** Brian May, Reinhold Mack / **Sound Engineer:** Alan Douglas

Accompanying the scene of the forced marriage of Dale Arden to Emperor Ming, this composition by May and Taylor is made up of several elements. Extracts from the movie's dialogue are heard over the layered chords of the synthesizer, interspersed with reprises of two important motifs from the movie: "Flash's Theme" and "Vultan's Theme."

CRASH DIVE ON MINGO CITY

Brian May / 1:00

Musicians: Freddie Mercury: piano, synthesizer / Brian May: guitar, piano, synthesizer / Roger Taylor: drums / John Deacon: bass, synthesizer / **Recorded:** The Town House, Advision Studios, London: October–November 1980 / The Music Centre, London: October–November 1980 / **Technical Team: Producers:** Brian May, Reinhold Mack / **Sound Engineer:** Alan Douglas

Composed by Brian May, this short instrumental track is driven by powerful guitar chords and multiple layered chords created using an Oberheim OB-X synthesizer.

FLASH'S THEME REPRISE (VICTORY CELEBRATIONS)

Brian May / 1:23

Musicians: Freddie Mercury: lead vocals / Brian May: guitar, piano, synthesizer, vocals / Roger Taylor: drums, vocals / John Deacon: bass / **Recorded:** The Town House, Advision Studios, London: October–November 1980 / The Music Centre, London: October–November 1980 / **Technical Team:** Producers: Brian May, Reinhold Mack / Sound Engineer: Alan Douglas

This track is another variation of "Flash's Theme" and "Vultan's Theme," to which Brian May added numerous extracts from the movie's dialogue. The track accompanies the final scene where Flash Gordon and Dale Arden are reunited.

In 1979, fans were wondering how Brian May could have composed the soundtrack for director George Miller's film, *Mad Max*, without anyone knowing that he was working on new music. The mystery was solved when they discovered that there was another Brian May, and that this Brian was a film composer living in Australia!

1980

THE HERO
Brian May / 3:31

> Freddie Mercury hit some of the highest notes in his vocal range during the recording of "The Hero."

Musicians
Freddie Mercury: lead vocals
Brian May: guitar, piano, synthesizer, vocals
Roger Taylor: drums, vocals
John Deacon: bass
Howard Blake: orchestration

Recorded
Utopia Studios, London: October 1980
Anvil Studios, Denham (orchestration): October–November 1980

Technical Team
Producers: Brian May, Reinhold Mack
Sound Engineer: Reinhold Mack
Sound Engineers for the Orchestration: Eric Tomlinson, John Richards

FOR QUEEN ADDICTS
Unusually, the solo that begins at the 2:10 mark of "The Hero" is not played on May's Red Special because May had left the instrument in Munich where the group was in the middle of recording their album *The Game*. Brian May played the solo on a guitar that he found lying around in the studio.

Genesis

The first version of the theme for "The Hero" was composed by Howard Blake, but in the end Blake's version of the song was not used in the movie. Originally intended to be used during the film's opening sequences, Blake's orchestration was eventually replaced by Queen's version, which can be heard beginning at 1:32, and which coincides with the point in the film where the battle between the Hawk Men and Ming's guards begins.

Brian May, who was allowed total freedom in the writing and production of the soundtrack, was delighted to be able to include such a "heavy" piece: "[It] was kind of revolutionary at that time, because nobody had done a rock underscore at that time."[109] This creative freedom was only constrained by the simple but unavoidable fact that the songs May created had to serve the interests of the movie. "For the first time we worked for someone else. We didn't create songs for our own pleasure, but for the film director. Anyway, we worked freely, I mean, nobody told us what we had to do."[92] "The Hero" is the second full-length song on the *Flash Gordon* album after "Flash's Theme."

Production

The recording of this track's vocal line was particularly demanding for Freddie Mercury since it featured a slew of exceptionally high notes. Brian May recalled: "He hated me making him sing the end title, which is incredibly high. [...] He hated it and loved it, because he loved the challenge." Freddie complained, nevertheless: "You always give me these fucking things that make my beautiful throat bleed!"[109]

Despite Freddie's pain, the song is a heavy metal triumph. It served to remind the group's critics who had deplored its sudden adoption of synthesizers that Queen was still a genuine rock band capable of moments of pure genius.

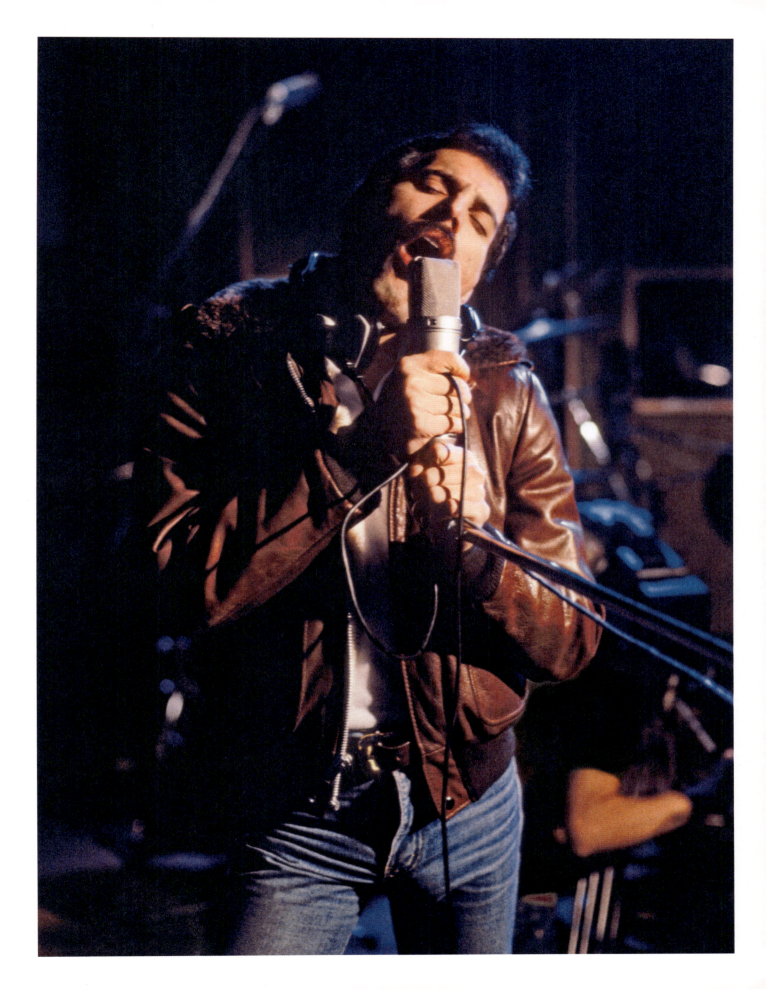

ALBUM

HOT SPACE

Staying Power . Dancer . Back Chat . Body Language . Action This Day .
Put out the Fire . Life Is Real (Song for Lennon) . Calling All Girls .
Las Palabras de Amor (The Words of Love) . Cool Cat . Under Pressure

RELEASE DATES
United Kingdom: May 21, 1982
Reference: EMI—EMA 797
United States: May 25, 1982
Reference: Elektra—E1-60128
Best UK Chart Ranking: 4
Best US Chart Ranking: 22

1982

Queen poses with Reinhold Mack.

THE ASSAULT ON THE 1980s

By the end of 1980, Queen had become the biggest band in the world, due to the international success of their eighth album, *The Game*, which had gone five times platinum and featured the hit singles "Crazy Little Thing Called Love" and "Another One Bites the Dust." The band had sold forty-five million albums in the space of seven years, and John, Roger, Brian, and Freddie entered the *Guinness Book of World Records* as the best-paid owner of a British company. The previous year each of them had been paid the equivalent of $3.5 million in today's currency.

In the autumn of 1980, the musicians went back on the road for a new European tour culminating in a show at the Munich Olympiahalle on December 18. Following a short pause in London so the group could spend time with their families for the Christmas holidays, the band set off again for Japan in February 1981 to celebrate the release of the film *Flash Gordon*, for which Queen had composed the original soundtrack. Five triumphal concert dates were scheduled at the Budokan in Tokyo.

The South American Epic

As the group's audience continued to grow around the world, a decision was made to send Queen out on a marathon tour of Argentina and Brazil directly following their tour of Japan. From February 28 to March 21, 1981, they played to stadiums with audiences of one hundred thousand people. These were stadiums that were otherwise reserved for the gods of soccer, and the adventure required a level of organization that the group's technical team had not really had time to prepare itself for. Despite the success of Queen's tour of South America, the "South America Bites the Dust" tour was in a constant state of near chaos, and was peppered with pitfalls including military escorts, a misguided dinner with Roberto Eduardo Viola, the very controversial leader of the Argentine junta, and payments of bribes to avoid losing the group's nearly sixty tons of equipment in a region that was still largely ruled by military dictatorships.

In the spring of 1981, after their whirlwind tours of Japan and South America, the group took a moment to rest and rejuvenate. Each member of the band used his time off to pursue his own personal interests. For Freddie Mercury, this meant monitoring the progress on the gargantuan remodeling project currently underway on his new home in the center of London, which was known as the Garden Lodge. He also set out in search of a New York pied à terre. Roger Taylor spent his time off promoting his first solo album, *Fun in Space*, which he had recorded at Mountain Studios in Montreux at the end of 1980. As for Brian May, he focused on his peaceful family life, including welcoming his second child, Louisa May, into the world.

Difficult Relationships

This period of calm was soon severely compromised when, in June 1981, the musicians joined their producer, Reinhold Mack, at Musicland Studios in Munich. The plan was to create the successor to the *Flash Gordon* album, but the atmosphere among the band members had soured, and the morale of the troops was no longer in a good place. "Here we had a total change of life for all of us, really," recalls

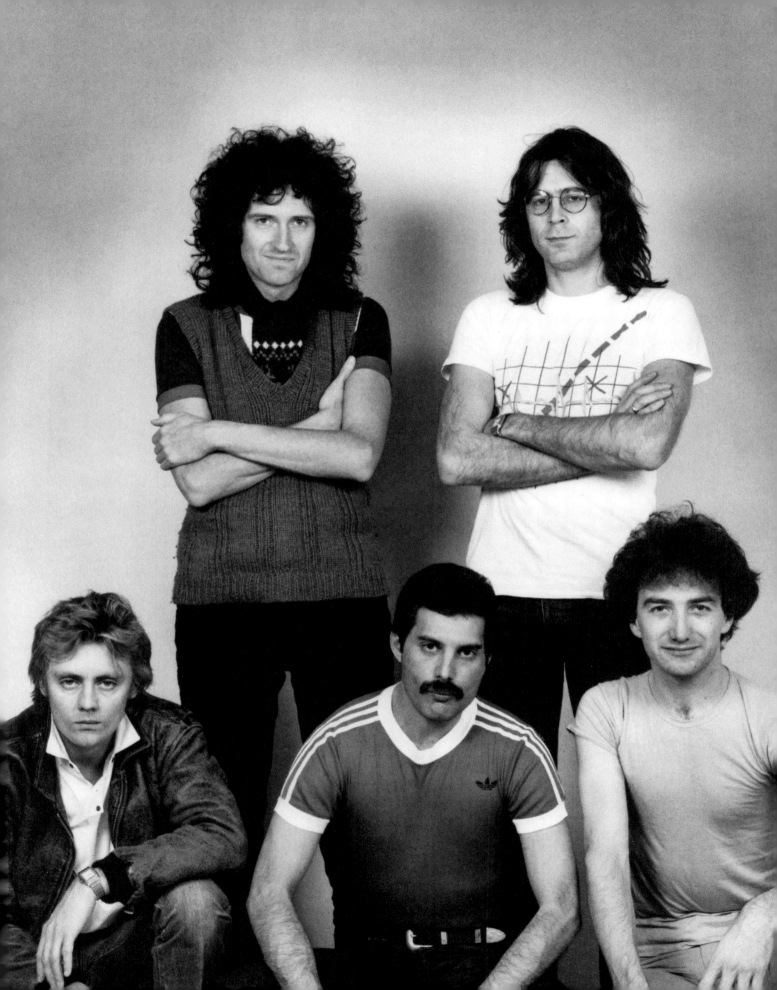

1982

A Queen technician stands outside one of the Boeing 747s used to transport staging equipment for the group's 1981 tour of South America.

Brian May. "We went back to Munich to do the next album and really I suppose things started to go down here. It's a grim place. It's a studio in a basement of a huge tower block, which is a hotel. And it's kind of depressing. A lot of people used to jump off the top of the building and kill themselves. Off that particular building! It was really well known for it. We didn't know when we went there."[110] But the motivation for writing and challenging themselves remained the main reason for this gathering, and Queen, despite the success they'd experienced in the previous year, was determined to step out of their comfort zone and explore new musical territories. Despite the fragile relationships among the group, the band got to work alongside Mack, who had already produced The Game and Flash Gordon. Some songs from these early sessions saw the light of day, including "Cool Cat," "Staying Power," and "Back Chat," but artistic disagreements quickly surfaced and the members of Queen inexorably began to distance themselves from each other. Mack himself would later describe the situation: "Making The Game was the last time the four of them were in the studio together. After that, it felt like it was always two of them in one studio and two of them in another. You'd come in one day and say, 'Oh, where's Roger?' and someone would say, 'Oh, he's gone skiing.'"[2]

Freddie and John quickly assumed control of the artistic direction. With a view to repeating the success of "Another One Bites the Dust," the two opted to impose a very funk-disco-centric feeling to the record. The group's continued desire to experiment, and their inability to all record at the same time, meant that some tracks were finalized even before Roger could record the drum portions, and this gave way to the use of a new instrument that was revolutionary at the time: the Linn LM-1 drum machine. The new-fangled machine appeared on other hits such as "Let's Go Crazy" or "When Doves Cry" by Prince, and it became Freddie's new toy. Freddie's goal was to give his new compositions a more straightforwardly "dance" direction, similar to the kind of music he would dance to all night long on his nightclub outings in Munich. At the time, the singer seemed to have lost himself in the madness of the city's nightlife scene, and the drugs and excess that it provided. The other members of the group also fell back on old habits while in Munich, and once again they began to frequent the Sugar Shack, about which Taylor commented: "The Sugar Shack is the hottest disco in the world. We like it that much, that we gave them some of our gold discs!"[111] More isolated than ever from the team, Freddie seemed to be following to the letter the advice of his personal manager, Paul Prenter. Having worked closely with John Reid in the 1970s, Prenter was initially engaged as Mercury's personal assistant. Appointing himself manager in 1982, he quickly increased his influence on the singer, often offering advice to him that many felt ran counter to Queen's best interests. As a controversial personality, Prenter has never been a favorite of the group's many fans, and it was felt at the time that he was at least partly responsible for the growing feeling of animosity

Freddie behind the console at Mountain Studios in Montreux in 1981. Brian May would later ban smoking in the studio.

within the group. "He hated guitar and thought Brian was old-fashioned,"[110] commented Mack. Taylor commented: "He was a very, very bad influence upon Freddie and on the band, really. He very much wanted our music to sound like you just walked in a gay club, and I didn't."[110] John Reid, Queen's former manager, who had introduced Prenter to Mercury, had even worse things to say about him: "He was a nice boy but turned into a real nightmare."[18]

The Montreux Gathering

In July 1981, the musicians moved to Mountain Studios in Montreux where, one evening, they met David Bowie. It was here that they recorded their future hit "Under Pressure." EMI was quick to bring out the song as a single, which they did on October 26, 1981, seeking to profit from this unexpected meeting between these British stars.

Later that September, Queen resumed their South American tour and gave a series of concerts in Venezuela and in Mexico, where their triumph was only somewhat tempered by the chaotic nature of the tour itself. This tour was to be their last in South America.

In November 1981 the group released their *Greatest Hits* album, which served as a celebration of ten years of hard work that had wrought a series of beloved, and highly successful songs. Everything seemed to be going right for the group when they returned to Munich in January 1982 to finish work on their new album. But the band's excesses were starting to get in the way of their work sessions. "We got up about 3 o'clock, and then we had breakfast," explained Peter Hince, the band's head technician. "Then a bit of work can be done, and you had dinner. Then, one of the roadies started mixing cocktails. And then other things would happen..."[11] Despite all this, Mack managed to keep the pressure on, and they finished the album, called *Hot Space*, in March 1982.

The group's career was going unbelievably well, and their idyll with the public lasted until the release of their new single, "Body Language," on April 19, 1982. Then came the brutal rupture.

The Album That Influenced Michael Jackson's *Thriller*

When "Body Language" appeared in April 1982, it was as though the entire world of the Queen fan base had come tumbling down. The disco-funk sounds in the song were disconcerting, to say the least. Even worse, Roger Taylor's drum playing had largely been replaced by a drum machine, and Brian May's guitar made only a furtive appearance. By the time the *Hot Space* album was released a month later on May 21, 1982, Queen's listening audience was in a state of almost total consternation.

Filled with omnipresent synthetic basses and synthesizers, *Hot Space* was overflowing with sound experimentation, but many listeners wondered what had happened to the biggest rock group in the world. Most fans were mystified by the layers upon layers of keyboards, dehumanized

1982

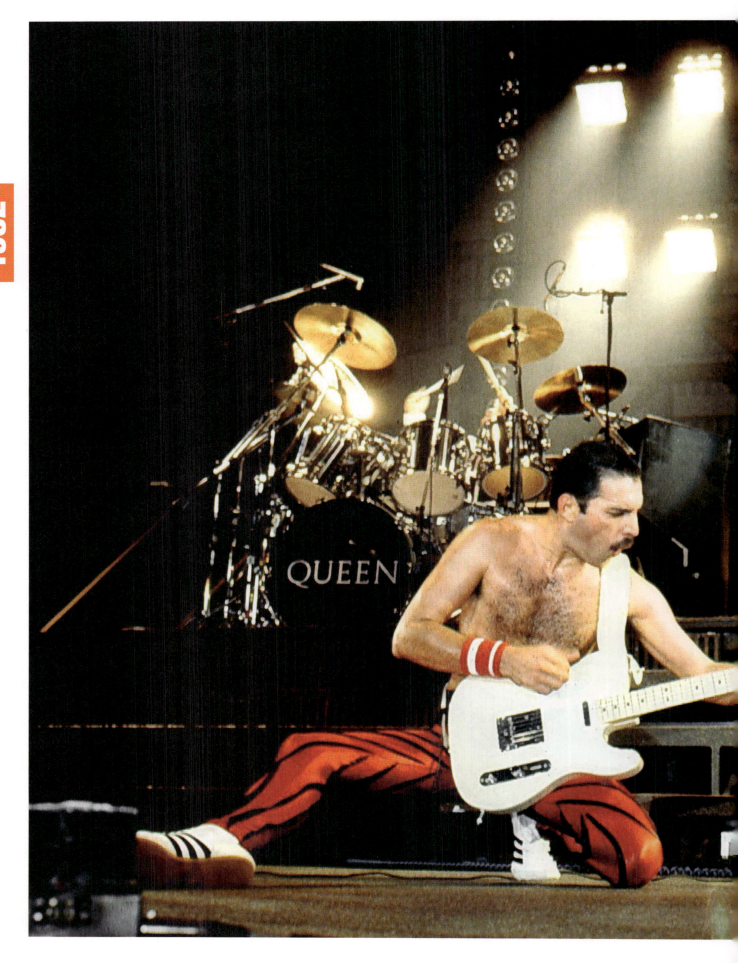

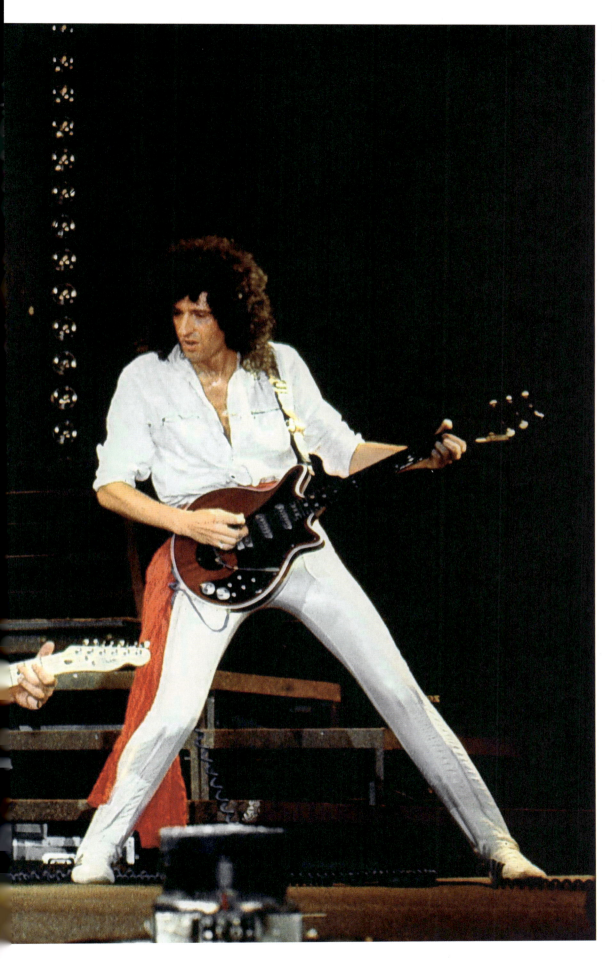

For this live performance of "Crazy Little Thing Called Love," Freddie played a white Fender Telecaster instead of using Brian's acoustic guitar.

1982

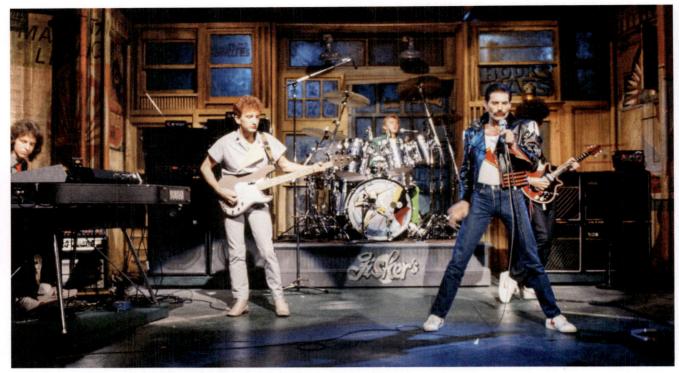

Queen appeared on *Saturday Night Live* on September 25, 1982. The band played two songs: "Under Pressure" and "Crazy Little Thing Called Love."

rhythms, and soulless songs. Having spent more time in the Sugar Shack than in the studio, the group seemed to have lost the magic that had once made it so special. In the end, the general consensus was this: *Hot Space* wasn't a bad album per se; it was just a bad Queen album.

Interestingly, not everyone was of the same opinion. Michael Jackson, who had already met the group the previous year, declared that the production of *Hot Space* had been a big influence on the creation of his own masterpiece, *Thriller*, which was released a few months later.

While some of the tracks on the album were nicely written and include remarkable performances, such as "Cool Cat" by John Deacon and Freddie Mercury, the disc suffers from a clear lack of cohesion between the funk-disco leanings of Mercury and Deacon, and the rock aspirations of May and Taylor. When *Hot Space* was released, Brian sought to defend the finished work: "It's sort of a challenge, you know, because we always said, "OK, we're selling great but that's not really what matters, you know, it's not commercial success that we're after. We're doing what we think is worthwhile, and if this album turned out to be not as big a seller as the previous two or three, then we would actually be putting ourselves to the test when we say, 'Well, do we really believe in this or not?' and I think the answer would be, 'Yes we do.'"[112] In reality, the bad press and ice-cold fan response to this latest opus only served to accentuate the discord growing within the team.

When the group flew to America in July 1982, the atmosphere between the musicians deteriorated further. Despite the growing rumblings of a strange and devastating illness that was disproportionately affecting the homosexual community in America, Freddie distanced himself from his friends and began to go out every night. The album sold badly in the United States, and the reception for the various singles was disastrous. Nevertheless, their tour was conducted with gusto, and the group's electronic songs were transformed into rock numbers for their stage performances. Unfortunately, this attempt at fan appeasement didn't really work, and *Hot Space* broke the link that Queen had spent many years forming with its American fans.

A Difficult Reassessment

Following this difficult year, and the tepid response to the group's latest album and tour in the United States, the group decided that a break would be the most beneficial thing for all involved. The time had come to face up to certain things, and beginning in January 1983, each of the band members set off on a well-earned holiday from touring and recording. As time has passed, different members of Queen's inner circle have offered their own opinions on why *Hot Space* was met with such dislike. "I think it's really a good album, but it's like half a year before its time,"[11] declared Mack. "The album [...] was not selling like hot cakes—more like soggy biscuits,"[87] Peter Hince suggested, ironically. Freddie Mercury offered his own opinion on this disc, owning up to his creative role in the process: "I think *Hot Space* was one of the biggest risks we've taken, but people can relate to something that's outside the norm. [...] This whole dance/funk mode was basically my idea and it obviously didn't do that well."[95] Finally, Roger Taylor, as a true, self-respecting rocker gave the following verdict on the group's tenth studio album: "It was absolute shit."[18]

Queen on the train in Japan, heading from Osaka to Nagoya in October 1982. Playing "Teo Torriatte (Let Us Cling Together)" as an encore every evening, this marked the group's fifth tour of the country and further consolidated their popularity with the Japanese public.

QUEEN: ALL THE SONGS 303

SINGLE

STAYING POWER
Freddie Mercury / 4:10

1982

Musicians
Freddie Mercury: lead vocals, backing vocals, synthesizer, programming
Brian May: electric guitar
Roger Taylor: electronic drums
Arif Mardin: trumpet

Recorded
Musicland Studios, Munich: June–December 1981

Technical Team
Producers: Queen, Reinhold Mack
Sound Engineer: Reinhold Mack
Assistant Sound Engineer: Stephan Wissnet

Single
Side A: Staying Power (Extended Remix by John Luongo) / 5:51
Side B: Back Chat (Extended Remix by John Luongo) / 6:55
US Release on Elektra: November 23, 1982 (ref. 0-67954)

FOR QUEEN ADDICTS
During the group's American tour in the summer of 1982, Fred Mandel played the synthetic bass part on "Staying Power," since John Deacon was busy, working to provide the rhythm on the guitar.

At the Frankfurt Festhalle on April 28, 1982, in the midst of a phalanx of protestations, Queen announced "Staying Power" as the next song they would be playing. When he was introducing the number, Freddie Mercury addressed the public: "If you don't wanna hear it, f—go home!"

Genesis
On listening to the first bars of "Staying Power," it's not difficult to imagine the fans' reaction. Those who had supported Queen since their beginnings, and who had sung along to "You'll Never Walk Alone" at the group's concerts just five years earlier, probably regretted parting with their hard-earned cash to buy a copy of *Hot Space* when it was released. Because, from the introduction of the song, the artistic direction is clear. A drum machine, electronic bass, and synthesizers are everywhere!

Written by Freddie Mercury, the song has all the features of a 1980s hit, or, more precisely, a hit from 1983. This same year also saw an accumulation of FM hits produced according to a similar formula, including songs like "Let's Dance" by David Bowie, "Sweet Dreams" by the Eurythmics, and "Lucky Star" by Madonna. But, as was often the case in the history of this particular group, Queen's boundary-pushing music did not find an audience. And this number, with its highly polished arrangements and totally modern production, has gone on to fall into obscurity, probably due to its excess of inventiveness. Or maybe because of its lyric writing. In fact, such a battery of electronic instruments can only really serve an impeccably written song. This was the case with the songs "Beat It" and "Billie Jean," from *Thriller*, which was released a few months later, and which achieved the kind of success that Queen could only have hoped for. "It's a shame that this track was put together in the studio," said Mack, the disc's producer. "Because later, on tour, they played that slightly differently. [...] I mean, it's not bad, but imagine if they would've played it a couple of times live—that would've been so much better because of the energy it had live."[11]

Production
Effectively, it was the production of "Staying Power" that was most disconcerting for the listener. First, no percussion was recorded. Instead, Freddie Mercury used a drum machine (the Linn LM-1) to confer a feeling of modernity on the song that he thought would please a nightclub-going clientele. Marketed in 1980 by the American Roger Linn and his company, Linn Electronics, the Linn LM-1 Drum Computer was a multifunctional instrument that was admittedly completely revolutionary, but it still sounded newfangled and slightly odd to the listener.

The talented arranger Arif Mardin worked with Aretha Franklin and her producer, Jerry Wexler, on "Respect" (1967), one of the acclaimed singer's biggest hits.

Second, the song had a glaring absence of acoustic bass. Following the extensive use of the Oberheim OB-X on *The Game* and *Flash Gordon*, Mercury used a new synthesizer called a Roland Jupiter-8 to play all the bass lines on this track. John Deacon, who was very partial to these new toys—even though they impinged on his role as the group's bassist—later described his relationship with the synthesizer as follows: "A Jupiter-8 and an Oberheim OB-X are the main two that we've used. None of us are very technical with them. We just try to get something out. We could be better."[103] In later years, many other artists and producers would follow Freddie and John's lead, playing the bass portions of their tracks on keyboard synthesizers (think of "Imaginary Love" by Shalamar, which appeared in 1987), but once again, Queen was ahead of its time.

Although Mercury's lead vocals were particularly convincing (on this song and on the entire album), the finest performance on the track belonged to the American trumpeter Arif Mardin, famous for his work with Aretha Franklin. Queen employed Mardin specifically to work on the brass arrangements, which take center stage on this track. Peter Freestone, Mercury's personal assistant, remembers the production of these trumpet tracks: "One night I was told that the following morning I was booked on the eleven o'clock flight to New York to take a slave/master tape of "Staying Power" to Arif Mardin in the Atlantic building. I gave Arif the tape about six p.m. He worked overnight so that he could record the brass arrangement he had written in order that I should be able to leave the morning after to return it for further work by the band in Europe."[113]

QUEEN: ALL THE SONGS 305

Brian prepares to press the "play" button on the famous Linn LM-1 drum machine, which served as the de facto fifth member of the group on *Hot Space*.

DANCER
Brian May / 3:47

1982

Musicians
Freddie Mercury: lead vocals, backing vocals
Brian May: electric guitar, programming, synthesizers
Roger Taylor: drums, electronic drums, tambourine, backing vocals

Recorded
Musicland Studios, Munich: June–December 1981

Technical Team
Producers: Queen, Reinhold Mack
Sound Engineer: Reinhold Mack
Assistant Sound Engineer: Stephan Wissnet

FOR QUEEN ADDICTS
The Linn drum machines were very frequently used in productions by other popular artists at the time, including Prince. Recognizable in the song "Pop Life," which appeared on Prince's 1985 album *Around the World in a Day*, the Linn drum machines produced sounds and a rhythmic pattern that call back to those heard on "Dancer."

Genesis
Brian May's guitar, once a guarantor of the group's rock credentials, is partly absent from *Hot Space*, and the musician felt himself somewhat excluded from the creative process of making the album. "A difficult period. We weren't getting along together. We all had different agendas. It was a difficult time for me, personally—some dark moments."[114]

May did, however, contribute the very modern and groovy "Dancer," which features perfect, sensual couplets and very catchy refrains. While totally on message with Mercury and Deacon's funk emphasis, May still managed to provide the album with a song that bore his particular trademarks, especially in the guitar solo, which includes a pleasantly heavy-sounding guitar, made all the more noticeable as it's surrounded by a sea of synthesizers.

Production
As was the case with other cuts on this album, the song's author did the drum machine programming himself. The rhythmic pattern executed by the Linn LM-1 is therefore straight and nonsyncopated, and leaves no room at all for any rolling, rhythmic funk that Deacon would have produced on the Telecaster. The beat is accompanied by a guitar riff, which almost enables one to forget for a moment the omnipresence of the synthesizers. The Red Special has not disappeared, and so much the better. The result is a very rock-centric number, in which there are some real cymbals, as well as a gospel break at 2:28 that is slightly reminiscent of "Dragon Attack," from *The Game*.

But the song's strength is undoubtedly the guitar solo, which powers out to the listener in all the gaps not filled by Mercury's voice. The moans of the six-string, produced with the help of some languorous bends, add a sensuality to the song.

It should be noted, too, that the song's refrain is reminiscent of the refrain from "White Man," composed by May for the album *A Day at the Races* in 1976. A totally underestimated track, "Dancer" is a hidden gem from the *Hot Space* album.

BACK CHAT
John Deacon / 4:33

1982

Musicians
Freddie Mercury: lead vocals, backing vocals
John Deacon: bass, electric guitar, programming, synthesizer
Brian May: electric guitar
Roger Taylor: electronic drums

Recorded
Musicland Studios, Munich: June–December 1981

Technical Team
Producers: Queen, Reinhold Mack
Sound Engineer: Reinhold Mack
Assistant Sound Engineer: Stephan Wissnet

Single
Side A: Back Chat (Single Remix) / 4:12
Side B: Staying Power / 4:10
UK Release on EMI: August 9, 1982 (ref. EMI 5325)
US Release on Elektra: November 23, 1982 (ref. 7-69941)
Best UK Chart Ranking: 40
Best US Chart Ranking: Not Ranked

Genesis
By the time Deacon began the production of "Back Chat," tensions were at their height within the group. Quarrels were almost constant, especially between May and Deacon. Taylor was often absent, and Mercury often played the role of peacekeeper. "Since it wasn't heavy on guitars, Brian didn't really fancy it, and then he left again, and then Deaky left again,"[1] said Mack. He did his best to try and calm the musicians down when, on occasion, they deigned to turn up at a recording session. The producer, who worked with Queen through the album *A Kind of Magic* in 1985, eventually had enough and finally declared: "It was easier to conceive and give birth to a child than it was to finish this disc."[115]

Production
John Deacon's admiration for soul-funk music is well known, and helped to contribute to the international success of "Another One Bites the Dust" with its famous bass groove. With "Back Chat," Deacon attempted to re-create some of this earlier magic, working to mimic the syncopated guitar rhythms used by some of the most famous guitarists of the funk tradition, including Nile Rodgers of Chic and Les Buie and Jimmy Nolen, who were known for playing with James Brown. Unfortunately, "Back Chat" never quite stuck in people's minds, despite it having certain good points, including a danceable beat that was close to Freddie Mercury's heart.

Deacon recorded the synthesizer and rhythm guitar parts on this track, leaving very little room for Brian May to contribute to the song. "There wasn't going to be a guitar solo [...]. We had lots of arguments about it, and what he was heading for in his tracks was a totally non-compromise situation [...]. I was trying to edge him back towards the central path and get a bit of heaviness into it. So one night I said I wanted to see what I could add to it [...] and he agreed, so I went in and tried a few things."[90]

Roger Taylor extended his experimentations with sound in "Back Chat." At 1:40, he played a percussion solo on an instrument that represented a revolution in drum playing: the Simmons electronic drums. Famous

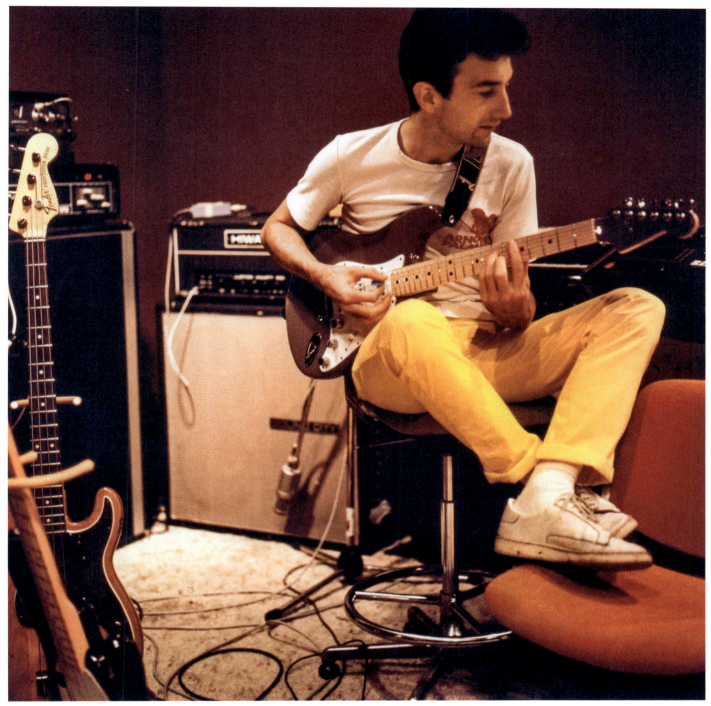
John Deacon was always ready to come up with a funk rhythm, a style of composition in which he excelled. His songwriting often featured precise and incisive use of the Fender Stratocaster.

for its octagonal red-and-black pads, these kits were to become an essential element of the music of the 1980s, after Queen had popularized them. As Taylor explained: "I have an entire drum kit of those [electronic drums]. [...] They're made by a small English company, called Simmons. [...]. They're a much better version of the synthetic drums. You can get a vast range of sound. I use them quite a lot, like for 'Another One Bites the Dust' and 'Action.' You probably heard them on the solo in 'Back Chat.' They're great for doing effects [...]. There's a nice tone quality that you can get out of them. A lot of groups have them now. Some of them use them instead of drums. They're very much the happening thing now. They're very good actually."[103]

1982

BODY LANGUAGE
Freddie Mercury / 4:32

Musicians
Freddie Mercury: lead vocals, backing vocals, synthesizer, programming
Brian May: electric guitar
Roger Taylor: electronic drums

Recorded
Musicland Studios, Munich: June–December 1981

Technical Team
Producers: Queen, Reinhold Mack
Sound Engineer: Reinhold Mack
Assistant Sound Engineer: Stephan Wissnet

Single
Side A: Body Language / 4:32
Side B: Life Is Real (Song for Lennon) / 3:31
UK Release on EMI: April 19, 1982 (ref. EMI 5293)
US Release on Elektra: April 19, 1982 (ref. E-47452)
Best UK Chart Ranking: 25
Best US Chart Ranking: 11

Freddie tempted by a "tasteful" T-shirt while shopping at a market in New Orleans in September 1981.

Genesis

The release of "Body Language" as a single in April of 1982 did not bode well for the fans in advance of the album's release. What were these futuristic sounds doing on the UK's FM airwaves? Everyone was wondering. For Freddie Mercury, the number was an artistic risk, but then again, Queen made its name by taking risks. No one could have predicted the success of "The March of the Black Queen" or "Bohemian Rhapsody." And yet, in many ways, these tracks helped to form the cornerstone of the group's reputation.

With no guitar (other than a few appearances on its outro), this song exasperated Brian May, who was concerned about the new artistic direction the group was taking: "I can remember having a go at Freddie because some of the stuff he was writing was very definitely on the gay side," he commented. "I remember saying, 'It would be nice if this stuff could be universally applicable, because we have friends out there of every persuasion.' It's nice to involve people. What it's not nice to do is rope people out. And I felt kind of roped out by something that was very overtly a gay anthem."[56] Communitarian or not, "Body Language" is, above all else, penalized by its writing, which is fairly run-of-the-mill. There is nothing much memorable about the song other than that it is the worst track in the group's repertoire. Its release as a single marked the decline of Queen in the United States, where its video, which is very overtly sensual, was censored. Mike Hodges produced the video and later commented with amusement: "I think it was the first video to be banned by MTV."[18]

Production

The synthetic bass rhythms in "Body Language" are not dissimilar to the hypnotizing sounds of the Moog Modular Synth, which was featured on Donna Summer's famous 1977 track, "I Feel Love," which had been produced by Giorgio Moroder. In fact, Queen was recording at Musicland Studios in Munich, where "I Feel Love" had been created five years before, with the expert input of sound engineer Reinhold Mack. Even Moroder, the inventor of disco himself, declared: "Thankfully, I had Reinhold Mack as my engineer back at the Musicland Studios in Munich, and it was thanks to his expertise that we were able to come through with everything: he knew the Moog inside out."[116]

ACTION THIS DAY

Roger Taylor / 3:32

Musicians
Freddie Mercury: lead vocals, backing vocals, piano
Brian May: electric guitar
Roger Taylor: lead vocals, backing vocals, drums, electric guitar
Reinhold Mack: synthesizer
Dino Solera: saxophone

Recorded
Musicland Studios, Munich: June–December 1981

Technical Team
Producers: Queen, Reinhold Mack
Sound Engineer: Reinhold Mack
Assistant Sound Engineer: Stephan Wissnet

Winston Churchill and Vice Admiral Bertram Ramsay, two of the heroes of World War II.

Genesis

Roger Taylor, who was accustomed to peppering Queen's albums with his compositions that featured light and carefree lyrics ("Tenement Funster," "I'm in Love with My Car"), seems to have developed a taste for making historical references in his songwriting. Following his lyrics covering the adventures of Capt. Robert Falcon Scott in "A Human Body" (on the B-side of "Play the Game"), here he quotes Winston Churchill. During World War II, the British prime minister attached a red label to the most important memoranda and military orders that he sent to his staff, and on which were written "Action This Day" in black capital letters.

Taylor's song concludes Side 1 of the *Hot Space* vinyl, a most testing set of songs for the standard Queen fan, who was most likely not prepared for the deluge of synthesizers and drum machines. Side 2, however, did include some numbers that were more faithful to the group's previous music.

Production

Even on his own song, Roger Taylor seems to have abandoned his role as drummer. The programming of the Linn LM-1 on this track was very close to that of "Delirious" by Prince, which was released a few months later on the album *1999*. In the case of "Action This Day," the drum sound is repetitive and cold, like many of the previous numbers on *Hot Space*. Freddie and Roger share the lead vocals, participating in a quite successful series of call-and-response, question-and-answer lyrics that allow the drummer to show off his different vocal ranges: low in the couplets and high in the refrains. Mercury's voice, which is bright, and used with perfect precision, brings light into the song, which is nonetheless of very limited interest.

As a little curiosity, in the middle of the song there's a seemingly anachronistic saxophone solo, reminiscent of the worst kind of music coming out of Italy in the 1970s. This little touch of the single reed is attributed to the Italian saxophonist Dino Solera, who lived in Munich and had already worked with Mack and Moroder in 1976, on the number "Classically Elise" by Munich Machine.

1982

PUT OUT THE FIRE
Brian May / 3:18

Musicians
Freddie Mercury: lead vocals, backing vocals
Brian May: electric guitar, backing vocals
Roger Taylor: drums, electronic drums, backing vocals
John Deacon: bass

Recorded
Musicland Studios, Munich: June–December 1981

Technical Team
Producers: Queen and Reinhold Mack
Sound Engineer: Reinhold Mack
Assistant Sound Engineer: Stephan Wissnet

FOR QUEEN ADDICTS

During the summer of 1981, the members of Queen met David Bowie in Montreux, where he was recording a song for the film *Cat People*, by Paul Schrader. Composed by Giorgio Moroder, the song is called "Cat People (Putting Out Fire)." Could this have been the inspiration for Brian May's "Put Out the Fire"?

Brian May wearing a Sugar Shack badge advertising the Munich club where the group often spent their evenings.

Genesis
While Side 1 of *Hot Space* might have disconcerted the listener with its excessive use of electronic instruments, "Put Out the Fire," on Side 2, launches a series of more conventional numbers. This song, written by the group's guitarist, calls upon Taylor's drums and Deacon's bass as major rhythmic elements, relinquishing the synthesizers and drum machines to the sidelines. With a very straightforward rock feel in its writing and in its production, "Put Out the Fire" recalls rock anthems such as "Fat Bottomed Girls," written by Brian May for *Jazz*. Driven by Brian May's furious riff on the Red Special and by beats produced by Taylor using the electronic snare drum on the Simmons pad, the song has a modern color that would find its place in the era just beginning, where the public in the stadiums played by Queen would be eager to hear these big guitar hits, such as "Hammer to Fall" or "Tear It Up." After the bold and courageous artistic experimentations of Mercury and Deacon on the first half of the disc, "Put out the Fire" relinks *Hot Space* with the efficient rock repertoire that the group was known for.

Production
As though on a mission to revenge himself for his eviction from some of the disc's earlier tracks, Brian May gets his Red Special out of its case and delivers a formidable, imposing solo that combines harmonics, tapping, bends, and other virtuosic techniques. If the objective was to show who was boss, it certainly worked. When asked whether executing his prodigious solo was difficult, May replied: "Actually, it was. I don't really know why. That wasn't a first take. I had done a lot of solos for that—hated every one of them. And then we came back from a club where we used to go to have some drinks. I think I was well on the way—you know, we were all plucked out and slightly inebriated—and we had a ridiculous echo effect [which] Mack was putting back through the cans. I said, 'That sounds unbelievable! I want to put it on every track [laughs].' [...] So we put it on the machine, and I just played though it. [...] I could hardly hear what I was doing, but it was sounding so good and I was so drunk. To be honest, I don't think it's that good a solo. It's got a sort of plodding thing going behind it; I never felt totally happy with it."[90]

1982

LIFE IS REAL (SONG FOR LENNON)

Freddie Mercury / 3:31

Musicians
Freddie Mercury: lead vocals, backing vocals, piano, synthesizer
Brian May: electric and acoustic guitars
John Deacon: bass
Roger Taylor: electronic drums

Recorded
Musicland Studios, Munich: June–December 1981

Technical Team
Producers: Queen, Reinhold Mack
Sound Engineer: Reinhold Mack
Assistant Sound Engineer: Stephan Wissnet

FOR QUEEN ADDICTS
On Tuesday, December 9, 1980, Queen, in concert at Wembley Arena near London, played "Imagine" after "Love of My Life," in homage to the singer-songwriter who had been killed the day before.

John Lennon was a hugely important musical influence for Mercury, May, and Taylor.

Genesis

On December 8, 1980, John Lennon was assassinated in front of the Dakota apartment building in New York City. Freddie Mercury, who had always declared his admiration for the Beatles, decided to pay homage to Lennon with this ballad recorded during the summer of 1981, and which Mercury led from the piano. The words, which he worked on before the music, were, unusually, written during an airplane flight. He detailed this creative process in 1982: "I write the song around the melody most of the time. Sometimes a lyric will get me started. 'Life Is Real' was one of those, because the words came first. I just really got into it, pages after pages, all kinds of words. Then I just put it to a song. I just felt that it could be a Lennon-type thing. [...] But otherwise I have melodies in my head. I play them on the piano and I used to tape record them."[103] As a touching homage paid to the idol of a whole generation, this song sits well with Queen's discography, with its melodic writing and clean, elegant arrangements.

Production

This number has multiple references to the song "Mother," which the former Beatle had recorded in 1970 for his album *John Lennon/Plastic Ono Band*, and on which one could hear church bells sounding four times (perhaps for the burial of his mother, to whom he says farewell in the text?). In "Life Is Real (Song for Lennon)," these church bell notes are called back to on the piano, where they are repeated four times in succession at the beginning of the track. The rest of the song is comprised of a series of hat tips to Lennon's earlier song: there is the piano, whose chords are played simply and without adornment, and there's also a discreet bass that allows space for the vocals, all of which are driven by a straightforward use of percussion. While Mercury was the first to pay homage to the former member of the Fab Four, Roger Taylor also said: "John Lennon was my ultimate hero. He was the best living songwriter, and one of the best rock 'n' roll voices I've ever heard. [...] I still haven't quite come to terms with the fact that he's not here anymore."[117] As Brian May confirms: "Lennon, for all of us [...] was, is, and always will be...IT. I rest my case."[118]

SINGLE

CALLING ALL GIRLS
Roger Taylor / 3:52

Musicians
Freddie Mercury: lead vocals, backing vocals
Roger Taylor: drums, electronic drums, percussions, electric guitar
Brian May: electric guitar
John Deacon: bass

Recorded
Musicland Studios, Munich: June–December 1981

Technical Team
Producers: Queen, Reinhold Mack
Sound Engineer: Reinhold Mack
Assistant Sound Engineer: Stephan Wissnet

Single
Side A: Calling All Girls / 3:52
Side B: Put Out the Fire / 3:18
US Release on Elektra: July 19, 1982 (ref. 7-69981)
Best US Chart Ranking: 60

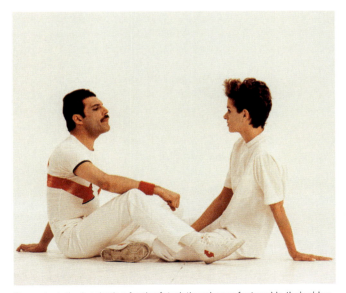

Queen took the inspiration for the futuristic universe featured in their video for "Calling All Girls" from George Lucas's film *THX 1138* (1971).

Genesis

The song "Calling All Girls," by Roger Taylor, was offered to the American public before Queen's tour of the United States in the summer of 1982. Elektra was unhappy about the previous choice of singles, and they decided to put all their support behind this pop-rock number. Unfortunately, the track never ranked higher than sixtieth on the US charts, and a futuristic music video created by Brian Grant did not help matters. Thus, the number was definitively buried, and any prospect of success for the album on the western side of the Atlantic was buried along with it. Freddie Mercury, who put all his energy into his performance of "Calling All Girls," defended its lightness, as well as the Queen repertoire in general, in his columns of *Melody Maker* in 1981: "I think Queen songs are pure escapism, like going to see a good film—after that, they can go away and say that was great, and go back to their problems. I don't want to change the world with our music. There are no hidden messages in our songs, except for some of Brian's. [...] People can discard them like a used tissue afterwards. You listen to it, like it, discard it, then on to the next. Disposable pop, yes."[119] The video for "Calling All Girls" is a curiosity in and of itself. It depicts a dystopian society controlled by police robots who seem to be determined to put a stop to a romantic interlude that Mercury and a young woman seem to be enjoying. Indulging his taste for the world of science fiction, Roger Taylor, alongside his comrades, plays the role of liberator, delivering Freddie from his authoritarian overlords. "Yeah, we all like science fiction, I think we all enjoy dabbling in this stuff!"[120]

Production

The twelve-string acoustic guitar on the introduction quickly eases back to give some room for a rhythm executed on a Schecter guitar, and both instruments are played by Roger Taylor himself. "That's a combination of acoustic and electric guitar," confirmed May. "[...] Roger played a lot of guitar. He's always bursting to play guitar."[89]

The melody line of the song, led by the gimmick of the six-string and bass on the couplets, is not unlike the song "Ferry Across the Mersey," released by Gerry and the Pacemakers in 1964. But the comparison ends there. The refrains on this song are very melodious and effective, and less furious than in the previous Taylor compositions.

SINGLE

LAS PALABRAS DE AMOR (THE WORDS OF LOVE)

Brian May / 4:29

1982

Musicians
Freddie Mercury: lead vocals, backing vocals
Brian May: backing vocals, electric and acoustic guitars, synthesizer, piano
Roger Taylor: drums, backing vocals
John Deacon: bass

Recorded
Musicland Studios, Munich: June–December 1981

Technical Team
Producers: Queen, Reinhold Mack
Sound Engineer: Reinhold Mack
Assistant Sound Engineer: Stephan Wissnet

Single
Side A: Las Palabras de Amor (The Words of Love) / 4:29
Side B: Cool Cat / 3:28
UK Release on EMI: June 1, 1982 (ref. EMI 5316)
Best UK Chart Ranking: 17

Originally opposed to the use of synthesizers, Brian May became a convert to the Jupiter-8, which was introduced in 1981.

Genesis

Just as he had done with "Teo Torriatte (Let Us Cling Together)" in 1976, which Brian May wrote after Queen returned from their tour of Japan, Brian May wrote this ballad in honor of all the South American fans they had met on Queen's first tour of Argentina and Brazil in the winter of 1981. "They knew all the songs," recalls the guitarist. "These people don't speak English, but they could sing along with all the Queen songs! So they were obviously genuine fans, and they were nuts!"[110]

"Las Palabras de Amor (The Words of Love)" is a true Queen song in the classic sense, with a catchy lead vocal and a melody in Spanish, and featuring harmonized backing vocals on the refrains. "I don't think my songwriting has changed as much as the others in the group. I tend to write more traditional Queen material […]. I still tend to write melodies [with a] certain sort of heaviness, which the group does well at its best."[103]

The song appeared as the third single from *Hot Space* (the first two, "Under Pressure" and "Body Language," had been released before the album appeared), but was only moderately successful in the United Kingdom. Since no video was created for this single, the group used their first appearance on *Top of the Pops* in five years as a way to promote the single. Broadcast on June 17, 1982, the group's appearance features a somewhat somber-looking Freddie Mercury, who seems confusingly far removed from his usual exuberant stage presence. Wearing an elegant smoking jacket and bow tie, and performing the song in a solemn manner, Mercury seems to be in total contrast with the world of fun and excitement that he sought to develop at the outset with the *Hot Space* album.

Production

From the song's introduction, Brian plays out a synthesizer part on which he uses the arpeggiator function. This revolutionary tool enables the synthesizer to play a complete arpeggio by holding down a single chord on the instrument's keyboard. The repetition of the arpeggio is then made adjustable in both duration and speed, and can thus be made to match the rhythm of the song. The effect is lightly sprinkled into the song and structured around the group's traditional base rhythm, and it is embellished by May's Red Special.

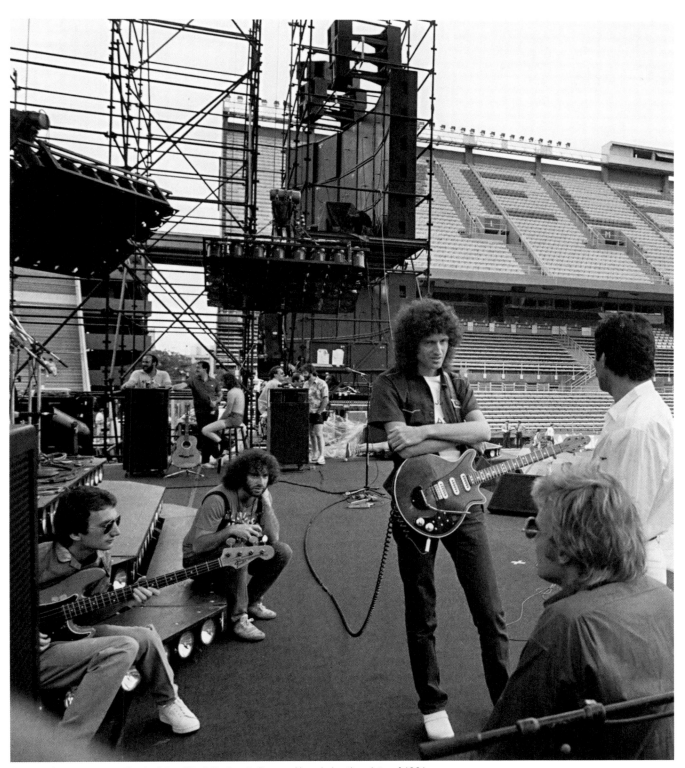
Queen before a concert at the José Amalfitani Stadium in Buenos Aires during the winter of 1981.

QUEEN: ALL THE SONGS 317

1982

COOL CAT
Freddie Mercury, John Deacon / 3:28

Musicians
Freddie Mercury: lead vocals, backing vocals, synthesizer
John Deacon: bass, electric guitar, clavinet, programming

Recorded
Musicland Studios, Munich: June–December 1981

Technical Team
Producers: Queen, Reinhold Mack
Sound Engineer: Reinhold Mack
Assistant Sound Engineer: David Richards

FOR QUEEN ADDICTS
The working title for the song was "Wooley Hat," but this was changed to "Cool Cat" when Freddie arranged the lyrics with John.

Having already authored the haunting cover of "I Feel It Coming" by the rapper The Weeknd in 2017, the talented lead singer and pianist Juliette Armanet offered a cover of "Cool Cat" with her own lyrics in French, in 2018, on the bonus disc of her album *Petite Amie Live*.

Genesis

"Cool Cat" was one of the first songs worked on in Munich, in June 1981. This was a collaboration between John Deacon and Freddie Mercury, and one of the rare instances of a joint composition on a Queen album. This track also marked the first time that these two musicians worked closely together, even though at the time they did not have any kind of special rapport, as the bassist later testified: "We don't see that much of each other socially when we aren't working. We all have our own friends. For instance, I would never think of going round to Fred's house and he would never come to mine. We're poles apart in that sense."[90] Even so, there is strength in unity, and from this artistic mutual understanding was born the most artistically successful song on the *Hot Space* album: a song of incredible sensuality, with refrains that feature an irresistible melody. Issued on the B-side of "Las Palabras de Amor (The Words of Love)" when the single was released on June 1, 1982, in the United Kingdom, "Cool Cat" should have been one of the most important songs from Queen's so-called Synth Era, which began with *The Game*.

Production

"Cool Cat"'s destiny should have been similar to that of "Under Pressure," as the first version recorded by the group includes backing vocals provided by David Bowie. Just a few days off the release of the album, the "Thin White Duke" received a note to let him know that this version was going to appear on the disc. But the lead vocalist, who was not happy with his performance, opposed this. According to Brian May, "David just did a backing track. I don't think anyone thought any more about it, except that it was a nice ornamentation."[121] The upshot of this was that EMI had to do a new pressing of the disc, without Bowie, and postpone the release of the album. Brian May concluded: "Queen are very pigheaded and set in our ways. And Mr. Bowie is too. In fact, he's probably as pigheaded as the four of us together."[122]

Everyone can now listen to this version on YouTube and form their own conclusions. The contributions provided by Bowie in the song are largely superfluous and really only of very limited interest.

Once again, John Deacon's bass playing is spot-on in the lazy, summery track "Cool Cat."

Full recognition should be given to Mercury's vocal mastery, and especially to the sensuality of his interpretation. Mack, the record's producer, explained in an interview with Martin Popoff in 2018 how the lead singer, with his exacting standards, would record his lead vocals tracks: "Freddie was superb. I mean, he usually did one take and that was it. […] He'd kind of look through the window and say, 'You didn't seem to be too excited about that one. Let me do another.' […] So, he did another one and, you know, that was it. On maybe some of the highest notes, he tried three or four times to get it, but that's it."[11]

But credit where it is due: It was John Deacon who was behind the creation of this languorous piece. With his Music Man StingRay, he provides the bass part, as well as all the Telecaster guitar parts, and the programming of the Linn LM-1 drum machine. The result is a magical number, which is enough to convince the listener of the artistic value of *Hot Space*, even though this is a very patchy album overall.

SINGLE

UNDER PRESSURE
Queen, David Bowie / 4:03

Musicians
Freddie Mercury: lead vocals, backing vocals, finger clicking
David Bowie: lead vocals, finger clicking
Brian May: electric guitar, finger clicking
John Deacon: bass, finger clicking
Roger Taylor: drums, backing vocals, finger clicking

Recorded
Mountain Studios, Montreux: July 1981
Power Station Studios, New York: September 1981

Technical Team
Producers: Queen, David Bowie
Sound Engineer: Reinhold Mack
Assistant Sound Engineer: David Richards

Single
Side A: Under Pressure / 4:03
Side B: Soul Brother / 3:40
UK Release on EMI: October 26, 1981 (ref. EMI 5250)
US Release on Elektra: October 27, 1981 (ref. E-47235)
Best UK Chart Ranking: 1
Best US Chart Ranking: 29

> When asked about the sampling of "Under Pressure" made by Vanilla Ice on his hit track, "Ice Ice Baby" from 1989, Roger Taylor declared, "He didn't write that, he actually took it from our record with David Bowie. [...] I don't like the record very much. He's a white rapper from Florida, great...with a funny haircut!"[124]

Genesis
When Queen went to Montreux's Mountain Studios (which they eventually bought) in the summer of 1981, they were visited by their fellow countryman and friend David Bowie, who had come to record the song "Cat People (Putting Out Fire)," which he had composed with the fashionable producer Giorgio Moroder. A jam session was then improvised with the Thin White Duke before they celebrated their getting together over a dinner. "We had fun kicking around a few fragments of songs we all knew," recalls Brian May. "But then we decided it would be great to create something new, on the spur of the moment. We all brought stuff to the table, and my contribution was a heavy riff in D which was lurking in my head. But what we got excited about was a riff, which Deaky began playing, [...]. Ding-Ding-Ding Diddle Ing-Ding, you might say."[123] But after the dinner, the bass player could not remember the riff. "It completely escaped his mind," Roger Taylor recalls with amusement in the *Days of Our Lives* documentary. "We got back, and I remembered it!"[110]

The group and Bowie then started to play around with this bass gimmick, and the session, which lasted twenty-four hours, gave rise to "Under Pressure," whose working title was "People on Streets."

Production
The instrument used by Deacon in the world-famous introduction to "Under Pressure" is a 1981 Fender Precision Special. New to the market, and manufactured by the prestigious American guitar maker, this Fender bass offered a new feature compared to the previous models. It had three potentiometers—volume, bass, and top range—whereas the traditional Precision models had only two buttons, for volume and tone. Deacon was thus able to drill down deeply into the sound frequencies his instrument was capable of producing until he found the appropriate sound he wanted for the introduction of the song. Brian May added some guitar arpeggios to Deacon's repetitive score, which he later dubbed in postproduction. ("David later was adamant it ought to be played on a 12-string,"[123] the guitarist explained.)

For the vocal parts, Bowie imposed on Freddie a method he had been experimenting with for some time with some

Mercury and Bowie never performed "Under Pressure" together live. Here, David Bowie appears alongside May, Deacon, and Taylor at the Freddie Mercury Tribute Concert in April 1992.

of the artists in his entourage. The two lead vocalists sang their part in turn, without having heard what the other had recorded. No structured lyrics, just parts of phrases. "[David] was kind of famous for writing lyrics by collecting different bits of paper with quotes on them," explains Brian May. "And we did a corresponding thing as regards writing the top line of the song. [...] That's why the words are so curious, some of them, anyway."[18] This was when Mercury recorded his famous onomatopoeic "De Da Day," scat-singing in the style of Louis Armstrong. The next day, Bowie informed the members of Queen that he was going to start again with the tapes and record some new ideas. "It was unusual for us all to relinquish control like that but really David was having a genius moment—because that is a very telling lyric,"[123] Brian May later confided.

When the time came to tackle the mixing of this number, things became more complicated. Mercury, Bowie, and Taylor met at the end of August 1981 at the Power Station Studios in New York, accompanied by Mack and David Richards, who had worked as the sound engineer at Mountain Studios and who immortalized the meeting of the stars. Following a working session lasting more than eighteen hours, Mercury and Bowie could not agree on the direction to be taken. In the end, a version derived from a rapid mixing ended up being included on the album. Brian May, who was tired of these quarrels and disagreements in the group, did not go to New York to take part in the squabbles between the two stars. He long regretted this, stating that he would have preferred to see a more honed version used as the final product. But no one had time to go back to the studio, as EMI, who were in a hurry to capitalize on this meeting, offered "Under Pressure" as a single on October 26 in the United Kingdom and on the following day in the United States.

QUEEN: ALL THE SONGS 321

> The close friendship between Mercury and Peter Hince made it possible for Hince to capture this intimate portrait of Queen's lead singer looking solitary and meditative.

SOUL BROTHER
Queen / 3:40

Musicians
Freddie Mercury: lead vocals, backing vocals, piano
Brian May: electric guitar
John Deacon: bass
Roger Taylor: drums

Recorded
Musicland Studios, Munich

Technical Team
Producers: Queen, Reinhold Mack
Sound Engineer: Reinhold Mack
Assistant Sound Engineer: David Richards

Genesis

Released on the B-side of "Under Pressure," "Soul Brother" came from the working sessions that occurred during the production of the album *The Game*. The title also takes us back to the world of *A Day at the Races*, with a spontaneity and freshness that are lacking in the sleeker, more modern production of tracks like "Another One Bites the Dust," "Body Language," and "Back Chat."

The piece is by Queen as a whole, rather than by any single musician, which was a curious feature at the time, and would remain unusual up until the album *The Miracle*, after which group songwriting credits became the norm. In reality, it was basically Freddie Mercury who wrote this deep, very soul-oriented song, intended for his friend Brian May, who explained its history in 2003: "Freddie told me one day he had a surprise for me. He said, 'I've written a song about you, but it needs your touch on it!' I think, curiously, we were both working on songs separately which referred to each other. Can't remember which one of mine it was, since a lot of my songs were obliquely aimed at him (as well as to be sung by him!). Anyway, we got in the studio and he played this song. Now whether it was really about me I don't know. But I thought it was fab. I know he wrote it in about 15 minutes!"[5]

The second half of "Soul Brother" contains multiple references to Queen's most famous songs. Mercury cites "You're My Best Friend," then "We Are the Champions," singing: *"He's my best friend / He's my champion."* And from the next phrase, he makes a fairly unsubtle but very touching allusion to two of the most famous songs by his guitarist friend: *"And he will rock you rock you rock you / 'Cause he's the saviour of the universe."* We recognize here references to "We Will Rock You" and "Flash."

Production

"Soul Brother" contains the same ingredients as the most mythical of Queen's albums. While the soul-inflected sound of the song points to Mercury's affection for the diva Aretha Franklin, the spontaneity that stands out from this (probably live) recording is evocative of "See What a Fool I've Been," a number from the group that was never released.

ALBUM

THE WORKS

Radio Ga Ga . Tear It Up . It's a Hard Life . Man on the Prowl .
Machines (Or "Back to Humans") . I Want to Break Free . Keep Passing the Open Windows .
Hammer to Fall . Is This the World We Created…?

RELEASE DATES
United Kingdom: February 27, 1984
Reference: EMI—EMC 240014
United States: February 28, 1984
Reference: Elektra—ST-12322
Best UK Chart Ranking: 2
Best US Chart Ranking: 23

Queen at the Sanremo Song Festival, where the band lip-synced "Radio Ga Ga" in front of two thousand spectators and a staggering 30 million television viewers.

BACK TO THEIR ROOTS

Nineteen eighty-two was a difficult year for Queen, who had been touring the world to promote their latest album since April, but the album was not proving as successful as they had hoped. After the last concert of the *Hot Space* tour at the Seibu Lions Stadium in Tokorozawa, Japan, on November 3, 1982, the musicians decided that a break was both necessary and well deserved.

At the beginning of 1983, Roger Taylor began recording his second solo album, "*Strange Frontier,*" at the Mountain Studios in Montreux. Freddie started producing an album in Munich, accompanied by producer Mack, while John Deacon was getting bored during this compulsory leave, as he later explained: "We're not so much a *group* anymore. We're four individuals that work together as Queen but our working together as Queen is now actually taking up less and less of our time. I mean basically [...] we were doing so *little*. I got really bored and I actually got quite depressed because we had so much time on our hands..."[125] The bassist, meanwhile, participated in the short-lived band Man Friday and Jive Junior, whose single "Picking Up Sounds" is strangely reminiscent of "The Message," by Grandmaster Flash and the Furious Five, released the previous year. The bass part in particular, written by Deacon, seems to have been inspired by this hit, which is considered one of the first hip-hop tracks in history.

In April 1983, Brian May took advantage of his vacation in Los Angeles to record his first solo album. "Queen propelled us into the world, but also in a sense, it confined us in a very small space. We just worked with each other, we didn't work with all the fabulous musicians in LA,"[110] the guitarist would later observe. On April 21 and 22, May recorded three tracks at the city's Record Plant Studios, accompanied by Phil Chen on bass, Fred Mandel on keyboards, Alan Gratzer on drums, and virtuoso Eddie Van Halen on the six-string guitar. The songs "Star Fleet," "Let Me Out," and "Blues Breaker" were immortalized on a mini-album entitled *Star Fleet Project,* which was created as a tribute to the Japanese *Star Fleet* series, which Brian's son Jimmy particularly enjoyed. The internationally popular television series featured animated puppets, including the hero Shiro Jinga and the Emperor, King Germa, and while the series had not been a great success in its home country, it found a loyal audience in France and the UK, including the guitarist's son and Brian himself. The record, inspired by the world of the series, is credited to "Brian May and Friends."

At the same time, Freddie Mercury was working on the soundtrack of the silent film *Metropolis* (1927), to which Giorgio Moroder had recently acquired the rights. In the end, however, the singer's participation in the colorful version of Fritz Lang's masterpiece was limited to the song "Love Kills."

At the beginning of the summer of 1983, another collaboration seemed to be of greater interest to Freddie, who had become friends with Michael Jackson long before the worldwide success of *Thriller* in 1982. "He used to come and see our shows all the time," the British singer would later explain, "and this is how the friendship grew. We were always interested in each other's styles. I would regularly

326 THE WORKS

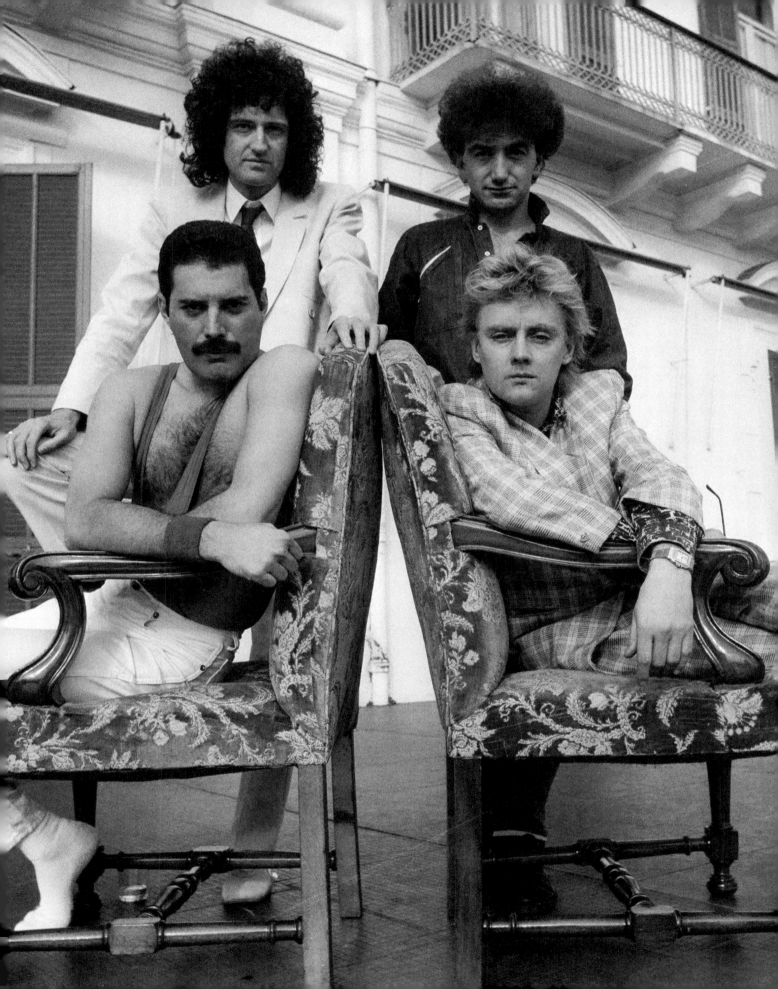

1984

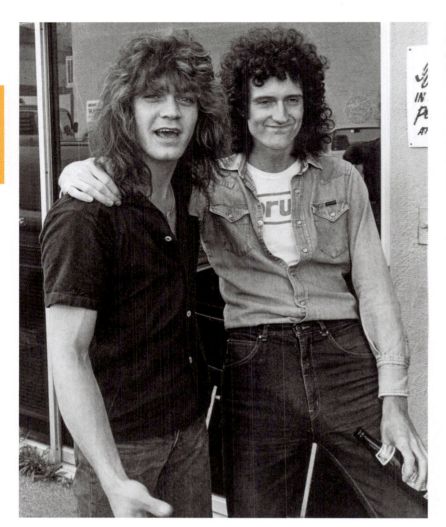

Fellow musician and friend of Brian May, Eddie Van Halen was one of the greatest guitarists of the 1980s.

> When Brian May returned from his holidays in Paris in the winter of 1983, he was denied boarding at Orly Airport because his Red Special exceeded the size limit allowed for a carry-on baggage item. Refusing to let it travel in the hold, the virtuoso didn't hesitate for a second and bought a seat for his mythical guitar, which was clearly priceless in his eyes.

play him the new Queen album when it was cut and he would play me his stuff. We kept saying, 'Why don't we do something together?'"[18] They worked on three songs during a recording session in the King of Pop's studio in Encino, California. However, all of these recordings would remain in the drawer.

Meanwhile, Jim Beach, Queen's manager, was busy orchestrating a change of label for the group. The band was convinced that Elektra was responsible for the failure of the *Hot Space* album in the United States, and they revoked their contract. After some fierce negotiations, the American record company eventually released Queen from their obligations in exchange for a check for $1 million. The band then signed with one of the American branches of EMI; its label in the United Kingdom was Capitol Records.

The Californian Year

In the summer of 1983, the musicians were asked by director Tony Richardson to compose the soundtrack for the film *The Hotel New Hampshire*, a big-screen adaptation of John Irving's novel of the same name. Willing to reinvest themselves in a common project, the band members all met in Los Angeles in mid-August, after an eighteen-month break, the longest in Queen's history. In the end, the director decided not to call on the rockers since his budget wouldn't allow it, but this didn't matter, as the desire to work together came back to the group. On Brian May's advice, the group booked the Record Plant in Los Angeles and began work on a new album. "We thought we wanted somewhere nice and warm, and not freezing bloody cold Munich. So that really made sense to go to LA to make that record,"[110] explained Roger Taylor. "We were all ready, there's no doubt. I think we've been off all of different things, refreshing ourselves. We were ready to get back in the studio,"[110] added Brian May.

But despite strong motivation to get back to work, relations within the group remained strained. Rumors of separation had been circulating for several months by then, denied during interviews where everyone put on their best smiles and jokes to show that everything was fine within the group. Mercury even offered this famous reply to a journalist: "It's got to the point where we're actually too old to break up. Can you imagine forming a new band at forty? Be a bit silly, wouldn't it?"[44] So they all put a brave face on it, and work began on the album *The Works* in August 1983 at the Record Plant. Mack was again co-producer of the record, and for the first time, a fifth musician took part in the recording sessions. This was keyboard player Fred

Fred Mandel sits between his two Jupiter-8s, which helped to shape Queen's sound on *The Works*. It was with this mythical synthesizer that the band created "I Want to Break Free."

Mandel, who had joined Queen on the 1982 American tour. This true virtuoso, always a source of inspiration, took part in the production of several tracks, including the renowned hit "I Want to Break Free."

Queen's Life and Death in the US

The recording sessions in Los Angeles—where by this time every member of Queen owned a house, except Freddie, who rented a villa on Stone Canyon Road—lasted until January 1984, when the musicians returned to Munich for a few extra sessions. The album was ready for release, and to stave off the impatience of fans, who had not heard any new songs by their idols since the summer of 1982, a single was released on January 23, 1984. "Radio Ga Ga," written by Roger Taylor, was a huge success in many countries. It reached number 1 in Italy, Belgium, and Germany, and it even found an enthusiastic audience in the United States, where the reception was encouraging. But this hope of reconquering America was short-lived for the musicians, as Capitol Records, their new label on the other side of the Atlantic, was going through difficult times. A scandal was shaking the record company, which was suspected of corruption. Some radio programmers were said to have taken bribes to promote the label's artists. Although the investigation was still in its preliminary stages in January 1983, Capitol's artists were facing a widespread boycott, and none of their songs were being played on the radio anymore. As Brian May recalled bitterly in 2005, "We had spent a million dollars getting out of our deal with [...] Elektra to get onto the Capitol label. And Capitol got themselves into trouble [...]. We had 'Radio Ga Ga,' which I think was top twenty and rising, but the week after that it disappeared from the charts."[126] Queen seemed to have nothing but bad luck in the United States, but that was nothing compared to an even worse storm that was now approaching.

On February 27, *The Works* was released in the United Kingdom, and it was released on the following day in the United States. For the cover photo, the band called on George Hurrell. Described as the "Rembrandt of Hollywood" for the quality of his famous shots of movie stars between 1929 and 1944, the photographer had attracted Freddie's attention as early as 1973, when Queen was working on the cover of their second album with photographer Mick Rock. It was in fact George Hurrell who had immortalized the actress Marlene Dietrich in a famous pose—with her hands folded and resting on her shoulders—that had inspired Freddie so much that he reproduced every detail of it for the cover of the album *Queen II*.

1984

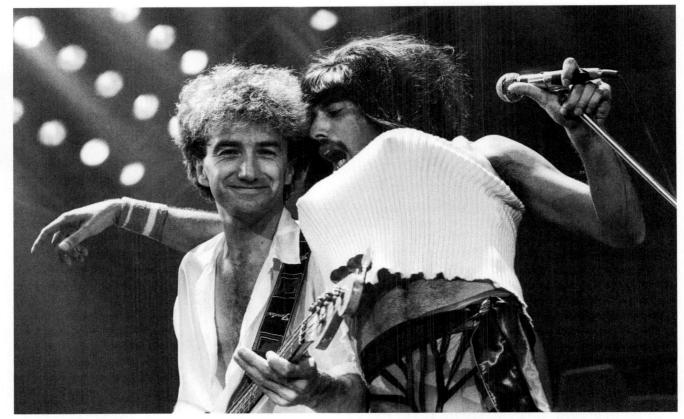

(Above) Queen performed four shows in a row at London's Wembley Arena on September 4, 5, 7, and 8, 1984. On the second night, Freddie unveiled his fake but generous breasts during "I Want to Break Free," showing them off to a bemused John Deacon. (Right) Far from his spectacular outfits of the past, Brian May would now wear only a discreet white shirt at Queen concerts; luckily, the shirt perfectly coordinated with the red of his Red Special.

The cover of *The Works* was the polar opposite of the cover for the ultracolorful *Hot Space*, released in 1982. The musicians are shown looking serious, in black-and-white, in the style of the Parisian studio Harcourt's shots. In terms of style, Queen had made quite the U-turn!

In the United States, the problems at Capitol did not help the promotion of *The Works*, which stagnated in twenty-third place in the charts. But with the release of the second single, "I Want to Break Free" in April 1984, the situation worsened: the video caused a scandal, and the entire country turned its back on Queen's music. The video, which presents the musicians in drag, is a hilarious parody of the British soap opera *Coronation Street*. The song was not at all to the taste of the relatively prudish Americans. Disgusted, Freddie refused to play on American soil as long as this disrespect lasted. "I think it was a huge mistake by Queen not to take that tour to America," explained technical manager Peter Hince in 2006. "It effectively killed the band there. The decision was because the singles from *The Works* had not done very well in the US, but were big hits everywhere else. Queen had just signed to Capitol Records and expected more I guess. The breaking point was the video for 'I Want to Break Free'—the 'drag' and comedy didn't go down well in America and Queen would not make an alternative video for the US market."[127] As incredible as it may seem, the band never played in America again, at least not with Freddie Mercury. "We became global, but we lost America."[110] concluded Brian May in 2011.

Sun City: The Disastrous South African Adventure

In the summer of 1984, the "Queen Works! (*The Works* Tour)" tour was launched in Europe, a third single was released—the magnificent ballad "It's a Hard Life," written by Freddie Mercury. In October, the group was offered a series of twelve dates at the Super Bowl in Sun City, a hotel complex built in 1979 in Bophuthatswana, a Bantu homeland of apartheid South Africa, a supposedly independent territory not recognized by the international community. Emblematic of white supremacy in a region where racial segregation still raged, Sun City was the Las Vegas of the African continent. Queen hesitated for a long time before accepting the invitation, breaking the then-current ban of the English Musicians' Union from performing in South Africa. The band then received a barrage of criticism from their peers and the British press. After playing ten concerts in the country (two dates were canceled—on October 9 and 10—due to Mercury's health problems), Queen was then placed on the United Nations blacklist. "Those criticisms are absolutely and definitely not justified,"

330 THE WORKS

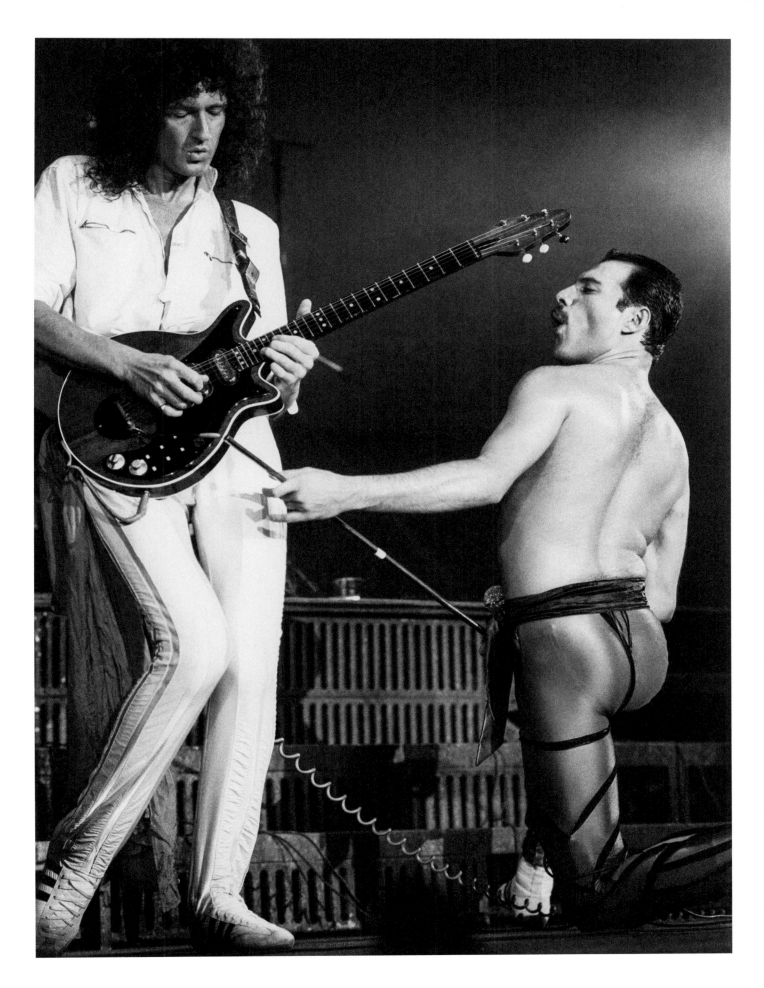

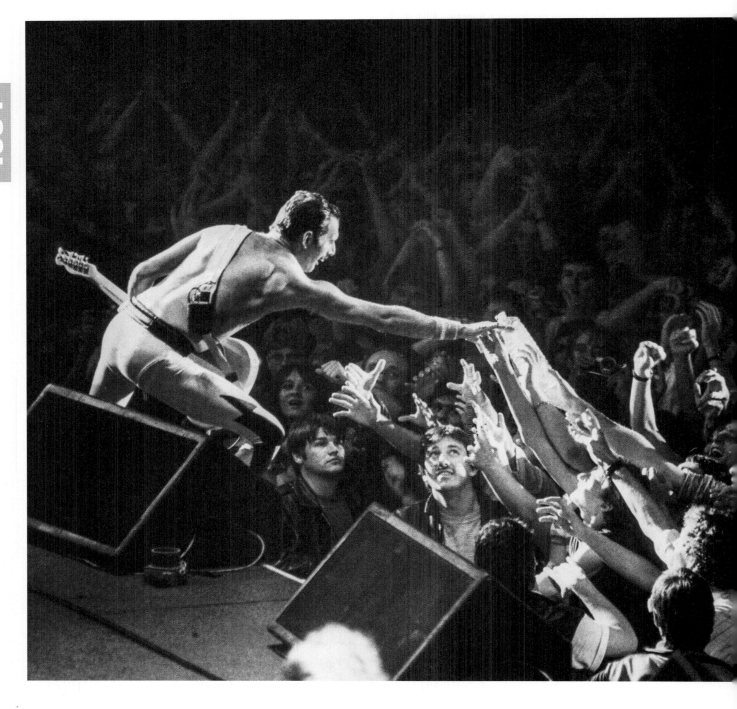

argued Brian May. "We're totally against apartheid and all it stands for, but I feel that by going there we did a lot of bridge building. We actually met musicians of both colours. They all welcomed us with open arms."[128] Despite numerous radio and television appearances in which the members of Queen attempted to justify themselves, their concerts in Sun City had a disastrous effect on their image.

So, when they released their single "Thank God It's Christmas" on November 26, 1984, it was totally eclipsed by the colossal success of "Do They Know It's Christmas?" by Band Aid, an association of British artists united to help fight famine in Ethiopia. The members of Queen were of course not invited to participate, which was a real slap in the face for the band at the end of 1984.

1985, a Pivotal Year

At the beginning of 1985, relations between Mercury and his fellow band members continued to deteriorate, especially as the star was busy promoting his first solo album, *Mr. Bad Guy*, which was released on April 29, 1985, but which failed to make a major impact. Encouraged by his personal manager, Paul Prenter, whose influence had become extremely unpleasant, Mercury hinted, at least during this period of

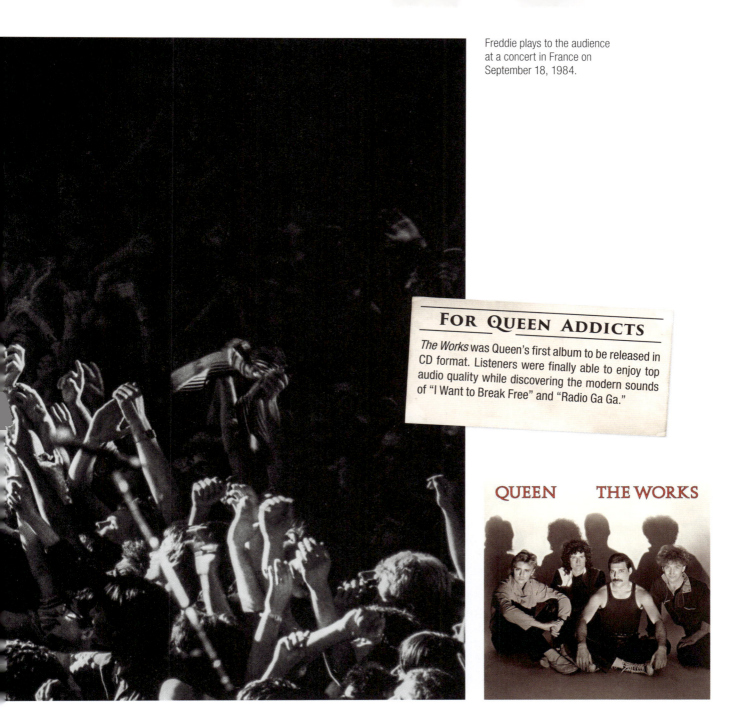

Freddie plays to the audience at a concert in France on September 18, 1984.

FOR QUEEN ADDICTS

The Works was Queen's first album to be released in CD format. Listeners were finally able to enjoy top audio quality while discovering the modern sounds of "I Want to Break Free" and "Radio Ga Ga."

promotion, that he was going to free himself from Queen to pursue his solo project.

The "Queen Works! (*The Works* Tour)" ended on May 15, 1985, at Osaka-jo Hall in Osaka, Japan. Two days later, the band returned to the United Kingdom. But this return to the home country was tainted by a bitter taste of misunderstanding. Deacon and Taylor headed off to the drummer's house in Ibiza while Brian May stayed with his family before flying to New Orleans, where he promoted the marketing of an official replica of his Red Special guitar by the American company Guild: the BHM01. Freddie Mercury, meanwhile, went to stay with Jim Hutton, an Irish hairdresser he had met two years earlier. A strong romantic relationship had developed between the two men, and it would last until the singer's death in 1991.

Despite the success of their last tour, the band seemed to be losing momentum, and their image had greatly deteriorated in the UK after the Sun City scandal, so when Bob Geldof, the singer from the Boomtown Rats, who had already organized Band Aid, asked Queen to take part in the charity concert he wanted to organize in the summer of 1985, the band, more divided than ever, saw this as an opportunity to get closer and to hopefully win back a perplexed, even lost, audience.

QUEEN: ALL THE SONGS 333

FOCUS ON...

Live Aid gave Queen twenty minutes in which to win back their audience. More than just a concert, the performance turned out to be a return to favor for Freddie, John, Brian, and Roger.

THE LIVE AID CONCERT: A CRAZY PROJECT, FROM LONDON TO PHILADELPHIA

On July 13, 1985, Bob Geldof brought together no less than seventy artists simultaneously on both sides of the Atlantic for the concert of the century. For sixteen hours, the cream of the rock and pop scene took to the stage in both London and Philadelphia to raise funds for the famine in Ethiopia. Broadcast on television in 150 countries, Live Aid reached two billion viewers around the globe. Queen's performance will go down in the annals of this truly legendary concert. The story behind Queen's involvement in the event is almost as fascinating as the celebrated performance.

A Daring Proposal

In December 1984 Queen was at a standstill, desperately trying to repair the damage caused by the series of concerts they played two months earlier in Sun City, which was part of apartheid South Africa. Spike Edney, the band's new keyboard player (he replaced Fred Mandel, who was now working with Elton John), took the opportunity to join the Australian tour of Bob Geldof's band, the Boomtown Rats, where he played the role of trombonist. It was during this trip, Edney recalled in 2017, that "Geldof said, 'I'm planning this show'—he originally said Shea Stadium, not Philadelphia. He said, 'We'll have a simultaneous show in Wembley in London and Shea Stadium.' I said, 'Oh, yeah. It'll never happen.' He said, 'No, it's going to happen and I want you to ask Queen if they'll appear.'"[129] But Queen had just been excluded from Band Aid, the first supergroup formed by Geldof to raise money against famine in Ethiopia. This first humiliation still hung heavy on the hearts of the British musicians, and Edney feared that the band would send him packing.

In January 1985, after a disastrous year in terms of image, Queen resumed their world tour. The "Rock in Rio" festival, held in Brazil, was a great success for the group, and they played in front of more than three hundred thousand spectators. They then flew on to New Zealand, Australia, and finally Japan. It was during this spring tour that things started to be organized. In New Zealand, Spike Edney took advantage of a relaxing moment over dinner to raise the subject of Geldof's bold project. The Queen musicians initially gave the proposal a frosty reception. "Why doesn't he ask us?" asked Deacon. "As soon as you tell him what your answer is, he will,"[130] replied the keyboard player, who had to deal with the overwhelming pride of both parties. Eventually, Geldof made the first move: He called Jim Beach in Japan, and after some hesitation Queen's manager accepted the proposal on behalf of the band.

Perfect Down to the Last Detail

The British concert took place at Wembley Stadium in London. Guest artists included David Bowie, Elton John, Paul McCartney, U2, Status Quo, and Dire Straits! Never before has a concert gathered such a lineup. Each band had to respect a set of specifications imposed by Geldof: no sound checks, the same sound volume for each performance and a timed set, limited to twenty minutes each. In

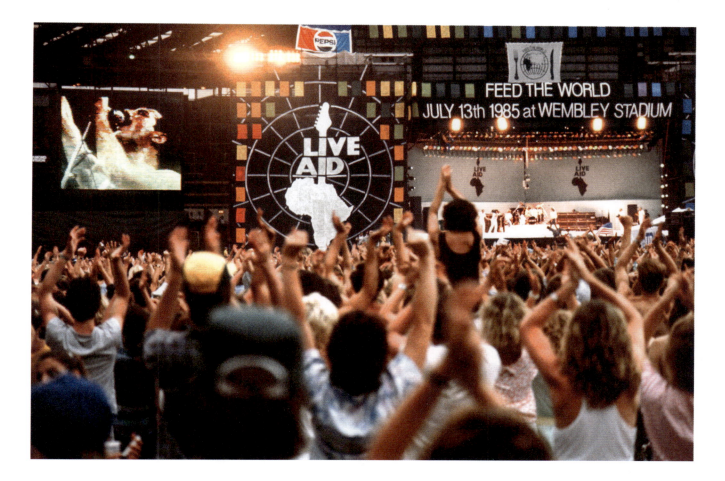

the forefront of the stage, spotlights were directed toward the artists, but curiously, they didn't light up the show. Their role was quite different, as revealed by Peter Hince in 2011: "In front of center stage was a traffic-light system, of green, amber and red lamps for the performers to monitor. The first light illuminated, to tell the band that they had five minutes left, the second light signaled two minutes remained, so finish your song ASAP, and the red was 'your time is up get off or we will pull the plug on you.'"[87]

Live Aid was an enormous challenge, which Queen took up with pleasure, seeing it as an opportunity to get back in the saddle and win back the hearts of their audience. On July 10, the band shut themselves away for three days at the Shaw Theatre in London to rehearse their set, which they saw as a real concert and not just as a convivial moment shared with the other artists. It was this approach that made all the difference on the day, with everyone working flat-out to create a medley of Queen's greatest hits.

The Day of Glory

On the afternoon of Saturday, July 13, Mercury traveled to Wembley Stadium accompanied by his partner, Jim Hutton. He was examined by a doctor who advised him not to sing, at the risk of aggravating an already advanced throat infection. The star ignored the specialist's advice, unable to miss this appointment with destiny.

At 6:43 p.m., the comedy duo Mel Smith and Griff Rhys Jones appeared onstage dressed as London policemen and entertained the audience with a sketch that enabled the technicians to ensure a quick set change for the next band. After a few jokes, the two entertainers announced to the tens of thousands of spectators: "Her Majesty…Queen."

"The energy that day was sensational," recalls Peter Hince, the band's technical manager. "They set the level for the PA with limiters. And then when Queen came on, Trip, who was Queen's sound engineer, switched the limiters, so Queen would be loud."[110]

At 6:44 p.m., Queen came onto the stage to thunderous applause. Video of the performance shows Freddie's radiant smile, which says everything about how much he enjoyed meeting his fans. From the very first notes of "Bohemian Rhapsody," the audience was enraptured. The group then went on to play a classic rendition of "Radio Ga Ga," with ninety thousand pairs of hands clapping together in time to the chorus. It was electric…Famous BBC host and rock specialist Paul Gambaccini would later say, "It was as if all the artists backstage had heard a dog whistle. Their heads turned and the thrill that you felt was '"They're stealing the show!"'"[110]

At 6:49 p.m., Freddie Mercury, tasting the glory that awaited his band once again, launched his famous "Eh-oh," to which the crowd went wild and responded immediately. This was followed by an electrifying *scat* exchange, and immediately "Hammer to Fall" was unleashed on the audience! "Freddie was our secret weapon," Brian May would later recount. "He was able to reach out to everybody in that

QUEEN: ALL THE SONGS 335

FOCUS ON...

Freddie made quite the impression at the London portion of the Live Aid concert, which took place at Wembley Stadium on July 13, 1985.

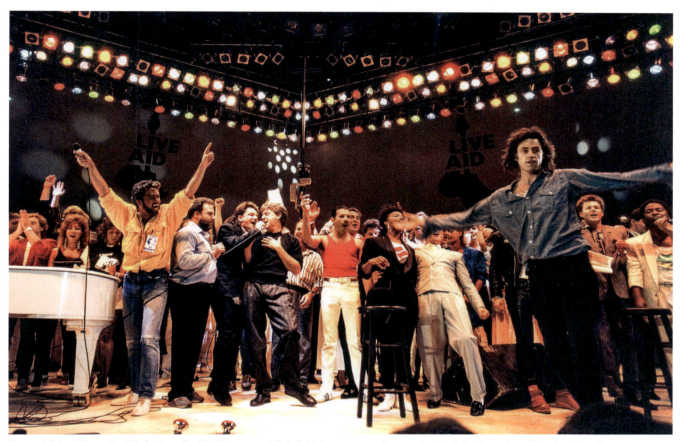

George Michael, Bono, Paul McCartney, Freddie Mercury, and Bob Geldof were among the prominent artists who gathered together to perform "Do They Know It's Christmas?" during the Live Aid finale in London.

stadium effortlessly, and I think it was really his night."[131] After the thunderous conclusion to the song, Freddie reached for his faithful Fender Telecaster and after a few words to the audience began the introduction to "Crazy Little Thing Called Love." The finale is epic, featuring a rockabilly guitar solo led by Brian and supported by Spike Edney's very Jerry Lee Lewis–style piano playing. "The cameras didn't pick it up," bemoaned the keyboard player. With the song finished, the unmistakable rhythm of "We Will Rock You" began. Taken up by the crowd for a verse, a chorus, and a mythmaking solo by Brian May, the song was then interrupted by a few piano notes by Freddie.

Shortly before 7:02 p.m., Freddie Mercury launched into "We Are the Champions." The communion between the musicians and their audience was at its peak, as the images filmed that day clearly show. Proud and amused, Roger Taylor later declared: "I remember looking up and seeing the whole place going completely bonkers in unison, and thinking, 'Oh, it's going well.'"[110] And this was an understatement indeed, because when their set ended with Mercury's phrase "We are the champions of the world," he and his band truly were on top of the world, and had left nothing but crumbs for the other artists present that day—including poor David Bowie, who had to play just minutes later on a stage devastated by hurricane Queen. As Bob Geldof later expressed it, "Queen were absolutely the best band of the day. They played the best, had the best sound, used their time to the full. They understood the idea exactly—that it was a global jukebox...they just went and smashed one hit after another...it was the perfect stage for Freddie: the whole world."[43]

In the space of twenty minutes, Freddie Mercury, Brian May, Roger Taylor, and John Deacon became the masters of the world, and the coming year would bring them a level of recognition that was completely unexpected just a few months before.

QUEEN: ALL THE SONGS 337

1984

Roger Taylor savoring the worldwide success of "Radio Ga Ga."

RADIO GA GA
Roger Taylor / 5:50

Musicians
Freddie Mercury: lead vocals, synthesizers
Brian May: guitar, backing vocals
Roger Taylor: programming, synthesizers, backing vocals
Fred Mandel: synthesizers

Recorded
The Record Plant, Los Angeles: August–October 1983

Technical Team
Producers: Queen, Reinhold Mack
Sound Engineer: Reinhold Mack

Single
Side A: Radio Ga Ga / 5:50
Side B: I Go Crazy / 3:45
UK Release on EMI: January 23, 1984 (ref. 12QUEEN 1)
US Release on Capitol Records: February 7, 1984 (ref. B-5317)
Best UK Chart Ranking: 2
Best US Chart Ranking: 16

Genesis

It took more than ten years for a song written by Roger Taylor to become a hit. But what a hit! The drummer here offers a pop song that was to become a true Queen classic.

Taking up the theme that had made the Buggles such a success with their 1979 hit "Video Killed the Radio Star," Taylor wrote a tribute to that iconic postwar object around which families gathered: the radio set. In lyrics filled with melancholy, the drummer, who owed much of his musical education to the radio, celebrates it for the moments of escape and fantasy that it offered him: *"I'd sit alone and watch your light / My only friend through teenage nights."*

Beyond simple nostalgia, because we know Taylor's taste for modernity and the latest trends, what emanates from "Radio Ga Ga" is Taylor's regret at seeing this precious ally disappear in favor of television, and in particular the almighty American music channel, MTV, which could make and break an artist's career.

As the drummer explained in 1984, "The song is a bit mixed up as far as what I wanted to say. It deals with how important radio used to be, historically speaking, before television, and how important it was to me as a kid. It was the first place I heard rock 'n' roll. I used to hear a lot of Doris Day but a few times each day, I'd also hear a Bill Haley record or an Elvis Presley song. Today it seems that video, the visual side of rock 'n' roll, has become more important than the music itself—too much so, really. I mean, music is supposed to be an experience for the ears more than the eyes."[23]

The enigmatic title of the song was suggested to Taylor by his young son, Felix. The boy's mother, Dominique Beyrand, whom Roger Taylor met at the Hyde Park concert in September 1976 (she was the personal assistant of businessman Richard Branson, who helped Queen obtain the necessary permits for the concert), was French and little Felix Taylor, who was then aged three, spoke French fluently. Taylor tells the story: "One Sunday afternoon, my son Felix came, and he just says, 'Radio caca' ('cause he's half French). I said it sounds quite nice!"[110] Equipped with all sorts of synthesizers, the drummer locked himself away in the studio for three days and then offered his demo to Freddie Mercury. The singer was immediately convinced by the song, whose working title at that point was still "Radio

338 THE WORKS

Caca." Once the song had been reworked and recorded, the vocal lines had to be laid down. The text was then changed to "Radio Ga Ga" on the choruses. But only partially—if you listen, you can hear something else, as Brian May confirmed in 2017: "All we hear is Radio Ca Ca [...] is what we actually sing on the record!"[29]

Production

Equipped with the all-new LinnDrum drum machine, the little sister of the LM-1 used on *Hot Space*, and assisted by Fred Mandel on keyboards, Roger Taylor polished up his new song. By then, the drummer was a huge fan of electronic instruments, which offered him a wide range of possibilities during his preproduction work on the tracks. "These days I find it much easier to write melodically on keyboards because the piano is more geared, I think, for songwriting than any other instrument," he declared. "The guitar is quite a difficult instrument, actually, when you're trying to compose melodically. You have to have all your chords together, and then you need to put something on top. With the keyboards, you can write the whole song right there. So what I've been doing is using a sequencer or something, and keyboards to write material."[23] Frequently used by Queen since *Hot Space*, the synthesizer sound would

1984

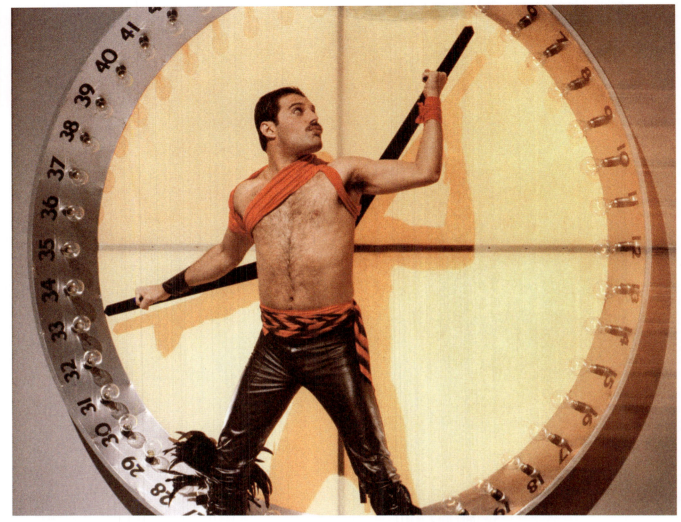

Freddie on the set of the "Radio Ga Ga" music video, directed by David Mallett and with sets inspired by Fritz Lang's movie *Metropolis*.

become Taylor's signature on "Radio Ga Ga." The bass lines of the title were created with the Roland Jupiter-8, and Mercury and Mandel also had fun with another keyboard by the same brand, the VP-330, which they had already featured on "A Human Body" on the *Hot Space* album; its Vocoder function gave the singer's voice a robotic aspect at various points in the song.

A Video with Controversial Symbolism

Released on January 23, 1984, the "Radio Ga Ga" single proved to be a huge hit in the UK, climbing to second place on the charts within two weeks. Paradoxically, playing the MTV game of big-budget music videos, the group accompanied their song with a video shot by David Mallet, the director who had immortalized the nude models racing on bicycles in the "Bicycle Race" video from September 1978.

The video was shot over two days at Shepperton Studios in London, on November 23 and 24, 1983. On the first day, the band was filmed in a futuristic vehicle, Roger Taylor was shown driving with both hands on the control stick, Mercury by his side. May and Deacon as passengers look somewhat lost in the back (a bottle of vodka was hidden in the vehicle to give the amateur actors a little extra courage). These images are mixed with numerous excerpts from Fritz Lang's classic film *Metropolis*, whose visual universe would later inspire the sets for the upcoming "Queen Works! (*The Works* Tour)."

On November 24, 1983, the most legendary scene of the video was shot. "It was a day that nobody who was there will ever forget,"[29] declared Brian May. Five hundred members of Queen's fan club, all dressed in white, were invited to come to Shepperton Studios to cheer on the four

340 THE WORKS

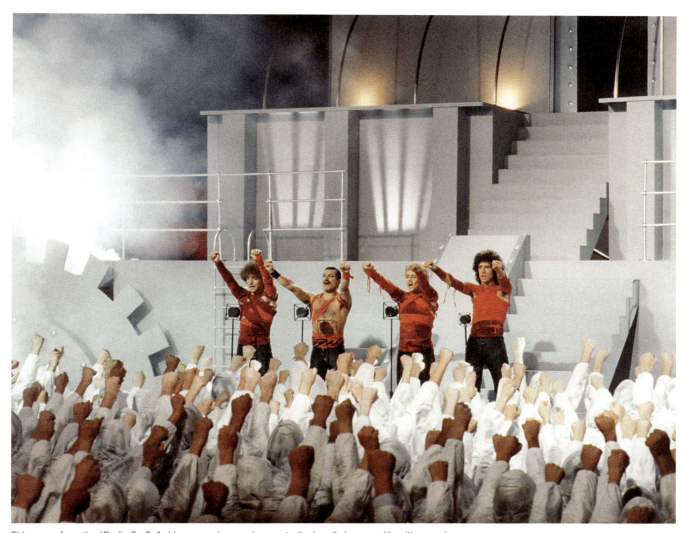
This scene from the "Radio Ga Ga" video caused some damage to the band's image, with critics arguing that it too closely resembled Nazi rallies in the 1930s.

musicians. The British rock critics—who had hated Queen since their debut and who seemed to have few limits when it came to their disdain for the band—were quick to compare the scene to a 1936 Nazi party convention, while Freddie Mercury likened the spectacular gatherings around his band to an Olympic celebration, which was certainly a more flattering comparison.

The result of these two days was a genuine flagship video of the 1980s, in which simply executed choreography, with the participants raising both arms in the air and concluding with two claps of the hands, became a rallying point for Mercury and his friends. The image of the ninety thousand spectators clapping their hands during the Live Aid concert in July 1985, in addition to causing an immediate thrill, sealed forever the figure of Queen in the collective unconscious.

FOR QUEEN ADDICTS

When the young Stefani Joanne Angelina Germanotta began her singing career at the age of twenty, her boyfriend, the producer Rob Fusari, kept calling her Gaga, because the timbre of her voice reminded him of the song by Queen. It was not long before the young woman added the title Lady to her stage name, creating the artist we all know as Lady Gaga.

1984

TEAR IT UP
Brian May / 3:25

Queen onstage performing at the Golden Rose festival in Montreux, Switzerland, on May 12, 1984.

Musicians
Freddie Mercury: lead vocals
Brian May: guitar, backing vocals
Roger Taylor: drums, tambourine, backing vocals
John Deacon: bass
Recorded
The Record Plant, Los Angeles: September–October 1983
Technical Team
Producers: Queen, Reinhold Mack
Sound Engineer: Reinhold Mack

Genesis

Brian May was back in business with this blistering track, which is reminiscent of some of his other compositions, such as "Dragon Attack" or "Fat Bottomed Girls." Indeed, the riff of "Tear It Up" comes from one of the live versions of "Fat Bottomed Girls," during which the guitarist liked to improvise digressions on his main riff. Placed on the album immediately after the single "Radio Ga Ga," the song clearly announces the band's new tone: Queen has abandoned the sound of Munich dance floors, opting instead to let the briefly forsaken Red Special express herself again, and so much the better.

On May 12, 1984, the band took part in the "La Rose d'Or," (Golden Rose) in Montreux. Created in 1961 by the founder of the Eurovision Song Contest, Marcel Bezençon, the Rose d'Or is an international awards festival for entertainment broadcasting and programming. In 1984, it was a major event, broadcast on TV throughout the world, and Queen performed four of their tracks, including the furious "Tear It Up" (they also played "Radio Ga Ga," "It's a Hard Life," and "I Want to Break Free"). But curiously enough, the band played their entire concert in full playback. Mercury seemed lost, forgetting some lyrics and not singing in front of his microphone. The only reason Queen agreed to play under these strictures imposed by the organizers was because of the massive retransmission of the concert, which was being broadcast in forty countries, and was therefore an opportunity the band couldn't miss, especially as they were losing momentum in the spring of 1984.

Production

With "Tear It Up," Brian May succeeded in some heavier-than-ever new sounds, bringing guitar riffs back to the forefront of Queen and squeezing them into Roger Taylor's brutal rhythm. He brought out the full panoply of the guitar hero as we knew it during the '80s, especially in his solo, where tapping featured heavily. It would seem that his collaboration with the master of the genre, Eddie Van Halen, on *Star Fleet Project* led to some truly inspired downstrokes. Queen fans certainly hadn't lost their favorite rock band, and this would soon be confirmed with tracks like "Princes of the Universe" and "I Want It All."

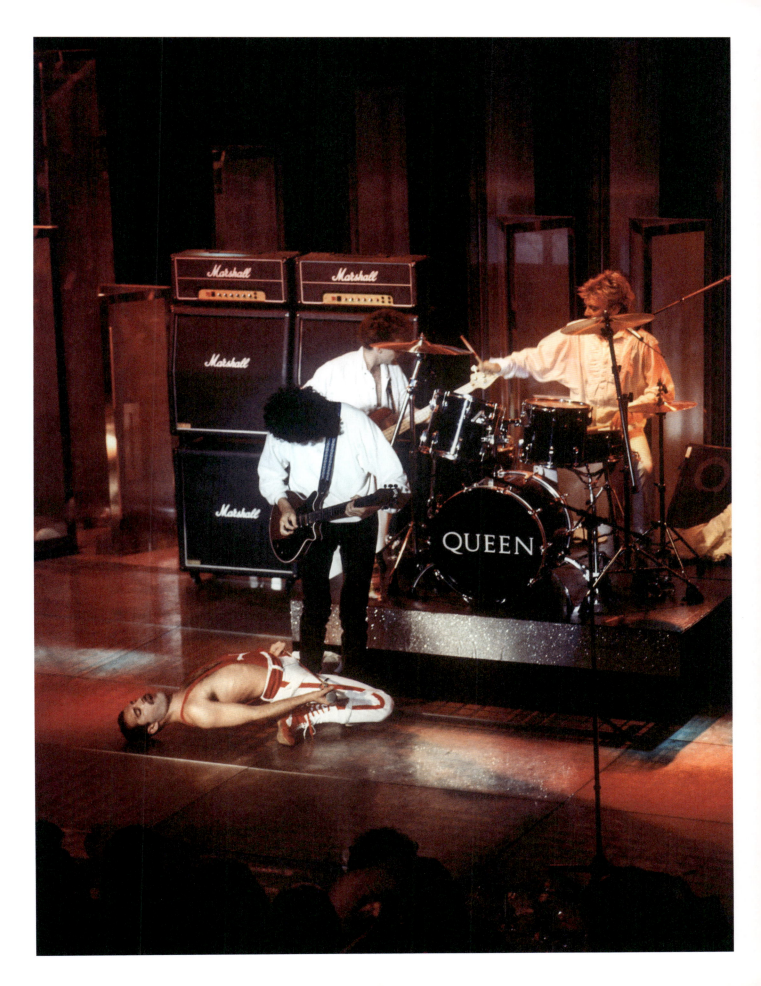

1984

SINGLE

IT'S A HARD LIFE
Freddie Mercury / 4:05

Musicians
Freddie Mercury: lead vocals, backing vocals, piano
Brian May: guitar, backing vocals
Roger Taylor: drums, backing vocals
John Deacon: bass

Recorded
Musicland Studios, Munich: January 1984

Technical Team
Producers: Queen, Reinhold Mack
Sound Engineer: Reinhold Mack
Assistant Sound Engineer: Stephan Wissnet

Single
Side A: It's a Hard Life / 4:05
Side B: Is This the World We Created…? / 2:13
UK Release on EMI: July 16, 1984 (ref. QUEEN 3)
US Release on Capitol Records: July 6, 1984 (ref. B-5372)
Best UK Chart Ranking: 6
Best US Chart Ranking: 72

Genesis

Tired of recounting his sexual exploits in interviews given for the promotion of *Hot Space* or in the texts written for this new album, Mercury returned to a deeper place on this track. The song was created in close collaboration with Brian May, who rediscovered the Freddie he loved: sensitive, in love, and far from the crazy Munich escapades. "Now, 'It's A Hard Life' is one of my favorite Freddie songs ever," May would later reveal, "and we did actually collaborate on some of the lyrics. […] We were looking for the core meaning of the song and were conscious of the fact that it didn't matter what kind of sexuality or love we were talking about; it was about feelings of abandonment and loneliness."[29]

It must be said that since January 1983, Freddie was no longer a free agent. To the surprise of those around him, he had begun a passionate relationship with Austrian actress Barbara Valentin (real name Ursula Ledersteger), whom he had met at a club in Munich. Long nicknamed "the Jayne Mansfield of German cinema" for her performances in films by Rainer Fassbinder and the German-speaking Swiss Helmut Förnbacher, the actress had a passionate love affair with Mercury, characterized by excesses of all kinds. "Barbara was very outrageous. She was the 'queen' of Munich,"[60] as Freddie's friend Peter Straker would later describe her.

"It's a Hard Life" includes lyrics in which the singer proclaims: *"It's a long hard fight / To learn to care for each other / To trust in one another right from the start / When you're in love,"* bearing witness to the sincere love that united the two stars, but also to the turmoil that reigned between these two personalities with powerful characters. "I know my mother was in love with him, 'cause she said so," explained Minki Reichardt, the daughter of Barbara Valentin. "I think their relationship was very close and very intense. They really liked the conflict. They were talking, and shouting, and arguing, and then they were in their arms again."[60]

The actress appears many times in the video for "It's a Hard Life," which was directed by Tim Pope. Shot over two days in Munich in June 1984, the film is the mirror image of the Mercury of the time: torn between exuberance and melancholy. The musicians, dressed in colorful tights and

344 THE WORKS

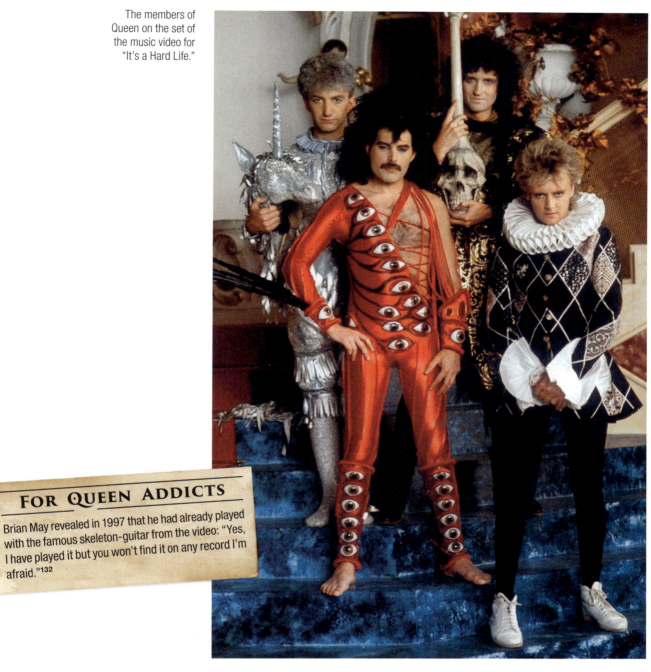

The members of Queen on the set of the music video for "It's a Hard Life."

FOR QUEEN ADDICTS

Brian May revealed in 1997 that he had already played with the famous skeleton-guitar from the video: "Yes, I have played it but you won't find it on any record I'm afraid."[132]

costumes (Deacon carries a unicorn's head in his arms!) are situated in the middle of a baroque setting reminiscent of a Venetian carnival, and they seem lost in the ridiculousness of the situation. May, meanwhile, is equipped with a skeleton-headed guitar, which he proudly brandishes, like Excalibur drawn from the stone. And yet Mercury still manages to be touching, despite the strangely long wig that falls to his rear, and he easily manages to convince, even while parading in this eccentric setting, as the lyrics he is singing are so clearly sincere.

Production

Though "It's a Hard Life" is definitely a successful ballad, as Mercury had the gift for writing them, the most majestic part of the song is undoubtedly its introduction. Built around a powerful chorus that supports Freddie's singing, this introduction is a great success. The star seems to cry out in despair: "*I don't want my freedom / There's no reason for living with a broken heart.*" For this passage, the singer had taken up one of the melodic lines of the very famous aria "Vesti la giubba," written by the Italian composer Ruggero Leoncavallo in 1892 for his opera *Pagliacci*. The rest of the piece is more classical, with Freddie's piano supporting his very melancholy vocal line. The guitar is not far behind, punctuating the refrains with power chords typical of 1980s ballads, and the choruses are reminiscent of Queen's glorious *A Day at the Races* period.

1984

MAN ON THE PROWL

Freddie Mercury / 3:25

Musicians
Freddie Mercury: lead vocals, backing vocals, piano
Brian May: guitar, backing vocals
Roger Taylor: drums
John Deacon: bass
Fred Mandel: piano finale

Recorded
Musicland Studios, Munich: January 1984

Technical Team
Producers: Queen, Reinhold Mack
Sound Engineer: Reinhold Mack
Assistant Sound Engineer: Stephan Wissnet

The influence of Jerry Lee Lewis (pictured) can be felt on the piano solo of "Man on the Prowl," played by Fred Mandel.

Genesis

A new foray into the rockabilly style that had brought enormous success and glory to Queen with "Crazy Little Thing Called Love" in 1980, "Man on the Prowl" unfortunately failed to please due to a strong feeling of déjà vu. Brian Setzer's Stray Cats, whose eponymous debut album was released by Arista in 1981, were undoubtedly the front runners in the leather-jacket-and-quiff category, performing their repertoire with irresistible sincerity and skill. Some of their tracks quickly became classics of the genre, including "Rock This Town" and "Runaway Boys." "Man on the Prowl" was perceived as a pale copy of their style, so in vogue at the time. This seems rather unfair, since Queen had tried their hand at the genre with brio long before the Stray Cats.

Production

Like their earlier hit "Crazy Little Thing Called Love," this track was produced with a *walking bass* provided by John Deacon, and it also featured a very swinging drum rhythm and an omnipresent piano sound that hewed closer to Jerry Lee Lewis than to Fats Domino. The classic piano solo at the end of the song is not Mercury's work, although he does play on the rest of the track. It was Fred Mandel, the keyboard player who joined Queen on the 1982 American tour, who provided this memorable finale, as he explained, "Fred said to me, 'Why don't you take over later and play that rock 'n' roll stuff. You do that better than me. Besides, they will all think it's me, darling!' I didn't care, I was being paid!"[2]

Brian May, as if possessed by the spirit of *The Game*, slaps on a guitar solo that feels a little too inspired by "Crazy Little Thing Called Love" (probably performed once again on the Telecaster, whose bite is unmistakable), while Mercury makes his voice tremble on the choruses, like Elvis Presley during his "All Shook Up" period.

MACHINES (OR "BACK TO HUMANS")

Brian May and Roger Taylor / 5:08

> **ON YOUR HEADPHONES**
> In "Machines (Or 'Back to Humans')," careful listeners can discover samples of older Queen songs, including "Ogre Battle" and "Flash." Your mission, should you choose to accept it, is to discover where in the track the alchemist-producer Mack has hidden the samples.

Musicians
Freddie Mercury: lead vocals, backing vocals, synthesizers
Brian May: guitar, backing vocals
Roger Taylor: drums, electronic drums, programming, synthesizers
John Deacon: bass
Reinhold Mack: synthesizers

Recorded
Musicland Studios, Munich: January 1984

Technical Team
Producers: Queen, Reinhold Mack
Sound Engineer: Reinhold Mack
Assistant Sound Engineer: Stephan Wissnet

Genesis

The duo of Roger Taylor and Brian May made a big impact with this experimental track, whose introduction opened each concert of their "Queen Works! (*The Works* Tour)." At the back of the set were giant gears, once again inspired by Fritz Lang's classic movie *Metropolis*. The stage set for the *Works* tour was meant to convey the war between man and machines, as Brian May explains: "A lot of the new album *The Works* is a synthesis of the two kinds, almost a battle [...] between machines and humans."[133] It must be remembered that for the two friends, who have been passionate about science fiction since childhood, the use of new technologies was a fantasy that could finally come true. The battle rages when, at 1:29, drums and guitars take the stage, taking precedence over the electronic instruments. Roger Taylor says, "['Machines (Or "Back to Humans")'] starts off where everything's electronic [...] and what you have is the 'human' rock band sort of crashing in. What you wind up with is a battle between the two."[23]

Production

If "Machines (Or 'Back to Humans')" was a curiosity on this album, which otherwise consisted of back-to-back hits, it's because the track's production was the result of a high-tech instrument wielded by the album's co-producer, Reinhold Mack. This instrument was the brand new Fairlight CMI synthesizer-sampler, whose main characteristic, revolutionary for the time, was the recording and processing of samples. Equipped with a keyboard, a computer screen, and a microphone, the instrument allowed the recording and processing of sound or musical excerpts, which could then be modified at will and reinjected into new compositions. This process was widely used over the following decade, especially with the advent of cheaper machines such as the MPC series from Japanese brand Akai.

Freddie overlooking Roger Taylor's gleaming Ludwig Chrome-O-Wood drums, which were used on both the *Hot Space* and *The Works* tours.

1984

SINGLE

I WANT TO BREAK FREE
John Deacon / 3:19

Musicians
Freddie Mercury: lead vocals, backing vocals, synthesizers
Brian May: electric guitar
Roger Taylor: drums
John Deacon: bass, electric guitar, synthesizers, programming
Fred Mandel: synthesizer

Recorded
The Record Plant, Los Angeles: September–October 1983

Technical Team
Producers: Queen, Reinhold Mack
Sound Engineer: Reinhold Mack

Single
Side A: I Want to Break Free (Single Mix) / 4:21
Side B: Machines (Or "Back to Humans") / 5:08
UK Release on EMI: April 2, 1984 (ref. QUEEN 2)
US Release on Capitol Records: April 13, 1984 (ref. B-5350)
Best UK Chart Ranking: 3
Best US Chart Ranking: 45

Genesis

The second single from *The Works*, "I Want to Break Free" is undoubtedly one of the band's most beloved and emblematic songs. Written by John Deacon—"Queen's Secret Weapon," as keyboard player Fred Mandel nicknamed him—it was an immediate success when it was released in the United Kingdom. The melody is unstoppable, offering up a catchy rhythm coupled with a modern, polished production. The trail blazed with the hit "Radio Ga Ga" enabled this song to touch the audience, who were delighted to find their idols returning to form after the sound experiments of *Hot Space*. This represented yet another success for the bassist, who wrote songs that were known for their efficiency and for the often naive messages they conveyed (the love-friendship of "You're My Best Friend" or the summer love affair of "In Only Seven Days," for example). Deacon worked alone on this track before offering it to the other musicians. He played guitars and synthesizers himself and was only occasionally accompanied by keyboard player Fred Mandel.

Production

It's the all-new LinnDrum drum machine that marks the beat on "I Want to Break Free," followed by Deacon's 1981 Fender Precision Special bass. Brian May plays discreetly on the song, accompanying the introduction and the power chord choruses that he lets ring out in the great tradition of the heavy tracks of the 1980s.

While the song is a masterpiece in the "FM hit" category, and it is celebrated for the quality of its melody and Mercury's vocal interpretation, the major keystone of this hit is undoubtedly its solo. The subject of endless debate on fan forums and a source of errors on the internet pages of many budding journalists, many have questioned whether this sound was the result of an effect pedal used by Brian May. If so, which one? The real answer lies elsewhere...One night at the Record Plant in Los Angeles, while Taylor, May, and Mercury were out, John Deacon and Mack decided to continue working on the song. "It was pretty much there, and there was this big hole in the middle,"[110] recalls the producer. Taking advantage of Brian May's absence, John asked Fred Mandel to try something on the Roland Jupiter-8

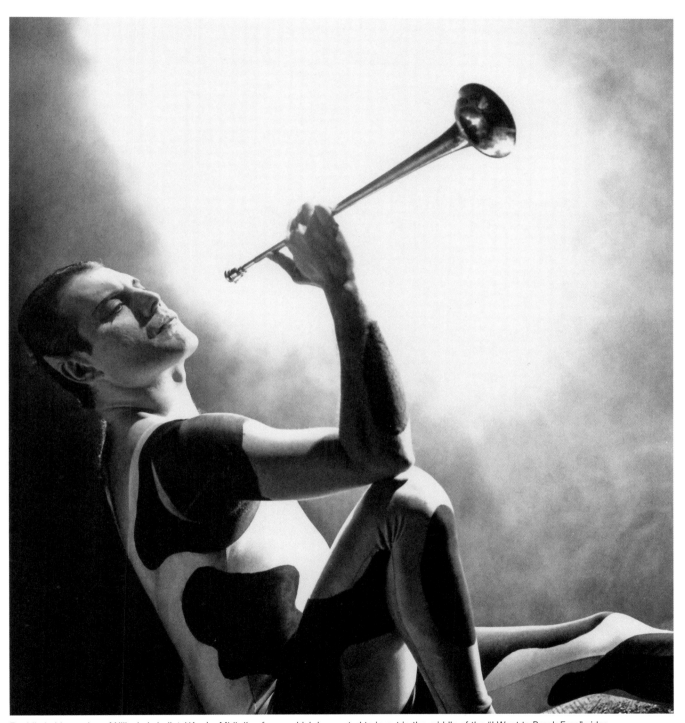
Freddie in his version of Nijinsky's ballet *L'Après-Midi d'un faune*, which he wanted to insert in the middle of the "I Want to Break Free" video.

1984

The members of Queen adjust their slippers and garter belts between takes from the "I Want to Break Free" video.

FOR QUEEN ADDICTS

Several years after recording the keyboard solo for "I Want to Break Free," Fred Mandel tried out a new Roland synthesizer as a musical instrument. It was equipped with a "May Sound" button that was supposed to reproduce the guitar sound of the famous solo. The Japanese brand was apparently unaware that the sound came from one of its own keyboards, and not from May's Red Special!

synthesizer, of which the band was growing increasingly fond. "This was controversial, as no one did solos apart from Brian," recalls Mandel. "But the band were out to dinner, so I did it."[2] Back at the studio, Brian May discovered the keyboard part Mandel had done to perfection, with breathtaking precision and grace. As the guitarist later admitted, "I wasn't too happy at the time, but I gave them my blessing."[110]

The Video

It was Roger Taylor who came up with the idea for the video for "I Want to Break Free." The idea was to paint a typical portrait of the average London family by caricaturing the hit British television series, *Coronation Street*. "Frankly we were stuck for ideas for 'Break Free,' we just couldn't get it worked out,"[134] remembers the video's director, David Mallet, who had already directed the videos for "Radio Ga Ga" and "Bicycle Race." "And Roger arrived late, having been stuck in traffic, to this meeting. And Roger walked straight in and said: I know what we've got to do. The Stones have done it, now we're gonna do it, we're gonna do it in drag!"[134] The main part of the video was shot over three days at Limehouse Studios in London in March 1984. Everyone was in drag: Roger Taylor as a young teenager, Brian May as a badly awoken mother with curlers on her head, and John Deacon as a grumpy grandmother. Naturally, Freddie Mercury didn't miss out on the fun, appearing as a scantily clad young lady, with stockings and a garter belt barely concealed under a tiny leather miniskirt as he vacuumed the living room where the other characters were sitting. The director recalls: "Fred [...] said, 'Of course, I'm gonna shave off my moustache, darling!' And I said no! The one thing you mustn't do! The funny thing is that your moustache is there, and you're in drag!"[134]

The domestic scenes were interspersed with excerpts from the ballet *L'Après-Midi d'un faune* (created in 1912 at the Théâtre du Châtelet in Paris by Vaslav Nijinski), performed by Freddie and the dancers of the London Royal Ballet. This time, Mercury shaved off his mustache.

The video was a resounding success with audiences in the United Kingdom, especially thanks to the humor of the domestic drag sequence. "We had done some really serious, epic videos in the past," Roger Taylor would later recall, "and we just thought we'd have some fun. We wanted people to know that we didn't take ourselves too seriously, that we could still laugh at ourselves. I think we proved that."[135]

The video was received very differently in the United States, however, with American audiences shocked by the musicians' appearance in drag. They simply weren't ready for the image of their idols dressed up in this manner. MTV censored the video, and the song floundered at forty-fifth place on the American charts. As Brian May recalled in 2010, "I remember being on the promo tour in the Midwest of America and people's faces turning ashen and they would say, no, we can't play this. We can't possibly play this. You know, it looks homosexual."[136] So while "I Want to Break Free" was becoming a worldwide hit, the American market was shutting out Queen because of a video they deemed scandalous.

350 THE WORKS

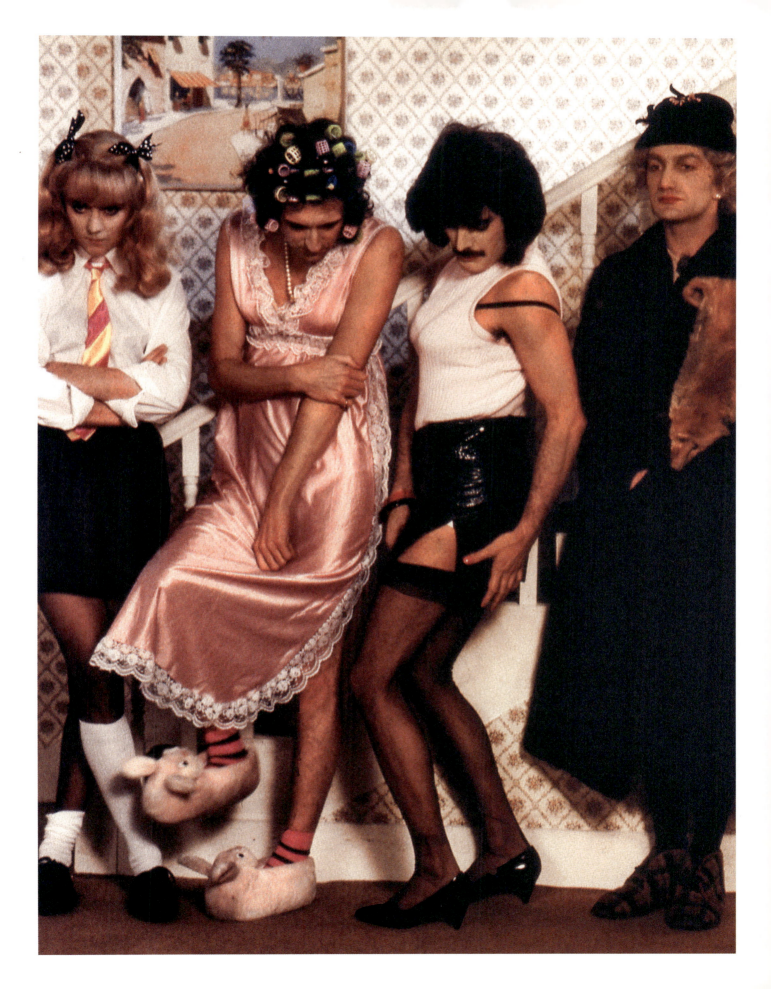

1984

KEEP PASSING THE OPEN WINDOWS
Freddie Mercury / 5:21

Musicians
Freddie Mercury: lead vocals, backing vocals, piano, synthesizer
Brian May: guitar, backing vocals
Roger Taylor: drums, backing vocals
John Deacon: bass

Recorded
The Record Plant, Los Angeles: September 1983
Musicland Studios, Munich: January 1984

Technical Team
Producers: Queen, Reinhold Mack
Sound Engineer: Reinhold Mack
Assistant Sound Engineer: Stephan Wissnet

John Irving, author of the novel *The Hotel New Hampshire*, which inspired the song "Keep Passing the Open Windows."

Genesis

In the summer of 1983, director Tony Richardson asked the members of Queen to compose the soundtrack for a big-screen adaptation of John Irving's novel *The Hotel New Hampshire*, which had been published two years earlier. They all met at the Record Plant in Los Angeles to discuss the idea, but Richardson was eventually forced to abandon the idea, as his budget would not allow him to use band's services.

Freddie wrote this song during the few weeks that the musicians took to consider their participation in the film. The title was directly inspired by the Canadian novelist's text (Irving was born in the United States but became a Canadian citizen in 2019). "*Keep passing the open windows*" is a mantra that the characters repeat throughout the novel. Irving explained the meaning of this mantra during an appearance on the French television program *La Grande Librairie* in 2016: "'You have to keep passing the open windows.' That's the last sentence of *The Hotel New Hampshire*, my fifth novel. And it's a way of saying, 'Don't kill yourself.' It's an antisuicide sentence. Because the youngest daughter in the family, one of three of my characters, who imagines she can see the future, Lily, she jumps out a window because of what she imagines is her future. And so, the family who have lost her develops this way of speaking to each other as a way of lifting their hearts and keeping them from killing themselves. You have to keep passing the open windows. You have to walk by."[137] Like John Irving in his book, Mercury's song is clearly one of hope: "*You keep telling yourself it's gonna be the end / Get yourself together / Things are looking better every day.*"

Production

Absolutely unmistakable thanks to its piano gimmick taken up by the singing on the choruses, "Keep Passing the Open Windows" has an introduction that's perfectly designed for the beginning of a film. Freddie Mercury, who read John Irving's novel with great care, as we can tell from his lyrics, put a huge amount of effort into writing this track.

The drumbeats, mixed with Brian May's powerful guitars at 0:40, are reminiscent of the power chords played by

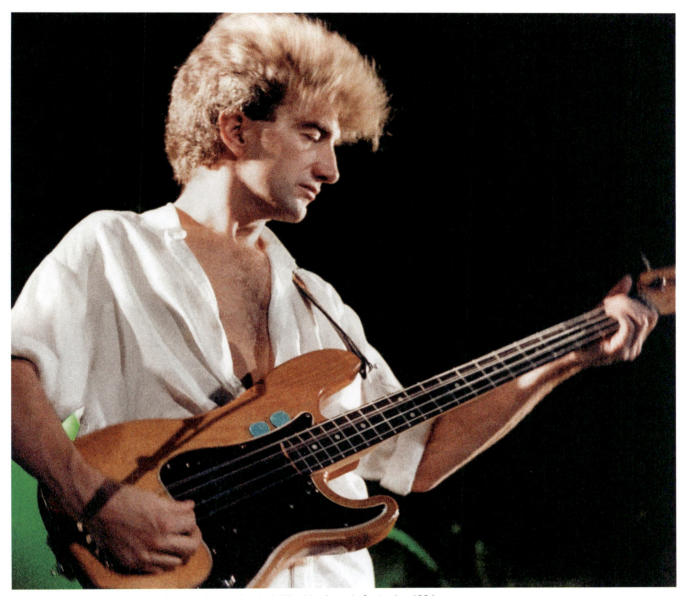

John Deacon and his trusty Fender Precision bass at London's Wembley Arena in September 1984.

the guitarist on the songs "Flash's Theme" and "The Hero" for the 1980 *Flash Gordon* soundtrack. This gives these three songs a very cinematic feel. We also find this way of marking the guitar chords in the song "Eye of the Tiger," performed in 1982 by the band Survivor for the movie *Rocky III*, which was written and directed by Sylvester Stallone. There are formulas in music that work, especially when composing for the movies!

John Deacon's bass line, from 0:21, announces another extremely famous Queen gimmick: the phrase "*It's a kind of magic*," which is repeated many times in the introduction of the song of the same name on the band's next album. "Keep Passing the Open Windows" is a very good pop song, which effectively reminds the listener that Queen always knows how to offer excellent compositions, even without relying excessively on synthesizers and drum machines.

1984

HAMMER TO FALL
Brian May / 4:25

> "Hammer to Fall" is one of the highlights of the Live Aid concert, and it was the third song in Queen's set.

Musicians
Freddie Mercury: lead vocals, backing vocals
Brian May: guitars, backing vocals
Roger Taylor: drums, backing vocals
John Deacon: bass
Fred Mandel: synthesizer

Recorded
Musicland Studios, Munich: January 1984

Technical Team
Producers: Queen, Reinhold Mack
Sound Engineer: Reinhold Mack
Assistant Sound Engineer: Stephan Wissnet

Single
Side A: Hammer to Fall (The Headbanger's Mix Edit) / 3:40
Side B: Tear It Up / 3:25
UK Release on EMI: September 10, 1984 (ref. QUEEN 4)
US Release on Capitol Records: October 12, 1984 (ref. B-5424)
Best UK Chart Ranking: 13
Best US Chart Ranking: Not Ranked

FOR QUEEN ADDICTS

Initially, the cover for the "Hammer to Fall" single bore a photograph of the band on stage. Brian May strongly opposed the release of this photo, fearing that buyers would believe that the single was a live version of the track. The single was withdrawn from sale at the last minute and replaced by a version with a plain red cover. The original edition of this single is now highly sought after by collectors!

In 1986, while recording several songs for Russell Mulcahy's film *Highlander*, Queen managed to discreetly slip "Hammer to Fall" into a scene from the film. We hear it at 1:17, on the Pontiac Firebird's car radio as it drives through New York.

Genesis
"Hammer to Fall" is a transition track. Written by Brian May, it is a hard rock song of the kind the band would offer two years later on their album *A Kind of Magic*. There are no more drum machines here and no more synth bass. All the members of Queen are present, each behind his instrument, and the result is a powerful track, worthy of the great rock anthems of the '80s.

The lyrics of "Hammer to Fall" make reference to the nuclear threat that was omnipresent during Brian May's childhood. Like all baby boomers, the guitarist lived through the Cold War years, punctuated by strong ideological tensions between the Soviet Union and the United States, and boiling over occasionally into events that would threaten world peace, such as the Cuban missile crisis in October 1962. This text served as an outlet for the tormented Brian May, who often took advantage of his songs to convey humanist messages ("The Prophet's Song" and "White Man" are just two other examples).

The fourth and final single off of *The Works*, "Hammer to Fall" met with modest success in the UK and did not make it onto the American billboard charts, as audiences in the United States had turned away from the band after the scandalous "I Want to Break Free."

Production
Brian May presents a powerful riff right from the intro, erasing in the process the scars left by the *Hot Space* album, whose sound experimentations already seem to have been left far behind. "I'm just like a little boy with the guitar," the guitarist explained, "I just like the fat, loud sound of it."[5] This goal was certainly achieved by May, who was back in his zone, making the Red Special roar with big bends and furious harmonics reminiscent of Kirk Hammett's lashing solos for the thrash metal band Metallica.

The harmonized backing vocals of May and Taylor appear from 0:30, in the first chorus, and Fred Mandel adds discreet synthesizer touches on the track, in no way detracting from its heavy rock aspect. The song was a real success, which would be celebrated by more than one hundred thousand spectators at Live Aid in July 1985, swayed by this unifying anthem. This is without a doubt one of the most outstanding tracks from Queen's Synth Era.

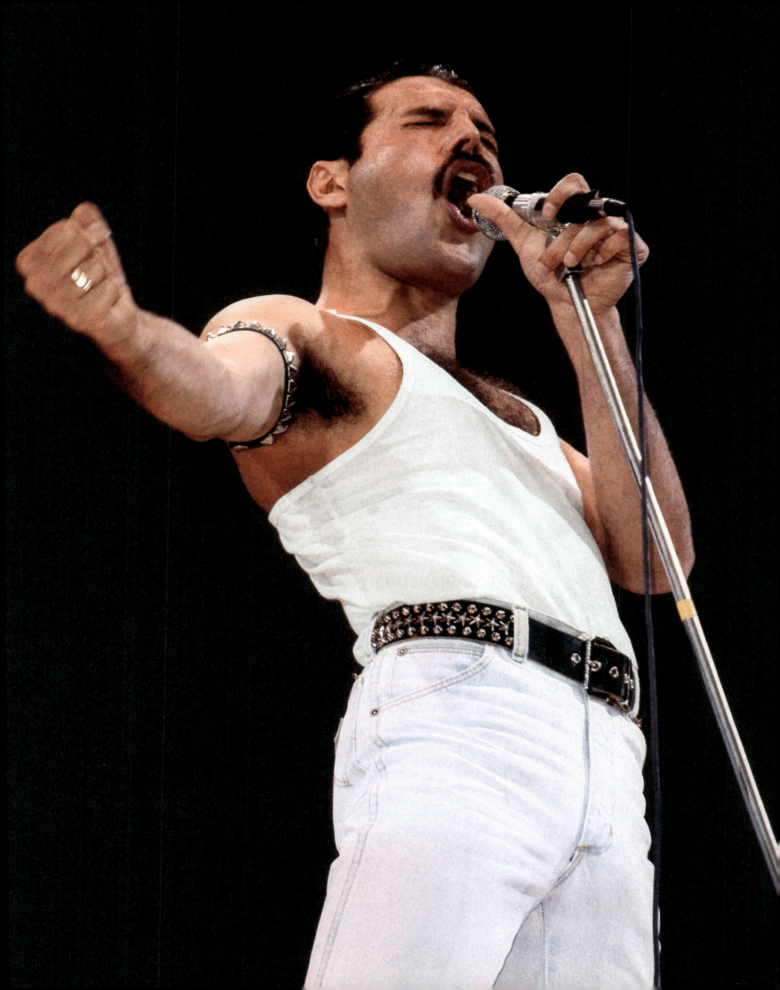

IS THIS THE WORLD WE CREATED...?

Brian May and Freddie Mercury / 2:13

Musicians
Freddie Mercury: lead vocals
Brian May: acoustic guitar
Recorded
Musicland Studios, Munich: January 1984
Technical Team
Producers: Queen, Reinhold Mack
Sound Engineer: Reinhold Mack
Assistant Sound Engineer: Stephan Wissnet

Genesis

Queen wished to end *The Works* with a calmer track to counterbalance the album's earlier, raging tracks such as "Tear It Up" and "Hammer to Fall." "There Must Be More to Life Than This" was demoed during the sessions with Michael Jackson in the summer of 1983 before being set aside for Freddie's solo album. Different options were then explored, with Mercury and May finally deciding to write a song together that would be worthy of "Love of My Life" and its poignant melody, and that the two of them could perform with guitar and voice during concerts, thus delivering a quality interlude.

The images of the famine in Africa inspired the two musicians to write a song with lyrics that are touching both in terms of their naiveté and their sincerity: "*Just look at all those hungry mouths we have to feed / Take a look at all the suffering we breed*," sings Mercury. "I like the way we approached that song," he would later reveal. "We were looking at all the songs we had on the album and we thought that the one thing we didn't have, was one of those real limpid ballads—the lilting 'Love of My Life' type thing. And rather than one of us going back and thinking of one, I just said to Brian, 'Why don't we just think of something right here?' and that song just evolved in about two days. He got an acoustic guitar and I sat next to him, and we worked it out together."[95]

Production

Mercury recorded a piano score that was ultimately removed from the mix in favor of a more refined version. The track is thus immortalized simply thanks to the Ovation Pacemaker 1615 guitar, which had already been used on "Love of My Life." However, when played on stage, Brian May more frequently used a Chet Atkins CE model Gibson electro-classical guitar with a cutout.

The long reverb added to Freddie's clear and powerful voice gives this ballad a less timeless aspect than that of "Love of My Life" (the effect giving the song a very 1980s tone), and it undoubtedly inspired many subsequent famous melodies, including the gentle and delicate "More Than Words" by the band Extreme, whose writers, Gary Cherone and Nuno Bettencourt, have always expressed their great admiration for Queen.

One month before Mercury and May played "Is This the World We Created…?" during the Live Aid finale in July 1985, the song appeared on the *Greenpeace—The Album* compilation, alongside tracks by Peter Gabriel, Kate Bush, and Eurythmics.

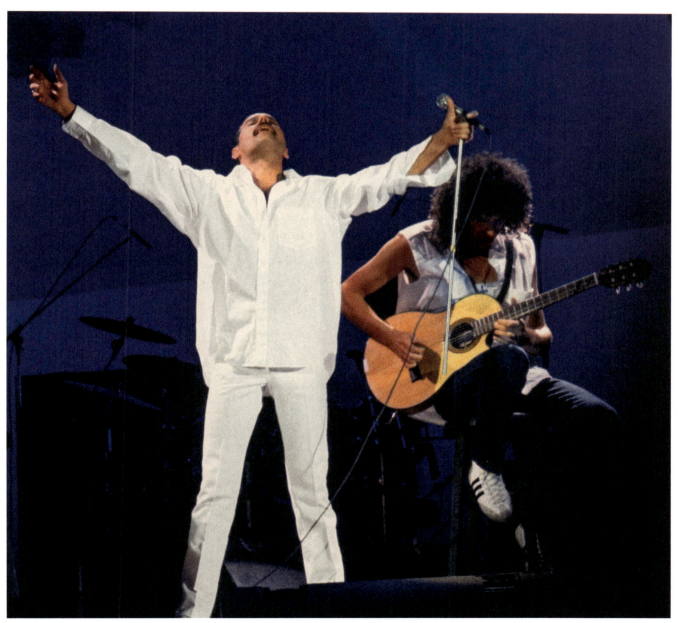

Freddie and Brian return to the stage to perform "Is This the World We Created...?" at the end of Live Aid on July 13, 1985.

OUTTAKES

I GO CRAZY
Brian May / 3:42

Musicians
Freddie Mercury: lead vocals, backing vocals
Brian May: guitar, backing vocals, bass
Roger Taylor: drums, percussion, backing vocals
John Deacon: bass

Recorded
Mountain Studios, Montreux: July 1981
The Record Plant, Los Angeles: August–October 1983
Musicland Studios, Munich: October–November 1983

Technical Team
Producers: Queen, Reinhold Mack
Sound Engineer: Reinhold Mack
Assistant Sound Engineers: David Richards (Mountain Studios), Michael Beiriger, Edward Delena

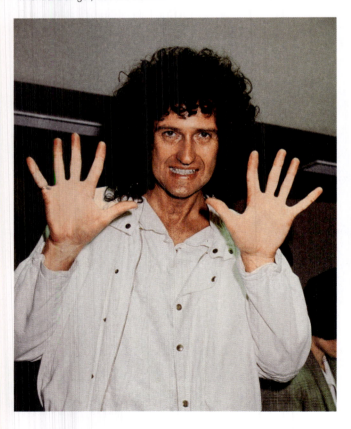

Genesis

During the inevitable selection process necessitated by the overflowing creativity of the four musicians, each band member had to be able to deal with the rejection of tracks that they personally liked. For Brian May, who had already been turned down for the release of "Let Me in Your Heart Again" on *The Works*, his colleagues' extremely negative reaction to his track "I Go Crazy" was frustrating, to say the least. He expressed how he felt about this rejection in the columns of *Faces Magazine* in 1984: "With this last album, now, I wrote a single, you might call it one of my heavy indulgences. It was very rough and raw, but I really liked the sound. The other three hated it so much they were ashamed to play it. So, it wound up as the B-side on 'Radio Ga Ga,' which is good as it gives the fans a song they didn't receive on the album, more for their money."[138] But democracy reigned within Queen, and as always, if there was any doubt, the song was put to a vote. "But you see, it was kept off the album by the majority,"[138] explained the guitarist, who accepted defeat with good grace.

Production

With a guitar rhythm that seems to be borrowed straight from Australian rock band AC/DC, "I Go Crazy" is a blues track on which Brian May's Red Special reigns supreme—even though we don't really recognize its usual sound; indeed, you could easily think you were listening to Angus Young's Gibson SG.

Initially recorded as an instrumental version at the time of *Hot Space*, the song was later rerecorded on tape in 1983 during the working sessions of the new album. Again, it was Greg Brooks, Queen's official archivist, who presented this original version of the song at a fan convention in 2006. When listening to "I Go Crazy," it's certainly true that it's difficult to imagine where the song could have fit onto *The Works*. Its spontaneity is seductive and reminiscent of another song rejected by the band, "See What a Fool I've Been," but the track's jam session–like sound doesn't place it on the same level as the other tracks on *The Works*.

Brian May good-naturedly accepted the rejection of his blues-rock song "I Go Crazy" from the original track listing of *The Works*.

LET ME IN YOUR HEART AGAIN

Brian May / 4:31

Musicians
Freddie Mercury: lead vocals, backing vocals
Brian May: electric guitar, backing vocals
Roger Taylor: drums, percussion, backing vocals
John Deacon: bass
Fred Mandel: piano

Recorded
The Record Plant, Los Angeles: August–October 1983
Musicland Studios, Munich: January 1984

Technical Team
Producers: Queen, Reinhold Mack
Sound Engineer: Reinhold Mack
Assistant Sound Engineers: Michael Beiriger, Edward Delena

Genesis

Stemming from the recording sessions for the album *The Works* in 1983, the track "Let Me in Your Heart Again" was not completed at the time. In 1988, the song's creator, Brian May, offered the track to the actress Anita Dobson for her album *Talking of Love*. No one can be sure whether it was the words of love that the song contained, or the melancholy that emerged from it that seduced her, but in 2000, Anita married the famous guitarist. It was Greg Brooks, Queen's official archivist, who discovered the original version of the song on a tape from the Record Plant dated September 22, 1983, on which "Master Reel II" was handwritten. The song appeared on the *Queen Forever* compilation album in November 2014, after being previewed on the BBC's *Chris Evans Breakfast Show* in September of the same year.

Production

The track's production does nothing to hide its "100 percent 1983" origins, and its arrangements certainly don't deceive the listener. We easily recognize the power of the rhythms provided by Deacon and Taylor, as well as the repeated bends—to our great delight—of Brian May on guitar.

Mercury's performance is far more moving than Anita Dobson's. He plays with the phrases and transforms the melody as he pleases, just as he did so brilliantly on "Spread Your Wings" and "It's Late." The backing vocals, provided by May and Taylor, underline the fact that this ballad is indeed 100 percent Queen.

In December 2014, a remix of the beautiful "Let Me in Your Heart Again" was created by British producer William Orbit for World AIDS Day. While the intention was unquestionably laudable, this version does nothing for the song, which it distorts by covering it with a veil of synthetic sounds.

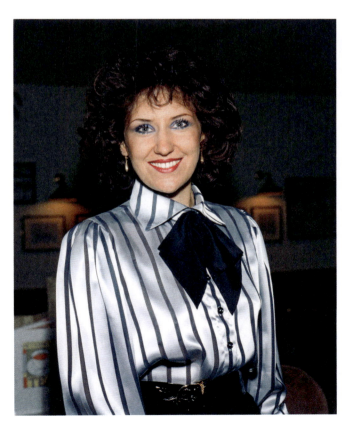

Anita Dobson, famous British actress and Brian May's new muse, would record her own version of "Let Me in Your Heart Again" in 1988.

QUEEN: ALL THE SONGS 359

OUTTAKES

THERE MUST BE MORE TO LIFE THAN THIS
Freddie Mercury / 3:27

Musicians
Michael Jackson: lead vocals
Freddie Mercury: lead vocals, piano
Brian May: electric guitar
Roger Taylor: drums, percussion
John Deacon: bass
William Orbit: synthesizers

Recorded
Michael Jackson's studio in Encino, Los Angeles (voice of Michael Jackson): Summer 1983
Musicland Studios, Munich: August 1983

Technical Team
Encino
Producer: William Orbit
Sound Engineer: William Orbit
Assistant Sound Engineers: Brent Averill, Justin Shirley-Smith, Joshua J. Macrae, Kris Fredriksson

Musicland Studios
Producer: Reinhold Mack
Sound Engineer: Reinhold Mack
Assistant Sound Engineer: Stephan Wissnet

> Freddie recorded all the sessions for "There Must Be More to Life Than This" with his boots and white jeans covered in mud, as Michael Jackson had introduced Freddie to his llamas in their enclosure, forcing the singer to tiptoe out to save what was left of his outfit!

Genesis

Since 1980, Queen and Michael Jackson had been meeting regularly at each of the band's concerts in California, where the famous star and creator of *Thriller* lived. "When I was spending some time in LA, we were friends, and he said, 'Why don't we try something?'"[139] explained Freddie Mercury. During the summer of 1983, Freddie accepted Michael Jackson's invitation and met him at the recording studios on Jackson's property in Encino. They worked on three songs together: "State of Shock," written by the King of Pop, which he eventually set aside for a duet with Mick Jagger on the Jacksons' *Victory* album, which would remain locked up in the drawers of Michael's heirs; and lastly "There Must Be More to Life Than This," written by Freddie Mercury as a sweet ballad with a message of peace and brotherhood, reminiscent of those found in the American star's repertoire (we're reminded of "Heal the World" or "Earth Song").

Production

The recording sessions lasted for only a few hours. As there were no other musicians present that day, the two stars' only working tools were a piano and their divine voices. A few lines of vocals were laid down on tape, accompanying a makeshift melody, and the adventure ended there, as Jackson and Mercury had no more time available to devote to the project. There are few traces left of that day. In an interview, Freddie Mercury attempted, with obvious embarrassment and regret, to explain why they had abandoned such a promising project: "He has commitments, I have commitments, and it's very difficult...I mean he's on tour, I'm going on tour and you got a sort of...You know, it's very difficult when two different musicians try to get together...He has to do his stuff."[139]

While the two men's schedules might not have allowed them to work together for longer, other reasons also appear to have shortened their collaboration. Journalist David Wigg, who was close to Mercury, suggested that the presence of Bubbles, Jackson's chimpanzee, made the Queen's singer very uncomfortable: "Michael made Bubbles sit between them and would turn to the chimp between takes and ask, 'Don't you think that was lovely?' or, 'Do you think we should do that again?'"[140] Legend has it that Mercury

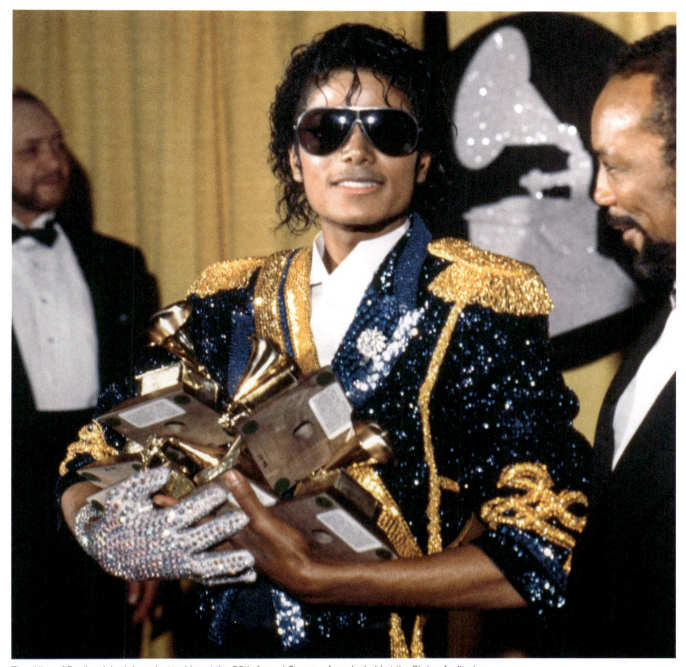

The "King of Pop" weighed down by trophies at the 26th Annual Grammy Awards, held at the Shrine Auditorium in Los Angeles on February 28, 1984.

called his personal manager, Paul Prenter, and ordered him to come and get him: "Get me out of this zoo!"[140] True or false, the anecdote at least confirms the extravagance of the two superstars.

Freddie Mercury finally included "There Must Be More to Life Than This" on his first solo album, *Mr. Bad Guy* (1985), in a refined and delicate version with discreet arrangements. The song was also revisited by Queen for their *Queen Forever* compilation album in 2014. With the agreement of the Jackson clan, the extraordinary meeting of two geniuses finally came to life through this simple track.

> While working on *Victory* with Michael Jackson, Mercury wasn't satisfied with the sound of the drum machine. He then asked his assistant, Peter Freestone—the only person present with the two stars at the time—to set the rhythm with…the bathroom door, whose sound he preferred!

SINGLE

THANK GOD IT'S CHRISTMAS
Brian May, Roger Taylor / 4:19

Musicians
Freddie Mercury: lead vocals, backing vocals
Brian May: guitar, synthesizers, backing vocals
Roger Taylor: drums, programming, bells, synthesizer
John Deacon: bass

Recorded
Sarm East Studios, London: July 1984
Musicland Studios, Munich: July 1984

Technical Team
Producers: Queen, Reinhold Mack
Sound Engineer: Feinhold Mack

Single
Side A: Thank God It's Christmas / 4:19
Side B: Man on the Prowl / 3:25;
 Keep Passing the Open Windows / 5:21
UK Release on EMI: November 26, 1984 (ref. QUEEN 5)
US Release on Capitol Records: November 27, 1984 (ref. V-8622)
Best UK Chart Ranking: 21
Best US Chart Ranking: Not Ranked

Genesis

It was in the purest Anglo-Saxon tradition that Brian May and Roger Taylor decided to work on a Christmas song in the summer of 1984. "The funny thing is that you have to make Christmas records in the summer, and you just don't feel like it," explained the guitarist. "'Cause if you start making them at Christmas, obviously it's all over before you've got it out."[5]

Each of them then put forward a song. Brian's song, "I Dream of Christmas," didn't appeal to the drummer and ended up on the 1988 album *Talking of Love* by actress Anita Dobson, for which May also wrote further tracks. Roger's song seemed more timely, with a real Christmas melody. With the right arrangements, it would do the trick.

The song received a lukewarm reception when it was released on November 26, 1984, then was totally eclipsed by the incredible success of "Do They Know It's Christmas" by Band Aid, the collective of musicians gathered around Bob Geldof to raise funds to fight famine in Ethiopia. Rejected from the project because of their concerts in Sun City (the group had given ten concerts in the temple of white supremacy and apartheid in October 1984), Queen was doubly humiliated by the failure of their Christmas song.

Production

The song was recorded in July 1984 in London, just before the band's European tour. Featuring a straight rhythm led by the LinnDrum drum machine that Taylor seems to have adopted, it perfectly showcases Mercury's voice, probably recorded at Musicland Studios during a second session. The layers of synthesizers are much stronger than the guitars, which gives the track a very cold aspect, narrowly compensated for by a production adapted to the Christmas period, including the the tinkling of jingle bells.

If the profits had been donated to charity, the track might have had a different fate, but unfortunately this was not the case, and faced with the astonishing success of the Band Aid single, "Thank God It's Christmas" sadly comes in a poor second.

Bob Geldof, the lead singer of the Boomtown Rats, was behind 1984's "Feed the World" campaign, which raised funds for famine relief in Ethiopia.

ALBUM

A KIND OF MAGIC

One Vision . A Kind of Magic . One Year of Love . Pain Is So Close to Pleasure .
Friends Will Be Friends . Who Wants to Live Forever . Gimme the Prize (Kurgan's Theme) .
Don't Lose Your Head . Princes of the Universe

RELEASE DATES
United Kingdom: June 2, 1986
Reference: EMI—EU 3509
United States: June 3, 1986
Reference: Capitol Records—SMAS 12476
Best UK Chart Ranking: 1
Best US Chart Ranking: 46

In 1986 everything seemed to be going right for Queen, who were riding high after their successful appearance at Live Aid.

MEETING ON THE SUMMIT BETWEEN QUEEN AND HIGHLANDER

Live Aid had a considerable impact on Queen's career. While the group was experiencing a downturn and rumors of a separation abounded, the four musicians emerged stronger after that crazy day on July 13, 1985, when they gave a live performance that was to become legendary. Between the month of July 1985 and the end of the "Magic Tour" in August 1986, Queen reigned supreme over the international rock scene, with the exception, of course, of the United States, where the group had fallen off the radar.

In August 1985, Freddie and his partner, Jim Hutton, flew off to Ibiza for a well-deserved holiday. Meanwhile, John Deacon and Roger Taylor were involved in recording the number "Too Young" by Elton John. The bassist recorded some bass parts and the drummer provided a straight but assured rhythm for this ballad, which appeared on the album *Ice on Fire* by the singer with a thousand pairs of glasses. Taylor then went to the Mountain Studios in Montreux to work with sound engineer David Richards on the first disc by the band Virginia Wolf, Jason Bonham's group. (Bonham is the son of John Bonham, the Led Zeppelin drummer who died in 1980.)

In September, when they had sworn to take a rest, Mercury, May, and Taylor joined up to work on a new number. Soon they were united with Deacon, who had cut short his holiday to come back and join the group. The single "One Vision" was created in an atmosphere of calm. As though to symbolize a rediscovered unity, the song was written by all four musicians. The impetus for the song came from Freddie, who seemed determined to recover the unity of his peers, from whom he had been only too distant in recent years.

During this same month, the lead singer recorded the video of "Living on My Own," a single from his first solo album, *Mr Bad Guy*. These images, which have since become famous, were recorded at the private party given in honor of his thirty-ninth birthday at the famous Munich club, Old Mrs. Henderson. More scenes were recorded the following day, when some of the guests were very happy to extend the party. Like the album and its other singles, "Living on My Own" turned out not to be a success. Once again, a member of Queen discovered that his success was not guaranteed when he strayed outside of the group.

A London / New York Collaboration

At the same time, Russell Mulcahy made contact with Queen. He had cut his teeth in the world of music videos, working with the likes of Duran Duran and Elton John, most notably producing the famous music video for "I'm Still Standing." The Scottish filmmaker was in the middle of filming *Highlander*, which tells the story of combat between immortal warriors across time. It starred the French actor Christophe Lambert, who had just won a César for his role in the film *Subway*, by Luc Besson. Mulcahy later described (in 2019) his meeting with the group: "I loved Queen, I was a huge fan of their music, and I really loved the soundtrack they had done to *Flash Gordon*. So we contacted them and I think they were a little skeptical at first, but we invited them over to the edit studio in London and

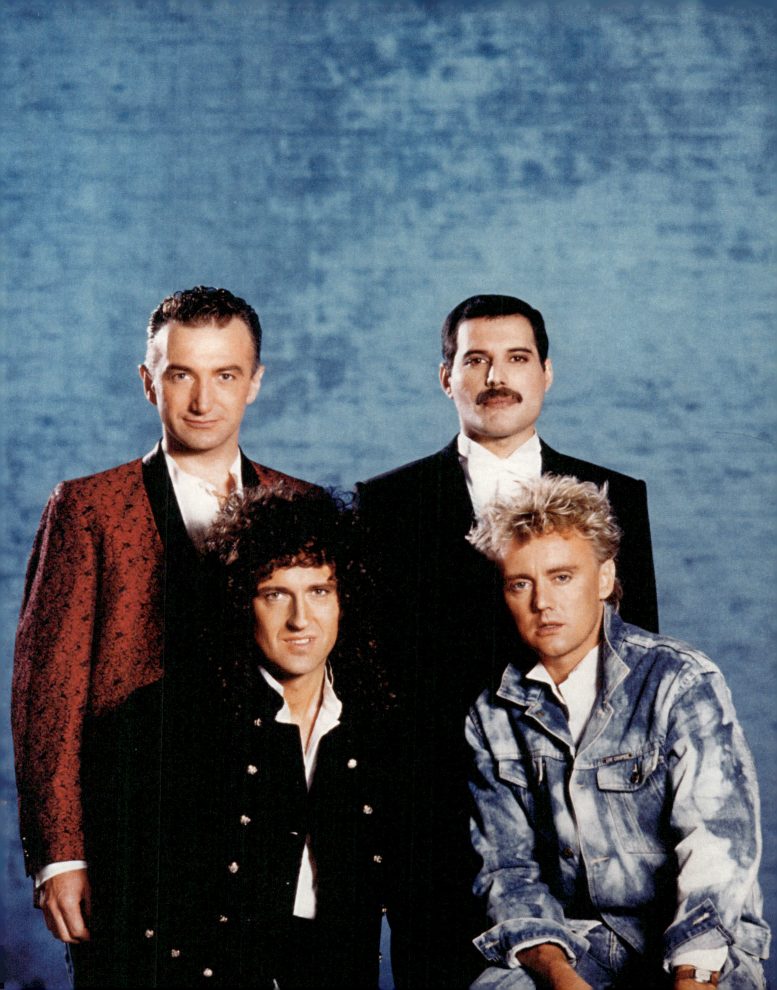

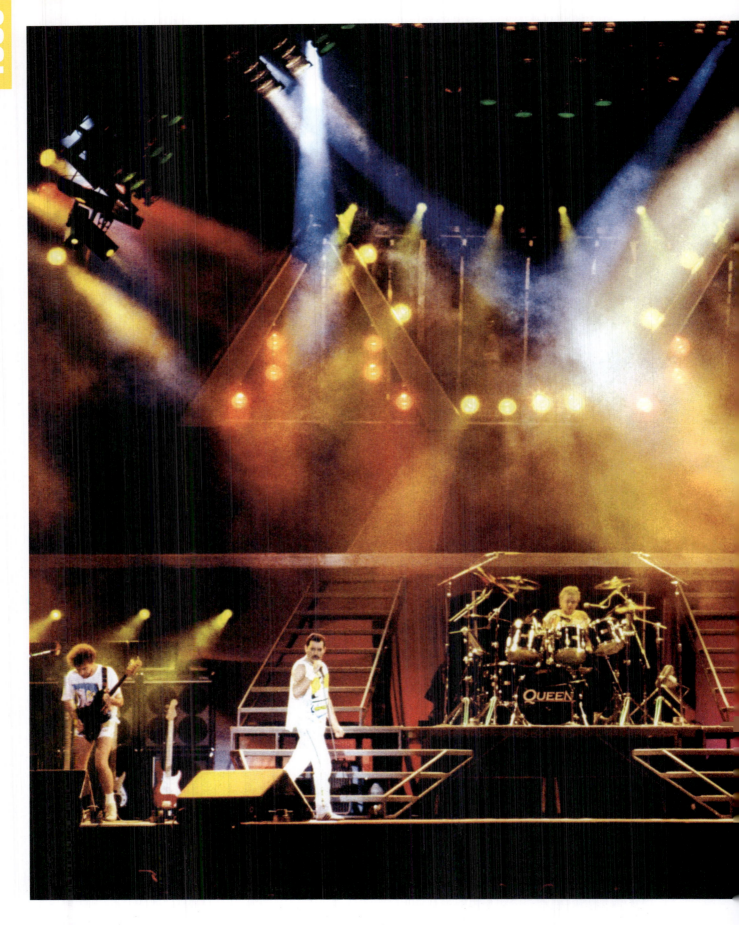

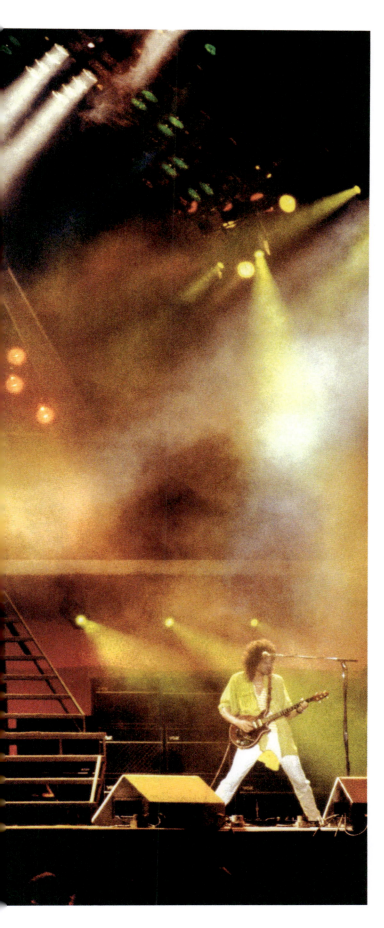

(Left) The "Magic Tour," which would be Queen's last tour, ended at Knebworth Park on August 9, 1986.

(Next Page) The group's fans at the Slane Castle concert in Dublin on July 5, 1986.

we showed them 20 minutes of cut footage—six or seven different scenes. All the band came over, and they came out and said, 'That's really cool.' So I thought we'd get one song out of them. But two days later we got the message back that they all wanted to write a song. [...] I ended up getting five songs in the end, which was amazing!"[14]

The cherry on the cake was that Russell Mulcahy, for whom the stars seemed to be in alignment, had no difficulty convincing the composer Michael Kamen to take part in the adventure. Famous for the orchestrations for *The Wall*, Pink Floyd's 1979 masterpiece, and for his work on *Brazil*, Terry Gilliam's classic 1985 film, Kamen was a not inconsiderable added value for Mulcahy, and his presence definitively ensured a quality soundtrack for the film. The composer assumed responsibility for the instrumental score. He quickly developed a friendship with Queen.

The group wrote five songs for *Highlander*, including "A Kind of Magic," "One Year of Love," "Who Wants to Live Forever," "Gimme the Prize (Kurgan's Theme)," and "Princes of the Universe," which were included in the original soundtrack of the film along with Kamen's compositions.

Beginning in November 1985, the group launched the recording of their twelfth studio album, for which the working sessions lasted until February 1986. The five numbers composed for the film appeared on this new opus, plus three other songs: "Pain Is So Close to Pleasure," "Don't Lose Your Head," and "Friends Will Be Friends." The single "One Vision," already in the can, opens the disc.

Although tensions seemed to have been eased, the way in which the musicians worked on the disc had elements of a parting of the ways of sorts. Freddie and John isolated themselves with Mack at Musicland, while Brian and Roger recorded with David Richards at the Mountain Studios in Montreux. This modus operandi deprived the album of cohesion and homogeneity.

A Success with a Backdrop of Crisis

When the album *A Kind of Magic* appeared in the United Kingdom on June 2, 1986, it was a big success, but each musician seemed to be going through a profound existential crisis. Brian May was fighting to save his relationship with his partner and experiencing the adverse effects of his rock star life. "We get enough of life on the road and life in studios to want to have our private lives apart from that. [...] You almost become, not exactly two different people, but it's a very different world, and you have to acclimatize [...]. I think when we're on tour, we live a touring life, and it's fun. It's not all glamorous, but it's fun. And when you go home, you have your everyday problems, you have your wife, and

QUEEN: ALL THE SONGS 369

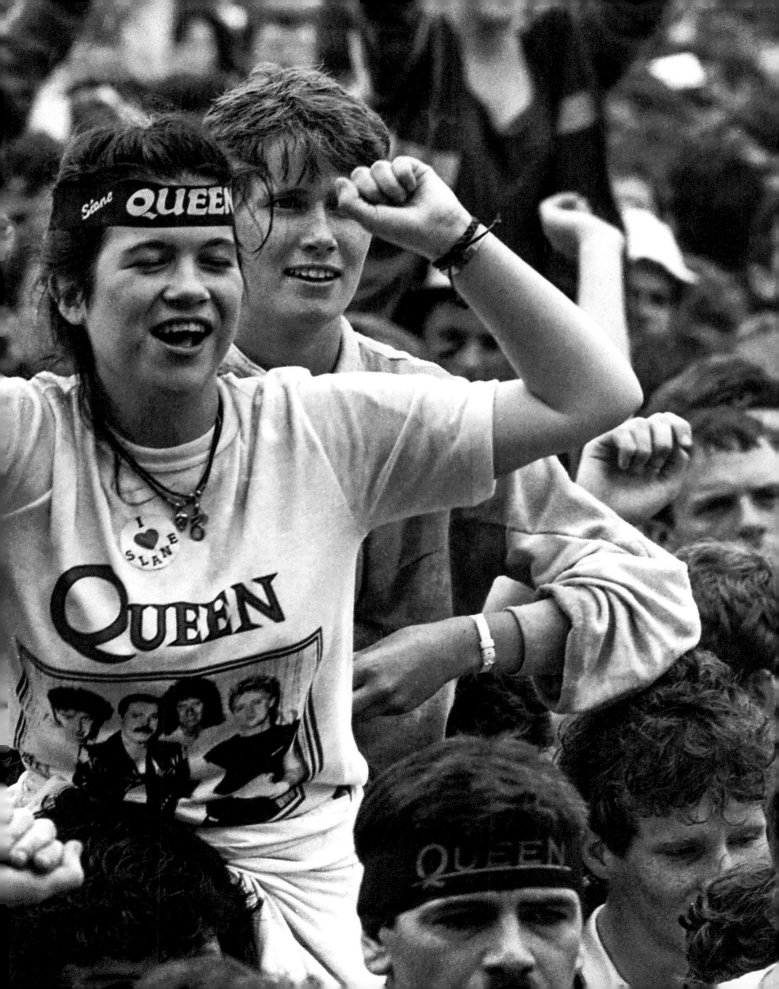

Freddie Mercury brandishes the Union Jack during the "Magic Tour" in 1986.

your family. [...] You know, you have bills to pay, and you have to have a semblance of normality."[141]

Meanwhile, John Deacon began working on the only song by the trio the Immortals, and with this band he wrote the song "No Turning Back," which appears in the 1986 movie *Biggles,* directed by John Hough. The bassist also seemed to be going through a period of self-questioning, full of doubts and uncertainties about the development of the group. As he put it, somewhat disenchantedly, in 1987: "When we first started, we were future thinking, we wanted to do this, [...] we wanted to go there, we wanted our albums to be successful [...]. We worked really hard at it. [...] We have achieved that in a lot of countries in the world."[141]

As for Roger Taylor, he focused on the artist's life and worked tirelessly at the Mountain Studios in Montreux on various musical projects, alongside David Richards, with whom he had become friends. As for Freddie, he seemed to have withdrawn from his nocturnal Munich lifestyle, abandoning the nightclubs and evening adventures in favor of a quiet life in the company of Jim Hutton, based out of his residence at Garden Lodge in London.

Toward the Dark Days

In December 1986, the group released their second live album, *Live Magic,* which retraces their triumphal European tour in the summer of 1986. On June 11 and 12, on the initiative of their promoter, Harvey Goldsmith, Queen filled Wembley Stadium on two nights in succession, playing each concert in front of audiences of more than seventy-two thousand. The seats were sold out in just a few hours. On August 9, it was at Knebworth, to the north of the British capital, that the group concluded their tour in front of an audience of more than 150,000 people. Although they did not realize it at the time, this was also the group's last-ever concert with Freddie Mercury.

The musicians were surrounded by a team of titans for the tour, including Roger's technician, Chris "Crystal" Taylor, who was promoted to technical manager following the departure of Peter Hince. The costumer Diana Moseley, with whom Mercury collaborated on the music video for "I Was Born to Love You," supervised the lead singer's costumes; in particular, she created the famous red cloak in ermine and velvet that he wore at the end of the concert, together with the crown. "We had a little tussle with the colors. He wanted yellow and I wanted red, but the compromise was the white, because white always looks so good in the big stadium."[142] In another interview, Diana Moseley expounded further on the subject of the lead singer: "His main fault? [...] His insistence on wearing white Adidas trainers with the three stripes, with everything!"[143]

372 **A KIND OF MAGIC**

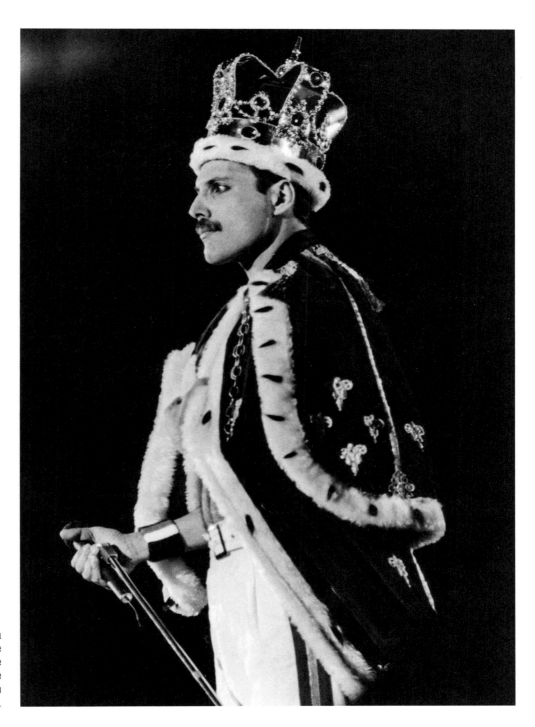

Costume designer Diana Moseley created the cape and crown that Freddie proudly wore at the group's Wembley Stadium concerts in July 1986.

But at the end of 1986, the tumult of this victorious tour already seemed far away. Freddie Mercury took advantage of this period of calm to record a reprise of the Platters song "The Great Pretender." He also had a life-changing encounter: he worked with the Spanish soprano Montserrat Caballé, which resulted, in 1988, in the release of the album *Barcelona*. Pop melodies and classical orchestrations combined on the album and were carried by the incredible voice of the internationally renowned singer.

This was a period of splendor for Freddie from an artistic point of view, but his health had gradually declined during the previous year. The lead singer, who was slowly accepting the awareness that this was no longer something he could do anything about, had often associated his malaises with accumulated tiredness and all kinds of excesses. But he now knew that he was one of the victims of AIDS, a disease that was decimating the gay community in the early 1980s. Within Queen, no one knew what was happening to the lead vocalist, but increasingly often, the star intimated to journalists that his life as an artist was going to change: "I know there'll be a time I cannot run onstage because it'll be ridiculous. There comes a time when you have to stop. But music will still be my thing."[141]

QUEEN: ALL THE SONGS 373

DAVID RICHARDS: MOUNTAIN STUDIOS' GIFTED TECHNICIAN

David Richards was born in 1956. His father, Bobby Richards, was a famous arranger and producer, who notably worked with the folk band the Seekers in the mid-1960s. No sooner had his young son celebrated his third birthday than Bobby Richards began giving him piano lessons. Little David developed a passion for keyboards of all kinds. At the age of seven, accompanying his father to a studio session, he was captivated by the musical alchemy of the studio, as he would later explain: "There was a huge sound, all these knobs and guys with smart clothes, very cool, behind the console. I realized that this was what I wanted to do."[150]

The years went by and young David, now aged eighteen, was determined to join a studio to learn the business as soon as possible. Thanks to his father's professional connections, he began working in 1973 at London's prestigious Chappell Studios. Founded in 1850, Chappell Studios was located in the basement of the oldest recording complex in Europe, and had notably published sonatas by Ludwig van Beethoven, among others. Originally located at 50 New Bond Street, the studios moved to 52 Maddox Street in 1967. Working as an assistant to the studio's highly respected chief sound engineer, John Timperley, David was in exactly the right place, and found himself working on many fascinating projects, including recordings for the famous crooner Bing Crosby.

Departure for Montreux

In 1975, Timperley was offered the role of chief sound engineer at Mountain Studios in Montreux, Switzerland, which was housed in a new casino that had been rebuilt after a spectacular fire in 1971. The sound engineer asked David Richards to go with him. The young man didn't hesitate in accepting his mentor's offer, and moved with his wife, Colette, to this tiny country that would become their permanent home. He participated in the development of the studio and contributed to its international reputation by working with the Rolling Stones on their album *Black and Blue*. When John Timperley left his post in 1977, Richards took over as head of the studios at the age of just twenty-one.

Meeting Queen

In 1978, the members of Queen made the decision, like the Rolling Stones before them, to record outside British territory in order to avoid paying UK taxes. They flew over to Montreux, where they met David Richards. Under the direction of producer Roy Thomas Baker, he worked on their album *Jazz* as sound engineer. In 1979, Queen purchased Mountain Studios, which would become the band's regular haunt. A close relationship was established between the musicians and Richards, who was entrusted with the production of Queen's *Live Killers* album, and then subsequently with the production of Roger Taylor's first two albums, *Fun in Space* and *Strange Frontier*.

For their 1984 album, *A Kind of Magic*, Queen worked in pairs. Freddie and John remained loyal to producer Mack, and recorded at Musicland Studios in Munich, while Brian and Roger moved to Mountain Studios in Montreux. David Richards thus worked as a co-producer on some of the songs from the album. "Dave was one of those people with a magic touch," recalled Brian May. "Softly spoken and always absorbed in his work."[151] Richards also worked closely with David Bowie, and it was he who initiated the session that gave birth to Bowie and Queen's famous hit "Under Pressure."

From Montreux to Attalens

In 1993, two years after Freddie's death, David Richards bought Mountain Studios from Queen. He then worked with the band on the *Made in Heaven* album, giving his time freely in order to realize this project that was so dear to his friend's heart.

In 2002, major work began on the casino that housed the recording studios. The noise pollution was such that

The talented David Richards was the architect of sound at Mountain Studios, which he bought from Queen in 1993.

the recording studios became unusable. Unable to find a solution with his noisy neighbors, the producer decided to relocate his studio to Attalens, a small village located eleven miles outside of Montreux. In a letter to his former colleague Ash Alexander, who had worked on the *Made in Heaven* album, Richards explained the reasoning behind this major change: "I was forced to find a new solution for having a recording studio. I found, by chance, a beautiful villa in the hills above Montreux and converted it into a studio plus a place I could also live in and invite a few artists to stay the night or two. [...] I kept the name, Mountain Studios, and although it was slow to start up, it is now in so much demand I am overwhelmed with work at the present time. This has led me to develop the enormous basement below the house, which has almost the same surface area, into a second studio facility."[152]

David Richards passed away in Attalens on December 20, 2013, in the mountains of his adopted Switzerland, where he had become a citizen in the 1990s.

QUEEN: ALL THE SONGS 375

1986

ONE VISION
Queen / 5:10

> While some see a reference to Bob Geldof in "One Vision," it was the Reverend Martin Luther King Jr. and his famous "I Have a Dream" speech that influenced Roger Taylor in the writing of the lyrics.

Musicians
Freddie Mercury: lead vocals, backing vocals, synthesizers
Brian May: electric guitar, synthesizers
Roger Taylor: drums
John Deacon: bass

Recorded
Musicland Studios, Munich: September 1985
Maison Rouge Studios, London: September 1985

Technical Team
Producers: Queen, Reinhold Mack
Sound Engineer: Reinhold Mack

Single
Side A: One Vision (Single Version) / 4:02
Side B: Blurred Vision / 4:40
UK Release on EMI: November 4, 1985 (ref. QUEEN 6)
US Release on Capitol Records: November 20, 1985 (ref. B-5530)
Best UK Chart Ranking: 7
Best US Chart Ranking: 19

ON YOUR HEADPHONES
At 4:42, a trained ear will easily hear Mercury, May, and Taylor concluding the rising refrain "*Gimme, gimme, gimme…*" with a brilliant "*Fried Chicken!*"

Genesis

In September 1985, Freddie Mercury was in Munich, where he was celebrating his thirty-ninth birthday with his close friends with a memorable party at the Old Mrs. Henderson club, immortalized in the music video for "Living on My Own," a single from his first solo album, *Mr. Bad Guy*. He had decided that the time for relaxation was over and called together the other members of the group. John Deacon recalls: "Freddie [...] wanted to go back in the studio and do some more recording. [...] We actually recorded another single. It was his idea, really, that we could go in and actually write a song together."[144]

Taking inspiration from Dr. Martin Luther King Jr., Roger Taylor wrote the lyrics in which he lists what outraged him at the time. Freddie retained his drummer friend's general idea, but modified the lyrics to make it a song of hope rather than of anger. The instrumental part of the number was initially composed by May, Taylor, and Mercury, then Deacon added his contribution a few days after studio work began.

The recording sessions for "One Vision" were independent of those for the album *A Kind of Magic* and are evidence of a moment of unity within Queen, where each member of the band still seemed to be enjoying some happy times following the success of Live Aid.

The song was released as a single on November 4, 1985, while the musicians were in the midst of recording their new album. It is no surprise that the British rock press criticized them for having sought to profit from the success of Live Aid. The journalists claimed that the words "*One man, one goal / One mission*" were an imitation of Bob Geldof's amazing project. Having been accused of opportunism, the group defended itself vehemently, as Roger Taylor put it: "I was absolutely devastated when I saw that in the press. It was a terrible mistake and I was really annoyed about it. Some public relations person got the wrong end of the stick. I went absolutely bananas when I read that."[128]

Even so, once again rising above the criticisms, the group was reenergized by their single and they came together again for the production of their twelfth studio album, which would open with "One Vision."

Although created in the same vein as numbers such as "Gimme the Prize (Kurgan's Theme)" or "Princes of the Universe," the song did not appear as part of the original

376 A KIND OF MAGIC

soundtrack of the *Highlander* film. It did, however, appear on the original soundtrack of the 1986 B-movie *Iron Eagle*, directed by Sidney J. Furie. An alternative version of "One Vision," with the title "Blurred Vision," combined an electronic rhythm with a deluge of synthesizers and was included on the B-side of the single.

An Exceptional Documentary

Since *News of the World*, for which behind-the-scenes footage had been filmed by Bob Harris in 1977, studio images of Queen had become very rare. Very exceptionally, the musicians agreed to the presence of cameras during the recording sessions for "One Vision." The Austrian filmmakers and producers Rudi Dolezal and Hannes Rossacher, known as the Torpedo Twins, were on hand to film the proceedings. They had interviewed the group following a concert in Austria, in 1982, and in the spirit of the friendship that was formed at that time, Queen agreed to their intrusion at the Musicland Studios during the fourteen days of their sessions for "One Vision." Even though the musicians came to regret this decision subsequently, on the grounds that it removed the natural aspect of the spontaneity of working ("The documentary cameras actually ruined the whole thing, because I think everyone was so conscious of them being there,"[5] as Brian May complained), the result is particularly touching and very instructive. The images, which appear in the documentary *Magic Years,* produced by the Torpedo Twins the following year, present a portrait of a team united around a common project, in a "well-behaved" atmosphere, working alongside their producer, Mack, as he sat very upright behind his console. The images from the filming, to which were added some videos filmed at various concerts, were used as a music video for "One Vision."

Production

While "One Vision" was a number with a resolutely rock emphasis, many secrets are hidden behind its production, which is powerful and incisive, and which was handled by Mack. The producer himself plays and creates the introduction to the number, which is full of mystery, before the Red Special riff cuts through the calm of these first bars. Using the brand new Kurzweil 250 synthesizer for the first time in a Queen song, Mack populates the beginning of the piece with an assortment of strange sounds. Like the Fairlight CMI that was used on *The Works*, the new synthesizer enabled the recording and processing of sounds, in addition to its

Queen poses in Munich in 1985. The group was in Germany for their last round of recording sessions at Musicland Studios.

factory-installed database. Mack explains: "I came into the studio early one morning, and started playing around with sampling some of his vocal lines into the Kurzweil and playing them back with a downward pitch change, with various effects."[145] The lyrics initially recorded by Mercury were: *"God works in mysterious ways, and hey! People around the world, I look forward to the glorious days once again."*

According to Mack, Brian May used the Kurzweil 250 (whose "Fast String" preset simulates a string ensemble) to play the rising chords at 0:44. Fans and music lovers who saw the Torpedo Twins film argue that this was actually played on a Yamaha DX7, which is seen in the hands of the guitarist at 7:49 in the documentary. The mystery of the keyboards chosen for the break and, indirectly, for the introduction, will perhaps never be solved.

The Red Special is given pride of place. Connected to the guitarist's two traditional Vox AC30 amps, it is also boosted with a Pete Cornish custom distortion pedal. Two simultaneously recorded guitar tracks are used (one for each amp), thus creating an impressive stereo. Some of the guitar parts, such as the break, at 4:07, were recorded at the Maison Rouge Studios in London, on a Gallien-Krueger amp. As for May's solo, this is executed with a dexterity matched only by its coldness, far from the innovations of baroque complexity found on "The Millionaire Waltz" ten years before. But never mind; it shines with power and triggers a sense of guilty pleasure in the listener.

Finally, Taylor's drums, a Ludwig Super Classic Chrome-O-Wood kit, are given a very special treatment. Certain elements, such as the snare drum, are "stacked." The principle is simple: a strike sensor is installed on the shell, and with each strike from the drummer a digital signal is sent to a sound module (in this case the Simmons SDS7 Digital-Analog Drum System). On the console, Mack could then use two drum tracks as required, offering the benefits from the natural Ludwig sound as well as the processed sound from the Simmons module as required. This technique gives the drum a sound that is sometimes very synthetic (as can be heard at 3:50 in the song), and sometimes very authentic in both tone and timbre.

1986

A KIND OF MAGIC

Roger Taylor / 4:24

Musicians
Freddie Mercury: lead vocals, backing vocals, synthesizers
Brian May: electric guitar
Roger Taylor: drums, programming, backing vocals
John Deacon: bass

Recorded
Mountain Studios, Montreux; The Town House, London: August 1985–February 1986

Technical Team
Producers: Queen, David Richards
Sound Engineer: David Richards
Assistant Sound Engineer: Paul "Croydon" Cook

Single
Side A: A Kind of Magic / 4:24
Side B: A Dozen Red Roses for My Darling / 4:44 (EMI); Gimme the Prize (Kurgan's Theme) / 4:34 (Capitol)
UK Release on EMI: March 17, 1986 (ref. QUEEN 7)
US Release on Capitol Records: June 4, 1986 (ref. B-5590)
Best UK Chart Ranking: 3
Best US Chart Ranking: 42

FOR QUEEN ADDICTS

When the musicians met up in Munich in September 1985 with a view to composing together, an initial number was proposed by Roger Taylor. Only the words of this number were retained and used as a basis for "One Vision." The melody was reused a few weeks later to create "A Kind of Magic."

Genesis

Originally written by Roger Taylor for the film *Highlander*, the song was significantly reworked by Freddie Mercury in February 1986 while the drummer, accompanied by Brian May, left for Los Angeles to attend the spotting sessions for the film music. Taylor approved the new arrangements, which were better suited to the number and agreed for the song to be the second single from the album. In the end, there were two versions of the song. The best known is, of course, the one that appears on the album. The second version, which owes more to Roger Taylor, has less of a pop feel, accentuating certain instrumental passages and playing over the credits at the end of the film. This was the first time that a Queen album carried the title of one of its songs, which gives the track a particular significance and underlines the drummer's writing talent.

For its release as a single on the March 17, 1986, "A Kind of Magic" was accompanied by a music video directed by Russell Mulcahy, who also directed *Highlander*. Filmed at London's Playhouse Theatre on March 3, 1986, the video shows May, Taylor, and Deacon in the guise of homeless people, similar to Phil Collins in the music video for "That's All," which was done with his band Genesis in 1983. Mercury appears as an elegant magician, transforming the unfortunates into rock stars. Equipped with their usual instruments, the musicians move around in the abandoned theater, which would eventually be restored following this video and once again become a preeminent cultural venue for the city of London.

Production

A diplomatic incident was narrowly avoided when Roger Taylor took advantage of Brian May's absence on one occasion to borrow his Red Special. "I was out of the studio—we were all in and out at different times, and it went on and on—and they'd got the bit where the lyric is *'I'm hearing secret harmonies.'* So Roger must have gone off and grabbed my guitar, plugged it into my amp and my system, and played that bit in the three-part harmony. [...] I always had that feeling that something had been slightly violated and it feels strange. [...] I wouldn't have done it that way!"[12]

Brian, Roger, and John dressed as tramps who are about to be transformed into rock stars by an elegant, hat-wearing Freddie Mercury, in a scene from the music video for "A Kind of Magic."

ONE YEAR OF LOVE
John Deacon / 4:26

Musicians
Freddie Mercury: lead vocals, backing vocals
John Deacon: bass, synthesizer, programming
Steve Gregory: saxophone
Lynton Naiff: string arrangements

Recorded
The Town House, London: November 1985–January 1986

Technical Team
Producers: Queen, Reinhold Mack
Sound Engineer: Reinhold Mack

Genesis

Despite its very kitschy aspect, "One Year of Love" was the only piece contributed by Deacon for the *Highlander* original soundtrack, and it is a perfect match in every respect to the ambiance of the film. It is positioned at 28:20 in the feature film, where Connor MacLeod meets Brenda Wyatt in a smoky New York bar. All the 1980s film clichés are combined in this one scene, and Deacon's song, which is schmaltzy to the ultimate degree, is a majestic fit with the tone of the sequence. Another version, played on the piano, appears at 1:04, in a scene where the hero finds the police at his house. The words of the song explain that, having suffered from a wound of love, its narrator will never be able to love again. In his lyrics, Deacon recalls the unfortunate destiny of Highlander—played by Christophe Lambert—who, as an immortal, is condemned for eternity to see his loves perish one after the other over the centuries.

Production

Crafted with Mack at London's Town House studios at the end of 1985, "One Year of Love" was the last song recorded for *Highlander*, when filming was drawing to a close. For the solo, which is perfectly suited to the atmosphere of the track, its author called upon an illustrious performer to make a guest appearance: the saxophonist Steve Gregory, who had distinguished himself two years earlier with the writing of one of the most famous saxophone lines in the history of pop music on the song, "Careless Whisper" by George Michael. For the song's string arrangements, John Deacon called upon the keyboard player Lynton Naiff, whose work can be heard beginning at 3:09. The production definitively anchors the song in the popular sound of the day, particularly by means of (or, one might say, because of) the massive use of the Yamaha DX7 synthesizer, whose sound is very much of its time. Mercury makes his usual contribution, providing an inspired interpretation with his powerful voice.

SINGLE

PAIN IS SO CLOSE TO PLEASURE

Freddie Mercury, John Deacon / 4:21

Musicians
Freddie Mercury: lead vocals, backing vocals, synthesizer, piano
Brian May: electric guitar
John Deacon: bass, electric guitar, synthesizer, programming

Recorded
The Town House, London: February–March 1986

Technical Team
Producers: Queen, Reinhold Mack
Sound Engineer: Reinhold Mack

Single
Side A: Pain Is So Close to Pleasure (Single Remix) / 3:52
Side B: Don't Lose Your Head / 4:38
US Release on Capitol Records: August 20, 1986 (ref. B-5633)
Best US Chart Ranking: Not Ranked

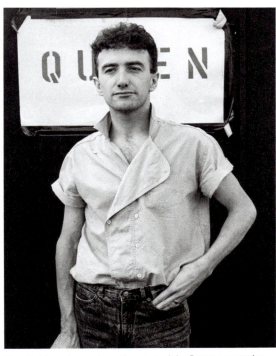

Despite his serious nature, the songs John Deacon wrote for Queen were often light and cheerful.

Genesis

"Pain Is So Close to Pleasure" was castigated by many fans when it was released, as they felt it was too reminiscent of the *Hot Space* years because of its (very relative) similarity with the song "Cool Cat," also written by the Deacon-Mercury duo. While it is true that its very Motown flavor underlines the bassist's love for soul music, the song is well written, with effective refrains similar to "Baby Love" or "Where Did Our Love Go" by the Supremes. As is often the case with Deacon songs, the text (albeit written with Mercury) offers the listener a moral lesson, explaining here that life requires achieving a balance on a day-to-day basis, and that happiness and misfortune often coexist: *"Sunshine and rainy weather go hand-in-hand together all your life."* With a title like "Pain Is So Close to Pleasure," one might expect more trenchant lyrics from Freddie Mercury! From an instrumental point of view, on the other hand, the song is a solid piece of work. "John is very organized and has a mathematical mind, so when he comes into the studio, he has a fairly precise idea of what he wants to do,"[145] explained Mack, the co-producer. But unfortunately, the steamroller of the 1980s has left its imprint, and the production of the number is symptomatic of its period, with drum machine and synthesizers detracting from the listener's enjoyment. The fans decried the sacrilege of hearing their favorite rock group giving in to this kind of exercise, as was demonstrated by the catastrophic sales of the single in the United States.

Production

The introduction of the piece is not unlike that of "We All Are One" by Jimmy Cliff, which appeared in 1983 on his album *The Power and the Glory*. "Pain Is So Close to Pleasure" is catchy and melodious, driven by its very soul-oriented rhythm. John Deacon laid down the bass and rhythm guitar, leaving Brian May a small slot at the end of the number for a discreet, down-mixed solo. Like many very good songs, "Pain Is So Close to Pleasure" is a victim of its time, and even though tastes and values are often subject to vagaries of fashion, it is a pity that this fine ballad, which is ideal for bringing some cheer to a rainy day, was not quickly rehabilitated, even just for its insistent refrains.

1986

FRIENDS WILL BE FRIENDS
Freddie Mercury, John Deacon / 4:07

Freddie floats above members of the Queen fan club during the filming of the "Friends Will Be Friends" music video.

Musicians
Freddie Mercury: lead vocals, backing vocals, piano, synthesizers
Brian May: electric guitar, backing vocals
Roger Taylor: drums, backing vocals
John Deacon: bass, electric guitar
Spike Edney: keyboards

Recorded
Musicland Studios, Munich: 1985
The Town House, London: February–March 1986

Technical Team
Producers: Queen, Reinhold Mack
Sound Engineer: Reinhold Mack

Single
Side A: Friends Will Be Friends / 4:07
Side B: Seven Seas of Rhye / 2:48
UK Release on EMI: June 9, 1986 (ref. QUEEN 8)
Best UK Chart Ranking: 14

Genesis
Composed by Freddie Mercury and John Deacon, "Friends Will Be Friends" arose out of the lead singer's desire to give his public a timeless anthem, similar to "We Are the Champions" or "Radio Ga Ga." This objective was achieved partly due to an effective and a readily memorable refrain melody. The song had the potential to be a hit when it was released as a 45 rpm on June 9, 1986, but in fact it received only a tentative response in the United Kingdom and failed to achieve the same rankings as "A Kind of Magic."

The music video was produced by the Torpedo Twins (Rudi Dolezal and Hannes Rossacher), who had already filmed the group during the recording sessions for "One Vision." It was shot on May 15, 1986, at the JVC Studios in Wembley, where the group was then preparing for its future tour. The video was a traditional one, showing the musicians onstage, in front of an enthusiastic public. Members of the Queen fan club were invited on the day of the shoot, as was the case with the video for "We Are the Champions," which was filmed in 1977.

Production
In the music video, John Deacon can be seen with an instrument with a strange shape. This is a Warwick bass, the Buzzard model, which he also used on stage at La Rose d'Or in Montreux, on May 11, 1986, a poorly remembered festival. The instrument was seemingly made for lip-syncing, because that was how the group performed their entire set.

"Friends Will Be Friends" was recorded at the Musicland Studios in Munich with the involvement of Mack, and it benefited from the location's advantages. An array of high-quality microphones enabled the producer to give Taylor's drums a really powerful sound: a Neumann U47 FET was used for the bass drum, and an AKG C414 was placed thirty centimeters from the snare drum, which provided a feel of natural space during mixing. The famous Neumann U87 was used for the tom-toms, and a Schoeps condenser for the hi-hat. The snare drum was once again stacked, as on "One Vision," and the sound provided by the Simmons SDS7 Digital-Analog Drum System module was processed with a delay on an AMS. A very effective recipe that resulted in a 100 percent 1980s drum sound!

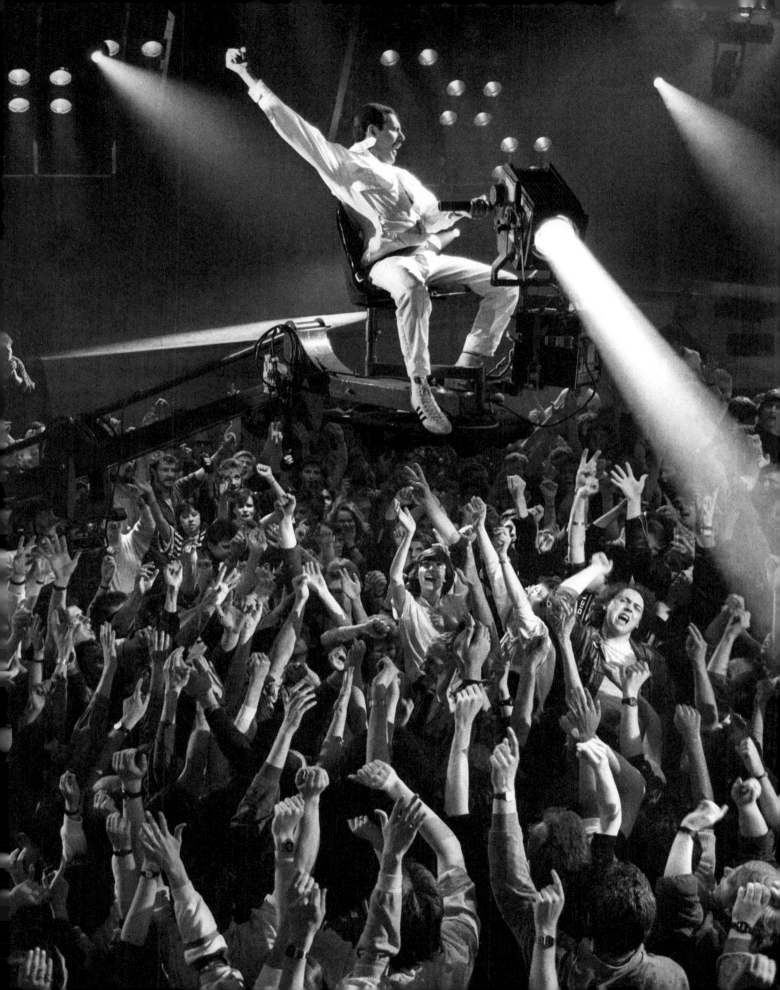

1986

SINGLE

WHO WANTS TO LIVE FOREVER
Brian May / 5:15

A solemn and elegant Brian May poses during the filming of the "Who Wants to Live Forever" music video on September 16, 1986.

Musicians
Freddie Mercury: lead vocals
Brian May: lead vocals, backing vocals, synthesizers, electric guitar, programming, strings arrangement
Roger Taylor: backing vocals, percussion
Michael Kamen: strings arrangement
National Philharmonic Orchestra: strings

Recorded
Mountain Studios, Montreux; The Town House, London: November–December 1985
Abbey Road Studios (orchestra): November–December 1985

Technical Team
Producers: Queen, David Richards
Sound Engineer: David Richards, Eric Tomlinson (Abbey Road Studios)
Assistant Sound Engineer: Paul "Croydon" Cook

Single
Side A: Who Wants to Live Forever / 4:00
Side B: Killer Queen / 3:00
UK Release on EMI: September 15, 1986 (ref. QUEEN 9)
Best UK Chart Ranking: 24

In 2014, a new version of the song, with the somber title of "Forever," was offered to the fans on the Queen Forever compilation. Delicately interpreted on the piano by Brian May and stripped of all arrangements, the new version features only the melody of the original number.

Genesis
Undeniably the most striking song on the album *A Kind of Magic*, "Who Wants to Live Forever" is an exceptional background track for the most touching scene in *Highlander*, where the immortal Connor MacLeod (Christopher Lambert) watches over his spouse, who is at the point of death.

In 2003 Brian May explained the very surprising genesis of the piece: "We went to see the *Highlander* rushes with Russell Mulcahy, and that was our first experience in any way with *Highlander*—I hadn't read the script; I don't think any of us had—and it was very moving…[It] kind of opened up a floodgate in me—I was dealing with a lot of tragedies in my life: the death of my father, the death of my marriage, and so forth. I could immediately hear this 'Who Wants to Live Forever' in my head, and it was almost complete in the car going home—I remember singing it to my manager as he drove me home."[5]

A music video was shot by David Mallet on September 16, 1986, in the Tobacco Wharf warehouses in London, and in the presence of the London-based National Philharmonic Orchestra and a choir of forty boys. The feeling of the video is solemn, and the Queen musicians lip-sync the number surrounded by thousands of candles.

Production
Arranged by Michael Kamen and Brian May, then recorded with the London-based National Philharmonic Orchestra at the Abbey Road Studios, the strings on "Who Wants to Live Forever" give this very melancholic song its full power. The backing vocals, provided by May and Taylor, support Mercury's voice, which is exceptionally moving. As they had done on "Sail Away Sweet Sister," Freddie and Brian share the main lead vocals together. The lead guitarist sings the first couplet, the first two phrases of the break, as well as the final *"Who waits forever anyway?"* An alternative version was recorded for the film, where Mercury takes the lead vocals for the whole number, depriving the piece of May's highly individual voice—which, although less powerful, is very well suited to the gentleness of his composition.

386 A KIND OF MAGIC

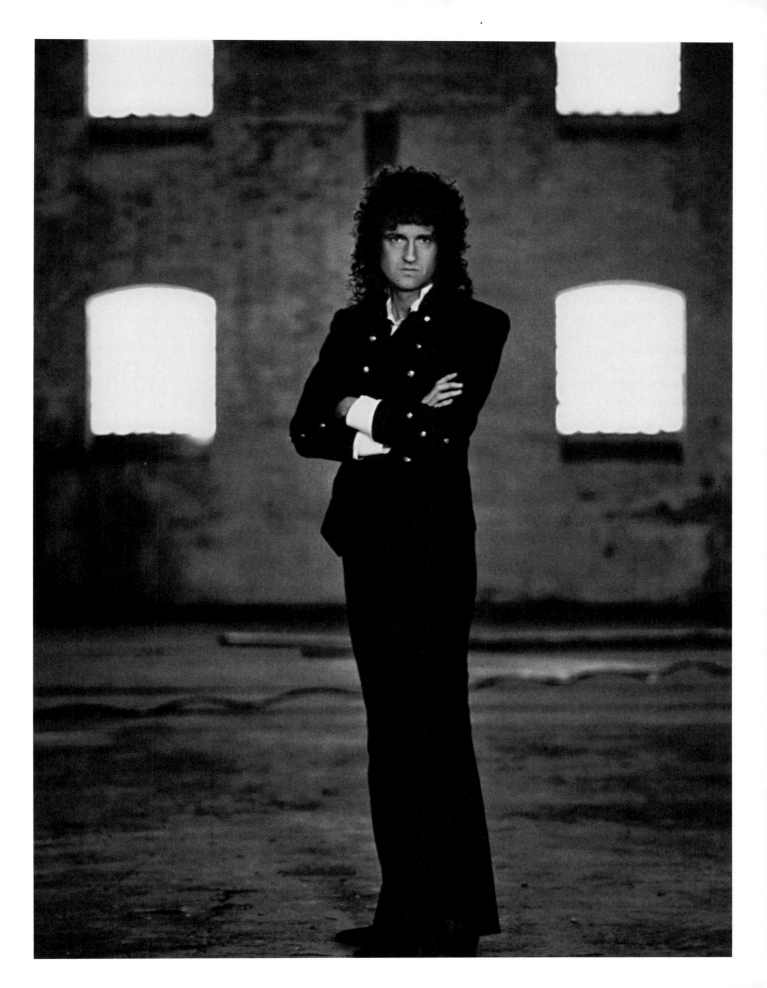

GIMME THE PRIZE (KURGAN'S THEME)
Brian May / 4:34

Musicians
Freddie Mercury: lead vocals
Brian May: electric guitar
Roger Taylor: drums
John Deacon: bass

Recorded
Mountain Studios, Montreux; The Town House, London: 1985

Technical Team
Producers: Queen, David Richards
Sound Engineer: David Richards
Assistant Sound Engineer: Paul "Croydon" Cook

Genesis
The song was inspired for Brian May by the character of the Kurgan, the sworn enemy of Connor MacLeod over the centuries, played on screen by the charismatic Clancy Brown. The Kurgan and the hero fight at the end of *Highlander* over "the Prize" (as it is called in the original version) which is given to the survivor of the final combat, who becomes the last of the Highlanders. It seems that this premise inspired the guitarist, who seems to have put a lot of hard work into the project, with a very heavy, almost violent writing style. The piece is the diametric opposite of "Who Wants to Live Forever," May's other contribution to the original film score, and it creates an additional level of tension for the film audience when the Kurgan, driving toward York at 24:00 in the feature film, picks up a cassette, inserts it into his car radio, and blasts "Gimme the Prize (Kurgan's Theme)" at full volume. The mass has been said, and the confrontation between good and evil is imminent!

Production
While the number is driven at full throttle by the heavy and repetitive guitar riffs fired off by May's Red Special, it also has the masterful touch of Mercury's powerful lead vocals. As in "The Hero" (also written by May), he seems to hit the highest point in his vocal range. Dialogue extracts from the film are added here and there, reminiscent of the work done on *Flash Gordon*.

Beyond the interest derived from its hard rock character, the most interesting passage in this piece remains the guitar solo at 2:36, during which Brian sought to pay homage to Highlander's Scottish origins, transforming a traditional six-string scoring into a bagpipes solo. Naturally executed on the Red Special, this incredible inspiration is very effective in the song. To give his notes this strange sonority, the guitarist uses a very sophisticated chorus effect that was fashionable in the 1980s, albeit one he only rarely used himself.

On November 6, 1998, while giving a concert at the DK Lensoveta in St. Petersburg to promote his album *Another World*, Brian May slipped the "Scottish" solo from "Gimme the Prize" right into the middle of "Fat Bottomed Girls," providing the Russian audience with an anthology moment.

A scene from the climactic final battle at the end of the film *Highlander*, for whose soundtrack Queen wrote five songs.

1986

DON'T LOSE YOUR HEAD
Roger Taylor / 4:38

Musicians
Freddie Mercury: lead vocals, synthesizers
Brian May: electric guitar
Roger Taylor: lead vocals, drums, programming, synthesizers
John Deacon: bass, electric guitar
Spike Edney: synthesizers
Joan Armatrading: spoken word

Recorded
Mountain Studios, Montreux; The Town House, London: 1985

Technical Team
Producers: Queen, David Richards
Sound Engineer: David Richards
Assistant Sound Engineer: Paul "Croydon" Cook

FOR QUEEN ADDICTS
On the B-sides of the singles "A Kind of Magic" and "Princes of the Universe," an instrumental remix of "Don't Lose Your Head" was provided for the fans. The remix is called "A Dozen Red Roses for My Darling," possibly as an homage to Joan Armatrading.

Genesis
The title of the song, "Don't Lose Your Head," undoubtedly refers to the only way in which the protagonists in *Highlander* can lose their lives, namely following decapitation in combat. But the inspiration of the piece seems to have come to Roger Taylor from a much more ignominious source. In 1985, having always been accustomed to driving a modest Volvo, John Deacon decided that he deserved an upgrade to a more impressive model, and bought himself a Porsche. After a Phil Collins concert, the Queen drummer and bassist shared a couple of glasses together before crossing the city. After being stopped by the police and required to take a breathalyzer test, Deacon lost his license for a year, and the Porsche was quickly sold. Roger Taylor makes reference to this incident in the song: *"Don't drink and drive my car / Don't get breathalyzed."* A few days after Deacon's brush with the law, Brian May also made an allusion to the event in a radio interview, dedicating a song to his friend: "Don't Drive Drunk" by Stevie Wonder!

Production
A veritable new wave piece, "Don't Lose Your Head" is closer to "People Are People" by Depeche Mode or "Sex Crime" by Eurythmics than to Queen's traditional repertoire. In this case the machines won the battle, and in that respect the song was a success if for no other reason than for its uncompromising production.

As a rare phenomenon in Queen's catalog, an external artist left her own unique mark on this number. This was the singer Joan Armatrading, a close acquaintance of Roger Taylor, who we hear repeating the title phrase of the song several times: *"Don't lose your head."* "I was in the Townhouse studio [...] and Queen were in the next studio to me, and Roger Taylor came over and asked me if I would just walk over to his studio and say these words on the song, which I did, and then after I'd finished, the next thing I knew was Roger walking in with a MASSIVE bunch of flowers!"[146]

Joan Armatrading performing in concert circa 1986.

390 A KIND OF MAGIC

SINGLE

PRINCES OF THE UNIVERSE
Freddie Mercury / 3:32

> **ON YOUR HEADPHONES**
> At 1:58 in "Princes of the Universe," Mercury tips his hat to his fans in a welcome moment of nostalgia for the band's earlier days. At this bridge passage, the listener is suddenly and spontaneously plunged into the world of "The March of the Black Queen."

Musicians
Freddie Mercury: lead vocals, backing vocals, piano, programming, synthesizers
Brian May: electric guitar, backing vocals
Roger Taylor: drums, backing vocals
John Deacon: bass

Recorded
Musicland Studios, Munich; The Town House, London: 1985

Technical Team
Producers: Queen, Reinhold Mack
Sound Engineer: Reinhold Mack
Assistant Sound Engineer: Stephan Wissnet (Musicland Studios), Paul "Croydon" Cook (The Town House)

Single
Side A: Princes of the Universe / 3:32
Side B: A Dozen Red Roses for My Darling / 4:44
US Release on Capitol Records: March 12, 1986 (ref. B-5568)

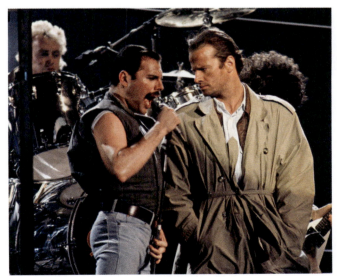

(Above) Freddie facing Christopher Lambert, the Highlander, in the music video for "Princes of the Universe."
(Next page) Brian May and his Washburn RR11V on the video's film set.

Genesis
A major contribution to the original soundtrack of the film *Highlander*, "Princes of the Universe" plays over the film's opening credits. Following in the footsteps of Queen, many other artists made memorable contributions to feature films in the 1980s, with which they will long be associated. One thinks of Ray Parker Jr. and his "Ghostbusters," which appeared in the film of the same name, or "Batdance" by Prince, which was made for Tim Burton's 1989 production of *Batman*. "Princes of the Universe" was created in the same vein, and from the first notes of its introduction, Queen transports the listener to the Scottish Highlands, alongside the movie's hero, Connor MacLeod.

Seeking to reach out once more to the American public with this very heavy number, in a decade when hard rock ruled FM radio, Queen released this song as a single in the United States on March 12, 1986, at a time when the *Highlander* film was also very successful. Russell Mulcahy crafted a special video for the occasion in the Silvercup Studios in Queens. The video depicts a fight between Freddie Mercury, armed with his famous microphone stand, and the actor Christophe Lambert, holding his katana. The pyrotechnic effects used were so impressive that Brian May, fearing for the safety of his Red Special, played the lip-sync track on a Washburn RR11V, leaving his precious six-string safely locked away in its case.

Production
Queen could not have provided a more magisterial finale for *A Kind of Magic*. No drum machine in sight, or Simmons pads, or other studio trickery, the group is very present, in flesh and blood, ready to face up with the Highlander.

Mack and his faithful assistant sound engineer, Stephan Wissnet, put a great deal of work into this number, even stepping outside their normal playbook to venture into more risky territory. The most adventurous was Wissnet, who, taking advantage of May's absence, went so far as to record a six-string part on his own. Mack explained, "There's the bending down of the note. For that, [between 0:38 and 0:44], Stefan, my assistant, played just the *eedly-eedly-eedly* and I ran the harmonizer down one octave. Freddie heard it and said, 'This is so huge, this is massive,' and then they started to pick up on that."

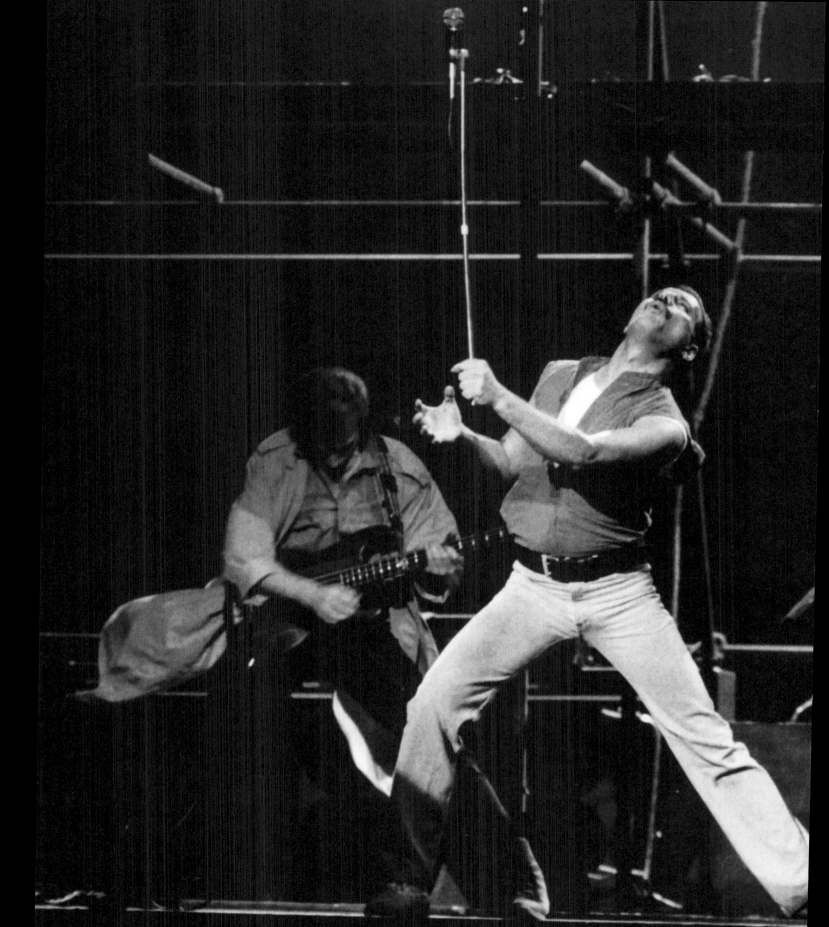

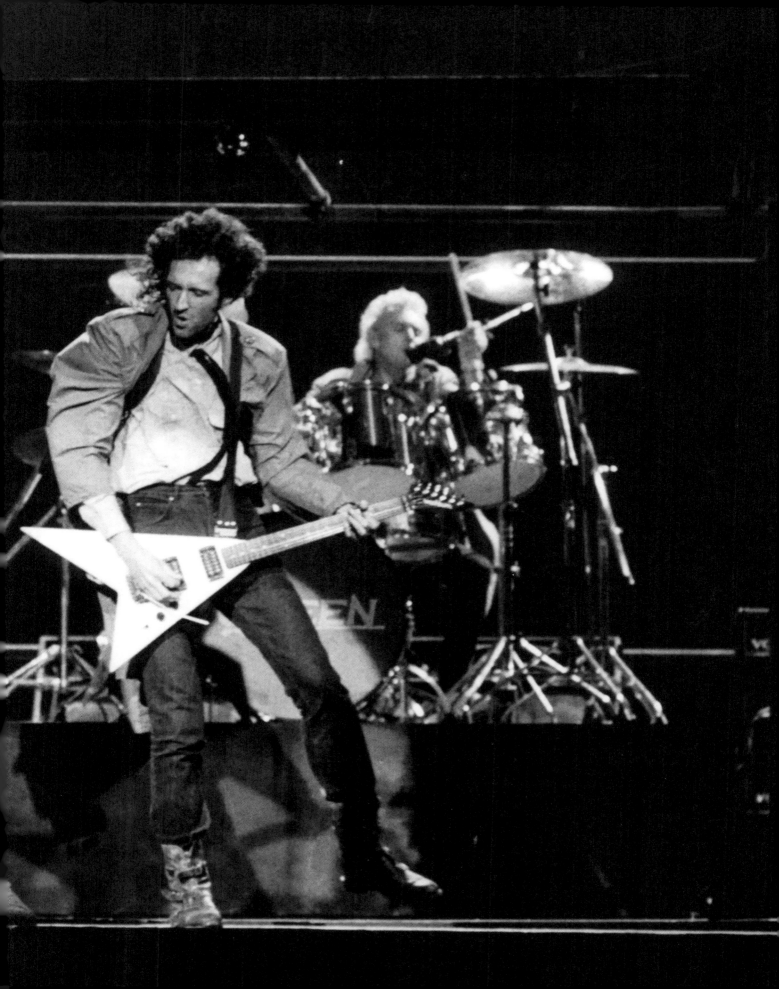

LIVE ALBUM

LIVE MAGIC

Release Dates
United Kingdom: December 1, 1986
Reference: EMI—EMC 3519
United States: August 13, 1996
Reference: Hollywood Records—HR-61267-2
Best UK Chart Ranking: 3
Best US Chart Ranking: Not Ranked

Recorded
Wembley Stadium, London: July 11–12, 1986
Népstadion, Budapest: July 27, 1986
Knebworth Park, Stevenage: August 9, 1986
(the Manor Mobile, the Rolling Stones Mobile, the Power Sound Mobile)

Mixing
The Town House, London: November 10–12, 1986
Sound Engineers: John "Teddy Bear" Brough
Producers: Queen, James "Trip" Khalaf

1. One Vision
2. Tie Your Mother Down
3. Seven Seas of Rhye
4. A Kind of Magic
5. Under Pressure
6. Another One Bites the Dust
7. I Want to Break Free
8. Is This the World We Created…?
9. Bohemian Rhapsody
10. Hammer to Fall
11. Radio Ga Ga
12. We Will Rock You
13. Friends Will Be Friends
14. We Are the Champions
15. God Save the Queen

Knebworth: Queen's Last Concert

What fan of Queen is not able to conjure the image of a Sikorsky S-76 helicopter flying over a crowd that seems to stretch out as far as the eye can see? We can see it crossing the sky above a huge audience from all over the United Kingdom, before it finally lands on the grass at Knebworth House, located close to the quiet town of Stevenage, about forty miles or so north of London. These famous images, filmed using a camera positioned just a few meters away, traveled all around the world. On the side of the helicopter, one can make out the inscription *Queen—A Kind of Magic,* and on board: the masters of the universe. The roads into Knebworth Park were jammed with thousands of vehicles converging on the venue, and the helicopter was the only way the band could get backstage. This sea of humanity was not unlike the crowds seen at Woodstock in the summer of 1969. As one might have expected, this concert was going to be an exceptional event.

This was August 9, 1986. For Queen this was the last stop on the "Magic Tour," and Freddie Mercury, Roger Taylor, Brian May, and John Deacon did not realize that this was going to be the last concert they would ever play together. The tension among the group was palpable, and the show was proportionate in scale to the reputation of these kings of rock: massive and extravagant. Most of the numbers from *Live Magic* are taken from this one evening, which was sadly marred by the death of a young fan who was stabbed to death by a gang of attackers.

Memories of a Final Year on the Road

The fifteen numbers featured on this album were all chosen from concerts performed in 1986, specifically at England's Wembley Stadium on July 11 and 12, at the Népstadion in Budapest on July 27, and at Knebworth Park on August 9.

Like *Live Killers* before it, the album had to synthesize the group's progress through its most famous songs. But as the group began to put the disc together at the Town House studios in London on November 10, 1986, Queen and Trip Khalaf, the group's front-of-house engineer now in charge of production for the live album, faced a seemingly insolvable problem. It was impossible to include all the songs they selected on a single album. Refusing to eliminate any from the track listing, the team decided to

Freddie arriving by helicopter at the site of the Knebworth concert, August 9, 1986.

edit down some of them, though dicing the songs would be deemed sacrilege by some. "Bohemian Rhapsody" had its middle cut (which can be heard—or not—at 2:25) and other tracks suffered a similar fate, effectively losing the character and the spirit of the concerts. In the end, the resulting album was patchy, and for a group that had rebelled against the poorly edited American version of their single "Liar" in 1974, such an artistic choice seemed clumsy. The mixing sessions ended in the small hours of the morning on November 12, and the tapes were then sent straight off to EMI. The disc was released on December 1, 1986.

Despite its defects, *Live Magic* is a fascinating record of a crazy year, where everything the band did was over the top and massive, and during which the group had the world at its feet.

LIVE ALBUM

Freddie electrifies a crowd of eighty thousand at Wembley Stadium on July 11, 1986.

ALBUM

THE MIRACLE

Party . Khashoggi's Ship . The Miracle . I Want It All . The Invisible Man . Breakthru . Rain Must Fall . Scandal . My Baby Does Me . Was It All Worth It

RELEASE DATES
United Kingdom: May 22, 1989
Reference: Parlophone—PCSD 107
United States: June 6, 1989
Reference: Capitol Records—C1-92357
Best UK Chart Ranking: 1
Best US Chart Ranking: 24

(Right) John, Brian, Freddie, and Roger with BBC Radio 1's DJ Mike Read in March 1989.

(Next page) Freddie Mercury and Montserrat Caballé singing "Barcelona" at the Ku Club in Ibiza on May 29, 1987.

BACK TOGETHER AGAIN

Queen took a break in 1987. The twelve months running up to the huge Knebworth concert of August 9, 1986—the culmination of their "Magic Tour," Queen's triumphant last tour with Freddie Mercury—took a heavy toll on each member of the group. Although it marked a revival of their success and recognition, no future recording sessions or concerts were planned. Taking advantage of this time off, each member was once again taken up with his own projects. Brian May explained later: "We said, 'Right we're going to take a little break.' We didn't split up, but we just needed some space for ourselves, and when the time is right, we'll make the album."[147]

But the clouds were gathering. By the beginning of 1987, Freddie Mercury was no longer in any doubt about his state of health. With the confirmation that he was HIV-positive, he decided to rest in his London house, Garden Lodge, and to concentrate on his collaboration with the Spanish soprano Montserrat Caballé (see page 373). This period was made more difficult when his private life made the headlines of the sensationalist daily British tabloid newspaper the *Sun*, thanks to the revelations of his former personal manager, Paul Prenter. Mercury had recently sacked Prenter after finally becoming aware of his manager's bad influence. For four days in succession beginning on May 7, the paper offered its readers a grotesque caricature of Freddie Mercury, with details of his sex life and coverage of every type of excess in which the singer had apparently indulged. It was a shock, but, as usual, Freddie ignored the journalists and, at the end of the month, flew to Ibiza to meet up with Montserrat Caballé to launch their first single disc, "Barcelona."

Brian May was also in the midst of an emotional crisis: "I split from my wife and kids, which was the worst of all, because my whole image of myself was based on being a husband and father. I fell apart. I became very depressed, incapable of doing almost anything. Getting out of bed was hard."[148] The guitarist found solace in his work, most significantly as a producer of the album *Talking of Love* by Anita Dobson, the actress with whom he had begun a relationship. The tabloids feasted on the revelations of this new love affair, especially since Anita Dobson was very famous at the time for her role as Angie Watts on the popular BBC series *EastEnders*. Mercury's problems with the *Sun*, coupled with his own persecution by journalists, inspired May to write a song aimed at the British press: "Scandal."

At the same time, Roger Taylor was hard at work at Mountain Studios preparing his third album under the name of his new group, the Cross. Working along with Taylor were Queen's keyboard player, Spike Edney, and other musicians whom Taylor had recruited by means of a small anonymous advertisement taken out in the music press.

Thus, 1987 was something of a blank for Queen, but it was not long before Mercury felt called upon to rally his troops. He suggested to his friends that they get together to work on a follow up to *A Kind of Magic*.

400 THE MIRACLE

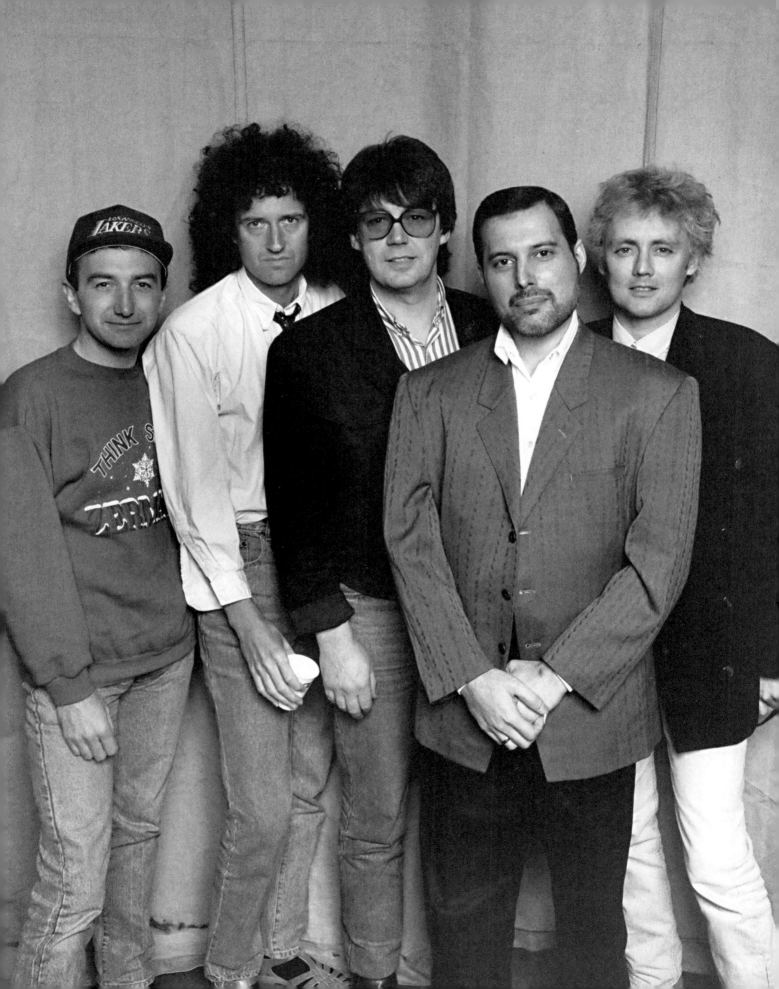

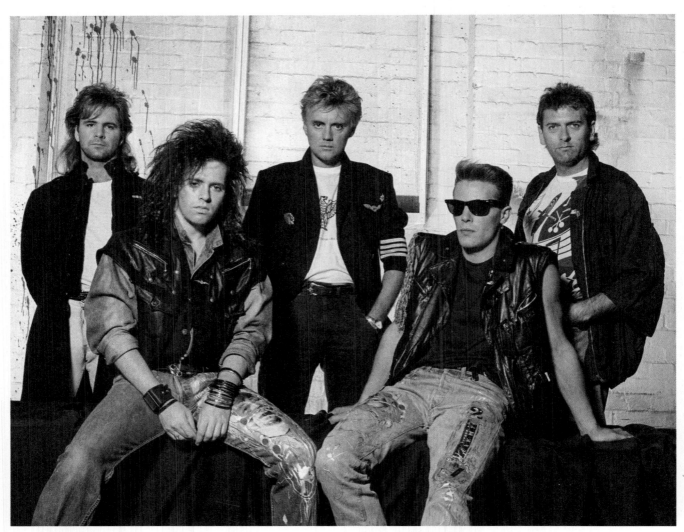
Roger Taylor and the other members of his band, the Cross: keyboardist Spike Edney, guitarist Clayton Moss, bass guitarist Peter Noone, and drummer Josh Macrae.

Queen Returns to the Early Days

In January 1988, the group met at Olympic Sound Studios in London. Roger Taylor's trusted collaborator, producer David Richards of Mountain Studios in Montreux, was brought on to co-produce the new album. Two important decisions were made. First, all songs would now be attributed to the entire group so as to allow for a more equitable sharing of royalties. That did not imply, however, that all the songs were created collectively by the four musicians; the majority of the songs were composed by individual members or sometimes by two or three members working together. Brian May was to comment: "We made a decision that we should have made fifteen years ago. We decided that we'd write as Queen, that we would credit everything to the four of us [...]. It also helps when you choose singles, because it's difficult to be dispassionate about a song that's purely of your own making."[14] Second, it was decided that the members of the group would all work together during the recording sessions rather than breaking off into pairs, as had been the case with the preceding album. May recalled: "It was like the old days, with all of us there and plenty of arguments, but constructive ones."[5] These working conditions favored the creativity of a group that was more closely bonded than ever. By February 1988, they had already come up with twenty-two ideas for songs.

It was not until recording for the album was under way that Freddie told the group about the state of his health. Brian May recalled later: "As soon as we realized Freddie was ill, we clustered around him like a protective shell. We were lying to everyone, even our own families, because he didn't want the world intruding on his struggle. He used to say, 'I don't want people buying our f—ing records out of sympathy.' We all became very close. We grew up a lot." He also said, "We never talked about it and it was a sort of unwritten law that we didn't, because Freddie didn't want to."[148]

The recording sessions lasted for two or three weeks at a time and were spread over twelve months in total so that Freddie could rest between sessions. While most of the sessions took place at Olympic Studios and the Town House in London, a few were completed in Montreux at Mountain

Freddie Mercury on the tennis court at Ibiza's Pikes Hotel in May 1987.

Three weeks before it came out, the album had the working title of *The Invisible Man*. Roger Taylor was the main composer of the original title song and has conceded that *The Miracle* corresponds more closely to the spirit of the disc.

Studios, the reason being, as Brian May explained: "It became difficult to work in London because there was such a terrible focus and attention on [Freddie]. People were sticking cameras through his toilet windows [...]. Montreux was a much more peaceful place to work, so we ended up a lot of stuff there."[22]

His Family Around Him

In January 1989, Queen's thirteenth album—a digest of rock ("Scandal," "Khashoggi's Ship," "Breakthru"), and heavy rock tracks ("I Want It All," "Was It All Worth It")—was complete. When *The Miracle* came out on May 22, 1989, it was preceded by the first single, "I Want It All," and Roger and Brian took on the job of promoting the disc. Evading journalists' questions about Freddie's health, the two musicians concentrated on the album's qualities, showcasing a tightly united group performing memorable rock songs in a worthy return to their earlier years. If anyone mentioned their singer, they lied, asserting that he was fine.

The highly original album sleeve shows the faces of the four musicians electronically manipulated and merged into one. The image was created by designer Richard Gray and his technician, Richard Baker, who produced this photomontage from photographs taken by Simon Fowler. The result is surprising but entirely suited to the spirit of the album. The musicians had become a single entity, and this is apparent throughout the album, the effect of which is both powerful and moving. It is the portrait of a family united, one described by Brian May: "The group tends to be the most stable family we've got, although it's hard to see how we've stayed together all this time. Roger is the most extreme in extravagance and the rock 'n' roll lifestyle. Freddie is a mystery, nobody ever knows quite where he's coming from. John, too, [is] the archetypal quiet bass player—he can be incredibly considerate and inexplicably rude, make someone curl up and die with a couple of sentences. He's very strange, but he's the leader on the business side [...]. And me, I think the others would tell you I'm the most pig-headed member of the band and I can see it in myself."[149]

PARTY

Freddie Mercury, Brian May, John Deacon, Roger Taylor / 2:24

Musicians
Freddie Mercury: lead vocals, backing vocals, piano, synthesizers, programming
Brian May: electric guitar, backing vocals
Roger Taylor: drums, programming, backing vocals
John Deacon: bass, electric guitar

Recorded
Olympic Sound Studios, London: January–February 1988, January 1989
The Town House, London: April–May 1988
Mountain Studios, Montreux: September 1988

Technical Team
Producers: Queen, David Richards
Sound Engineer: David Richards

Freddie in the arms of the amazing dancer and choreographer Wayne Sleep, at the London premiere of the musical *42nd Street*, on August 8, 1984.

Genesis

Sequencing an album is not an easy thing to do. It requires an understanding of the structure of a disc: an introduction that makes you sit up and listen, then, from the second track onward, tunes that carry the album along in the same way a movie progresses, with action, suspense, tenderness and, finally, a dramatic finale. Queen chose an energetic piece for the introduction to this long-awaited disc, which was their first in three years. Here, Freddie as lead singer recalls a party he had been at the night before: "*We had a good night jamming away / There was a full moon showing / And we wanted to play.*" But beneath the apparently light-hearted surface, "Party" contains a more subtle message; each verse concludes with a melancholy evocation of the day after: "*But in the cold light of day next morning / Party was over,*" and "*Everybody's gone away.*" The song sets the tone: the party is over. This is the paradox of *The Miracle*: the group appears with its old unity intact, presenting a number of songs that are truly exceptional, but it was also a time of reckoning for Freddie. Later, in the album's last track, "Was It All Worth It," Freddie gives his answer to the questions raised in "Party": "*Yes it was a worthwhile experience / It was worth it.*"

Production

The guitar riffs in "Party" are impressive, the compulsive rhythm programmed on a Linn 9000, the most recent of the Linn drum machines. Unfortunately, after the considerable advantages offered by the Linn LM-1 and the LinnDrum, used in much of the pop music of the early 1980s, the Linn 9000 produced thin and uninteresting sounds that were no better than those available from an entry-level electric keyboard of the period. As a result, there is little difference between the rhythm section of "Party" and that of the great Donna Summer's disappointing "This Time I Know It's for Real," which came out in the same year. This probably explains why Roger Taylor went back to his drums for the other tracks on the album. A wise decision.

KHASHOGGI'S SHIP
Freddie Mercury, Brian May, John Deacon, Roger Taylor / 2:47

Musicians
 Freddie Mercury: lead vocals, backing vocals, synthesizers
 Brian May: electric guitar
 Roger Taylor: drums, percussions
 John Deacon: bass

Recorded
 Olympic Sound Studios, London: November 1988, January 1989

Technical Team
 Producers: Queen, David Richards
 Sound Engineer: David Richards

> Listening to the extraordinary *Pornograffitti* by Extreme—the only group at the time that could be seen as Queen's heirs—it would appear that tracks like "He-Man Woman Hater" and "Get the Funk Out," which were written in August of 1990, were heavily influenced by "Khashoggi's Ship," with its four-square rhythm and guitar alternating between silences and powerful riffs.

Genesis

If "Party" emphasized the less appealing aspects of the so-called day after, Mercury shows the other side of the coin right from the first words of "Khashoggi's Ship," asking: *"Who said that my party was all over / I'm in pretty good shape."* In this song, attributed mainly to Brian May, the narrator describes his holiday on board the ship belonging to the Saudi millionaire Adnan Khashoggi, who became famous in the 1980s not only for the arms contracts to which he owed his wealth but also for his extravagant and luxurious lifestyle. May admitted later that the song's description could equally well have applied to his own, everyday life as a rock star: "We feel that we've touched on those areas at some time. We've been through it."[14] The ship in the song was, at that time, the longest private yacht in the world at 280 feet, and it came equipped with a nightclub, eleven luxury suites, and a swimming pool, providing all the necessary comforts for the millionaire's world-famous parties. Originally called *Nabila* after Khashoggi's daughter, the yacht was sold to the sultan of Brunei when Khashoggi fell from grace in 1988. The party was over for him, too.

Production

Here the group was able to show that it was truly back in top form. When the first recording sessions got under way, Roger Taylor commented: "It's more back to the old style. I mean it's almost like echoes of Led Zeppelin and everything in there. It's great and it's all live in the studio, which is great. It gives it more spark and energy, I think."[153] Listening to May's emphatic and dominant guitar playing, we are bound to agree.

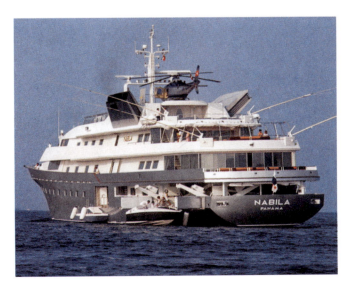

Adnan Khashoggi's yacht, *Nabila*, on the Côte d'Azur in July 1983.

THE MIRACLE

Freddie Mercury, Brian May, John Deacon, Roger Taylor / 5:01

Musicians
Freddie Mercury: lead vocals, backing vocals, piano, synthesizers
Brian May: electric guitar, backing vocals
John Deacon: bass
Roger Taylor: drums, backing vocals

Recorded
Olympic Sound Studios, London: January–February 1988, November 1988, January 1989
The Town House, London April–May 1988
Mountain Studios, Montreux: September 1988

Technical Team
Producers: Queen, David Richards
Sound Engineer: David Richards

Single (45 rpm)
Side A: The Miracle / 5:01
Side B: Stone Cold Crazy (Live at the Rainbow Theatre, 1974) / 2:12
UK Release on Parlophone: November 27, 1989 (ref. QUEEN 15)

Single (CD)
1. The Miracle / 5:01
2. Stone Cold Crazy (Live at the Rainbow Theatre, 1974) / 2:12
3. My Melancholy Blues (Live from the Summit, Houston 1977) / 3:48

UK Release on Parlophone November 27, 1989 (ref. CDQUEEN 15)
Best UK Chart Ranking: 21

Genesis

"The Miracle" is the kind of song that Freddie Mercury had been writing since the early '80s. It has idealistic elements, the words speaking of a better world without wars and praising the miracles of nature and the creations of humankind. Names and places are mentioned and appear in no particular order: Jimi Hendrix, the Hanging Gardens of Babylon, and the explorer James Cook are all mentioned. The recording sessions were therapeutic, with the group feeling more united than ever. Brian said about those days: "I remember the joy we had in the studio: it was one of those moments where we really did work together, all four of us, on the ideas, building it up, painting the picture, as if we all had brushes in our hands with different colors."[5]

The song was panned by the British rock press, who called the musicians dreamers with a naive message. Brian May commented: "We got pasted to the wall for this in England. Everybody hated it, for some reason. It's very uncool to be idealistic in Britain, I suppose, at the moment, and they said, 'How can they talk about peace?' and all that sort of stuff, then of course, China happened [Tian'anmen Square] and everything. It seems very relevant to us."[154] Roger Taylor added: "In England 'idealism' is 'naivety,' which is wrong, it's not. There's nothing wrong with idealism. Nick Lowe wrote that great song, great title—'What's so bad about peace, love and understanding,' yeah, and what is so bad about it?"[154] While the track is perhaps rather unvaried overall, it's hard not to be touched by the quality of the musicianship and evident sincerity of the words sung by Mercury, almost as a cry for help, *"It's the miracle we need / The miracle we're all waiting for today."*

The Video

For the song's video, the group once again turned to the Torpedo Twins, Rudi Dolezal and Hannes Rossacher, who had produced the videos for "One Vision" and "Friends Will Be Friends." Filmed at Elstree Studios in London on November 23, 1989, the video retraces Queen's stage performances. Standing in for the musicians are children, dressed in the various clothes worn by Queen at different

Queen and their doubles during the filming of the video for "The Miracle" on November 23, 1989. (Left to Right): Paul Howard, James Currie, Ross McCall, and Adam Gladdish.

periods in their career. Their ability to imitate the group is astonishing. "We were prepared for it to be good but we were still quite shocked and stunned how good these young guys were."[155] A nationwide search was undertaken for budding actors resembling the members of Queen. John Deacon was played by James Currie, Roger Taylor by Adam Gladdish, Brian May by Paul Howard, and Freddie Mercury by Ross McCall, the latter of whom would go on to appear in the successful 2001 HBO series *Band of Brothers*, produced by Tom Hanks and Steven Spielberg.

Production

With its delicate introduction of staccato notes on the synthesizer, "The Miracle" provides a transition on the album between the angry "Khashoggi's Ship" and the devastating "I Want It All." As in "Is This the World We Created…?" or "One Vision," Mercury uses the song to express his desire for friendship between peoples and to build a better world. Although the message is a gentle one, the singer's voice is forceful, reinforced by vocals from May and Taylor, who contribute to the choruses with evident gusto. David Richards, the disc's co-producer, revealed his infallible technique for bringing out the best of the group's vocals: "As far as the vocals are concerned, I sometimes use an old Fairchild valve compressor to warm things up, because modern consoles like the SSL can sound too clean, and if you're not careful you'll get a very garish sound."[156]

I WANT IT ALL

Freddie Mercury, Brian May, John Deacon, Roger Taylor / 4:41

Musicians
Freddie Mercury: lead vocals, backing vocals
Brian May: lead vocals, backing vocals, electric and acoustic guitars
Roger Taylor: drums, backing vocals
John Deacon: bass

Recorded
Olympic Sound Studios, London: January–February 1988, November 1988, January 1989
The Town House, London: April–May 1988
Mountain Studios, Montreux: September 1988

Technical Team
Producers: Queen, David Richards
Sound Engineer: David Richards

Single (45 rpm)
Side A: I Want It All (Single Version) / 4:00
Side B: Hang On in There (Single Edit) / 3:43
UK Release on Parlophone: May 2, 1989 (ref. QUEEN 10)
US Release on Capitol Records: May 10, 1989 (B-44372)

Single (CD)
1. I Want It All / 4:41
2. Hang On in There (Single Edit) / 3:43
3. I Want It All (Single Version) / 4:00

UK Release on Parlophone: May 2, 1989 (ref. CDQUEEN 10)
Best UK Chart Ranking: 3
Best US Chart Ranking: 50

FOR QUEEN ADDICTS

Norman Sheffield, founder of Trident and producer of Queen's early albums, has claimed that the title of the song was inspired by a visit from Mercury to his office. Demanding an advance on payment due to him, he is supposed to have said, "I am not prepared to wait any longer. I want it all. I want it now!"[158]

Genesis

The majority of the tracks on *The Miracle* were composed co-operatively by all four members of the group. "I Want It All" is an exception. This unrepentant piece of rock 'n' roll was composed by Brian May, who later related how he had come up with the idea for the song while pulling up weeds in his garden in Los Angeles. The first song from *The Miracle* to be completed, it owes its title to an expression used by Brian May's new partner, the actress Anita Dobson, who frequently said "I want it all, and I want it now!" She was, May said, "a very ambitious girl."[14]

The heavy rock style of the track once again reminds us that the members of Queen were early proponents of this genre, though the scene had since become dominated by Joe Satriani, Dream Theater, and, of course, Iron Maiden. Brian May said at the time: "It re-establishes our old image in a way. It's nice to come back with something strong that reminds people we're a live group."[14]

This song was the first single to come from the album, though the selection had not been an easy choice. As Brian May commented, "Out of the whole process of making an album, choosing the first single is probably the hardest bit of all. It's always really dreadfully difficult to know what to put out. [...] So I suppose yes, it was democratic, we also tried to get a few other people's input, you know, people in the business, friends, people in the record companies that we work with the whole time. And in the end you never know if you've made the right decision."[157]

A video was created by David Mallet at Elstree Film Studios in April 1989, showing the group onstage, proudly defying the critics. Freddie Mercury is noticeably weak, his face hidden behind a short beard that concealed the lesions on his skin, which were caused by his illness. Peter Freestone, Freddie's personal assistant, would later write "Watching [the video] now, I get the impression that Freddie didn't really want to be there."[113]

Production

While the single version of "I Want It All" begins with the chorus sung a cappella, the album version has an introduction played on acoustic guitar. This stops as Brian May's riff on guitar begins, accompanied by ear-splitting percussion

410 THE MIRACLE

Brian May's Red Special is notable for its adaptability, whether it's used for the baroque rock of the 1970s or the heavy riffs on "I Want It All."

from Taylor. The song is constructed as a midtempo ballad up to the chorus, which May intended to be sung by thousands of voices in the same way as the group had done on "We Will Rock You." Sadly, it was never performed live by Freddie Mercury. May sings part of the bridging section at 2:18, following it with a guitar solo consisting of two parts. First, he accompanies the song and its melody in the best hard rock FM ballad tradition. At 3:07, Taylor's drums are unleashed in a pattern borrowed from Metallica's thrash metal style, giving the impression that drummer Lars Ulrich and his guitarist partner Kirk Hammett have dropped in to assist. There follows a second, classic solo from May, fast and powerfully rhythmical. Only the return of the synthesizers at 3:20 reminds us that we are not listening to Metallica's classic "Master of Puppets."

The break that follows, where the lead singer and drums lead the way, is also clearly written with Queen's massive concerts in mind. What an unforgettable moment that would have been, with an audience of 150,000 in a place like Knebworth echoing the passage in one voice and clapping in unison to accompany Roger's snare drum! But the song never came alive in this way onstage; Freddie, now much weaker, had decided to stop touring. Brian May very much missed appearing live, voicing his frustration in an interview in 1989: "Once you adapt to the lifestyle [...], I think it's something which becomes part of your life, and when it's taken away [...] you're suddenly back to responsibilities and you can't think 'Oh I can stick with this for the next couple of weeks, 'cause I'm going to be on tour soon,' you think, 'This is life,' and it became very hard."[154]

QUEEN: ALL THE SONGS 411

SINGLE

THE INVISIBLE MAN
Freddie Mercury, Brian May, John Deacon, Roger Taylor / 3:57

> Roger Taylor once again turned to literature for ideas while writing "The Invisible Man." This time he drew inspiration from the novel by H. G. Wells in 1897.

Musicians
Freddie Mercury: lead vocals
Brian May: guitar
Roger Taylor: lead vocals, backing vocals, drums, synthesizers, electronic drums, programming
John Deacon: bass
David Richards: synthesizers

Recorded
Mountain Studios, Montreux: August 1988
Olympic Sound Studios, London: November 1988, January 1989

Technical Team
Producers: Queen, David Richards
Sound Engineer: David Richards

Single (45 rpm)
Side A: The Invisible Man / 3:57
Side B: Hijack My Heart / 4:11
UK Release on Parlophone: August 12, 1989 (ref. QUEEN 12)

Single (CD)
1. The Invisible Man (12-inch Version) / 5:29
2. Hijack My Heart / 4:11
3. The Invisible Man / 3:57
UK Release on Parlophone: August 12, 1989 (ref. CDQUEEN 12)
Best UK Chart Ranking: 12

ON YOUR HEADPHONES
Each member of Queen is introduced as they enter the song. Roger announces Freddie's entry at 0:17, then Freddie introduces John at 0:54, Brian at 2:10, and Roger at 3:12.

Genesis

"The Invisible Man" takes us into the imaginary fantasy world so beloved by Roger Taylor, who was chiefly responsible for this song's composition. Inspired by the novel of the same name by H. G. Wells, the song speaks to the invisible man's presence among us, a character who is both frightening and impossible to capture. "I'm to blame for that one, sort of, but everybody came in and that went through quite a few changes, due to everybody else putting in different bits, and restructuring it, etc, etc. [...] I don't quite remember where the ideas did come from. I think it came from a book I was reading, and it just seemed to fit in with a rhythmic pattern I had in mind."[157] While some detractors were quick to point out that there were similarities between "The Invisible Man" and Ray Parker Jr.'s hit "Ghostbusters," the rumor was not pursued. In fact, with "Ghostbusters," Parker had already been sued for very obviously plagiarizing Huey Lewis and the News's "I Want a New Drug." The episode was settled with a financial arrangement and a confidentiality clause between the two parties.

The video for "The Invisible Man" was produced by the now-indispensable Torpedo Twins (Rudi Dolezal and Hannes Rossacher) at the Pinewood Studios in London on July 26, 1989—Roger Taylor's fortieth birthday—and was much praised for its visual effects. We see the members of Queen first as figures in a video game and then appearing in person in the bedroom of a young boy sitting at his computer. One particularly effective section shows multiple Brian Mays playing a magnificent solo while laser rays shoot out of his Red Special.

Production

Roger Taylor's contribution on this song is unusual. Each sound from his drum kit was recorded separately, stored, and then used as a sample, controlled by the Linn 9000 drum machine. David Richards, the disc's co-producer, described how and why this was done: "It sounds a bit purist but it's worth doing in the end—if you use other people's sounds you'll soon lose the identity of the band. I just carry around a PCM tape of various drums and we sample them and trigger them from the real drums or from the Linn."[156]

412 THE MIRACLE

SINGLE

BREAKTHRU
Freddie Mercury, Brian May, John Deacon, Roger Taylor / 4:07

Musicians
Freddie Mercury: lead vocals, backing vocals, synthesizers
Brian May: electric guitar, backing vocals
Roger Taylor: drums, synthesizers, programming
John Deacon: bass
David Richards: keyboards, synthesizers, programming

Recorded
Olympic Sound Studios, London: Late 1988–January 1989

Technical Team
Producers: Queen, David Richards
Sound Engineer: David Richards

Single (45 rpm)
Side A: Breakthru / 4:07
Side B: Stealin' / 3:58 (Parlophone); Breakthru / 4:07 (Capitol Records)
UK Release on Parlophone: June 19, 1989 (ref. QUEEN 11)

Single (CD)
1. Breakthru (12-inch Version) / 5:44
2. Stealin' / 3:58
3. Breakthru / 4:08

UK Release on Parlophone: June 19, 1989 (ref. CD QUEEN 11)
Best UK Chart Ranking: 7
Best US Chart Ranking: Not Ranked

Genesis
Bearing a passing resemblance to AC/DC's "Whole Lotta Rosie," the strongly rhythmic motif of "Breakthru" gave Roger Taylor the idea of a train hurtling across a plain, as visualized in the Torpedo Twins' video. John Deacon explains: "We'd just been listening to the song, you know, pootoo pootoo pootootoo, and he had the suggestion of like an express train. Then I think Freddie and I came up with the idea of having a train and calling it 'The Miracle Express,' [and] it just went from there. I looked at the possibility of doing it, and it was possible so we had a go!"[147] The actress who features at the beginning of the video was Deborah Leng, Roger's new girlfriend, made famous in the UK in 1987 for her appearance in a highly sensual advert for Cadbury's Flake. Throughout the "Breakthru" video, we see the musicians performing the song on the open air deck of a railroad car, defying the laws of gravity. Brian May was to comment later: "I suppose you imagine these things are done by trickery, but we actually were on top of this train, going about 40 or 50 mph! So you have to have incredible trust. If the driver had had to change speed even a tiny bit, we would have been off that thing and dead! So once we forgot that the train was moving and developed a sort of trust in the driver, we just behaved as normal."[159]

Production
Once again, listeners underlined the resemblance of Queen's song to a hit written by another performer. This time, they were thinking of "The Boys of Summer" by the American singer Don Henley. While there are some similarities in the song's refrain, it could not be described as plagiarism, and the comparison was quickly forgotten in light of the quality of Queen's song. For the introduction, Freddie brings in a melody called "A New Life Is Born" which had already been sketched out while working on *The Miracle*. Having gotten no further than the demo stage, the song now seemed ideal for the introduction to "Breakthru." Queen fans were able to recognize a chord sequence already used for the introduction to "Lily of the Valley" from the *Sheer Heart Attack* album.

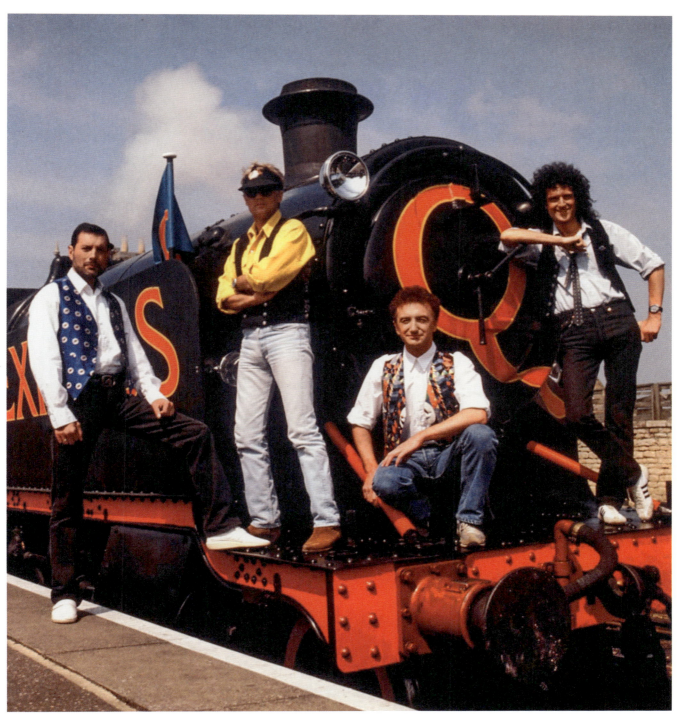

Freddie Mercury, Roger Taylor, John Deacon, and Brian May on the "Miracle Express" train during the filming of the video for "Breakthru," produced by the Torpedo Twins.

QUEEN: ALL THE SONGS 415

RAIN MUST FALL

Freddie Mercury, Brian May, John Deacon, Roger Taylor / 4:22

Musicians
Freddie Mercury: lead vocals, backing vocals, synthesizers
Brian May: electric guitar
Roger Taylor: electronic drums
John Deacon: bass, electric guitar, synthesizers
David Richards: programming

Recorded
Olympic Sound Studios, London: January–February 1988, November 1988, January 1989
The Town House, London: April–May 1988
Mountain Studios, Montreux: September 1988

Technical Team
Producers: Queen, David Richards
Sound Engineer: David Richards

Genesis

After the wealth of virtuoso guitar playing on the first few tracks of the album, this moment is reserved for John Deacon and a calypso-like song typical of his light and cheerful style. British critics might have poured scorn on this undemanding summer-holiday song, but it is irresistible. The tune is instantly memorable, not unlike "Pain Is So Close to Pleasure," another song coauthored with Mercury on the album *A Kind of Magic*. But beneath its summery tone, the song conceals a more complex message. Mercury sings: *"Your every day is full of sunshine / But into every life a little rain must fall."* In his book *The Dead Straight Guide to Queen*, Phil Chapman has pointed out that these words are probably influenced by the poem "The Rainy Day," written by Henry Wadsworth Longfellow in 1842, which concludes like this: "Into each life some rain must fall, / Some days must be dark and dreary." "Rain Must Fall" exemplifies the paradox of *The Miracle* as a whole: Seemingly positive and bright, the songs conceal a more somber truth, one that intimately involved Freddie Mercury and, by extension, all his friends. In light of all of this, "Rain Must Fall" is still a lighthearted song, as are all those written by John Deacon. He defended this stance, saying: "We are musicians and entertainers as well. And I think that's something sometimes people don't see, but we actually believe a lot of what we do is entertainment. We're not terribly ultra serious [...]. That's what people want sometimes. If you've been working all day, you want something that is entertaining, [...] you know...something to get lost in."[147]

Production

Fans have always criticized their favorite rock groups when they stray into enemy territory, and Queen's incursion into Caribbean rhythms on "Rain Must Fall" did not escape censure. Blondie's 1982 song "Island of Lost Souls" had the group going for an upbeat calypso style, and it received a similarly lukewarm reception.

Deacon is omnipresent in "Rain Must Fall," not only playing the rhythm guitar but also the synthesizers. Although Roger Taylor uses electronic percussion in many passages, it was David Richards, the co-producer of the

416 THE MIRACLE

Florence Griffith Joyner at the Olympic Stadium in Seoul during the 1988 Summer Olympics.

album, who took charge of programming the rhythm section. He commented, "I did the drums and the sequencing on the Linn 9000. [...] I find the Linn stops you getting too involved, otherwise you can spend hours shifting notes around."[156]

Brian May, absent for most of the track, has a virtuoso solo at 1:43, introduced by Mercury, who shouts "Flo Jo!" That was the nickname of the well-known sprinter Florence Griffith Joyner. In the summer of 1988, when Queen was recording "Rain Must Fall," she was in the news for her historic performances at the Olympic Games in Seoul, South Korea. Her success was considerably tarnished by accusations of drug usage, a scandal whipped up by the tabloids. The album *The Miracle* regularly addressed the attacks directed at the group by the press, and here Freddie seems to be lending his support to the young sportswoman whom he saw as another victim of the witch hunts fostered by British journalists.

QUEEN: ALL THE SONGS 417

SCANDAL

Freddie Mercury, Brian May, John Deacon, Roger Taylor / 4:42

Musicians
Freddie Mercury: lead vocals, backing vocals
Brian May: electric guitar, synthesizers
Roger Taylor: drums, vibraslap
John Deacon: bass

Recorded
Olympic Sound Studios, London: Late 1988—January 1989

Technical Team
Producers: Queen, David Richards
Sound Engineer: David Richards

Single (45 rpm)
Side A: Scandal / 4:42
Side B: My Life Has Been Saved (Original 1989 Version) / 3:17
UK Release on Parlophone: October 9, 1989 (ref. QUEEN 14)
Best UK Chart Ranking: 25

Single (CD)
1. Scandal (12-inch Version) / 6:23
2. My Life Has Been Saved (Original 1989 Version) / 3:17
3. Scandal / 4:42
UK Release on Parlophone: October 9, 1989 (ref. CD QUEEN 14)

Genesis

Having been the object of abuse for some time, it was not surprising that Queen finally produced a song directed at the British press. Brian May was not aiming at the rock magazines with his composition, but at the tabloids that made their money by exposing the private lives of celebrities. The members of Queen had recently been the target of such papers. After revelations from Paul Prenter, Freddie Mercury's disaffected one-time personal manager, the singer saw his private life splashed over the front pages of the *Sun* for four days in a row. The journalists' next victim was Brian May, whose every action and gesture was spied on in the hope of revealing his relationship with the actress Anita Dobson. He responded angrily: "It's something which has affected us, individually, as members of the group recently. It's very strange, 'cause we were fairly famous for a long time in England, […] but we didn't become a prey to these kind of scummy papers until recently. And it's not related to what you are doing, you know. They are not interested what music you play, or anything. They just want the dirt, and if they can't find any they'll invent it if they choose to pick on you."[154]

Already badly affected by the death of his father and the end of his marriage, May was going through a bad period at the time. "To contemplate not waking up with your kids is unthinkable. Anyone who finds themselves in that position can never forgive themselves, but I know in my heart that there was no other way."[44] Revelations in the *Daily Mirror* and its sister papers contributed to his already deep depression: "It actually screwed me up completely. For nearly a year I was incapable, so depressed. It wasn't all because of the papers, but they don't help."[14] In 1992, he ripped up pages of the *Daily Mirror* as a gesture of protest in the *Good Morning Britain* television studio.

"Scandal" is still one of the most underrated numbers in Queen's repertoire. Its release as a single on October 9, 1989, ought to have assured its lasting fame, but it did nothing of the kind. The song was even removed from the track listing of the successful compilation *Greatest Hits 2* (1991);

Freddie in a clip from the music video for "Scandal," a largely underrated Queen single.

the group never seemed to have been greatly interested in the track despite its many qualities.

The filming of the video by the Torpedo Twins at Pinewood Studios in October was not a moment the group remembered with pleasure. Roger Taylor's comment was: "Not one of my favorite songs, one of the most boring videos we ever made. Don't remember much about it, I just remember being bored. Didn't do anything for me, and for something called 'Scandal,' it wasn't very scandalous. I think we were going through the motions here."[159]

Production

There is a brilliant riff in "Scandal," played in unison by the synthesizer and the Red Special. Brian May took a great deal of care over this track, producing a precise and powerful musical motif running clearer and purer than ever beneath Mercury's vocal line. The solo, rising over the chorus, then makes way for the vocoder, already used in tracks including "A Human Body" and "Radio Ga Ga," before ending in a fade-out. "Scandal" provides one of the keys to *The Miracle*, an album where joy and suffering are co-mingled, culminating with Mercury's question "Was it all worth it?"

MY BABY DOES ME

Freddie Mercury, Brian May, John Deacon, Roger Taylor / 3:23

Musicians
Freddie Mercury: lead vocals, backing vocals, synthesizers
Brian May: electric guitar
John Deacon: bass, synthesizers
David Richards: programming

Recorded
Olympic Sound Studios, London: January–February 1988, November 1988, January 1989
The Town House, London: April–May 1988
Mountain Studios, Montreux: September 1988

Technical Team
Producers: Queen, David Richards
Sound Engineer: David Richards

Genesis

John Deacon took his role as a composer very seriously. As a member of Queen, he was the calm one, tempering the wild sounds of May's Red Special. This is particularly true on this album, where the guitarist plays a prominent role, his bass emerging again and again on each track much to the great delight of his fans. With "My Baby Does Me," the combination of Deacon and Mercury results in a very peaceful piece reminiscent of soul music and offering a welcome pause before the final track of the album. Mercury made this clear in a 1989 interview: "I wanted something a little more relaxed than the way the other songs were going, [...] there was a lot of guitar input in some songs, and I felt that we didn't have something that was quite sort of pristine [...]. We decided that we should have something with just a very easy backbeat, and something very listenable, and I don't think it was going to go on the album at first. We just decided that would be a nice breather at the end of the second side."[157] And so it is: a summery tune that evokes lying on the beach and sharing a fruity cocktail. Its appearance here, among the other heavy rock tracks of *The Miracle*, is curious, even if its gentle character provides the listener with three minutes and twenty-three seconds of calm.

Production

Acoustic instruments have little place in "My Baby Does Me" (the working title of which was "My Baby Loves Me"). The rhythm is provided by a Linn 9000, the secret of its unique sonority explained by the disc's co-producer, David Richards: "The band wrote 'My Baby Does Me' using a drum machine, and we decided to keep it in; we had two different patterns and I used an SRC (SMPTE Reading Clock) to put them on separate tracks with a slight delay between them. That produced a slight phasing effect, which we decided to keep—it's the most natural type of phasing you can have, and I like that sort of spontaneity."[156]

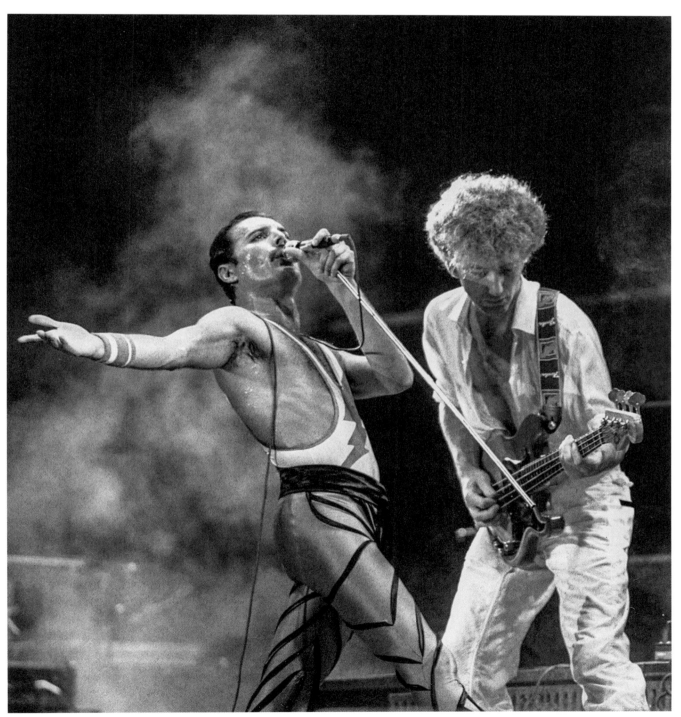
Freddie and John onstage during *The Works* tour in 1984.

WAS IT ALL WORTH IT
Freddie Mercury, Brian May, John Deacon, Roger Taylor / 5:44

Musicians
Freddie Mercury: lead vocals, backing vocals, synthesizers
Brian May: electric guitar, backing vocals, synthesizers
John Deacon: bass
Roger Taylor: drums

Recorded
The Town House, London: April–May 1988
Mountain Studios, Montreux: September 1988
Olympic Sound Studios, London: November 1988, January 1989

Technical Team
Producers: Queen, David Richards
Sound Engineer: David Richards

Genesis
One could not hope for a more majestic finale for *The Miracle*! The album's closing track has it all: power, melody, and a certain mystery. Not surprisingly, this multilayered song is the work of the great Freddie Mercury. The words are serious, assessing life's achievements and finally asking a question: "*What is there left for me to do in this life / Did I achieve what I had set in my sights / Am I a happy man, or is this sinking sand / Was it all worth it?*" At the very end of the piece, the answer seems to be yes, but the questions about the life of a rock star and an existence without restraining limits remain.

For the instrumental parts of the track, the members of Queen sought to return to the working methods they followed in their early days. May described the feeling of unity they experienced when the disc was being promoted: "We made a very conscious decision that the technology wasn't going to take us over, and we were going to keep the human element as far to the front as we could and use the technology to preserve and augment that. [...] We think it's very exciting. We enjoy what we're doing, and the sound reflects us as a group more so than the last few albums. It's not like, sit down with a drum machine and a synthesizer. We played together and we evolved things that seemed to excite us, and then built everything around that."[5]

Production
When *The Miracle* came out in 1989, a new music scene was emerging in Seattle, led by groups like Nirvana, Soundgarden, Alice in Chains, and Pearl Jam. Grunge, like punk in its day, would sweep away established groups, and particularly those whose trademark was heavy usage of the now-despised synthesizer. Although Queen did not sink to imitating the new taste for grunge on *The Miracle*, the earsplitting introduction to "Was It All Worth It" would certainly have reminded the young upstarts in the Pacific Northwest who was boss. With hindsight, it is extraordinary to note how, in the bars between 0:40 and 1:04, everything we find in grunge and fusion in the early 1990s is already present on Queen's track. In less than thirty seconds, and several years early, Queen demonstrates the recipe that would go on to

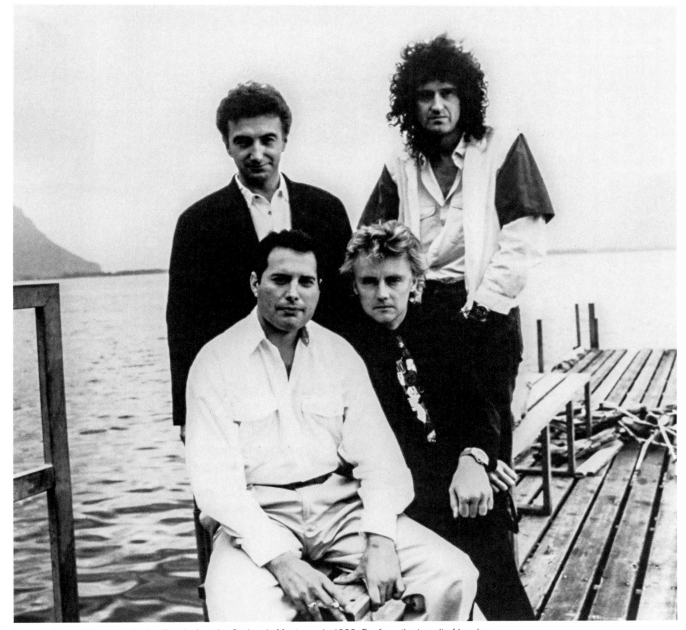

The members of Queen on the landing dock at the Casino de Montreux, in 1988. Far from the tumult of London, Montreux became a place of rest and serenity for Freddie.

inspire groups like Rage Against the Machine and Urban Dance Squad: a modern, powerful sound, free of synthesizer effects and featuring four-square percussion brought out in the mixing, with a repetitive and melodic guitar riff and a bass guitar accompanying it in unison. It's a recipe that works.

The track continues in a more classic style with the introduction of a Kurzweil K250 keyboard at 2:48, imitating a string orchestra, and then takes up the riff with a typically 1980s sound. The most extraordinary section of the track comes, without a doubt, at the break at 4:02, and sounds as if it was intended to illustrate a movie like *Flash Gordon*. In a later interview, Brian May commented: "It is [kitsch], really, and we were conscious of that—which is why there is a little hooter in there, because we thought, my God, we're really getting too overblown here! [...] We did laugh at ourselves."[160]

The group used the large hall of the Barrière Casino in Montreux for the recording, having already recorded their *Jazz* album there in 1978. Co-producer David Richards explained why they had made this choice: "There's a huge concert hall beneath the studio which we can hire for a week, and we take 54 microphone tie-lines [...] down there. We can set drums up on the stage and you can get a very big sound."[156] The orchestral portion was produced entirely on a Kurzweil K250.

QUEEN: ALL THE SONGS 423

OUTTAKES

HANG ON IN THERE

Freddie Mercury, Brian May, John Deacon, Roger Taylor / 3:45

Musicians: Freddie Mercury: lead vocals, backing vocals, piano, synthesizers / **Brian May:** electric guitar, synthesizers / **John Deacon:** bass / **Roger Taylor:** drums / **Recorded:** Olympic Sound Studios, London: January–February 1988, November 1988, January 1989 / **The Town House, London:** April–May 1988 / **Mountain Studios, Montreux:** September 1988 / **Technical Team: Producers:** Queen, David Richards / **Sound Engineer:** David Richards / **Assistant Sound Engineers:** Andrew Bradfield, John Brough, Angelique Cooper, Claude Frider, Andy Mason, Justin Shirley-Smith

The result of a jam session that the group had while working on *The Miracle*, "Hang On in There" sounds like nothing so much as work in progress. Nevertheless, the group makes its personality felt in this piece with vocals that are 100 percent Queen and a fierce and abrupt guitar interjection at 3:02. Brian May commented: "We thought 'Hang On in There' had gotten a bit too obscure. Devotees of the band would get off on it, but it's not regular album material."[14] This piece (the working title of which was "Fiddle Jam") came out on May 2, 1989, on the B-side of the first single taken from the album, "I Want It All."

CHINESE TORTURE

Freddie Mercury, Brian May, John Deacon, Roger Taylor / 1:45

Musicians: Brian May: electric guitar, synthesizers, programming / **Freddie Mercury:** synthesizers, programming / **Roger Taylor:** drums / **Recorded:** Olympic Sound Studios, London: January–February 1988, November 1988, January 1989 / **The Town House, London:** April–May 1988 / **Mountain Studios, Montreux:** September 1988 / **Technical Team: Producers:** Queen, David Richards / **Sound Engineer:** David Richards / **Assistant Sound Engineers:** Andrew Bradfield, John Brough, Angelique Cooper, Claude Frider, Andy Mason, Justin Shirley-Smith

With its short improvisation on the Red Special, "Chinese Torture" is a kind of snapshot, taken during working sessions for "Was It All Worth It." As he did on earlier tracks like "Procession," "God Save the Queen," and "The Wedding March," this instrumental piece was entirely harmonized by Brian May. Unlike the three earlier tracks, where May played one line after another until they were able to make an ensemble worthy of an orchestra, here there is only one line. A harmonizer is applied to the sound, which has the effect of modifying the pitch, thereby doubling the output.

STEALIN'

Freddie Mercury, Brian May, John Deacon, Roger Taylor / 3:58

Musicians: Freddie Mercury: lead vocals, backing vocals, synthesizers / **Brian May:** acoustic guitar / **John Deacon:** bass / **Roger Taylor:** drums / **Recorded:** Unknown / **Technical Team: Producers:** Queen, David Richards / **Sound Engineer:** David Richards

Listening to "Stealin'" is like spying on the group in the middle of a working session. Through the notes of this apparently innocent blues number we can perceive the co-operative method of working used by Queen at this period in their career. Starting with a twelve-string guitar, the song has all the lamenting characteristics of a blues classic. The singer tells of his life as a thief and conman, justifying his crimes by explaining that his financial situation means he can't pay his rent.

The song moves into a jam session where interesting guitar and vocal improvisations mingle together, offering a fascinating fragment rather than a fully realized Queen track.

HIJACK MY HEART

Freddie Mercury, Brian May, John Deacon, Roger Taylor / 4:11

Musicians: Roger Taylor: lead vocals, drums, percussions, synthesizers / **Brian May:** electric guitar / **Recorded:** Olympic Sound Studios, London: January–February 1988, November 1988, January 1989 / **The Town House, London:** April–May 1988 / **Mountain Studios, Montreux:** September 1988 / **Technical Team: Producers:** Queen, David Richards / **Sound Engineer:** David Richards / **Assistant Sound Engineers:** Andrew Bradfield, John Brough, Angelique Cooper, Claude Frider, Andy Mason, Justin Shirley-Smith

Not so much a co-operative work for all four members of the group as some of the other tracks on *The Miracle*, this piece was very personal to Roger Taylor. All his favorite themes are present: pretty women in fast cars, unexpected encounters, the joys of falling in love, and the pleasure of knowing that something new can happen at any moment. The track has more in common with the musical universe of Taylor's solo albums—*Fun in Space* or *Strange Frontier*—than with Queen.

Brian during a recording session for Rock Aid Armenia in July 1989.

ALBUM

The album Innuendo was primarily composed and recorded for a compact disc edition, and it is the track listing of that CD (which lasts seventy-four minutes) that is referred to here. For the album's release on vinyl, Queen edited and shortened certain songs so that the album could be released on an LP, which could not exceed thirty minutes per side.

INNUENDO

Innuendo . I'm Going Slightly Mad . Headlong . I Can't Live with You . Don't Try So Hard . Ride the Wild Wind . All God's People . These Are the Days of Our Lives . Delilah . Don't Try So Hard . The Hitman . Bijou . The Show Must Go On

RELEASE DATES
United Kingdom: February 4, 1991
References: Parlophone—PCSD 115 (LP)—CDPCSD 115 (CD)
United States: February 5, 1991
Reference: Hollywood Records—HR-61020-2 (CD)
Best UK Chart Ranking: 1
Best US Chart Ranking: 30

After so many years spent working together, John, Brian, and Roger remained close to Freddie as he struggled with his health.

SWAN SONG

Freddie Mercury's health was in decline. In March 1989, Queen's thirteenth album, *The Miracle*, had not yet been released, but Freddie still wanted to record. He appealed to his friends, and the whole team immediately returned to the Mountain Studios in Montreux and rallied around the singer, who proposed a first track, "Delilah." "We became closer. He wanted to work—he wanted to occupy his mind and his days," recalled Roger Taylor. "So we spent long, cloistered periods abroad, just backing him up and forming a protective wall. It was actually a good time in a way, because we felt very close—the closest we've ever been."[161]

The recording sessions, which lasted through November 1990, were scheduled at a relaxed pace and took place at the studios in Montreux and at London's Metropolis Studios. The band worked for three weeks at a time and then took a two-week break so that everyone could devote themselves to their own projects, and so that Freddie could rest since, by this point, the singer was in an extremely bad way. Even hidden under loose clothing, his weight loss was clearly visible, and everyone around him was concerned. Only Brian, John, and Roger knew the truth of Freddie's condition, but Freddie asked them to keep it a secret, and each of the band members honored Freddie's request, even keeping the truth from their own families. May recalls: "Freddie just said: 'I want to go on working [...] until I fucking drop. That's what I want. And I'd like you to support me, and I don't want any discussion about this.'"[14]

The months went by, and many songs were started even as the band was largely occupied with promoting *The Miracle*, which was released on May 22, 1989. Throughout the summer of 1989, Queen worked on the promotion of different singles from the record, and by November of that year the recording sessions for *Innuendo* began again in earnest, with David Richards working in co-production and Brian May injured! Indeed, the guitarist was forced to join his friends in Montreux with his arm in a cast, the unfortunate consequence of taking a spin on his son's skateboard during a family holiday in Los Angeles.

Freddie's Last Public Appearance

On February 18, 1990, Queen received an award for their exceptional contribution to British music at the British Phonographic Industry Awards, which were held at the Dominion Theatre in London. As Brian gave a short speech, a frail-looking Freddie could be seen standing behind him with an emaciated face; he spoke only for a quick moment, saying "Thank you, good night." From this point on, speculation in the press was rife, but Roger and Brian formally denied any suspicion of the singer's illness. "He definitely hasn't got AIDS," declared May, "but I think his wild rock 'n' roll lifestyle has caught up with him."[14]

In the summer of 1990, a young white rapper known as Vanilla Ice was number one on the American charts, and his single "Ice Ice Baby" was playing on every radio station record deck. But the problem was, the track was built around a sample of "Under Pressure," which was originally recorded by Queen and David Bowie in 1981, and for which Vanilla Ice had neglected to ask for

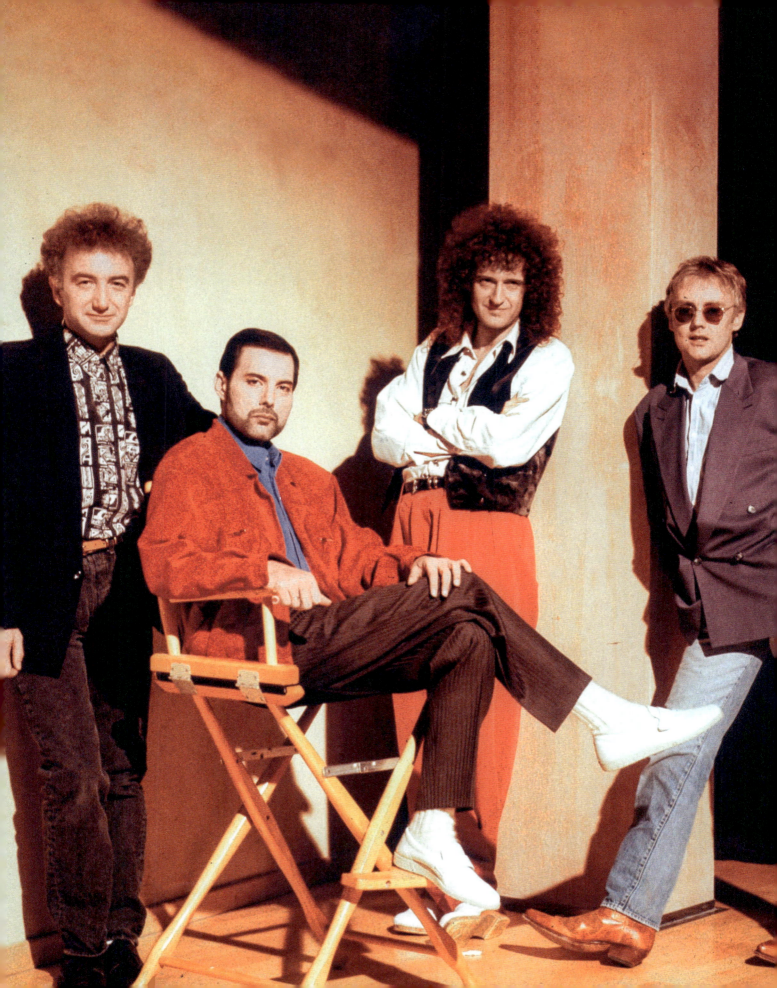

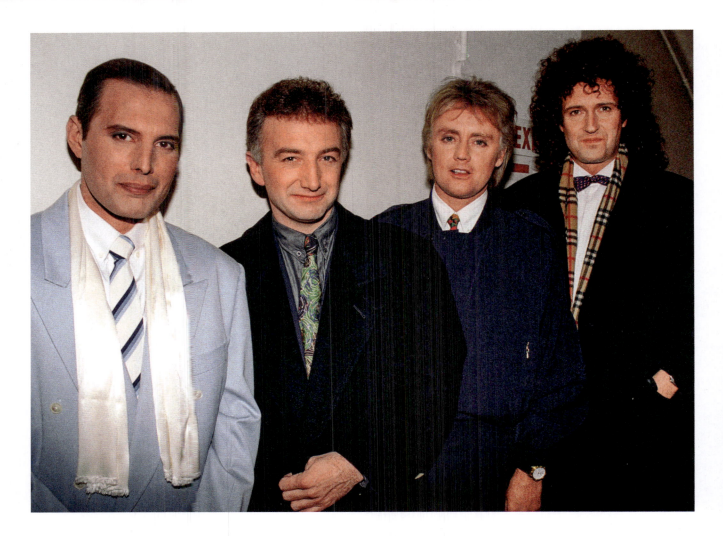

the rights. This of course sparked the fury of the members of Queen, and in particular of Brian May, who declared to an American interviewer: "He should have [asked for permission], but he didn't, and for this reason Hollywood Records are suing his white ass off, if I may be so bold. [...] He doesn't seem to have an enormous number of friends here."[162] May mentioned the label Hollywood Records, which was relatively unknown to the band's fans, because at the same time that the Vanilla Ice controversy was brewing, their loyal manager, Jim Beach, had achieved another professional victory. After finally breaking the contract that bound the members of Queen to Capitol Records, whose involvement in the band's career had clearly left a great deal to be desired in recent years, Beach had successfully negotiated a deal with the Disney-owned Hollywood Records. The band was delighted with this new partnership, which would include a remastered release of their entire catalog in the months to follow. As Brian May explained: "We're very very happy to be with them, and I don't think that we've ever been so close to a record company in our lives. They have a very good attitude, very open, and it corresponds to our way of doing things. They always want to do things different, they don't want to do anything through the established channels. [...] It's a great relationship."[162]

A Loyal Public

On January 14, 1991, even as Freddie was aware that his days were numbered, the single "Innuendo" was released in the United Kingdom and became an immediate success. The single rocketed to the top of the British charts and paved the way for the album of the same name, which was released on February 4, 1991. The album's booklet was illustrated with drawings by the French caricaturist Grandville (1803–1847), whose work Roger Taylor had recently discovered. These drawings were taken from the book *Another World*, which was originally published by Henri Fournier in 1844. On page 142 of the book, there is a portrait of a character who juggles with globes of the world. This illustration, entitled "Le Jongleur des mondes" (The World Juggler), was selected to illustrate the album's cover. Embellished with a banana and hand colored by Richard Gray, who had also created the covers for *A Kind of Magic* and *The Miracle*, the drawing on the album cover is strikingly modern.

Although rock critics of the day were almost unanimous in their disapproval of the perceived extravagance of the band's latest album, *Innuendo* was a resounding success with the public.

By the time Queen presented the video for the second single off the album, "I'm Going Slightly Mad," in March 1991, it was becoming increasingly difficult for Freddie to

Surrounded by his friends, Freddie said a simple "Thank you, good night" to the audience at the Brit Awards on February 18, 1990.

Elton John, one of Freddie's most loyal friends, offered these last words on a floral tribute at Freddie's funeral: "Thank you for being my friend. I will love you always."

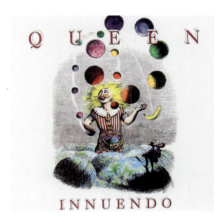

hide behind disguises and makeup. And yet, when he was once again questioned about the state of his friend's health, Brian May told journalists: "All I will say is that Freddie is healthy and fit. Listen to his singing on the album. Does it sound like someone who's sick or dying?"[163]

Freddie's Last Lines of Vocals

Freddie Mercury still had things to say and sing, and he urged his friends to follow him in his desire to record more and more. Having recently bought an apartment on the shores of Lake Geneva, Freddie made Montreux his haven of peace, since it was located far from the turbulence of London, where photographers camped out in front of Garden Lodge and made his life intolerable. In May 1991, the four musicians gathered to compose a few more songs. The songs "You Don't Fool Me," "A Winter's Tale," and "Mother Love" emerged from this working session, even as the singer was very much in decline. "In the end Freddie was doing all the singing in the control room because he couldn't walk into the studio,"[161] recalled an emotional Roger Taylor.

In August 1991, Paul Prenter, Freddie's former personal manager, died of AIDS. Now back at Garden Lodge, the singer's closest friends and chosen family now remained close to him at all times. One year earlier, Freddie had given a festive dinner for his forty-fourth birthday, and it had been attended by many of his friends: Barbara Valentin, Mary Austin, and Peter Straker, as well as Jim Beach and David Richards, who were both accompanied by their wives. However, by September 5, 1991, there were very few guests invited to wish him a happy birthday. Only the the most faithful members of his circle were there, including his ex-girlfriend Mary Austin, who had always retained a unique place in the star's heart. At the beginning of November 1991, Freddie Mercury decided to end his medical treatment. On November 25, 1991, at 6.48 p.m., Freddie passed away at his home at Garden Lodge, watched over by Jim Hutton and Peter Freestone.

FOR QUEEN ADDICTS

The title of the album was suggested by Freddie, who declared: "*Innuendo* is a word I often use in Scrabble—I'm a demon at Scrabble! For Queen, it's a perfect title."[95]

QUEEN: ALL THE SONGS 431

The illustration "Melody for 200 Trombones" was used for the cover of the "Innuendo" single.

INNUENDO
Queen / 6:32

Musicians
Freddie Mercury: lead vocals, backing vocals, synthesizers
Brian May: electric and classical guitars
John Deacon: bass
Roger Taylor: drums, percussion
Steve Howe: classical guitar
David Richards: synthesizers

Recorded
Mountain Studios, Montreux, and Metropolis Studios, London: March 1989–November 1990

Technical Team
Producers: Queen, David Richards
Sound Engineer: David Richards
Assistant Sound Engineers: Justin Shirley-Smith, Noel Harris

Single (45 rpm)
Side A: Innuendo / 6:32
Side B: Bijou / 3:37
UK Release on Parlophone: January 14, 1991 (ref. QUEEN 16)

Single (CD)
1. Innuendo (Explosive Version) / 6:44
2. Under Pressure / 4:03
3. Bijou / 3:37
UK Release on Parlophone: January 14, 1991 (ref. CDQUEEN 16)
Best UK Chart Ranking: 1

Genesis

When the band got together at the Mountain Studios at the end of the winter of 1989, the first few days were spent jamming in the big lounge of the Barrière casino, where everyone was once again getting to know one other. "We often find it's very good to play together without too many fixed ideas to begin with," explained Roger Taylor. "[...] We usually have two or three days just playing, finding sounds, getting the feel of each other again."[5] Meanwhile, the recorder was spinning and taking down all of their ideas. "Innuendo" was born out of one of these improvisation sessions, where the band was free to experiment, innovate, and take risks. They each contributed to the whole: Freddie and Roger worked on the lyrics, while Brian arranged the rock sections. The singer then focused on the central part of the song and decided to give it a Spanish sound; his recent collaboration with the singer Montserrat Caballé having undoubtedly opened up unsuspected artistic perspectives. "In the end, it came together like a jigsaw puzzle,"[16] Brian May would later say.

The song was chosen as the first single from the album. Its structure is not classical and is more reminiscent of some of the group's longer, drawn-out tracks like "The March of the Black Queen" or "Bohemian Rhapsody." Despite its length, which was unsuitable for radio broadcasts, and its rather intimate tone, "Innuendo" was a huge success when it was released in the United Kingdom on January 14, 1991.

Like the album cover, the sleeve featured an illustration by Grandville that had been colored by Richard Gray. Entitled "Melody for Two Hundred Trombones," the illustration lends itself perfectly to the song's high-flown and slightly pompous character.

The Video

The Torpedo Twins, who had been loyal partners of Queen since working on the videos for "A Kind of Magic" and "The Miracle," were called upon once again. But this time they had to work without the musicians themselves, who were too busy putting the finishing touches to their album. The project was set into motion with the assistance of Jerry Hibbert, an animation specialist whom Mercury had met at Ealing Art College. Thanks to Hibbert, a video truly worthy of the song was produced. He redrew the musicians

using old photos and videos, and inserted images of religious gatherings and armed conflicts, which gave the video an anxiety-inducing character that was perfectly suited to the song. The video contains images of the American intervention in Kuwait in 1991, and these images proved problematic for many television stations. In the end, the group was forced to offer two versions of the video: one for adults, and a second one that was more suitable for younger viewers, and from which the war images had been removed.

Production

With a duration of 6:32, the video for "Innuendo" holds a wealth of surprises. Initially reminiscent of Led Zeppelin's 1975 track "Kashmir," the song changes course at 2:45 and moves in a surprising direction that was heavily influenced by the sounds of Spain. Coming to greet the producer, David Richards, with whom he had worked on the Yes album *Going for the One* in 1977, Steve Howe, the guitarist from Yes, was propositioned by the musicians of Queen. "I go in, and they played me the whole album, but they saved 'Innuendo' until last," he recalled. "I was incredibly blown away. They said, 'We want you to play on that. Why don't you race around like Paco de Lucía?' Brian May had three Gibson Chet Atkins […]. I found one I liked, we started doing takes, we tried different approaches, and then we went to dinner. After dinner, we went back to the studio, listened through, and comped together what you hear today. It was just a lovely experience with a lovely bunch of guys."[164] The Spanish-accented guitar part contains music by both Howe and May, and gives way to a Red Special solo, whose rhythm and harmonizations at 4:28 are reminiscent of the solo from Iron Maiden's "The Loneliness of the Long Distance Runner" from their 1986 album *Somewhere in Time*.

"Innuendo" contains all the classic elements that make up a Queen song. As Queen had already instinctively understood at the time of "Bohemian Rhapsody," knowing how to take risks and not being afraid to stand out is what sets truly great artists apart. "That's going to be the first single here," Brian May had warned. "It's a bit of a risk, but it's different, and you either win it all or you lose it all. It had a nice sound and feel, and we stuck with that."[14]

FOR QUEEN ADDICTS

After having used Grandville's drawings from the book *Another World* to illustrate the album *Innuendo*, Brian May kept the concept in mind and, in 1998, named his second solo album *Another World*.

QUEEN: ALL THE SONGS 433

SINGLE

I'M GOING SLIGHTLY MAD
Queen / 4:22

Freddie Mercury is almost unrecognizable behind layers of makeup on set for the video of "I'm Going Slightly Mad," directed by the Torpedo Twins: Rudi Dolezal and Hannes Rossacher.

Musicians
Freddie Mercury: lead vocals, backing vocals, synthesizers, piano, programming
Brian May: electric guitar, backing vocals
John Deacon: bass
Roger Taylor: drums, programming

Recorded
Mountain Studios, Montreux, and Metropolis Studios, London: March 1989–November 1990

Technical Team
Producers: Queen, David Richards
Sound Engineer: David Richards
Assistant Sound Engineers: Justin Shirley-Smith, Noel Harris

Single (45 rpm)
Side A: I'm Going Slightly Mad / 4:22
Side B: The Hitman / 4:57
UK Release on Parlophone: March 4, 1991 (ref. QUEEN 17)

Single (CD)
1. I'm Going Slightly Mad / 4:22
2. The Hitman / 4:57
3. Lost Opportunity / 3:54

UK Release on Parlophone: March 4, 1991 (ref. CDQUEEN 17)
Best UK Chart Ranking: 22

The video for "I'm Going Slightly Mad" perfectly illustrates the song's message. Shown alongside Freddie, who is wearing heavy makeup so you can't see the traces of illness on his face, the group members wander aimlessly. John Deacon plays with a yo-yo, Roger Taylor rides a tricycle, and Brian May goes for a walk with a penguin!

Genesis

The fruit of the imagination of Freddie Mercury, who by then was much weakened by illness, "I'm Going Slightly Mad" could easily be interpreted as a cry of distress. Yet Freddie wrote this song in a quiet and joyful moment at Garden Lodge with his longtime friend Peter Straker (see page 214). Jim Hutton, the singer's then companion, remembers that creative night: "Freddie explained [to] Peter what sort of thing he wanted to say in the song. The inspiration for it was the master of camp one-liners, Noël Coward. Freddie set about with Peter trying to come up with a succession of goofy lyrics, each funnier than the last. He screamed when they came up with things like 'I'm knitting with only one needle' [...]. But the master-stroke was: 'I think I'm a banana tree.' Once that came out there was no stopping Freddie and Straker—they were then in full flow. I went to bed to fall asleep listening to their laughter wafting upstairs."[165]

But Freddie would soon cut off all contact with his friend. At a lunch at Joe's Café in Knightsbridge, Peter Straker turned up a little too drunk, much to Freddie's displeasure. Although by this time Freddie was extremely attentive to his state of health, and far removed from some of the temptations of his past, this latest event was enough to break the bond between the two artists, and Straker was not credited on *Innuendo* despite his contribution to the lyrics.

Production

Recorded at the Mountain Studios in March 1990, the song is immediately recognizable right from the introduction thanks to its three-note gimmick played on the synthesizer. Although the song is rather monotonous in its execution, it nevertheless shines because of Freddie's restrained interpretation. As always, Queen knows how to surprise the listener, and when Brian May comes out of the shadows at 2:30, it's to present a slide guitar solo with a Hawaiian flavor. This part of the track clearly shows that everyone was working relentlessly to give Freddie some last, unforgettable songs, as Roger Taylor would later recall, "The sicker he got, the more he seemed he needed to record."[166]

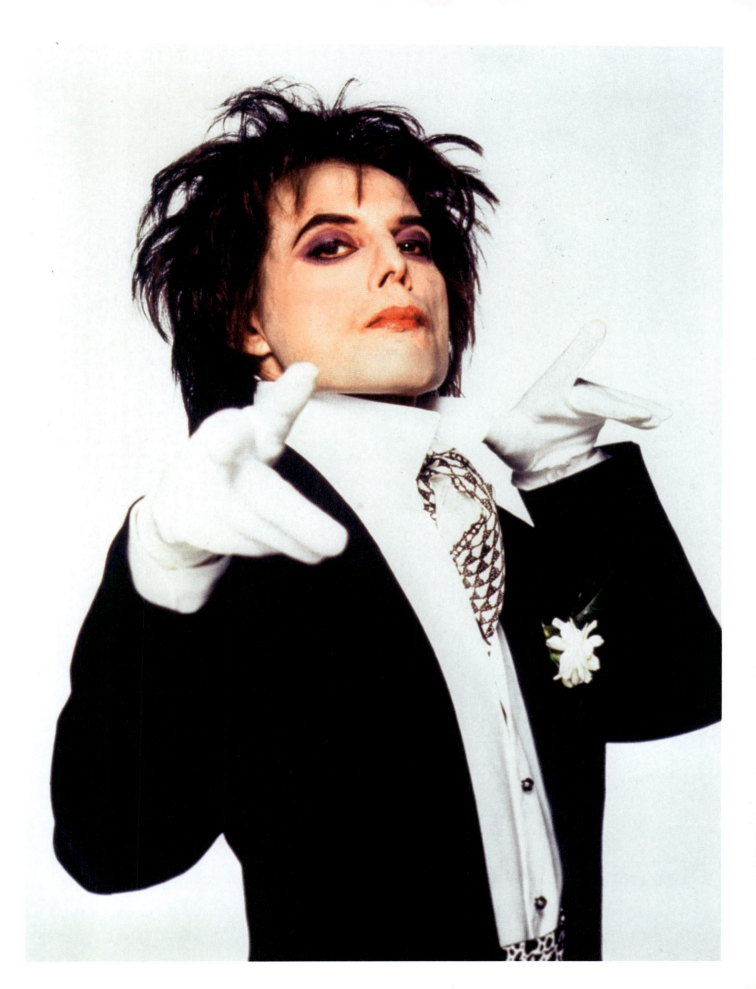

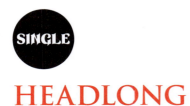

HEADLONG
Queen / 4:38

Musicians
Freddie Mercury: lead vocals, backing vocals
Brian May: electric guitar, backing vocals, piano, synthesizers, programming
John Deacon: bass
Roger Taylor: drums, backing vocals

Recorded
Mountain Studios, Montreux, and Metropolis Studios, London: March 1989–November 1990

Technical Team
Producers: Queen, David Richards
Sound Engineer: David Richards
Assistant Sound Engineers: Justin Shirley-Smith, Noel Harris

Single (45 rpm)
Side A: Headlong (Single Edit) / 4:33
Side B: All God's People / 4:21
UK Release on Parlophone: May 13, 1991 (ref. QUEEN 18)

Single (CD)
1. Headlong (Single Edit) / 4:33
2. All God's People / 4:21
3. Mad the Swine / 3:23
UK Release on Parlophone: May 13, 1991 (ref. CDQUEEN 18)
Best UK Chart Ranking: 14

FOR QUEEN ADDICTS
"Headlong" was selected as the first single to be released in the American market on January 17, 1991. Queen was hoping to reach the United States with this effective rock track, which they considered more accessible than the complex "Innuendo." The attempt ended in failure on the overall *Billboard* chart, but the song did manage to reach third place on the rock chart.

Genesis
Like "I Want It All" or "Hammer to Fall" before it, "Headlong" bears Brian May's unmistakable signature. The guitarist's love for the heavy metal style, which suits Queen so well, is instantly recognizable. As May himself would later explain, "'Headlong' came from me, at our studio in Montreux, a home recording studio for us that's very state-of-the-art, lovely for creating. The ideas came in a couple of days. At first I thought about it as a song for my solo album but, as always, the band is the best vehicle. As soon as I heard Freddie sing it, I said, 'That's it!' Sometimes it's painful to give the baby away, but what you gain is much more. It became a Queen song."[5]

If we look at the red costume that May wears in the video, as well as the very fair complexion of his partner, Anita Dobson, we can sense in the lyrics some allusions to their relationship: *"When a red hot man meets a white hot lady / Soon the fire starts raging gets you more than half crazy."*

Production
Recorded by the entire band during the summer of 1990 in Montreux, the song had initially been recorded as a demo by Brian May at the Allerton Hill Studios, the recording complex he had built on the first floor of his Surrey property in southwest London when he was writing his first solo album. "I've always resisted the idea of having a studio there because I've always felt that you should be able to get away from your work…but it never worked out like that anyway. The reason I did my own album at home was because of the feeling of pressure that you can get working in one of the major recording studios. It's often a case of, 'Well here I am, standing in this studio, just playing about, and it's costing more than £1,000 a day.' It just seems so wasteful."[167]

I CAN'T LIVE WITH YOU

Queen / 4:33

> Gambling on a potential single, Hollywood Records distributed a promotional release of "I Can't Live with You" to the American market. Despite having been remixed by the notoriously deft Brian Malouf, who managed to give it some consistency, the song failed to seduce the American audience.

Musicians
Freddie Mercury: lead vocals, backing vocals
Brian May: electric guitar, synthesizers, programming
John Deacon: bass
Roger Taylor: backing vocals
David Richards: programming

Recorded
Mountain Studios, Montreux, and Metropolis Studios, London: March 1989–November 1990

Technical Team
Producers: Queen, David Richards
Sound Engineer: David Richards
Assistant Sound Engineers: Justin Shirley-Smith, Noel Harris

Genesis

Like "Headlong" before it, "I Can't Live with You" was written by Brian May for his first solo album, before the members of Queen lobbied to keep it for *Innuendo*. Inspired by his recent divorce from Chrissie Mullen, the guitarist testifies to the kind of love dilemma that everyone can face one day: "*I can't live with you / But I can't live without you / I can't let you stay / But I can't live if you go away.*" It wasn't the first time that Brian had tackled this most universal of subjects. In "It's Late," the musician had already spoken out about his illicit relationship with the mysterious Peaches, whom he had met in New Orleans. "It's very personal," May revealed about "I Can't Live with You," "but I tried not to make it autobiographical because that narrows things too much. I tried to express it in a form that everyone can relate to. When you describe an experience in a song, it's nice because you can examine it, inject some humor and put it into perspective."[168]

Production

Most of the track comes from the original demo made by Brian at the Allerton Hill Studios. It features the drum machine programming, as well as the majority of the guitar lines. Mixing was a challenge for the band and for David Richards, as Brian May later revealed: "That track was almost impossible to mix. It was one of those things where you put all the faders up and it sounds pretty good, and you think, 'We'll work on this for a couple of hours.' Then it gets worse and worse and worse. We kept going back to the rough mix. [...] I think it sounds so special because we kept a lot of the demo stuff on it. Usually it all gets replaced."[168] "I Can't Live with You" would undoubtedly have benefited from having a real set of drums, because the drum machine seems to be totally lost in the mix, like at 2:45 where it gets lost behind Mercury's vocals as recorded by David Richards.

Brian May and his wife Chrissie Mullen at the end of the 1970s.

DON'T TRY SO HARD

Queen / 3:39

Musicians
Freddie Mercury: lead vocals, backing vocals, synthesizers
Brian May: electric guitar
John Deacon: bass
Roger Taylor: drums

Recorded
Mountain Studios, Montreux, and Metropolis Studios, London:
March 1989–November 1990

Technical Team
Producers: Queen, David Richards
Sound Engineer: David Richards
Assistant Sound Engineers: Justin Shirley-Smith, Noel Harris

As early as the mid-1990s, when online fan forums were first created, there was a lot of discussion about the authorship of "Don't Try So Hard." Some claimed that Deacon was the creator, but Brian May finally put a stop to the debate by saying that the track was Freddie's work.

Genesis

After the powerful opening tracks of *Innuendo*, Freddie Mercury now offers listeners a moving and touching ballad, thanks to the song's melody and the singer's interpretation. His voice becomes crystal clear as he urges the listener to step back when a situation seems insurmountable: *"When your problems seem like mountains / You feel the need to find some answers / You can leave it for another day / Don't try so hard"* or *"Thank your lucky stars / Just savor every mouthful / And treasure every moment / When the storms are raging round you / Stay right where you are."* This song, like "Was It All Worth It" or "The Show Must Go On," represents a message from Mercury to those who live on after him. Thanks to its lyrics and the singer's particularly touching interpretation, "Don't Try So Hard" is undoubtedly one of the highlights of the album.

Production

Although drowned in a flood of synthesizers, the song features Freddie's soaring vocal flights, reminiscent of the powerful "Who Wants to Live Forever," from *A Kind of Magic*. Brian May celebrated the energy that his friend managed to inject into his songs, even when he was at his lowest ebb: "It's wonderful, because he's always full of ideas. You couldn't ask for more of anyone. He's never still, and very inspiring, and the stuff he managed to produce out of the instrument he calls his voice, this time around, is unbelievable."[162]

May and Taylor's backing vocals are also strongly present, especially in the introduction to the guitar solo at 2:20. Accompanied by a shaker, the Red Special then delivers a discreet score that effectively pays tribute to the gentleness of the track, which then ends on harmonics from Brian.

RIDE THE WILD WIND

Queen / 4:43

Musicians
Freddie Mercury: lead vocals, synthesizers
Brian May: electric guitar
John Deacon: bass
Roger Taylor: backing vocals, synthesizers, programming

Recorded
Mountain Studios, Montreux, and Metropolis Studios, London: March 1989–November 1990

Technical Team
Producers: Queen, David Richards
Sound Engineer: David Richards
Assistant Sound Engineers: Justin Shirley-Smith, Noel Harris

FOR QUEEN ADDICTS

When Electronics Arts released its new video game *Queen: The eYe*, in 1998, various songs from the band were chosen for the game's soundtrack. An instrumental version of the track was then put forward, entitled "Ride the Wild Wind (The eYe Version)," showcasing May's Red Special.

Genesis

Listening to "Ride the Wild Wind," we have no difficulty in detecting the presence of Roger Taylor behind the song. Despite Freddie Mercury's impeccable performance, there is nothing very deep in the lyrics, simply an invitation to escape: *"Get your head down baby / We're gonna ride tonight / Your angel eyes are shining bright / I wanna take your hand / Lead you from this place / Gonna leave it all behind."* The song was first demoed by Roger Taylor, with his voice serving as a vocal guide. This fascinating version of the track, which shows all the work done by the drummer before the sessions with Queen, is available on the rerelease of *Innuendo*, which came out in 2011.

Production

Some elements of the original demo were retained, such as the drum machine and some of the synthesizers. Brian May, who worked in the same way on his tracks "Headlong" and "I Can't Live with You," shed some precious light on the band's recently adopted working method: "As much as possible we've done it live in the studio, with three or four of us playing at one time. [...] Sometimes we would start off by programming something and working around it but in almost every case we replaced original material with real stuff as we went along. [...] In the old days, you would say: 'That's very nice as a demo, but now we'll do it properly.' Now you can say: 'That's great as a demo; we'll use this piece and incorporate it into the finished product.'"[169]

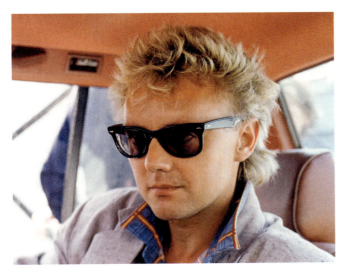

Starting at the end of the 1980s, Roger Taylor would always hide behind his dark glasses during interviews.

ALL GOD'S PEOPLE
Queen / 4:21

During the writing sessions for *Barcelona*, the working title of "All God's People" was "Africa by Night."

Musicians
Freddie Mercury: lead vocals, backing vocals, synthesizers
Brian May: electric guitar
John Deacon: bass
Roger Taylor: drums, timbales
Mike Moran: synthesizers

Recorded
The Town House, London: 1987
Mountain Studios, Montreux, and Metropolis Studios, London: March 1989–November 1990

Technical Team
Producers: Queen, David Richards
Sound Engineer: David Richards
Assistant Sound Engineers: Justin Shirley-Smith, John Brough

Musician and composer Mike Moran worked with Freddie Mercury and Montserrat Caballé on the album *Barcelona*.

Genesis
Written by Freddie Mercury for the album *Barcelona*, which he recorded with Montserrat Caballé in 1987, the song "All God's People" was discarded by the duo and reworked by Queen for possible inclusion on *The Miracle*. Discarded for a second time and put away in a drawer, the song was presented again by Freddie during the working sessions for *Innuendo*, when it was finally adopted by the band.

With this piece, Queen revisited the gospel style they had already experimented with on "Somebody to Love" in 1976, as well as in the breaks of "Dragon Attack" in 1980 and "Dancer" in 1982. *"Don't turn your back on the lesson of the Lord,"* sings Mercury, in a return to the religious piety of his earlier days, such was when he sang *"All going down to see the Lord Jesus,"* on "Jesus," on the band's first album in 1973.

Production
The majority of the version of "All God's People" that appears on *Innuendo* comes from the 1987 recordings made at the Town House studios in London. Mike Moran, the co-producer of *Barcelona* along with Mercury and David Richards, was also the pianist on many tracks, and plays synthesizers on this track. He is credited for his contribution on the album cover. It is not specified that he co-authored the song with Freddie Mercury; however, this is probably the case.

John Brough was the assistant sound engineer on *Barcelona* in 1987, and he has shed some interesting light on the recording of the guitar solo: "Brian did a good solo, but decided he could do better and played it again. Freddie said, 'No, I don't like it' [...], and I could see Brian getting more and more tense. After another solo, Freddie said, 'Oh, that's rubbish.' David Richards, Mike Moran and I were all looking at each other. At the time, it seemed horrific. After another solo, Freddie made some comment like, 'Oh, come on! You and that fireplace guitar...play it like you mean it!' So Brian let rip with this great solo, and, of course, Freddie had this big grin on his face. He knew what Brian could do, and he was just pushing him."[2]

THESE ARE THE DAYS OF OUR LIVES

Queen / 4:16

Musicians
Freddie Mercury: lead vocals, backing vocals
Brian May: electric guitar
John Deacon: bass
Roger Taylor: synthesizers, drums, percussion

Recorded
Mountain Studios, Montreux, and Metropolis Studios, London: March 1989–November 1990

Technical Team
Producers: Queen, David Richards
Sound Engineer: David Richards
Assistant Sound Engineers: Justin Shirley-Smith, Noel Harris

An emaciated Freddie Mercury was still as charismatic as ever at the Brit Awards on February 18, 1990.

Genesis

When Roger Taylor composed "These Are the Days of Our Lives," he wrote the lyrics with his children, Felix and Rory Eleanor, in mind. He recalls with nostalgia the happy days of his carefree childhood ("*When life was just a game*"), but by the end of the song he realizes that deep down nothing has changed ("*When I look and I find no change*"), and that life still has much to offer him through his own children. Sung by Freddie Mercury, the lyrics take on a poignant meaning. In the last verse, the singer bids farewell to the audience and, facing the camera at the end of the accompanying video, he fades away after a moving "I still love you."

This video was shot by the Torpedo Twins at the Limehouse Studios in London on May 30, 1991, while Brian May was busy promoting *Innuendo* in the United States. John, Freddie, and Roger were filmed performing the song, and Brian was added later during the editing.

The song wasn't released as a single, but as a double A-side with "Bohemian Rhapsody," which was re-released on December 9, 1991, as a tribute to Freddie Mercury, who had passed away shortly before. All of the profits from the double single were donated to the Terrence Higgins Trust, a British charity set up to fight the spread of HIV around the world and to provide care and support for the victims. "These Are the Days of Our Lives" met with a huge success and was broadcast on the radio on a massive scale.

Production

Set to a conga score that accompanies a very mechanical drum machine, "These Are the Days of Our Lives" could have been, in a different context, a sweet song for summer evenings, but as sung here by Freddie, who offers a gentle and touching interpretation, it takes on a tragic significance. May's guitar is omnipresent but set back behind the singer, giving the song just the right amount of warmth, alternating between arpeggios and light Red Special riffs. The inclusion of modern, cold synthesizers set "These Are the Days of Our Lives" firmly in the early '90s, and won't help it stand the test of time. While Queen's story ends in spectacular fashion with "The Show Must Go On" at the end of the album, "These Are the Days of Our Lives" provided Freddie with the perfect way to say good-bye to his fans in a delicate and intimate way.

> In December 1991, shortly after Freddie Mercury's death, "Delilah" was released as a single in Thailand, where it topped the charts.

DELILAH
Queen / 3:35

Musicians
Freddie Mercury: lead vocals, backing vocals, piano, synthesizers, programming
Brian May: electric guitar, backing vocals
John Deacon: bass

Recorded
Mountain Studios, Montreux, and Metropolis Studios, London: March 1989–November 1990

Technical Team
Producers: Queen, David Richards
Sound Engineer: David Richards
Assistant Sound Engineers: Justin Shirley-Smith, Noel Harris

Genesis
During the last years of his life, Freddie Mercury shared his home at Garden Lodge with his companion, Jim Hutton, and his six cats: Romeo, Miko, Oscar, Lily, Goliath, and Delilah, who was his favorite. Here he sings a song in her honor, as if to leave a trace of his memory. During 1990, the singer moved to the Montreux Palace Hotel with Jim Hutton; his cook, Joe Fanelli; and his former lover, Barbara Valentin, with whom he remained very close. One morning, when he woke up at seven o'clock, Hutton found Barbara and Freddie still up after a sleepless night spent chatting. "Jim," Freddie exclaimed, "I've written a new song. It's about my Delilah."[165] After a few hours' rest, the singer went back to work, testing various rhymes before finally offering his song to his fellow musicians from Queen.

Production
It was Mercury himself who took charge of the programming, as well as some of the synthesizer parts. Roger Taylor and Brian May enjoyed themselves by adding a few meows at 2:16, which lends the track a humorous tone and gives a touch of lightness to the album. It's the Red Special's response to the feline cries, however, that remains the track's great curiosity. Always given to experimentation, Brian May managed to literally make his guitar meow for a few surprising bars. To achieve this effect, which is similar to that of a Vocoder, the musician used a talk box. This pedal, popularized by British musician Peter Frampton in his song "Show Me the Way" and even more so in the solo of "Do You Feel Like We Do" on the live album *Frampton Comes Alive* (1976), enables the sound to be modified thanks to the musician's voice. The extremely ingenious process works like this: the guitar is plugged into a talk box pedal, from which a plastic pipe emerges, which the guitarist holds in his mouth. The notes played leave the guitar, enter the pedal, and escape through the tube where they are modified by the musician's vocals, before passing once more through the tube and exiting the pedal. This was how Brian May transformed his Red Special into a cat!

Freddie and one of his cats in 1980. When he passed away, he left six cats behind: Romeo, Miko, Oscar, Lily, Goliath, and Delilah.

THE HITMAN

Queen / 4:57

Musicians
Freddie Mercury: lead vocals, synthesizers
Brian May: electric guitar, backing vocals
John Deacon: bass
Roger Taylor: drums

Recorded
Mountain Studios, Montreux, and Metropolis Studios, London: March 1989–November 1990

Technical Team
Producers: Queen, David Richards
Sound Engineer: David Richards
Assistant Sound Engineers: Justin Shirley-Smith, Noel Harris

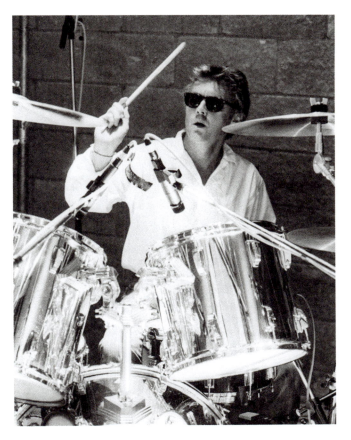

Roger Taylor behind his Ludwig Chrome-O-Wood during a recording session for Rock Aid Armenia at Metropolis Studios in London on July 8, 1989.

Genesis

You'd be forgiven for thinking that this pure moment of heavy rock, offered just before the delicate "Bijou" on the track list, was the work of Brian May, so explosive are the guitars and the fury unleashed from throughout the track. Yet, as the guitarist himself later explained, he was absent from the creation of "The Hitman," even if it is indeed his voice that appears on the demo, some extracts of which can be heard on the cassette *Hints of Innuendo*, released as a promotional supplement in January 1991, one month before the release of the album. The identity of the song's creator remains a total mystery.

The track, as powerful as the earlier "Tie Your Mother Down" or "Tear It Up," offers the listener a welcome moment of release, also reminiscent of "Gimme the Prize" on the album *A Kind of Magic*. The lyrics paint the picture of a hitman, ready to do anything to bring his mission to a successful conclusion. Although we don't grasp all the narrator's intentions in the course of the song's lyrics, we can nevertheless appreciate the rage that escapes from this powerful and stunning track.

Production

"[The] finished version had very little to do with the original idea," declared May. "Most of the riff came from Freddie. I wasn't even in the room when they wrote it. I changed the key and some of the notes to make it playable on the guitar."[5] The track was reworked as a team, and everyone put their personal touch on it. The voices were added, and then John Deacon, as usual, began to restructure the track, which was his specialty. Brian had to adapt, and put his Red Special lines on this new version of the song.

It's a real pleasure to find the band playing in the flesh once again! Roger Taylor, whose drum sound here is powerful and resounding, explained Queen's intentions for this track: "What I think people really wanted to see was sort of this return to thickly textured guitar, drums, bass and now I suppose keyboards lineup and those big harmonies. This album is really all about that."[166]

Pioneering guitarist Jeff Beck with his Fender Stratocaster.

BIJOU

Queen / 3:37

Musicians
Freddie Mercury: lead vocals, synthesizers
Brian May: electric guitar

Recorded
Mountain Studios, Montreux, and Metropolis Studios, London: March 1989–November 1990

Technical Team
Producers: Queen, David Richards
Sound Engineer: David Richards
Assistant Sound Engineers: Justin Shirley-Smith, Noel Harris

On the occasion of a celebration of the British music industry in 2005, Brian May found himself alongside his idol Jeff Beck for a special meeting with Queen Elizabeth II at Buckingham Palace. Also present at the event were Jimmy Page and Eric Clapton.

Genesis

Every Queen fan has expressed their opinion concerning the lyrics of "Bijou." Who is this Bijou to whom Mercury declares eternal love? One can easily get lost in speculation. Some believe that it was Mary Austin or Jim Hutton, who shared the star's life. Others are convinced that it was one of the singer's cats, but there were no cats of that name at Garden Lodge. As is often the case with Queen's songs, this track remains a mystery, and it's the perfect fuel for endless discussion.

The musical part of the track, on the other hand, was certainly inspired by one of Brian May's heroes, Jeff Beck. Released on the album *Jeff Beck's Guitar Shop* in 1989, the instrumental track "Where Were You" plunges the listener into a dreamy atmosphere, which we also find at the heart of "Bijou." The composition appeared on the B-side of the single "Innuendo" when it was released on January 14, 1991. The version on the vinyl album was shortened by 2:20 from the original version released on the CD album. Indeed, the band had made the decision to shorten a number of tracks so that the work would fit onto an LP.

While the track may seem light and ephemeral, it was nevertheless described in 2014 as "the darkest, saddest song on Queen's darkest, saddest album"[170] by the British newspaper the *Guardian*.

Production

Strictly speaking, "Bijou" is not so much a song as it is a musical interlude before the album's grand finale, with a very short text written by Mercury. The track is seductive thanks to the atmosphere that May creates with his Red Special. The synthesizers are omnipresent, as fashion dictated during the early '90s, and they drape the song with sounds that now seem somewhat dated. But it's the guitar that plays the leading role, cutting a swath through the keyboard score. This kind of structure had been quite widespread for a few years already (reminiscent of "Always with Me, Always with You" by Joe Satriani from *Surfing with the Alien* in 1987), and these guitar-synthesizer atmospheres would be repeated throughout the decade, as in Pink Floyd's *The Division Bell* (1994) and its introduction "Cluster One."

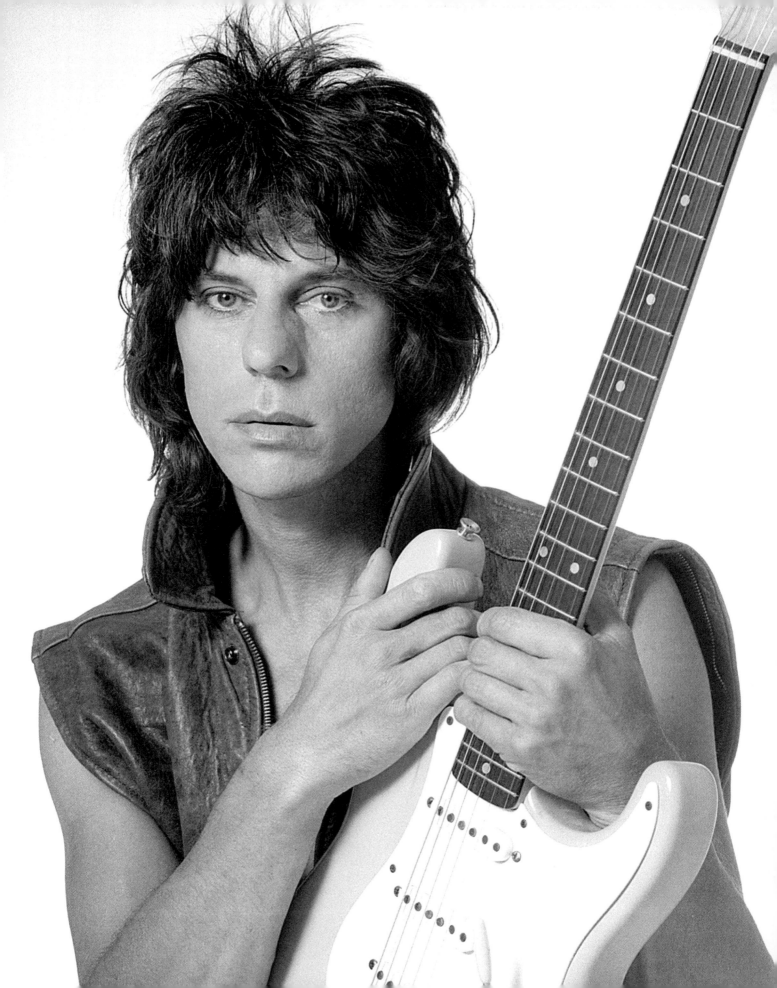

SINGLE

THE SHOW MUST GO ON
Queen / 4:31

Musicians
Freddie Mercury: lead vocals
Brian May: electric guitar, synthesizers, backing vocals
Roger Taylor: drums, backing vocals
John Deacon: bass

Recorded
Mountain Studios, Montreux, and Metropolis Studios, London: March 1989–November 1990

Technical Team
Producers: Queen, David Richards
Sound Engineer: David Richards
Assistant Sound Engineers: Justin Shirley-Smith, Noel Harris

Single (45 rpm)
Side A: The Show Must Go On / 4:31
Side B: Keep Yourself Alive / 3:47
UK Release on Parlophone: October 14, 1991 (ref. QUEEN 19)

Single (CD)
1. The Show Must Go On / 4:31
2. Keep Yourself Alive / 3:47
3. Queen Talks / 1:46
4. Body Language / 4:32

UK Release on Parlophone: October 14, 1991 (ref. CDQUEEN 19)
Best UK Chart Ranking: 16

An illustration by the French artist Granville used for the cover of the single "The Show Must Go On."

Genesis

How can one possibly describe the emotional power that emanates from this legacy song; this masterpiece written by eight hands that enabled the singer to say good-bye to the entire planet? After putting his affairs in order over the course of this album, confessing his shortcomings in "I'm Going Slightly Mad," offering wise advice in "Don't Try So Hard," and taking stock of a lifetime in "These Are the Days of Our Lives," the singer finally thanks and pays tribute to those he loves in "Delilah" (his cat), "Bijou" (his love), and lastly, "The Show Must Go On" (his audience).

The synthesizer sequence in the introduction was written by John, Freddie, and Roger, and then Brian worked on the track by trying out various structures. "It's something that came as a gift from heaven, I suppose," explained the guitarist. "I did some demos, chopped things up, did some singing demos and some guitar and got it to a point where I could play it to the guys, and they all thought it was something worth pursuing."[171]

The message of the song's lyrics is explicit, and it's the fruit of a collaboration between the guitarist and the singer, even if the guitarist provided most of the basic outline, as he emotionally testified: "I did most of the lyrics for Freddie to sing and you can imagine what I felt like. I did ask him at one point if he was okay about it and he said, 'Yeah, totally OK about it. I will give it my all.' And he did. He sang, I think, some of the best vocals of his life on that track [...]. He really was getting very weak by that time, but he could still summon up that strength to sing."[18]

At the heart of the lyrics are some chilling and poignant phrases, such as: "*I'll soon be turning round the corner now / Outside the dawn is breaking / But inside in the dark I'm aching to be free,*" and "*My soul is painted like the wings of butterflies / Fairy tales of yesterday will grow but never die / I can fly, my friends.*"

The track was the last Queen single made during Freddie Mercury's lifetime. It was released on October 14, 1991, in the United Kingdom, and it was accompanied on the B-side by the very first song the band released as a single, in 1973, and whose title now seems strangely premonitory: "Keep Yourself Alive." If the message is clear, so is the symbolism.

446 INNUENDO

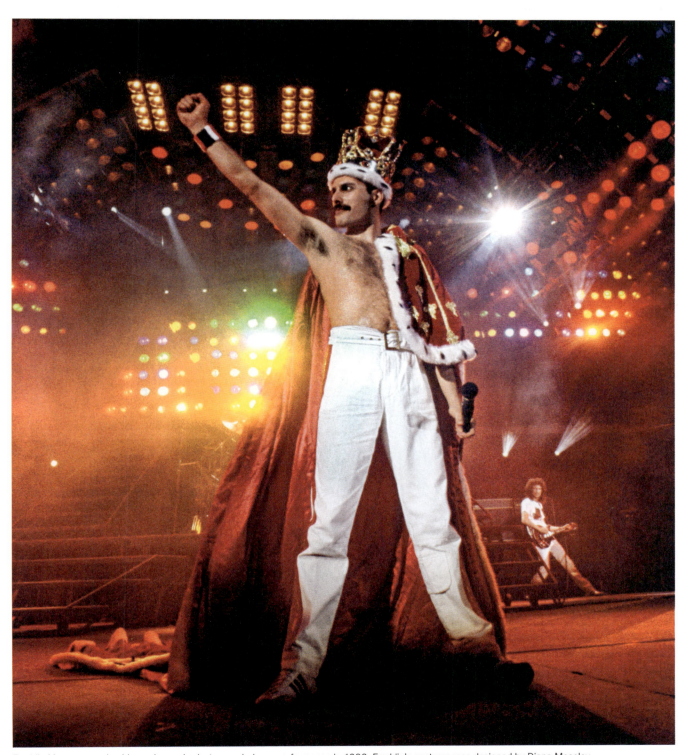
Freddie Mercury wearing his ermine and velvet cape during a performance in 1986. Freddie's costume was designed by Diana Moseley.

John Deacon, Brian May, and Roger Taylor celebrate the memory of their friend at the Freddie Mercury Tribute Concert on April 20, 1992. The concert was held at Wembley Stadium in London, and Elton John performed "The Show Must Go On" with the surviving members of Queen.

Queen brought together their first single and their last. The loop is closed. The story can end here.

Production

The famous synthesizer introduction of "The Show Must Go On" is of course the major element of the track. But it's Mercury's voice and legendary performance that make the song a rock classic, carried by a poignant melody. As Brian May would later explain, "I was very pleased with the way it came out, especially the way Freddie pushed his voice to ridiculous heights. Some of that stuff I mapped out in falsetto for him, and I remember saying, 'I really don't know if this is asking way too much...' and he went, 'Oh darling, not a problem. I'll have a couple of vodkas then go ahead and do it.' And he did."[171]

John Deacon's Farewell in 1997

In January 1997, the French choreographer Maurice Béjart staged *Le presbytère n'a rien perdu de son charme, ni le jardin de son éclat* in the Jean-Vilar Hall at the Théâtre National de Chaillot in Paris. The title was taken from Gaston Leroux's novel *Le Mystère de la chambre jaune*, and the ballet is an original creation based on Mozart's symphonies and several songs by Queen. The costumes were designed by Gianni Versace, and the premiere took place at the Salle Métropole in Lausanne on December 15, 1996. At the world premiere at Chaillot on January 17, 1997, a major event took place on the Parisian stage: Brian May, John Deacon, and Roger Taylor performed "The Show Must Go On" live for the finale of the ballet, accompanied by Elton John on vocals. "We talked about being

John Deacon, Roger Taylor, Elton John, Spike Edney, and Brian May surround choreographer Maurice Béjart during the premiere of the ballet *Le presbytère n'a rien perdu de son charme, ni le jardin de son éclat* at the Théâtre National de Chaillot in Paris on January 17, 1997.

there. We said, 'We'd like to be there.' We thought, 'Oh dear...' 'cause it's a strange thing...Firstly we hadn't played for God knows how long. We don't have our singer. It's one song and you have to get a whole production for one song, one performance. And then this message came from Elton, saying, 'Let's play.'"[172] The performance of the four British musicians was moving and particularly successful. The song not only marked the departure of Freddie Mercury, but it was also on this performance of "The Show Must Go On" that John Deacon left Queen and the world of music forever. Never again would he play with the band after Chaillot. "He has been severely traumatized by losing Freddie,"[172] explained Roger Taylor. Never again would we see onstage John "Deaky" Deacon, Queen's quiet bassist, who gave so much to his band.

FOR QUEEN ADDICTS

The third track on the CD single from "The Show Must Go On," which was released on October 14, 1991, is entitled "Queen Talks." It is a montage of numerous radio interviews featuring the members of Queen, and which particularly showcase their sense of humor. The first sentence is from Mercury, who can be heard proudly declaring, "Hello, I'm Kim Basinger."

QUEEN: ALL THE SONGS 449

OUTTAKE

Brian May onstage during a sound check in 1991.

LOST OPPORTUNITY
Queen / 3:50

Musicians
Freddie Mercury: synthesizer
Brian May: lead vocals, electric guitar
Roger Taylor: drums
John Deacon: bass

Recorded
Mountain Studios, Montreux: May 1991

Technical Team
Producers: Queen, David Richards
Sound Engineer: David Richards

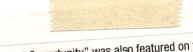

"Lost Opportunity" was also featured on the re-release of *Innuendo* in 2011, alongside the precious demos of "Ride the Wild Wind" and "Headlong," sung by Roger Taylor and Brian May, respectively.

Genesis

In January 1991, Freddie Mercury insisted that the band go back into the studio to record a few extra songs that could be offered as bonus tracks with the singles from *Innuendo*. It's always great to discover a new song when you buy a single from an artist that you love, as Freddie was well aware. And while the fact of offering this little bonus to fans is a testament to the singer's generosity, it's also extremely satisfying from a commercial point of view, as the record companies were well aware. A fan who already owned the band's album would then purchase the single for the unreleased track. For one purpose or another, "Lost Opportunity" was released as part of the CD single of "I'm Going Slightly Mad" on March 4, 1991, where it was accompanied by "The Hitman." While Brian May's lyrics are full of the themes that are dear to bluesmen: work, a hard life, and the bad decisions that you sometimes make, listeners can also identify an allegory of the life of a rock star in the lyrics: *"With the morning I face the sun / I lift my head and smile for everyone / Every afternoon you'll find me working on / I got my new shoes on."*

Production

Written by Brian May, the very bluesy "Lost Opportunity" was the first song sung by Queen's guitarist since "Sail Away Sweet Sister," which appeared on the album *The Game* in 1980. Worthy of a jam session recorded in the middle of a night's work, we feel the weight of weariness in his performance, which fits the blues genre like a glove. "Lost Opportunity" was recorded in a single take by the band, and the song is more of a blues improvisation than a typical song from the Queen repertoire. It's a delight to rediscover a dry and natural drum sound, far from the triggered and reverb-filled snare drums that Taylor had accustomed us to for a decade. It's a kind of return to their roots that Queen offers us here, like the delicate "See What a Fool I've Been," recorded in 1973 and offered on the B-side of the single "Seven Seas of Rhye," on February 25, 1974.

450 LOST OPPORTUNITY

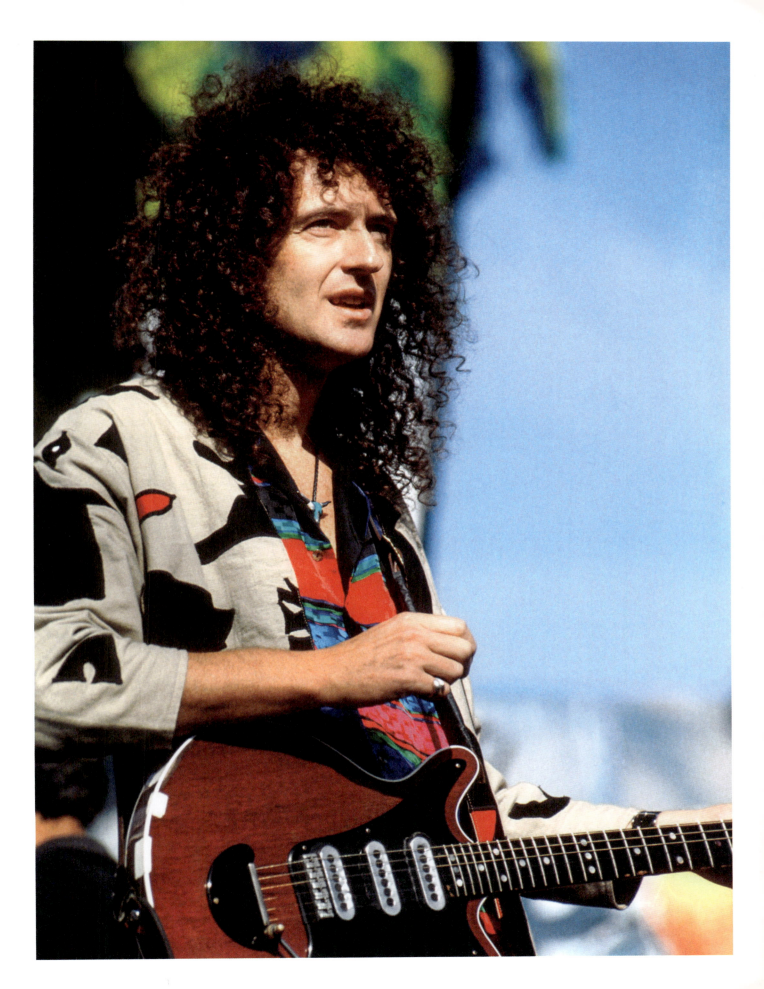

FOCUS ON...

(Right) David Bowie and Queen during rehearsals for the Freddie Mercury Tribute Concert.

(Next page) Seventy-two thousand spectators gathered together at Wembley Stadium to celebrate the life of Freddie Mercury.

THE FREDDIE MERCURY TRIBUTE CONCERT

On February 12, 1992, the twelfth British Phonographic Industry Awards ceremony—commonly known as the "Brit Awards"—was held at the Hammersmith Apollo in London. Roger Taylor and Brian May accepted a posthumous award for Freddie Mercury in honor of his outstanding contribution to British music. John Deacon, still reeling from the untimely death of his friend, was not present at the ceremony. At the end of his speech, Brian gave the floor to Roger, who announced from behind his sunglasses: "We hope that a lot a you will be able to join us on April 20 at Wembley Stadium for a celebration of Freddie's life and career. A lot of friends are coming and you're all welcome. Please join us."[173]

Farewell to Freddie

The announcement was a bombshell for fans, because the secret had been carefully kept. "The night Freddie died," said Brian, "we said: well, we should give him an exit in the true style to which he's accustomed."[14] For his friends, this commemoration would have to be worthy of the life that the singer led. Jim Beach, Queen's loyal manager, asked Harvey Goldsmith, the band's tour manager who had previously taken charge of the live show at Knebworth in 1986, to organize a giant concert at Wembley Stadium. On the day the ticket office opened, the seventy-two thousand tickets were sold out in just three hours, despite the fact that at that point no one knew the list of artists who would perform. In addition to serving as a tribute to the celebrated Queen front man, the event was also intended to raise awareness of the ravages of AIDS, and the profits from the concert were to be donated to research on the prevention of the disease.

When the list of performers was finally announced, the lucky ticketholders were stunned and delighted. Alongside May, Deacon, and Taylor would be: Metallica, Extreme, George Michael, David Bowie, Guns N' Roses, Def Leppard, Seal, and Liza Minnelli. The party promised to be worthy of Mercury's memory.

Rock 'n' Roll's Finest Pay Tribute to Queen

As D-Day approached, rehearsals to organize collaborations between Queen and the guest artists were held at the Nomis Studios in London and at Bray Studios near Maidenhead before finally moving to Wembley Stadium on the day before the concert. "It was a massive strain on our shoulders," explained Brian May, "because we weren't just performing, we were also organizing everybody else. It was difficult enough just choosing the acts who would appear."[14] But the artists all behaved well, and despite some of the notorious rock 'n' roll egos on hand, everyone was willing to play the game and accept the order of play imposed by Queen. The atmosphere of the event was one of honor and celebration, and egos were put aside.

Terry Giddings, Mercury's faithful driver who had been at his side during his final hours, gave his impression of the atmosphere that reigned during rehearsals: "Everybody turned up on time and nobody seemed to mind hanging around. [...] People would start out trying to do the songs like Freddie, but then they'd have to give up and just do it like themselves."[14]

Queen's Last Wembley Stadium Performance

On April 20, 1992, Queen took to the stage and Brian addressed the crowd: "Good evening Wembley and the world! We are here tonight to celebrate the life and work and dreams of one Freddie Mercury. We're gonna give him the biggest send-off in history!"[174] And it was indeed a night to remember.

452 THE FREDDIE MERCURY TRIBUTE CONCERT

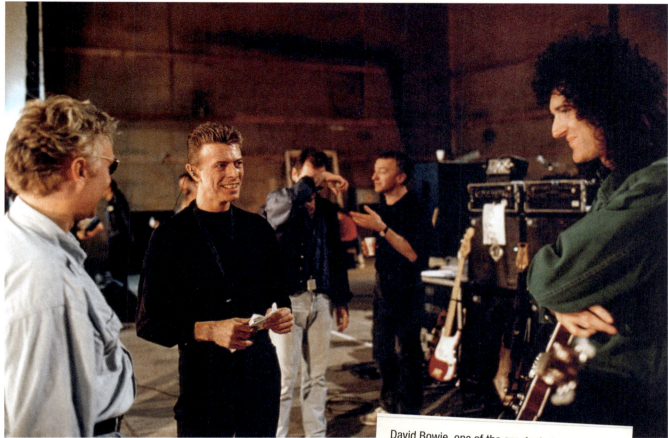

David Bowie, one of the greatest stars to take part in this mythical concert, surprised everyone when he knelt down onstage and launched into an Our Father that was not on the program, forcing the musicians and the tens of thousands of spectators into silence.

The concert consisted of two parts. During the first "warm-up" period of the show, the entire hard-rock scene was brought together to perform the hits of the moment. Metallica opened the concert with "Enter Sandman," "Sad but True," and the hit "Nothing Else Matters." They were followed by Extreme, who performed their single "More Than Words," preceded by a tribute to Freddie with a cover of "Love of My Life." Then came high-octane performances from Def Leppard, Bob Geldof, Guns N' Roses and Mango Groove. Even the fictional band Spinal Tap—famous since the eponymous parodic mockumentary about them directed by Rob Reiner appeared in 1984—performed one of their tracks: "The Majesty of Rock."

After this introduction, things got serious. From the beginning of the second part of the concert, the May-Deacon-Taylor trio opened proceedings with a classic "Tie Your Mother Down," followed by some twenty other Queen classics, each accompanied by a prestigious guest. One of the highlights of the concert was the Annie Lennox–David Bowie duo singing "Under Pressure," which both the audience and Annie Lennox herself will never forget: "I was so completely bowled over to be singing a duet with him that it felt like I was dreaming."[18]

But it was George Michael's entrance to the stage that really set Wembley alight. After an excellent performance of "'39"—a song he listened to when he was a young singer looking for a contract—he performed a version of "Somebody to Love," accompanied by Queen and a gospel choir that Freddie would have loved. George Michael brought the whole world to its feet, just as his idol had done in the same place on July 13, 1985. The performance was breathtaking, with absolute precision and remarkable power, so much so that in the months that followed, rumors spread in London that George Michael could well be joining Queen as its new lead singer. This rumor was quickly denied by the band, which did not prevent Brian May from acknowledging the stunning performance of their guest: "I would have to say it was a thrill to work with George Michael [...]. He was one of the great surprises, to most people, of the evening, I know. It wasn't a surprise to me 'cause I knew he could do it, I knew he had that in him. Because in addition to the great delicacy which he has, and great control, great dynamics, he has enormous power. And from the moment he stepped into the rehearsal room and was doing 'Somebody to Love' we went, 'Whoa!' I think in most people's feeling he got closest to the range of Freddie himself."[175] "It was probably the proudest moment of my career," recalled George Michael, "because it was me living out a childhood fantasy: to sing one of Freddie's songs in front of 80,000 people."[14]

QUEEN: ALL THE SONGS 453

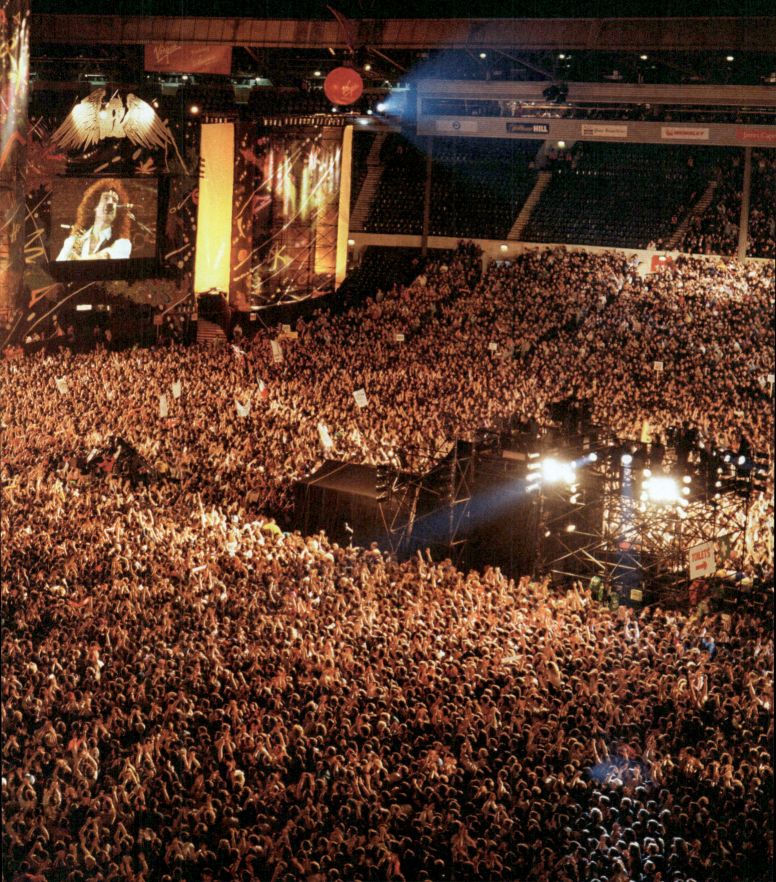

FOCUS ON...

George Michael takes the stage to perform one of his favorite Queen songs, "'39." The singer admitted that he listened to this folk ballad over and over during his youth.

One of the most highly anticipated moments of the night was the performance of "Bohemian Rhapsody" by the duo of Elton John and Axl Rose. The presence of the bad boy Guns N' Roses rocker, then at the height of his career, was a delicate situation to handle, after a number of negative remarks he had made regarding homosexuals. Elton John, who paid no attention to idle rock star gossip, didn't hold it against his colleague. Nevertheless, Axl Rose remained locked in his dressing room all day long, and nobody knew quite what would happen when the time came to perform "Bohemian Rhapsody." But once again, the magic happened when the lead singer of Guns N' Roses took to the stage in the middle of the fireworks created during the rock portion of the song, which occurs after the famous operatic interlude. You only have to see the smile on Roger Taylor's face during the hug between Elton John and Axl Rose during the finale of the song to understand that the moment is a truly exceptional one. John Reid, Queen's former manager, later recalled this unforgettable moment: "I remember sitting in the box [...], just weeping. The entire audience was weeping."[18]

The concert ended with a rendition of "We Are the Champions" performed by all the artists, but the final word went to Liza Minnelli, one of Freddie Mercury's great idols. The woman who inspired the singer so much in his early years closed this exceptional day with modest but moving words: "Thanks Freddie. We just wanted to let you know, we'll be thinking of you."[174]

> Robert Plant refused to allow his performance of "Innuendo" to appear on the VHS of the concert, which was released on November 23, 1992. The Led Zeppelin singer's performance was indeed below par, the lyrics having eluded him on several occasions.

456 THE FREDDIE MERCURY TRIBUTE CONCERT

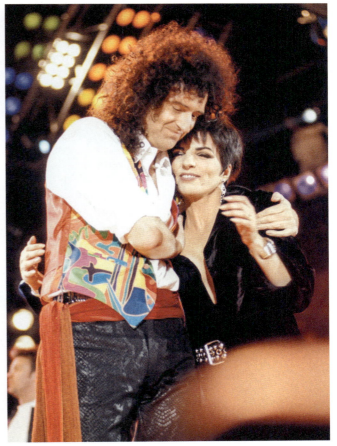

(Top) A battle of the titans between Brian and fellow guitar hero Slash, from Guns N' Roses. (Bottom Left) Two worlds collide as Elton John and the lead singer of Guns N' Roses, Axl Rose, come together to perform a cover of "Bohemian Rhapsody." (Bottom Right) Brian May with Freddie Mercury's idol, Liza Minnelli, at the concert finale.

ALBUM

Made in Heaven was principally composed and recorded for release in compact disc format, and it is the CD track listing, with a playing time of seventy-four minutes, that is described here.
For the album's release on vinyl, Queen edited and shortened certain songs so that the album could be released on an LP.

MADE IN HEAVEN

It's a Beautiful Day . Made in Heaven . Let Me Live . Mother Love .
My Life Has Been Saved . I Was Born to Love You . Heaven for Everyone .
Too Much Love Will Kill You . You Don't Fool Me . A Winter's Tale .
It's a Beautiful Day (Reprise) . Yeah . "13"

RELEASE DATES
United Kingdom: November 6, 1995
Reference: Parlophone—PCSD 167 (33 rpm)—CDPCSD 167 (CD)
United States: November 7, 1995
Reference: Hollywood Records—HR-62017-2 (CD)
Best UK Chart Ranking: 1
Best US Chart Ranking: 58

Created by Irena Sedlecká, this statue of Freddie Mercury stands on the banks of Lake Geneva, in Montreux.

QUEEN'S FINAL ALBUM

Following the Wembley concert on April 20, 1992, which was a moment of communion, it was time to face the facts: Things would never be the same again. The press feedback was exceptional, and since its release in October 1991, the *Greatest Hits II* compilation, which showcased all of Queen's hits since "Under Pressure" on the *Hot Space* album, had been met with huge success. In the United States, another event further boosted Queen's reputation: In May 1992 the film *Wayne's World* was released. Directed by Penelope Spheeris, *Wayne's World* features the popular characters of Wayne Campbell and Garth Algar, two friends from the little town of Aurora, Illinois, who were both hard rock enthusiasts. Wayne and Garth ran a local television program from their basement. In one of the cult scenes from the film, Wayne, played by Mike Myers (who was later to have an important role in the film *Bohemian Rhapsody*), inserted a cassette tape into his car stereo, with the comment: "*I think we'll go with a little 'Bohemian Rhapsody,' gentlemen.*"[176] The five characters sitting in Wayne's car then sing out the operatic part of this landmark number by Queen, then, when the rock portion of the song begins, they launch into a famously epic bout of head-banging, emblematic of so many heavy metal fans who are known for their love of shaking their heads vigorously in time with the music. The Canadian Mike Myers explained in 2015: "I grew up in Scarborough, Ontario, of British parents. I'd gone to England in '75 with my family and heard 'Bohemian Rhapsody' on the radio. We were obsessed with it [...]. It's just something that I always back-pocketed. *Wayne's World* was my childhood. I knew only to write what I knew."[177] This short sequence sent the song right up to second place on the American charts, although the land of Uncle Sam had basically shunned Queen since 1984.

In Europe, this was still a time of mourning for May, Deacon, and Taylor. May described this time as one of great emotion, saying that "Apart from the grief of losing someone so close, suddenly your whole way of life is destroyed. All that you have tried to build up for the last twenty years is gone."[14] In order to distract himself from his sorrow, the guitarist worked assiduously throughout 1992, focusing on the production of his first solo album *Back to the Light*, which was mainly recorded at home in his Allerton Hill studio. When the single "Too Much Love Will Kill You," which May had performed at the April Wembley concert, was released in 1992, it was a success.

In November 1992, *The Freddie Mercury Album* appeared in Europe, including some solo numbers by the singer, such as "Barcelona" and "The Great Pretender." The song "Living on My Own" was also remixed by producers Serge Ramaekers, Colin Peters, and Carl Ward in the autumn of 1993, and it became an international success.

More Than a Tribute—A True Queen Disc

When "Living on My Own" was playing in clubs throughout the world, Brian May was promoting his solo album on an international tour between Rio and Buenos Aires. He then joined Guns N' Roses, where he played on the first parts of their North American tour, accompanied by

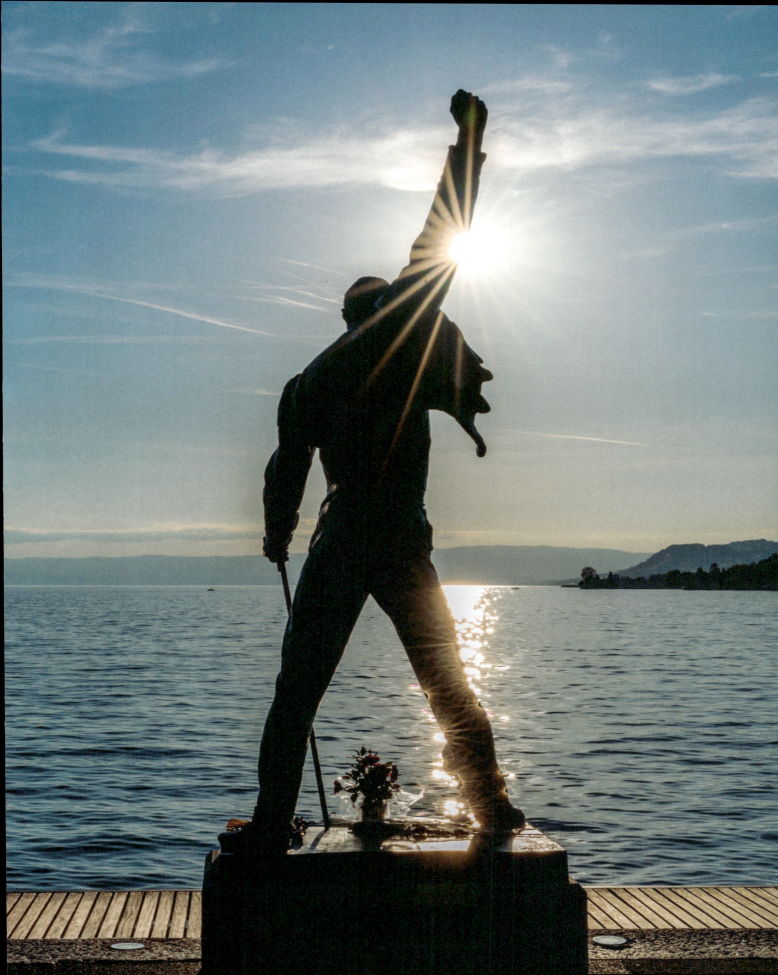

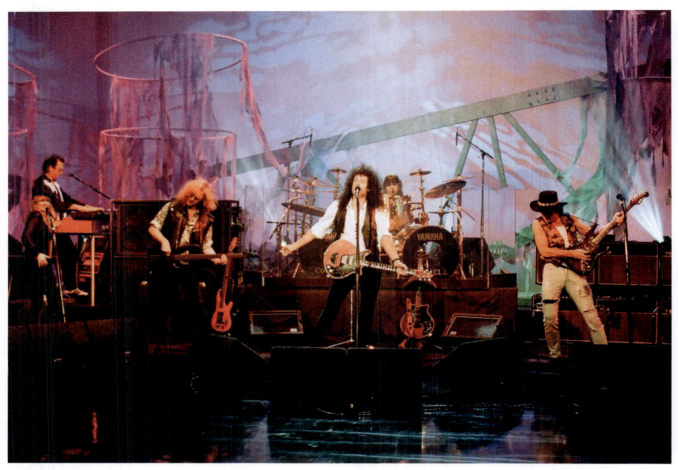
Brian May, accompanied by the Brian May Band, during an appearance on *The Tonight Show with Jay Leno* on April 5, 1993.

the Brian May Band, which featured Cozy Powell on percussion, Mike Casswell on guitar, and Spike Edney on keyboards, along with vocalists Maggie Ryder, Miriam Stockley, and Chris Thompson. In London, John Deacon remained with his wife and children, trying as best he could to get over the loss of Mercury, which had profoundly affected him. During this time, Roger Taylor, the hyperactive member of the group, was dreaming of injecting new life into Queen's music.

Nineteen ninety-three passed by with no new album. While May made multiple appearances with his musician friends—he was in particular seen with Paul Rodgers on numerous occasions—Deacon and Taylor met up from time to time, and rumors started to circulate. The guitarist himself had instilled some hope for the fans in the columns of the *Boston Globe*: "We'll see if there's anything to release in a dignified manner, but it has to be of the required quality or we don't want it to go out."[178]

In the spring of 1991, although he was very ill, Freddie Mercury had in fact wanted to get back to work as soon as possible following *Innuendo*. Some of the numbers, such as "You Don't Fool Me," "A Winter's Tale," and "Mother Love," had been recorded in the group's little studio in Montreux. Freddie expressed his wish for these songs to have life, and to be heard and enjoyed by the public: "Keep writing me words, keep giving me things, I will sing, I will sing. And then you do what you like with it afterwards and finish it off."[110]

Meticulous Work in Honor of Their Friend Freddie

At the beginning of 1994, Roger and John met up to finalize the numbers that had been put to the side for three years. As he was on tour in Europe, May was unaware of any of these sessions. The work had not progressed much: some of the bass parts had been laid down, some guitar lines recorded, and possibly some of the percussion scores as well—nothing too significant. But this was enough to infuriate the guitarist: "When I went on the *Back to the Light* tour, I heard that the other members of Queen had already taken the decision to go ahead with this last album, without even asking my opinion. [...] I was not convinced that releasing this album was a good idea. As soon as I heard the news, I contacted Roger and John to make my disapproval known to them. To that they answered, that if it didn't suit me, they would go ahead without me! I was already fuming to have been treated that way, but even that was nothing compared to the anger I had after having listened to what they had put down on tape during my absence: it was truly catastrophic!"[5]

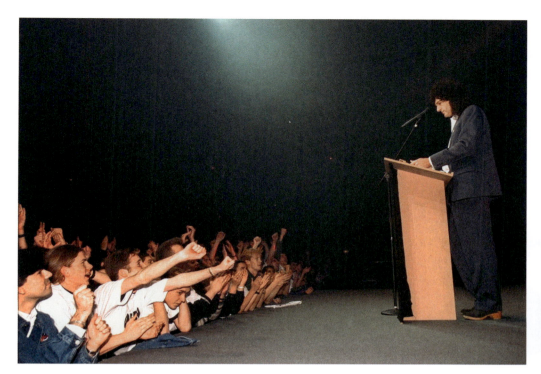

Brian May addresses Queen fans at the presentation of "Made in Heaven" in Paris on October 30, 1995.

May then decided to rework the tapes himself, in his studio at Allerton Hill. It took him eighteen months to work through the numbers, reviewing the structures of the songs, and above all, enabling the project to mature in quality. "Doing *Made in Heaven* was like assembling a jigsaw puzzle,"[79] he explained.

The project finally came together at the end of 1994. Brian May declared in the pages of *Guitarist* magazine that the three musicians had met up over the summer at the Metropolis Studios, and on March 9, 1995, John Deacon officially announced in a letter to the group's fan club that they were working on a Queen album. During the summer, they redoubled their efforts, working separately on the songs for the forthcoming disc. Roger and John set themselves up in the drummer's studio at Cosford Mill, and May worked in his own studio. In September 1995, three weeks were booked at the Town House studios in London to finish off this opus. "The album was released in November, so there was only a 4 week window to manufacture the CD after we had finished the final recordings, mixes & mastering," recalled Ash Alexander, the location's assistant sound engineer.[152] In the space of one month, the album was finished, and the promotion of the album was launched.

On November 6, 1995, *Made in Heaven* was released. Six singles were derived from it: "Heaven for Everyone," "A Winter's Tale," "Too Much Love Will Kill You," "Let Me Live," "You Don't Fool Me," and "I Was Born to Love You," though the last track was released as a single only in Japan. Queen's final album was a success in the United Kingdom, where it reached first place in the charts. The British press were not kind to this opus, which does, however, contain some real treasures, often reminiscent of Queen from the *Game* era. For the music videos, the three members of the group wanted to provide a new vision of their music, and to avoid appearing without Mercury. They therefore called upon various filmmakers from the British Film Institute to make eight short films, one each for selected songs from the album. The *Made in Heaven: The Films* project was presented at the Cannes film festival in May 1996. These films were also made available on a DVD of the same name, which was released in 2013.

The album sleeve was designed by Richard Gray, who had already worked on the group's previous discs. He created a montage that depicted the façade of the "Duck House" cabin, the little house in Clarens, a few kilometers from Montreux, where Freddie went to rest. In the foreground, there is the statue of the singer that has been placed on the banks of Lake Geneva and is shown in the emerging brightness of the dawn. This statue was a work by the Czech artist Irena Sedlecká and was originally intended to be placed in the heart of London. "We actually tried London," explained Brian May at the unveiling of the statue on November 25, 1996, "but although the fans were very keen on the idea, the authorities were not. So we eventually gave up the idea of having it in London because we couldn't find a suitable site. Montreux is very close to the heart of the band, really, particularly Freddie, because the last few years of his life were mostly spent here. And it was a very peaceful place for Freddie because he wasn't pursued by the press like he was in England [...]. So it's a logical place to have the statue."[180] On the monument, at the feet of the singer, a plaque carries the very understated caption:

<div style="text-align:center">

Freddie Mercury
1946–1991
Lover of life—Singer of songs

</div>

QUEEN: ALL THE SONGS

IT'S A BEAUTIFUL DAY
Queen / 2:32

Musicians
 Freddie Mercury: lead vocals, piano
 Brian May: electric guitar
 Roger Taylor: percussion
 John Deacon: bass, synthesizers

Recorded
 Musicland Studios, Munich: April 1980
 The Town House, London: September 1995

Technical Team
 Producers: Queen, David Richards, Justin Shirley-Smith, Joshua J. Macrae
 Sound Engineers: David Richards, Justin Shirley-Smith, Joshua J. Macrae, Reinhold Mack
 Assistant Sound Engineers: Ashley Alexander (Town House), John Brough (Town House)

FOR QUEEN ADDICTS
"It's a Beautiful Day" (Single Version) appears on the CD single of "Heaven for Everyone," which was released on October 23, 1995. This mixing of the song includes passages taken from "It's a Beautiful Day" and "It's a Beautiful Day (Reprise)."

Genesis

Accompanying himself on the piano, Freddie Mercury recorded this short melody at the Musicland Studios in Munich during the recording sessions for *The Game*, which took place in 1980. Known by fans as "It's a Beautiful Day" (Original Spontaneous Idea, April 1980), this studio "off-cut" was used in 1994 to create the number "It's a Beautiful Day." The original version of the song appeared as a bonus on the remastered edition of *The Game* that was released in 2011.

There are a good number of references to the absence of Mercury on *Made in Heaven*, starting with references to paradise made in the song's title. Beginning with this hymn to life was an astute choice, as it sets the overall tone of the album, keeping the emphasis upbeat and full of hope, although also marked by an undeniable melancholy. The song "It's a Beautiful Day" is a fine tribute to Freddie, who managed to keep his head held high, even as his health was declining. The words emphasize the singer's spirit and zest for life, calling out to whoever wants to hear it: *"It's a beautiful day / The sun is shining / I feel good / And no-one's gonna stop me now."*

Production

John Deacon in particular took care of the orchestrations on this track, which were done on the synthesizer. Brian May then inserted the guitar sections, which remain very much in the background but are very subtly executed and are perfectly fitting for the *ambient* aspect of the piece. This ambient style of music, which is very often instrumental, was dominant in the mid-1990s, with its repetitive and relaxing tones that combine psychedelic and electronic experimentation. Roger produced pleasing cymbal rolls and crashes, accompanying the powerful Red Special chords at 1:15, just as Freddie's voice hits the high notes.

Background noises of birdsong are also added, which contribute to the positive and cheerful emphasis placed on the introduction to the album.

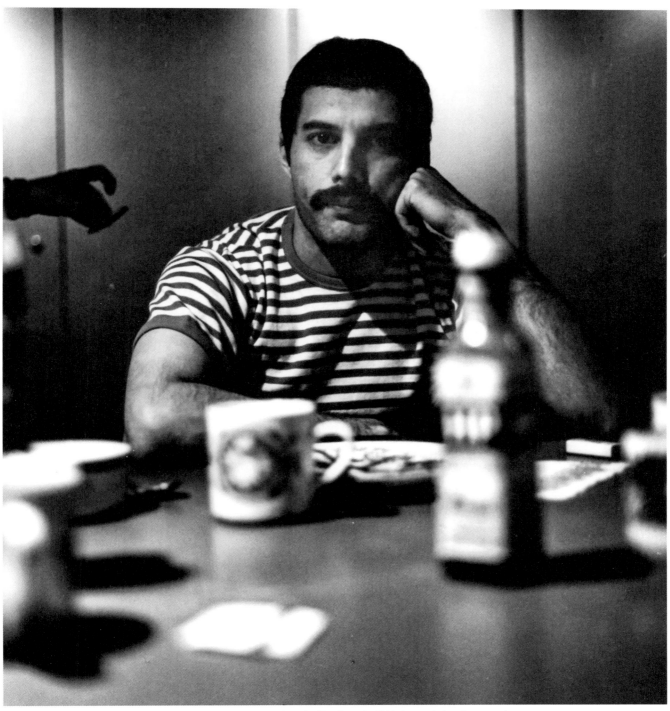

A photograph of Freddie Mercury taken during the recording sessions for *The Game* in 1981. It was during these sessions that Freddie recorded some of the fragments of what would become "It's a Beautiful Day."

Freddie in the "Made in Heaven" music video, a song that he had recorded for his album *Mr. Bad Guy* in 1985.

MADE IN HEAVEN
Freddie Mercury / 5:26

Musicians
Freddie Mercury: lead vocals, backing vocals, piano, synthesizers
Brian May: electric guitar
Roger Taylor: drums, percussion
John Deacon: bass

Recorded
Musicland Studios, Munich: May 31, 1984
The Town House, London: September 18–22, 1995

Technical Team
Producers: Queen, David Richards, Justin Shirley-Smith, Joshua J. Macrae
Sound Engineers: David Richards, Justin Shirley-Smith, Joshua J. Macrae, Reinhold Mack
Assistant Sound Engineers: Ashley Alexander (Town House), John Brough (Town House)

Genesis

Following the disc's introduction, "It's a Beautiful Day," the second track begins the album's more serious content. In the same vein as "Let Me in Your Heart Again," which was recorded by Queen at the end of 1983 during their sessions for *The Works*, "Made in Heaven" is a well-crafted, powerful, and extremely melodic ballad. The song was eventually finished by Mack at the Musicland Studios in Munich in 1985. By this point, Mack was serving as co-producer of Queen's albums, and the song, which was written by Freddie Mercury, had originally been composed for his album *Mr. Bad Guy*, where it served as the second single. "Made in Heaven" was exhumed from *Mr. Bad Guy*—which had been a commercial failure—and it was given a second chance to live again, this time with purely authentic Queen arrangements.

Production

Only the voice and synthesizer were retained from the original version of the song that was recorded by Mercury. After removing the guitar track by Paul Vincent, Fred Mandel's piano, Stephan Wissnet's bass (Wissnet was also Mack's assistant sound engineer) and Curt Cress's drums, Queen then put its own mark on the number. Brian May said that he spent many months editing the piece in his personal studio at Allerton Hill, until he achieved the perfect structure.

While this new version did not differ much from the one on *Mr. Bad Guy* in terms of construction, the listener can still enjoy finding the Red Special harmonizations in the main riff, which comes in as an introduction, and then appears after each refrain. The guitar solo is played with a bottleneck slide by Brian May. With these new arrangements, the piece takes on a more modern and rock-oriented tone. It is certain that Mercury would have been pleased that his song assumed new life in this context. For his part, Brian May commented that the work done on "Made in Heaven" had made it "possibly the best-sounding Queen song ever."[181]

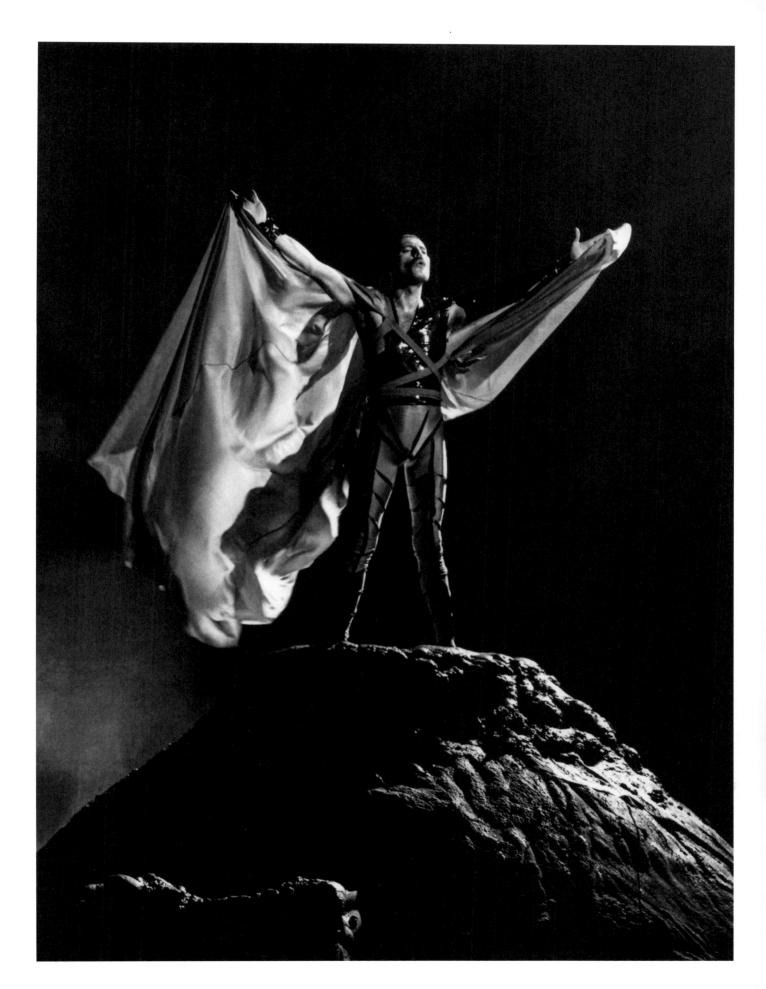

LET ME LIVE
Queen / 4:46

> This is the second time that Queen was accompanied by a choir. At the Freddie Mercury Tribute Concert on April 20, 1992, when the group performed "Somebody to Love" with George Michael, there was a gospel choir behind the scenes supporting the lead singer.

> Rod Stewart appeared on the original track of "Let Me Live" in 1983, but he was replaced by Roger Taylor, whose voice actually sounds quite similar.

Musicians
Freddie Mercury: lead vocals, piano
Brian May: lead vocals, electric guitar, backing vocals
Roger Taylor: lead vocals, drums, percussion, backing vocals
John Deacon: bass
Gary Martin: backing vocals
Catherine Porter: backing vocals
Miriam Stockley: backing vocals
Rebecca Leigh-White: backing vocals

Recorded
The Record Plant, Los Angeles: September 2, 1983
Cosford Mill, Surrey: Spring 1995, over three days (harmonies and backing vocals)
The Town House, London: September 18–22, 1995 (mixing)

Technical Team
Producers: Queen, David Richards, Justin Shirley-Smith, Joshua J. Macrae
Sound Engineers: David Richards, Justin Shirley-Smith, Joshua J. Macrae, Reinhold Mack
Assistant Sound Engineers: Ashley Alexander (Town House), John Brough (Town House)

Single (45 rpm)
Side A: Let Me Live / 4:46
Side B: Fat Bottomed Girls (1994 Remaster Error) / 4:16; Bicycle Race / 3:01
UK Release on Parlophone: June 17, 1996 (ref. QUEENPD 24)

Single (CD—Part 1)
1. Let Me Live / 4:46
2. Fat Bottomed Girls (1994 Remaster Error) / 4:16
3. Bicycle Race / 3:01
4. Don't Stop Me Now / 3:29

UK Release on Parlophone: June 17, 1996 (ref. CDQUEEN 24)

Single (CD—Part 2)
1. Let Me Live / 4:46
2. My Fairy King (BBC Session 1—1995 Stereo Swap) / 4:06
3. Doin' Alright (BBC Session 1—1995 Stereo Swap) / 4:11
4. Liar (BBC Session 1—1995 Stereo Swap) / 6:28

UK Release on Parlophone: June 17, 1996 (ref. CDQUEEN 24)
Best UK Chart Ranking: 9

Genesis
On September 2, 1983, when Queen was recording *The Works* at the Record Plant in Los Angeles, Rod Stewart popped into the studio, accompanied by the six-string virtuoso Jeff Beck, of whom Brian May was a great admirer. In 1976, during the group's *A Day at the Races* era, an initial jam session with Stewart had led to the writing of a song called "Another Piece of My Heart." With the impromptu meeting in 1983, the musicians started up the track again and set to work. But once again, the song was put aside, and the collaboration stopped there. In 1994, the song was exhumed for *Made in Heaven* and revisited by the group.

Production
Roger Taylor launched into writing the lyrics, as only one couplet had been recorded by Freddie in 1983. Very unusually, the vocal parts were shared between Mercury on the first couplet, Taylor on the second, and May on the third.

The production of the track was sumptuous: modern, brilliant, and with a lightness reminiscent of ballads such as "It's a Hard Life" and "Play the Game." But the key element on the track was its gospel choir sections, which were composed by the two vocalists in the new Brian May Band—Catherine Porter and Miriam Stockley—and by Gary Martin and Rebecca Leigh-White. The latter was particularly well-known for her work on the Pink Floyd album *The Division Bell*, which was released in 1994. In the spring of 1995, the choir section was recorded over three days at Cosford Mill, Roger Taylor's personal studio. The choir can be heard at the beginning and end of the piece in a perfectly recorded rendition. At the time of the recording, the choir sang the following phrase: *"Take another little piece of my heart now baby,"* following a melodic line and a text very similar to the very famous song by Erma Franklin (Aretha's sister), "Piece of My Heart." Written by Jerry Ragovoy and Bert Berns in 1967, the number was also performed by Janis Joplin in 1969, who, at the time, was the lead singer with Big Brother and the Holding Company. Concerned by the risk of a possible plagiarism lawsuit from copyright holders, Deacon, May, and Taylor decided to edit the part recorded by the choir. The phrase finally used was: *"Take a piece of my heart."*

MOTHER LOVE
Freddie Mercury, Brian May / 4:49

Musicians
Freddie Mercury: lead vocals
Brian May: electric guitar, lead vocals, synthesizers
Roger Taylor: drums
John Deacon: bass

Recorded
Mountain Studios, Montreux: May 13, 16, and 22, 1991
Metropolis Studios, London: October 13, 1993
The Town House, London: September 1995

Technical Team
Producers: Queen, David Richards, Justin Shirley-Smith, Joshua J. Macrae
Sound Engineers: David Richards, Justin Shirley-Smith, Joshua J. Macrae, Reinhold Mack
Assistant Sound Engineers: Ashley Alexander (Town House), John Brough (Town House)

FOR QUEEN ADDICTS

Now called Queen: The Studio Experience, the Mountain Studios in Montreux have been transformed into a museum celebrating the work of Queen. In the original studio control room, access to the console enables visitors to do their own mixing of various Queen numbers. By bringing down all the faders except for the one controlling the vocals, listeners can create an a capella version of the song.

Genesis

Definitely the darkest number on the album, but also one of the most successful, "Mother Love" is the last piece ever to have been recorded by Freddie Mercury. This recording took place on May 22, 1991, in Montreux. The lyrics, written by May, are striking, and are well suited to the limitless melancholy of the melody. Freddie sings of the desire to go back and to rewind his life until he can be returned to the comforting arms of his mother, like when he was a child: *"I don't want to make no waves / But you can give me all the love that I crave / I can't take it if you see me cry / I long for peace before I die / All I want is to know that you're there / You're gonna give me all your sweet / Mother love."*

Production

Mercury had been terribly afflicted by illness at this point, and he recorded only the first two couplets of the song. Brian May emotionally explains: "Mercury was exhausted by the effort. We got as far as the penultimate verse and he said, 'I'm not feeling that great, I think I should call it a day now. I'll finish it when I come back, next time.' But, of course, he didn't ever come back to the studio after that."[182]

The song's highest note, at 1:50, was particularly difficult for the lead singer to reach, as the guitarist testified: "He downs a couple a vodkas, stands up and goes for it [...]. This is a man who can't really stand any more without incredible pain and is very weak, you know, has no flesh on his bones, and you can hear the power, the will that he's still got."[5]

Brian May recorded the song's last couplet at the final sessions in September 1995 at the Town House studios in London. With a warm and almost trembling voice, he gives the song an additional level of emotion. He also added a guitar solo with a strange sound to it. For this recording he made an exception to his accustomed use of the Red Special and instead used a Parker Fly, which is a guitar made partly from carbon fiber and fitted not only with the usual electromagnetic sensors one finds on electric guitars, but also with a second piezoelectric pickup, which is traditionally used

Freddie Mercury's mother, Jer Bulsara, sharing a portrait of the young Farrokh.

on acoustic guitars. It is the simultaneous use of these two pickups that gives May's solo such a special color.

But the number's most memorable feature appears at the end. In order to symbolize the aspect of going back in time, May, Deacon, and Taylor created an audio montage that appears suddenly at 4:06. We hear various extracts from Mercury's discography, combined with a tape rewind sound effect: the introduction from "One Vision," then Freddie's traditional improvised lyrics sung for his public (taken from *Live at Wembley Stadium*), mixed with a fleeting passage from "Tie Your Mother Down." After the tape rewind effect, we find Freddie singing under his alias Larry Lurex, as he performs the first phrase of his reprise from "Goin' Back" by Carole King, recorded in 1973: *"I think I'm going back to the things I loved so well in my youth."* "I'm very fond of 'Mother Love.' And it has a little piece of 'Goin' Back,' which was the very first thing that Freddie ever sang in the studio. I wrote to Carole King to ask her permission, and she was delightful, she was so supportive,"[14] said May. Finally, the song plays out on the sounds of a baby crying, which evokes the idea that Freddie's prayer had been answered, and he was back in his mother's arms.

QUEEN: ALL THE SONGS 471

MY LIFE HAS BEEN SAVED

Queen / 3:15

Musicians
Freddie Mercury: lead vocals
Brian May: electric guitar
Roger Taylor: drums
John Deacon: bass
David Richards: programming, synthesizers

Recorded
Mountain Studios, Montreux; and/or Olympic Sound Studios, London; and/or The Town House, London: 1988
The Town House, London: September 18–22, 1995 (mixing)

Technical Team
Producers: Queen, David Richards, Justin Shirley-Smith, Joshua J. Macrae
Sound Engineers: David Richards, Justin Shirley-Smith, Joshua J. Macrae, Reinhold Mack
Assistant Sound Engineers: Ashley Alexander (Town House), John Brough (Town House)

Nichola Bruce created the music video for "My Life Has Been Saved." The film, called *O*, is provided on the *Made in Heaven: The Films* VHS.

Genesis

The first version of "My Life Has Been Saved" was written by John Deacon and recorded in 1988 during the *Miracle* sessions. Although not included in the album track listing, it was granted the distinction of appearing on the B-side of "Scandal," released October 9, 1989.

With a view to giving it a second chance, John Deacon reworked the song on *Made in Heaven*. The number underwent a bit of reworking and numerous synthesizers were added, but unlike a piece such as "I Was Born to Love You," this track ultimately had relatively few modifications made when compared to its original version. At the end of the 1989 track, Freddie Mercury speaks a few words that can be made out at 3:00: *"I'm in the dark / I'm blind / I don't know what's coming to me."* The message of these words probably felt too dark to be included in the new version, and Deacon chose to remove these three phrases from the song.

Production

This number was reworked at the beginning of the *Made in Heaven* project. In 1994, still at the cutting edge of production methods, the remaining Queen trio adopted a revolutionary modus operandi: May refined some of the numbers at the Allerton Hill Studios, and Roger Taylor, often accompanied by John Deacon, worked at his place at Cosford Mill. The guitarist detailed how the musicians approached the project during the album production: "We've kept talking along the way so that we know what each other is doing, and we have a system of swapping tapes to hear where each of us has got to—it's like recording via E-mail! But we are planning to have some time together to do actual recording and we've already had a couple of weeks together at Metropolis. But on the whole we've been doing it separately."[183]

I WAS BORN TO LOVE YOU

Freddie Mercury / 4:49

Musicians
Freddie Mercury: lead vocals, backing vocals, piano, synthesizers
Brian May: electric guitar, synthesizers
Roger Taylor: drums, percussion
John Deacon: bass

Recorded
Musicland Studios, Munich: May 25, 1984
The Town House, London: September 3–17, 1995

Technical Team
Producers: Queen, David Richards, Justin Shirley-Smith, Joshua J. Macrae
Sound Engineers: David Richards, Justin Shirley-Smith, Joshua J. Macrae, Reinhold Mack
Assistant Sound Engineers: Ashley Alexander (Town House), John Brough (Town House)

ON YOUR HEADPHONES
Extracts from famous songs recorded by Freddie Mercury are incorporated into "I Was Born to Love You." One can also hear, at 4:29, the proclamation: *"Ah ah ah, it's magic!"* then *"I get so lonely lonely lonely, yeah,"* two phrases originating, respectively, from "A Kind of Magic" and "Living on My Own."

Genesis

As with "Made in Heaven," "I Was Born to Love You" is borrowed from the *Mr. Bad Guy* album that Mercury released in 1985. The song was also the first single from the original album, and it was released in April 1985 along with an accompanying music video by David Mallet in which "Freddie's Army" appears, consisting of two hundred women dressed by the costume designer Diana Moseley. Queen decided to repromote the number in 1994, and they added arrangements with a greater rock emphasis. This new version was used again in 1997 by Maurice Béjart in his ballet *Le presbytère n'a rien perdu de son charme ni le jardin de son éclat* (The Rectory Has Lost Nothing of Its Charm, Nor the Garden Its Brilliance), which included music by Mozart and Queen. "I Was Born to Love You" was also a big success in Japan, following its use in advertising for Kirin beers, and its appearance as a single in 1996. The number was regularly performed live by Queen + Adam Lambert in 2014, when the group gave its first concerts in the Land of the Rising Sun.

Production

Despite featuring sounds that were in keeping with the trends of the time and a musical aesthetic suitable for clubs, the 1985 version of this track was not met with the success that had been expected. Taking the view that Freddie was not able to give the number the level of production it merited at the time, Brian May decided to rework it in his personal studio. "Freddie did [it] very hurriedly. So we stripped everything away, and lovingly, cherishingly re-edited all his vocals. I spent months piecing together our bits to make it sound like we were all in the studio together."[14] The song came to life with the lively rhythm provided by the duo of Taylor and Deacon, and the Red Special was given prominence with a very heavy solo. The song was completed and mixed at the Town House studios in London between September 3 and 17, 1995, by Queen along with David Richards and Ashley Alexander, the location's assistant sound engineer.

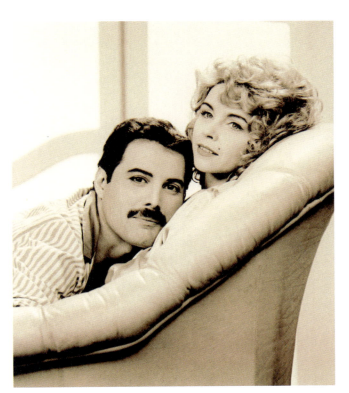

Freddie and the comedic actress Debbie Ash, in an image from the music video made for the original version of "I Was Born to Love You," in 1985.

HEAVEN FOR EVERYONE
Roger Taylor / 5:36

Musicians
Freddie Mercury: lead vocals, backing vocals
Brian May: electric guitar, backing vocals
Roger Taylor: drums, backing vocals, synthesizers
John Deacon: bass

Recorded
The Town House, London: December 1987, September 1995

Technical Team
Producers: Queen, David Richards, Justin Shirley-Smith, Joshua J. Macrae
Sound Engineers: David Richards, Justin Shirley-Smith, Joshua J. Macrae, Reinhold Mack
Assistant Sound Engineers: Ashley Alexander (Town House), John Brough (Town House)

Single (CD—Part 1)
1. Heaven for Everyone (Single Version) / 4:43
2. It's a Beautiful Day (Single Version) / 3:57
3. Heaven for Everyone / 5:36

UK Release on Parlophone: October 23, 1995 (ref. CDQUEENS 21)

Single (CD—Part 2)
1. Heaven for Everyone (Single Version) / 4:43
2. Keep Yourself Alive / 3:47
3. Seven Seas of Rhye / 2:48
4. Killer Queen / 3:00

UK Release on Parlophone: October 30, 1995 (ref. CDQUEEN 21)

Single (CD)
1. Heaven for Everyone (Single Version) / 4:43
2. Soul Brother (Remaster Error) / 3:40

US Release on Hollywood Records: June 1996 (ref. HR-64006-2)

Best UK Chart Ranking: 2
Best US Chart Ranking: Not Ranked

Genesis

At the beginning of 1988, when the Cross, Roger Taylor's new group, was recording its new album, *Shove It*, the drummer asked Freddie Mercury to sing the lead on one of the band's new compositions: "Heaven for Everyone." This is a calm and melodious number, and its lyrics express concern for a world in which so many things could be so much better. Freddie was happy to agree, hoping that his reputation might help his friend to launch his new musical project. Two versions of the song were then recorded. The first version of the song featured a lead sung by Mercury with incursions by Taylor on the intro, break, and outro. This version appeared on the British version of *Shove It*. The second version, which serves as the album's single, was performed by Roger, retaining only a few discreet backing vocals by Freddie.

In 1995, it was Freddie's voice that was used for this new version of the piece, which, on October 23, 1995, became the first single off of *Made in Heaven*.

Two music videos were created to promote the song. The first, by David Mallet, combined images of the group and extracts from the famous silent film *A Trip to the Moon*, which was made by Georges Méliès in 1902. The video appears on the *Greatest Flix III* VHS, which includes music videos by the group, as well as extracts from their concerts. The second video was made by Simon Pummell as part of the collaboration between Queen and the British Film Institute. With the title *Evolution*, it appears on both the *Made in Heaven: The Films* VHS and the DVD version released in 2003.

Production

For the song to have a place on *Made in Heaven*, Taylor had to provide a version that was different from the one used by the Cross. So Queen worked during September 1995 at the Town House studios on an edit that featured only Mercury, and the instrumental tracks were rerecorded by Deacon and May. Brian provided a powerful solo, though it did lack a certain magic, and numerous backing vocals were added at the final studio sessions.

474 MADE IN HEAVEN

The music video of "Heaven for Everyone" used images from the film *A Trip to the Moon*, which was directed by Georges Méliès in 1902. Once again, Taylor's love of science fiction found expression in a Queen music video.

TOO MUCH LOVE WILL KILL YOU

Brian May, Frank Musker, Elizabeth Lamers / 4:20

Musicians
Freddie Mercury: lead vocals
Brian May: electric guitar, synthesizer, backing vocals
Roger Taylor: drums
John Deacon: bass
David Richards: synthesizers, programming

Recorded
Mountain Studios, Montreux; and/or Olympic Sound Studios, London; and/or The Town House, London: April 1988
The Town House, London: September 1995

Technical Team
Producers: Queen, David Richards, Justin Shirley-Smith, Joshua J. Macrae
Sound Engineers: David Richards, Justin Shirley-Smith, Joshua J. Macrae, Reinhold Mack
Assistant Sound Engineers: Ashley Alexander (Town House), John Brough (Town House)

Single (45 rpm)
Side A: Too Much Love Will Kill You / 4:20
Side B: We Will Rock You / 2:01; We Are the Champions / 3:00
UK Release on Parlophone: February 26, 1996 (ref. QUEEN 23)

Single (CD)
With Parlophone:
1. Too Much Love Will Kill You / 4:20
2. Spread Your Wings / 4:36
3. We Will Rock You / 2:01
4. We Are the Champions / 3:00

UK Release on Parlophone: February 26, 1996 (ref. CD QUEEN 23)

With Hollywood Records:
1. Too Much Love Will Kill You / 4:20
2. Rock in Rio Blues (US Version) / 4:35

US Release on Hollywood Records: December 5, 1995 (ref. HR-64005-2)

Best UK Chart Ranking: 15
Best US Chart Ranking: Not Ranked

Genesis

In 1988, just before the start of the recording sessions for *The Miracle*, Brian May took some time out at his property in Los Angeles, during which he wrote "Too Much Love Will Kill You" with two of his composer friends, Elizabeth Lamers and Frank Musker. When the group launched into the recording of the disc, May had them listen to this number, which immediately won over Mercury. But, according to a new golden rule in the group, all tracks had to be credited to May, Taylor, Mercury, and Deacon. Brian informed his peers that he had not written this number alone, and, as was done for "All God's People," which Mercury had composed with Mike Moran, "Too Much Love Will Kill You" was left out of the disc's track listing.

In 1992, when Brian May released his first solo album *Back to the Light*, he promoted it with the single "Too Much Love Will Kill You," which appeared in August of the same year. The song's music video was straight out of the 1990s, with images of the guitarist walking by the sea, sometimes in slow motion, sometimes blurred, and combined with close-ups where he seems somewhat uncomfortable in the role of lead singer.

This was not the first time that the public had heard this number, as May had also performed it at the tribute concert for Freddie Mercury on April 20, 1992, at Wembley Stadium. Supported by Spike Edney on keyboard, May sang this lead solo in front of an audience of seventy-two thousand, who were largely won over by this new ballad. He recalled: "It was a big step to do it and I wanted to do it for Freddie. [...] It was a song that I felt was the best way of expressing myself and also the best thing I had to offer at the time. [...] As I was walking over to the piano I was thinking, 'Should I really be doing this?' So it was difficult, it really was."[184] The number was a success in many countries and remains the guitarist's only solo vocal hit.

While "Too Much Love Will Kill You" was not included on *The Miracle*, Freddie did have time to record a version in 1988 while he was at the Mountain Studios in Montreux. When the time came to select the songs for *Made in Heaven*, it seemed logical to Brian to take this track out of the Queen archives and dedicate it to Freddie, who liked it so much.

Brian May performs onstage in Modena, Italy, in 2003.

Production

The lead vocal takes recorded by Freddie in 1988 were used for the 1995 version, which were mainly worked on in May's studio at Allerton Hill. The updated number has the same style and tone at the beginning as the original version, and this is mainly due to the omnipresence of a synthesizer vainly attempting to reproduce the gentleness and warmth of a Fender Rhodes electric piano. Emblematic of the 1990s, the synthesizer has not withstood the test of time and now has a very outdated feel on the songs in which it was used. Happily, from 2:31, the drums come in, followed by the Red Special, all of which confer a welcome rock 'n' roll aspect to the number. The finale of the song reveals a Mercury with his full vocal powers intact, and it reminds us all that at the time of the recording, our hero was capable of incredible, soaring vocals.

SINGLE

YOU DON'T FOOL ME
Queen / 5:24

Musicians
Freddie Mercury: lead vocals, backing vocals
Brian May: electric guitar
Roger Taylor: drums, percussion, synthesizers, backing vocals
John Deacon: bass

Recorded
Mountain Studios, Montreux: April–May 1991
The Town House, London: September 5–7 and 9–13, 1995

Technical Team
Producers: Queen, David Richards, Justin Shirley-Smith, Joshua J. Macrae
Sound Engineers: David Richards, Justin Shirley-Smith, Joshua J. Macrae, Reinhold Mack
Assistant Sound Engineers: Ashley Alexander (Town House), John Brough (Town House)

Single (The Remixes CD)
1. You Don't Fool Me / 5:24
2. You Don't Fool Me (Dancing Divaz Club Mix) / 7:05
3. You Don't Fool Me (Sexy Club Mix—Mis-Pressed Edit) / 10:13
4. You Don't Fool Me (Late Mix) / 10:34

UK Release on Parlophone: November 18, 1996 (ref. CDQUEEN 25)
Best UK Chart Ranking: 17

Genesis

"You Don't Fool Me" is one of the three songs on the album that were created with Mercury in May 1991. The other two songs are "A Winter's Tale" and "Mother Love." Not many lyrics had been recorded at that time, and the instrumental portion was produced after the death of the lead singer.

"You Don't Fool Me" is of a surprising length on the CD version of the album (5:24). Not much is added to augment the admittedly effective melody, other than May's solo guitar. Given the lack of additional vocals recorded by Mercury, the song repeats the instrumental sections in a loop and often feels slightly overlong. The group had made listeners accustomed to protracted songs from its early days, with rock monuments such as "The March of the Black Queen" or "Bohemian Rhapsody," but here the piece seems to be stretched out solely for the enjoyment of the nightclubbers for whom it was intended. For the vinyl version of the disc, "You Don't Fool Me" was edited down to 4:40.

The number was chosen to be the fifth single from *Made in Heaven* and was released in February 1996. When the song was released the group approached a number of DJs in the hopes that they would create their own remixes, and a multitude of versions emerged, all equally forgettable. Some of the names of these remixes were pretty implausible: "Dancing Divas Club Mix," "Late Mix," "Sexy Club Mix," "Freddy's Club Mix," and even "Dub Dance Single Mix"!

The song was only moderately successful, despite receiving massive radio airtime. It does, however, remain one of the key tracks from the album, if only for its catchy rhythm and driving melody.

Production

Work began on the song in 1991 without Brian May, in an artistic moment between Roger, John, and Freddie. Not surprisingly, the aesthetic was not clear to the guitarist, who did not see what kind of direction the group could give it. Four years later, for *Made in Heaven*, David Richards took things in hand, revising the rhythm part with Taylor and replacing the glacial sound of the drum machine, which was no longer so much in vogue by the mid-1990s. Instead, Richards programmed a more acoustic sound that was closer to that of a real drum kit. The harmonic line was then mapped out, carrying the number through to its final

The sound control room at Mountain Studios in Montreux, Switzerland, where numerous Queen tracks were recorded, including the early takes of "You Don't Fool Me," in May 1991.

production. During the final work sessions at the Town House studios in London, in September 1995, a considerable amount of time was devoted to the final overdubs on "You Don't Fool Me."

On September 5, Brian recorded his last guitar parts between 9 p.m. and midnight. Ash Alexander, the location's assistant sound engineer, describes the session: "During the afternoon Brian's guitar and a Vox AC30 amp appeared in the studio, brought in by Brian's guitar tech Pete Malandrone. [...] David asked me to put two Shure 421 microphones pointing into the back of the speaker cabinet. We did have two SM57's on the front but these weren't used in the recording. [...] Brian put on his guitar that was linked to his amp with one lead. No pedals. His sound was instant and we were soon ready to record. He stood in front of the console in the control room facing David & me. Brian had an idea of what he wanted to play. The guitar riff had already been recorded. The solo guitar is what was added. Brian used a scrap of paper that he drew a map of dots on. Not like musical notation but his own shorthand."[152]

Brian May commented on this episode on his website in 2014: "It was very early—very spontaneous and happened because I could hear it in my head, and the moment was right. Suddenly I really felt empathy for the track...because of the good work that had been done on it, I could now feel the passion in the vocal, and the track had an intensity to feed off and stoke up. [...] There was a lot of magic around in the making of *Made in Heaven*, and though some of it was painful, I agree that it's possibly, in the end, the best Queen album. Life is odd."[185]

As a great admirer of Queen and a member of its fan club for many years, Ash Alexander had originally met Brian May in November 1983. He was also one of the extras in the mythical scene in the "Radio Ga Ga" music video, where an immense crowd executes the song's famous hand-clapping sequence.

SINGLE

A WINTER'S TALE
Queen / 3:49

Musicians
Freddie Mercury: lead vocals, backing vocals
Brian May: electric guitar, synthesizers, backing vocals
Roger Taylor: drums, backing vocals
John Deacon: bass

Recorded
Mountain Studios, Montreux: May 1991
The Town House, London: September 13–15, 1995

Technical Team
Producers: Queen, David Richards, Justin Shirley-Smith, Joshua J. Macrae
Sound Engineers: David Richards, Justin Shirley-Smith, Joshua J. Macrae, Reinhold Mack
Assistant Sound Engineers: Ashley Alexander (Town House), John Brough (Town House)

Single (CD)
1. A Winter's Tale (Single Version) / 3:52
2. Now I'm Here / 4:13
3. You're My Best Friend / 2:50
4. Somebody to Love / 4:56

UK Release on Parlophone: December 11, 1995 (ref. CDQUEEN 22)
Best UK Chart Ranking: 6

The Château de Chillon in the snow, in Montreux, Switzerland.

Genesis

The last piece ever written by Freddie Mercury, this song was written at a time of rest and grace, while the lead singer was in Montreux with Jim Hutton during the winter of 1991. Although the title of this song might have been borrowed from Shakespeare's *The Winter's Tale*, its subject has nothing to do with the work by the English playwright. Enjoying the calm of the town that he was so fond of, Mercury decided to pay tribute to it. His companion tells the story of the song's creation in his book *Mercury and Me*, which was first published in 1994 before the release of *Made in Heaven*. "That day, [...] Freddie sat at the water's edge and was inspired to write a song called 'A Winter's Tale.' It was a Christmas song about Switzerland and life in the mountains. It was never heard. Freddie recorded the song, I'm certain of that, but the tape has never seen the light of day."[165] The lyrics describe the life in the country that the star had come to love, and emphasizes the beauty of the location: "*So quiet and peaceful / Tranquil and blissful / There's a kind of magic in the air.*" The instrumental additions created by Queen for the version that appeared on *Made in Heaven* evoke Christmas carols that British pop stars liked to release for the end of the year, in true Anglo-Saxon fashion. "A Winter's Tale" appeared on the album's second single, which was released on December 11, 1995.

Production

"A Winter's Tale" was originally recorded at the Mountain Studios by Justin Shirley-Smith, one of the location's sound engineers and a co-producer on some of the numbers from *Made in Heaven*. The song was reworked by the other members of Queen in 1994. Mixing took place at the Town House studios in London on September 13, 14, and 15, 1995. The backing vocals added by May and Taylor throughout the number take us back to the great days of the vocal harmonies that made the group's reputation, especially between 2:38 and 2:48.

A second mixing also took place and resulted in a version of the song that is referred to as "A Winter's Tale" (Cozy Fireside Mix). On this version the group's voices are given prominence over the synthesizers. This is the version that appeared on the remastered edition of *Made in Heaven*, which was released in 2011.

IT'S A BEAUTIFUL DAY (REPRISE)

Queen / 3:01

Musicians: Freddie Mercury: lead vocals, piano / **Brian May:** guitars, backing vocals / **Roger Taylor:** drums, programming, backing vocals / **John Deacon:** bass, keyboards / **Recorded:** Musicland Studios, Munich: April 1980 / The Town House, London: September 6 and/or 8, and 18–22, 1995 / **Technical Team: Producers:** Queen, David Richards, Justin Shirley-Smith, Joshua J. Macrae / **Sound Engineers:** David Richards, Justin Shirley-Smith, Joshua J. Macrae, Reinhold Mack / **Assistant Sound Engineers:** Ashley Alexander (Town House), John Brough (Town House)

"It's a Beautiful Day (Reprise)" revisits the first track of the disc, but this time the group ramps up the song's power, using drums and electric guitar to provide a somewhat strange conclusion to this tribute album that was nevertheless very successful. The track is a long improvisation that centers around Freddie's voice, and it contributes nothing to the album. The one element of any note on "It's a Beautiful Day (Reprise)," is the piano introduction, which can be recognized as the same piece of music that appears at 2:21 on "Seven Seas of Rhye."

YEAH

Freddie Mercury / 0:04

Musicians: Freddie Mercury: lead vocals

Taken from "It's a Beautiful Day (Reprise)," at 2:05, and placed in a track on its own, the sole purpose of this four-second long extract is to let fans hear Mercury proclaiming "Yeah!" This is doubtlessly meant to sow confusion among the fans and to feed the discussions on the forums.

"13"

22:33

Musicians: Freddie Mercury: vocals / **Brian May:** keyboards / **Roger Taylor:** keyboards / **David Richards:** synthesizers / **Recorded:** The Town House, London: September 1995 / **Technical Team: Producers:** Queen, David Richards / **Sound Engineers:** David Richards / **Assistant Sound Engineer:** Ashley Alexander

Previously referred to as "Untitled," this hidden track from the CD version of *Made in Heaven* definitively earned the name "13" when *The Studio Collection* box set was released in 2015. This box set combined all of the group's albums, and it included this instrumental track on which Mercury sings only three words throughout its 22:33 duration. The assistant sound engineer Ash Alexander recalled that the song was played almost entirely by David Richards in September 1995. "David Richards had constructed the track at his own studio, he was using a new piece of gear called an ASR 10 (rack). It was a sampler/sequencer that had reverbs, filter and delays built into it. He was amazed with it and had clearly spent time experimenting with its capabilities. [...] I remember we used an AMS delay for a few of the effects. [...] We also had a handful of vocal samples of Freddie. David let me set the samples up in an Akai S3000 and then recorded me playing them throughout the piece. This was played to and then amended that evening by Brian, which is what you hear on the album."[165]

In the tribute he paid to David Richards after his death in 2013, Brian May described this night working with him: "One of my favorite moments with him was the creation of 'Track 13' for that album. David and I lit up joss sticks and candles in the control room, powered up every machine in the building, and sat 'painting pictures' with synthesizers and samplers [...] for the whole night [...]. Roger wafted in, enjoyed the vibe, and played a 'solo' halfway through, and wafted out. [...] In the refreshing emergence we thought we could hear Freddie laughing—still not sure where that particular sample came from, but we left it in. [...] And—no—we didn't take any drugs!!!"[151]

Although "13" is nothing like a classic Queen number, this track has its place on the album as a farewell from Richards to his friend, Freddie Mercury.

CODA

LIVE ALBUMS

Live at Wembley '86 . Queen on Fire: Live at the Bowl . Rock Montreal 1981 .
Hungarian Rhapsody . Live at the Rainbow '74 .
A Night at the Odeon

COMPILATIONS

Greatest Hits . Greatest Hits II . Queen Rocks . Greatest Hits III . Absolute Greatest .
Deep Cuts 1 / Deep Cuts 2 / Deep Cuts 3 . At the Beeb . Forever . On Air .
Bohemian Rhapsody OST

SINGLES

No-One but You (Only the Good Die Young) . Love Kills—The Ballad

COLLABORATIONS

Queen + Paul Rodgers . Queen + Adam Lambert

REISSUE

News of the World—40th Anniversary Edition

LIVE ALBUMS

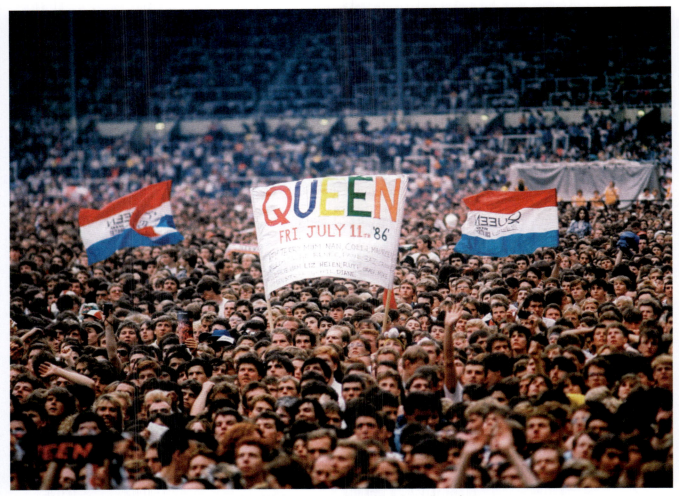

One year after setting Wembley Stadium alight during Live Aid, Queen returned to their London audience for two unforgettable concerts on July 11 and 12, 1986.

LIVE AT WEMBLEY '86

Release Dates: United Kingdom: May 26, 1992, no. 2 / United States: June 2, 1992, no. 53 / **References:** Parlophone—PCSP 725 (LP); Parlophone—CDPCSP 725 (CD) / Hollywood Records—HR-61104-2 / **Track Listing: CD 1:** One Vision / Tie Your Mother Down / In the Lap of the Gods…Revisited / Seven Seas of Rhye / Tear It Up / A Kind of Magic / Under Pressure / Another One Bites the Dust / Who Wants to Live Forever / I Want to Break Free / Impromptu / Brighton Rock Solo / Now I'm Here • **CD 2:** Love of My Life / Is This the World We Created…? / (You're So Square) Baby I Don't Care / Hello Mary Lou / Tutti Frutti / Gimme Some Lovin' / Bohemian Rhapsody / Hammer to Fall / Crazy Little Thing Called Love / Big Spender / Radio Ga Ga / We Will Rock You / Friends Will Be Friends / We Are the Champions / God Save the Queen / **Recorded:** Wembley Stadium, London, July 12, 1986 / **Producer:** Queen / **Sound Engineer:** Reinhold Mack / **Mixing:** Brian Malouf

On May 26, 1992, Queen immortalized the memorable concert of July 12, 1986, in a double live album. The concert at Wembley Stadium had been attended by eighty thousand spectators, all of whom witnessed the coronation of King Mercury, who appeared wearing a crown and ermine cape (the work of renowned costume designer Diana Moseley). Mercury truly was a sovereign adored by his people. His fans had been offering him unconditional love since Queen brought the world to its feet at the same venue a year before during the Live Aid concert.

On a gigantic stage, which only a great showman like Mercury could occupy, the band performed a series of hits. The singer was in poor health, however, and this tour, which ended at Knebworth Park the following month, would be his last. Mercury gave his entire soul to rock 'n' roll here, which he honored in the middle of the set with a medley of old hits that he and May listened to as teenagers: "(You're So Square) Baby I Don't Care" by Buddy Holly, "Hello Mary Lou" by Ricky Nelson, and "Tutti Frutti" by Little Richard.

Some of the tracks are truly outstanding, particularly "In the Lap of the Gods…Revisited" with its unforgettable finale.

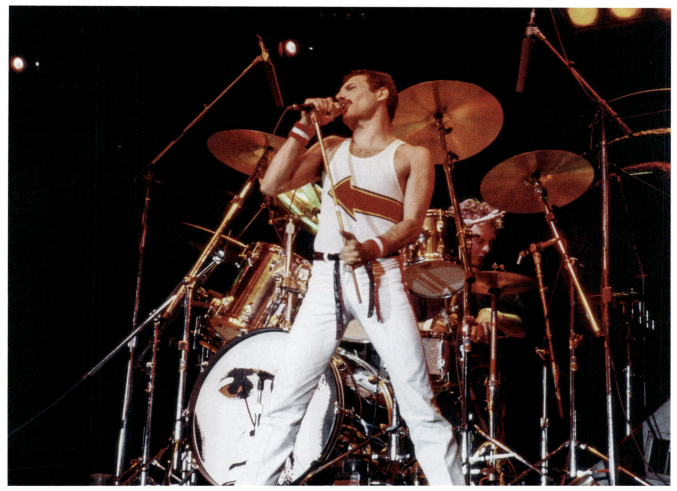

Freddie Mercury at the Milton Keynes Bowl concert near London on June 5, 1982.

QUEEN ON FIRE: LIVE AT THE BOWL

Release Dates: United Kingdom: October 25, 2004, no. 20 / United States: November 9, 2004, no ranking / **References:** Parlophone—7243 8 63214 2 8 / Hollywood Records—2061-62479-2 / **Track Listing: CD 1:** Flash / The Hero / We Will Rock You (Fast) / Action This Day / Play the Game / Staying Power / Somebody to Love / Now I'm Here / Dragon Attack / Now I'm Here (Reprise) / Love of My Life / Save Me / Back Chat • **CD 2:** Get Down, Make Love / Guitar Solo / Under Pressure / Fat Bottomed Girls / Crazy Little Thing Called Love / Bohemian Rhapsody / Tie Your Mother Down / Another One Bites the Dust / Sheer Heart Attack / We Will Rock You / We Are the Champions / God Save the Queen / **Recorded:** Milton Keynes Bowl, Milton Keynes, UK: June 5, 1982 / **Sound Engineers:** Reinhold Mack, Mick McKenna, assisted by Pete "the Fish" Stevens and Greg Cox in the Rolling Stones Mobile / **Producer:** Justin Shirley-Smith / **Mastering:** Tim Young at Metropolis Mastering

Recorded at the Milton Keynes Bowl, fifty-five miles from London, on June 5, 1982, this live album bears witness to a difficult period for Queen. The album *Hot Space* had just been released and was highly controversial due to its modern and cold sound. Many of Queen's most ardent fans felt left by the wayside. At the end of "Play the Game" and before starting "Staying Power," one of the band's new songs, Mercury spoke to the audience: "Now, most of you know that we've got some new sounds out, in the last week, and for what it's worth, we're gonna do a few songs in the fun/black category...whatever you call it. That doesn't mean we've lost our rock and roll feel, okay? I mean, it's only a bloody record. People get so excited about these things...We just want to try out a few sounds...This is 'Staying Power.'"[186] The concert was filmed by Gavin Taylor, who also directed the *Live at Wembley* film in 1986 and immortalized the last date of the *Hot Space* European and UK tours in the spring of 1982.

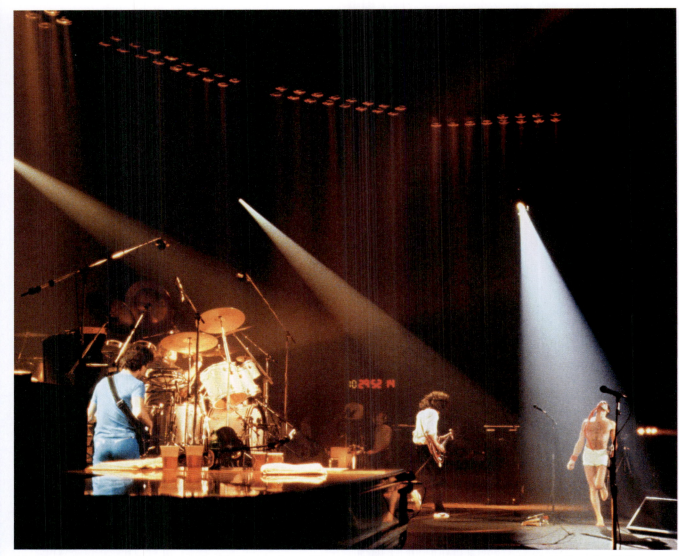

John Deacon (from behind), Brian May, and Freddie Mercury at one of the two concerts Queen gave at the Forum de Montréal in November 1981.

ROCK MONTREAL 1981

Release Dates: United Kingdom: October 29, 2007, no ranking / United States: October 30, 2007, no ranking / **References:** Parlophone—504 0472 / Hollywood Records—000097302 / **Track Listing: CD 1:** Intro / We Will Rock You (Fast) / Let Me Entertain You / Play the Game / Somebody to Love / Killer Queen / I'm in Love with My Car / Get Down, Make Love / Save Me / Now I'm Here / Dragon Attack / Now I'm Here (Reprise) / Love of My Life • **CD 2:** Under Pressure / Keep Yourself Alive / Drum and Tympani Solo / Guitar Solo / Flash / The Hero / Crazy Little Thing Called Love / Jailhouse Rock / Bohemian Rhapsody / Tie Your Mother Down / Another One Bites the Dust / Sheer Heart Attack / We Will Rock You / We Are the Champions / God Save the Queen / **Recorded:** Forum de Montréal, Montreal: November 24–25, 1981 / **Sound Engineers:** Reinhold Mack, Kooster McAllister / **Mixing:** Justin Shirley-Smith, Kris Fredriksson, Joshua J. Macrae / **Executive Producers:** Roger Taylor, Brian May

In November 1981 the band was at a major turning point in its career, preparing to embark on a tormented decade that would see the musicians experience glory, periods of extreme doubt, internal tensions, and many dark days. Soon, their album *Hot Space* would be decried all over the world, and a few years later the group's much-sought-after success in America would come to a screeching halt. But, for the moment, Queen was confident. Nothing seemed to be able to prevent them from making their way to the height of rock superstardom, and this concert, recorded at the Forum de Montréal, bears witness to this period of grace where everything was going well for the band. You only have to listen to the rendition of "Somebody to Love" to understand how truly majestic Freddie Mercury is on this album.

John Deacon and Freddie Mercury are honored with a traditional gift upon arriving in Budapest in July 1986.

HUNGARIAN RHAPSODY

Release Dates: United Kingdom: November 5, 2012, no. 137 / United States: November 6, 2012, no ranking / **References:** Island Records—06025371 / Eagle Vision—EVB334359 / **Track Listing: CD 1:** One Vision / Tie Your Mother Down / In the Lap of the Gods…Revisited / Seven Seas of Rhye / Tear It Up / A Kind of Magic / Under Pressure / Another One Bites the Dust / Who Wants to Live Forever / I Want to Break Free / Looks Like It's Gonna Be a Good Night—Improv / Guitar Solo / Now I'm Here • **CD 2:** Love of My Life / Tavaszi Szél Vizet Áraszt / Is This the World We Created…? / (You're So Square) Baby I Don't Care / Hello Mary Lou (Goodbye Heart) / Tutti Frutti / Bohemian Rhapsody / Hammer to Fall / Crazy Little Thing Called Love / Radio Ga Ga / We Will Rock You / Friends Will Be Friends / We Are the Champions / God Save the Queen / **Recorded:** Nepstadion, Budapest: July 27, 1986 / **Sound Engineer:** Reinhold Mack / **Mixing:** Justin Shirley-Smith, Joshua J. Macrae, Kris Fredriksson / **Producers:** Brian May, Roger Taylor, Jim Beach

On July 27, 1986, in the middle of their "Magic Tour," Queen gave the first international rock concert on the other side of the Iron Curtain at the Nepstadion ("the People's Stadium") in Budapest, Hungary. It was a landmark event, and many of the eighty thousand tickets that went on sale were reserved for the five thousand members of Queen's Hungarian fan club. The band put their heart and soul into their performance throughout the entire set, making for a magical moment in the middle of their most triumphant tour. The audience was completely won over by Freddie and May's performance of the traditional Hungarian song "Tavaszi Szél Vizet Áraszt" (The Spring Wind Makes the Water Swell).

"I don't think the Hungarians understood a word, though," quipped Roger Taylor. "Freddie had the words written, in Hungarian, on his hand."[36] The concert and the backstage area were both filmed with government approval, and the footage appeared in the documentary *A Magic Year*.

Queen's live performance in Budapest was entitled "Hungarian Rhapsody" in reference to the Hungarian composer Franz Liszt and his "Hungarian Rhapsodies," as well as providing a nod to Queen's "Bohemian Rhapsody." The live performance was not released in the classic album format, but instead was part of the concert's DVD and Blu-ray boxed sets released in November 2012.

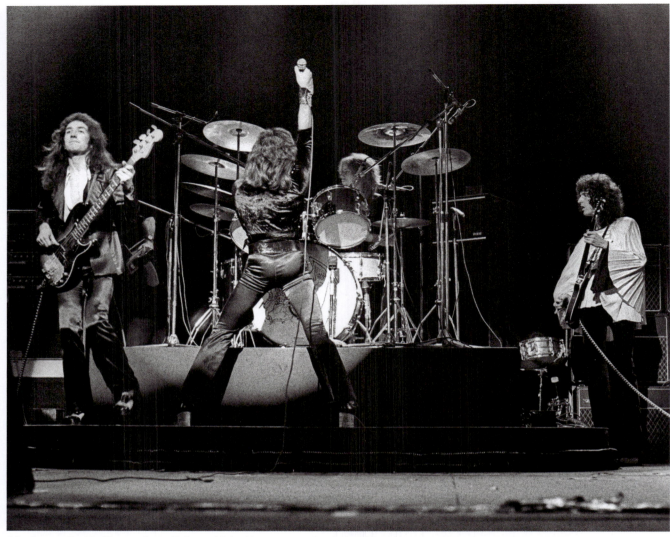

John Deacon, Freddie Mercury, Roger Taylor, and Brian May onstage at London's Rainbow Theatre on November 19, 1974. From Bob Marley to Pink Floyd, the biggest stars of pop have all performed at this music mecca.

LIVE AT THE RAINBOW '74

Release Dates: United Kingdom: September 8, 2014, no. 11 / United States: September 9, 2014, no. 66 / **References:** Virgin EMI—3791067 (CD)—602537910687 (2 CD Special Edition) / Hollywood Records—D002044902 (2 CD Special Edition) / **Track Listing:** Procession / Now I'm Here / Ogre Battle / Father to Son / White Queen (As It Began) / Flick of the Wrist / In the Lap of the Gods / Killer Queen / The March of the Black Queen / Bring Back That Leroy Brown / Son and Daughter / Guitar Solo / Son and Daughter (Reprise) / Keep Yourself Alive / Drum Solo / Keep Yourself Alive (Reprise) / Seven Seas of Rhye / Stone Cold Crazy / Liar / In the Lap of the Gods…Revisited / Big Spender / Modern Times Rock 'n' Roll / Jailhouse Rock / God Save the Queen / **Recorded:** Rainbow Theatre, London: March 31, November 19–20, 1974 / **Sound Engineers:** Roy Thomas Baker, Mike Stone / **Producers:** Justin Shirley-Smith, Joshua J. Macrae, Kris Fredriksson / **Executive Producers:** Brian May, Roger Taylor

Recorded during the group's concerts at the Rainbow Theatre in London on March 31 and on November 19 and 20, 1974, the twenty-four songs on the album retrace Queen's early years before the "Bohemian Rhapsody" tsunami. The album presents tracks from the first three albums, including "Father to Son," "Ogre Battle," and "In the Lap of the Gods…Revisited," the last of which which made its way onto Queen's set list and would soon close their concerts.

A double version entitled the "Special Edition" offers the November and March recordings in their entirety. For the true obsessive, the Super Deluxe Edition presents, in addition to the recordings of March and November 1974, a DVD and a Blu-ray featuring the November concert as well as four of the songs performed during the March concert. It is also the perfect opportunity to discover a title rarely presented in a live format: "The Fairy Feller's Master-Stroke."

The marquee of the Hammersmith Odeon in London announces Queen's performance in December 1975.

A NIGHT AT THE ODEON

Release Dates: United Kingdom: November 20, 2015, no. 40 / United States: November 20, 2015, no ranking / **References:** Virgin EMI—0602547500694— 0602547500779 (Super Deluxe Box Set) / Hollywood Records—D002236102 / **Track Listing:** Now I'm Here / Ogre Battle / White Queen (As It Began) / Bohemian Rhapsody / Killer Queen / The March of the Black Queen / Bohemian Rhapsody (Reprise) / Bring Back That Leroy Brown / Brighton Rock / Guitar Solo / Son and Daughter / Keep Yourself Alive / Liar / In the Lap of the Gods…Revisited / Big Spender / Medley: Jailhouse Rock, Stupid Cupid, Be Bop a Lula / Seven Seas of Rhye / See What a Fool I've Been / God Save the Queen / **Recorded:** Hammersmith Odeon, London: December 24, 1975 / **Sound Engineers:** Graham Haines, Adrian Revell, Martin Tranter, David Goatham, Chris Jenkins / **Producers:** Justin Shirley-Smith, Joshua J. Macrae, Kris Fredriksson / **Executive Producers:** Brian May, Roger Taylor

On December 24, 1975, Queen took the stage at the Hammersmith Odeon in London to celebrate the success of their masterpiece *A Night at the Opera*, which had been released a month earlier. Presented by radio host and friend of the band Bob Harris, the event was broadcast live on the BBC2 television channel as part of the music show *The Old Grey Whistle Test*, and then broadcast in its entirety on February 28, 1976, on BBC1 radio. The performance recorded that night bears witness to this period when Queen was still playing songs such as "Ogre Battle" live onstage, to the delight of fans of the band's heavier sound, which was still very much influenced by Led Zeppelin's compositions. Because it was broadcast on the radio, this concert is one of the band's most pirated, and many LPs with improbable names were released, including *Command Performance*, *Christmas at the Beeb*, and even *Halfpence*.

Interviewed on the day of the concert by journalist Harry Doherty, Brian May tried to explain the artistic approach of the band, which had just released "Bohemian Rhapsody" as a single: "You see, you have to understand it's romantic music we're playing—in the old sense of the word. It's music to tear your emotions apart […]. We're sort of schizophrenic. We like to be serious about some things and not as serious about others."[14] Emotions or not, it's impossible to remain indifferent to the charm of the 1975 version of Queen when you listen to their live versions of "The March of the Black Queen," "Flick of the Wrist," and "Son and Daughter."

On October 8, 2015, a preview of the remastered version of the BBC images was presented to the press at the former Olympic Studios, which have since been transformed into a cinema. Brian May, answering questions from *Rolling Stone* magazine journalist Mark Sutherland, commented on the film he had seen just minutes earlier: "It was very weird. It seems like watching another person, that young boy. I look so thin! I look very serious and the body language is so different now—I was quite shy in those days. […] It felt great at the time. There was a lot of adrenaline, a lot of joy because all our fans who'd followed us on the tour had all scrambled to get in there. Roger was really sick—he looks pretty good but he was feeling really bad. I think he threw up afterwards but you wouldn't know."[187] This film was offered to fans in a Super Deluxe box set, including three bonus tracks from a live performance in Japan and an interview with Roger Taylor and Brian May by Bob Harris.

COMPILATIONS

Each country adapted Queen's compilations to its own audience. The track listings presented here are those of the compilations released on CD in the British territory, with the exception of titles that were first released on vinyl. Multiple CD references are provided in cases where different versions of the album were released with different track listings.

GREATEST HITS

Release Dates: United Kingdom: November 2, 1981, no. 1 / United States: November 3, 1981, no. 14 / **References:** EMI—EMTV30 / Elektra—5E-564 / **Track Listing:** Bohemian Rhapsody / Another One Bites the Dust / Killer Queen / Fat Bottomed Girls (Single Edit) / Bicycle Race / You're My Best Friend / Don't Stop Me Now / Save Me (Original Single Mix) / Crazy Little Thing Called Love / Somebody to Love / Now I'm Here / Good Old-Fashioned Lover Boy / Play the Game / Flash (Single Version) / Seven Seas of Rhye / We Will Rock You / We Are the Champions

To the great delight of the fans, the British version of *Greatest Hits* brings together all of Queen's singles since the release of their first album in July 1973, with the exception of "Tie Your Mother Down," "Spread Your Wings," and the live version of "Love of My Life." The compilation was an enormous success, and in 2014, when the 6-million-seller mark was passed in the UK (more than 25 million copies were sold worldwide, all versions combined), Brian May recorded a short video for fans, in which he told them: "[It's] incredible. So I just want to say thanks to everyone who supported us through the years, and we hope to continue to serve you."[188]

The choice of tracks varied from country to country. In Japan, for example, the inclusion of "Teo Torriatte (Let Us Cling Together)", was highly popular with the local fans, and seemed absolutely essential. In Argentina, Brazil, Mexico, and Venezuela, countries where Queen has a loyal fan base, the live version of "Love of My Life" replaces the much more rock-heavy "Seven Seas of Rhye."

To illustrate the disc, the group called upon photographer Anthony Armstrong-Jones, better known as Lord Snowdon following his marriage to Queen Elizabeth II's younger sister, Margaret, in 1960. Brian May recalls the day on which the photograph was taken: "I can't say I was his friend, though perhaps I would like to have been. [...] Snowdon was a delightful, thoughtful, modest and gentle man. [...] We assumed that this accomplished photographer would bring a fresh approach [...]. Snowdon told us that he didn't want an overriding theme—he didn't think we need[ed] to 'try so hard.' He said he wanted us naturally filling the space, and he was absolutely insistent that the lighting would be natural too...only the daylight which pervaded his studio."[189] The musicians and the photographer spent so much time talking together that when they were finally ready to make the photograph, it was too dark. They met again the next day, when one of the most beautiful portraits of Queen was taken in a matter of moments.

Despite the absence of "It's Late" (excluded from the selection because it was released only as a single in the United States), which fully deserved a wider audience, the *Greatest Hits* compilation is undoubtedly the best record to buy for those wishing to discover the world of Queen.

GREATEST HITS II

Release Date: United Kingdom: October 28, 1991, no. 1 / **References:** Parlophone—PMTV 2 (33 rpm)—CDP 7 97971 2 (CD) / **Track Listing:** A Kind of Magic / Under Pressure / Radio Ga Ga / I Want It All (Single Version) / I Want to Break Free (Single Mix) / Innuendo / It's a Hard Life / Breakthru / Who Wants to Live Forever / Headlong (Single Edit) / The Miracle / I'm Going Slightly Mad (Vinyl Edit) / The Invisible Man / Hammer to Fall (The Headbanger's Mix Edit) / Friends Will Be Friends / The Show Must Go On / One Vision (Single Version)

If we consider that the *Greatest Hits* compilation covers Queen's "No Synth Era"—with the exception of the songs from *The Game*—its sequel offers a summary of the band's "Synth Era."

Initially planned for release at the end of 1989, the release of the compilation was postponed to the autumn of 1991 in order to avoid overshadowing the album *The Miracle*, which was enjoying great success at the time.

A double disc would have been necessary in order to bring together all of the singles the group had released in Great Britain since 1981, but the selling price of such a large compilation seemed prohibitive to the band, who refused this option. Many tracks are therefore excluded from the track listing, starting with most of the singles from *Hot Space*, including "Back Chat" and, regrettably, "Las Palabras de Amor (The Words of Love)." Other singles are also missing, including the underrated "Scandal" and the Christmas song "Thank God It's Christmas." The compilation was a huge success when it was released in October 1991, partly due to the untimely death of Freddie Mercury.

QUEEN ROCKS

Release Dates: United Kingdom: November 3, 1997, no. 7 / United States: November 3, 1997, no ranking / **References:** Parlophone—7243 8 23091 2 3 / Hollywood Records—HR-62132-2 / **Track Listing:** We Will Rock You / Tie Your Mother Down (Single Version) / I Want It All (Rocks Mix) / Seven Seas of Rhye / I Can't Live with You (1997 "Rocks" Retake) / Hammer to Fall / Stone Cold Crazy / Now I'm Here / Fat Bottomed Girls (1994 EMI Remaster Error) / Keep Yourself Alive / Tear It Up / One Vision / Sheer Heart Attack / I'm in Love with My Car (Rocks Mix) / Put Out the Fire / Headlong / It's Late / No-One but You (Only the Good Die Young)*

While *Queen Rocks* is certainly not the most essential compilation, it nevertheless has a very particular importance in the eyes of Brian May. "The record company wanted to put out a compilation album and we thought it would be a good idea to encourage people to remember the heavy stuff that Queen recorded. I have always had a fondness for the rockier side of things."[44] The guitarist was undoubtedly delighted at the prospect of bringing together some of the fieriest tracks from the band's repertoire. The album features such gems as "Tear It Up," "Put Out the Fire," and "It's Late," the majority of which were written by Brian May.

Fans were also introduced to a new and previously unreleased track, "No-One but You (Only the Good Die Young)". This song was recorded with John Deacon and pays tribute to their friend Freddie Mercury, who had passed away six years earlier. The compilation also includes a new mix of "I Can't Live with You" featuring a new drum track from the *Innuendo* sessions. "We thought it would be nice to give people what we never gave them,"[190] declared Brian May. "Queen were in essence a hard rock band,"[190] added Roger Taylor.

Created by Richard Gray, the album cover features an adaptation of the historic Queen logo. Mocked by the fans, it was defended, without much conviction, by Brian May during the press conference given for the release of the disc: "Shall we be honest? It was done in pretty much of a hurry and the concept behind it is the crest, which we lived with for years and it's kind of exploding. I think we all felt that perhaps it wasn't quite how we imagined it would be, but time was very short, but...we think it's fabulous yes,"[191] quipped the guitarist. And Roger Taylor humorously added: "On T-shirts it looks like somebody has been sick over it..."[191]

* Previously unreleased, see page 498.

COMPILATIONS

GREATEST HITS III

Release Dates: United Kingdom: November 8, 1999, no. 5 / United States: November 8, 1999, no ranking / **References:** Parlophone—7243 5 23894 2 1 / Hollywood Records—HR-62250-2 / **Track Listing:** The Show Must Go On (Live with Elton John) / Under Pressure (Rah Mix) / Barcelona (Single Version) / Too Much Love Will Kill You / Somebody to Love (Live with George Michael) / You Don't Fool Me / Heaven for Everyone (Single Version) / Las Palabras de Amor (The Words of Love) (Greatest Hits III Version) / Driven by You / Living on My Own (Julian Raymond Mix) / Let Me Live / The Great Pretender / Princes of the Universe / Another One Bites the Dust (Wyclef Jean Remix—LP Version) / No-One but You (Only the Good Die Young) / These Are the Days of Our Lives / Thank God It's Christmas

In 1999, Brian May and Roger Taylor seemed determined not to slow down the release of compilations and other "souvenir records." The third part of the *Greatest Hits* compilation series is credited to "Queen +" because it goes well beyond the band's career. It includes remixes, duets, and even solo tracks by the musicians. Apart from certain songs that it's good to finally find on such a collection, such as "Las Palabras de Amor (The Words of Love)," "Princes of the Universe," or extracts from *Made in Heaven*, the record's main asset is an indispensable version of "Somebody to Love," performed with George Michael at the Freddie Mercury Tribute Concert on April 20, 1992. There is an additional solo track by May ("Driven by You"), another by Freddie Mercury ("Barcelona"), and a remix of "Another One Bites the Dust" performed as a duet with Wyclef Jean. The bad taste award undoubtedly goes to the dance remix of "Under Pressure," entitled "Under Pressure (Rah Mix)," which revisits the famous hit via an indigestible mix of samples and outdated drum machines. Avoid this one at all costs!

A boxed set of the three *Greatest Hits* compilations was released one year later, on November 13, 2000, and titled *The Platinum Collection*.

ABSOLUTE GREATEST

Release Dates: United Kingdom: November 16, 2009, no. 3 / United States: November 17, 2009, no ranking / **References:** Parlophone—50999 6 86642 2 0—50999 6 86643 2 9 (Special Edition) / Hollywood Records—D000512802 / **Track Listing:** We Will Rock You / We Are the Champions / Radio Ga Ga / Another One Bites the Dust / I Want It All (Single Version) / Crazy Little Thing Called Love / A Kind of Magic / Under Pressure / One Vision (Single Version) / You're My Best Friend / Don't Stop Me Now / Killer Queen / These Are the Days of Our Lives / Who Wants to Live Forever (Greatest Hits II Edit) / Seven Seas of Rhye / Heaven for Everyone (Single Version) / Somebody to Love / I Want to Break Free (Single Mix—Greatest Hits II CD Edit) / The Show Must Go On / Bohemian Rhapsody

The *Absolute Greatest* compilation focuses on Queen's biggest hits. There are no unreleased tracks here, not even any remixes or notable curiosities—except, on the Special Edition version of the compilation, a CD entitled *Absolute Narrative* on which Roger Taylor and Brian May provide comments on the songs. Although it's unpleasant to listen to, since May and Taylor talk over the songs, this record offers some interesting insights regarding the band's career.

Despite a lack of general interest, the compilation reached number three on the UK charts in November 2009. This achievement is probably due to its release date, at a time when people are seeking Christmas presents.

492 COMPILATIONS

DEEP CUTS 1 (1973-1976)

Release Date: United Kingdom: March 14, 2011, no. 92 / **Reference:** Island Records—276 542-4 / **Track Listing:** Ogre Battle (Deep Cuts Version) / Stone Cold Crazy / My Fairy King / I'm in Love with My Car / Keep Yourself Alive / Long Away / The Millionaire Waltz / '39 (Single Version) / Tenement Funster / Flick of the Wrist / Lily of the Valley / Good Company / The March of the Black Queen (Deep Cuts Version) / In the Lap of the Gods…Revisited

DEEP CUTS 2 (1977-1982)

Release Date: United Kingdom: June 27, 2011, no. 175 / **Reference:** Island Records—277 178 2 / **Track Listing:** Mustapha / Sheer Heart Attack / Spread Your Wings / Sleeping on the Sidewalk / It's Late / Rock It (Prime Jive) / Dead on Time / Sail Away Sweet Sister / Dragon Attack / Action This Day / Put Out the Fire / Staying Power / Jealousy (With Reinstated Bass Drum) / Battle Theme

DEEP CUTS 3 (1984-1995)

Release Date: United Kingdom: September 5, 2011, no. 155 / **Reference:** Island Records—278 002 9 / **Track Listing:** Made in Heaven / Machines (Or "Back to Humans") / Don't Try So Hard / Tear It Up / I Was Born to Love You / A Winter's Tale (Single Version) / Ride the Wild Wind / Bijou / Was It All Worth It / One Year of Love / Khashoggi's Ship (Stand-Alone Version) / Is This the World We Created…? / The Hitman / It's a Beautiful Day (Reprise) (Deep Cuts 3 Version) / Mother Love

In 2011, as Queen's catalog passed from the hands of EMI to those of Island Records, Universal Music's label, Brian May and Roger Taylor judged that it would be the right moment, on the sidelines of the imminent publication of the band's entire catalog in a remastered version, to offer three compilations of titles little known to the general public. Selected with the help of Taylor Hawkins, the Foo Fighters' drummer and one of Queen's biggest fans, the forty-three tracks spread over the three volumes draw a portrait of the band that novices of Queen will be fascinated to discover. For fans of Her Majesty, there's nothing new, but it's still an opportunity to savor the compilation as a luxury Queen playlist, including such gems as "Long Away," "The Millionaire Waltz," "Sail Away Sweet Sister," and "Dragon Attack," as well as "Made in Heaven" and "Machines (Or 'Back to Humans')."

AT THE BEEB

Release Date: United Kingdom: December 4, 1989, no. 67 / **Reference:** Band of Joy—BOJCD 001 / **Track Listing:** My Fairy King (BBC Session 1) / Keep Yourself Alive (BBC Session 1) / Doin' Alright (BBC Session 1) / Liar (BBC Session 1) / Ogre Battle (BBC Session 3 Edit) / Great King Rat (BBC Session 3) / Modern Times Rock 'n' Roll (BBC Session 3) / Son and Daughter (BBC Session 3)

Bringing together eight tracks recorded live during the BBC Sessions of February 5 and December 3, 1973, for the radio program *Sound of the Seventies*, the *At the Beeb* compilation was published on the Band of Joy label, which, with the agreement of the labels concerned, distributed the official recordings of the BBC Sessions. These sessions, and many more, were included in the *On Air* box set, published by Virgin EMI and released in November 2016.

COMPILATIONS

FOREVER

Release Dates: United Kingdom: November 10, 2014, no. 5 / United States: November 11, 2014, no. 38 / **References:** Virgin EMI—4704083—4704085 (Deluxe Edition) / Hollywood Records—D001911502—D001911702 (Deluxe Edition) / **Track Listing Single CD:** Let Me in Your Heart Again* / Love Kills—The Ballad** / There Must Be More to Life Than This (William Orbit Mix)*** / It's a Hard Life / You're My Best Friend / Love of My Life (Forever Version) / Drowse (Forever Early Fade) / Long Away / Lily of the Valley (Single Version) / Don't Try So Hard / Bijou / These Are the Days of Our Lives / Las Palabras de Amor (The Words of Love) / Who Wants to Live Forever / A Winter's Tale / Play the Game (Forever Version—No Intro) / Save Me / Somebody to Love (Forever Edit) / Too Much Love Will Kill You / Crazy Little Thing Called Love / **Track Listings Deluxe Edition—CD 1:** Let Me in Your Heart Again* / Love Kills—The Ballad** / There Must Be More to Life Than This (William Orbit Mix)*** / Play the Game (Forever Version—No Intro) / Dear Friends / You're My Best Friend / Love of My Life (Forever Version) / Drowse (Forever Early Fade) / You Take My Breath Away (Forever Edit) / Spread Your Wings (Forever Early Fade) / Long Away / Lily of the Valley (Single Version) / Don't Try So Hard / Bijou / These Are the Days of Our Lives / Nevermore (Forever Version) / Las Palabras de Amor (The Words of Love) / Who Wants to Live Forever • **CD 2:** I Was Born to Love You / Somebody to Love (Forever Edit) / Crazy Little Thing Called Love / Friends Will Be Friends / Jealousy (With Reinstated Bass Drum) / One Year of Love / A Winter's Tale (Forever Edit) / '39 (Single Version) / Mother Love / It's a Hard Life / Save Me / Made in Heaven / Too Much Love Will Kill You / Sail Away Sweet Sister / The Miracle (Forever Cross-Fade Version) / Is This the World We Created...? (Forever Cross-Fade Version) / In The Lap of the Gods...Revisited / Forever

While *Queen Rocks* showcased Queen's heavier tracks, this compilation instead chooses to underline the melodic and romantic aspects of the band. The Deluxe Version of the disc offers fans the opportunity to rediscover with great pleasure the underestimated "Sail Away Sweet Sister," as well as the moving "Made in Heaven." The single CD edition also contains a number of precious tracks, including "Lily of the Valley" and "Long Away."

But what makes this compilation a must-have in Queen's discography is of course the three hitherto unreleased songs, available on both versions of the record. The first, "Let Me in Your Heart Again," dates back to the recording sessions for *The Works* and clearly fits in with the rest of that album. On track 2, we discover a new recording of "Love Kills" (entitled "Love Kills—The Ballad"), which Mercury had made with Giorgio Moroder in 1983 for the soundtrack of the colorized version of Fritz Lang's *Metropolis*. May and Taylor give the track a new twist here, with a more rock flavor, whereas their singer had wanted it to be 100 percent disco. But the track that all fans were waiting for was the duet that Freddie Mercury recorded with Michael Jackson in the summer of 1983. Reworked by the band and mixed by William Orbit, "There Must Be More to Life Than This" was finally revealed to the general public as a long-awaited and coveted curiosity. The song, sadly, is ultimately of little interest apart from the meeting of two music legends.

Finally, closing the second disc of the Deluxe Version of the compilation, "Forever" is an instrumental version of "Who Wants to Live Forever," played solely by Brian May on piano and synthesizer, which was released on the 45 rpm maxi version of "Who Wants to Live Forever" in 1986.

With his usual candor, Roger Taylor later said of the disk: "It is an [...] odd mixture of our slower stuff. I didn't want the double-album version they've put out. It's an awful lot for people to take in, and it's bloody miserable! I wouldn't call it an album, either. [...] It's more a record company confection. It's not a full-blooded Queen album."[14]

* Previously unreleased. See page 359.
** Previously unreleased. See page 326.
*** Previously unreleased. See pages 360–361; 500.

ON AIR

Release Dates: United Kingdom: November 4, 2016, no. 25 / United States: November 4, 2016, no ranking / **References:** Virgin EMI—0602557082319 / Hollywood Records—D002424002 / **Track Listing: CD 1:** BBC Sessions: My Fairy King (BBC Session 1) / Keep Yourself Alive (BBC Session 1) / Doin' Alright (BBC Session 1) / Liar (BBC Session 1) / See What a Fool I've Been (BBC Session 2) / Keep Yourself Alive (BBC Session 2) / Liar (BBC Session 2) / Son and Daughter (BBC Session 2) / Ogre Battle (BBC Session 3) / Modern Times Rock 'n' Roll (BBC Session 3) / Great King Rat (BBC Session 3) / Son and Daughter (BBC Session 3) • **CD 2:** BBC Sessions: Modern Times Rock 'n' Roll (BBC Session 4) / Nevermore (BBC Session 4) / White Queen (As It Began) (BBC Session 4) / Now I'm Here (BBC Session 5) / Stone Cold Crazy (BBC Session 5) / Flick of the Wrist (BBC Session 5) / Tenement Funster (BBC Session 5) / We Will Rock You (BBC Session 6) / We Will Rock You (Fast) (BBC Session 6) / Spread Your Wings (BBC Session 6) / It's Late (BBC Session 6) / My Melancholy Blues (BBC Session 6) • **CD 3:** Queen Live on Air Golders Green Hippodrome, London—September 13, 1973: Procession (Intro Tape) / Father to Son / Son and Daughter / Guitar Solo / Son and Daughter (Reprise) / Ogre Battle / Liar / Jailhouse Rock • Estádio Do Morumbi, São Paulo—March 20, 1981: Intro / We Will Rock You (Fast) / Let Me Entertain You / I'm in Love With My Car / Alright Alright / Dragon Attack / Now I'm Here (Reprise) / Love of My Life • Maimarktgelände, Manheim, Germany—June 21, 1986: A Kind of Magic / Vocal Improvisation / Under Pressure / Is This the World We Created...? / (You're So Square) Baby I Don't Care / Hello Mary Lou (Goodbye Heart) / Crazy Little Thing Called Love / God Save the Queen • **CD 4:** The Interviews (1976–1980): Freddie with Kenny Everett, 1976 / Queen with Tom Browne, 1977 / Roger with Richard Skinner, 1979 / Roger with Tommy Vance, 1980 / Roy Thomas Baker, The Record Producers • **CD 5:** The Interviews (1981–1986): John, South American Tour, 1981 / Brian with John Tobler, 1982 / Brian with Richard Skinner and Andy Foster, 1984 / Freddie on Newsbeat, 1984 / Brian on Newsbeat, 1984 / Freddie with Graham Neale, 1984 / Freddie with Simon Bates, 1984 / Brian with David "Kid" Jensen, 1986 • **CD 6:** The Interviews (19861992): Roger with Andy Peebles, 1986 / Queen with Mike Read, 1989 / Brian with Simon Bates, 1992 / Brian with Johnnie Walker, 1992

On Air provides a comprehensive overview of the collaboration between Queen and the BBC, the renowned British radio and television production and broadcasting company. The first two discs contain all the BBC Sessions recorded between July 1973 and October 1977, with the exception of the album version of "The March of the Black Queen," broadcast during the April 1974 Session, and the alternative version of "Good Old-Fashioned Lover Boy," specially recorded for the band's appearance on the *Top of the Pops* show of June 15, 1977. The third disc features recordings of the three Queen concerts broadcast by the BBC: the Golders Green Hippodrome in London on September 13, 1973, the Estádio Do Morumbi in São Paulo on March 20, 1981, and the Maimarktgelände in Germany, on June 21, 1986.

BOHEMIAN RHAPSODY OST

Release Dates: United Kingdom: October 19, 2018, no. 3 / United States: October 19, 2018, no. 1 / **References:** Virgin EMI—0602567988700 / Hollywood Records—D002984302 / **Track Listing:** 20th Century Fox Fanfare / Somebody to Love / Doin' Alright…Revisited / Keep Yourself Alive (Live at the Rainbow) / Killer Queen / Fat Bottomed Girls (Live in Paris) / Bohemian Rhapsody / Now I'm Here (Live at Hammersmith Odeon) / Crazy Little Thing Called Love / Love of My Life (Rock in Rio) / We Will Rock You (Movie Mix) / Another One Bites the Dust / I Want to Break Free / Under Pressure / Who Wants to Live Forever / Bohemian Rhapsody (Live Aid) / Radio Ga Ga (Live Aid) / Ay-Oh (Live Aid) / Hammer to Fall (Live Aid) / We Are the Champions (Live Aid) / Don't Stop Me Now…Revisited / The Show Must Go On

Bryan Singer's movie *Bohemian Rhapsody* was released in theaters in November 2018. The film's soundtrack is also the soundtrack of the group's career, from its earliest debut to the triumphant Live Aid concert held at Wembley Stadium on July 13, 1985. It is a rare document indeed, because with the exception of "Is This the World We Created," performed during the finale by Mercury and May, their entire Wembley appearance appears on this record. While a novice can explore the universe of Queen in a more thorough manner with the first two *Greatest Hits* compilations, the *Bohemian Rhapsody* soundtrack allows us to dive back into the 1970s and 1980s, which offered the band its greatest moments of glory. A special mention has to go to the introduction of the record where we discover that the famous 20th Century Fox theme music (originally composed by Alfred Newman), has been Queen-ified by Brian May and his Red Special.

A fictional reenactment of the Live Aid concert for Bryan Singer's movie *Bohemian Rhapsody*, released in 2018, with actors Rami Malek (Freddie), Gwilym Lee (Brian), Ben Hardy (Roger), and Joseph Mazzello (John).

SINGLE

NO-ONE BUT YOU (ONLY THE GOOD DIE YOUNG)

Brian May / 4:13

Brian May posing with a Fender Stratocaster in 1998.

Musicians
Brian May: lead vocals (first and third verse), backing vocals, piano, electric guitar
Roger Taylor: lead vocals (second verse), backing vocals, drums
John Deacon: bass

Recorded
Allerton Hill Studios and Cosford Mill Studios, Surrey: 1997

Technical Team
Producers: Queen
Sound Engineers: Justin Shirley-Smith, Joshua J. Macrae

Single (45 rpm)
Side A: No-One but You (Only the Good Die Young) / 4:13;
We Will Rock You (Rick Rubin "Ruined" Remix) / 5:00
Side B: Tie Your Mother Down (Single Version) / 3:45;
Gimme the Prize (The Eye Instrumental Remix) / 4:02
UK Release on Parlophone: January 5 1998 (ref. QUEENPD 27)

Single (CD)
1. No-One but You (Only the Good Die Young) / 4:13
2. Tie Your Mother Down (Single Version) / 3:45
3. We Will Rock You (Rick Rubin "Ruined" Remix) / 5:00
4. Gimme the Prize (The Eye Instrumental Remix) / 4:02

UK Release on Parlophone: January 5 1998 (ref. CDQUEEN 27)
Best UK Chart Ranking: 13

> When Brian May added this song to his *Another World* tour in 1998, it had lost none of its topicality. Since the recording of the track, Princess Diana had also tragically passed away, as had fashion designer Gianni Versace, who had collaborated with Queen.

Genesis

On January 17, 1997, at the premiere of Maurice Béjart's ballet in Paris, Brian May, John Deacon, and Roger Taylor took to the stage together for the last time. They performed "The Show Must Go On," accompanied on vocals by their friend Elton John.

Inspired by the event, May sent a demo of "No-One but You (Only the Good Die Young)" to Roger Taylor weeks later. "He [Roger] put it away in a drawer somewhere, you know, 'cause he was busy, or whatever," explained May. "And it was months later when Roger phoned up, suddenly excited, and said, 'I just listened to the track and it's amazing! We have to do it as a Queen song.'"[192]

Intended for their lost friend, the text evokes Freddie Mercury in every line. From the very first paragraph, there is a reference to the statue of the singer erected on the shores of Lake Geneva, in Montreux: *"A hand above the water / An angel reaching for the sky."* But beyond this tribute, the track offers a more universal message: It's the people we love most who are taken from us too soon.

Production

In the footage of the video shot by the Torpedo Twins at Bray Studios, John Deacon appears even though he had already left Queen. The bassist, who had announced to his musician friends that he would never play with the band again, nevertheless participates in the tribute by laying down a discreet bass line. This would prove to be his last contribution to the group.

The song is sung by Brian May, who offers the second verse to Taylor before returning to sing the third. With its slightly syrupy melody, this ballad is more appreciable for its message and its tenderness than for its traditional Queen-style qualities.

Recorded at May's Allerton Hill Studios and Taylor's Cosford Mill Studios during the summer of 1997, "No-One but You (Only the Good Die Young)" was included on the *Queen Rocks* compilation in November 1997. It is, to date, the very last song recorded by the three remaining original members of Queen.

SINGLE

> Renowned producer Giorgio Moroder, who asked Freddie Mercury to collaborate on the soundtrack for the colorized rerelease of *Metropolis*.

LOVE KILLS - THE BALLAD
Freddie Mercury, Giorgio Moroder / 4:17

Musicians
Freddie Mercury: lead vocals
Brian May: electric guitar, keyboards, bass
John Deacon: bass, additional guitars
Roger Taylor: drums

Recorded
The Record Plant, Los Angeles: September 2, 1983
Allerton Hill Studios and/or The Priory, Surrey: June 2014

Technical Team
Producers (1983): Queen, Reinhold Mack, Giorgio Moroder
Producers (2014): Chris Thomas, Queen, William Orbit
Sound Engineer: Reinhold Mack
Assistant Sound Engineers: Michael Beiriger, Edward Delena

Single
1. Love Kills—The Ballad / 4:17
UK Release on Virgin EMI: September 26 2014 (digital release)

Genesis

In the midst of the recording sessions of *The Works*, in 1983, Mercury laid the foundations for "Love Kills." He worked on this song at the request of producer Giorgio Moroder, the owner of Musicland Studios in Munich, where Queen had been recording since 1980. Moroder had recently acquired the rights to adapt Fritz Lang's classic black-and-white movie, *Metropolis*, and he wanted to produce a new version in color. For the soundtrack, the talented producer, who was most famous for his work with Donna Summer, began working on a set of tracks featuring modern arrangements with a disco influence. These new tracks would replace the original music of the film, which had been composed in 1927 by Gottfried Huppertz.

In January 1984, Mercury called Moroder and played him the first version of "Love Kills" over the telephone. Enthusiastic, the producer decided to move forward on the lyrics with his colleague Pete Bellotte, author of numerous Donna Summer tracks, including "I Feel Love" and "Love to Love You Baby." Taking this liberty with the songwriting did not please Freddie, who insisted on being the sole author of the lyrics.

A recording session was scheduled at Musicland in January, and together the duo of Mercury and Moroder created this highly effective track. Roger Taylor came along to participate in the programming, John Deacon took the opportunity to lay down some guitar rhythms, and Brian May added various discreet touches with his Red Special. Mercury thought that he should perhaps keep "Love Kills" for the album Queen was currently preparing, but he was ultimately convinced by Moroder—who saw the song as a potential hit that could help promote his new movie—to give the track to him.

The song was released as a single on September 10, 1984, and it reached number ten on the British charts, which was a huge success for a solo single by one of Queen's members.

In 2014, when Brian May and Roger Taylor embarked on the production of a compilation album entitled *Forever*, "Love Kills" was taken from the singer's discography and reworked to appear alongside the previously unreleased "There Must Be More to Life Than This," recorded as a duet with Michael Jackson in 1983, and "Let Me in Your Heart Again," which was also taken from sessions of *The Works*.

The honor of performing this new version on stage went to singer Adam Lambert, who accompanied Queen on their North American tour.

Production

As usual, when Brian May decided to revisit a track, he did so with gusto: he did away with the song's disco beats, removing the drum machine programming that was so characteristic of the "Moroder sound," and kept only a few traces of the synthesizers recorded for the original song. The song quickly took a new direction, devoid of the electric guitar rhythm originally recorded by John Deacon and embellished with new studio tracks. Taylor recorded a real drum part on the track, which was transformed into a moving ballad led by May's acoustic guitar. The work done on "Love Kills—The Ballad" is highly reminiscent of the flavor of the album *Made in Heaven*, on which Queen covered old Mercury tracks to give them a second life.

Numerous remixed versions of "Love Kills" were released between 1984 and 2014, but the most notable is undoubtedly the one offered in the *Freddie Mercury—The Solo Collection* box set in 2000. It was remixed in 1992 by the Fugitive Brothers collective (Carl Ward, Colin Peter, John Beckett, and Ray Burdis), which gave the track a much more rock sound. "Love Kills (Rock Mix)" is accompanied by the six-string guitar of Johnny Bivouac, the former guitarist with Adam and the Ants.

QUEEN: ALL THE SONGS 501

COLLABORATION

Queen and Paul Rodgers onstage in Cologne, Germany, on July 6, 2005.

QUEEN + PAUL RODGERS

The Collaboration Between Brian May and the Idol of His Youth

On September 24, 2004, Brian May took to the stage at London's Wembley Arena for a concert organized by Fender in honor of the fiftieth anniversary of the legendary Stratocaster guitar. The Strat Pack was the name given to the supergroup created for the occasion, which featured some of the most notable users of the famous American six-string—David Gilmour and Hank Marvin among others—and prestigious guests, including Brian May and Paul Rodgers. "All Right Now," the 1970 hit by the former singer of Free and Bad Company, was like mother's milk to the young May. When May and Rodgers played it together that evening in September 2004, a real artistic "love at first sight" occurred between the two musicians. But it was Paul Rodgers's wife who lent a decisive little hand to destiny, as Brian May explained: "Paul and I came offstage after this one-off appearance, and his lovely wife was in the dressing room, beaming. She said: 'Well it's all there, isn't it? All you need is a drummer.' I thought for a moment and said, 'Well, actually, I do know a drummer.'"[29]

May also recalled, "I suddenly found myself playing with Paul at a Fender anniversary gig, and there was just great chemistry and understanding there…a little reminiscent of the way I would interact with Freddie. There was a distinct 'lightbulb' moment, and we thought this could really work. I immediately phoned up Roger and said, 'You know who we never thought of playing with? Paul Rodgers.' Roger just went, 'That's a great idea.' We had all been fans of Paul and we loved Free…Freddie perhaps most of all."[193]

On October 10, at the first UK Rock 'n' Roll Hall of Fame ceremony, Queen was accompanied by Rodgers when they performed the classic double of "We Will Rock You" and "We Are the Champions." Paul Rodgers recalled the rehearsals for the famous evening, during which the makeshift band enjoyed performing other songs from Queen's repertoire: "The next thing we did in the rehearsal room was "Tie Your Mother Down," and it absolutely blew the doors off the studio. […] It was like, 'OK, we'll open with that one then.' It felt fantastic from the first time we played together, and we came off the stage and we said, 'You know what? We should definitely do more of this.' We followed up on that."[193]

The "Return of the Champions"

A collaboration was organized between the musicians, and under the same impetus a series of concerts was planned under the name Queen + Paul Rodgers. The tour, which kicked off on March 28, 2005, played dates through Europe, the United Kingdom, Japan, and the United States. In September of the same year, a live album was released, entitled *Return of the Champions*, and recorded on May 9, 2005, at the Hallam FM Arena in Sheffield, England (renamed the Sheffield Arena in 2007). The concert clearly proved that the collaboration was working. While the show featured some of Queen's most famous tracks, the band also performed several songs that highlighted Paul Rodgers's career, including "Wishing Well," "Feel Like Makin' Love," and of course the famous "All Right Now." After the final date of the North American leg of the tour at the Pacific Coliseum in Vancouver on April 13, 2006, Paul Rodgers remembered thinking: "'We have to do some more.' We weren't sure what that 'more' would be, but the natural step was to go into the studio and see what happened. Brian actually said to me, 'Let's do more, I don't want this to end.'"[14]

The Cosmos Rocks: The Only Queen + Paul Rodgers Album

The musicians decided to meet up in Roger's new studio, the Priory, which had been set up in his home in Surrey. The sessions took place intermittently over the course of a year, beginning in the summer of 2007. No additional musicians were hired, and everything was played by Brian, Roger, and Paul. In April 2008, the title of the future album, *The Cosmos Rocks*, was revealed on the British TV show *Al Murray's Happy Hour*. A first song was performed live: "C-Lebrity." Written by Roger Taylor, the song openly

criticizes the ephemeral and illusory glory of the life of reality stars that had become so ubiquitous on television shows around the globe. "It's to do with the phenomenon of celebrity culture; the desperation to get your face on the telly. The assumption that if somebody becomes famous they'll also be rich is so naive. It annoys me that there are so many famous, useless people."[194]

The album, released on September 15, 2008, contains various rock gems, including "Cosmos Rockin'" and "Still Burnin'," and features a number of ballads, such as "Some Things That Glitter" and the extremely successful "Small." Queen + Paul Rodgers may not be Queen, but it is still an excellent rock 'n' roll band.

Unfortunately, the album was not as favorably received as the three musicians had hoped, as Roger Taylor later explained: "I felt the album was badly promoted by EMI, who were falling to bits at the time. We were on tour in Europe, and I went into record stores and we weren't in them. And I remember being furious, thinking: 'Why did we make this fucking record?' It certainly made us think twice about making a Queen album with another singer. [...] When you lose the brand, people aren't interested. [...] People want the brand. It's a horrible word, but very apt."[14]

The collaboration lasted through one final tour, called the *Cosmos Rocks* tour, after which all the musicians went back to their own projects. "It became difficult as time went on, though," Brian May would later recall. "We would play South America, where people didn't know that music [Paul's songs], so we played more Queen songs. Paul dealt with it well, but I think it was hard for him to abandon a lot of his material. We really enjoyed it as an experiment, but as an experiment it had...limits. Eventually, we thought, 'It's probably gone as far as it can. Paul needs to get back to his own career.' Because he couldn't just go on being the frontman of Queen. By mutual agreement, we thought, 'That's it.'"[195]

Brian May, proud of the work they'd achieved, summed up the relationship: "People have said, 'Is it a marriage?' I would say, 'No...it's not a marriage, but it's a damn good affair.'"[193]

COLLABORATION

QUEEN + ADAM LAMBERT

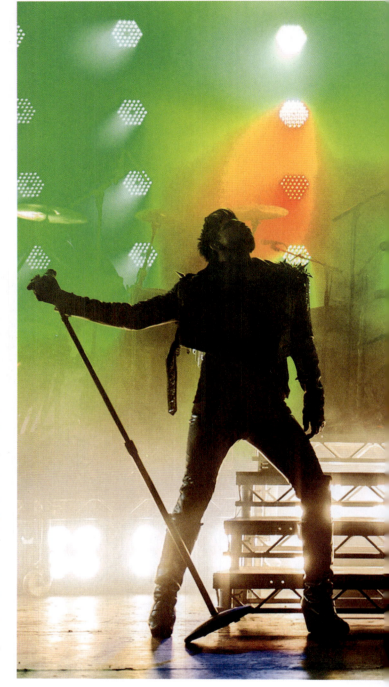

Queen and Adam Lambert's high-octane show at the HMV Hammersmith Apollo in London on July 12, 2012.

At the end of November 2008, once the tour with Paul Rodgers was over, Brian May and Roger Taylor seemed to want to put the Red Special and drumsticks away for good, believing that a page in the band's history had definitely been turned. "Roger and I felt we were done, and probably that would be the end of Queen touring,"[29] recalled Brian May in 2017.

A Fan Instead of Freddie

In January 2009, the eighth season of *American Idol* began airing in the United States. As the weekly eliminations went on, a young male singer began to stand out from the rest: Adam Lambert. At twenty-six years old, he had already drawn a lot of attention when he performed "Bohemian Rhapsody" during the show's televised audition process. As he advanced through the competition, the young man really began to shine, putting his own stamp on hits, including "I Can't Get No (Satisfaction)" by the Rolling Stones, "Black or White" by Michael Jackson, and "The Tracks of My Tears" by the Miracles. On the other side of the Atlantic, Brian May soon heard about the budding artist: "I suddenly started getting messages saying: 'There is this incredible guy on *American Idol* who has sung one of your songs in the competition, and looks like he may win the whole season.'"[29] May began watching the candidate's performances on the internet, and was immediately convinced by his version of "Bohemian Rhapsody." On May 5, 2009, Roger Taylor (who just six months earlier had decried the talent show system in the song "C-Lebrity") fell for Adam Lambert's voice and charisma when he heard him singing at the top of his voice—and with real virtuosity—on Led Zeppelin's "Whole Lotta Love."

Adam Lambert: A Gift from God

For the show's finale, which saw Adam Lambert pitted against Kris Allen, on May 20, 2009, the production invited Queen's musicians to accompany the contestants on "We Are the Champions." "They were both good singers and both had a good presence on stage, and it was easy to interact with them," May later revealed. "But it was really blindingly obvious that there was a chemistry already between us and Adam." He also said, "We didn't go out looking out for a singer who sounded like Freddie and we didn't embark on one of these TV searches for Stars. We just quietly got on with our business. But fate was to intervene. A gift from God?!"[29]

Adam Lambert finished second. Immediately following his participation in *American Idol*, he recorded his first official album, *For Your Entertainment*, and then went on tour for several months. It wasn't until November 2011 that the planets (and everyone's schedules) aligned and led

Lambert to cross Queen's path once again. Like May and Taylor, the young singer was invited to the MTV Europe Music Awards, which were held at Belfast's Odyssey Arena on November 6, 2011. Queen's musicians asked Lambert to play a medley with them onstage including "The Show Must Go On," "Under Pressure," "We Will Rock You," and "We Are the Champions." The young American singer had undergone something of a metamorphosis since his appearance on *American Idol*, and he now wore costumes and makeup that made him look like a real rock star. The feedback was unanimous: Lambert's performance was in perfect harmony with Queen's music, and the show was a convincing success. Their collaboration began in 2012, and an international tour of Queen + Adam Lambert was officially organized. With real humility, Freddie's worthy successor explains his role in the band, which was still ongoing in 2020: "There's never going to be another [Freddie Mercury], and I'm not replacing him. That's not what I am doing. I'm trying to keep the memory alive, and remind people how amazing he was, without imitating him. I'm trying to share with the audience how much he inspired me."[14]

REISSUE

NEWS OF THE WORLD—40TH ANNIVERSARY EDITION

NEWS OF THE WORLD – 40TH ANNIVERSARY EDITION

Release Date: United Kingdom: November 17, 2017 / **Reference:** Virgin EMI Records – 00602557842678

VINYL LP: *NEWS OF THE WORLD* (NEW PURE ANALOG CUT)

Track Listing: A-Side: We Will Rock You / We Are the Champions / Sheer Heart Attack / All Dead, All Dead / Spread Your Wings / Fight from the Inside / **B-Side:** Get Down, Make Love / Sleeping on the Sidewalk / Who Needs You / It's Late / My Melancholy Blues / **Executive Producers:** Brian May, Roger Taylor / **Producers:** Queen / **Production Assistant:** Mike Stone / **Sound Engineer:** Mike Stone / **Mastering:** Sean Magee (LP), at Abbey Road Studios

CD #1: *NEWS OF THE WORLD* (BOB LUDWIG 2011 MASTER)

Track Listing: We Will Rock You / We Are the Champions / Sheer Heart Attack / All Dead, All Dead / Spread Your Wings / Fight from the Inside / Get Down, Make Love / Sleeping on the Sidewalk / Who Needs You / It's Late / My Melancholy Blues / **Executive Producers:** Brian May, Roger Taylor / **Producers:** Queen / **Production Assistant:** Mike Stone / **Sound Engineer:** Mike Stone / **Mastering:** Bob Ludwig, at Gateway Mastering Studios

CD #2: *NEWS OF THE WORLD* (RAW SESSIONS)

Track Listing: We Will Rock You (Alternative Version) / We Are the Champions (Alternative Version) / Sheer Heart Attack (Original Rough Mix) / All Dead, All Dead (Original Rough Mix) / Spread Your Wings (Alternative Take) / Fight from the Inside (Demo Vocal Version) / Get Down, Make Love (Early Take) / Sleeping on the Sidewalk (Live in the USA 1977) / Who Needs You (Acoustic Take) / It's Late (Alternative Version) / My Melancholy Blues (Original Rough Mix) / **Executive Producers:** Brian May, Roger Taylor / **Producers:** Joshua J. Macrae, Justin Shirley-Smith, Kris Fredriksson, Queen / **Production Assistant:** Mike Stone / **Sound Engineer:** Mike Stone / **Mastering:** Adam Ayan, at Gateway Mastering

CD #3: *NEWS OF THE WORLD* (BONUS TRACKS)

Track Listing: Feelings Feelings (Take 10, July 1977) / We Will Rock You (BBC Session) / We Will Rock You (Fast) (BBC Session) / Spread Your Wings (BBC Session) / It's Late (BBC Session) / My Melancholy Blues (BBC Session) / We Will Rock You (Backing Track) / We Are the Champions (Backing Track) / Spread Your Wings (Instrumental) / Fight from the Inside (Instrumental) / Get Down, Make Love (Instrumental) / It's Late (USA Radio Edit 1978) / Sheer Heart Attack (Live in Paris 1979) / We Will Rock You (Live in Tokyo 1982) / My Melancholy Blues (Live in Houston 1977) / Get Down, Make Love (Live in Montreal 1981) / Spread Your Wings (Live in Europe 1979) / We Will Rock You (Live at the MK Bowl 1982) / We Are the Champions (Live at the MK Bowl 1982) / **Executive Producers:** Brian May, Roger Taylor / **Producers:** Jeff Griffin (2, 6), Queen (1, 7, 12) / **Production Assistant:** Mike Stone (1, 7, 12) / **Sound Engineers:** Mike Robinson (2, 6), John Etchells (13, 17), Kooster McAllister (16), Reinhold Mack (16, 18, 19), Mick McKenna (18, 19), Mike Stone (1, 7, 12), Mr. Takanashi (14) / **Mix:** Mike Robinson (2, 6), Mike Stone (12), Queen (12) / **Mastering:** Adam Ayan, at Gateway Mastering Studios

DVD: QUEEN: *THE AMERICAN DREAM* (DOCUMENTARY)

Director: Christopher Bird / **Producers:** Jim Beach, Simon Lupton

A Gift for Devoted Fans

When *News of the World* was released in 1977, the world was Queen's for the taking, and they seized it within a matter of months thanks to their hits "We Will Rock You" and "We Are the Champions." Forty years later, to celebrate the anniversary of this truly phenomenal disc, it would take nothing less than a prestigious object full of rarities to satisfy the fans.

On November 17, 2017, the eagerly awaited *News of the World–40th Anniversary Edition* was finally released. This box set contained a rerelease of the original vinyl album, as well as a remastered CD version by Bob Ludwig, the acknowledged king of mastering, who in the past had worked on records by a host of luminary names including Eric Clapton, Metallica, Dire Straits, and Daft Punk. The set also contained two discs featuring unreleased or very rare versions of songs from *News of the World* and a DVD of the documentary *Queen: The American Dream*, which chronicled Queen's tour of the United States in the winter of 1977. A range of goodies was also offered to the lucky owners of the box set, including a reproduction of an "All Access" badge from the American tour, as well as photos, posters, stickers, and other facsimiles of period documents.

Versions Never Before Released

The record pressing was made from the original analogue tapes, and connoisseurs can rediscover the sound of the era, without the digital transfer that can detract from the original warmth and color of a recording.

The first CD, entitled *News of the World (Bob Ludwig 2011 Master)*, is the version of the album released in 2011, when Queen signed with Island Records, a subsidiary of Universal Music, for the international distribution of its fifteen studio albums (except in North America, which remained in the hands of Hollywood Records). Bob Ludwig was entrusted with the task of remastering the records, which also contained rare or previously unreleased tracks.

It is on the second CD when things begin to get serious. Entitled *News of the World–Raw Sessions*, the disc used the original track listing of the album but presented each song in a previously unheard version. We also hear behind-the-scenes snippets from the recording sessions, including the discussions during the takes, and the natural banter of the musicians who talk to each other before playing, as they do on "We Will Rock You" and "Get Down, Make Love." "Sheer Heart Attack" is revealed here in its most raw and primary form, with an introduction led by a harsh guitar, presumably played by Roger Taylor. "Sleeping on the Sidewalk," sung here by Mercury and not by May, comes from an undated American concert, while a version of "Who Needs You" is included from the earliest songwriting stage; Freddie was still looking for the lyrics, and he can be heard punctuating the recording with onomatopoeia and the jazzlike scats he was renowned for. The centerpiece of the record is a hitherto unreleased version of "All Dead, All Dead," sung in its entirety by Freddie Mercury. He brings a different tone to this track, which had been written by Brian May and inspired by a childhood trauma: the loss of a cat that had been very dear to him.

A Gold Mine for Queen Addicts

The third disc offers many versions of the songs from the album, including a number of tracks recorded during the band's tours between 1977 and 1982, some of which were recorded at the Milton Keynes Bowl on June 5, 1982, and which subsequently reappeared in the fall of 2004 on the DVD *Queen on Fire: Live at the Bowl*. There is also a rare track, "Feelings Feelings," which remained at the demo stage when it was recorded on July 10, 1977. Finally, hidden away in the middle of the instrumentals and other bonus tracks is the USA Radio Edit version of the magical "It's Late," which was, as the title indicates, released to the American market on April 25, 1978. In order to correspond to radio time standards, the song unfortunately lacks both its guitar solo and part of its break.

Lastly, the DVD *Queen: The American Dream* brings together the images of Queen's American tour that host Bob Harris, a friend of the band, had made in 1977 for a documentary to be broadcast on the BBC. The project was ultimately abandoned by the channel and the images put away in a drawer. The film presented here is extremely valuable because it shows the band as it had never been seen, in the studios, rehearsing for the American tour and then on the road. This rare and important document transports us right into the heart of a band taking its destiny into its own hands and bringing the world to its feet.

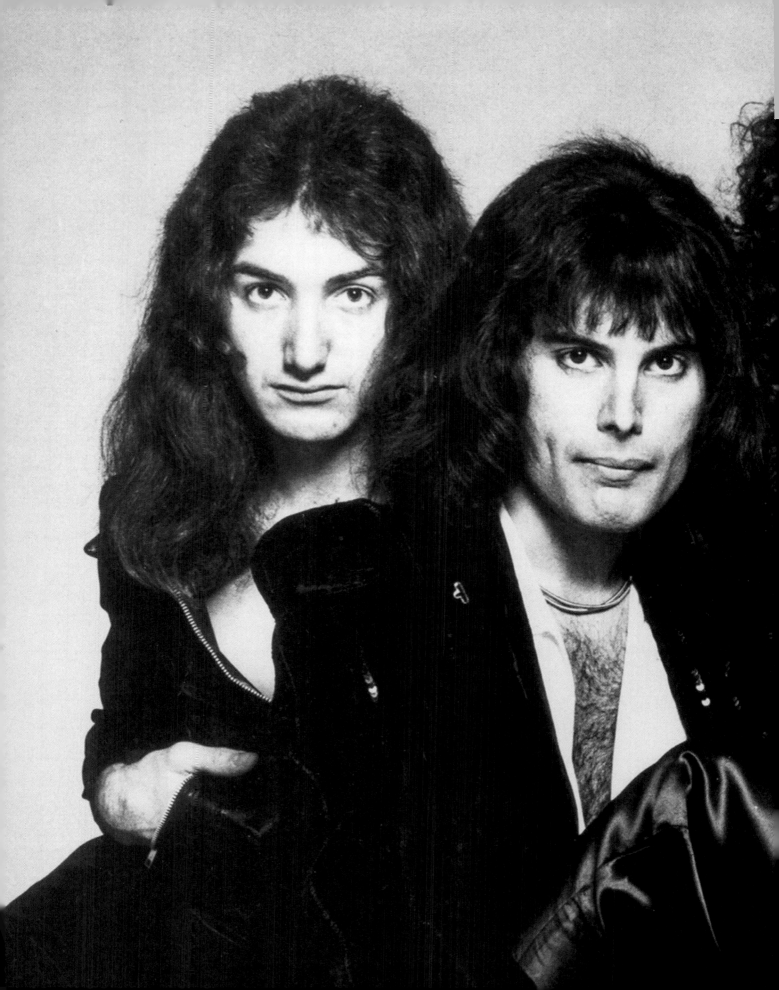

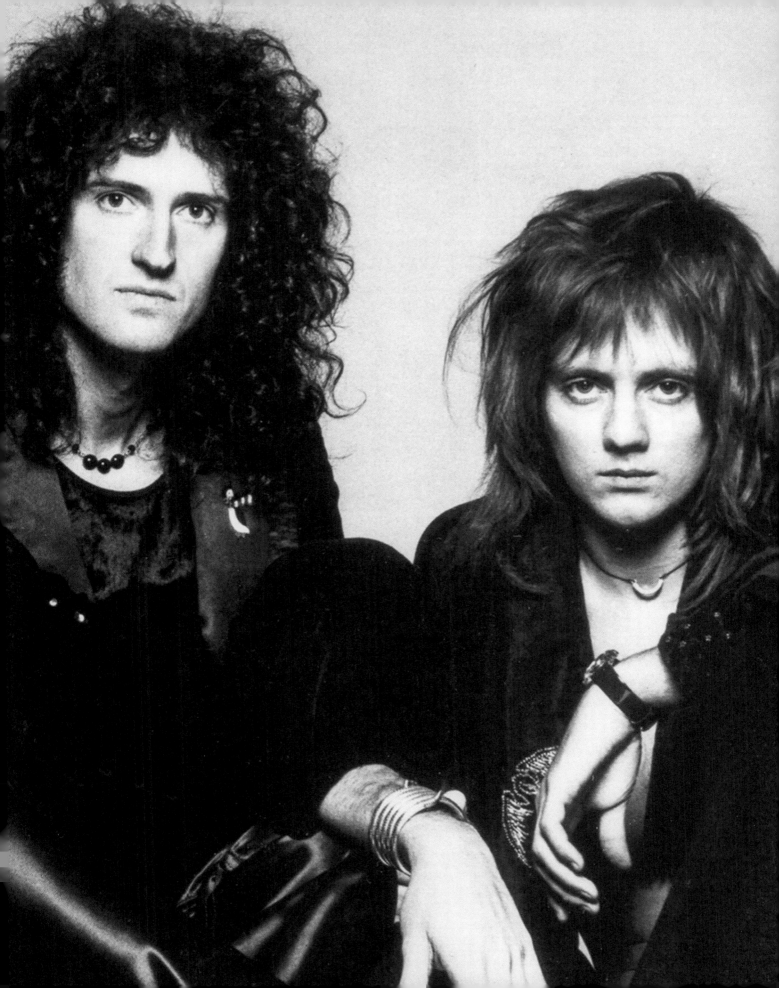

GLOSSARY

Action (of a guitar's neck): term describing the distance between the strings and the neck of a guitar. A "high action" refers to a guitar with strings quite high above the fingerboard; a "low action" has the strings close to the frets.

Backing tracks: instrumental or vocal (or sometimes simply rhythmical) tracks pre-recorded to accompany a singer or group of players.

Backliner: technician who prepares and maintains the musicians' equipment (instruments, amplifiers, accessories) for a concert or tour.

Bend: technique practiced by guitarists where one or more stings are pushed sideways, parallel to the neck. This causes the pitch of a sounded note to rise by a semitone or more.

Bottleneck: a glass or metal tube that the guitarist places on one finger and then slides over the strings to get a metallic sound. Blues players developed this way of playing using, as the name indicates, the neck of a bottle.

Bounce: a way of gaining space on the tape deck where separate tracks were recorded on individual tapes and then mixed together on a final tape.

Bourdon (or drone): an insistent and continuous sound created by an instrument.

Bridge: transition between two passages of a song.

Coda: word taken from Italian used for the conclusion, or "tail," of a piece of music.

Cowbell: small bell used as a percussion instrument, derived from the bells placed around the necks of cows.

Crunchy: used of a slight distortion of a sound or an instrument resulting in a loss of clarity but a warmer and more powerful color.

Delay: audio effect reproducing the acoustic effect of an echo. Integrated into an effect pedal or mixing console, it can be used for voices or instruments and can repeat a sound with different time intervals.

Detuning: modification of the pitch of one or more notes obtained by altering the tuning of an instrument or a recorded sound.

Distortion: audio effect created by degrading the quality of the signal; this is done by saturating the channel of an amplifier through the device's distortion effect or through a distortion pedal.

Dobro: brand of guitar with sound amplified by a metal resonator. The name Dobro is a contraction of the name of its American producers, immigrants from Slovakia, the Dopyera Brothers, as well as being the Slovakian word for "good."

Effects pedal: small electronic device used to transform the sound of an instrument while it is being played.

Electroacoustic (guitar): acoustic guitar with at least one microphone to amplify the sound in the same way as an electric guitar.

Fader: a control that slides up and down on a mixing board. It is used to control the volume of each individual track of a recording.

Frets: raised metal strips embedded at regular intervals across the neck of several types of stringed instruments, particularly guitars. They are used to vary the pitch of a note according to the vibrating length of the string between the bridge and the point where the finger presses down, and also to ensure accurate tuning.

Fuzz: audio effect producing a saturated, thick and, coarse sound, the notes being distorted by the intermediary of a fuzz box. Popularized by musicians such as the Rolling Stones and Jimi Hendrix, fuzz is principally used with electric guitars.

Gimmick: a short series of notes with an easily recognizable melody that attracts attention and remains in the listener's memory. Originally found in jazz, it has progressively been taken up by other musical genres.

Groove: a rather unspecific term applied principally to the rhythm of a song created by the bass and drums. The word spread from black American music during the twentieth century.

Harmonization: technique of multiplying the vocal or instrumental line with the same notes in unison or an octave apart. If the line or lines added to the original are played or sung on other notes (thirds or fifths, for example), the term "polyphonic harmonization" is used.

Jam session: improvisatory session where several musicians get together informally for the simple pleasure of playing.

Larsen effect: physical phenomenon that occurs when the amplified output (the loudspeaker, for example) and the input (the microphone used by the singer or instrumentalists, for example) are placed too close to one another. The sound produced is a strident whistle or crackling. Rock musicians using electric guitars—like Jimi Hendrix in the 1960s—used this effect in a highly creative way for some of their numbers.

Lo-fi: recording method where the high frequencies are accentuated to the detriment of bass frequencies, giving the deliberate impression that the material used for the piece was of inferior quality.

Outtake: piece of music recorded in a studio or onstage that is omitted from the official version of an album. It can be an unreleased item or an alternative version of an existing title and is sometimes revived for inclusion in a compilation or new edition.

Overdubs: new sounds recorded (voice and/or instruments) and added to an already existing recording.

Palm muting: technique used with guitar and bass guitar where the notes are muffled by placing the palm of the hand (right hand for right-handers and left for left-handers) across the strings near the bridge. It is done to dampen the sound of the notes played with the plectrum.

Pattern: repeating rhythmical or melodic sequence in a piece of music.

Phasing: audio effect obtained by filtering a signal and creating a series of highs and lows in the frequency spectrum. Available as a pedal or a rack, the effect is often a sweeping, wavelike oscillation.

Pitch bending: modification of the note pitch of a synthesizer obtained by sliding a wheel situated on the left-hand side of the instrument. The range of intervals is no more than one or two semitones.

Playback: lip-synching done by a singer and/or musician to a prerecorded audio track. When used in a live stage performance, it has the advantage of giving the sound a studio quality while allowing the performers to concentrate on the live performance aspect of the number as well as covering any imperfections.

Reissue: republication of an album or single.

Reverb: natural or artificial echo effect added to an instrument or voice during recording or mixing.

Reverse: deliberate reversal of a sound on an audio track so that it is heard backward.

Riff: an abbreviation of the expression "rhythmic figure"; a riff is a short fragment of a few notes that returns regularly during a piece and accompanies the melody.

Slide: technique used on the guitar consisting of a continuous and rapid sliding of a chord or of one note into another so that the intermediate notes can be heard.

Solid body: type of guitar with a solid body as opposed to a "hollow body" guitar.

Songwriter: the author of the words and/or music of a song.

Strumming: guitar technique where the right hand sweeps across all the strings from top to bottom (or the left hand in the case of left-handed players).

Sustain: capacity of an instrument to prolong the sound of a note. This term is mainly used to describe the sound qualities of a guitar.

Track listing: list of the songs featured on an album.

Trigger: sensor designed to digitize the sounds of a drum kit. Placed in contact with the instrument's batter head, it transforms the beats into electric signals, which are then sent to a module that produces the sounds.

Truss rod: metal rod, usually of steel, set within the neck of a guitar. It serves to stabilize and adjust the curvature of the neck and to compensate for the tension of the strings.

Vibrato bar: accessory consisting of a lever screwed onto the bridge tailpiece of an electric guitar that controls the pitch of the sounds made by the instrument.

Violining: effect where the starting notes of a guitar are concealed by playing the first chords at zero volume before progressively increasing the sound by means of a potentiometer or a volume pedal. The resulting sound, seeming to rise up from a great distance, is reminiscent of a violin, hence the term "violining".

Wah-wah: audio effect produced by the oscillation of the sound frequency between bass and treble, giving a sound that resembles a human voice repeating the onomatopoeic "wah." Mainly used with electric guitars, this effect can be achieved using the pedal of the same name.

Walking bass: bass line typical of jazz, where a note is played or improvised on each beat to create a melody. By playing all the quarter notes, the bass player sets the tempo for the other musicians in the group.

BIBLIOGRAPHY

1. Gunn, Jacky, and Jim Jenkins. *Queen: As It Began*. London: Sidgwick & Jackson, 1992.

2. Blake, Mark. *Is This the Real Life? The Untold Story of Queen*. London: Aurum Press Limited, 2010.

3. *Life Special Edition: Queen*. New York: Life Books, 2018.

4. Interview with Roger Taylor, *Sounds*, 1974.

5. Purvis, Georg. *Queen: Complete Works, Revisited & Updated*. London, Titan Books, 2018.

6. Review of the album "Queen," *Melody Maker*, July 7, 1974.

7. Fletcher, Gordon. Review of the album "Queen," *Rolling Stone*, no. 149, June 12, 1973.

8. Interview with Freddie Mercury, *Circus Magazine*, 1977.

9. Interview with Brian May by Lisa Sharken, *Vintage Guitar Magazine*, December 1998.

10. Booklet of the "Queen: On Air" box set, Virgin EMI, 2016.

11. Popoff, Martin. *Queen: Album by Album*. Beverly, MA: Voyageur Press, 2018.

12. May, Brian, and Simon Bradley. *Brian May's Red Special: The Story of the Home-Made Guitar That Rocked Queen and the World*. Milwaukee, WI: Hal Leonard Books, 2014.

13. Interview with Freddie Mercury by Don Rush, *Circus Magazine*, March 17, 1977.

14. *Classic Rock Magazine—Queen: The Complete Story*. London: Future PLC, 2019.

15. Wilkinson, Roy. "The Majesty of Rock," *Mojo Magazine*, no. 125, April 2004.

16. Power, Martin. *Queen: The Complete Guide to Their Music*. London: Omnibus Press, 2006.

17. Foster, Neil. Video for the launch of the book *Brian May's Red Special*, published by Carlton Books, October 1, 2014.

18. Richards, Matt, and Mark Langthorne. *Somebody to Love: The Life, Death and Legacy of Freddie Mercury*. London: Blink Publishing, 2016.

19. Interview with Freddie Mercury by Caroline Coon, *Melody Maker*, December 21, 1974.

20. Interview with Freddie Mercury by Julie Webb, *New Musical Express*, November 2, 1974.

21. "Rocket Engineering, Motown Propulsion," adampwhite.com, May 31, 2019.

22. Matt O'Casey, documentary, *Queen: Days of Our Lives, Part 1*, BBC 2, 2011.

23. Interview with Roger Taylor by Robert Santelli, *Modern Drummer*, October 1984.

24. Interview with Brian May, *Mojo*, December 1999.

25. Brianmay.com, 1998.

26. Queenlive.ca.

27. Interview with Brian May by Jamie Humphries, *Guitar Interactive*, no. 40, November 2016.

28. Murray, Tiffany. "The Time Freddie Mercury Came to Stay," theguardian.com, January 30, 2010.

29. May, Brian. *Queen in 3-D*. London: London Stereoscopic Company, 2017.

30. Sheffield, Norman J. *Life on Two Legs*. London: Trident Publishing Ltd., 2013.

31. DVD Classic Albums: *Queen—The Making of "A Night at the Opera,"* Eagle Rock Entertainment, 2006.

32. "A Night at the Opera" podcast, *In the Studio with Redbeard*, 1989, inthestudio.net.

33. *Cars and Queenie Days*, Crystal Tales, letter from Chris "Crystal" Taylor to the Queen fan club, during the 1990s.

34. Gensler, Howard. "That Classic Sound," *Philadelphia Daily News*, March 13, 2006.

35. "Brian May—The Power Behind Queen's Throne," interview with Brian May by Harry Doherty, *Melody Maker*, December 6, 1975.

36. "The Making of Innuendo," interview with Bob Coburn, *Rockline*, February 4, 1991.

37. Interview with Freddie Mercury by Julie Webb, *New Musical Express*, September 27, 1975.

38. Doherty, Harry. "Caught in a Landslide," *Classic Rock Magazine Queen, The Complete Story*. London: Future PLC, 2019.

39. Murray, Tiffany. "The Time Freddie Mercury Came to Stay," theguardian.com, January 30, 2010.

40. Cunningham, Mark. "Roy Thomas Baker & Gary Langan: The Making of Queen's 'Bohemian Rhapsody,'" *Sound on Sound*, October 1995.

41. Interview with Freddie Mercury by Molly Meldrum for Australian television, April 1985.

42. Doherty, Harry. *The Treasures of Queen*. London: Carlton Books, 2019.

43. Thomas, David. "Their Britannic Majesties Request," *Mojo Magazine*, no. 69, August 1999.

44. Jackson, Laura. *Brian May: The Definitive Biography*. London: Portrait Books, 2007.

45. Interview with Eddie Howell by Andy Davis, *Record Collector*, no. 188, April 1995.

46. Interview with Roger Taylor by Tom Browne, BBC Radio December 1, 1977.

47. "40 years ago: Queen in Hyde Park—Coronation in the Park," *Rock Magazine Eclipsed*, no. 183, September 2016.

48. Interview with Roger Taylor and Freddie Mercury by Wesley Strick, *Circus Magazine*, January 31, 1977.

49. Review of "A Day at the Races" by Nick Kent, *New Musical Express*, December 18, 1976.

50. "Brian May—Cash for Questions," interview with Brian May, *Q Magazine*, July 1998.

51. Interview with Freddie Mercury by Kenny Everett, Capital Radio, November 1976.

52. Interview with Brian May by Matt Blackett, GuitarPlayer.com, November 28, 2017.

53. "Live at Hyde Park" 1976, youtube.com.

54. Interview with Brian May by Jas Obrecht, *Guitar Player Magazine*, January 1983.

55. Bradley, Simon. "Brian May's Other Guitars," musicradar.com, February 24, 2011.

56. Interview with Brian May, *Guitar World Magazine USA*, October 1998.

57. Chapman, Phil. *The Dead Straight Guide to Queen*. Penryn, UK: Red Planet Publishing, 2017.

58. Jones, Lesley-Ann. *Freddie Mercury: The Definitive Biography*. London: Hodder & Stoughton, 2011.

59. *Classic Rock Presents the Complete Story of Queen*. London: Future PLC, 2019.

60. Documentary, *Freddie's Loves*, Channel 5, North One Productions, 2004.

61. Interview with Roger Taylor by Sally James, *Supersonic Saturday Scene*, ITV, 1976.

62. Massey, Howard. *The Great British Recording Studios*. Milwaukee, WI: Hal Leonard Books, 2015.

63. Tony Stewart, *New Musical Express*, June 18, 1977.

64. Documentary, *Queen: Rock the World*, Christopher Bird, BBC 4, 2017.

65. Desert Island Discs, BBC podcast, September 15, 2002.

66. Interview with Freddie Mercury and Brian May by Rosy Horide, *Circus Magazine*, no. 173, January 19, 1978.

67. Interview with Brian May, *Guitar World Magazine*, January 1993.

68. Mettler, Mike. "Brian May, the Maker of a Style," *Guitar Tricks Insider Magazine*, May/June 2017.

69. Henke, James. "Queen Holds Court in South America," *Rolling Stone*, June 11, 1981.

70. Brianmay.com, April 10, 2003.

71. Interview with Brian May, *In the Studio with Redbeard*, 2017, inthestudio.net.

72. Interview with John Deacon, *Hitkrant*, 1978.

73. Interview with Brian May by Mick Houghton, *Circus Magazine*, February 28, 1977.

74. Interview with Brian May by Alexis Korner, BBC Radio 1, 1983.

75. Interview with Brian May and Nuno Bettencourt, *Guitar for the Practicing Musician*, September 1993.

76. "A Gibbons-May-Van Halen Thang?" woodytone.com, January 12, 2009.

77. Eulogy for Mike Stone by Brian May, 2002, queenpedia.com.

78. Interview with Roger Taylor by Ray Bonici, *Record Mirror*, February 10, 1979.

79. Blake, Mark. *Freddie Mercury: A Kind of Magic*. Milwaukee, WI: Backbeat Books, 2016.

80. Review of "Jazz" by Dave Marsh, *Rolling Stone*, February 8, 1979.

81. Interview with Queen by Gilles Verlant at the Forest National Arena, Brussels, January 26, 1979, sonuma.com.

82. Interview with Brian May by Robert Sandall, *Q Magazine*, March 2008.

83. Savoie, Randy. "Freddie Mercury and Queen: A Night at the Fairmont," *OffBeat Magazine*, offbeat.com, November 1, 2001.

84. "Queen: The Gems Beyond the Gilded Headgear of the Greatest Hits," TheQuietus.com, November 26, 2009.

85. Interview with Brian May, *Total Guitar*, no. 216, July 2011.

86. Interview with Freddie Mercury by Mark Mehler, *Circus Magazine*, December 12, 1978.

87. Hince, Peter. *Queen Unseen: My Life with the Greatest Rock Band of the 20th Century*. London: John Blake Publishing, 2011.

88. "Taking Chances and Making Hits," interview with Roy Thomas Baker by Rick Clark, mixonline.com, April 1, 1999.

89. Interview with Brian May, *On the Record*, queenarchives.com, 1982.

90. Hudson, Jeffrey. "The Invisible Man," *Bassists & Bass Techniques*, April 1996.

91. Interview with Brian May, Absolute Radio, August 17, 2011.

92. Interview with Brian May, *Pelo Magazine*, March 1981.

93. Review of "Live Killers" by David Fricke, *Rolling Stone*, September 6, 1979.

94. Reinhold Mack's Facebook page, October 27, 2014.

95. Brooks, Greg, and Simon Lupton. *Freddie Mercury: A Life, in His Own Words*. London: Mercury Songs Ltd., 2006.

96. Jackson, Laura. *Mercury: The King of Queen*. London: Smith Gryphon Ltd., 1996.

97. Interview with Peter Freestone by Luigi Jorio, SwissInfo.ch, November 27, 2011.

98. Chilton, Martin. "He Was Music: Reinhold Mack on Working with Freddie Mercury," Udiscovermusic.com, December 10, 2019.

99. Runtagh, Jordan. "Freddie Mercury Went to a Kid's Party in a Queen Video Costume to Fulfill a Boy's Birthday Wish," people.com, February 22, 2019.

100. "Mack, the Man Who Reinvented Queen," deaky.net, 2000.

101. Gonzales, Michael A. "Chic!" *Vibe*, August 1997.

102. Hudson, Jeffrey. "The Invisible Man," *Bassists & Bass Techniques*, April 1996.

103. "Queen—On the Road Again," *International Musician and Recording World*, November 1982.

104. Interview with Queen, "The Game," *In the Studio with Redbeard*, 1989.

105. Rogertaylor.info

106. Interview with Roger Taylor, *Sounds Magazine*, 1980.

107. Hogan, Richard. "For Queen, a Royal Tour and a Triumphant Year," *Circus Magazine*, December 31, 1980.

108. Note by Howard Blake on howardblake.com.

109. Downs, Lisa, documentary, *Life After Flash*, Life After Ltd., 2019.

110. Matt O'Casey, documentary, *Queen: Days of Our Lives*, Part 2, BBC 2, 2011.

111. Interview with Roger Taylor in *Pop-Corn Magazine*, June 1981.

112. Interview with Queen, *Soundbites*, 1982.

113. Freestone, Peter and David Evans. *Freddie Mercury: An Intimate Memoir by the Man Who Knew Him Best*. London: Tusitala, 1998.

114. Interview with Brian May by Jon Wilde, *Uncut*, no. 94, March 2005.

115. Sutcliffe, Phil. *The Ultimate Illustrated History of the Crown Kings of Rock*. Beverly, MA: Voyageur Press, 2009.

116. Esch, Rudy. Electri_City: *The Düsseldorf School of Electronic Music*. London: Omnibus Press, 2016.

117. Brooks, Greg. *Queen Live: A Concert Documentary*. London: Omnibus Press, 1995.

118. May, Brian. "Why I Love John Lennon," loudersound.com, September 8, 2019.

119. Interview with Freddie Mercury, *Melody Maker*, May 2, 1981.

120. "Queen, Brian and Roger about *Calling All Girls*," youtube.com.

121. "Queen & David Bowie—Cool Cat, Unreleased Early Mix, 1982," davidbowienews.com, July 23, 2017.

122. Jones, Dylan. *David Bowie: The Oral History*. New York: Crown Archetype, 2017.

123. May, Brian. "How David Bowie and Queen Wrote the Legendary Track 'Under Pressure,'" *Daily Mirror*, January 11, 2016.

124. Van Der Veen, Sikke, and René Kroon, documentary, *Queen Forever in Nederland*, 2014.

125. "Bored? Depressed? Lonely? Cheer Up," interview with John Deacon by Martin Townsend, *The Hit*, 1985.

126. Wall, Mike. "Stone Cold Crazy," *Q Classic—Queen: The Inside Story*, March 2005.

127. Interview with Peter Hince, queenarchives.com, July 27, 2006.

128. Interview with Brian May and Roger Taylor by William Shaw, *Smash Hits*, March 26, 1986.

129. Fessier, Bruce. "From Isle of Wight to Joshua Tree: The Spike Edney Story," *The Desert Sun*, February 23, 2017.

130. Greene, Andy. "Queen Keyboardist Spike Edney on Live Aid: What Freddie Mercury Was Really Like," rollingstone.com, August 28, 2019.

131. Barker, Emily. "Live Aid 30 Years on: U2, Queen, Bob Geldof and More on the Charity Gig That United the Music World," nme.com, July 10, 2015.

132. Interview with Brian May and Roger Taylor, *Pop of the Line*, BBC, November 16, 1997.

133. Interview with Brian May for French television, youtube.com, September 18, 1984.

134. Grant, Brian, documentary, *Video Killed the Radio Stars—Queen*, 2009.

135. Furniss, Matters. *Queen—Uncensored on the Record*. Henley-in-Arden, UK: CODA Books Ltd., 2011.

136. Interview with Brian May by Terry Gross, NPR, July 28, 2010.

137. Interview with John Irving by François Busnel, *La Grande Librairie*, France 5, May 26, 2016.

138. Interview with Brian May, *Faces Magazine*, 1984.

139. Interview with Freddie Mercury by Rudi Dolezal, 1984.

140. Johnson, Angella. "Bubbles the Chimp Delayed Jacko and Freddie's Duet by Nearly 30 Years…as He Drove the Queen Frontman Ape," *The Mail on Sunday*, November 8, 2014.

141. Dolezal, Rudi. Rossacher, Hannes, documentary, *Queen—The Magic Years, Volume 3*, DoRo Productions, 1987.

142. Green, Cynthia. "Freddie Mercury, Addressing the Audience," thevoiceoffashion.com, February 18, 2019.

143. Grabet, Laurent, interview with Diana Moseley, queenworld.fr, September 2008.

144. "The Making of One Vision," *Queen—Greatest Video Hits 2*, 2003.

145. Betteridge, Jim. "Track Record: Queen," *International Musician and Recording World*, February 1986.

146. Chat with Joan Armatrading, theguardian.com, May 15, 2018.

147. Documentary, *The Miracle Express*, ITV, 1989.

148. Deriso, Nick. "30 Years Ago: Queen Overcome Trying Times to Finish 'The Miracle,'" ultimateclassicrock.com, May 22, 2015.

149. Sutcliffe, Phil. "Happy and Glorious?" *Q Magazine*, no. 54, March 1991.

150. Perrone, Pierre. "David Richards: Producer, Engineer and Musician at Montreux's Mountain Studios Who Worked with Bowie, Queen and Duran Duran," *Independent*, March 20, 2014.

151. Tribute to David Richards, brianmay.com, December 20, 2013.

152. Alexander, Ash. "When I Met Queen, Part 2," queenonline.com, April 23, 2014.

153. Interview with Roger Taylor by Hayden Tenant Smith, University Radio Bath, Cardiff University, March 2, 1988.

154. Interview with Brian May and Roger Taylor, *Hard'n'Heavy Video Magazine*, Vol. 3, Picture Music International, 1989.

155. "Queen—Greatest Video Hits 2," *Making of the Miracle Videos* documentary, disc 2, Parlophone, 2003.

156. Jenkins, Mark. "David Richards, Royal Engineer," *Sound on Sound*, August 1989.

157. "Queen for an Hour," interview by Mike Read, BBC Radio 1, May 29, 1989.

158. Sheffield, Norman. "Freddie Mercury Felt Like a God. Then He Started Behaving Like One," *Daily Mail*, July 20, 2013.

159. "Queen—Greatest Video Hits 2," DVD audio commentary, disc 1, Parlophone, 2003.

160. "Brian May Talks about Queen's Miracle," *Classic Rock*, May 25, 2014.

161. Interview with Roger Taylor by Adam Jones, *Rhythm Magazine*, September 2002.

162. "The Making of Innuendo," interview with Queen by Bob Coburn, *Rockline*, February 4, 1991.

163. Interview with Brian May by Dennis Hunt, *Los Angeles Times*, February 24, 1991.

164. Prato, Greg. "Steve Howe Examines His Career on 'Anthology'" guitarplayer.com, August 25, 2015.

165. Hutton, Jim, and Tim Wapshott. *Mercury and Me*. London: Bloomsbury Publishing, 1994.

166. Hart, Ron. "Remembering Freddie Mercury's Last Masterpiece," *Rolling Stone*, February 5, 2016.

167. Interview with Brian May, *Gold Compact Disc Magazine*, vol. 1, no. 7, 1992.

168. "The Life of Brian," interview with Brian May by Nuno Bettencourt, *Guitar World Magazine*, August 1991.

169. Interview with Brian May by Peter K. Hogan, *Vox Magazine*, March 1991.

170. Chick, Steve. "Queen: 10 of the Best Album Tracks," theguardian.com, November 12, 2014.

171. Interview with Brian May by Dave Thompson, *Goldmine USA*, August 10, 2001.

172. Wake, Lynne, documentary, *Queen + Béjart—Ballet for Life*, Eagle Vision, 2018.

173. British Phonographic Industry Awards, February 12, 1992, youtube.com.

174. *The Freddie Mercury Concert Tribute*, DVD, Special 10th Anniversary Ed., Queen Productions, 2002.

175. Interview with Brian May by John Norris, MTV, April 20, 1993.

176. Spheeris, Penelope. *Wayne's World*, DVD, Paramount Home Entertainment, 2001.

177. Peisner, David. "The Oral History of the Wayne's World 'Bohemian Rhapsody' Scene," *Rolling Stone*, November 30, 2015.

178. Interview with Brian May, *Boston Globe*, January 31, 1993.

179. "Brian May—Cash for Questions," interview with Brian May, *Q Magazine*, July 1998.

180. Speech by Brian May for the unveiling of the statue of Freddie Mercury at Montreux, youtube.com, 2010.

181. Brianmay.com, February 2004.

182. Moreton, Cole. "Inside the Studio Where Freddie Mercury Sang His Last Song," *The Telegraph*, December 1, 2013.

183. *Guitarist Magazine*, October 1994.

184. "Harmony in My Head," interview with Brian May by David Mead, *Guitarist Magazine*, December 1992.

185. Brian May's reply to a fan, brianmay.com, January 15, 2014.

186. "Queen on Fire—Live at the Bowl," The DVD Collection, Parlophone, 2004.

187. Sutherland, Mark. "Brian May Talks Queen's 1975 Concert Film, Performing 'Bohemian Rhapsody' Live," *Rolling Stone*, October 12, 2015.

188. Video message from Brian May, official charts, youtube.com, February 10, 2014.

189. "RIP Lord Snowdon," brianmay.com, January 13, 2017.

190. Interview with Brian May and Roger Taylor, *Top Billing*, January 2, 1998.

191. Press conference for the release of "Queen Rocks," Cologne, November 3, 1997.

192. "The Making of No One but You, Only the Good Die Young," *Queen Rocks—The Video*, Queen Productions, November 1998.

193. Interview with Brian May and Paul Rodgers by Jonathan Wingate, *Record Collector*, 2008.

194. Interview with Roger Taylor, *Classic Rock*, June 2008.

195. Bosso, Joe. "Queen's Brian May on Freddie Mercury's Guitar Skills, Bohemian Rhapsody Actors and the Most Difficult Song to Play Live," guitarworld.com, June 10, 2019.

Additional Bibliography

Dean, Ken. *Queen: A Visual Documentary*. London: Omnibus Press, 1986.

Di Nardo, Dario. *The Drums of Roger Meddows Taylor*, unedited, 2018.

Hodkinson, Mark. *Queen: The Early Years*. London: Omnibus Press, 1995.

Holzman, Jac, and Gavan Daws. *Follow the Music: The Life and High Times of Elektra Records in the Great Years of American Pop Culture*. Santa Monica, CA: FirstMedia, 1998.

Lecocq, Richard, and François Allard. *Michael Jackson, La Totale*. Paris: E/P/A, 2018.

Lemieux, Patrick, and Adam Unger. *The Queen Chronology—Second Edition*. Toronto: Across the Board Books, 2018.

Life Special Edition: Queen. New York: Life Books, 2018.

Rock, Mick. *Classic Queen*. London: Omnibus Press, 2007.

Sources Web

Brianmay.com, Deaky.net, Queenarchives.com, Queenonline.com, Queensongs.info, Queenvault.com, Rogertaylor.info

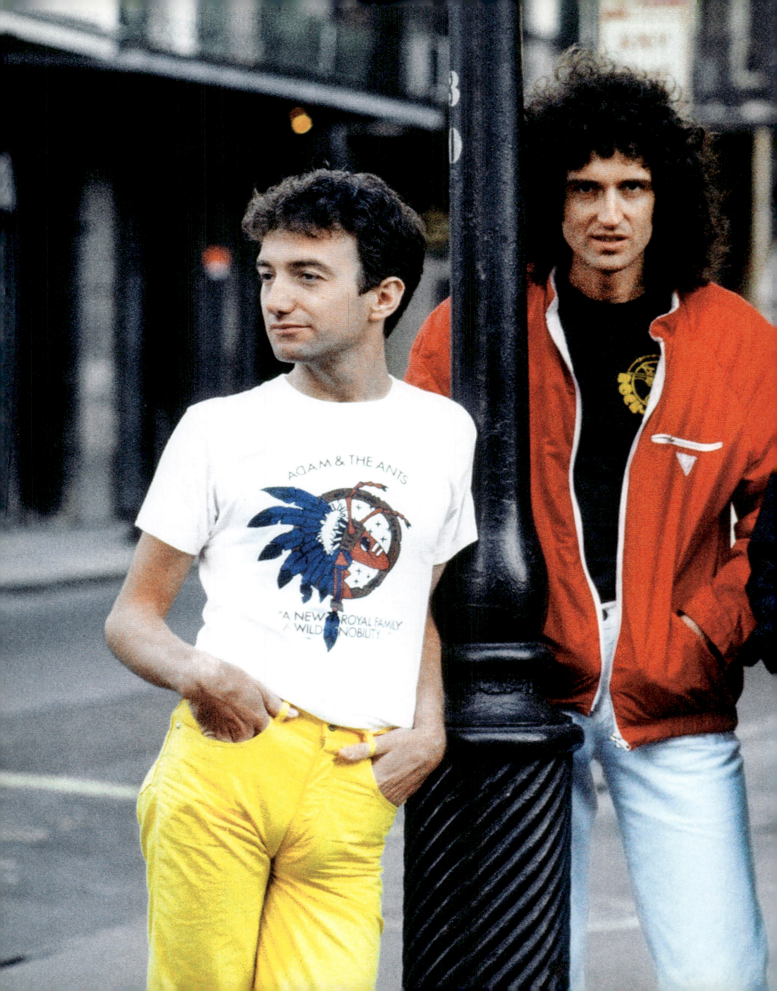

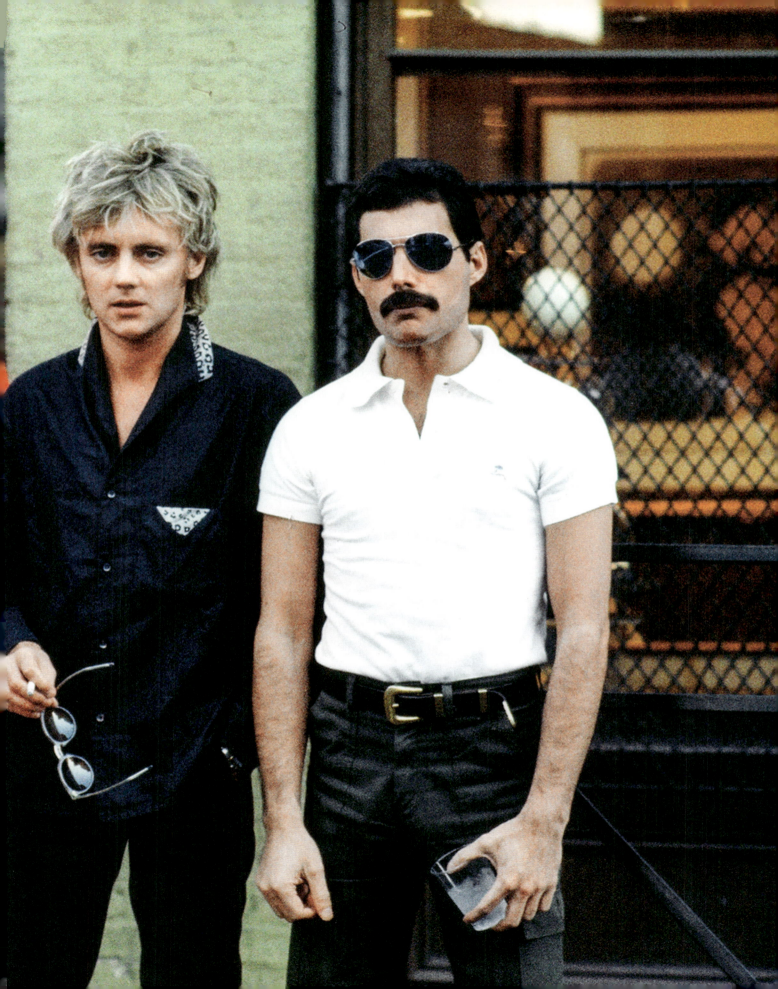

INDEX

Queen songs and albums are set in ***bold italics***.

2001: A Space Odyssey 130
Abbey Road [album] 94
Abbey Road Studios 34, 386, 506
Absolute Greatest [album] 492
Absolute Narrative [album] 492
AC/DC 358, 414
Action Strikes 288
Action This Day 295, 309, 311, 325, 365, 399, 427, 485, 493
Adam and the Ants 501
A Day at the Races [album] 23, 136, 154, 156-181, 182, 186, 192, 196, 200, 206, 218, 230, 240, 272, 276, 306, 322, 345
A Dozen Red Roses for My Darling 380, 390, 391
Aerosmith 262
A Human Body 260, 274, 276, 311, 340, 419
Ain't That a Shame 271
A Kind of Magic 365, 380, 473, 484, 487, 491, 492
A Kind of Magic [album] 308, 354, 364-393, 394, 399, 400, 416, 427, 430, 432, 438, 443, 459, 483
Alexander, Ash 375, 463, 464, 466, 468, 470, 472, 473, 474, 476, 478, 479, 480, 481
Alice in Chains 422
Allach, studios 258
All Dead, All Dead 185, 198, 506, 507
All Dead, All Dead (Original Rough Mix) 198, 506
Allen, Kris 504
Allerton Hill, studio 436, 437, 460, 463, 466, 472, 477, 498, 500
All God's People 427, 436, 440, 442, 472, 474, 476
Allison, Mike 215
All Right Now 26, 502
All Shook Up 346
Al Murray's Happy Hour 502
Always with Me, Always with You 444
A Magic Year 487
American Bell 88
American Idol 504
Anarchy in the UK 188

Andrews, Bernie 28
A New Life Is Born 414
A Night at the Odeon [album] 483, 489
A Night at the Opera [album] 23, 48, 64, 67, 77, 109, 111, 114-151, 152, 158, 164, 168, 178, 186, 189, 212, 230, 234, 238, 240, 244, 249, 290, 489
A Night at the Opera Tour 71
Animals, The 20, 30
Another One Bites the Dust 251, 257, 263, 264-265, 272, 283, 295, 296, 298, 308, 309, 322, 325, 365, 394, 399, 427, 459, 483, 484, 485, 486, 487, 490, 492, 495
Another One Bites the Dust (Wyclef Jean Remix—LP Version) 492
Another Piece of My Heart 468
Another World [album] 53, 389, 433, 498
Anthony, John 11, 12, 13, 30, 56, 78
Anvil Studios 282, 283, 284, 285, 287, 288, 292
Appleton, Mike 32
April Lady 11
Arboria (Planet of the Tree Men) 279, 288
Arista 346
Armanet, Juliette 318
Armatrading, Joan 390
Armstrong-Jones, Anthony 490
Around the World in a Day [album] 306
Barrett, Syd 62
Basinger, Kim 449
Basing Street Studios 186, 194, 198, 200, 202, 207, 208
Bastin, Tony 260
Batdance 391
Batman 391
Battle Theme 279, 289, 493
Austin, Louis 12, 30, 40
Austin, Mary 14, 23, 74, 87, 98, 116, 121, 136, 431, 444
Averill, Brent 360
A Winter's Tale 459, 462, 463, 478, 480, 493, 494
A Winter's Tale (Cozy Fireside Mix) 480
A Winter's Tale (Single Version) 480, 493
A Whiter Shade of Pale 38

Ayan, Adam 506
Ay-Oh (Live Aid) 495
Ayton, Sylvia 60
Baba O'Riley 65
Baby Love 383
Bach, Johann Sebastian 214
Back Chat 295, 298, 304, 308, 316, 322, 325, 365, 399, 427, 459, 483, 485, 491
Back to the Light [album] 460, 462, 476
Bad Bad Leroy Brown 108
Bad Boy Boogie 358
Bad Company 502
Baker, Ginger 10
Baker, Richard 405
Baker, Roy Thomas 12, 13, 30, 46, 48-49, 56, 64, 65, 66, 67, 68, 70, 72, 74, 76, 77, 78, 79, 80, 84, 86, 90, 91, 92, 94, 96, 98, 100, 102, 103, 104, 106, 108, 110, 112, 119, 122, 124, 125, 126, 128, 130, 132, 133, 134, 135, 136, 138, 140, 141, 142, 144, 148, 158, 169, 212, 215, 218, 220, 221, 227, 228, 230, 231, 232, 234, 236, 238, 239, 240, 242, 244, 246, 247, 374, 488
Band Aid 145, 332, 333, 334, 362
Band of Joy 493
Barcelona 400, 460, 492
Barcelona [album] 92, 373, 440
BBC 359, 493, 495, 506, 507
BBC 2 106, 120, 489
BBC Radio 1 146, 202, 495
BBC Radio 2 495
BBC Sessions 28, 29, 34, 37, 43, 66, 75, 80, 208, 220, 493, 495
Beach Boys, The 28, 78, 111

Beach, Jim 88, 116, 191, 226, 227, 254, 271, 328, 334, 430, 431, 452, 487, 506
Beast, The 242
Beat It 304
Beatles, The 8, 12, 13, 73, 78, 94, 112, 138, 152, 314
Blue Danube, The 171
Beautiful People, The 176
Be Bop a Lula 28, 489
Beckett, John 501
Beck, Jeff 91, 444
Bee Gees, The 260
Beethoven, Ludwig von 311
Beiriger, Michael 358, 359
Béjart, Maurice 448, 473, 498
Bellamy, Matthew 42, 97, 205
Bellotte, Pete 500
Be My Baby 78
Bergman, Ingmar 280
Bersin, Mike 38
Berry, Chuck 41, 101, 267
Besson, Luc 366
Bettencourt, Nuno 101, 356
Beyrand, Dominique 186, 338
Bezençon, Marcel 342
B. Feldman & Co. 28
Bicycle Race 217, 221, 224, 230, 232-233, 234, 236, 238, 246, 247, 248, 251, 295, 325, 340, 350, 365, 399, 468, 490
Biggles 372
Big Spender 484, 488, 489
Bijou 427, 432, 443, 444, 446, 459, 493, 494
Billy Jean 304
Birch, John 201
Birch, Martin 30
Bird, Christopher 506
Bivouac, Johnny 501
Black and Blue [album] 252
Black Clouds & Silver Linings [album] 94
Black Night 237
Black or White 504
Black Sabbath 8, 29, 30, 35
Black Side 56, 66, 68, 72, 74, 78
Blag 90
Blake, Howard 282, 283, 284, 286, 287, 288, 292

Blessed, Brian 289
Blondie 62, 242, 416
Blues Breaker 326
Blue Thumb 28
Blurred Vision 376, 377
Body Language 295, 299, 310, 316, 322, 325, 365, 399, 446, 491
Bogie, Doug 12
Bohemian Rhapsody 33, 35, 36, 48, 49, 64, 71, 76, 77, 115, 118, 119, 120, 126, 128, 134, 140-145, 147, 154, 155, 158, 171, 174, 176, 194, 195, 212, 218, 248, 254, 255, 335, 394, 432, 433, 441, 456, 460, 478, 484, 485, 486, 487, 488, 489, 490, 492, 495, 504
Bohemian Rhapsody [film] 34, 460, 495
Bohemian Rhapsody (Live Aid) 495
Bohemian Rhapsody OST [album] 483, 495
Bohemian Rhapsody (Reprise) 489
Bolan, Marc 60
Bonham, Jason 366
Bonham, John 126, 142, 366
Bon Jovi 234
Boomtown Rats 333, 334
Boston Globe 462
Boulting, John 90
Bowie, David 13, 26, 37, 56, 58, 62, 79, 87, 130, 212, 221, 282, 299, 304, 312, 318, 320, 321, 334, 337, 374, 430, 452, 453
Boys of Summer, The 414
Branson, Richard 154, 158, 186, 338
Bray Studios 452, 498
Brazil 369
Breakthru 399, 405, 414, 427, 459
Brel, Jacques 215
Brewis, Peter Russell 215
Brian May Band 462, 468
Brian May Guitars 53
Brighton Rock 43, 83, 84, 90-91, 135, 248, 484, 489
Brighton Rock Solo 484
Bring Back That Leroy Brown 83, 93, 108-109, 110, 124, 138, 215, 488, 489

British Film Institute 463, 474
British Phonographic Industry Awards 428, 452
Broadcasting Studios 37
Brooks, Greg 81, 358, 359
Brough, John "Teddy Bear" 394, 440, 464, 466, 468, 470, 472, 473, 474, 476, 478, 480, 481
Brown, Errol 140
Brown, James 308
Brown, Pete 118, 120, 144
Browne, Tom 202
Browning, Robert 36
Bruce, Nichola 472
'B' Side, The 146
Bubblingover Boys, The 18
Buckmaster, Paul 282
Buggles, The 338
Buie, Les 308
Bullen, Nigel 20
Bulsara, Farrokh 11, 12, 14, 16, 228
Burbridge, Derek 195
Burdis, Ray 501
Burton, Tim 391
Bush, Kate 254, 357
Bush, Mel 58, 120

Caballé, Montserrat 373, 400, 432, 440
Cabaret 93, 210
Cable, Robin Geoffrey 28, 56, 74, 76, 78, 180
Callaghan, James 191
Calling All Girls 315
Calvar, Geoff 12, 30, 32
Candle in the Wind 37, 145
Capital Radio 92, 134, 145, 146, 147, 166, 171, 495
Capitol Records 325, 328, 329, 330, 338, 344, 348, 354, 362, 365, 376, 380, 383, 391, 399, 410, 414, 430
Careless Whisper 382
Carnival Midway 91
Carousel 192
Cars, The 49, 218
Case, Neko 106
Cash, Dave 146
Casswell, Mike 462
Castledine, Clive 20
Cat People (Putting Out Fire) 312, 320

518 INDEX

Cavern Club 12
Changeling [album] 215
Changes 37
Chappell Studios 374
Chen, Phil 326
Cherone, Gary 101, 356
Chiasson, Roger 380
Chic 264, 308
Chicago 174
Chinese Torture 424
Chopin, Frédéric 290
Chow, Tina 60
Christmas at the Beeb [album] 489
Christmas on Earth Continued Festiva 8
Chrysalis Records 152
Chuck Berry Is on Top [album] 101
Churchill, Winston 311
Circus 172, 191
Clapton, Eric 444, 507
Clash, The 164, 186
Classically Elise 311
C-Lebrity 502, 504
Cliff, Jimmy 383
Cluster One 444
Coattail Riders, The 170
Cohen, Leonard 112
Collins, Phil 152, 380, 390
Collins, Sam 80
Coming Soon 251, 254, 274, 276, 280, 295
Command Performance [album] 489
Cook, James 408
Cool Cat 20, 295, 298, 302, 316, 318, 322, 383
Coon, Caroline 76
Coronation Street 330, 350
Cosford Mill, studios 463, 468, 472, 438
Cosmos Rockin' 503
Cosmos Rocks, The [album] 502
Cosmos Rocks Tour, The 503
Cousin Jacks, The 18
Coward, Noel 92, 434
Cowboys from Hell 33
Cowboy Song, The 140
Cox, Greg 485
Crash Dive on Mingo City 279, 290

Crazy Little Thing Called Love 254, 255, 256, 258, 260, 266, 267-269, 270, 271, 280, 296, 337, 346, 484, 485, 486, 487, 490, 492, 494, 495, 506
Crazy Tour 127
Cream 10
Croker, David 88
Crosby, Bing 374
Crosby, Stills & Nash 131
Cross, The 34, 400, 474
Croydon, Paul Cook 380, 386, 388, 390, 391
Crystals, The 78
Cure, The 14
Currie, James 409
Curry, Tim 62

Dadd, Richard 72
Da Doo Ron Ron 78
Daft Punk 507
Daily Mirror, The 418
Dale, Dick 283
Dalí, Salvador 72
Damned, The 164, 186
Dancer 295, 306, 325, 365, 440
Daniel 107
Darkness, The 49
Dark Side of the Moon, The [album] 64
Day, Doris 338
Dead End Street 153
Dead on Time 217, 238, 240, 246, 247, 493
Deane, Derek 254
Dear Friends 74, 83, 84, 104, 110
Death on Two Legs (Dedicated To...) 77, 115, 122-123, 158, 182, 206, 248
de Burgh, Chris 49
Decca Records 26, 48, 140, 146
Dee, Kiki 154
Deep Cuts 1 (1973-1976) [album] 493
Deep Cuts 2 (1977-1982) [album] 493
Deep Cuts 3 (1984-1995) [album] 493
Deep Purple 8, 14, 38, 220, 224, 237, 252
Def Leppard 104, 452, 453

De Lane Lea Sessions 30, 32, 35, 40, 44
De Lane Lea Studios 12, 30, 40, 48
De Laurentiis, Dino 280, 282
Delena, Edward 358, 359
Delilah 427, 428, 442, 446, 459, 472, 474, 476
De Lucía, Paco 433
De Palma, Brian 35, 102
Depeche Mode 243, 260, 390
De Sousa, Barry 152
De Vallance, Dennis 232, 268
Diana, Lady 61, 145, 498
Dietrich, Marlene 62, 329
Diggins, John 201
Dilloway, Dave 8, 16, 40
Dire Straits 334, 507
Dirty Deeds Done Dirt Cheap [album] 358
Division Bell, The [album] 444, 468
Dobson, Anita 359, 362, 400, 410, 418, 436
Doherty, Harry 489
Doing All Right 25, 28, 29, 34-37, 38
Doing All Right... Revisited 495
Doing All Right (BBC Session 1) 493, 495
Doing All Right (BBC Session 1—1995 Stereo Swap) 468
Dolezal, Rudi 377, 384, 408, 412
Domino, Fats 271, 346
Donner, Richard 280
Don't Drive Drunk 390
Don't Lose Your Head 365, 369, 383, 390, 399, 427, 459
Don't Shoot Me I'm Only the Piano Player [album] 107
Don't Stop Me Now 217, 246, 247, 248, 490, 492
Don't Stop Me Now... Revisited 495
Don't Try So Hard 438, 439, 444, 446, 493, 494
Don't Try Suicide 251, 264, 271, 275, 295, 325, 365, 399, 427, 459
Do They Know It's Christmas 145, 332, 362

Douglas, Alan 284, 286, 287, 288, 289, 290, 291
D'Oyly Carte Opera Company 140
Do You Feel Like We Do 442
Dragon Attack 251, 257, 262, 264, 272, 295, 306, 325, 342, 365, 440, 485, 486, 493
Dreamers Ball 210, 217, 240, 248, 251, 295
Dream Theater 94, 410
Driven by You 492
Drowse 157, 180, 182, 276
Drowse (Forever Early Fade) 494
Duck House 463
Dudgeon, Gus 48
Duggan, Rod 180
Duran Duran 261, 366
Dwight, Reg (aka Elton John) 88
Dylan, Bob 8

Ealing College of Art 8, 11, 14, 16
Earth 8, 11, 34
Earth Song 360
EastEnders 400
Easy Street 152, 153
Eddie Howell's Gramophone Record [album] 152
Edge of Seventeen 33
Edmonds, Wendy 60
Edney, Spike 334, 337, 384, 390, 400, 462, 476
Edwards, Bernard 264, 308
Edwards, Cliff 108
Electric Light Orchestra, The 252, 258
Electrifying Aretha Franklin, The [album] 175
Elektra 28, 32, 38, 40, 150, 166, 170, 172, 174, 217, 227, 230, 231, 232, 233, 236, 246, 248, 251, 260, 264, 266, 267, 268, 279, 284, 295, 304, 308, 310, 315, 320, 328, 329, 490
Elektra Records 91, 103
Elizabeth II, Queen 148
Ellis, Kerry 136
Elstree Studios 119, 145, 409, 410
Elton John [album] 78

EMI 28, 29, 32, 38, 116, 118, 122, 128, 140, 144, 161, 164, 166, 174, 182, 185, 188, 190, 194, 200, 215, 217, 226, 227, 230, 232, 236, 246, 248, 249, 254, 257, 260, 264, 265, 267, 275, 279, 284, 295, 299, 308, 310, 316, 318, 320, 321, 325, 328, 338, 344, 348, 354, 362, 376, 380, 384, 386, 395, 490, 493, 494, 503, 506
Encino, studio 328, 360
Enter Sandman 453
Eruption 209
Escape from the Swamp 279, 288
Escher, Maurits Cornelis 167, 181
Essex, Clifford 50, 53
Essex, David 92
Etchells, John 28, 34, 220, 228, 230, 231, 232, 234, 236, 238, 239, 240, 242, 244, 246, 247, 248, 506
Eurythmics 304, 357, 390
Evans, David 214
Everett, Kenny 92, 120, 134, 141, 145, 146-147, 166, 169, 171
Evolution 474
Exciter 132
Execution of Flash 279, 287
Exercices [album] 48
Extreme 101, 356, 407, 452, 453
Eye of the Tiger 353

Fairy Feller's Master-Stroke, The 55, 72-73, 74, 76, 488
Fanelli, Joe 178, 186, 430, 442
Fassbinder, Rainer 344
Fat Bottomed Girls 135, 176, 217, 221, 230, 232, 238, 240, 247, 268, 312, 342, 389, 485
Fat Bottomed Girls (1994 EMI Remaster Error) 491
Fat Bottomed Girls (1994 Remaster Error) 468
Fat Bottomed Girls (Live in Paris) 495
Father to Son 28, 42, 55, 64, 65, 488
Featherstone, Roy 28

Feelings Feelings 506, 507
Feelings Feelings (Take 10, July 1977) 506
Feel Like Makin' Love 502
Fellini, Federico 280
Ferry Across the Mersey 315
Fight from the Inside 185, 202, 204, 506
Fight from the Inside (Demo Vocal Version) 506
Fight from the Inside (Instrumental) 506
Fisher, Morgan 299
Flash 284, 286, 322, 326, 347, 485, 486
Flash Gordon [album] 64, 278-293, 296, 298, 299, 305, 388
Flash Gordon [film] 134, 261, 282, 283, 288, 296, 353, 366, 423
Flash (Single Version) 490
Flash's Theme 134, 282, 283, 284, 288, 290, 291, 292, 353
Flash's Theme Reprise (Victory Celebrations) 291
Flash to the Rescue 279, 288, 289
Flea 265
Fleetwood Mac 33
Flick of the Wrist 83, 92, 94, 96, 206, 232, 488, 489, 493
Flick of the Wrist (BBC Session 5) 495
Flicks, Rock 193, 201
Foo Fighters 167, 170, 493
Football Fight 279, 282, 284, 286
Foreigner 49
Forever [album] 359, 361, 386, 483, 494, 500, 506
Formby, George 108, 109, 138
Förnbacher, Helmut 344
For Your Entertainment [album] 504
Fosse, Bob 93
Fowler, Simon 405
Fox, Marc 215
Fox, Samantha 153
Frampton Comes Alive [album] 224, 442
Frampton, Peter 224, 442
Franklin, Aretha 164, 174, 175, 305

Franklin, Erma 468
Franks, Mike 215
Freas, Frank Kelly 189
Freddie Mercury Album, The [album] 460
Freddie Mercury—The Solo Collection [albums] 501
Freddie Mercury Tribute Concert 131, 452-457, 492
Fredriksson, Kris 360, 486, 487, 488, 489, 506
Free 26, 502
Freestone, Peter 255, 256, 305, 410, 428, 431
Fricke, David 249
Friends Will Be Friends 365, 369, 384, 394, 399, 408, 427, 484, 487, 491
Friese-Greene, Timothy 166, 168, 170, 171, 172, 176, 180, 181, 215
Fryer, Greg 53
Fugitive Brothers, The 501
Fun in Space [album] 254, 274, 276, 282, 296, 374, 424
Fun It 217, 224, 231, 242-243, 247
Funny How Love Is 55, 67, 78, 111
Furie, Sidney J. 376
Fusari Rob 341

Gabriel, Peter 357
Gallagher, Rory 166
Gambaccini, Paul 335
Game, The [album] 234, 250-277, 279, 280, 282, 283, 292, 295, 296, 298, 299, 305, 306, 318, 322, 325, 346, 365, 399, 427, 459, 463, 464, 483
Game Tour, The 229
Garnham, John "Jag" 16, 50
Gateway Mastering Studios 506
Gaye, Marvin 129
Geldof, Bob 333, 334, 337, 362, 376, 453
Genesis 152, 380
Gensler, Howard 131
Germanotta, Stefani Joanne Angelina 341
Gerry and the Pacemakers 315
Get Down, Make Love 185, 204-205, 208, 237, 248, 265, 485, 486, 506
Get Down, Make Love (Early Take) 506
Get Down, Make Love (Instrumental) 506
Get Down, Make Love (Live in Montreal 1981) 506
Get It On 26
Get the Funk Out 407
Ghostbusters 391, 412

Gibb, Andy 260
Gibb, Barry 260
Gibb, Maurice 260
Gibb, Robin 260
Gibbons, Billy 209
Gibson, Bob 226
Giddings, Terry 452
Gieves-Watson, John 138
Gilliam, Terry 369
Gilmour, David 502
Gimme Some Lovin' 484
Gimme the Prize (Kurgan's Theme) 365, 369, 376, 380, 388, 389, 399, 427, 443, 459
Gimme the Prize (The Eye Instrumental Remix) 498
Gladdish, Adam 409
Goatham, David 489
Godfrey, Lexi 145
Godiva, Lady 246
God Save the Queen 64, 115, 148, 189, 290, 394, 424, 487
Goin' Back 28, 471
Going for the One [album] 433
Golders Green Hippodrome 495
Goldsmith, Harvey 372, 452
Goldthorpe, Maureen 93
Gonna Make You a Star 92
Goodbye Stranger 129
Goodbye Yellow Brick Road [album] 107
Good Company 64, 109, 115, 138, 171, 178, 238, 244, 493
Good Morning Britain 418
Good Old-Fashioned Lover Boy 157, 164, 178, 181, 182, 192, 194, 196, 212, 228, 230, 232, 234, 236, 238, 246, 490, 495
Good Times 264
Goose Productions Ltd. 215
Gowers, Bruce 33, 119, 145, 174
Grandmaster Flash and the Furious Five 193, 326
Grandville [artist] 430, 432, 433, 446
Grant, Brian 261
Gratzer, Alan 326
Grave, Robert 66
Gray, Richard 380, 405, 430, 432, 463, 491
Grease 267
Greatest Flix III 474
Greatest Hits [album] 299, 483, 490, 491
Greatest Hits II [album] 419, 460, 483, 491
Greatest Hits III [album] 483, 492

Greatest Hits I, II, III—Platinum Collection 492
Greatest Video Hits 1 [DVD] 38
Great King Rat 12, 25, 30, 35, 36, 45, 46
Great King Rat (BBC Session 3) 493, 495
Great King Rat (De Lane Lea Demo) 30
Great Pretender, The 373, 460, 492
Greene, Graham 90
Greenpeace—The Album [album] 357
Gregory, Steve 382
Grey Seal 107
Griffin, Jeff 506
Griffith-Joyner, Florence 417
Groce, Jim 108
Grohl, Dave 167
Grose, Mike 12, 103
Groove, The 42
Grundy, Bill 164
Guardian, The 444
Guitarist Magazine 463
Guns N' Roses 452, 453, 456, 462
Gute Nacht, Gottschalk 81
Guyton, Andrew 176, 201

Haines, Graham 489
Hair 214
Haley, Bill 338
Halfpence [album] 489
Hallelujah 112
Hall, Eric 93
Hammersmith Odeon 120, 489
Hammerstein II, Oscar 192
Hammer to Fall 312, 325, 337, 354, 356, 394, 436, 484, 487, 491
Hammer to Fall (Live Aid) 495
Hammer to Fall (The Headbanger's Mix Edit) 491
Hammett, Kirk 354, 411
Hampton, Lionel 138
Hang On in There 410, 424, 481, 483, 484, 486
Hanks, Tom 409
Happy Days 267, 268
Hardin, Tim 34
Harper, Roy 154
Harris, Bob 32, 106, 120, 154, 195, 377, 489, 507
Harris, John 14, 126, 127, 224, 256
Harris, Jonathan 126
Harris, Noel 432, 434, 436, 437, 438, 439, 441, 442, 443, 444, 446
Harris, Richard 145
Harrison, Philip 138

Hasebe, Koh 249
Have a Cigar 206
Hawkins, Taylor 167, 170, 493
Headlong 427, 436, 437, 439, 450, 459, 483, 491
Headlong (Single Edit) 491
Heal the World 360
Heartbreaker 43
Heaven for Everyone 459, 463, 464, 474, 476
Heaven for Everyone (Single Version) 474, 492
Heiraten (Married) 210
Hello Mary Lou 35, 266, 484, 487
He-Man Woman Hater 407
Hendrix, Jimi 8, 14, 16, 30, 53, 80, 91, 154, 176, 242, 290, 408
Henley, Don 414
Hentschel, David 13
Hero, The 279, 283, 289, 292, 353, 388, 485, 486
Herrmann, Bernard 123
Hey Jude 34, 37
Hibbert, Jerry 432
Highlander 289, 354, 366-391
Hijack My Heart 424
Hillage, Steve 154
Hinault, Bernard 232
Hince, Peter 59, 128, 189, 220, 227, 233, 256, 258, 267, 269, 285, 299, 302, 330, 335, 372
Hints of Innuendo 443
Hitchcock, Alfred 123
Hitman, The 427, 434, 443, 450, 459, 470, 493
Hodges, Mike 261, 280, 284, 310
Holly, Buddy 16, 41, 484
Hollywood Records 47, 427, 430, 437, 459, 474, 476, 484, 485, 486, 488, 489, 491, 492, 494, 495, 507
Hollywood Revue of 1929, The 108
Hollywood Swinging 264
Home 26
Horide, Rosemary 116
Hostage, The 252
Hot Chocolate 140
Hotel New Hampshire, The 328, 352
Hot Space [album] 204, 224, 294-323, 325, 328, 330, 339, 340, 344, 348, 358, 365, 383, 399, 427, 459, 460, 483, 485, 486, 491
Hot Space Tour 36, 284, 299, 326, 485
Hough, John 372
Howard, Paul 409

Howell, Eddie 23, 136, 152, 153, 168, 215
Howe, Steve 432, 433
Huey Lewis and the News 412
Hungarian Rhapsody [album] 487
Hughes, Glenn 204
Humphries, Jamie 103
Humpy Bong 11
Hunter, Ian 160
Hunter, The [album] 242
Huppertz, Gottfried 500
Hurrell, George 62, 329
Hutton, Jim 333, 335, 366, 372, 428, 430, 431, 434, 442, 444, 480
Hyde Park (concert in) 78, 154-155, 160, 168, 174, 186
Hypnotic Seduction of Dale 279, 284, 286

Ibex 11, 14, 29, 38
I Can Hear Music 28, 78
I Can't Get No (Satisfaction) 504
I Can't Live with You 427, 437, 439, 459, 483, 491
I Can't Live with You (1997 "Rocks" Retake) 491
Ice Ice Baby 320, 428
Ice on Fire [album] 366
I Do Like to Be Beside the Seaside 79, 91, 103, 106, 181
I Dream of Christmas 362
I Feel It Coming 318
I Feel Love 252, 310, 500
If I Was a Carpenter 34
If You Can't Beat Them 217, 234, 236, 238, 239, 246, 247, 251, 295, 325, 365, 399, 427
If You Leave Me Now 174
Iggy and the Stooges 196
I Go Crazy 338, 358
I Just Called to Say I Love You 239
Imaginary Love 305
Imagine 314
I'm Going Slightly Mad 430, 434, 436, 446, 450
I'm Going Slightly Mad (Vinyl Edit) 491
I'm in Love with My Car 41, 115, 121, 126, 128, 132, 140, 145, 151, 180, 202, 248, 311, 486
I'm in Love with My Car (Rocks Mix) 491
Immigrant Song, The, 37
Immortals, The 372
Imperial College 8, 10, 16, 18
Impromptu 484
I'm Still Standing 366

Indochine 243
Innuendo 427, 430, 432-433, 436, 444, 450, 456, 459, 464, 466, 483, 491
Innuendo [album] 273, 426-453, 462, 491
In Only Seven Days 217, 239, 246, 251, 266, 295, 325, 348
In the Death Cell (Love Theme Reprise) 279, 287, 288, 289
In the Lap of the Gods 83, 102, 488
In the Lap of the Gods... Revisited 83, 112, 155, 175, 194, 484, 487, 488, 489, 493
In the Space Capsule (The Love Theme) 279, 286, 287
In the Studio with Redbeard 198
Invisible Man, The 399, 405, 412, 424, 427, 491
Iron Butterfly 33
Iron Maiden 30, 132, 410, 433
Irving, John 328, 352
Island of Lost Souls 416
Island Records 487, 493, 507
Is This the World We Created...? 325, 344, 356-357, 394, 484, 487, 493
It's a Beautiful Day 459, 464, 466, 483
It's a Beautiful Day (Original Spontaneous Idea, April 1980) 464
It's a Beautiful Day (Reprise) 464, 481, 483, 484, 486
It's a Beautiful Day (Reprise) (Deep Cuts 3 Version) 481, 493
It's a Beautiful Day (Single Version) 464, 474
It's a Hard Life 258, 325, 330, 342, 344-345, 365, 399, 427, 459, 468, 483, 491, 494
It's Late 100, 110, 185, 196, 208-209, 359, 490, 491, 493, 506, 507
It's Late (Alternative Version) 506
It's Late (BBC Session) 506
It's Late (BBC Session 6) 495
It's Late (USA Radio Edit 1978) 506
I Wanna Testify 188, 202
I Want a New Drug 412
I Want It All 342, 399, 405, 409, 410, 424, 436
I Want It All (Rocks Mix) 491

I Want It All (Single Version) 491
I Want to Break Free 20, 325, 329, 330, 333, 342, 348-351, 354, 365, 394, 399, 427, 484, 487, 491, 492, 495
I Want to Break Free (Greatest Hits II CD Edit) 492
I Want to Break Free (Single Mix) 491
I Was Born to Love You 372, 463, 466, 472, 473, 493

Jackson Five 41
Jackson, Michael 264, 296, 299, 302, 304, 326, 356, 360, 394, 500, 504
Jacksons, The 360
Jagger, Mick 62, 360
Jailhouse Rock 266, 486, 488, 489
Jamaica Jerk-Off 107
James, Sally 180
Jarre, Jean-Michel 260
Jarvis, Brian 79
Jazz [album] 48, 66, 124, 127, 135, 176, 208, 216-247, 248, 252, 254, 274, 312, 423
Jazz European Tour 127
Jazz Tour 224, 252
Jealousy 66, 217, 231, 251, 295, 325, 365, 399, 427, 459, 483
Jealousy (With Reinstated Bass Drum) 493
Jean, Wyclef 492
Jeepster 94
Jeff Beck's Guitar Shop [album] 444
Jenkins, Chris 489
Jesus 12, 25, 30, 44, 46, 440
Jesus (De Lane Lea Demo) 30
Jethro Tull 154
Jezebel 153
Joffé, Rowan 90
John, Elton 13, 26, 48, 78, 88, 106, 116, 118, 144, 145, 212, 334, 366, 449, 456, 498
John Lennon/Plastic Ono Band [album] 314
Johnny B. Good 41
Johnny Quale and the Reaction 18
Johnson, Christine 192
Johnson, Tommy 80
Jones, Percy 152
Jones, Sam 280
Jones, Steve 197
Jonesy's Jukebox 197

Jon Roseman Productions 145
Journey 49, 260
Joy Division 242
Judas Priest 132
Jump 286
JVC Studios 384

Kamen, Michael 369, 386
Kashmir 433
Keep Passing the Open Windows 352-353, 362
Keep Yourself Alive 12, 25, 28, 29, 30, 32-33, 38, 40, 42, 45, 56, 150, 172, 212, 248, 446, 448, 486, 488, 489, 491, 493, 495
Keep Yourself Alive (BBC Session 1) 493, 495
Keep Yourself Alive (De Lane Lea Demo) 30
Keep Yourself Alive (Live at the Rainbow) 495
Keep Yourself Alive Long Lost Retake 150
Keep Yourself Alive (Reprise) 488
Kennedy, Ray 35
Kenny & Cash Show 146
Kenny Everett Audio Show, The 146
Kent, Nick 161, 178, 179
Kernon, Neil 92, 94, 96, 98, 102, 103, 104, 106, 108, 110, 112, 148
Khalaf, James "Trip" 256, 394
Khashoggi, Adnan 407
Khashoggi's Ship 399, 405, 407, 409, 427, 437, 459, 483
Khashoggi's Ship (Stand-Alone Version) 493
Killer Queen 83, 84, 86, 87, 92-93, 94, 109, 116, 129, 150, 194, 218, 232, 248, 386, 486, 488, 489, 490, 492, 495
Killing in the Name 176
King, Carole 471
King, Martin Luther 376
Kinks, The 153
Kirkby, Stanley 133
Kiss (Aura Resurrects Flash), The 279, 282, 288, 290
Kleiser, Randal 267
Knebworth Park 372, 394, 400, 411, 452
Knees 146
Knetemann, Gerrie 232
Kool and the Gang 264
Kraftwerk 243
Kubrick, Stanley 130
Kujiraoka, Chika 181

Lady Gaga 341
Lambert, Adam 500, 504
Lambert, Christopher 366, 382, 386, 391
Lamers, Elizabeth 476
Langan, Gary 84, 122, 123, 124, 128, 130, 132, 133, 134, 136, 138, 140, 142, 144, 150, 152, 166, 168, 170, 172, 174, 176, 178, 180, 181, 192, 194, 196, 198, 200, 202, 204, 206, 207, 208, 210
Lang, Fritz 326, 340, 347, 494, 500
Lansdowne Studios 119, 122, 126
Last Christmas 239
Laughing Policeman, The 108
Lazing on a Sunday Afternoon 109, 115, 124-125, 132
Leaving Home Ain't Easy 130, 208, 217, 238, 244
Ledersteger, Ursula 344
Led Zeppelin 8, 29, 35, 37, 41, 43, 81, 92, 126, 142, 176, 224, 242, 249, 252, 366, 407, 433, 456, 489, 504
Led Zeppelin III [album] 37
Led Zeppelin IV [album] 68
Lee, Gypsy Rose 236
Leigh-White, Rebecca 468
Lemieux, Patrick 80
Leng, Deborah 414
Lennon, John 40, 170, 314
Lennox, Annie 453
Leoncavallo, Ruggero 345
Leroux, Gaston 448
Let Me Entertain You 217, 236, 238, 246, 248, 251, 295, 325, 365, 399, 427, 486
Let Me in Your Heart Again 358, 359, 466, 494, 500
Let Me Live 459, 463, 468, 483, 492
Let Me Out 326
Let's Go Crazy 298
Let There Be Rock 358
Lewis, Jerry Lee 41, 337, 346
Liar 12, 28, 29, 30, 33, 38-39, 40, 44, 45, 46, 395, 488, 489
Liar (BBC Session 1) 493, 495
Liar (BBC Session 1—1995 Stereo Swap) 468
Liar (BBC Session 2) 495
Liar (De Lane Lea Demo) 30
Liar (US Edit) 38
Life at Last 35
Life Is Real (Song for Lennon) 295, 310, 314, 325, 365, 399, 427, 459

Life on Mars 37
Lily of the Valley 74, 83, 87, 94, 96, 98, 100, 104, 414, 493, 494
Lily of the Valley (Single Version) 494
Limehouse Studios 441
Linn, Roger 304
Little Queenie 101
Live Aid 334-337, 341, 354, 357, 366, 376, 495
Live at Leeds [album] 224
Live at the Rainbow '74 [album] 483, 488, 490
Live at the Rainbow [DVD] 41
Live at Wembley 112
Live at Wembley '86 [album] 483, 484, 485, 486
Live Killers [album] 28, 136, 137, 224, 248-249, 252, 374, 394
Live Magic [album] 372, 394-395
Living on My Own 366, 376, 460, 473
Living on My Own (Julian Raymond Mix) 492
Lockwood, Joseph 254
Logical Song, The 129
Lohengrin 64, 290
London Royal Ballet 350
Loneliness of the Long Distance Runner, The 433
Long and Winding Road, The 78
Long Away 130, 157, 170, 172, 206, 244, 493, 494
Longfellow, Henry Wadsworth 416
Looks Like It's Gonna Be a Good Night—Improv 487
Lord, Jon 38
Lord Snowdon, Anthony Armstrong-Jones 490
Loser in the End, The 55, 68, 94
Lost Opportunity 273, 434, 450
Louis Armstrong, Louis 321
Love Kills (Rock Mix) 501
Love Kills—The Ballad 326, 494, 500-501
Love, Mike 78
Love of My Life 23, 74, 75, 115, 135, 136, 314, 356, 453, 484, 485, 486, 487, 490
Love of My Life (Forever Version) 494
Love of My Life (Rock in Rio) 495
Love to Love You Baby 252, 500
Lovine, Jimmy 33
Lowe, Nick 408

Lucas, George 280
Lucky Star 304
Lucy in the Sky with Diamonds 40, 73
Ludwig, Bob 506, 507
Luongo, John 304
Lupton, Simon 487, 506
Lurex, Larry 28, 78, 471
Lyons, Gary 122, 124, 128, 130, 132, 133, 134, 136, 138, 140, 150, 152, 166, 168, 170, 172, 174, 176, 178, 180, 181, 192, 194, 196, 198, 200, 202, 204, 206, 207, 208, 210

MacArthur Park 145
Machines (Or "Back to Human") 325, 347, 348, 365, 383, 391, 399, 407, 427, 437, 493
Mack, Reinhold 252, 254, 256, 257, 258, 260, 262, 264, 265, 266, 267, 269, 270, 271, 272, 274, 275, 276, 282, 284, 286, 287, 288, 289, 290, 291, 292, 296, 298, 299, 302, 304, 306, 308, 310, 311, 312, 314, 315, 316, 318, 319, 320, 321, 322, 326, 328, 338, 342, 344, 346, 347, 348, 352, 354, 356, 358, 359, 360, 362, 369, 376, 377, 379, 382, 383, 384, 391, 464, 466, 468, 470, 472, 473, 474, 476, 478, 480, 484, 485, 486, 487, 506
Macrae, Joshua J. 360, 464, 466, 468, 470, 472, 473, 474, 476, 478, 480, 481, 486, 487, 506
Made in Heaven 459, 466, 473, 483, 492, 493, 494
Made in Heaven [album] 374, 375, 458-481, 492, 501
Made in Heaven—The Films 463, 472, 474
Made in Japan [album] 224
Madison Square Garden 178, 190, 191
Madman Across the Water [album] 26, 78
Madonna 256, 304
Mad the Swine 46-47, 436
Magee, Sean 506
Magic Tour, The 366, 394, 400, 487
Magic Years, The 377
Maison Rouge Studios 376, 379
Majesty of Rock, The 453
Malandrone, Pete 176, 479
Mallet, David 340, 350, 354, 410, 473, 474
Malouf, Brian 484

Mandel, Fred 299, 304, 326, 329, 334, 338, 339, 340, 346, 348, 350, 354, 359, 466
Man Friday & Jive Junior 326
Man from Manhattan 23, 152-153, 215
Mango Groove 453
Manning, Roger Jr. 132
Man on the Prowl 325, 346, 362, 365, 382, 399
Manor Mobile 248, 394
Manor, The, studios 154, 158, 168, 171, 174, 176, 178, 180
Mansfield, Mike 33
Manson, Marilyn 176
March of the Black Queen (Deep Cuts Version), The 493
March of the Black Queen, The 36, 55, 58, 66, 76-77, 134, 143, 391, 432, 478, 488, 489, 493, 495
Mardin, Arif 304, 305
Marmalade 161
Marquee Club 28, 34
Marriage of Dale and Ming (And Flash Approaching) 290
Marshall, John 88
Marsh, Dave 221, 228, 233, 236
Martin, Gary 468
Martin, George 138
Marvin, Hank 16, 50, 502
Marx Brothers 164, 188
Marx, Groucho 161, 164, 188
Master of Puppets 411
Maybe this Time 210
May, Harold 16, 50, 53, 108, 138, 190, 191
May, James 220, 244
May, Jimmy 326
May, Ruth 16, 138, 190
McAllister, Kooster 486, 506
McCall, Ross 409
McCartney, Paul 13, 40, 110, 124, 244, 274, 334
McCulloch, Derek 108
McGhee, Brownie 81
McKenna, Mick 485, 506
McMillan, Keith 275
Meldrum, Molly 189
Melody Maker 29, 76, 315
Mercer, Bob 116
Mercury Records 11
Message, The 326
Metallica 103, 112, 411, 452, 453, 507
Metropolis 326, 340, 347, 494, 500
Metropolis Mastering 485

Metropolis Studios 428, 432, 434, 436, 437, 438, 439, 440, 441, 442, 443, 444, 446, 463, 470, 472
Michael, George 382, 452, 453, 468, 492
MIDEM 28 1984 8, 10, 14, 16
Miller, Glenn 138
Miller, Mandy 108
Millionaire Waltz, The 88, 157, 164, 171, 207, 240, 379, 493
Milton Keynes Bowl 485, 507
Ming's Theme (In the Court of Ming the Merciless 279, 286
Minnelli, Liza 92, 210, 452, 456
Minns, David 23, 121, 136, 152, 168, 178, 186, 271
Miracles, The 504
Miracle, The 399, 408, 409, 427, 459, 483, 491
Miracle, The [album] 38, 322, 398-425, 428, 430, 432, 440, 472, 476, 491
Misfire 83, 106, 108, 110, 266
Misirlou 283
Mitchell, Barry 12
Mitchell, Mitch 10
Moby Dick 176
Modern Drummer 94
Modern Times Rock 'n' Roll 25, 41, 68, 94, 180, 188, 488
Modern Times Rock 'n' Roll (BBC Session 3) 493, 495
Modern Times Rock 'n' Roll (BBC Session 4) 495
Montreux Jazz Festival 221
Moore, Gary 152, 252
Moran, Mike 92, 440, 476
Morello, Tom 42
More of That Jazz 217, 224, 246, 247
More than Words 356, 453
Moroder, Giorgio 242, 252, 310, 311, 312, 320, 326, 494, 500, 501
Moseley, Diana 372, 473
Moss, Kate 62
Mother 314
Mother Love 431, 459, 462, 470-471, 478, 483, 493
Motown 20, 41, 383
Mott the Hoople 29, 56, 58, 59, 84, 100, 158, 160, 208, 299

Mountain Studios 218, 220, 224, 228, 230, 231, 232, 234, 236, 238, 239, 240, 242, 244, 246, 247, 248, 254, 276, 296, 299, 320, 321, 326, 358, 366, 369, 372, 374, 375, 380, 386, 388, 390, 400, 404, 405, 406, 408, 410, 412, 416, 420, 422, 424, 428, 432, 434, 436, 437, 438, 439, 440, 441, 442, 443, 444, 446, 450, 470, 472, 476, 478, 480
Mozart, Wolfgang Amadeus 448, 473
Mr. Bad Guy [album] 258, 332, 361, 366, 376, 436, 473
MTV 145, 234, 249, 338, 310, 350
MTV Europe Music Awards 505
Mulcahy, Russell 289, 354, 366, 369, 380, 386, 391
Mullen, Chrissie 100, 116, 121, 158, 208, 220, 437
Munich Machine, The 253, 311
Murray, Tiffany 118, 140
Muse 42, 97, 133, 205, 264
Music Centre, The 284, 286, 287, 288, 289, 290, 291
Musicians Union 153
Musicland Studios 252, 256, 260, 262, 264, 266, 267, 270, 271, 272, 274, 275, 276, 296, 304, 306, 308, 310, 311, 312, 314, 315, 316, 318, 322, 344, 346, 347, 352, 354, 356, 358, 359, 360, 362, 369, 374, 376, 377, 384, 391, 464, 465, 473, 431, 500
Music Life Magazine 119
Musker, Frank 476
Mustapha 25, 115, 157, 217, 228-229, 230, 232, 234, 236, 238, 246, 247, 251, 279, 493
Muti, Ornella 280, 288
My Baby Does Me 399, 420, 427, 459
My Coo Ca Choo 270
Myers, Mike 460
My Fairy King 25, 28, 36-37, 46, 493
My Fairy King (BBC Session 1) 493, 495
My Fairy King (BBC Session 1—1995 Stereo Swap) 468
My Life has Been Saved 4 8, 459, 472, 474, 476, 483
My Melancholy Blues 185, 210, 506
My Melancholy Blues (BBC Session) 506
My Melancholy Blues (BBC Session 6) 495

My Melancholy Blues (Live in Houston 1977) 506
My Melancholy Blues (Original Rough Mix) 506

Naiff, Lynton 382
National Philharmonic Orchestra 386
Nazareth 48
Need Your Loving Tonight 251, 266, 270, 295, 325, 365, 399
Nellie the Elephant 108
Nelson, Ricky 35, 266, 484
Népstadion 394, 487
Nevermore 55, 58, 74-75, 78
Nevermore (BBC Session 4) 495
New Bingley Hall 192
Newman, Alfred 64, 495
New Musical Express 137, 161, 186
New Opposition, The 20
News of the World [album] 97, 100, 175, 184-211, 215, 218, 228, 237, 240, 377, 506, 507
News of the World—40th Anniversary Edition 506-507
News of the World Tour 136
New York Yankees 194
Nicks, Stevie 33
Night Comes Down, The 12, 30, 40, 46
Night Comes Down, The (De Lane Lea Demo) 30
Nijinsky, Vaslav 350
Nine Inch Nails 205
Nirvana 422
Nobody Like You 175
Nolen, Jimmy 308
Nomis Studios 452
No-One but You (Only the Good Die Young) 483, 491, 492, 498
Nothing Else Matters 112, 453
No Turning Back 372
Now I'm Here 83, 84, 86, 98, 100-101, 104, 120, 150, 208, 244, 248, 480, 484, 485, 486, 487, 489, 490, 491
Now I'm Here (BBC Session 5) 495
Now I'm Here (Live at Hammersmith Odeon) 495
Now I'm Here (Reprise) 486

Off the Wall [album] 265
Ogre Battle 55, 58, 70, 72, 76, 134, 155, 347, 488, 489
Ogre Battle (BBC Session 3) 495

Ogre Battle (BBC Session 3 Edit) 493
Ogre Battle (Deep Cuts Version) 493
Oldfield, Mike 158
Old Grey Whistle Test, The 32, 106, 120, 489
Olympia Brass Band 226
Olympic Sound Studios 404, 406, 407, 408, 410, 412, 414, 416, 418, 420, 422, 424, 472, 476, 489
On Air [album] 493, 495
One Vision 365, 366, 369, 376-379, 380, 384, 394, 399, 408, 471, 484, 487, 491
One Vision (Single Version) 491, 492
One Way Ticket to Hell… And Back [album] 49
One Year of Love 365, 369, 382, 399, 427, 459, 483, 493
Orbit, William 359, 360, 494
Orwell, George 8
Overnight Angels [album] 160

Page, Jimmy 8, 35, 91, 444
Pagliacci 345
Pain Is So Close to Pleasure 365, 369, 383, 391, 399, 407, 416, 437
Palabras de amor, Las (The Words of Love) 181, 295, 316, 318, 491, 492, 494
Palabras de amor, Las (The Words of Love) (Greatest Hits III Version) 492
Panic Station 264
Pantera 33
Papa Charlie Jackson 80
Parfitt, Rick 81
Parker Jr, Ray 391, 412
Parker, Sarah Jessica 61
Parliaments, The 188
Parlophone 152, 399, 410, 414, 418, 427, 432, 434, 436, 446, 459, 468, 474, 476, 478, 480, 484, 486, 491, 492, 498
Parton, Dolly 261
Party 399, 406, 407
Pasadena 139
Pasche, John 10
Patton, Charley 80
Peaches 208, 437
Pearl Jam 422
Peel, John 28
Penny Lane 152
Penrose, Charles 108
People Are People 390
Perkins, Carl 101
Peters, Colin 460, 501

Petite Amie Live [album] 318
Peyton, Mary 146
Phantom of the Opera, The 214
Phantom of the Paradise 35, 102
Philadelphia 76ers 194
Phillips, Arlene 268
Picking up Sounds 326
Pinewood Studios 412, 419
Pink Floyd 8, 10, 62, 64, 110, 154, 206, 280, 369, 444, 468
Pin Ups [album] 56, 62
Plant, Robert 8, 81
Platters, The 373
Play the Game 256, 257, 260-261, 262, 264, 272, 276, 284, 286, 288, 292, 311, 468, 485, 486, 490
Play the Game (Forever Version—No Intro) 494
Polar Bear 12
Police, The 195, 271
Pope, Tim 344
Pop Life 306
Popoff, Martin 44, 124, 319
Pornograffitti [album] 407
Porter, Catherine 468
Powell, Cozy 462, 498
Power and the Glory, The [album] 383
Power, Martin 123
Power Sound Mobile 394
Power Station Studios 320, 321
Prenter, Paul 186, 298, 332, 361, 400, 418, 431
Presley, Elvis 266, 267, 268, 338, 346
Prince 102, 242, 296, 298, 306, 311, 391
Princes of the Universe 342, 365, 369, 376, 391, 399, 492
Procession 45, 55, 64, 65, 74, 79, 148, 290, 424, 488
Procol Harum 38
Prophet's Song, The 115, 119, 130, 134-135, 139, 141, 145, 230, 354
Psychose 123
Psycho Suite 123
Puddifoot, Douglas 28, 30
Pulp Fiction 283
Pummell, Shirum 474
Purvis, Georg 94, 180
Put Out the Fire 295, 312, 314, 315, 325, 365, 399, 427, 491, 493
Pye Recording Studios 12, 30

Quadrophenia [album] 56
Queen + Adam Lambert 176, 473, 504-505

Queen [album] 25-47, 48, 98
Queen II [album] 36, 45, 48, 54-81, 91, 98, 102, 111, 119, 134, 143, 145, 148, 231, 290, 329
Queen Music Ltd. 191
Queen On Fire: Live at the Bowl [album] 483, 485, 487, 489, 507
Queen + Paul Rodgers 502
Queen Rock Montreal 249
Queen Rocks [album] 491, 494, 498
Queen's First EP [album] 178, 182
Queen Talks 446, 449
Queen—The Studio Experience 470
Queen Works! The Works Tour 36, 340

Rackham, Arthur 72
Radio Ga Ga 276, 329, 333, 335, 338-341, 342, 348, 350, 358, 384, 394, 419, 479, 484, 487, 491, 492
Radio Ga Ga (Live Aid) 495
Radio London 146
Radio One 120
Rage Against the Machine 42, 176, 423
Ragtime Piano Joe 215
Rainbow 30
Rainbow Children 102
Rainbow Theatre 41, 86, 96, 145, 488
Raincloud Productions Ltd. 191
Rain Must Fall 20, 399, 416-417, 427
Ramaekers, Serge 460
Ramones, The 62
Raymond, Alex 280
Reaction, The 18
Reay, Ken 166
Record Mirror 68
Record Plant Studios 326, 338, 342, 348, 352, 358, 359, 468
Red Hot Chili Peppers 265
Reed, Lou 56, 62
Reggatta de Blanc [album] 271
Reichardt, Minki 344
Reid, John 88, 116, 119, 136, 144, 154, 171, 186, 190, 200, 214, 299, 456
Reiner, Rob 453
Reizner, Lou 11
Return of the Champions [album] 502
Revell, Adrian 489
Revolution Club 11
Reznor, Trent 205
Rhodes, Zandra 58, 60-61

Rhys Jones, Griff 335
Richard, Cliff 267
Richards, Bobby 374
Richards, David 47, 248, 318, 320, 321, 322, 366, 369, 372, 374-375, 380, 386, 388, 390, 404, 406, 407, 408, 409, 410, 412, 414, 416, 417, 418, 420, 422, 423, 424, 428, 431, 432, 433, 434, 436, 437, 438, 439, 440, 441, 442, 443, 444, 446, 450, 464,466, 468, 470, 472, 473, 474, 476, 478, 480, 481
Richards, John 286, 287, 288, 292
Richards, Little 484
Richardson, Tony 328, 352
Ride the Wild Wind 439, 444, 450, 493
Ridge Farm Studios 118, 128
Rimson, Jerome 152, 153
Ring (Hypnotic Seduction of Dale), The 279, 286, 288
Rise and Fall of Ziggy Stardust and the Spiders from Mars, The 26
Risqué [album] 264
Robinson, Mike 506
Rocket Record Company 48
Rocket Ship Flight 288
Rockfield Studios 84, 90, 94, 96, 102, 103, 104, 106, 112, 119, 122, 124, 126, 128, 130, 132, 133, 134, 136, 138, 140, 141, 142
Rock in Rio 334
Rock in Rio Blues *(US Version)* 476
Rock It (Prime Jive) 251, 266, 270, 271, 493
Rock Legends [festival] 101
Rock, Mick 58, 60, 61, 62, 86, 119, 141, 145
Rock Montreal 1981 [album] 483, 486
Rock'n'Roll America Tour 299
Rock This Town 346
Rocky Horror Picture Show, The 62, 87, 214
Rocky III 353
Rodgers, John 257
Rodgers, Nile 264, 308
Rodgers, Paul 462, 502, 503, 504
Rodgers, Richard 192
Rogers, Ginger 133
Rolling Stone 29, 193, 221, 228, 233, 236, 249, 489
Rolling Stones Mobile 394, 485
Rolling Stones, The 8, 10, 30, 188, 191, 192, 252, 374, 504, 510

Ronettes, The 78
Ronson, Mick 56
Roosters, The 8
Rose, Axl 456
Ros, Elisabet 473
Rossacher, Hannes 377, 384, 408, 412
Rotten, Johnny 189, 196
Roundhouse Studios 119, 122, 126, 140, 148
Roxy Music 56, 62
Royal Philharmonic Orchestra 282, 284
Rubáiyát [album] 103
Rubin, Rick 48
Runaway 234
Runaway Boys 346
Run-DMC 262
Ryder, Maggie 462

Sad but True 453
Sail Away Sweet Sister (To the Sister I Never Had) 42, 251, 254, 272-273, 280, 386, 450, 493, 494
Sanger, John 16
Santelli, Robert 94
Sarm East Studios 119, 122, 123, 124, 126, 128, 130, 132, 133, 134, 136, 138, 139, 140, 141, 142, 150, 152, 158, 161, 166, 168, 170, 172, 174, 176, 178, 180, 181, 192, 194, 196, 198, 200, 202, 204, 206, 207, 208, 210, 215, 362
Satriani, Joe 101, 410, 444
Savage, Alan 215
Savage, Rick 104
Save Me 251, 254, 256, 260, 272, 275, 280, 295, 485, 486, 490, 494
Save Me (Original Single Mix) 490
Scandal 399, 400, 405, 418-419, 427, 459, 472
Schrader, Paul 312
Scorpions 66, 252
Scorpio Studios 119, 122, 126
Scottish Festival of Popular Music 154, 160
Scott, Robert Falcon 276, 311
Seal 452
Search and Destroy 196
Seaside Rendezvous 109, 115, 132, 133, 178, 181, 215
2nd Law, The [album] 264
Sedlecká, Irena 463
Seekers, The 374
See What a Fool I've Been 29, 79, 80-81, 358, 450, 489

See What a Fool I've Been (BBC Session 2) 495
Setzer, Brian 268, 346
Seven Nation Army 193
Seven Seas of Rhye 55, 68, 79, 81, 84, 91, 98, 103, 384, 394, 450, 481, 484, 487, 488, 489, 490, 491, 492
Seven Seas of Rhye 25, 45
Sex Crime 390
Sex Pistols, The 164, 186, 188, 196, 197
Shadows, The 50
Shalamar 305
Sharman, Jim 87
Sheer Heart Attack 185, 188, 196, 200, 202, 208, 228, 230, 232, 234, 236, 238, 242, 246, 248, 414, 485, 486, 491, 493, 506, 507
Sheer Heart Attack [album] 43, 48, 74, 82-113, 118, 120, 124, 128, 138, 148, 257
Sheer Heart Attack (Live in Paris 1979) 506
Sheer Heart Attack (Original Rough Mix) 506
Sheer Heart Attack Tour 86, 107, 112
Sheffield, Barry 12, 22, 28, 33
Sheffield, brothers 78, 87, 96, 116, 118
Sheffield, Norman 12, 22, 28, 30, 48, 88, 122, 123, 147, 249, 410
She Makes Me (Stormtrooper in Stilettoes) 83, 84, 110, 208
Shepperton Studios 340, 341
Sheridan, Mark 79
Shirley-Smith, Justin 360, 432, 434, 436, 437, 438, 439, 440, 441, 442, 443, 444, 446, 464, 466, 468, 470, 472, 473, 474, 476, 478, 480, 481, 485, 486, 487, 488, 489, 498, 506
Shove It [album] 474
Show Me the Way 442
Show Must Go On, The 427, 438, 441, 446-449, 491, 492, 495, 498, 505
Show Must Go On (Live with Elton John), **The** 492
Silvercup Studios 391
Simmons, Sylvie 226, 242
Simone, Nina 175
Sin 205
Singer, Bryan 495
Singing in the Rain 108
Sisters of Mercy, The 242

Sleeping on the Sidewalk 130, 185, 206, 208, 244, 493, 506, 507
Sleeping on the Sidewalk (Live in the USA 1977) 506
Smile 8, 10, 11, 12, 14, 16, 18, 29, 30, 34, 80, 90, 103, 140
Smith, Chris 10, 140
Smith, Jacky 81
Smith, Mel 335
Smoke on the Water 220
Snider, Dee 39, 73
Snoop Dogg 318
Solera, Dino 311
Somebody to Love 157, 164, 167, 174-175, 176, 195, 212, 263, 440, 453, 468, 480, 485, 486, 490, 492, 495
Somebody to Love (Forever Edit) 494
Somebody to Love (Live with George Michael) 492
Some Day One Day 55, 67, 110
Some Things That Glitter 503
Somewhere in Time [album] 433
Son and Daughter 29, 32, 42, 44, 65, 262, 488, 489
Son and Daughter (BBC Session 2) 495
Son and Daughter (BBC Session 3) 493, 495
Son and Daughter (Reprise) 488
Song Remains the Same, The [album] 224
Soul Brother 320, 322, 360
Soul Brother (Remaster Error) 474
Soundgarden 422
Sound of the Seventies 28, 493
Sounds 29, 226
Sour Milk Sea 11, 14
South America Bites the Dust 296
Space Oddity [album] 79, 221
Spector, Phil 48, 78
Spencer, Lady Diana 498
Spheeris, Penelope 145, 460
Spielberg, Steven 409
Spinal Tap 453
Spirit Is Willing, The 214
Spread Your Wings 88, 185, 192, 196, 200-201, 202, 204, 248, 359, 476, 490, 493, 506
Spread Your Wings (Alternative Take) 506
Spread Your Wings (BBC Session) 506
Spread Your Wings (BBC Session 6) 495

Spread Your Wings (Instrumental) 506
Spread Your Wings (Live in Europe 1979) 506
Springfield, Dusty 28
Staffell, Tim 8, 10, 11, 12, 14, 16
Stallone, Sylvester 353
Stardust, Alvin 270
Star Fleet 326
Star Fleet Project [album] 258, 326, 342
Star Licks 209
Star Wars 110, 233
State of Shock 360
Status Quo 81, 334
Staying Power 295, 298, 304-305, 306, 308, 325, 365, 399, 485, 493
Stealin' 414, 424
Step on Me 11, 12
Stevens, Pete "the Fish" 485
Stewart, Rod 468
Stewart, Tony 186
Stickells, Gerry 236, 255
Still Burnin' 503
Still Loving You 66
St. Johns Wood Studios 33
Stockley, Miriam 462, 468
Stokes, Richard 192, 196, 204, 206, 210
Stone Cold Crazy 12, 83, 103, 488, 491, 493
Stone Cold Crazy (BBC Session 5) 495
Stone, Mike 56, 64, 65, 66, 67, 68, 70, 72, 74, 78, 84, 90, 92, 94, 96, 98, 100, 102, 103, 106, 108, 110, 112, 119, 122, 124, 126, 128, 130, 132, 133, 134, 136, 138, 140, 148, 152, 158, 166, 168, 169, 170, 171, 172, 174, 176, 178, 180, 181, 192, 193, 194, 196, 198, 200, 202, 204, 206, 207, 208, 210, 212, 218, 506
Stooges, The 62
Straker, Peter 214-215, 220, 344, 431, 434
Strange Frontier [album] 258, 326, 374, 424
Stranglers, The 49
Strat Pack, The 502
Strauss, Johann 171
Stray Cats 268, 346
Strick, Wesley 172
Studio Collection, The [album] 481
Stupid Cupid 489
Subway 366
Sugarhill Gang, The 193
Summer, Donna 252, 261, 310, 406, 500
Sun, The 400, 418

Super Bear Studios 218, 220, 221, 228, 230, 231, 232, 234, 236, 238, 239, 240, 242, 244, 246, 247
Supercharge 154
Superman 280
Supermassive Black Hole 42
Supertramp 129
Supremes, The 383
Surfin with the Alien [album] 444
Survivor 353
Sutherland, Mark 489
Sweet Dreams 304
Sweet Lady 115, 132
Sydow, Max von 280

Takanashi 506
Talking of Love [album] 359, 362
Tamla Motown 20, 88
Tangerine Dream 260
Tarantino, Quentin 283
Taste 166
Tatlock, John 228
Tavaszi Szél Vizet Áraszt (The Spring Wind Makes the Water Swell) 487
Taylor, Chris "Crystal" 126, 220, 256, 372
Taylor, Elizabeth 61
Taylor, Felix 338, 441
Taylor, Gavin 485
Taylor, Rory Eleanor 441
Tear It Up 312, 342, 354, 356, 380, 443, 484, 487, 491, 493
Teenage Dream 94
Temperance Seven, The 138, 139
Tenement Funster 41, 83, 94, 182, 188, 202, 311, 493
Tenement Funster (BBC Session 5) 495
Tenement Lady 94
Teo Torriatte (Let Us Cling Together) 157, 181, 224, 316, 490
Terence Higgins Trust 441
Terry, Sonny 80
Tetzlaff, Veronica 128
Thames Television 164
Thank God It's Christmas 332, 362, 491, 492
That's All 380
That's How I Feel 81
The Best Of—Far Beyond the Great Southern Cowboys' Vulgar Hits [album] 33
There Must Be More to Life Than This 356, 360-361, 494, 500
There Must Be More to Life Than This (William Orbit Mix) 494

There's Gonna Be Some Rockin' 358
These Are the Days of Our Lives 427, 441, 443, 446, 459, 470, 492, 494
"13" 459, 481
'39 115, 121, 128, 130-131, 134, 136, 137, 244, 248, 453, 493
This One's on Me [album] 214-215
This Time Is for Real 406
Thompson, Chris 462
Thomson, Richard 16
Thriller 360
Thriller [album] 296, 299, 302, 304, 326
Tie Your Mother Down 155, 157, 166-167, 168, 172, 176, 181, 182, 200, 244, 248, 257, 394, 443, 453, 471, 484, 485, 486, 487, 490, 491, 502
Tie Your Mother Down *(Single Version)* 498
Timperley, John 374
Today with Bill Grundy 164, 188
Tolkien, John Ronald Reuel 70, 72
Tomlinson, Eric 286, 287, 288, 292
Tommy [album] 56, 65, 214
Too Much Love Will Kill You 460, 463, 476, 492, 494
Too Young 366
Toplady, Augustus 90
Top of the Pops 37, 58, 79, 86, 100, 101, 119, 145, 179, 316, 495
Topol, Chaim 283
Torpedo Twins, The 377, 379, 384, 408, 412, 419, 432, 441, 498
Total Guitar 231
Townhouse Studios, The 284, 285, 286, 287, 288, 289, 290, 291, 382, 390, 394, 404, 406, 408, 410, 416, 420, 422, 424, 440, 463, 464, 466, 468, 470, 472, 473, 474, 476, 478, 480, 481
Townshend, Pete 28
Track of My Tears, The 504
Transformer [album] 56, 62
Tranter, Martin 489
Tremeloes, The 161
T. Rex 10, 26, 60, 94, 258
Trident Productions 26, 28, 33, 48, 249, 410
Trident Studios 11, 12, 13, 32, 34, 35, 36, 38, 41, 42, 44, 45, 46, 56, 64, 65, 66, 67, 68, 70, 72, 74, 75, 76, 78, 79, 80, 87, 88, 90, 92, 93, 94, 96, 98, 100, 102, 103, 104, 106, 108,
110, 112, 116, 118, 119, 122, 125, 147, 148, 212
Trillion Studios 261, 268
Tubular Bells [album] 158
Tumbleweed Connection [album] 78
Turner, Andy 193
Turn on the TV 188, 202
Tutti Frutti 484, 487
20th Century Fox Fanfare 495
Twisted Sister 39, 73, 234
Tyrannosaurus Rex 10, 154

U2 334
UK Rock'n'Roll Hall of Fame 502
Ulrich, Lars 411
Uncle Mac's Children's Favourites 108, 138
Under Pressure 295, 299, 316, 318, 320-321, 322, 374, 394, 428, 432, 453, 460, 484, 485, 486, 487, 491, 492, 495, 505
Under Pressure *(Rah Mix)* 492
Union Studios 258
Universal Music 493, 507
Unterberger, Richie 44
Urban Dance Squad 423
Uris Theater 84

Vai, Steve 101
Valentin, Barbara 344, 431, 442
Van Halen, Eddie 209, 270, 286, 326, 342
Vanilla Ice 320, 428
Vasarely, Victor 221
Verlant, Gilles 248
Versace, Gianni 448, 498
Vicious, Sid 189
Victory 360
Victory [album] 360
Video Killed the Radio Stars 338
Village People 204
Vincent, Gene 28
Vincent, Paul 466
Viola, Roberto Eduardo 296
Virgin 506
Virgin EMI 488, 489, 493, 495
Virginian, The [album] 106
Virginia Wolf [band] 366
Virgin Records 154, 158
Visconti, Tony 48
Vultan's Theme (Attack of the Hawk Men) 279, 289, 290, 291

Wagner, Richard 64, 283, 290
Walking on the Moon 271

Walk This Way 262
Wall, The [album] 369
Ward, Carl 460, 501
Warner, label 152, 153
Was It All Worth It 399, 405, 406, 422, 424, 493
Waters, Roger 256
Watts, Paul 144
Wayne's World 145, 460
We All Are One 383
We Are the Champions 112, 175, 185, 193, 194-195, 228, 232, 248, 322, 337, 384, 394, 456, 476, 484, 485, 486, 487, 490, 492, 502, 504, 505, 506, 507
We Are the Champions *(Alternative Version)* 506
We Are the Champions *(Backing Track)* 506
We Are the Champions *(Live Aid)* 495
We Are the Champions *(Live at the MK Bowl 1982)* 506
Wedding March, The 64, 290, 424
Weeknd, The 318
Weinreich, Dennis 122, 126
Wells, H.G. 412
Wembley concert 175, 460, 471, 476
Wembley Stadium 131, 372, 394, 452, 484, 495
We're Not Gonna Take It 234
Wessex Sound Studios 84, 92, 94, 96, 98, 102, 106, 108, 158, 161, 166, 168, 170, 171, 172, 174, 176, 180, 181, 188, 192, 193, 196, 204, 206, 210, 215
We Will Rock You 88, 185, 189, 192-193, 194, 195, 196, 200, 212, 228, 230, 232, 234, 236, 238, 246, 248, 322, 337, 394, 411, 476, 484, 485, 486, 487, 490, 491, 492, 495, 498, 502, 505, 506, 507
We Will Rock You *(Alternative Version)* 506
We Will Rock You *(Backing Track)* 506
We Will Rock You *(BBC Session)* 506
We Will Rock You *(BBC Session 6)* 495
We Will Rock You *(Fast)* 485, 486
We Will Rock You *(Fast) (BBC Session)* 506
We Will Rock You *(Fast) (BBC Session 6)* 495
We Will Rock You *(Live at the MK Bowl 1982)* 506
We Will Rock You *(Live in Tokyo 1982)* 506

We Will Rock You *(Rick Rubin "Ruined" Remix)* 498
Wham! 239
What's So Bad About Peace, Love and Understanding 408
When Doves Cry 298
When the Levee Breaks 68
Where Did Our Love Go 383
Where Were You 444
White Man 157, 174, 176, 178, 306, 354
White Queen (As It Began) 55, 66, 68, 182, 231, 488, 489
White Queen *(BBC Session 4)* 495
White Side 56, 64, 67, 68
Whitesnake 212
White Stripes, The 193
Whole Lotta Love 504
Whole Lotta Rosie 414
Who Needs You 185, 202, 207, 506, 507
Who Needs You *(Acoustic Take)* 506
Who, The 28, 56, 65, 185, 192, 202, 224
Who Wants to Live Forever 365, 369, 386, 388, 399, 427, 438, 484, 487, 491, 494, 495
Who Wants to Live Forever *(Greatest Hits II Edit)* 492
Wigg, David 360
Williams, Boris 14
Williams, John 283, 284
Wilson, Brian 78
Winkler, Henry 268
Wishing Well 502
Wissnet, Stephan 304, 306, 308, 310, 311, 312, 314, 315, 316, 344, 346, 352, 356, 360, 391, 466
Wolstenholme, Christopher 264
Wonder, Stevie 239, 390
Wood, Natalie 60
Woodstock 8
Workman, Geoff 84, 92, 94, 96, 98, 102, 106, 108, 220, 228, 230, 231, 232, 234, 236, 238, 239, 240, 242, 244, 246, 247
Works, The [album] 324-359, 365, 377, 399, 427, 459, 466, 468, 483, 494, 500
Wreckage 11, 14

Yardbirds 8, 20
Yeadon, Terry 12, 30, 32
Yeah 459, 481
Yeah! [album] 104
Yellow Dog Blues 80
Yes 10, 433

You and I 157, 166, 167, 170, 172
You Can Do a Lot of Things at the Seaside 133
You Don't Fool Me 431, 459, 462, 463, 478-479, 480, 492
You Don't Fool Me *(Album Version)* 478
You Don't Fool Me *(Dancing Divas Club Mix)* 478
You Don't Fool Me *(Dub Dance Single Mix)* 478
You Don't Fool Me *(Edit)* 478
You Don't Fool Me *(Freddy's Club Mix)* 478
You Don't Fool Me *(Late Mix)* 478
You Don't Fool Me *(Sexy Club Mix—Mis-Pressed Edit)* 478
You'll Never Walk Alone 192, 304
Young, Angus 358
Young, Richard 20
Young, Tim 485
You're Driving Me Crazy 138
You're My Best Friend 20, 73, 106, 115, 121, 128-129, 132, 158, 172, 174, 181, 200, 218, 239, 248, 266, 322, 348, 480, 490, 492, 494
You're So Square (Baby I Don't Care) 484, 487
Your Song 34, 37
You Sexy Thing 140
You Take My Breath Away 23, 157, 160, 168-169, 181
You've Got to Hide Your Love Away 112

Zellis, Brian "Jobby" 256
Ziggy Stardust 87
Zoetemelk, Joop 232
ZZ Top 209, 230

ACKNOWLEDGMENTS

Thanks to the authors cited in the bibliography for the passion and the time invested in the writing of works that were invaluable to my research.

Thanks to Flavie Gaidon, from Éditions E/P/A, for her trust.

Thanks to Laurence Basset and Myriam Blanc, without whom this book would not have been possible.

Thanks to Sara Quémener and Zarko Telebak for the hours spent finding the perfect photos of John, Brian, Freddie, and Roger, and to Charles Ameline for his attentive ear.

Thanks to Nathalie Lefebvre, Jérôme Clerc, and Romain Clerc for their unfailing support.

This book is dedicated to my parents, Gérard and Chantal Clerc, who used to let me rummage through their vinyl collection when I was a child and place the stylus on their *News of the World*, *The Game*, and *Jazz* albums, whose covers and songs inspired so many of my dreams.

PHOTO CREDITS

© **ABACA:** The Sun/News Licensing/ABACA 327 • © **AGENCE DALLE:** Peter Mazel–Sunshine/DALLE 9, 67 • LFI/DALLE 47, 429, 435 • Mick Rock/DALLE 59, 86 • Terry O'Neill–Iconic Image/DALLE 144 • DPA/DALLE 335 • Simon Fowler– Avalon/DALLE 415 • Paul Rider –Avalon/DALLE 419 • Pictorial/DALLE 423 • © **ALAMY:** Tracksimages.com/Alamy Stock Photo 169 • John Henshall/Alamy Stock Photos 282, 293 • Zoonar GmbH/Alamy Stock Photo 461 • DPA Picture Alliance/Alamy Stock Photo 477 • Prisma by Dukas Presseagentur GmbH/Alamy Stock Photo 480 • © **BRIDGEMAN:** 205 • Derek Bayes/Bridgeman Images 73 • © **FASTIMAGE:** Christian Rose/Fastimage 499 • © **GAMMA–RAPHO:** Steve Emberton/Gamma 132, 145 • Steve Emberton/Camera Press/Gamma–Rapho 161 • Terence Spencer/Camera Press/Gamma–Rapho 189, 211 • Brian Aris/Camera Press/Gamma 453 • Clara Molden/Telegraph/Camera Press/Gamma–Rapho 471 • © **GETTY IMAGES:** Keystone/Getty Images 7 • Mark and Colleen Hayward/Getty Images 10, 255 • Mark and Colleen Hayward/Redferns/Getty Images 11, 27, 39 • RB/Redferns/Getty Images 13, 219 • Michael Putland/Getty Images 15, 17, 19, 21, 29, 43, 51, 57, 61, 65, 71, 77, 87, 89, 91, 146, 153, 321, 411, 413, 425, 443, 451, 457 • Evening Standard/Hulton Archive/Getty Images 23, 214 • Michael Ochs Archives/Getty Images 35, 48–49, 100, 109, 121, 165, 173, 179, 180, 187, 188, 197, 199, 206, 346, 437, 501, 508–509 • Historica Graphica Collection/Heritage Images/Getty Images 37, 45 • Jeff Hochberg/Getty Images 40 • Jay Dickman/Corbis/Corbis via Getty Images 42 • George Wilkes/Hulton Archive/Getty Images 44 • Joseph Branston/Guitarist Magazine/Future via Getty Images 52, 53 • Berry Berenson/Condé Nast via Getty Images 60 • Denise Truscello/WireImage/ Getty Images 63 • Koh Hasebe/Shinko Music/Getty Images 69, 85, 111, 117, 118, 127, 245, 303, 525 • Ray Avery/Getty Images 78 • Tony Evans/Getty Images 81 • Museum of London/Heritage Images/Getty Images 90 • Gijsbert Hanekroot/Redferns/Getty Images 93 • Ian Dickson/Redferns/ Getty Images 95, 97, 488 • Terence Spencer/The LIFE Images Collection via Getty Images/Getty Images 99 • Fin Costello/Redferns/Getty Images 101, 259, 404, 440 • Jorgen Angel/Redferns/ Getty Images 105, 177 • Guitarist Magazine/Future via Getty Images, November 23, 2010 108 • Howard Barlow/Redferns/Getty Images 112 • Suzie Gibbons/Redferns/Getty Images 113 • Anwar Hussein/Getty Images 120, 142–143, 149 • Martyn Goddard/Corbis via Getty Images 123, 135 • GP Library/Universal Images Group via Getty Images 126 • Paul Natkin/Getty Images 131 • Monitor Picture Library/Photoshot/Getty Images 137 • Mike McKeown/Daily Express/Hulton Archive/ Getty Images 139 • Chris Walter/WireImage/Getty Images 141, 151 • Dave Hogan/Getty Images 147, 373, 395 • Denis O'Regan/Getty Images 154–155, 162–163, 195, 368–369, 372, 447, 487 • Lichfield Archive via Getty Images 159 • Louise Wilson/Getty Images 167 • Rick Smee/Redferns/ Getty Images 170 • Richard Creamer/Michael Ochs Archives/Getty Images 171, 190–191, 209 • Donaldson Collection/Michael Ochs Archives/Getty Images 174 • Richard E. Aaron/Redferns/Getty Images 183 • Brad Elterman/FilmMagic/Getty Images 203 • Hulton Archive/Getty Images 215 • Georges De Keerle/Getty Images 222–223, 241, 336, 337 • Rob Verhorst/Redferns/Getty Images 225, 263 • Michael Montfort/Michael Ochs Archives/Getty Images 226, 227 • Daily Mirror/Albert Foster/Mirrorpix/Mirrorpix via Getty Images 233 • Kevin Cummins/Getty Images 235 • Ed Perlstein/ Redferns/Getty Images 238, 247 • Ross Marino/Getty Images 256 • John Rodgers/Redferns/ Getty Images 257 • Bettmann/Getty Images 268, 277 • Pete Still/Redferns/Getty Images 275 • Dick Darrell/Toronto Star via Getty Images 281 • Lothar Heidtmann/Picture Alliance via Getty Images 283 • Kenneth Stevens/Fairfax Media via Getty Images 291 • Al Levine/NBC/NBCU Photo Bank 302 • Bobby Bank/WireImage/Getty Images 305 • Capt. Horton/ Imperial War Museums via Getty Images 311 • Ron Howard/Redferns/Getty Images 314 • Ron Galella/Ron Galella Collection via Getty Images 328, 469 • Nigel Wright/Mirrorpix/Getty Images 330, 331, 526–527 • Patrick Aventurier/Gamma–Rapho via Getty Images 332–333 • David Redfern/Redferns/Getty Images 343 • Phil Dent/Redferns/Getty Images 347, 353, 355, 454–455 • Toronto Star Archives/Toronto Star via Getty Images 352 • Duncan Raban/Popperfoto via Getty Images 357, 439 • Keystone/Hulton Archive/Getty Images 359 • CBS via Getty Images 361 • Std/Daily Express/Hulton Archive/Getty Images 363 • Independent News And Media/Getty Images 370–371 • CNP/Getty Images 377 • Lynn Goldsmith/Corbis/VCG via Getty Images 390 • FG/Bauer–Griffin/Getty Images 396–397, 402–403, 405, 484 • Tim Roney/Radio Times/Getty Images 401 • Tom Wargacki/WireImage/Getty Images 406, 441 • Laurent Sola/Gamma–Rapho via Getty Images 407 • Wally McNamee/Corbis/Corbis via Getty Images 417 • Hulton-Deutsch/Hulton–Deutsch Collection/Corbis via Getty Images 421 • Ken Lennox/Mirrorpix/Getty Images 431 • Robert Knight Archive/Redferns 445 • Mick Hutson/Redferns/Getty Images 448, 457 • Philippe Pache/Gamma–Rapho via Getty Images 449 • Kevin Mazur/WireImage 456 • Margaret Norton/NBCU Photo Bank/NBCUniversal via Getty Images via Getty Images 462 • Stephane Cardinale/Sygma via Getty Images 463 • Apic/Getty Images 475 • Fox Photos/Hulton Archive/Getty Images 485 • Brill/Ullstein Bild via Getty Images 503 • Neil Lupin/Redferns via Getty Images 504–505 • Kent Gavin/Mirrorpix/Getty Images 516– 517 • © **PETER HINCE :** 75, 129, 175, 201, 213, 220–221, 239, 249, 253, 254, 255, 261, 262, 265, 266, 267, 269, 270, 271, 273, 274, 276, 285, 297, 298, 299, 307, 309, 313, 315, 316, 317, 319, 323, 329, 340, 341, 349, 351, 367, 375, 378–379, 381, 387, 392–393, 465, 467, 473, 479, 486, 489 • © **LEEMAGE:** Mirrorpix/Leemage 310 • © **JENNY LENS:** 243 • © **MIRRORPIX:** 164 • © **SIPA:** 58 • Andre Csillag/REX/Shutterstock/SIPA 107, 119, 160–161, 229, 383 • Andre Csillag/ REX Features/REX/SIPA 125 • Fraser Gray/REX/SIPA 193 • Mary Evans/AF Archive/SIPA 237 • Ilpo Musto/REX Features/REX/SIPA 300–301 • ANL/REX/SIPA 339 • Mark Mawson/REX/SIPA 345 • Philip Dunn/REX Features/REX/SIPA 385 • Studiocanal Films Ltd/Mary Evans/SIPA 391 • Young/REX Features/SIPA 409 • Alan Davidson/REX/SIPA 430 • Sheila Rock/REX/Shutterstock/ SIPA 442 • © **TCD PHOTOTHÈQUE:** Prod DB © De Laurentiis–Starling Films / DR 287, 289 • Prod DB © EMI–20th Century Fox / DR 389 • 20th Century Fox–GK Films–New Regency Pictures–Queen Films Ltd.–Tribeca Productions 496–497 • © **OTHERS:** Wikimedia Commons 31 • All rights reserved 10, 22, 32, 61, 79, 102, 128, 182, 191, 230, 248, 333, 362, 382, 394, 405, 431, 433, 446, 463, 478, 490, 491, 492, 493, 494, 495, 506.

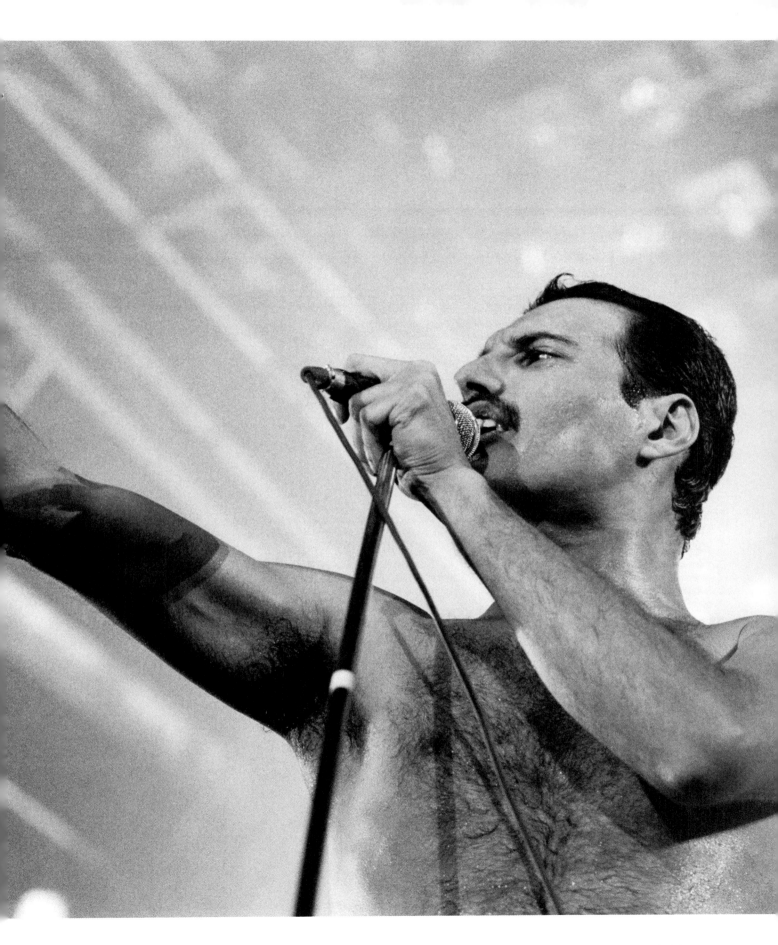

Copyright © 2019, Éditions E/P/A—Hachette Livre
Translation copyright © 2020 by Black Dog and Leventhal Publishers
Translation by Simon Burrows, Caroline Higgitt and Paul Ratcliffe by arrangement with
Jackie Dobbyne of Jacaranda Publishing Services Limited

Jacket design by Katie Benezra
Jacket copyright © 2020 by Hachette Book Group, Inc.

Front cover photograph © Mick Rock 1974, 2020

Back cover photograph © Denis O'Regan/Getty Images

Original title: Queen, *La Totale*
Texts: Benoît Clerc
Published by Éditions E/P/A—Hachette Livre, 2019

Hachette Book Group supports the right to free expression and the value of copyright. The purpose of copyright is to encourage writers and artists to produce the creative works that enrich our culture.

The scanning, uploading, and distribution of this book without permission is a theft of the author's intellectual property. If you would like permission to use material from the book (other than for review purposes), please contact permissions@hbgusa.com. Thank you for your support of the author's rights.

Black Dog & Leventhal Publishers
Hachette Book Group
1290 Avenue of the Americas
New York, NY 10104

www.hachettebookgroup.com
www.blackdogandleventhal.com

First English-language Edition: October 2020

Black Dog & Leventhal Publishers is an imprint of Perseus Books, LLC, a subsidiary of Hachette Book Group, Inc. The Black Dog & Leventhal Publishers name and logo are trademarks of Hachette Book Group, Inc.

The publisher is not responsible for websites (or their content) that are not owned by the publisher.

The Hachette Speakers Bureau provides a wide range of authors for speaking events. To find out more, go to www.HachetteSpeakersBureau.com or call (866) 376-6591.

LCCN: 2020938922

ISBNs: 978-0-7624-7124-9 (hardcover), 978-0-7624-7123-2 (ebook)

Printed in China

10 9 8 7 6 5 4 3 2 1